PLACE-MAKING FOR THE IMAGINATION:
HORACE WALPOLE AND STRAWBERRY HILL

To Joshua and Jennifer

Place-making for the Imagination:
Horace Walpole and Strawberry Hill

Marion Harney

ASHGATE

Published by
Ashgate Publishing Limited
Wey Court East
Union Road
Farnham
Surrey, GU9 7PT
England

Ashgate Publishing Company
110 Cherry Street
Suite 3-1
Burlington, VT 05401-3818
USA

www.ashgate.com

British Library Cataloguing in Publication Data
A catalogue record for this book is available from the British Library.

The Library of Congress has cataloged the printed edition as follows:
Harney, Marion.
 Place-making for the imagination : Horace Walpole and Strawberry Hill / by Marion Harney.
 pages cm
 Includes bibliographical references and index.
 ISBN 978-1-4094-7004-5 (hardback) -- ISBN 978-1-4094-7005-2 (ebook) -- ISBN 978-1-4094-7006-9 (epub) 1. Walpole, Horace, 1717-1797--Aesthetics. 2. Strawberry Hill (Twickenham, London, England) 3. Aesthetics, British--18th century. 4. Walpole, Horace, 1717-1797--Homes and haunts--England--London. 5. Twickenham (London, England)--Buildings, structures, etc. I. Title.
 PR3757.W2Z647 2013
 823'.6--dc23

2013004545

ISBN 9781409470045 (hbk)
ISBN 9781409470052 (ebk – PDF)
ISBN 9781409470069 (ebk – ePUB)

FSC
www.fsc.org
MIX
Paper from
responsible sources
FSC® C013985

Printed in the United Kingdom by Henry Ling Limited,
at the Dorset Press, Dorchester, DT1 1HD

Contents

Illustrations

Preface
Walpole moves from Strawberry Hill to Connecticut

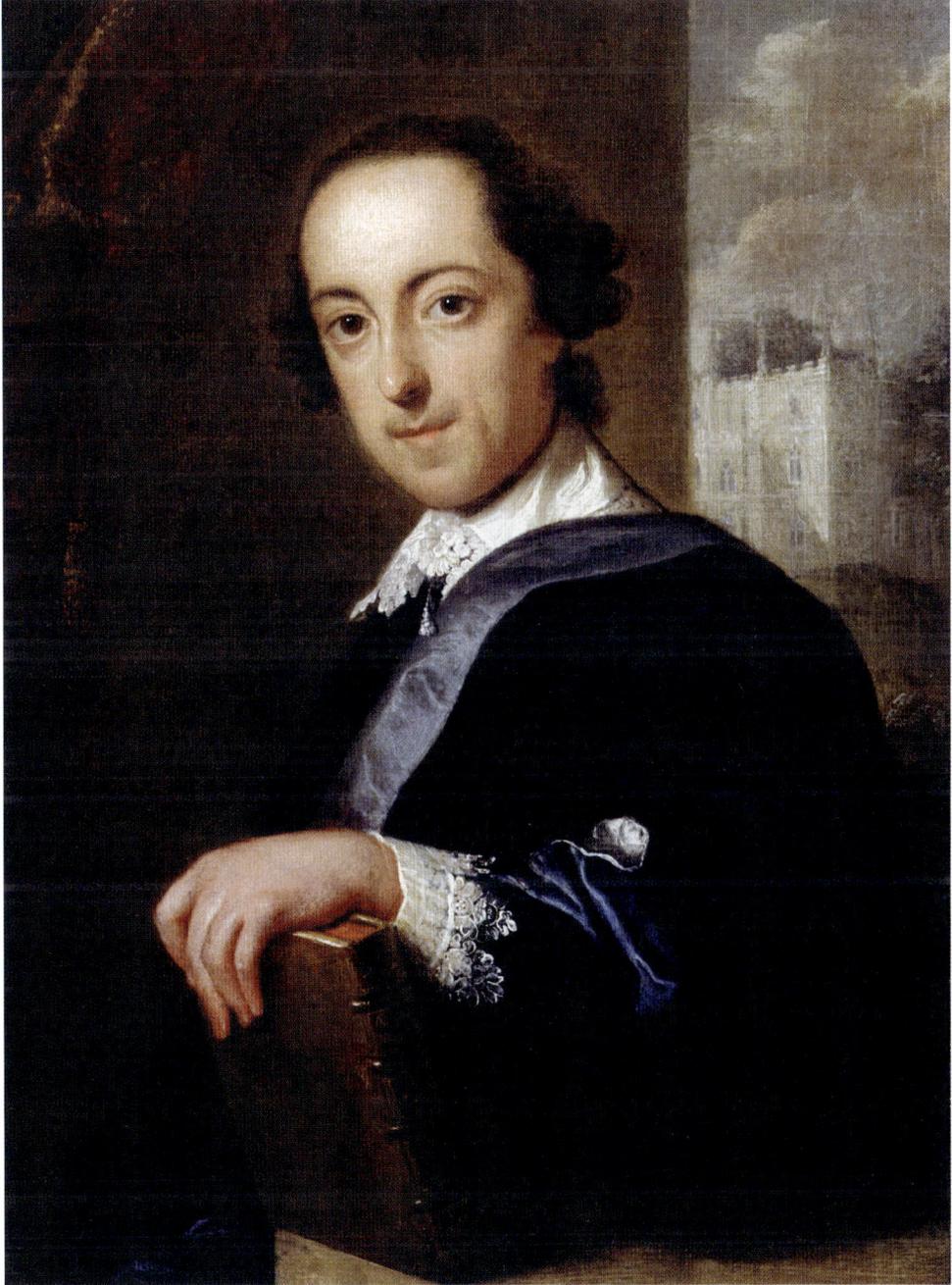

P.1 *Horace Walpole* by John Giles Eccardt, 1754

Strawberry Hill, the Gothic villa and associated landscape, seat of Horace Walpole (1717–97), is mandatory in any assessment of eighteenth-century British architecture, yet the reasons for its creation have never been adequately explained or fully understood. Here it is demonstrated, for the first time, that Walpole's ideas which informed Strawberry Hill are inspired by theories that stimulate 'The Pleasures of the Imagination' as articulated in essays by Joseph Addison (1672–1719) published in *The Spectator* (1712).[1] Walpole's reasons for choosing Gothic have been largely misunderstood, valuing as he did this 'true' style of British architecture for its associative and imaginative connotations and as a means of expressing historical interpretation through material objects. This book affirms that Strawberry Hill expressed the idea that it was based on imagined monastic foundations using architectural quotations from Gothic tombs, representing visual links to historical figures and events. Moreover, an argument develops as to how Walpole's theories expressed in *Anecdotes of Painting in England* (1762–71) and *The History of the Modern Taste in Gardening* (1780) became manifest at Strawberry Hill.[2]

The villa at Strawberry Hill which Walpole designed with the aid of a 'committee' made up of close friends altered the course of architectural history. For the first time an entire house was conceived in a picturesque native antique Gothic style deliberately designed to convey a sense of accretion over time. Strawberry Hill has been conventionally viewed (often disparagingly) as the precursor to nineteenth-century Gothic Revival.[3] However, the principles adopted by the later archaeological Gothic Revival would have been anathema to Walpole and the anachronistic observations miss the point of Walpole's objectives. Far from the nineteenth-century Gothic Revivalists' religious, ethical bias, Strawberry Hill embodies an entirely different set of ideas to which the key lies in the cultural pursuits and theories of imaginative pleasure that Walpole engaged with. Crucially, in his later antiquarian writing Walpole cultivated a consistent philosophical approach to theories on Gothic architecture and its imaginative and associational aspects which are most notably expressed in *Anecdotes of Painting*.

Strawberry Hill is depicted here as a sequence of theatrical spaces playing with scale, colour and atmosphere, specifically designed to create surprise and wonder in order to stimulate the imagination. A series of sensory effects and moods, based on contemporary landscape theory, create a background to Walpole's collection of cultural and historical artefacts – each 'singular', 'unique', or 'rare' – artfully displayed to produce their own narrative.

Unlike previous studies, the villa and landscape are evaluated as an entity, a structured essay in associative, imaginative thought. Finally, Strawberry Hill is reconstructed as it existed in Horace Walpole's time, leading the reader on an integrative virtual tour of buildings, gardens, emblematic models and associative inspirations.

The *Genius Loci* of Strawberry Hill lies somewhere betwixt and between Strawberry Hill, the Gothic villa that Horace Walpole created on the banks of the Thames from 1747 at Twickenham, England and the Lewis Walpole

library located in the town of Farmington, Connecticut, USA. The latter, sited amid manicured lawns and white clapboard colonial houses is now the prime resource for material relating to Horace Walpole after its contents were dispersed from Strawberry Hill following the 1842 sale. Wilmarth Sheldon Lewis (1895–1979), a Yale scholar and affluent, passionate American collector, was fascinated by Walpole and the view of the eighteenth century expressed in his letters and those of his contemporaries. He began accumulating *Walpoliana* in the early 1920s, amassing an impressive collection of items, starting out at first with literary artefacts, books that Walpole had owned or printed at Strawberry Hill. But the remit grew exponentially to include portraits of Walpole or those he had owned, furnishings, stained glass, snuff boxes, prints, engravings – the list goes on. In 1980 he bequeathed his extensive collection to constitute the Lewis Walpole Library, a research centre for eighteenth-century studies and a department of Yale University Library.

Lewis edited and published Walpole's *Correspondence* and much else besides.[4] There is a significant quantity of publications of Walpole's life and works ranging from biography, criticism of his innovative Gothic novel *The Castle of Otranto* (1764), to critiques of the influential Gothic Revival villa at Strawberry Hill, Twickenham, Middlesex and collections of his *Correspondence*. Posthumous publications, the collection at Strawberry Hill and its subsequent sale in 1842 all received attention at the time with many of the issues from Walpole's private press becoming collectors' items. Some of his books and items from his collection now reside in repositories including the British Library, the Royal Collection, the British Museum and the Victoria and Albert Museum.

The immense volume of Walpole's writing, combined with an abundance of other material, has resulted in the tendency to compartmentalise or catalogue his activities in discrete fields without reference to other areas. This has led to a misunderstanding of the integration of ideas that Walpole was striving to draw together at Strawberry Hill. The diversity, complexity and volume of Walpole's output has made it difficult to locate an integrated theoretical approach to his literature, architecture and landscape design. As a consequence this has led to a misguided or, at best, a limited view of the themes and topics that Walpole addresses through various media.

Lewis's greatest contribution to Walpole studies stems from the project to collect and publish a scholarly edition of his *Correspondence* – for it is Walpole's reputation as a letter writer that gives most support for his claim to posterity. Lewis took an opposing view to the generally accepted portrayal of Walpole as a social and intellectual butterfly, an 'ingenious trifler' as Edward Gibbon (1737–94) the English historian and MP mockingly referred to him.[5] To Lewis, Walpole's library and literary works indicated that he consciously sought to be viewed as an informal historiographer, recording social and historical events of the eighteenth century. So Lewis embarked on a project to reinstate respect for Walpole and rescue his reputation from the obscurity in which it had hitherto languished.

In order to continue the rehabilitation process, Lewis published a paper titled, 'A Library Dedicated to the Life and Works of Horace Walpole', in *The Colophon, A Book Collectors Quarterly* (1930). Lewis explained in the preface to the first volume of Walpole's *Correspondence* the need for a completely new, heavily annotated, definitive edition which would rectify the errors, omissions and inaccuracy of previous publications:

There are three good reasons for a new edition of Walpole's correspondence: to give a correct text, to include for the first time letters to him, and to annotate the whole with the fullness that the most informative record of the time deserves … Its primary intention is to facilitate the studies of scholars in the eighteenth century. Sooner or later, the eighteenth century scholar, be his subject what it may, must consult Walpole's correspondence. Politics, Society, Literature and the Arts, these are the subjects which immediately come to mind when Horace Walpole is thought of, but there are as many more as there were divisions in eighteenth century life.[6]

Lewis's intervention provoked a resurgence in Walpole studies, considerably raising his profile by writing critical studies, editing his works and documenting his collecting activities. Walpole was a compulsive and prolific writer, brilliant essayist and his epistolary standing is formidable and this is amply demonstrated by the sheer volume of over 4,000 extant letters. The Yale edition of *The Correspondence of Horace Walpole* (1937–83) conceived by Lewis in the 1930s began in earnest in July 1933. The first two volumes, Walpole's correspondence with his friend the Cambridge clergyman and antiquary William Cole (1714–82), were published in 1937. The 48 volumes were complete in 1983, but sadly Lewis died without seeing the final volumes published. Not all the volumes have won critical acclaim; the six volumes of correspondence with Madame du Deffand (1697–1780) a prolific letter writer who presided over an informal literary salon in Paris are particularly disappointing because Walpole had destroyed most of his letters to her. There was some criticism too of the earlier volumes over inclusions and omissions, or lack of translation of Greek passages. That said, the standard of scholarship in the erudite footnotes and insightful commentary, particularly in the later volumes, is exemplary, adding greatly to the body of knowledge of eighteenth century, life and culture. However, this process had the effect of demoting Walpole's status. As James Johnson says in his essay 'Horace Walpole and W.S. Lewis:'

From his hypothetical position as keeper of the most informative record of his times, Walpole was implicitly relegated to the position of a major source, the central link of a cultured nexus. And simultaneously, the Yale edition of the *Correspondence* became less a definitive edition of Walpole's letters, or even a variorum edition, than a synopticon of views connected solely by their form and their addressee.[7]

Nevertheless, the Yale edition of the *Correspondence* complemented by Hazen's detailed study of Walpole's Library and the collection of published and unpublished material at the Lewis Walpole Library combined with the British Library holdings remain an unrivalled resource for studying Walpole and his contemporaries.[8]

The villa of Horace Walpole in Twickenham, acquired in 1747, started life in 1698 as a 'shapeless little box', Chopped Straw Hall, which he renamed Strawberry Hill. The design of the house and naturalistic landscape setting was one of the earliest picturesque ensembles in England and, in Walpole's time, Strawberry Hill received many visitors. Until recently, however, both house and garden were relatively little known or visited, and it is no longer possible to experience the villa or garden in its original conception because much has been altered or developed. Following its listing in 2002 by the World Monuments Fund as one of the hundred most endangered buildings in the world, the Strawberry Hill Trust, formed in 2002 commissioned a conservation plan to restore the house and what remained of the garden, reinstating a context for Walpole's Gothic villa; the project has plans to restore the Prior's Garden, recreate the 'theatrical' border and replant the Grove. To coincide with the renovation and reopening of the house to the public in 2011 a lively and colourful exhibition, organised in 2010 by the Victoria and Albert Museum, the Lewis Walpole Library, Yale University and the Yale Center for British Art, brought together part of Walpole's collection. This included pictures, silver, ceramics and glass, miniatures and enamels, and curious objects of virtù. There has also been a corresponding flurry of recent publications on Strawberry Hill.

All quotations from Horace Walpole and other contemporaries are reproduced throughout the text with original spellings, punctuation and layout.

Acknowledgements

I am especially grateful to Professor Vaughan Hart as my PhD supervisor, for his invaluable advice, time and expertise. I am immensely grateful to Dr Michael Forsyth for his consistent support, valuable time and expert guidance, which was given freely. Sincere thanks are due to the Lewis Walpole Library for providing me with excellent accommodation at no charge in order to carry out my primary research and for allowing access to their collection and facilities. Special thanks are owed to Margaret Powell, W.S. Lewis Librarian and Executive Director and to Susan Walker, Head of Public Services for their unstinting help during the many hours spent in the library and for providing most of the images for this book. I would like to thank the staff at the University of Bath Library (particularly the Inter-Library Loans section) and the librarians of the British Library, Bodleian Library, Richmond Local Studies Library and the Fitzwilliam Museum for their help, patience and support during the period of my research. I am indebted to Dr Jonathan Foyle, Chief Executive of the World Monuments Fund and the Chairman of the Strawberry Hill Trust Michael Snodin for allowing me generous access to the site and buildings and to Peter Inskip of Inskip and Jenkins for making available documentation and other materials uncovered during their conservation project. Special thanks are due to Lucie Pursell for her help and

patience and I am grateful to Mark Wilson Jones for his timely advice and to Gaelle Jolly for her French translations. Finally I would like to thank my family for being so immensely supportive, cooperative and understanding.

<div align="right">Marion Harney, December 2012</div>

Endnotes

1. Addison, J. *The Spectator*, No. 411, 22 June 1712. *The works of Joseph Addison*: complete in three volumes: embracing the whole of the 'Spectator', &c. (3 vols, New York, 1837). All quotations are from this edition.

2. *Anecdotes of Painting in England and a Catalogue of Engravers* (5 vols, Twickenham, 1762–80). The final volume containing the *History of the Modern Taste in Gardening* was printed in 1771 but not published until 1780. All quotations are from this facsimile edition; *The History of the Modern Taste in Gardening* (New York, 1995), p. 26.

3. His villa has been the subject of much opprobrium since its inception. C.L. Eastlake (ed.) *A History of the Gothic Revival* (New York, 1970) describes Strawberry hill as a 'this small and whimsical abode' and continues acerbically of Walpole's eclecticism in choosing models for the interior decoration: 'Ceilings, screens, niches. &c., are all copied, or rather parodied, from existing examples, but with utter disregard for the original purpose of the design. To Lord Orford Gothic was Gothic, and that sufficed. He would have turned an altar-slab into a hall table, or made a cupboard of a piscine, with the greatest complacency if it only served his purpose', p. 47. McCarthy, M. *The Origins of the Gothic Revival* (New Haven and London, 1987) argues that Strawberry Hill's significance is in 'introducing asymmetry into domestic architecture and historicism into the Gothic Revival'.

4. The definitive edition is *The Yale Edition of Horace Walpole's Correspondence,* Lewis, W.S. *et al.* (eds) (48 vols, New Haven and London, 1937–83). All quotations are from this edition.

5. Johnson, J.W. 'Horace Walpole and W.S. Lewis', *Journal of British Studies*, vol. 6, No. 2 (May 1967), pp. 64–75.

6. Lewis, Preface to *Horace Walpole's Correspondence with the Rev. William Cole*, vol. 1 (New Haven and London, 1937).

7. Johnson, J.W. 'Horace Walpole and W.S. Lewis', pp. 64–75.

8. Hazen, A.T. and Kirby, J.P. *A Bibliography of Horace Walpole* (New Haven and London, 1948). Hazen also completed the excellent, *A Catalogue of Horace Walpole's Library* (3 vols, New Haven and London, 1969) and *A Bibliography of the Strawberry Hill Press* (New Haven and London, 1942).

Introduction
'Things come to light': Experiment and Experience –
The Philosophical and Cultural Context

> Visions, you know, have always been my pasture; and so far from
> growing old enough to quarrel with their emptiness, I almost think
> there is no wisdom comparable to that of exchanging what is called
> the realities of life for dreams. Old castles, old pictures, old histories,
> the babble of old people make one live back into centuries that cannot
> disappoint one. One holds fast and surely what is past …[1]

So remarked Horace Walpole, 4th Earl of Orford and youngest son of the
Whig politician Robert Walpole (1676–1745) 1st Earl of Orford, Member of
Parliament for King's Lynne, Norfolk and the first 'Prime Minister' of Great
Britain.[2]

Horace Walpole was Member of Parliament for Callington, Cornwall
(1741–54), Castle Rising, Norfolk (1754–57) and Kings Lynne, Norfolk (1757–68)
and member of the Society of Antiquaries from 1753. He was simultaneously
historian, collector, connoisseur, social and political commentator, writer and
author. Here is a figure revelling in a lifelong fascination with English history
and the past with all its associative connections and interactions between events
and artefacts that inform the present and stimulate the imagination. Horace
Walpole is something of a contradiction; although not forgotten, his influence
and reputation in matters of taste have waned and he is remembered for
different things by different people, some of them controversial. He remains
an ambivalent character and this is represented in the differing approaches
that past and present authors have adopted when discussing him. Many have
written of his shortcomings – a malicious gossip, his effeminate traits, a tendency
to spiteful comments – but less attention has been paid to his positive attributes
– loyalty to his circle of friends and family, his altruism and tolerance. In the
eighteenth century he received critical acclaim for his antiquarian works and
as the author of the first Gothic novel, but paradoxically, to his contemporaries,
he was either an object of contempt or sympathy for his unwitting involvement
in the Thomas Chatterton (1752–70) affair in which he was unfairly accused of

2 PLACE-MAKING FOR THE IMAGINATION: HORACE WALPOLE AND STRAWBERRY HILL

causing the death of the poet/forger whom he had never met. The stigma of blame for Chatterton's suicide caused Walpole much pain and sadness during his lifetime and the criticism and unjust attacks went with him to the grave and beyond. Castigated and maligned by the poet, historian and politician Thomas Babington Macaulay (1800–1859) in his famous essay Walpole's reputation suffered irreparable damage during the nineteenth century.[3] Thereafter he drifted into obscurity and only began to emerge from the layers of critical disapproval which obscured his serious achievements in the late nineteenth and early twentieth century. Walpole's rehabilitation was largely achieved through the publication of his copious *Correspondence* which critically re-evaluates him as a thinker, critic and author of note.

A prominent figure of his age, he embraced a range of interests, wrote prolifically, recording his thoughts in extensive correspondence and other texts, throughout most of the eighteenth century. A man of taste and letters, he was acquainted with many fields of study: antiquarianism, architecture, literature, and the sister arts of poetry, painting and gardening. His quest for understanding, perpetual curiosity and pursuit of antiquarian knowledge epitomised the spirit of enquiry that characterises the Age of the Enlightenment.

The formation of the Royal Society (1660), the Society of Antiquaries (1717) and the Society of Dilettante (1734) played a crucial role in the Enlightenment in disseminating discourses and providing a forum for public participation and debate where factual observation, ideas, hypotheses and projects could be presented to a like-minded audience.[4] Many members belonged to more than one society and were polymaths themselves and this led to a cross-fertilisation of ideas across disciplines – history, antiquities, art, commerce, natural history, the condition of man. For example, Sir Isaac Newton's (1642–1727) observations and experiments in mathematics and physics formulated a number of natural laws that discredited earlier notions of divine forces. In the field of antiquarianism the public availability of manuscripts, coins and seals combined with discoveries made by antiquarians like Richard Gough (1735–1809), Fellow of the Society of Antiquaries whom Walpole knew – and initially despised – resulted in reinterpretations of history and the identification of interrelationships across different fields.[5] Nowhere is this more evident than in Walpole's own building and collection where he made links between artefacts, history, people and places, bringing the items to life through provenance, description, association and imagination. It was this investigative curiosity that epitomised antiquarian studies and for Walpole the new spirit of enquiry generated a sense of patriotism, nationhood and national identity, inextricably linked to personal identity. This led to a fundamental change in methodology and approach:

Historians traditionally dealt with tracing political events, heavily reliant on the accounts of the classical authors and writers considered to be contemporary with events. Antiquaries, on the other hand, in their 'learned curiosity' described all aspects of life, systematically, through the evidence provided by language, literature, custom and the material remains of the past, ruins and relics.[6]

Education of the reader in matters of taste, 'polite imagination' and sensory response was a central concern of eighteenth-century cultured thought.

Walpole knew the work of the philosopher and physician John Locke (1632–1704) well. Locke had compared the mind to a cabinet and collecting, in the sense of the physical museum or the metaphorical 'furnishing the empty cabinet of the mind'. The idea of filling the space of the imagination with visual images and impressions was a vital Enlightenment trope.[7]

The same concept is expressed by Addison in his 'Pleasures of the Imagination' essays where he advised his readers to include the reading of histories, fables and engagement with nature as well as contemplating illustrious objects as means of soothing the mind and giving pleasure.[8] It was from this desire to educate, inform and 'fill the Mind with splendid and illustrious Objects' that the British Museum was founded. Walpole was made a trustee of the collection of Sir Hans Sloane (1660–1753), physician and collector, which formed the basis of the British Museum's collection when it was offered to the nation in 1753 and was preserved as a single entity for the enlargement of knowledge and the good of the nation.

The availability of objects, monuments, material remains and antiquities for study at first-hand formed a significant advance in the search for information, as reliance previously had been on written sources, enabling new insights into past and present cultures and civilisations. The collecting of coins and medals marked the eighteenth-century gentleman as much as collecting art, sculpture, drawings and natural history objects. Walpole had a good collection of coins and medals himself. These were the sculptural equivalent of paintings in miniature depicting heroes and gods, and the images and inscriptions, combined with knowledge of Classical texts, enabled antiquaries to transcribe and decipher history through their iconography, adding to knowledge of ancient civilisations. Representing Enlightenment thought in microcosm Walpole's collection of art and artefacts gives us a unique insight into the world of the eighteenth-century collector. Strawberry Hill was the parochial counterpart to the British Museum or the British Library. However, in contrast to the ordered and carefully arranged display at the national museum where you could discover the world, Strawberry Hill offered a heterogeneous alternative narrative where the building and the objects told their own spontaneous, imaginative history while revealing much about the collector's character and status.

Walpole's writing and collecting represent a small-scale manifestation of that same spirit of enquiry and educational remit that drove the eighteenth-century Enlightenment process of discovery and learning and seeking knowledge in order to display and share it with a wider public body for the good of the British nation. Horace's friend George James [Gilly] Williams (1719–1805) recorded Walpole's intention in respect of creating a museum interior where he 'would breathe life into history' at Strawberry Hill: 'He [Walpole] is going to make an addition to Strawberry, consisting of a Gothic Museum. I think, as Bays says, "that will be a stroke", and the contents of it beyond any repository in the world.'[9]

In April 1746 Walpole wrote a letter under a pseudonym for a periodical entitled *Museum* in which he clearly, if self-deprecatingly, outlined what he thought a museum might contain:

The notion I have of *Museum* is a Hospital for everything that is *singular*; whether the Thing have acquired Singularity, from having escaped the Rage of Time; from any natural Oddness in itself, of from being so insignificant, that nobody ever thought it worth their while to produce any more of the same Sort. Intrinsic Value has little or no Property in the merit of *Curiosities*.

Strawberry Hill was a veritable 'cabinet of curiosities', of objects acquired for their singularity, uniqueness or rarity value, some of which themselves ended up in the British Museum collection. Indeed, one of Walpole's greatest treasures, a great 'speculum', also known as 'The Devil's Looking Glass', that had belonged to John Dee (1527–1608), the Tudor mathematician, astrologist, astronomer and navigator, became a key item of the Museum. In *A Description of the Villa of Mr Horace Walpole* ... (1774 and 1784), the earliest fully illustrated account of any British house, Walpole describes it matter-of-factly as 'A speculum of kennel-coal, [actually a piece of Aztec black obsidian] in a leathern case. It is curious for having been used to deceive the mob by Dr Dee, the conjuror, in the reign of queen Elizabeth.'[10] In this description we witness Walpole's typical mixture of rationalist description of a mystic object combined with its essential associative provenance, having belonged to a significant historical personage connected to the court of Elizabeth I (1533–1603). Strawberry Hill represents, in microcosm, the philosophical and cultural context of the Enlightenment with its commemorative portraits, busts, paintings, sculptural antiquities, eclectic range of artefacts and its library. It was the first purpose-built antiquarian 'museum' interior, a sequence of theatrical spaces that played with scale, atmosphere and colour as a background to his collection of objects, all 'singular', 'unique', or 'rare'.

The antiquarian spirit of enquiry which characterised Enlightenment thinking saw an unprecedented increase in the production and circulation of books, pamphlets and other printed materials. When Addison launched the influential periodical *The Spectator* on Thursday 1 March 1710 he nicely encapsulated the Enlightenment ideal of educating a wider public:

I shall publish a sheet full of my thoughts every morning, for the benefit of my contemporaries; and if I can any way contribute to the diversion, or improvement of the country in which I live, I shall leave it when I am summoned out of it, with the secret satisfaction of thinking that I have not lived in vain.[11]

Walpole was familiar with Addison's *Spectator* essays having been presented by his father with 21 volumes of *The Spectator* and other works when he was 11.[12] Walpole admitted that he greatly admired Addison's prose style:

Eloquence may bestow an immortal style, and one of more dignity; yet eloquence may want that ease, that genteel air that flows from or constitutes grace. Addison himself was master of that grace, even in his pieces of humour, which do not owe their merit to style; and from that combined secret he excels all men that ever lived.[13]

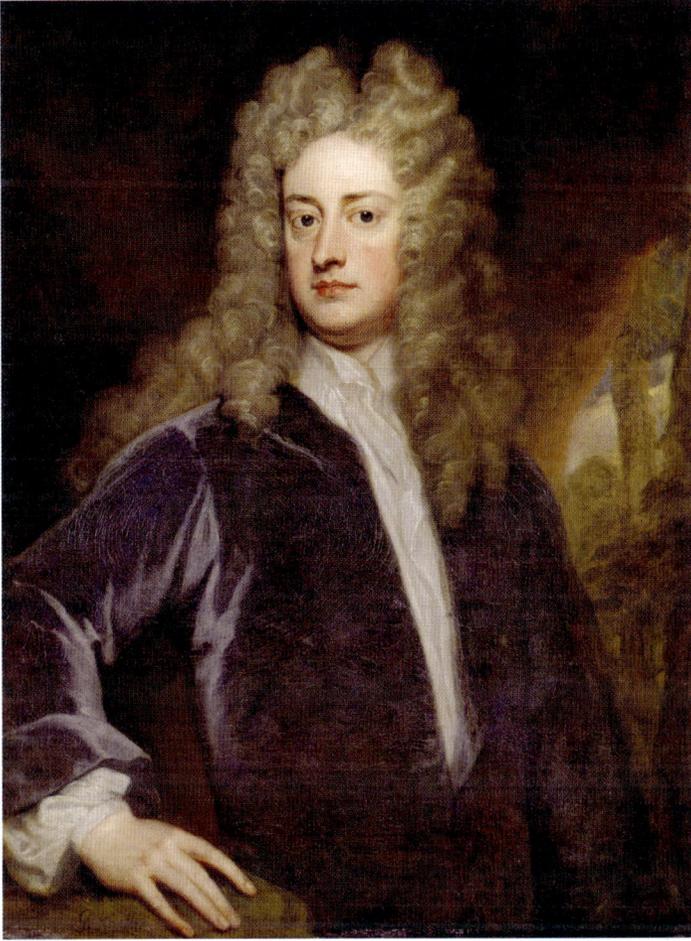

I.1
Joseph Addison
by Sir Godfrey
Kneller,
c.1703–1712

These essays provided an alternative locus of learning to the more structured environment of the formal institutions. Addison testifies to the significantly enlarged numbers of reading public encompassing a wide social spectrum who had access to the explosion of ideas, information and knowledge through this route:

My publisher tells me, that there are already three thousand of them distributed every day: so that if I allow twenty readers to every paper, which I look upon as a modest computation, I may reckon about threescore thousand disciples in London and Westminster, who I hope will take care to distinguish themselves from the thoughtless herd of their ignorant and inattentive brethren.[14]

In his *Spectator* essays, Addison expressed theories on association, in particular 'The Pleasures of the Imagination' where he explores the idea that works of art, artefacts, buildings and settings could induce a series of associative thoughts, trigger memories and invoke emotions.

The stimulating and pleasurable psychological effects produced by the imagination were an essential element of the new sensation psychology theories being discussed in the seventeenth and eighteenth century.[15] Walpole possessed various copies of John Locke's *Essay Concerning Human Understanding* (1690), and Addison was echoing Locke who was first to suggest the concept of association but for Locke it had negative connotations.[16] This was a pessimistic notion that Joseph Addison would seek to disrupt in 'Pleasures of the Imagination'. Walpole concurred with Addison's more optimistic assessment in promoting the positive associational effects of buildings and landscapes and put these into practice at Strawberry Hill, the most enduring testament to his accomplishments in these fields.[17] His many talents and endeavours did not, however, subsequently do him justice because of his fall from grace during the late eighteenth and nineteenth centuries. The immense proliferation of published and unpublished material often had a detrimental effect, obscuring the extent of his creative achievements.[18] But the villa, garden and the idiosyncratic collection he created at Strawberry Hill, combined with his library, constitute one man's voyage of discovery while simultaneously charting his personal taste, sense of decorum and development as an antiquary. Walpole was renowned both for these and for his erudition in the cultural world of the arts and antiquarianism; his opinions and public demonstrations in matters of taste were of consequence to eighteenth-century connoisseurs as well as wider society. His reputation was only tarnished following the unfortunate literary encounter with Thomas Chatterton who later killed himself.[19]

In many ways Walpole, accomplished across a wide range of activities, personified the trend towards diversification that characterised the period, gaining respectability as a serious antiquarian and making significant contributions to historical research and literature. Engaging with a number of significant influential theories and issues such as association, imagination and counter-histories through objects and material remains, he had a pervasive influence on the taste for picturesque Gothic architecture and antiquarian interiors and on the history and development of landscape design.

This book demonstrates for the first time the coherent thread to Walpole's philosophy, tracing the pattern of his thoughts through distinct areas of enquiry to reveal key concepts of association and imagination that are fundamental to the presentation of Strawberry Hill. Walpole thought in terms of images and was adept at connecting a range of topics that interested him, sourced from disparate areas of his life. A work of art or text, a view or vista, a building or landscape could set off a chain of thoughts and recollections. His view of the world was always coloured by his imaginative response to it and this makes the operations of his mind and the products of his speculations intriguing to encounter.

'A confusion of wine and bawdy and hunting and tobacco':
Walpole's Recollection and Reputation

It is important to appreciate Walpole's formative early experiences to understand fully the motivation for Strawberry Hill, which is essentially an autobiographical site. This section analyses the early relationship with his father, which is of particular interest for establishing the subversive, licentious and reactionary notions of the Gothic villa as opposed to the antithetical Palladian style chosen by his father at Houghton Hall, Norfolk (1722–35). It also traces relationships and influences from his Grand Tour which were to make a significant impact on the associative qualities of the landscape and architecture at Strawberry Hill.

Walpole was a prominent member of eighteenth century society, Member of Parliament, Trustee of the British Museum, renowned author and whose house was visited by royalty and aristocracy. *The Dictionary of National Biography* styles him as 'author, politician, and patron of the arts' which is a woefully inadequate description of his accomplishments.[20] Macaulay scathingly described him as 'the most eccentric, the most artificial, the most fastidious, the most capricious of men.' Of Strawberry Hill he added, 'to decorate a grotesque house with pie-crust battlements, – to procure rare engravings and antique chimney-boards, – to match old gauntlets, – to lay out a maze of walks within five acres of ground, – these were the grave employments of his long life.'[21]

His villa at Strawberry Hill, Twickenham has been the subject of much opprobrium since its inception. The art historian Kenneth Clarke (1903–83) criticised it remarking it had been studied 'as least as much as it deserves' and observed that 'to the chilly and humourless historian of taste Strawberry Hill is not merely absurd; it is a ghastly portent' acerbically concluding that Walpole had 'killed craftsmanship.'[22]

Of Walpole's early life little is known except that he was devoted to his mother and that his love for her was reciprocated. He spent most of his time with his mother while his father consorted with his mistress at Houghton and Richmond Park, London and it is apparent in early letters that Horace preferred his mother to his father. He destroyed much correspondence written and received during his formative years at Eton College, Windsor and King's College, Cambridge but from what does remain it is clear that the death of his mother affected him greatly and that he made strong friendships during this period that mostly endured. His father, [later Sir] Robert Walpole, hailed from a land-owning political family that had served as members of Parliament for Kings Lynne and Castle Rising in Norfolk.

Robert succeeded to the family estate at Houghton and the family borough of Castle Rising in 1700 on the death of his father. Shortly before the death of his father Robert Walpole had married Catherine Shorter (1682–1737) who came from a mercantile background. They produced six children, two of which died in infancy, of which Horatio (contracted to Horace because it was 'theatrical and not English') was the youngest.[23] Following the sudden death of his wife in

1737 Robert Walpole married his long-term mistress Maria Skerrett (1702–1738) with indecent haste but she too died a few months after their marriage.

Horace, born at his father's house in Arlington Street, London on 24 September 1717, was a delicate child who was kept at home and cosseted by his mother beginning his education with private tutors from the age of eight at Bexley, Kent and later at Twickenham. He was sent to Eton College in April 1727 until September 1734, having formed strong friendships with George Montagu (1713–80) and Charles Lyttlelton (1714–1768) collectively known as 'the triumvirate'; he was also a member of another more important, intimate circle known as the 'quadruple alliance' consisting of the poet Thomas Gray (1716–71), Richard West and Thomas Ashton.

The group assumed romantic titles from poetry and Classical literature, Walpole was Celadon, Gray Orosmades, West Favonius and Ashton Almanzor.[24] Walpole never forgot his fictional persona or its connections, later hanging a watercolour of the '*Story of Celadon and Astrea*', by W. Baur in the Tribune at Strawberry Hill.[25] The beginnings of Walpole's indulgence in the pleasures of the imagination would appear to date from this time. He fondly recalls the time that he spent at Eton on the banks of the Thames which furnish him with many happy, enduring memories, evoking intimate friendships and pastoral, Virgilian associations: 'Gray is at Burnham, and, what is surprising, has not been at Eton. Could you live so near without seeing it? That dear scene of our quadruple alliance would furnish me with the most agreeable recollections.'[26]

Commencing at King's College, Cambridge in March 1735, he was reunited with his friend Thomas Gray who was already ensconced there. The first visit to his father's seat at Houghton, Norfolk did not occur until 1736, when he was 19, which is recorded in correspondence from Gray, who was acutely aware of the activities that Walpole was exposed to and patently loathed. Gray's observations obviously stem from intimate conversations and go some way to explain Walpole's reluctance to travel to the family estate to engage in 'a confusion of wine and bawdy and hunting and tobacco'.[27] However, the uncouth company aside, it is clear that from an early age Walpole took solace from the landscape, wherever he was:

I am returned to Cambridge, and can tell you what I never expected, that I like Norfolk. Not any of the ingredients, as hunting or country gentlemen, for I have nothing to do with them, but the county; which a little from Houghton is woody, and full of delightful prospects. I went to see Norwich, and Yarmouth, both which I like exceedingly. I spent my time at Houghton for the first week almost alone; we have a charming garden all wilderness; much adapted to my romantic inclinations.[28]

Horace's mother, Lady Walpole, died on 20 August 1737 at Chelsea. He reacted very badly to her death, his health suffered and he withdrew from communicating with friends. The following letter is one of only two extant from the 30-month period following her demise, suggesting that Walpole later destroyed the others because they contained overt criticism of his father:

You will not wonder that I have so long deferred answering your friendly letter as you know the fatal cause. You have been often witness to my happiness, and by that may partly figure what I fell for losing so fond a mother. If my loss consisted solely in being deprived of one who loved me so much, it would feel lighter to me than it now does, as I doated on her. Your goodness to me encourages me to write at large my dismal thoughts; but for your sake I will not make use of the liberty I might take, but will stifle what my thoughts so much run on … I am now got to Cambridge out of a house which I could not bear …[29]

His mother's death was the first and most profound emotional experience of Horace's life and caused him great sorrow which was exacerbated by the indifference of his father and other relatives to the event. Horace later erected an affectionately inscribed monument to her memory in the chapel of Henry VII (1457–1509) in Westminster Abbey; the chapel later became Walpole's model for the ceiling in the Gallery at Strawberry Hill. This act of association firmly linked his mother's presence to Strawberry Hill and he also displayed 'the model of her statue in Westminster-abbey' in the Tribune.[30] It is probable that the studied air of emotional detachment that Walpole cultivated throughout his life stemmed from these tragic early experiences.

Walpole left Cambridge without obtaining a degree and he and Gray left for Paris, their first destination on the Grand Tour in March 1739, thereafter travelling through France and Italy until 1741.[31] The Grand Tour was a formative experience enduing him with a lifelong love of collecting and a passion for antiquarian pursuits which began with this excursion. Writing to his cousin Henry Seymour Conway (1721–95) Walpole states 'I am far gone in medals, lamps, idols, prints, etc. and all the small commodities to the purchase of which I can attain: I would buy the coliseum if I could.'[32] It is already clear from the correspondence that under Gray's expert tutelage in antiquarian matters Walpole was exposed to great buildings, Gothic churches, cultural sites and artefacts which were to remain obsessions throughout his life: '… St Denis, which we saw on the road, and excels Westminster; for the windows are all painted in mosaic and the tombs as fresh and well preserved as if they were of yesterday.'[33]

During their travels through France Walpole first recorded a visit at a Carthusian convent, a significant building type for Walpole displaying a melancholic atmosphere eventually influential at Strawberry Hill:

We saw last week a place of another kind, and which has more the air of what it would be, than anything I have met with: it was the convent of Chartreux [now demolished]. All the conveniences, or rather (if there was such a word) all the *adaptments* are assembled here, that melancholy, meditation, selfish devotion, and despair would require. But yet 'tis pleasing. Soften the terms, and mellow the uncouth horror that reigns here, but a little, and 'tis a charming solitude. It stands on a large space of ground, is old and irregular. The chapel is gloomy: behind it through some dark passages, you pass into a large obscure hall, which looks like a combination-chamber for some hellish council. The large cloister surrounds the burying-grounds. The cloisters are narrow, and very long, and let into the cells, which are built like little huts detached from each other …[34]

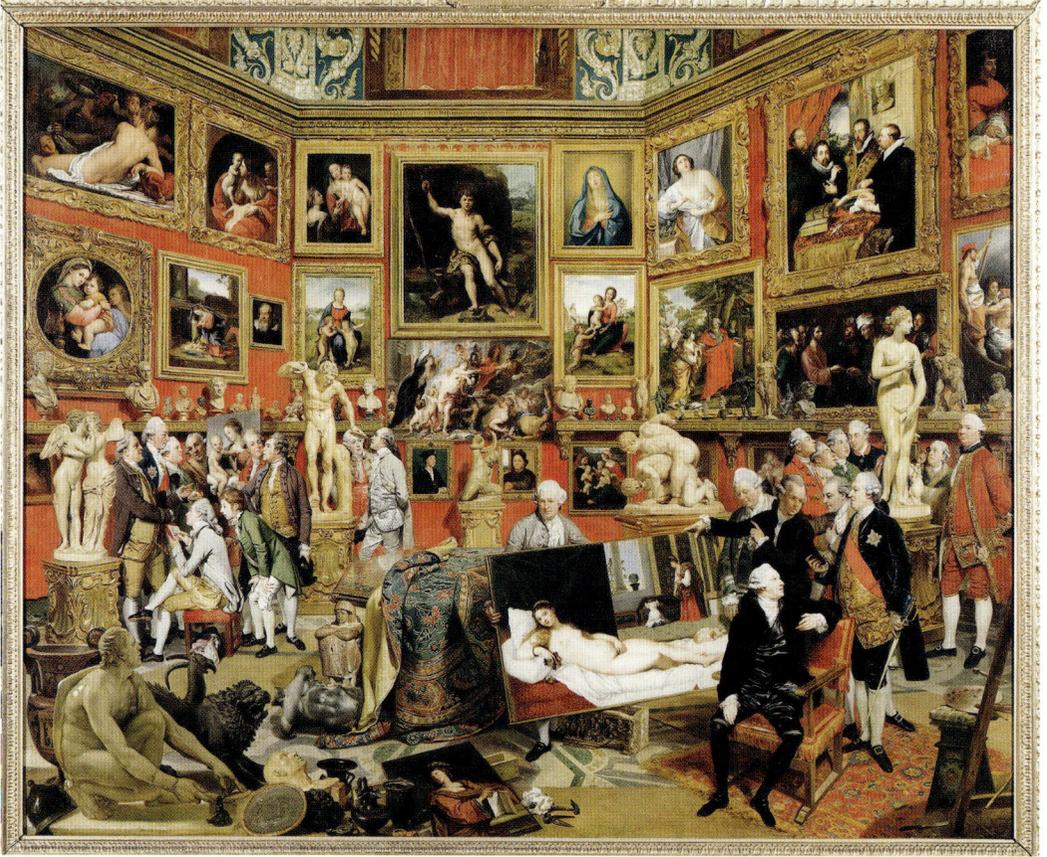

I.2 *The Tribuna of the Uffizi* by Johann Zoffany, 1772–7

His penchant for imagining himself in a different guise first witnessed at Eton manifested itself again in a variety of persona during the liberating experience of the tour. '… Yesterday I was a shepherd of Dauphiné; today an Alpine savage; tomorrow a Carthusian monk; and Friday a Swiss Calvinist'.[35]

Subsequently Walpole met Sir Horatio Mann (Horace) (1706–86), British diplomat and envoy-extraordinary at the court of Tuscany, who became one of his most important regular correspondents when they arrived at Florence in December 1739. 'I am lodged with Mr Mann, the best of creatures. I have a terreno all to myself, with an open gallery on the Arno, where I am now writing to you. Over against me is the famous Gallery [Uffizzi]; and, on either hand, two fair bridges.'[36] It is clear that Walpole enjoyed Florence society and they stayed with Mann for over a year, first at Casa Mannetti, his official residence in the Via Santo Spirito then at Casa Ambrogi, located between the Via de' Bardi and the Arno. It was adjacent to the Galleria Uffizzi, containing the Tribuna, a treasure-house that was to influence the interior at Strawberry Hill.

They used Mann's residences as a base for further travels including an interim visit to Rome, Walpole commenting that it would not be worth

seeing at a future date through current ignorance and neglect. It is an early manifestation of Walpole's attitude toward conservation of important monuments that would inform his desire to record Gothic archaeological precedents by incorporating them into the fabric of Strawberry Hill, before they disappeared for future generations to enjoy:

I am very glad that I see Rome while it yet exists: before great number of years are elapsed, I question whether it will be worth seeing. Between the ignorance and poverty of the present Romans, everything is neglected and falling to decay; the villas are entirely out of repair, and the palaces are so ill kept, that half the pictures are spoiled by damp.[37]

On their return to Florence they resumed their routine of regular visits to churches, palaces, galleries and collections, recorded in Gray's letters to his mother. The architecture of the Tribune and the method of display adopted there were later to become influential models for Strawberry Hill recalling for Walpole imaginative associations to the original:

In the meantime it is impossible to want entertainment; the famous gallery, [Uffizzi] alone, is an amusement for months; we commonly pass two or three hours every morning in it, and one has perfect leisure to consider all its beauties. You know it contains many hundred antique statues, such as the whole world cannot match, besides the vast collection of paintings, medals and precious stones, such as no other prince was ever master of; in short, all that rich and powerful house of Medicis has in so many years got together. And besides this city [Florence] abounds with so many palaces and churches, that you can hardly place yourself any where without having some fine one in view, or at least some statue or fountain, magnificently adorned …[38]

Walpole was critical of Rome and was enamoured by the Uffizzi but the Grand Tour did not imbue him with a lasting interest in Classical art and antiquities but the discovery of Herculaneum, near Naples and its material remains simultaneously awed and enraptured him: 'This underground city is perhaps one of the noblest curiosities that ever has been discovered.'[39]

 Walpole's future role as an antiquarian and chronicler of historical events appears to have their roots in this memorable visit to the buried city of Herculaneum. He brought back two dried dates from Herculaneum, the only natural items in his collection, which he kept in a box in the Tribune at Strawberry Hill as poignant reminders of his visit. For he was not interested in archaeological excavation unless it demonstrated potential for uncovering finds that would inform the present by shedding 'light into its use and history:'

There might certainly be collected great light from this reservoir of antiquities, if a man of learning had the inspection of it; if he directed the working, and would make a journal of the discoveries … Tis certainly an advantage to the learned world, that this has been laid up so long. Most of the discoveries in Rome were made in a barbarous age, where they only ransacked the ruins in quest of treasure, and had no regard to the form and being of the building; or to any circumstances that might give light into its use and history.[40]

His fascination with the material remains of the past as a means of imaginatively engaging with history was sparked by this enthralling encounter so that by 1752 Walpole would write 'I have done with virtù, and deal only with Goths and Vandals'.[41]

Walpole and Gray left Florence together but quarrelled at Reggio Emilia on the way to Venice though neither party was willing to disclose the reasons for the break. They were reconciled some three years later and Gray became an important and influential member of Walpole's architectural committee, alongside John Chute (1701–1776) of the Vyne, Hampshire whom Walpole and Gray met on the Grand Tour. Together they formed a learned committee to oversee the design, particularly of the internal architectural elements of Strawberry Hill. Gray possessed extensive knowledge of medieval architecture and assisted Walpole with his antiquarian publications as well as contributing to the building project at Strawberry Hill.

Walpole returned to Britain in September 1741 to take his seat as MP for Callington, Cornwall, a position he had been elected to in his absence. Following his mother's death his father had secured him positions as Inspector of the Imports and Exports at Custom House, resigning a few months later on being appointed Usher of the Exchequer. When he came of age his father bestowed on him the lucrative sinecure posts of Comptroller of the Pipe, Clerk of the Eastreates and Usher of the Exchequer, collectively worth £1,200 a year.[42]

Despite his father obtaining these profitable appointments for Horace when his father's fall from power was anticipated he could nevertheless write to Mann with total disregard for the benefactions he received:

Trust me, if we fall, all the grandeur, the envied grandeur of our house, will not cost me a sigh: it has given me no pleasure while we have it, and it will give me no pain when I part with it. My liberty, my ease, and choice of my own friends and company will sufficiently counterbalance the crowds of Downing Street. I am so sick of it all, that if we are victorious or not, I propose leaving England in the spring.[43]

His father Robert was appointed Knight of the Garter in 1726, an honour rarely bestowed on a commoner. His inauguration in St George's Chapel, Windsor, spiritual home of the Garter, a medieval chivalrous order, has important associative connotations and is an iconographic emblem for Walpole. Sir Robert resigned as first Minister on the 11 February 1742 upon which he was created first Earl of Orford. Horace Walpole informs Mann of these events caustically remarking:

I remain in town, and have not taken at all to withdrawing, which I hear has given offence, as well as my gay face in public; but as I had so little joy in the grandeur, I am determined to take as little part in the disgrace – I am looking for a new house.[44]

It is clear from this letter to Mann that despite his protestations and stoic defence of Sir Robert in later years, young Horace had enjoyed the financial gain his father's high office had brought but was acutely embarrassed by

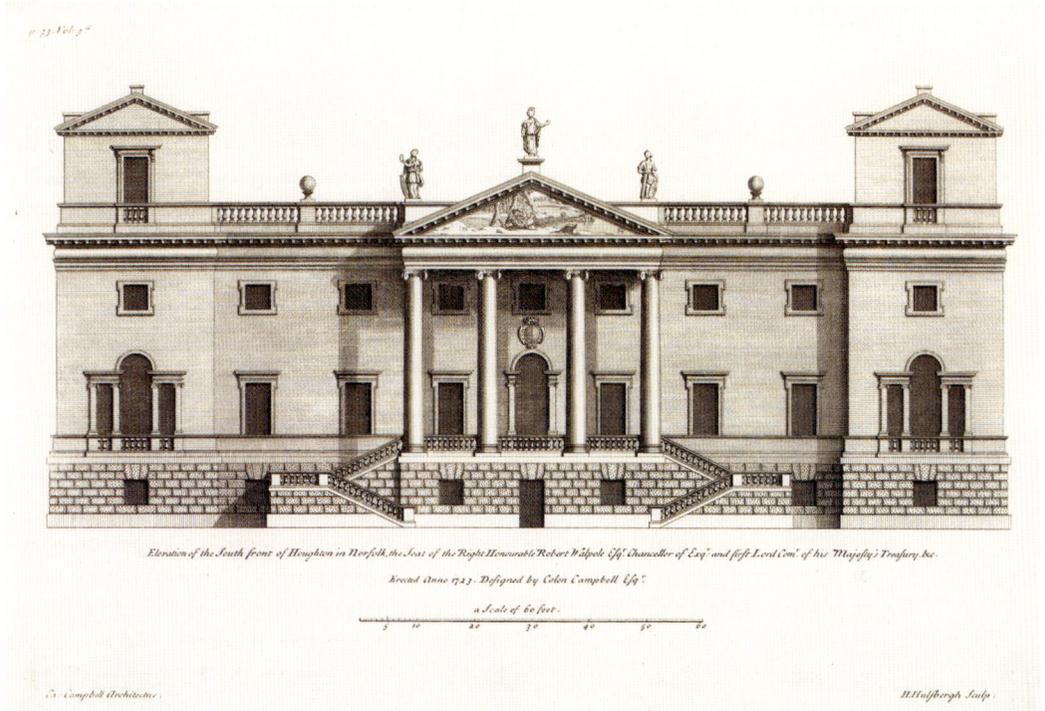

Elevation of the South front of Houghton in Norfolk, the Seat of the Right Honourable Robert Walpole Esq. Chancellor of Exq. and first Lord Com. of his Majesty's Treasury &c.

Erected Anno 1723. Designed by Colen Campbell Esq.

a Scale of 60 feet.

I.3 *The Façade of Houghton Hall*, from Colin Campbell, *Vitruvius Britannicus*, 1715–25

his subsequent 'disgrace'. Walpole however suggests that his feelings of resentment are long standing and that he does not look forward to spending time in his father's presence:

Our Earl [Sir Robert Walpole] is still at Richmond; I have not been there yet; I shall go once or twice, for however little inclination I have to it, I would not be thought to grow cool just now. You know I am above such dirtiness, and you are sensible that my coolness is of much longer standing.[45]

It is also abundantly clear that his dislike of Houghton had not changed during his travels abroad commenting to Mann: 'We are moving as fast as possible to Siberia [Houghton]'.[46] Walpole clearly does not relish long sojourns into Norfolk '… to be prisoner in a melancholy barren province …'[47] The parochial social scene fills Walpole with utter distaste and he does not endeavour to join in the pursuits which occupy his father, colloquially referred to by friends and enemies alike as the 'fat old Squire of Norfolk':

… we set out for Houghton for three months – but I scarce think that I shall allow thirty days apiece to them. Next post I shall not be able to write to you; and when I am there, shall scarce find materials to furnish a letter above every other post. I beg however that you will write constantly to me; it will be my only entertainment, for I neither hunt, brew, drink, nor reap. When I return in the winter, I will make amends for this barren season of our correspondence.[48]

Despite his abhorrence of all entertainments associated with his father, Horace seems to have become somewhat reconciled to him following his leaving government and the death of Maria Skerrett. He shared his home in Downing Street, London until his father's resignation, then occupied a small house next door to him in Arlington Street, London and, albeit reluctantly, spending more time with him in Norfolk.[49] It is at Houghton that we first find evidence of Walpole's practice of using actual or printed design sources for inspiration that were central to the design and decoration of Strawberry Hill. An early example of his using the taste and knowledge of Classical interiors acquired during his travels manifests in the decoration of the interior of his father's Palladian house. Horace utilised the design of Sebastiano Serlio (1475–1554) for St Mark's, Venice inner library for the gallery at Houghton, and derived the detail for the frieze from Sybil's Temple at Tivoli: '... he is making a gallery, [Lord Orford] for the ceiling of which I have given the design of that of the little library of St Mark at Venice; ... and for the frieze, I have prevailed to have that of the temple of Tivoli.'[50]

His father clearly valued young Walpole's knowledge of art and sought his advice on selecting and buying paintings, although it remains abundantly clear that Horace still disliked going to Houghton and indulging in the social gatherings that his father enjoyed, commenting sarcastically, 'I can't help wishing that I had never known a Guido from a Teniers – but who would ever suspect any connection between painting and the wilds of Norfolk?'[51]

It is clear however that it is not isolation in the countryside but Houghton and the social circle which frequented Sir Robert's seat to which he was averse. This is confirmed when he expresses that:

... If I had a house of my own in the country, and could live there now and then alone, or frequently changing my company, I am persuaded I should like it; at least, I fancy I should, for when one begins to reflect why one doesn't like the country, I believe one grows near liking to reflect in it ...[52]

He composed a *Sermon on Painting* for his father in 1742 and in the following year produced *Aedes Walpolianae: or, A Description of the Collection of Pictures at Houghton Hall in Norfolk* (1747), a detailed catalogue of Sir Robert's collection including an opinionated introduction in which he discussed the merits or otherwise of different schools of painting.[53] This was subsequently printed privately in 1747. Walpole did not excel in this early attempt at art criticism but he was nevertheless praised by contemporaries for his taste and learning: 'My young Walpole, blest with truest taste / Adorn'd with learning, with politeness grac'd.'[54]

Lord Orford died on the 18 March 1745. On his death Horace wrote to Mann criticising his father's profligacy in building and furnishing Houghton Hall:

It is certain, he is dead very poor: his debts, with his legacies which are trifling, amount to fifty thousand pounds. His estate, a nominal eight thousand a

year, much mortgaged. In short, his fondness for Houghton, has endangered Houghton. If he had not so overdone it, he might have left such an estate to his family, as might have secured the glory of the place for many years; another such debt must expose it to sale![55]

A tone of resentment and criticism may be detected with regard to his father's perceived recklessness concerning Houghton which could result in losing the estate for future generations of the family. Walpole envisages that the longer-term effects of his father's actions will have serious consequences for the 'glory of Houghton' and will undoubtedly impinge on Horace's reputation:

As to my own history, the scene is at present a little gloomy … but I cannot with indifference see the family torn to pieces, and falling into such ruin, as I foresee: for should my brother die soon, leaving so great a debt, so small an estate to ape it off, two great places sinking, and a wild boy of nineteen to succeed, there would soon be an end to the glory of Houghton, which had my father proportioned more to his fortune, would probably have a longer duration.[56]

The act of creating a small Gothic villa at Twickenham, the complete antithesis of the sumptuous Palladian mansion his father built in Norfolk may have its psychological roots embedded in these events. In addition, Walpole perpetually associated the Palladian mansion with uncouth behaviour, boredom and fatigue:

I indeed find this fatigue worse in the country than in the town, because one can avoid it there and has more resources, but it is here too – I fear 'tis growing old – but I literally seem to have murdered a man whose name was ennui, for his ghost is ever before me.[57]

On his death in 1745 Sir Robert left him the lease of the Arlington Street house, £5,000 and revenue of approximately £1,400 from the Collectorship of the Customs held by his brother Edward (1706–84). His cumulative income was therefore in excess of £3,400 per annum ensuring that he could carry out his project at Strawberry Hill and enable him to pursue his literary ambitions and collecting, if not with impunity, at least secure in the knowledge of a guaranteed income.[58]

The death of his father left Walpole virtually estranged from his family and free to indulge his own pursuits. Although he was left the lease of his father's house in Arlington Street he spent the spring of 1746 looking for a house in the vicinity of Windsor, eventually settling on one of the cannon's houses, a 'little tub of forty pounds a year', now No. 4 the Cloisters within the precinct of Windsor Castle.[59]

Even though George Montagu resided two doors away and other friends were in the vicinity Walpole did not remain there long and by May 1747 he had acquired the leasehold of a small house in Twickenham that was to evolve into the Gothic villa at Strawberry Hill.

Mrs Chenevix owner of a famous London toy shop owned the lease; however Walpole succeeded in subsequently purchasing it in 1749 by an

Act of Parliament, because it was owned by three minors. It is clear that from the beginning that in his imagination he associated the place with the enchanted ground of Ovid's *Metamorphosis*: 'I am a good deal out of humour, my purchases hitch, and new proprietors start out of the ground, like the crop of soldiers in the *Metamorphosis*'.[60] This purchase was to be a pivotal point in Walpole's life. With the acquisition of this 'shapeless little box' situated on the edge of countryside on the banks of the River Thames he seems to gain a sense of security and independence not previously evident. The creation of his seat at Strawberry Hill was to become the central passion in his life and he settled into a regular pattern which allowed his interests in building, gardening, collecting, writing and politics to develop.

His establishment at Strawberry Hill allowed Walpole to indulge in the literary pursuits that were a fundamental part of his existence. He, like Addison in his periodical writing, made a conscious decision to be a *Spectator* of life rather than attempting to take centre stage. The quantity of Walpole's correspondence increased as he set about chronicling contemporary life and events in this novel epistolary form with the majority written as source material for contemporary history. 'Casual memoirs' was how Walpole self-deprecatingly referred to the letters and extensive notes he wrote for the use of 'my superiors the historians of Britain.'[61] But in reality he saw himself as chronicling the history of his own times for posterity, documenting political occurrences in his historical *Memoirs* and selecting appropriate correspondents to be recipients of his missives on particular subjects – antiquarianism, politics, literature, the social scene and so on. For example, on his return to Britain from the Grand Tour Walpole exchanged weekly letters with Mann until his death 45 years later. Mann was chosen to receive a weekly discourse of current events because he had been 'absent long enough to read of your own country as history' and was requested from the outset to return the letters so that they could form part of Walpole's *Memoirs*.[62] Likewise his friends George Montagu and subsequently the Countess of Upper Ossory (1737/8–1804) were entertained with the contemporary social scene in London. William Cole was the longest serving and penultimate in a succession of correspondents on antiquarian matters, literature was discussed with the poet Thomas Gray, and after he died with another poet, William Mason (1724–97). All Walpole's letters were written with an eye to posterity as sources for a contemporary history which is why he insisted on either making copies or the return of the originals at regular intervals. They were then subjected to editing, alteration, amendment and annotation to varying degrees as preparation for informing and enlightening future generations as a social and historical chronicle of the eighteenth century. His authorship on antiquarian matters saw a similar increase in activity. Elected to the Society of Antiquaries in 1753, admitted in 1754 and council in 1758, Walpole's contribution to the antiquarian research of the society was negligible and he contributed nothing to the Society's publication *Archaeologia*. Instead he published his own antiquarian research at the

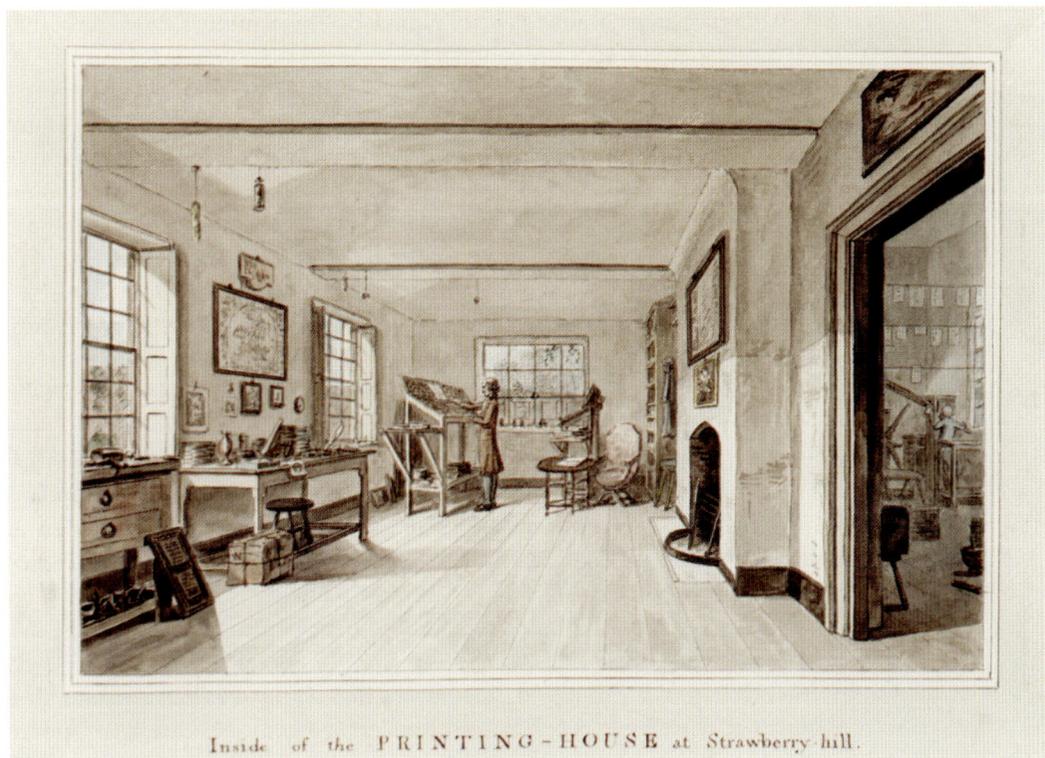

Inside of the PRINTING-HOUSE at Strawberry-hill.

press which he established at Strawberry Hill in 1757, one of the earliest, significant private presses:[63] 'On Monday next the Officina Arbuteana opens in form' with the publication of Gray's *Odes*.[64] 'In short, I am turned printer, and have converted a little cottage here into a printing office – My abbey is a perfect college or academy – I keep a painter in the house and a printer'.[65]

Paul Hentzner's (1558–1623) *Journey into England* (1757) was the next literary work to be published at the press.[66] Walpole's major works following the creation of his seat and the establishment of the press are all directly or indirectly concerned with antiquarian subjects.[67] *A Catalogue of Royal and Noble Authors* (1758), his first major work, constitutes a biographical dictionary of English writers and was unfavourably received.[68] The five-volume *Anecdotes of Painting in England*, his most significant work, written in an entertaining accessible manner is likewise a biographical dictionary of fine art and artists, engravers, sculptors, architects and architecture. It is the first history of English painting and also included an evaluation of English architects and architecture.[69] The final volume of *Anecdotes of Painting, The History of the Modern Taste in Gardening* (1780)[70] was the first book to give a historical account of gardens and a contemporary view of landscape theory.[71] *Historic Doubts on the Life and Reign of King Richard III* (1768) criticised and refuted the traditional view of Richard III (1452–1485) as a villainous murderer of the Princes in the Tower and perpetrator of other crimes. Based on documentary

I.4 Inside of the printing house at Strawberry Hill, J. Carter

research Walpole's revisionist *Historic Doubts* itemised the seven crimes that were levelled at Richard III closely analysing and dismissing them through systematic cogent argument. Walpole's premise was based on the material evidence of an 'authentic monument lately come to light' a newly discovered 'coronation roll' which apparently showed that Edward V attended Richard's coronation.[72] 'A very curious monument or memorial has been lately discovered, which opened such a new scene, that it set me upon looking farther, and the more I have sifted that dark period, the more discoveries, I think, I have made.'[73]

His attempt to rewrite the history of Richard III fits perfectly with the trope of Enlightenment historiography where 'things come to light' which change perceptions of history. 'If time brings new materials to light, if facts and dates confute historians, what does it signify that we have been for two or three years under an error? Does antiquity consecrate darkness?'[74]

One of Walpole's favourite aphorisms was that 'History is a romance that is believed; romance, a history that is not believed'.[75] However, his attempt to offer an alternative history, made available through material remains, came in for much criticism from scholars within the Society of Antiquaries because his evidence was actually based on a set of Wardrobe accounts which Walpole had misinterpreted. The heated debate that ensued eventually prompted his resignation from the Society. Nevertheless, Walpole gained respectability as a serious antiquarian and historian through publication of his *Anecdotes of Painting* and other areas of historical research, literature and antiquarian studies, all of which attest to his competence as a writer. Walpole also enjoyed a considerable reputation as the author of the first Gothic novel *The Castle of Otranto* (1764) and his tragedy *The Mysterious Mother* (1768) both of which were influential in the development of the genre and in the Romantic imagination. His *Works* and *Memoirs and Journals of the Reign of George II and III* were published posthumously.[76]

Walpole was a published poet by 1748 and contributed nine entertaining articles to *The World* (1753–7), often adopting the manner Addison had used in *The Spectator* of assuming the character of supposed editor or disguised as a contributor.[77] The content of the papers too followed Addison presenting learned antiquarian and other erudite material in a witty, entertaining and accessible style. He wrote further poetry and political pamphlets while continuously publishing the bulk of his own texts and that of others at his press. Meanwhile, his collection of books, works of art and artefacts continued to grow with the villa expanding simultaneously to contain them. He opened Strawberry Hill to public view and it received a constant flow of visitors which Walpole eventually came to regret, complaining:

My house is full of people and has been so from the instant I breakfasted, and more are coming – in short I keep an inn: the sign; 'the Gothic Castle'. Since my gallery was finished I have not been in it a quarter of an hour together; my whole time is passed in giving tickets for seeing it and hiding myself while it is seen.[78]

He eventually built himself a bower in the garden as a place of retreat to escape from the hordes as Gilly Williams commented that Walpole too had become a tourist attraction: 'Horry is now as much a curiosity to all foreigners as the tombs and lions.'[79] This first-hand physical description of his personal appearance by the novelist Miss Laetitia-Matilda Hawkins (1759–1835), daughter of Walpole's author friend and frequent visitor to Strawberry Hill Sir John Hawkins (1719–1789), is particularly striking:

His figure was as has been told, and everyone knows, not merely tall, but more properly long and slender to excess; his complexion and particularly his hands, of a most unhealthy paleness. His eyes were remarkably bright and penetrating, very dark and lively: – his voice was not strong, but his tones were extremely pleasant, and if I may say so highly gentlemanly. I do not remember his common gait; but he always entered a room in that style of affected delicacy, which fashion had then made almost natural; *chapeau bras,* between his hands as if he wished to compress it, or under his arms – knees bent, and feet upon tiptoe, as if afraid of a wet floor.

His dress in visiting was most usually, in summer when I saw him a lavender suit, the waistcoat embroidered with a little silver or white silk worked in the tambour, partridge silk stockings, and gold buckles, ruffles and frills generally lace. I remember when a child thinking him very much under dressed, if at any time except in mourning, he wore hemmed cambric. In summer no powder, but his wig combed straight and showing his smooth pale forehead, and queued behind, in winter powder.[80]

Contemporaries of Walpole remember him as a virtuoso for his antiquarian publications, for Strawberry Hill and his heterogeneous collection. Posthumously however his fame and reputation relies on the letters which have been published sporadically since the eighteenth century.

Most of the publications were generally well received; however, as discussed earlier, the 1833 edition of Walpole's correspondence with Horace Mann provoked the hostile enmity of Macaulay. He assassinated Walpole's character in a scathing attack on the man accusing him of possessing 'an unhealthy and disorganised mind …' a mind that was 'a bundle of inconsistent whims and affectations, his features were covered by mask within mask.'[81] Despite his prolonged tirade against Walpole himself Macaulay nevertheless congratulated him on his writing ability. It is worth quoting at length because Macaulay's praise of Walpole's writing is little known as most observers only quote the negative comments on Walpole's character. However, in addition it captures nicely Walpole's idiosyncratic nature and encapsulates his fascination with association and imagination in a way that later observers have not surpassed. Macaulay asks the reader to consider:

What then is the charm, the irresistible charm of Walpole's writings? It consists, we think, in the act of amusing without exciting. He never convinces the reason, nor fills the imagination, nor touches the heart; but he keeps the mind of the reader constantly entertained. He had a strange ingenuity peculiarly his

own, – an ingenuity which appeared in all that he did, – in his building, in his gardening, in his upholstery, in the matter and in the manner of his writings … In his villa, every apartment is a museum, every piece of furniture is a curiosity; there is something strange in the shape of the shovel; there is a long story belonging to the bell-rope. We wander among a profusion of rarities, of trifling intrinsic value, but so quaint in fashion, or connected with remarkable names and events, that they may well detain our attention for a moment. A moment is enough. Some new relic, some new unique, some new carved work, some new enamel, is forthcoming in an instant. One cabinet of trinkets is no sooner closed than another is opened. It is the same with Walpole's writings. It is not in their utility, it is not in their beauty, that their attraction lies. They are to the works of great historians and poets, what Strawberry Hill is to the great collection of Sir Hans Sloane, or to the Gallery of Florence. Walpole is constantly showing us things, – not of very great value indeed – yet things which we are pleased to see, and which we can see nowhere else. They are baubles; but they are made curiosities either by his grotesque workmanship, or by some association belonging to them … Walpole perpetually startles us with the ease with which he yokes together ideas between which there would seem, at first sight, to be no connexion … we at once see Walpole's superiority, not in industry, not in learning, not in accuracy, not in logical power, but in the art of writing what people will like to read. He rejects all but the attractive parts of his subject. He keeps only what in itself is amusing, or what can be made so by the artifice of his diction. The coarser morsels of antiquarian learning he abandons to others; and sets out an entertainment worthy of a Roman epicure, an entertainment consisting of nothing but delicacies …[82]

Dr Samuel Johnson (1709–1784) an author whom Walpole intensely disliked also 'allowed that [Horry Walpole] got together a great many curious little things and told them in an elegant manner.'[83]

Walpole could never hope to emulate his father's achievements in the political arena, lacking the combative instincts his father possessed which were essential for success in the eighteenth-century House of Commons. Walpole was not suited to the cut and thrust of political debate much preferring to operate behind the scenes writing anonymous articles and pamphlets and indulging in clandestine machinations and political intrigue. Nevertheless he was a committed and enthusiastic politician and attended the House of Commons regularly during his 27-year career as a Member of Parliament making copious notes throughout for his anticipated *Memoirs*, continuously serving as an MP until 1768.

His closing years though generally content were marred by the Chatterton affair and the Revolution in France which caused him much consternation. Not least, a major concern was the on-going decline and eventual ruin of Houghton by his nephew George 3rd Earl of Orford (1730–91). He had inherited Houghton on the death of Horace's eldest brother Robert (1700–51) 2nd Earl of Orford who had succeeded to the estate with its immense debts. The highly eccentric George suffered from bouts of insanity and the estate deteriorated considerably during his ownership. March 1761 saw Walpole in Norfolk for the forthcoming election when he took the opportunity to revisit the estate, an event which triggers a flood of melancholic memories:

Here I am, at Houghton! And alone! In this spot, where (except two hours last month) I have not been in sixteen years! Think, what a crowd of reflections! No, Gray and forty churchyards could not furnish so many. Nay, I know one must feel them with greater indifference than I possess, to have patience to put them into verse. Here I am, probably for the last time in my life, though not for the last time – every clock that strikes tells me I am an hour nearer to yonder church – that church, into which I have not had courage to enter, where lies that mother on whom I doted, and who doted on me! There are two rival mistresses of Houghton, neither of whom ever wished to enjoy it! There too lies he who founded its greatness, to contribute to whose fall Europe was embroiled … For what has he built Houghton? For his grandson to annihilate, or for his son to mourn over![84]

Loyalty to his family was one of Walpole's positive traits and despite swearing he would not visit Houghton again Walpole returned following his nephew's further degeneration into insanity and as an interim measure assumed complete responsibility for affairs, where he 'found a scene infinitely more mortifying than I expected.'[85]

Clearly distraught by the chaotic situation, Walpole diligently endeavoured to sort out the state of utter confusion. He managed to reform the position through acts of retrenchment only for his nephew to recover the following year and resume his profligate, extravagant ways. The recovery however proved temporary with George descending into raving madness three years later and Walpole was summoned once again in an attempt to salvage the situation with assistance from his brother Edward. Lord Orford accepted trying to settle the precarious state of affairs following a plea from Walpole apparently agreeing for the sake of family honour and respect for Sir Robert's achievement. 'We are both old men now, and without sons to inspire future visions. We wish to leave your Lordship in as happy and respectable a situation as you were born to, and we have both given you all the proof in our power, by acquiescing to your proposal immediately.'[86]

Horace Walpole had advised his father on collecting and helped him acquire works of art for Houghton Hall and had spent his early years admiring the collection his father had hung in Downing Street. Sir Robert's art collection was sold for around £45,000 to the Empress Catherine the Great (1729–1796) of Russia in 1779 to help alleviate the burden of debt. This sale and turn of events enraged Walpole for although he had never overtly praised the Palladian mansion the art collection that Sir Robert had amassed predated Houghton and was deeply embedded in Walpole's imagination. 'I have outlived the glory of my family and my country – Houghton and England are alike stripped of all their honours …'[87]

Previously he had fondly remembered that 'Not a picture here, but recalls a history; not one, but I remember in Downing Street or Chelsea, where Queens and crowds admired them.'[88]

Never in robust health Walpole had suffered his first attack of gout in 1755 and the condition plagued him with increasing levels of disability throughout the remainder of his life. He still managed to outlive most of his friends continuing to divide his time between his beloved villa at Twickenham

and London taking a lease on a house in Berkeley Square when the lease on Arlington Street fell in. *Reminiscences, written for the Amusement of Miss Mary and Miss Agnes Berry* (1788), his friends and new tenants in a house he owned near Strawberry Hill was his last literary work comprising his early recollections.[89]

Unexpectedly succeeding to the Earldom when his relapsed nephew died in 1791 after a further bout of insanity followed by a short illness Walpole admitted, 'he has restored me to my birthright, and I shall call myself obliged to him, and be grateful to his memory …'[90] In the event, the mortgage debts amounted to nearly £87,000 and Walpole declared 'I am not vain of being the poorest Earl in England; nor delighted to have outlived all my family, its estate, and Houghton, which, while it was *complete*, would have given me so much pleasure – now it will be a mortifying ruin, which I will never see.'[91] However, by the time Walpole made his will on 15 May 1793 there was only £17,500 outstanding in two mortgages. It is obvious from these figures that he endeavoured to clear the burden of debt on the estate for future generations. Despite acquiring the title of Lord Orford he never returned to Houghton or took up his place in the House of Lords informing divine and author William Beloe (1758–1817) in 1792, that:

The unfortunate death of my nephew has involved me in trouble; and the remnant of a ruined estate has given me no credit or influence. I have not set my foot in Norfolk since his death nor for many previous years, nor have taken my seat in the House of Lords since that unwelcome title came to me, nor intend it.[92]

Despite his animosity toward his father for his behaviour toward his mother, his coarse behaviour and his recklessness in squandering huge sums of money in constructing and furnishing Houghton Walpole eventually became reconciled to his father's notoriety and family history:

You know me an unalterable Englishman, who loves his country and devoutly wishes its prosperity. Such I am, ardent for England and ever shall be … My father is ever before my eyes – not to attempt to imitate him, for I have none of his matchless wisdom, or unsullied virtues, or heroic firmness – but sixty-two years have taught me to gaze on him with ten thousand times the reverence, that, I speak it with deep shame, I felt for him at twenty-two, when he stood before me![93]

After unexpectedly inheriting the title, Horace Walpole 4th and last Earl of Orford died on 2 March 1797 in his house in Berkeley Square. He chose not be buried at his beloved Strawberry Hill, which he had created in reaction to his father and Houghton; eventually returning to his family roots, he was interred in the family vault beneath Houghton Church.

The picture that clearly emerges from this portrayal of Walpole's relationship with his father, until his death, is one of disrespect, antipathy and aversion. Walpole abhorred the social events that he was periodically subjected to at Houghton and came to associate the Palladian mansion and his father's coterie with similar contempt and disdain, for Walpole admits

that he had 'great difficulty of not connecting every inanimate thing with the idea of some person'.[94] These were obviously not models that he would wish to emulate, for although Robert Walpole, like his son Horace had attended Eton and King's College, Cambridge his father was forced to withdraw when his eldest brother died and his assistance was needed to help on the 600-year old family estate, he could not be described as an aristocratic gentleman.[95] Contemporaries describe Robert as having a taste for hunting, drinking and politics at the regular congresses he held at Houghton. One such event is described by Lord Hervey (1696–1743): 'Our company at Houghton swelled at last into so numerous a body that we used to sit down to dinner a little snug party of about thirty odd, up to the chin in beef, venison, geese, turkeys etc; and generally over the chin in claret, strong beer and punch.'[96]

Robert Walpole was the antithesis of Horace in every sense; in his physical appearance, lack of taste and apparent absence of social graces and different interests. Horace was delicate, slender and fastidious, read books and poetry and kept the company of young men with similar interests. In contrast his father is described as coarse, vulgar and boisterous, enjoying high living and the company of women. His main interests appear to have been politics, horses, hounds, hunting, bawdy and drunkenness. Clearly Horace was not going to be inculcated in matters of taste and decorum at his father's knee as he represented the complete converse of Horace's aspirations to be a gentleman, antiquary, arbiter of taste and connoisseur. This could only be achieved through auto-didactic means. To this end he read and collected Henry Peacham's (1578–1644) courtesy books *The Compleat Gentleman* and immersed himself in Addison's *Spectator* essays where the rules of taste and for behaving with propriety and correctness in all situations were delineated on a daily basis.[97]

Endnotes

1. *Correspondence*, Walpole to Montagu, 5 January 1766, vol. 10, p. 192.

2. 'He took the title of Orford from his favourite residence Orford House in Chelsea', Plumb, J.H. *Sir Robert Walpole: The Making of a Statesman* (London, 1956), p. 206.

3. Macaulay, T.B. 'Review of letters of Horace Walpole, Earl of Orford to Sir Horace Mann', *The Edinburgh Review*, vol. 58 (Oct 1833) pp. 227–258.

4. Walpole was made a fellow of the Royal Society 19 February 1747. He was also a member of The Royal Society of Arts, 24 March 1762.

5. Gough became a fellow of the Society of Antiquaries in 1767 and elected Director from 1771–91. Walpole writes to Cole 'Mr Gough wants to be introduced to me! Indeed! I would see him as he has been midwife to Masters, but he is so dull that he would only be troublesome – and besides you know I shun authors, and would never have been one myself, if it obliged me to keep such bad company. They are always in earnest, and think their profession serious, and dwell upon trifles, and reverence learning. I laugh at all those things, and write only to laugh at them and divert myself … Mr Gough is very welcome to see Strawberry Hill, or I would help him to any scraps in my possession that would assist his publications, though he is one of those industrious who are only reburying the dead – but I cannot be acquainted with him. It is contrary to my system and my humour; and besides I know nothing of barrows, and Danish entrenchments, and Saxon barbarisms, and Phoenician characters – in short I know nothing of those ages that knew nothing – then how should I be of use to modern *literati?*' *Correspondence*, Walpole to Cole, 27 April 1773, vol. 1, pp. 308–310.

6. Sloan, K. (ed.) with Burnett, A. *Enlightenment: Discovering the World in the Eighteenth Century* (London, 2003) p. 21.

7. Silver, S.R. *The Curatorial Imagination in England, 1600–1752*, unpublished PhD thesis (Los Angeles, University of California, 2008).

8. Addison, *The Spectator*, No. 411, 21 June 1712. Addison quotes Sir Francis Bacon's (1561–1626) Essay on Health (1623) to support his contention. Bacon had advised his readers 'to pursue Studies that fill the Mind with splendid and illustrious Objects, as Histories, Fables and Contemplations of Nature' to dissuade them from engaging in 'knotty and subtile Disquisitions'.

9. Jesse, J.H. *George Selwyn and His Contemporaries* (4 vols, London, 1882). 'Gilly' Williams to Selwyn, 12 December 1764 and *Correspondence*, Williams to Selwyn, 12 December 1764, vol. 30, p. 177.

10. Walpole, H. *A Description of the Villa of Horace Walpole, Youngest Son of Sir Robert Walpole, Earl of Orford, at Strawberry Hill, near Twickenham. With an inventory of the furniture, pictures, curiosities etc.* (Twickenham, 1774 and 1784). Walpole added the following appendices to later editions: c.1786 Appendix; c.1789 Curiosities added; c.1791 More additions. All quotations are from the facsimile edn (London, 1964), p. 77.

11. Addison, *The Spectator* No. 1, 1 March 1710–11.

12. Horace Walpole was known to have these books at Eton where he attended 1727–34; Hazen, *Walpole's Library*, vol. 3 (New Haven and London, 1969) p. 290.

13. *Correspondence*, Walpole to Pinkerton, 26 June 1785, vol. 16, p. 269.

14. Addison, *The Spectator*, No.10, 12 March 1710–11.

15. See, Robert Boyle, *Experiments and Considerations touching Colours. First occasionally written, among some other Essays, to a friend; and now suffer'd to come abroad as the beginning of an experimental history* … (London, 1664); David Hume, *A Treatise of Human Nature: Being an Attempt to Introduce the Experimental Method of Reasoning into Moral Subjects* (London, 1739–1740); William Hogarth, *The Analysis of Beauty, written with a view of fixing the fluctuating ideas of taste* (London, 1753); John Locke, *An essay concerning human understanding* (London, 1690); Thomas Reid, *Essays on the intellectual powers of man* (Edinburgh, 1785); Samuel Johnson, *A Dictionary of the English Language* sometimes published as *Johnson's Dictionary* (London, 1755) 'The operation or function of the senses; 'perception by means of the senses'.

16. Walpole owned the 2nd edn (London, 1694) fol. and 10th edn (London, 1731).

17. Walpole was also known to have Locke's books with him at Eton; Hazen, *Catalogue of Horace Walpole's Library*, vol. 3, p. 290.

18. Walpole left an immense body of *Works* many of which were which were published posthumously by his friend Mary Berry and her father *The Works of Horatio Walpole, Earl of Orford* (eds) Berry, R.G. and Berry, M. (9 vols, London, 1798–1825), These included art historical and antiquarian books, political pamphlets, various essays and catalogues of collections including a catalogue of his collection at Strawberry Hill, memoirs, and miscellanies and over 4,000 extant letters which chronicle the social and political milieu of the eighteenth century which are published in the Yale edition of the *Correspondence*.

19. Walpole was later wrongly accused in the press of being responsible for his death, a regrettable incident from which Walpole's public reputation never really recovered. Walpole tried to distance himself from the ensuing controversy which culminated with Chatterton's suicide, and whilst the letters acquit Walpole of any culpability in his death they do not exonerate Walpole of all responsibility and call into question his conduct and veracity in the affair. See, Ingram, J.H. *The True Chatterton* (London, 1910), Meyerstein, E.H.W. *A Life of Thomas Chatterton* (London, 1930), Nevill, J.C. *Thomas Chatterton* (London, 1948) and Walpole's *Correspondence*, particularly vol. 16 and his letter to Lady Ossory July 1792 for various, sometimes conflicting accounts of the affair.

20. *Oxford Dictionary of National Biography*, http://www.oxforddnb.com/, accessed July 2011.

21. Macaulay, *Review*, pp. 227–258.

22. Clark, K. *The Gothic Revival: An Essay in the History of Taste* (London, 1995), pp. 46–65.

23. 'The name of *Horatio* I dislike. It is theatrical; and not English. I have, ever since I was a youth, written and subscribed Horace, an English name for an Englishman. In all my books (and perhaps you will think of the *numerosus Horatius*). I so spell my name'. *Walpoliana*, Pinkerton. J. (compiler) (2 vols, London, 1805) vol. 1. LXXXII 'Trifles', pp. 61–62.

24. The character of Celadon is probably from D'Urfé's *Astrée* a complex pastoral French novel published between 1607 and 1627 which portrays the perfect love between a shepherd (Celadon) and a shepherdess (Astrée) as its central theme. An alternative source is John Dryden's *Secret Love* (1679) in which the character Celadon is a courtier.

25. Walpole, *Description of the Villa*, p. 68.

26. *Correspondence*, Walpole to West, 17 August 1736, vol. 13, pp. 107–108.

27. Ibid., Gray to Walpole, 15 July 1736, vol. 13, p. 104.

28. Ibid., Walpole to Lyttleton, 27 July 1736, vol. 40, p. 21.

29. Ibid., Walpole to Lyttleton, 18 September 1737, vol. 40, p. 24.

30. Walpole, *Description of the Villa*, p. 55.

31. Taking the Grand Tour was an educational 'rite of passage' undertaken mainly by young, upper-class Englishmen of means and could last anything between a few months to several years. The tradition began in the sixteenth century, increased in popularity in the mid-seventeenth, flourished in the eighteenth and declined in the early nineteenth-century with the arrival of the railways which opened travel to a greater spectrum of society.

32. *Correspondence*, Walpole to Conway, 23 April 1740, vol. 37, p. 57.

33. Ibid., Walpole to West, 21 April 1739, vol. 13, p. 163.

34. Ibid., Walpole to West, 15 May 1739, vol. 13, pp. 168–169.

35. Ibid., Walpole to West, 28 September 1739, vol. 13, p. 181.

36. Ibid., Walpole to Conway, 5 July 1740, vol. 37, p. 68.

37. *The Correspondence of Thomas Gray,* Toynbee, P. and Whibley, L. (eds) (3 vols, Oxford, 1935) vol. 1, letter 76, and *Correspondence,* Walpole and Gray to West, 16 April 1740, vol. 14, p. 206.

38. *Correspondence of Thomas Gray,* vol. 1, letter 77, Gray to Mrs Gray, Nov 1739.

39. *Correspondence*, Walpole to West, 14 June 1740, vol. 14, p. 224.

40. Ibid., Walpole to West, 14 June 1740, vol. 14, p. 224.

41. Ibid., Walpole to Montagu, 14 December 1752, vol. 9, p. 144.

42. Ketton-Cremer, R.W. *Horace Walpole: A Biography* (London, 1940, 1946) (3rd edn, London and Ithaca, 1964), p. 49.

43. *Correspondence*, Walpole to Mann, 17 December 1741, vol. 17, p. 248.

44. Ibid., Walpole to Mann, 9 February 1742, vol. 17, p. 334.

45. Ibid., Walpole to Mann, 3 March 1742, vol. 17, p. 358.

46. Ibid., Walpole to Mann, 14 July 1742, vol. 17, p. 495.

47. Ibid., Walpole to Mann, 20 August 1742, vol. 18, p. 30.

48. Ibid., Walpole to Mann, 29 July 1742, vol. 18, p. 8.

49. Ibid., Walpole to Mann, 6 January 1743, vol. 18, p. 137 '… I have the prettiest warm little apartment with all my baubles and Patapans and cats! Next as to Arlington Street; Sir R[obert] is in a middling kind of house, which has long been his, and was let: he has taken a small one next to it for me, and they are laid together.'

50. Ibid., Walpole to Mann, 25 September 1742, vol. 18, p. 63.

51. Ibid., Walpole to Mann, 25 April 1743, vol. 18, p. 218.

52. Ibid., Walpole to Mann, 16 August 1744, vol. 18, p. 499.

53. *Aedes Walpolianae* or *A Description of the Collection of Pictures at Houghton-Hall in Norfolk, the seat of the Right Honourable Sir Robert Walpole, Earl of Orford* (London, 1747). The work was complete in 1743 but not published until 1747 and is the earliest catalogue of an English private collection.

54. Charles Hanbury Williams, *Epistle to the Right Hon. Henry Fox*, written in August 1745. Quotation cited in Ketton-Cremer, *Horace Walpole: A Biography*, p. 91.

55. *Correspondence*, Walpole to Mann, 15 April 1745, vol. 19, p. 32.

56. Ibid., Walpole to Mann, c. August, 1748, vol. 19, p. 496.

57. Ibid., Walpole to Chute, 20 August 1743, vol. 35, p. 43.

58. Walpole himself is the best source for a detailed description of his inheritance and financial position; see 'Account of my Conduct relative to the Places I hold under Government, and towards

Ministers' (1782) *Works*, II, 364–392. Although in the terms of his father's will he was to receive £5,000, Walpole says he only ever received £1,000; presumably because of the enormous debts his father had incurred on the estate.

59. *Correspondence*, Walpole to Montagu, 11 August 1746, vol. 9, p. 44.

60. Ibid., Walpole to Montagu, 18 May 1749, vol. 9, p. 83.

61. *Memoirs* (1751–1791).

62. *Correspondence*, Walpole to Mann, 7 May 1760, vol. 21, p. 403.

63. 'The press at Strawberry Hill has long been celebrated as the first private press in England. This may not be technically correct – Archbishop Parker had a private press at Lambeth Palace in the 1570s, and even in the early eighteenth century, the Rev Francis Blomefield printed the first volume of his *History of Norfolk* on his own press at his rectory at Fersfield. But the Strawberry Hill Press is unchallenged for its combination of longevity, quality of production, importance of content, and the extent to which its records have survived.' Clark, S. 'The Strawberry Hill Press', p. 1, Inskip, P. and Jenkins, P. *Conservation Management Plan for Strawberry Hill* (London, 2006).

64. *Correspondence,* Walpole to Chute, 12 July 1757, vol. 35, p. 98.

65. Ibid., Walpole to Mann, 4 August 1757, vol. 21, p. 120.

66. Hentzner, P. *A Journey into England in the year 1598 (being a part of the itinerary of P.H. translated by R. Bentley,* Walpole, H. (ed.) (Twickenham, 1757).

67. Hazen, *Bibliography of the Strawberry Hill Press* (1942) remains the definitive account of the publications from the press, often correcting Walpole's own statements in his *Journal of the Printing-Office at Strawberry Hill*. See also Toynbee, P. *Journal of the Printing office at Strawberry Hill* (London and Boston, 1923), p. 93. The first publication printed 8 August 1757 was Gray's *The Progress of Poesy* and the *Bard* followed by 220 copies of Hentzner's *Journey* 17 October 1757. Another significant antiquarian publication issued from the press was *The Life of Lord Herbert of Cherbury, Written by Himself* (Twickenham, 1764) which Walpole edited and wrote the preface for.

68. *A Catalogue of Royal and Noble Authors* (2 vols, Twickenham, 1758). *A postscript* was printed at Strawberry Hill (1786).

69. Walpole's *Anecdotes of Painting* relies partly on research carried out by George Vertue whose notebooks Walpole had purchased from his widow in 1759 compounded, expanded and interpreted by his own research, experience and visits. 'Anecdotes of Painting' in Sabor, P. (ed) *The Works of Horatio Walpole, Earl of Orford, 1798. From the 1798 edition* (5 vols, London, 1998), vol. III. All quotations are from this edition.

70. As with *Anecdotes of Painting*, his *History of the Modern Taste* too relies partly on research carried out by George Vertue.

71. In some respects Walpole's book distorted perceptions of garden history through his insistence that the English garden style had reached its epitome at the time he was writing and that it was a purely English phenomenon, with no foreign influences – a perception that garden historians are still attempting to rectify.

72. Walpole, *Historic Doubts on the Life and Reign of King Richard the Third* (London, 1768), p. 134.

73. *Correspondence*, Walpole to Dalrymple, 8 November 1767, vol. 15, p. 115.

74. Walpole, *Historic Doubts*, p. 111.

75. Walpole, 'Detached Thoughts' *Works*, vol. 1V, p. 368.

76. See Walpole, H. *Memoirs of the Reigns of George II and George III* (London, 1822–59); *Memoirs of King George II: The Yale Edition of Horace Walpole's Memoirs* (ed.) Brooke, J. (New Haven and London, Yale University Press, 1985); *Memoirs of the Reign of King George III: The Yale Edition of Horace Walpole's Memoirs* (ed.) Jarrett, D. (New Haven and London, Yale University Press, 1999).

77. Robert Dodsley published the first of three volumes of *A Collection of Poems by Several Hands* (3 vols, London, 1748), with three contributions from Walpole included: 'Epistle to Thomas Ashton from Florence', 'The Beauties', and 'Epilogue to Tamerlane'.

78. *Correspondence*, Walpole to Montagu, 3 September 1763, vol. 10, p. 98.

79. Jesse, *George Selwyn and His Contemporaries*, Williams to Selwyn, 13 November 1764, I. 332.

80. Hawkins, L.M. *Anecdotes, Biographical Sketches and Memoirs* (3 vols, London, 1822–24), I, pp. 105–106.

81. Macaulay, *Review*, pp. 227–258.

82. Ibid., pp. 227–258.

83. Boswell, J. *Life of Johnson* (Oxford, 1980), p. 1308.

84. *Correspondence*, Walpole to Montagu, 30 March 1761, vol. 9, p. 348.

85. Ibid., Walpole to Conway, 30 August 1773, vol. 39, p. 173.

86. Ibid., Walpole to Lord Orford, 5 October 1778, vol. 36, p. 165.

87. Ibid., Walpole to Mann, 11 February 1779, vol. 25, p. 310.

88. Ibid., Walpole to Montagu, 25–30 March 1761, vol. 9, p. 348.

89. *Reminiscences Written By Horace Walpole in 1788,* Toynbee, P. (ed.) (Oxford, 1924).

90. *Correspondence*, Walpole to Lady Ossory, 10 December 1791, vol. 34, p. 134.

91. Ibid., Walpole to Lady Ossory, 18 January 1792, vol. 34, p. 136.

92. Ibid., Walpole to Beloe, 5 August 1792, vol. 15, p. 216.

93. Ibid., Walpole to Mann, 19 August 1779, vol. 24, p. 507.

94. Walpole, *Books of Materials* (1759), p. 52.

95. Plumb, *Sir Robert Walpole,* p. 88.

96. Hervey, J. *Lord Hervey and His Friends, 1726–38* (London, 1950), John Lord Hervey to Frederick, Prince of Wales, July 1731, pp. 73–74.

97. Walpole owned 3 copies of Peacham's *The Compleat Gentleman* (1634).

'The Pleasures of the Imagination': Tropes of Taste

This chapter explores Addison's theories of taste and association as expressed in his *Spectator* essays, in particular 'The Pleasures of the Imagination' and their influence on Walpole, who was to extend and develop Addison's theories and put them into practice in his project at Strawberry Hill. Writing in 1756 the social commentator, dramatist and essayist George Colman the Elder (1732–1794) decried the great fashion of his time:

Taste is at present the darling idol of the polite world and the world of letters. The fine ladies and gentlemen dress with taste, the architects whether Gothic or Chinese build with taste, the painters paint with taste, critics read with taste, and in short, fiddlers, players, singers, dancers and mechanics themselves are all the sons and daughters of taste.[1]

The eighteenth century heralded a cultural change which was to redefine social hierarchies and alter the appearance of exterior and interior architectural features, gardens and landscapes; even the dress codes of society were affected. The change was stimulated by a tide of new wealth flowing into the country through trade and manufacture, with Britain emerging as the leading commercial power. A more prosperous society became obsessed with propriety and the pursuit of 'taste' – a concept which came to define the eighteenth century. Taste was a metaphor for the senses and is closely linked to moral and intellectual judgement and the faculty to discriminate. Acquiring the ability to make judgments on the nature of beauty and perfection in the arts and literature and to demonstrate tasteful preferences signified morality and virtue.

Taste, according to Lord Shaftesbury (1671–1713) in *Characteristicks of Men, Manners, Opinions, Times,* which Walpole owned, was the province of the aristocracy.[2] Shaftesbury played a leading role in the promotion of taste but for him the capacity to acquire taste could only be obtained by certain defined classes of society – it was an aristocratic, country-based faculty. Writing in 1989 Ronald Paulson comments, 'Taste required the disinterestedness gained by distance, conferred by retirement in the country surrounded by ancient texts, and authorized by ownership of landed property.'[3]

1.1 Grown gentlemen taught to dance, M. Rennoldson

GROWN GENTLEMEN taught to DANCE.

Engraved after an Original Picture of Mr John Collett, in the Possession of Mr Smith.

Printed for Jnº Smith, Nº.35, in Cheapside, & Robt. Sayer, Nº.53, in Fleet Street, as the Act directs 20th Augt 1768.

The idea of taste was also seen by some as a socially subversive idea that undermined the hierarchies of class because it suggested that anyone could acquire ordered, elegant gentility and behave in an appropriate manner in polite society, regardless of birth. Shaftesbury's contemporary Joseph Addison was to become the leading proponent of the exercise of taste through his *Spectator* essays where he made it an absolute fundamental of being a modern citizen. Addison's position on matters of taste was the opposite of Shaftesbury's, being city-based and populist – his intention was to educate

the new emerging middle-classes with moral standards and rules for social conduct. Addison's purpose in his essays was clear:

It was said of Socrates, that he brought philosophy down from heaven, to inhabit among men; and I shall be ambitious to have it said of me that I have brought philosophy out of closets and libraries, schools, and colleges, to dwell in clubs and assemblies, at tea-tables, and in coffee-houses.[4]

Walpole, a self-styled arbiter of taste, is a figure of primary importance in any discussion of eighteenth-century manners, taste and judgement, the latter two being synonymous and interchangeable at that time. He spent a lifetime promoting the supremacy of English taste in all its cultural aspects. The reader will recall that Walpole knew Addison's works intimately and quotes liberally from *The Spectator* in his correspondence and other texts. As a young man Walpole aspired to emulate Addison in his own writing and he wrote a letter to Gray in 1735 'in the style of Mr Addison's *Travels*' and he owned the third edition of Addison's *Remarks on Several Parts of Italy* (1726).[5] 'I believe you saw in the newspapers that I was going to make the tour of Italy, I shall therefore give you some account of the places I have seen which are not to be found in Mr Addison, whose method I shall follow ...'[6]

Walpole greatly admired Addison's authorial style and writing to Mary Hamilton (1756–1816) (Mrs John Dickenson), he praises Addison's ability to bring his subjects to life in, 'a finished picture of a most amiable character drawn by the exquisite pencil of Mr Addison.'[7] He adopted Addison's style of writing both in his own essay writing and in larger authored works such as the *Anecdotes of Painting in England* and in the *History of the Modern Taste in Gardening*. Walpole's texts are effortless and amusing and almost certainly based on Addison's entertaining manner in his *Spectator* essays.

The subject of taste was evident in almost every issue of *The Spectator*. Addison continually extolled the benefits of the elegant and refined arts and educated the reader through literary examples, usually of false or bad taste. He defines taste as 'that Faculty of the Soul, which discerns the Beauties of an Author with Pleasure, and the Imperfections with Dislike' and attributes this pleasurable response to the imagination reacting to the perception of objects capable of providing delight.[8]

Addison continually inculcated his audience with the ability to distinguish correct taste and tried to ensure that they would not succumb to baser pleasures and appetites. The capacity of the individual to discern the qualities of taste would be the distinguishing mark of the cultivated, modern citizen. It would make the reading public receptive to topics that would enable participation in all forms of polite social engagement, from the ability to discuss appropriate subjects in the coffee houses to conversing with women in society. Addison delineated how social interaction could be used profitably, stating that: 'Conversation with men of polite genius is another method of improving our natural taste.'[9] The rules pertaining to taste permeated through all aspects of society and were used to oppose anything that was seen as excessive or

licentious, including religious enthusiasm. The promotion of 'true Taste' in periodical literature was used to regulate and enrich every facet of life, from the philosophical to the practical. The *Gentleman's Magazine* reports:

So much depends on true Taste, with regard to eloquence and even morality, that no one can be properly stil'd a gentleman who takes not every opportunity to enrich his own capacity, and settle the elements of Taste which he may improve at leisure. It heightens every science, and is the polish of every virtue; the friend of society, and the guide to knowledge …[10]

The trope of 'taste' was a term used to denote a way of behaviour that demonstrated appropriate values and virtues to all areas of life – the now deeply unfashionable concept of 'propriety'.[11] This theme became an essential tenet of Addison's publication and his message was often conveyed through metaphors as he considered that figures of speech pleased the senses.

Addison had earlier expressed sentiments regarding the ability of poetry to stimulate the imagination. In an early 'Essay on the Georgics' published as a preface in the translation of *The Georgics* (1697) by John Dryden (1631–1700) he uses landscape metaphors to describe the effect of this style of poetry:[12]

But this kind of poetry, I am now speaking of, addresses itself wholly to the imagination; it is altogether conversant among the fields and woods, and has the most delightful parts of nature for its province. It raises in our minds a pleasing variety of scenes and landscapes, whilst it teaches us; and makes the driest of its precepts look like a description. A Georgic, therefore, is some part of the science of husbandry put into a pleasing dress, and set off with all the beauties and embellishments of poetry.[13]

In the 'Pleasures of the Imagination' Addison expands on poetic description and explains precisely how the poet triggers sensory responses in the reader:

… we find the poets, who are always addressing themselves to the imagination, borrowing more of their epithets from colours than from any other topic … Thus, any continued sound, as the music of birds, or a fall of water, awakens every moment the mind of the beholder, and makes him more attentive to the several beauties of the place that lie before him. Thus if there arises a Fragrancy of Smells or Perfumes, they heighten the Pleasures of the Imagination, and make even the Colours and Verdure of the Landskip appear more agreeable; for the Ideas of both Senses recommend each other.[14]

Addison affirms the sensory aspects of pleasure, as derived from Locke, where the apprehension of colour and scents produce an effect in the mind of the observer, sparking memory and moods and physiological response in the spectator, whether they are written or directly experienced.[15] Smell and colour combined, the effect of one or more senses being stimulated simultaneously, serves to increase pleasurable sensations and enjoyment. The cumulative effect of many senses is highly evocative and enhances the experience through an overwhelming profusion of sensations that heighten gratification. Addison consistently uses tropes from poetry, art and landscape to delineate his concepts of taste and imagination. Walpole makes the same connections

on taste as Addison with his apothegm: 'Poetry, Painting, and Gardening, or the Science of landscape, will forever by men of taste be deemed the Three Sisters, or the *Three New Graces* who dress and adorn nature.'[16]

Addison applied association theory to ideas of taste which are fundamentally linked to imagination and these concepts were to be widely disseminated and creatively expressed in Addison's *Spectator* essays. Addison firmly states that the pleasures of the imagination are only available to those who possess taste and refinement:

A Man of Polite Imagination is let into a great many Pleasures, that the Vulgar are not capable of receiving. He can converse with a Picture, and find an agreeable Companion in a Statue. He meets with a secret refreshment in a Description, and often feels a greater Satisfaction in the Prospect of Fields and Meadows, than another does in their Possession.[17]

Addison further intimates that pleasurable emotions are an innate response that occur spontaneously and that a synergy exists between the object and the observer in men who possess breeding and education. He contends that it is not necessary to own or possess the entity or view that gives pleasure; you merely need to have the requisite ability to appreciate and enjoy it.

Addison's theory of imagination is primarily a faculty of visual representation. He distinguishes between primary pleasures which 'entirely proceed from such Objects as are before our Eyes' and secondary pleasures that 'flow from the Ideas of visible Objects, when the Objects are not actually before the Eye, but are called up into our Memories, or formed into agreeable Visions of Things, that are either absent or Fictitious.'[18] Secondary pleasures are either recalled by the operations of the mind through memory, 'or on occasion of something without us, as Statues or Descriptions.'[19] The power of association then leads to an instantaneous train of thought that not only recalls the original, but embellishes and enhances the vision by conjuring up 'a whole Scene of Imagery' as it runs through a series of connections resulting in the final imaginative, pleasurable response through what the poet William Wordsworth (1770–1850) would later define as 'emotion recollected in tranquillity.'[20]

There are thus two types of pleasure, the immediate and the associative, or remembered. In an earlier *Spectator* essay, No. 110, Addison refers to John Locke's *Essay Concerning Human Understanding*, which Walpole too was familiar with, to explain the mental processes involved in this train of associative thought.[21] However, Locke viewed the association of ideas as a negative concept, defining it as 'Something unreasonable in most men' eliciting the 'Wrong connexion of ideas a great cause of errors.'[22]

Mr. Locke, in his Chapter of the Association of Ideas, has very curious Remarks to show how, by the Prejudice of Education, one Idea often introduces into the mind a whole Set that bear no Resemblance to one another in the Nature of things. Among several Examples of this Kind, he produces the following Instance. The Ideas of Goblins and Sprights have really no more to do with Darkness than Light: Yet let but a foolish Maid inculcate these often on the Mind of a Child, and raise them

there together, possibly he shall never be able to separate them again so long as he lives; but Darkness shall ever afterwards bring with it those frightful Ideas, and they shall be so joined, that he can no more bear the one than the other.[23]

1.2 The end of a barn transformed into a Hobgoblin!! The effect of imagination!! Woodward, 1797

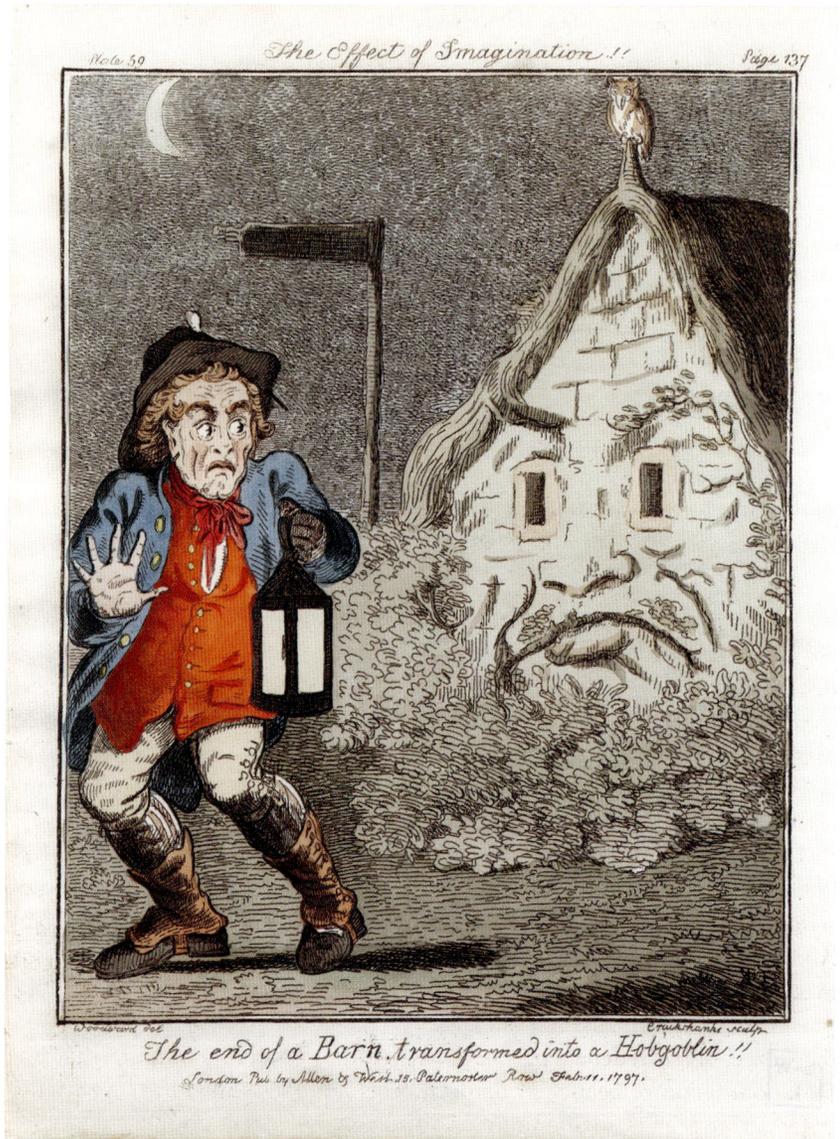

The Effect of Imagination !!

The end of a Barn transformed into a Hobgoblin !!

Although many of Addison's ideas on association are partially derived from Locke, Addison consistently inverts Locke's negative example, suggesting the idea that works of art, artefacts and settings could induce a series of positive associative thoughts, trigger memories and invoke emotions. Addison unequivocally asserts that he values imagination as a positive life-enhancing

attribute. 'The truth of it is, I look upon a sound imagination as the greatest blessing of life, next to a clear judgement, and a good conscience.'[24]

For instance, he stresses the affirmative attributes of imagination and the concomitant association of ideas using a landscape trope to describe how the concept works by evoking a sensory, verdant scene as an example:[25]

We may observe, that any single circumstance of what we have formerly seen often raises up a whole scene of imagery, and awakens numberless ideas that before slept in the imagination; such a particular smell or colour is able to fill the mind, on a sudden, with the picture of the fields or gardens where we first met with it, and to bring up into view all the variety of images that once attended it. Our imagination takes the hint, and leads us unexpectedly into cities or theatres, plains or meadows. We may further observe, when the fancy thus reflects on the scenes that have passed in it formerly, those which were at first pleasant to behold appear more so upon reflection, and that the memory heightens the delightfulness of the original.[26]

Addison use tropes of painting and landscape to demonstrate how the precept works:

… we have the Power of retaining, altering and compounding those Images, which we have once received, into all the Varieties of Picture and Vision that are most agreeable to the Imagination; for by this Faculty a Man in a Dungeon is capable of entertaining himself with Scenes and Landskips more beautiful than any that can be found in the whole Compass of Nature.[27]

He includes architecture and landscape gardening as proficient primary pleasures. However, his explanation, quoted above, patently contradicts this assertion. He elucidates on how the spectator's mind amalgamates complex notions and allows increasing pleasure through the secondary act of imaginative escapism from the dungeon to the landscape. His writing on landscapes in 'The Pleasures of the Imagination,' other *Spectator* essays and elsewhere was innovative and inspirational.

The pursuit of nature and the rejection of formality was a constant theme in his writing and this became one of the essential tenets of English landscape style. The principles and practice of landscape painting as delineated by Addison played a significant role in the development of garden theory and many of our perceptions of landscape stem from eighteenth-century theory and practice. Moreover, taste and judgement and the ability to discriminate were the subject of much debate particularly in Addison's literary output, regarding the appreciation of beauty in natural forms and landscape, their associative potential and links to literature. Addison makes an important connection between particular classic authors and different types of landscapes:

Reading the *Iliad*, is like travelling through a country uninhabited, where the fancy is entertained with a thousand savage prospects of vast deserts, wide uncultivated marshes, huge forests, misshapen rocks and precipices. On the contrary, the *Æneid* is like a well ordered garden, where it is impossible to find out any part unadorned, or to cast our eyes upon a single spot that does not produce some beautiful plant or flower. But when we are in the *Metamorphoses*, we are walking on enchanted ground, and see nothing but scenes of magic lying round us.[28]

Landscape is one of the main subjects of Ovid's *Metamorphoses* for the setting of the narrative and as the subject and location where many of the transformations and changes occur. Writing to West in 1740 Walpole comments on Addison's predilection for poetic description in his *Remarks*, written some 40 years earlier, as a means of visualising scenes. He compares his own observations on Italy, ironically commenting that 'Mr. Addison travelled through the poets, and not through Italy; for all his ideas are borrowed from the descriptions, and not from the reality. He saw places as they were, not as they are.'[29]

However, Ovid's literature was to play an important role in garden iconography and particularly in Walpole's perception of the landscape of the imagination he was to create on 'enchanted ground' at Strawberry Hill.[30]

In *Dialogues upon the Usefulness of Ancient Medals* (1726), Addison, in the fictional persona of Philander recalls his strolls around the Magdalen water walks while a student at Oxford, remembering the pleasurable sensations they evoked and applying the theory of association to landscape using terminology derived from painting principles:

Philander used every morning to take a walk in a neighbouring wood, that stood on the borders of the Thames. It was cut through with an abundance of beautiful alleys, which terminating on the water, looked like so many painted views in perspective. The banks of the river and the thickness of the shades drew into them all the birds of the country, that at Sun-rising filled the wood with such a variety of notes that made the prettiest confusion imaginable. I know in descriptions of this nature the scenes are generally supposed to grow out of the author's imagination ...[31]

Long before 'The Pleasures of the Imagination' essays were published Addison had been writing and deliberating on landscape and the imagination from the early 1690s, mostly deploying landscape tropes to explain how the theories worked in practice. He had, by the late 1690s, written an earlier version of 'The Pleasures of the Imagination' essays, exploring the notion of pleasurable delight and its causes, and investigating the visual and psychological effects of landscape.[32] This brief continuous narrative was later considerably expanded and updated to become the series of *Spectator* essays, Nos. 411–21 published in 1712. In an early *Spectator* essay (1711), Addison created an imaginary country seat for his fictional character Sir Roger De Coverley, an amiable country squire.[33] Walpole wrote of Addison's character portrayal of De Coverley that, 'Addison in some of his Spectators approaches nearest to Shakespeare's natural humour, that is character ... Sir Roger de Coverley is the best drawn character next to Falstaff.'[34] Just as imaginative pleasure played an essential role in Addison's life and works, they provided Walpole with sanctuary and solace too. During his formative years Walpole appears to have found refuge and comfort in imaginative escapism which had its beginnings in the playing fields of Eton. His cousin Conway remembers him perpetually 'buried in romances and novels; I really believe you could have said all the *Grand Cyrus's*, the *Cleopatra's*, and *Amadis's* in the world by heart, nay, you carried your taste for it so far that not a fairy-tale escaped you.'[35]

Walpole too was to adopt a fictional persona while at Eton, not unlike Addison's Philander, or the fictional De Coverley. The role of Celadon, a pastoral shepherd, providing him with a creative means of escape from the occasionally brutal, harsh reality of everyday existence of eighteenth-century public school:

I agree with you entirely in the pleasure you take in talking over old stories, but I can't say but I meet every day with new circumstances, which will be still more pleasure to me to recollect ... Little intrigues, little schemes, and policies, engage their thoughts, and at the same time they are laying the foundation for their middle age of life, the mimic republic they live in furnishes material of conversations for their latter age; and old men cannot be said to be children a second time with greater truth from one cause, than their living over again their childhood in imagination ... Dear George, were not the playing fields of Eton food for all manner of flights? ... As I got further into Virgil and *Clelia*, I found myself transported into Arcadia, to the garden of Italy, and saw Windsor Castle in no other view than the *capitoli immobile saxum* ...[36] One of the most agreeable circumstances I can recollect is the Triumvirate, composed of yourself, Charles and Your sincere friend Hor. Walpole.[37]

Walpole's imagination was further fuelled by reading the classics and stories of romance amid the tranquil setting of Eton. These texts provided consolation and intellectual escapism while furnishing Walpole's mind with visions and ideas in precisely the manner that Addison describes in the 'Pleasures of the Imagination'. The stimulation he enjoyed in the semi-rural situation is not dissimilar to that experienced by Addison's fictional character De Coverley discovering that his surroundings too feed the imagination. 'Mr Spectator' perceptively describes his visit to De Coverley's delightful country garden and the stimulating and pleasurable psychological effects of the countryside on the individual – where we will find the components he determined as being necessary for imaginative pleasure present. Although De Coverley's garden is an imaginative creation, it clearly illustrates the passions, instincts and natural response of man in his engagement with nature that was an essential element of sensation psychology theories under discussion at this time. Addison portrays De Coverley responding to nature as a sort of 'everyman' displaying passion and emotion and experiencing a romantic notion of joy and reverie from the close proximity to nature. It also illustrates the beneficial, stimulating and sensational psychological effects where 'the mind is lost in a certain transport which raises us above ordinary life.' The garden contained the variety, diversity of nature, uniqueness, irregularity and character essential for stimulating the emotions 'and yet is not strong enough to be inconsistent with tranquillity,' but also allows the opportunity for introspection that was a vital part of speculation at that time.[38]

Addison had acquired a country estate at Bilton Hall, Warwickshire in 1711. The Warwickshire chronicler Smith, described Bilton thus:

The situation is desirably retired, and the windows of the principal rooms
command a fair prospect. On the north side of the grounds is a long walk,
still termed Addison's walk, once the chosen retreat of the writer, when intent
on solitary reflection. In its original state, no spot could be better adapted to
meditation, or more genial to his temper; the scenery round is bounded by soft
ranges of hills, and the comely spire and Gothic ornaments of the adjacent village
church, impart a soothing air of pensiveness to the neighborhood.[39]

The setting of Bilton therefore accords with Addison's advocating prospects
and borrowed views as an essential requirement for pleasurable stimulation
of the senses.

It is apparent from the following portrayal that he formed the ideas
expressed in his essays on empirical experience and had carried the theories
articulated in the 'Pleasures of the Imagination' essays into practice. Keen to
distance himself in his pointed criticism expressed in *Spectator* No. 414 from
those gardeners who 'instead of humouring Nature, love to deviate from
it as much as possible.' The 'Pleasures of the Imagination' essays contain
some of the earliest and most influential theses on landscape theory, thereby
placing gardens firmly within Enlightenment philosophical tradition.
Addison states that 'Works of Nature are more pleasant to the Imagination
than those of Art' and argues that the diversified and expansive scenes of
wild nature can liberate the imagination into unfettered realms where it can
roam unrestrained and consequently produce pleasurable sensations and
delight in the 'polite' observer:

If we consider the Works of *Nature* and *Art*, as they are qualified to entertain the
Imagination, we shall find the last very defective, in Comparison of the former; for
though they may sometimes appear Beautiful or Strange, they can have nothing
in them of that Vastness and Immensity, which afford so great an Entertainment
to the Mind of the Beholder.[40]

Addison attempts to persuade his readers of the pleasures to be obtained
from engaging with nature. The importance of 'prospect', continual change,
variation and movement as sources of pleasure also play a significant role
in his precepts. In the 'Pleasures of the Imagination' essays he defines
'novelty' as a principal source of pleasurable emotions, by which he generally
means 'new to the observer'. He contends that the new or unusual event or
occurrence encompassed in his terms of 'agreeable surprise', 'variety', 'new
ideas', 'curiosity', 'uncommon' and 'strange' elicit an emotional response in
the onlooker. He advocates leaving nature to its own devices and explores
the stimulation to be received from different colours and natural forms. His
exposition of his garden as 'a natural wilderness and one of the uncultivated
parts of our country,' must have seemed quite radical at the time, but whether
or not this rendering is a precise description of Addison's actual garden is
unimportant. What is important is that it contains the sources necessary for
stimulating imaginative pleasure, using picture-conscious terminologies
'that compose a picture of the greatest variety.' There is an absence of the
monotony, sameness or uniformity that he denigrated in the formal gardens

as being hindrances to the imagination: his own garden is designed to appeal to the imagination and is characterised by its naturalness, 'natural wilderness' and diversity of nature and natural forms, 'so mixed and interwoven', and contains elements of agreeable surprise, curiosity and unexpected encounters through its labyrinthine, irregular structure. This garden is not merely to be observed: the narrative allows the observer to move through the garden and experience different sensations and psychological responses close at hand by actively walking through diverse scenes and views to witness the 'irregularity in my plantations'. The reader is immersed in the 'confusion', and 'profusion', of 'ten thousand different colours' scents and sounds, light and shade and water features that are simultaneously functional and pleasurable – the rill of water concealed by art so that it 'seems to be of its own producing.' The garden functions to stir the passions and provide the maximum stimulation to the senses through a plethora of different sensory experiences – the novelty of encouraging birds to eat his fruit that in return provide 'music of the seasons in its perfection' and the delight of seeing 'the jay or thrush hopping about my walks.' The spontaneous intellectual and emotional impact on the mood of the onlooker when observing picturesque landscape compositions and visual scenes of variety are concepts present throughout this depiction and in *The Spectator* essays.

Also playing an important role are the beneficial effects derived from the stimulation of the senses through perceptions that aid reflection and association. The subjective association of ideas stimulated other suggestions evoking a train of secondary imaginative thoughts enhancing recollection and aiding a pleasurable response: 'Memory heightens the Delightfulness of the Original.'[41] Addison advises a natural disposition of landscape consciously enhanced to take advantage of prospects or manipulated to conceal unwanted scenes through the judicious use of 'art'. He also recommends the contemplation of scenes and promotes the idea of a garden estate. Later we shall see Addison's psychological theory of sensation and his search for the cause and effects of stimulating the imagination through the principles of taste and association of ideas. We will explore the effect on the senses of engagement with nature, animated prospect, novelty, variety and contrast, all principal concepts realised in the work of the poet Alexander Pope (1688–1744), and William Kent (1685–1748) the most prolific and well known garden designer of the early eighteenth century and particularly, Walpole where they found expression at Strawberry Hill. These elements combine to satisfy taste, rather than assuage the reason, and thus prefigure the romantic notion of psychological engagement and sensory response.

Addison clearly followed his own observations on the pleasures associated with landscape and rural retreats away from the pressures of the city and he is obviously delighted in his acquisition of a country seat. He, like De Coverley, gained immense satisfaction from its ability to transport him to another, happier world where it allowed the all-important opportunity for introspection:

True happiness is of a retired nature and an enemy to pomp and noise; it arises, in the first place from the enjoyment of one's self; and in the next, from the friendship and conversation of a few select companions; it loves shade and solitude, and naturally haunts groves and fountains, fields and meadows: in short, it feels every thing it wants within itself, and receives no addition from multitudes of witnesses and spectators.[42]

These sentiments were echoed by Walpole and he too described a garden as a retreat and a place of 'retirement from affairs to the delights of rural life.' Strawberry Hill was chosen as the perfect location in which to be sequestered, like Addison had done at Bilton, away from the trials and tribulations of the political scene.[43]

Clearly, Addison's idea for the 'Pleasures of the Imagination' series, where he articulates an appeal for natural landscape without 'artificial shows', is based on empirical experience and imaginative creation, carrying his own precepts into practice having acquired his own landscape, where 'a Man might make a pretty Landskip of his own Possessions.'[44]

Alexander Pope, like Walpole, borrowed from Addison when outlining his own ideas for landscape design. Pope first met Addison in 1712 and visited him at Bilton Hall in 1713.[45] In that year he too formulated an argument directly derived from Addison in denigrating the artificial in favour of the natural on the basis that buildings in contrived formal settings lack the necessary qualities for stimulation.[46] In the preface to *Epistle IV, to Richard Boyle, Earl of Burlington* Pope explains in his argument *Of the Use of Riches* with reference to architecture and gardening:

… that the first principle and foundation, in this as in everything else, is Good Sense: The chief proof of this is to follow Nature, even in works of mere Luxury and Elegance. Instanced in Architecture and Gardening, where all must be adapted to the Genius and Use of the Place, and the Beauties not forced into it, but resulting from it.[47]

The 'poetic garden' as a concept defined by Pope was like Addison's precept designed to stimulate the imagination and appropriate the landscape for creative reflection through its associative potential and literary qualities. The literary concept of painting scenes in narrative together with gardening practices first delineated by Addison were to become an important part of Pope's poetics and Walpole's philosophy.

'How history pleases the imagination': The Effects of Association

Concurrent with Addison's series of essays and creating his own landscape at Bilton, theories of association and imagination were being practised by architects and landscape designers. Addison's associate, Sir John Vanbrugh (1664–1726), architect and playwright, was familiar with his theories which he put into practice at Blenheim Palace, Woodstock, Oxfordshire.

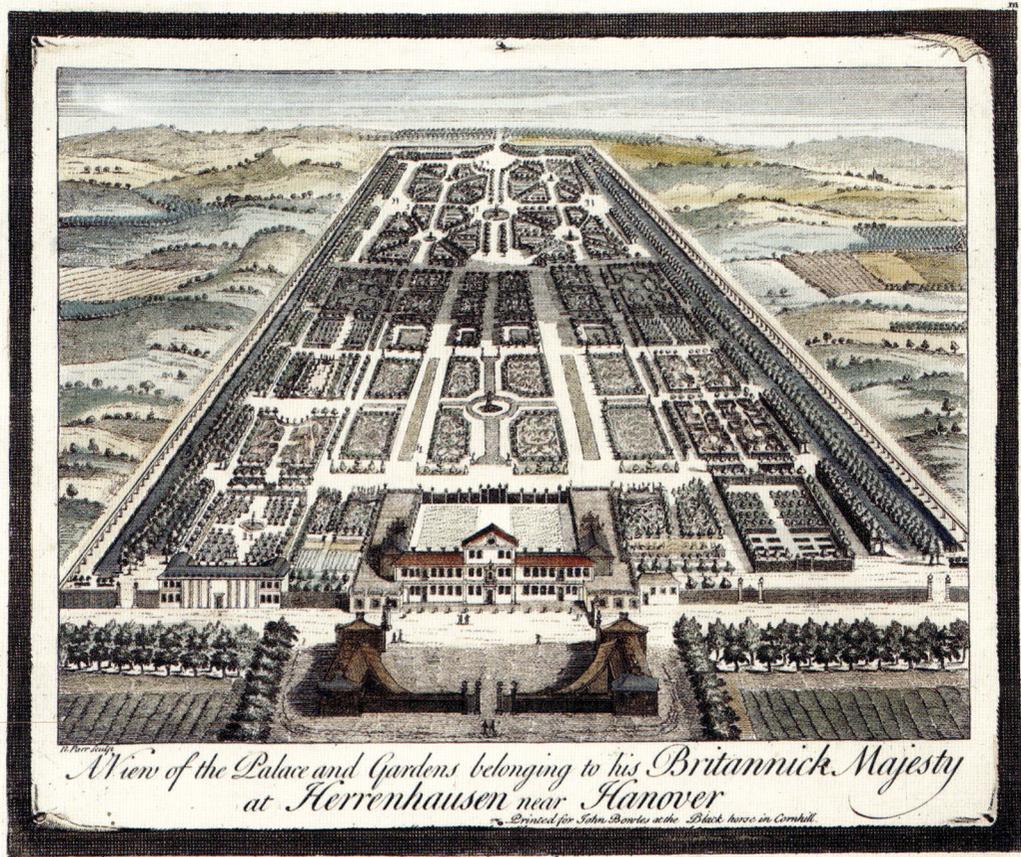

A View of the Palace and Gardens belonging to his Britannick Majesty at Herrenhausen near Hanover

Printed for John Bowles at the Black horse in Cornhill

1.3 The palace and gardens at Herrenhausen, engraving by N. Parr (c.1745)

Addison served as a politician and in various positions of high office in the Whig administration until its dismissal from Government in 1710; retreating to Bilton he produced much of his writing during this fertile literary period. Walpole's father Robert Walpole knew Addison, a fellow Whig and political ally serving in his administration. Robert Walpole became a member of the Kit-Kat Club in 1703 and Addison and Vanbrugh were members too. Vanbrugh's reputation as an architect and landscape designer was evidently well known to Robert as he commissioned Vanbrugh in 1714 to alter and embellish Orford House, Chelsea and again in 1715 to erect a large octagon summerhouse in the garden. Robert Walpole expanded the landscape considerably, 'adding about nine and a half acres of land which he laid out as a garden, planting rare shrubs and flowers.'[48] We have already established that Robert knew *The Spectator* and Addison's other works and Vanbrugh had subscribed to the 1712 and 1721 editions of *The Spectator*.[49] We also know that Addison and Vanbrugh travelled to Herrenhausen near Hanover in 1706 where no doubt they saw the formal Baroque Herrenhäuser Gärten, created for Sophia of Hanover (1630–1714) by the French gardener Martin Charbonnier (1696–1714) – a uniformity

of style that Addison was to unequivocally condemn some six years later in *The Spectator* as hindering the potential for the imagination.[50]

It is probable that on the many occasions they must surely have met they would have discussed 'the stimulating effects of their surroundings', and their potential for inspiring the imagination given their similar approach to the subject.[51] In the 'Pleasures of the Imagination' Addison had affirmed 'how history pleases the imagination' and could evoke a reflective, associational response and Vanbrugh too shared this view.[52] Vanbrugh put the theory into practice at Blenheim and elsewhere, emphasising the positive effects on the imagination of the associational aspects of buildings and landscapes in their compositions. Vanbrugh was an early promoter of informal landscape and the associative quality of ruins through their link to history, connections with painting and their picturesque appeal to the senses.[53] In *Spectator* essay, No. 110, Addison relates how the combination of sight, sound and setting of monastic ruins have the ability to induce a powerful emotional response, stimulating the imagination so that the 'spectator could not but fancy it but one of the most proper scenes for a ghost to appear in.' He again makes reference to Locke's *Essay Concerning Human Understanding* to explain how this phenomenon of associating the various components encountered in this gothic experience triggers a particular imaginative response:[54]

The ruins of the abbey are scattered up and down on every side, and half covered with ivy and elder-bushes, the harbours of solitary birds which seldom make their appearance till the dusk of the evening. The place was formerly a church-yard, and still has several marks in it of graves and burying places. There is such an echo among the old ruins and vaults, that if you stamp but a little louder than ordinary, you hear the sound repeated. At the same time the walk of elms, with the croaking of the ravens which from time to time are heard from the tops of them, looks exceedingly solemn and venerable. These Objects naturally raise Seriousness and Attention; and when Night heightens the Awfulness of the Place, and pours out her supernumerary Horrours upon every thing in it, I do not at all wonder that weak Minds fill it with Spectres and Apparitions.[55]

At Blenheim, Vanbrugh prefigured the picturesque in the fusion of landscape, architecture and the appeal of ruins. For the composition of a particular scene (towards Woodstock Manor) he advocated principles of landscape painting – the use of light and shade, perspective and the appropriate disposition of architectural fragments as a focal point sympathetic to the natural contours of the setting. In an oft-quoted memorandum to John Churchill, 1st Duke of Marlborough (1650–1722) and Sarah, Duchess of Marlborough (1660–1744) he petitioned for the retention of the old ruined manor 'So that all the Buildings left (which is only the Habitable Part and the Chapell) might Appear in two Risings amongst 'em, it wou'd make One of the Most Agreable Objects that the best of the Landskip Painters can invent.'[56] He argued, at Blenheim, for the retention of the 'Small Remains of ancient Woodstock Manour' because of their ability to initiate a chain of ideas through links to British history, their appeal to the senses and pleasurable stimulating potential:

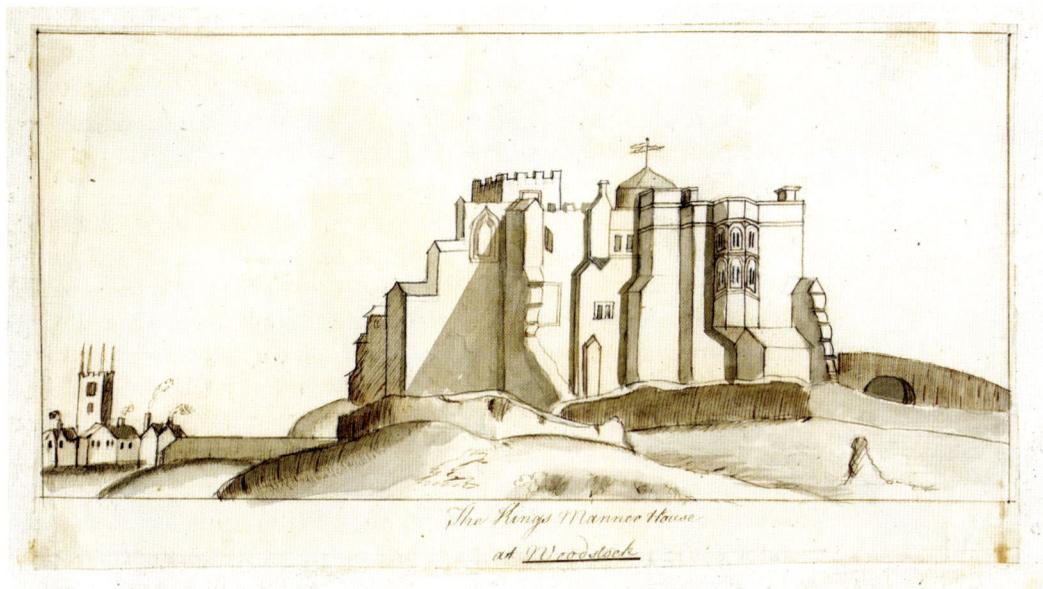

The Kings Mannor House at Woodstock

There is perhaps no One thing, which the most Polite part of Mankind have more universally agreed in; than the Vallue they have ever set upon the Remains of distant Times. Nor amongst the Severall kinds of those Antiquitys, are there any so much regarded, as those of Buildings; Some for their Magnificence, or Curious Workmanship; And others; as they move more lively and pleasing Reflections (than History without their aid can do) on the Persons who have Inhabited them; On the Remarkable things which have been transacted in them, Or the extraordinary Occasions of Erecting them.[57]

1.4 The King's manor house at Woodstock, 1710

Vanbrugh's emphasis on the ability of the picturesque disposition of buildings in an appealing naturalistic landscape setting to evoke an emotional, associative and reflective response accords with Addison's theories delineated in the 'Pleasures of the Imagination' essays. Vanbrugh, like Addison, recognised how the combination of architecture and landscape could evoke a reflective, emotive response in the onlooker through the association of ideas. Walpole was familiar too with Addison's opera, *Rosamund* (1707) which opens with 'a prospect of Woodstock Park, terminating in the bower' and the Queen's opening libretto conveys her enchantment and invokes Ovid:

What place is here!
What scenes Appear!
Where'er I turn my eyes,
All around
Enchanted ground
And soft Elysiums rise:
Flowr'y mountains,
Mossy fountains,
Shady woods,
Crystal floods,
With wild variety surprise ...[58]

The notion portrayed in Vanbrugh's 'pleasing Reflections' as well as Addison's influential 'Pleasures of the Imagination' essays, where he suggests that the imagination is a positive source of pleasure, is a concept that was to exert a considerable influence on Walpole's creation of 'enchanted ground' at Strawberry Hill.

Walpole supported and echoed the positive aspects of association, inevitably recalling people, places, events, and history through buildings and settings. The following letter is important for establishing and understanding how the 'Pleasures of the Imagination' and their powers of association operated for Walpole. The primary pleasure he feels when he experiences the architecture, garden or location and the secondary pleasure he receives from his recollections evoke the emotional and contemplative transaction that precisely accords with Addison's theories and Vanbrugh's practice.

Writing to his artist friend and sometime protégé Richard Bentley (1708–82) Walpole recollects fond memories of the ruined Netley Abbey, a Cistercian foundation of c.1239 which Walpole and Chute had visited during a tour to the Southampton area in 1755, which he remembered as 'charming Netley'. The composition constitutes his personal manifesto for inspirational ecclesiastic Gothic situated in the perfect location in which to participate in the cloistered retreat he was hoping to recreate at Strawberry Hill. Walpole's mind is not suffused with terrifying 'spectres and apparitions'; he, like Vanbrugh, positively associates the ruins with its former inhabitants and with historic events. In this instance he remembers Pope's lines from the *Dunciad* on the 'purple abbots' associated with the abbey's defunct ecclesiastical purpose, which undoubtedly recalls too the Dissolution of the Monasteries (1536–41), a key event in the reign of Henry VIII.

It is worth quoting at length as it encapsulates, in its awed tones, how deeply passionate and emotionally charged he was by the encounter. His reaction is to describe how this enchanted spot could be transformed into the perfect habitation for indulging in associative, imaginary pursuits:

But how shall I describe Netley [Abbey] to you? I can only, by telling you that it is the spot in the world for which Mr Chute and I wish. The ruins are vast, and retain fragments of beautifully fretted roofs pendent in the air, with all variety of Gothic patterns of windows wrapped round and round with ivy – many trees are sprouted up amongst the walls, and only want to be increased with cypresses! A hill rises above the Abbey, encircled with wood: the fort, in which we would build a tower for habitation, remains with two small platforms. The little castle is buried from the Abbey in a wood, in the very centre, on the edge of the hill: on each side breaks in the view of the Southampton sea, deep blue, glistening with silver and vessels; on one side terminated by Southampton, on the other side by Calshot Castle; and the Isle of Wight rising above the opposite hills, – In short, they are not the ruins of Netley, but of Paradise – Oh! The purple abbots, what a spot they had chosen to slumber in![59] The scene is so beautifully tranquil, yet so lively, that they seem only to have retired *into* the world.[60]

Animated prospect, water, Gothic architecture, round towers, tranquillity but liveliness, all the ingredients Addison prescribed to stimulate the imagination are combined in one vision manifested here. In addition to the emotional rapture of the scene which pleased and delighted Walpole, it is noticeable that the composition contains all the features that later made an appearance in Walpole's designs at Strawberry Hill and which he was to advocate through his *History of the Modern Taste* 25 years later.

In an interesting footnote in *Anecdotes of Painting*, Walpole comments ironically on Vanbrugh's Blenheim Palace and Castle Howard, Yorkshire. His remarks further confirm that he believes the effect of seeing the structures in ruins offer a rich opportunity for imaginative speculation:

Large edifices might be erected from unnecessary excrescencies of stone that load the palaces above mentioned: and however admirable Vanbrugh's structures may be in the present state of *perfection*, I will venture to guess that there ruins will have far greater effect, not only from their massive fragments, but from the additional piles which conjecture will supply, in order to give meaning to the whole.[61]

The ability of the spectator to fill the narrative gaps in the story suggested by its ruinous state enhances intellectual and emotional engagement more than the complete structure. The vast palace at Blenheim still had the power to provoke associative thoughts and reflection in Walpole as he records in a later letter to his cousin Henry Seymour Conway, 'I have not seen the improvements at Blenheim. I used to think it was one of the ugliest places in England; a giant's castle who had laid waste all the country round him. Everybody now allows the merit of Brown's achievements there.'[62]

Walpole's description of Queensbury House, or Queensbury Villa, Richmond-on-Thames, built by George, 3rd Earl of Cholmondeley (1703–1770), Horace Walpole's brother-in-law, gives an important insight into how Walpole's historical imagination and his automatic associative response to buildings operates. Queensbury House was constructed by Cholmondeley 'above 30 years after 1708' when most of Richmond Palace was pulled down. Walpole responds emotively to the sense of the place, and its association with the former Palace of Shene and its replacement Richmond Palace built by Henry VII which was destroyed by fire at Christmas 1497 that had previously stood 'on that spot'. 'I could only have been more pleased if (for half an hour) I could have seen the real palace that once stood on that spot, and the persons represented walking about! – a visionary holiday in old age … the taste remains long in one's memory's mouth.'[63]

This quotation provides evidence of how Walpole's antiquarianism and his theories of association and the imagination combine to give him the most pleasurable memories and sensations. We will see that this is a recurrent theme of his associative thought as articulated by Addison in the 'Pleasures of the Imagination'. Walpole constantly recalls works of architecture and locations and, through his imagination, connects them to individuals and historical events.

'One must have taste to be sensible of the beauties of Grecian architecture; one only wants passion to feel Gothic': Walpole and Gothic Architecture

In the essays Addison writes relatively little on architecture and its associative qualities in comparison with his extensive writings on the effects of landscape on the imagination. He appears to imply that architecture is an immediate primary (as opposed to secondary, imaginative) pleasure, apparently providing only limited imaginative potential. Addison states that it 'has a more immediate Tendency, than any other to produce those primary Pleasures of the Imagination.'[64] It would be pertinent to note at this point however that in his *Remarks on several parts of Italy*, Addison contradicts his own assertion when he demonstrates an imaginative, associative response to architectural remains, commenting that:

… a man who is in Rome can scarce see an object that does not call to mind a piece of a Latin poet or historian … There is however so much to be observe'd in so spacious a Field of Antiquities, that it is almost impossible to survey them without taking new Hints, and raising different Reflexions, according as a Man's natural turn of Thoughts, or the Course of his Studies direct him.[65]

In addition, Addison's correspondence records his visit to Rome in July 1701 which reinforces the notion that he recalls art, literature, history, events and people through the lens of architecture.

The streets are marked out with Obelisks, Porphyry is as common as Free-stone, and one sees something in evry wall that woud be preserv'd in the Cabinets of other Countrys. There are Buildings the most magnificent in the world, and Ruins more magnificent than they. One can scarce hear the name of a Hill or a river near it that dos not bring to mind a piece of a Classic Authour, nor cast ones Eyes upon a single Spot that has not bin the Scene of some extra-ordinary action.[66]

Equally, Gothic architecture inspires an associative and imaginative response. In a letter to Richard West during a visit to Siena, Walpole refers to Addison's *Remarks* on the cathedral at Siena. He disagrees with Addison's observations on the 'wonderful Gothic nicety' of the cathedral, explaining that he had seen better examples. 'You must not believe Mr Addison about the wonderful Gothic nicety of the dome [the Duomo] the materials are richer, but the workmanship and taste are not near so good as in several I have seen.'[67] This clearly indicates that Walpole was familiar with other examples of Gothic architecture and confirms that his knowledge and understanding of European Gothic was further enhanced by his Grand Tour. It also corroborates that he was intimate with Addison's text and that Addison's *Remarks* most likely accompanied him on the Grand Tour. Despite Addison's assertion that he is not emotionally engaged with Gothic he recounts that he admires the Cathedral at Siena which he considers to be 'one of the Master-pieces of *Gothic* Architecture.'[68]

Walpole's *Anecdotes of Painting* is the first published attempt to define a theory of Gothic architecture and he expresses his own innovative theories on

the ability of Gothic to inspire the imagination. He does not mention Addison's *Spectator* or his *Remarks on several parts of Italy* as a source for consideration when discussing the merits of Classical versus Gothic architecture but it will become apparent that the arguments are closely related and are the catalyst for his antithetical opinion. It is likely that Walpole's view of Addison's condemnation of Gothic as 'mean' as something of a challenge and willingly embraced the task of rebutting Addison's charge by promoting taste in English Gothic. Walpole's comments in the *Anecdotes of Painting* certainly appear to recall Addison's earlier statement in *Remarks* and his observations expressed in the 'Pleasures of the Imagination'. Walpole expresses a divergent opinion to Addison's with his unequivocal support for English Gothic architecture, a style that he had studied and admired since his time at Eton. Walpole is always a patriot and this is reflected in his preferences and he is determined to establish the supremacy of England in matters of taste. He contradicts Addison by adopting his terminology and subverting it, inverting his example of St Peter's, Rome to compare it unfavourably, in terms of imaginative potential, with Westminster Abbey, London:

It is difficult for the noblest Grecian temple to convey half so many impressions to the mind, as a cathedral does of the best Gothic taste – a proof of the skill in the architects and of address in the priests who erected them. The latter exhausted their knowledge of the passions in composing edifices whose pomp, mechanism, vaults, tombs, painted windows, gloom and perspective infused such sensations of romantic devotion; and they were happy in finding artists capable of executing such machinery. One must have taste to be sensible of the beauties of Grecian architecture; one only wants passion to feel Gothic. In St Peter's one is convinced it was built by great princes – in Westminster Abbey, one thinks not of the builder; the religion of the place makes the first impression; and though stripped of its altars and shrines, it is nearer converting one to popery than all the regular pageantry of Roman domes. Gothic churches infuse superstition – Grecian admiration.[69]

When discussing the merits of architecture in the 'Pleasures of the Imagination' essays, Addison compounds his support for Classical models when he describes the specific attributes of architecture that he believes display most taste and erudition: '*Greatness*, in the Works of Architecture, may be considered as relating to the Bulk and Body of the Structure, or to the *Manner* in which it is built. As for the first, we find the Antients, especially among the Eastern Nations of the World, infinitely superior to the Moderns …'[70]

In his argument Addison quotes almost verbatim the French architectural theorist Roland Fréart (1606–76) to support his preference for Classical Roman buildings to Gothic architecture.[71] His preference for Neo-Classical architecture could be seen as a reaction against the excesses associated with the Baroque style prevalent in England at that time. In this he chimes with Walpole's views on the extravagant nature of this style expressed in *Anecdotes of Painting*, where he condemns Vanbrugh's architecture in particular. Clearly Addison's opinions predate by almost 20 years the Palladian Revivalists' predilection for looking back to the models of antiquity and Rome in particular for the revival

of Classicism. However, Addison's partiality for ancient Classical architecture built by the 'Eastern Nations' as 'infinitely superior' to the 'modern' Gothic is a notion that undoubtedly prompted Walpole to respond vehemently in defence of reviving a taste for English Gothic in the *Anecdotes of Painting*. Addison illustrates his comparisons by citing the 'ancient' Pantheon in Rome as a preferable structure to 'modern' Gothic architecture which was associated with barbarism at this period:

> Let any one reflect on the Disposition of Mind he finds in himself, at the first Entrance into the *Pantheon* at *Rome*, and how his Imagination is filled with something Great and Amazing; and, at the same time, consider how little, in proportion, he is affected with the Inside of a *Gothick* Cathedral, tho' it be five times larger than the other; which can arise from nothing else but the Greatness of the Manner in the one, and the Meanness in the other.[72]

Addison may have preferred the pagan Pantheon to the Gothic church because of the latter's association with Catholicism and possibly an individual preference for architectural massing, boldness and simplicity over small ornamental details which he thought detracted from imaginative potential. Again, Walpole's position is antithetical to Addison's regarding the superiority of foreign Classical model's potential to incite the imagination. Whereas Addison had invoked the Pantheon at Rome as an example where the 'Imagination is filled with something Great and Amazing', Walpole vehemently rejects this, arguing instead for the inherent potential of indigenous Gothic architecture to stimulate a pleasurable response in the onlooker. He compares the capacity of the two styles concluding that English Gothic possesses superior qualities to Classical for producing imaginative effect. Importantly, he inverts Addison's affirmation and emphasises that it is because of the associative connections that can be made between the building and English history, events and people that he inevitably makes when critiquing architecture, that inform his decision:

> If two architects of equal genius and taste, or one man possessing both, and without the least degree of partiality was ordered to build two buildings (and supposing him unlimited in expence) one in the Grecian and one in the Gothic style, I think, the Gothic would strike most at first, the Grecian would please the longest. But I believe this approbation would in some measure flow from the impossibility of not connecting with Grecian and Roman architecture, the ideas of the Greeks and Romans, who imagined and inhabited that kinds of buildings. If (which but few have) one has any partiality to old knights, crusadoes, the wars of York and Lancaster, &c., the prejudice in favour of Grecian buildings will be balanced. All this is supposed to be referred to men who think for themselves; it is idle to address supposition to men who think by rote. Ten thousand or ten million of men who do not think for themselves are but as one man, and that one a mimic or copy of somebody else. If one was to discover in a new country a Grecian and a Gothic building, equally perfect in their several kinds, and have never seen of either style before, I question which one should prefer. I, who have great difficulty of not connecting every inanimate thing with the idea of some person, or of not affixing some idea of imaginary persons to whatever I should see, should prefer that building that furnished me with most ideas, which is not judging fairly of

the merit of the buildings abstractedly. And for this reason, I believe, the gloom, ornaments, magic of the hardiness of the buildings, would please me more in the Gothic than the simplicity of the Grecian.[73]

Walpole admits that his assessment is not objective but is based on the ability to think innovatively and independently. He also possesses powers of association and has propensity for invoking his historical imagination. Walpole cannot look at Greek and Roman buildings without thinking of Greeks and Romans whereas Gothic furnishes his imagination with people and events from English history – 'old knights, crusadoes, the wars of York and Lancaster, &c'. His decision to include a history and critical analysis of the inherent qualities of English architecture in *Anecdotes of Painting* is intended to refute Addison's notion regarding the greater merits of Classical versus Gothic architecture. While his resolution to build a diminutive Gothic castle at Strawberry Hill seems designed to prove Addison's emphatic statement that 'Greatness of Manner' in a small building imbued associative imaginative potential: '*Greatness of Manner* in Architecture, which has such force upon the Imagination, that a small Building, where *it* appears, shall give the Mind nobler Ideas than one twenty times the Bulk, where the Manner is ordinary or little.'

We will find that Walpole's diminutive 'castle' at Strawberry Hill precisely fits Addison's category of greatness of manner in its pretensions to emulate the form of Hugh May's (1621–1684) Windsor Castle (though deliberately rejecting his round-headed arches) and through its references to castle structures in general. The unexpectedness, novelty and surprise it would engender in passers-by would certainly fit Addison's criteria of *Greatness of Manner*. Situated on the River Thames, in close proximity to the ancient royal seat of Hampton Court Palace and through association recalling Windsor Castle, Strawberry Hill's physical presence and visual impact would far exceed its actual size by its sheer audacity. Through its white walls, round towers, crenellations and spiry pinnacles it possessed the ability to impart 'nobler ideas' that Addison stressed in the 'Pleasures of the Imagination' were important for achieving a forceful impact on the imagination.

Addison also expresses a preference for concave and convex forms which he concludes are more conducive to pleasure than other forms. Arches he concludes are the most agreeable shape of all because he finds them more pleasing to the eye. Walpole sets out to rebut Addison, directly contradicting his assertion when he singles out the round arch, to criticise it declaring that it signifies: 'when unaccompanied by any graceful ornaments, a mark of a rude age.' He uses the pretext to launch another defence of the superiority of Gothic to stimulate the imagination based on the inherent good taste of the onlooker:[74]

The pointed arch, that peculiar of Gothic architecture, was certainly intended as an improvement on the circular, and the men who had had not the happiness of lighting on the simplicity and proportion of the Greek orders were however so lucky as to strike out a thousand graces and effects which rendered their buildings magnificent, yet genteel, vast, yet light, venerable and picturesque.[75]

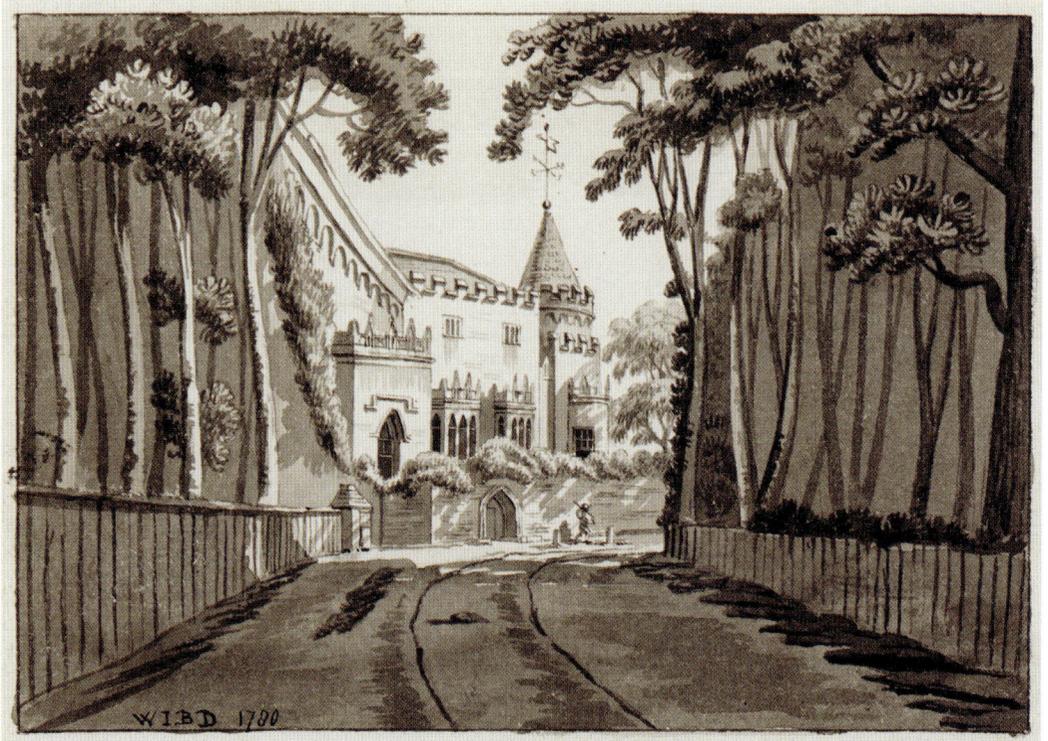

1.5
Mr. Walpole's
house at
Strawberry Hill
Twickenham:
looking up the
road toward
Hampton Court,
W.I.B.D. 1780

This statement confirms why Walpole rejected the round-arched window at Strawberry Hill. Writing to Horace Mann in 1756, Walpole seems to have Addison's statement on the Pantheon uppermost in his mind when he asks, 'Is it true what we see in the gazettes, that the Pantheon is tumbled down? Am not I a very Goth, who always thought it a dismal clumsy performance, and could never discover any beauty in a strange mass of light poured perpendicularly into a circle of obscurity?'[76] Writing to the antiquary Cole, Walpole makes clear that it is not the religious association but the atmosphere and effect of Gothic churches and ecclesiastical buildings and their ability to arouse the imagination that attracted him:

I like Popery as well as you and have shown I do. I like it as I like chivalry and romance. They all furnish one with ideas and visions … a gothic church or a convent fill one with romantic dreams, but for the mysterious, the Church in the abstract, it is a jargon that means nothing or a great deal too much, and I reject it and its apostles from Athanasius to Bishop Keene.[77]

If Walpole fundamentally disagreed with Addison on the architectural style with most potential to stimulate the imagination he nevertheless wholeheartedly concurred with him on the imaginative possibilities of landscape. Walpole elucidated on correct taste and the associative potential of landscape in the *History of the Modern Taste*. It will be demonstrated that

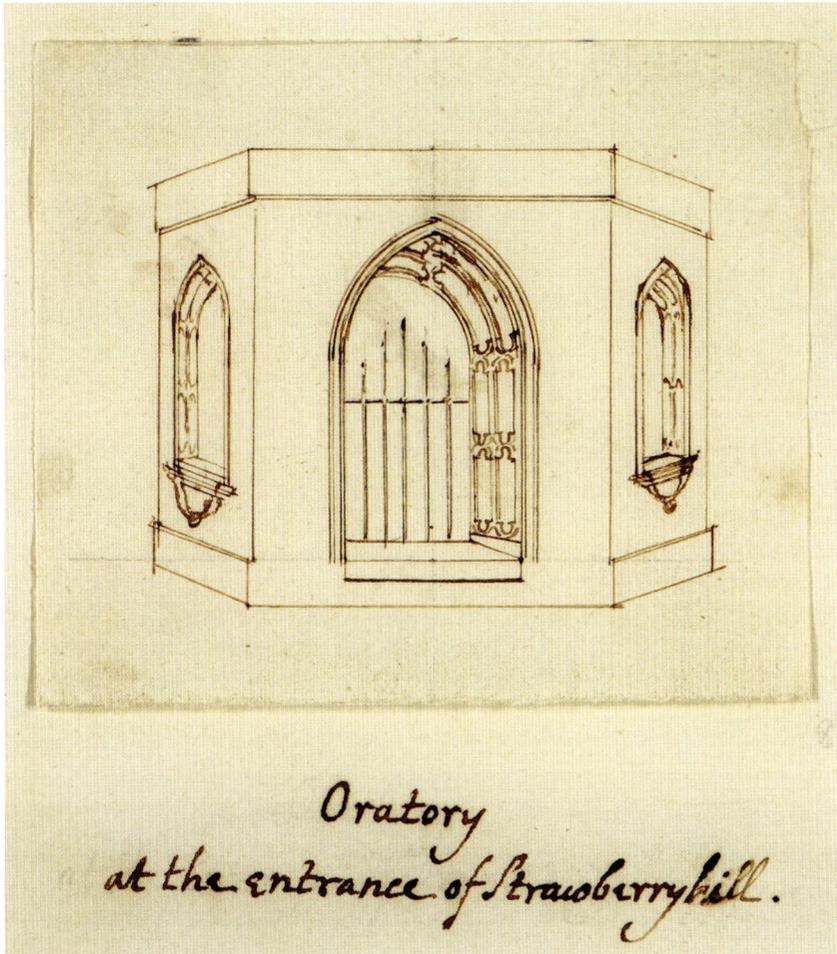

1.6 Oratory at the entrance of Strawberry Hill, J. Chute, 1753

Oratory
at the entrance of Strawberry hill.

the landscape theories of Walpole and Pope replicate Addison in important aspects, a debt that has not hitherto been sufficiently acknowledged. Addison's precepts anticipate Walpole's theories and their impact on him found expression and effectively 'set the scene' for the principles of design that subsequently found expression at Strawberry Hill.

'A Man might make a pretty Landskip of his own Possessions': *The Spectator* in the Landscape

This section explores Walpole's concepts articulated in *The History of the Modern Taste,* comparing and contrasting them with Addison's theories on landscape as expressed in his *Spectator* essays, in particular the 'Pleasures of the Imagination'.[78] It also explores Pope's discourse on gardens articulated in his poetry and correspondence and establishes that his ideas also derive directly from Addison.

Traditions of husbandry, garden making and landscape design have always held a poignant place in the English psyche, and garden visiting in the eighteenth century was, as now, a favourite cultural pursuit. In *The History of the Modern Taste,* Walpole claims credit for the 'natural style' of garden as indisputably English, a claim that has distorted perceptions of garden history down the centuries.[79] He attributes the beginning of the naturalistic style to the description by the poet John Milton (1608–74) of the Garden of Eden in *Paradise Lost* (1667) as the first garden laid out in the English Landscape style. Walpole heaps praise on William Kent as Milton's successor in his ability to envision the pictorial qualities in landscape, declaring, in what is now probably the most famous quotation in garden history, 'He leaped the fence, and saw that all nature was a garden.'

Mainly written during the period 1750–60, but not published until 1780, *The History of the Modern Taste* is contemporaneous with the construction and expansion of Strawberry Hill. It is the most famous (and now infamous) early essay on the history and theory of gardens and is undoubtedly the most influential. Written in an easy and witty prose style very like Addison's manner in *The Spectator,* Walpole adopts a similar rhetorical tactic of gentle persuasion through amusing anecdotes, wit and pithy turns of phrase. In the *History of the Modern Taste* we find the arguments and landscape constituents Addison had deemed necessary for imaginative pleasure forming the foundation of Walpole's essay, and these are evident throughout. Walpole's assertion in the *History of the Modern Taste* that the new 'natural' style of gardening was an entirely patriotic English innovation is a direct riposte to Addison's promotion of foreign models in the 'Pleasures of the Imagination' essays. Addison advocates French and Italian models, not for un-patriotic reasons, but based on his own observations, as potential precursors for natural landscape design. This premise probably forms the primary reason why Walpole omits mention of Addison's influential theory from his fiercely partisan *History of the Modern Taste*, while whole heartedly appropriating its inherent principles.[80] In his notes to William Mason's *An Heroic Epistle to Sir William Chambers* (1773) Walpole stridently declares 'The imitation of Nature in Gardens, or rather in laying out Ground, still called Gardening for want of a specific term to distinguish an Art totally new, is Original and indisputably English.'[81]

Walpole's politically motivated argument for English supremacy as delineated in the *History of the Modern Taste* first appeared as an essay in the fourth volume of *Anecdotes of Painting*, thus bringing gardening into the creative arts alongside painting, poetry and architecture. Walpole opines that the epitome of perfection in architecture and gardening, if not in art, occurred during the period 1727–60 – significantly, contemporaneous with Walpole. With this assertion and precise dating, Walpole effectively omits reference to Addison's influential but significantly earlier notions of the principles associated with the art of creating landscapes set out in *The Spectator* essays as a source for consideration.

Addison's insistence that landscapes were about engaging with nature and his emphasis that 'designed' landscapes should not appear to contain artifice or manifest signs of intervention were notions that were to have considerable influence on Walpole's theory and practice for successive generations of landscape designers. As early as 1710 Addison wrote about a dream vision of the Alps recollecting the 'agreeable prospect' and the great beauty of the natural irregular landscape:

I looked down from hence into a spacious plain, which was surrounded on all sides by this mound of hills, and which presented me with the most agreeable prospect I had ever seen. There was a greater variety of colours in the embroidery of the meadows, a more lively green in the leaves and grass, a brighter crystal in the streams, than what I ever met with in any other region ...'[82]

Despite his polemic in favour of English precedents, Walpole too found himself admiring the disorderly beauty and stimulating effects of foreign landscape. He recorded enthusiasm for rugged Alpine scenery en-route to Italy with Thomas Gray during their Grand Tour as a stimulating, sublime experience some 20 years before Burke writes on the subject of sublimity:[83] 'Precipices, mountains, torrents, wolves, rumblings, Salvator Rosa – the pomp of our park and the meekness of our palace! Here we are, the lonely lords of glorious desolate prospects ...'[84] Walpole continues his passionate poetic description as he writes in rapturous tones to his friend Richard West of their experience, a description which belies his dismissal of French and Italian landscapes in the *History of the Modern Taste*. He records his own enthusiastic response to Alpine scenery on his Grand Tour, writing to West:

Did you ever see anything like the prospect we saw yesterday? I never did. We rode three leagues to see the Grand Chartreuse; and the finest convent in the kingdom. We were disappointed pro and con. The building is large and plain, and has nothing remarkable but its primitive simplicity ... But the road, West, the road! Winding round a prodigious mountain, and surrounded with others, all shagged with hanging woods, obscured with pines or lost in clouds! Below, a torrent breaking through cliffs, and tumbling through fragments of rocks! Sheets of cascades forcing their silver speed down channelled precipices, and hasting into the roughened river at the bottom! Now and then an old foot-bridge, with a broken rail, a leaning cross, a cottage, or the ruin of an hermitage! This sounds too bombast and too romantic to one that has not seen it, too cold for one that has. If I could send you my letter post between two lovely tempests that echoed each other's wrath, you might have some idea of this noble roaring scene, as you were reading it. Almost on the summit, upon a fine verdure, but without any prospect, stands the Chartreuse. We stayed there two hours, rode back through this charming picture, wished for a painter, wished to be poets! ...[85]

Walpole's companion, Gray, confirms that the scenes had a profound impact on the two young men. Gray's letter corroborates Walpole's account in emphasising Addison's notion of how greatness and magnitude in nature inspire awe and stimulate the imagination:

I own I have not as yet any where met with those grand and simple works of
Art, that are to amaze one, and whose sight one is to be the better for: but those
of Nature have astonished me beyond expression. In our little journey up to
the Grand Chatreuse, I do not remember to have gone ten paces without an
exclamation, that there was no restraining: not a precipice, not a torrent, not a
cliff, but is pregnant with religion and poetry. There are certain scenes that would
awe an atheist into belief, without the help of other argument. One need not
to have a very fantastic imagination to see spirits there at noon-day: You have
Death perpetually before your eyes, only so far removed, as to compose the mind
without frighting it. I am persuaded St. Bruno was a man of no common genius,
to choose such a situation for his retirement; and perhaps should have been a
disciple of his, had I been born in time. You may believe Abelard and Heloise
were not forgot upon this occasion ...[86]

Pope's poem *Eloisa To Abelard* (1717) held a particular fascination for Walpole
and Gray and here we have an early example of the association of locations
or individuals invoked by strong emotions. These are imaginatively linked
to the story of the tragic couple combined with the idea of romantic exile in a
convent, monastic solitude and the contemplative life.

In this romantic, impulsive response Walpole and Gray echo Addison's
description on the effect of what is essentially a sublime landscape related
in picturesque terms, 'We are flung into a pleasing Astonishment at such
unbounded Views, and feel a delightful Stillness and Amazement in the
Soul at the Apprehension of them.'[87] Constantly changing factors relieve the
tedium of the familiar, and provide new experiences of the beautiful, rare or
uncommon to give stimuli and pleasure. Walpole's ecstatic responses register
amazement, astonishment and a certain degree of apprehension at the
diversity and prospects which precisely coincide with Addison's observation
that 'Our Imagination loves to be filled with an Object, or to grasp at anything
that is too big for its Capacity.'[88]

As stated above, Walpole remarkably does not mention Addison in the
History of the Modern Taste and revealingly does not disclose the pleasure
he himself sensed on viewing foreign landscapes during his Grand Tour
experiences: 'You can't imagine how pretty the country is between this [Siena]
and Florence; millions of little hills planted with trees, and tipped with villas
or convents.'[89] Gray too records the beauty of the Italian landscape as he and
Walpole travelled through the country of Lombardy: '... hitherto, is one of
the most beautiful imaginable; the roads broad, and exactly straight, and on
either hand vast plantations of trees, chiefly mulberries and olives, and not
a tree without a vine twining about it and spreading among its branches.'[90]

Walpole's insistence that modern landscape design was a wholly English
invention was politically motivated and evidently linked to the British
constitution and this polemic forms the basis of his entire discussion. The
overt political dimension of Walpole's account accords with the less explicit
political theories expounded by Addison; however, he too asserts that
'a spacious Horizon is an Image of Liberty' – a particularly Whig notion of
landscape.[91] This notion of liberty, freedom and disorder and the principles of

painting are a recurring theme in Addison's writing on landscapes. Addison's poem *Liberty* (1701) addresses this theme of landscape in relation to the British Constitution. It records his response to the Italian landscape, wherein he compares the oppression of its inhabitants and alludes to the freedom enjoyed by those under British rule. The concept of Liberty as a requisite of imaginative freedom is reinforced in the 'Pleasures' essays:[92] '… a spacious Horizon is an Image of Liberty, where the Eye has Room to range abroad, to expiate at large on the Immensity of its Views, and to lose itself amidst the Variety of Objects that offer themselves to its Observation.'[93] Walpole too embraces a Whig interpretation of landscape associated with freedom and liberty which has a considerable impact on his understanding of the meaning and origins of English landscape. In his notes to Mason's *Satirical Poems* Walpole expands this notion and he too makes explicit links between landscapes created under Whig rule, the idea of freedom, and the English Constitution:

At least it will show what a Paradise was England while she retained her Constitution – for perhaps it is no paradox to say, that the reason why Taste in Gardening was never discovered before the beginning of the present Century, is, that It was the result of all the happy combinations of an Empire of Freemen, an Empire formed by Trade, not by a Military & conquering Spirit, maintained by the valour of independent Property, enjoying long tranquillity after virtuous struggles, & employing its opulence & good Sense on the refinements of rational Pleasure. Let it be considered that the Composition of Gardens depends on wealth, on extended possession, on the beauties and animation of Agriculture, Farming and Navigation. Walls are thrown down to admit the prospect of inclosures, villages, great roads & moving Life. What would be the view from a Nobleman's garden in an arbitrary monarchy, if views of the country were called in? – Desolation, poverty, misery; barren rocks, & plains covered with thistles … The English Taste in Gardening is thus the growth of the English Constitution, & must perish with it.[94]

In the 'Pleasures of the Imagination' essays Addison articulates his preference for the landscapes of France and Italy as models precisely because they display the same combination of variety and utility. He illustrates how the neat and elegant English landscape could be made more visually appealing and simultaneously productive. Addison denigrates wasting land by ornamenting it without utilitarian value and suggests how cultivation would enhance the prospect and make it more visually appealing and therefore stimulating, and simultaneously, profitable:

On this account our *English* Gardens are not so entertaining to the Fancy as those in *France* and *Italy*, where we see a large Extent of Ground covered over with an agreeable Mixture of gardens and Forest, which represent everywhere an artificial Rudeness, much more charming than that Neatness and Elegancy which we meet with in those of our own Country. It might, indeed, be of ill Consequence to the Publick, as well as unprofitable to private Persons, to alienate so much Ground from Pasturage, and the Plow, in many Parts of a Country that is so well peopled, and cultivated to a far greater Advantage. But why not a whole Estate be thrown into a kind of Garden by frequent Plantations, that may turn as much to the Profit, as the Pleasure of the Owner? A Marsh overgrown with Willows, or a Mountain

shaded with Oaks, are not only more Beautiful, but more beneficial, than when they lie bare and unadorned. Fields of Corn make a pleasant Prospect, and if the Walks were a little taken care of that lie between them, if the natural Embroidery of the Meadows were helpt and improved by some small Additions of Art, and the several Rows of Hedges set off by Trees and Flowers, that the soil was capable of receiving, a Man might make a pretty Landskip of his own Possessions.[95]

What Addison is condemning here is the tendency of formal English gardens to exclude totally the surrounding cultivated and inhabited countryside rather than incorporating it into the larger picture.

He is implicitly criticising the contemporary trend for constructing ordered Dutch-style gardens like Dyrham Park, Gloucestershire and advocating the concept of British liberty manifested through unfettered, disordered natural landscape and 'borrowed views' which were to become the essential ingredient of English Landscape style as depicted in Walpole's *History of the Modern Taste*. He emphatically does not praise the grand formal gardens at Versailles, France or the Villa D'Este, Tivoli but, rather, those extensive forest landscapes like 'Fontaine-bleau' in France which Addison describes: 'It is situated among rocks and woods that give you a fine varietie of Savage prospects …' Then using Virgil's concept of a 'genius of the place', a phrase which would be later borrowed by Shaftesbury and become synonymous with the writings of Pope, he adds, 'The King has Humourd the Genius of the Place and only made use of so much Art as is necessary to Help and regulate Nature without reforming her to much.' He goes on to describe the scene, which is essentially a natural landscape designed to take advantage of its intrinsic features:

The Cascades seem to break through the Clefts and cracks of Rocks that are cover'd over with Moss and look as if they were pil'd upon one another by Accident. There is an Artificial Wildness in the Meadows Walks and Canals and the Garden instead of a Wall is Fenc'd on the Lower End by a Natural mound of Rock-work that strikes the Eye very Agreeably. For my part I think there is something more charming in these rude heaps of Stone than in so many Statues and would soon see a River winding through Woods & Meadows as it does near Fountain-bleau than when it is toss'd up in such a Variety of Figures at Versailles.[96]

Addison is describing a natural garden situated in a productively cultivated landscape that is not incongruous in its setting and complements and enhances its topographical situation rather than being imposed upon it. This is a model of variety and prospect that will have considerable influence on Walpole. This idea is reflected in his landscape at Strawberry Hill and his subsequent writings on the English landscape style in the *History of the Modern Taste*. Addison advocates that the English countryside should be cultivated with trees, and that land is farmed for utility with agriculture that is a combination of arable and pastureland populated with animals. According to Addison, it is the ever-changing animated scene that enlivens and stimulates the imagination. The continual alteration of a view caused by movement, water and seasonal change provides contrast, difference and perpetual interest through reflection and diversity:

Everything that is new or uncommon, raises a pleasure in the imagination because it fills the soul with an agreeable surprise, gratifies its curiosity, and gives it an idea of which it was never before possessed … It is this that recommends Variety, where the mind is every instant called off to something new, and the Attention not suffered to dwell too long, and waste itself on any particular Object.[97]

The notion of an animated landscape providing continual pleasure and stimulation was one that was to have a considerable impact on Walpole. This is evident in the theories he promulgates throughout the *History of the Modern Taste* and more particularly the theme of animation consistently surfaces in relation to his practice in the designed landscape and setting at Strawberry Hill.

Addison consistently condemned the confined cultivated nature of formal gardens, as restrictions on the imagination arguing that they had a negative effect on the mind – the intellect requires extensive prospects of uncultivated nature on a large scale to furnish it with ideas. This too was a notion that Walpole was to make central in his *History of the Modern Taste* and the ethos of his landscape designs at Strawberry Hill. Addison may have had in mind the 50-acre Herrenhäuser Gärten laid out in a strict geometrical pattern of lawns, hedges and walks interspersed with statuary when he was writing his series where he professed that:

There is something more bold and masterly in the rough careless Strokes of Nature, than in the nice Touches and Embellishments of Art. The Beauties of the most stately Garden or Palace lie in a narrow Compass, the Imagination immediately runs them over, and requires something else to gratify her; but, in the wide Fields of Nature, the Sight wanders up and down without Confinement, and is fed with an infinite variety of Images, without any certain Stint or Number. For this Reason we always find the Poet in Love with a Country-Life, where Nature appears in the greatest Perfection, and furnishes out all those Scenes that are most apt to delight the Imagination.[98]

Despite Walpole's omission in acknowledging Addison's essays his main precepts of variety, prospect and the associative potential of landscapes form the foundations of Walpole's *History of the Modern Taste* and were clearly influential on Walpole's theories and his designed landscape. Comparison between the authors reveals that in the *History of the Modern Taste* Walpole, too, approached the subject of formality with relish explicitly criticising these gardens as 'these impotent displays of false taste.'[99] Although he never acknowledges Addison his indebtedness is apparent; for example in this quotation Addison complains that:

Our *British* Gardener's, on the contrary, instead of humouring Nature, love to deviate from it as much as possible. Our Trees rise in Cones, Globes, and Pyramids. We see the Marks of the Scissors upon every Plant and Bush. I do not know whether I am singular in my Opinion, but, for my own part, I would rather look upon a Tree in all its Luxuriancy and Diffusion of Boughs and Branches, than when it is thus cut and trimmed into a Mathematical Figure; and cannot but fancy that an Orchard in Flower looks like infinitely more delightful than all the little Labyrinths of the most finished Parterre.[100]

Walpole uses precisely the same arguments in his *History of the Modern Taste,* castigating the formal garden that shut out prospects and condemning deviations from nature declaring that 'every improvement that was made, was but a step further from nature.'[101] He goes on to express Addison's sentiments regarding the strict formality practised in earlier gardens, singling out 'parterres embroidered in patterns like a petticoat' as 'the childish endeavours of fashion and novelty' but saves his severest criticism for the disfigurement of natural forms as 'impotent displays of false taste.' In emotive language he states:

The sheers were applied to the lovely wildness of form with which nature has distinguished each various species of tree and shrub. The venerable oak, the romantic beech, the useful elm, even the aspiring circuit of the lime, the regular round of the chestnut, and the almost moulded orange tree, were corrected by the fantastic admirers of symmetry.[102]

He argues against the 'unsatisfying sameness' of geometrical gardens laid out with 'compass and square' complaining that they cannot stimulate the imagination, contending that in the views of the seats of the nobility and gentry depicted by Johannes Kip (1652/3–1722) 'we see the same tiresome and returning uniformity.'[103]

The transition from Baroque to an informal, naturalistic landscape was largely complete by mid-century parallel to a similar progression in architecture with Classical Palladian replacing Baroque. However, the progression was not linear, and both large and small irregular landscape parks and gardens existed side-by-side with formal gardens throughout much of the period. Kip's birds-eye view of the garden at Dyrham (1710), the seat of William Blathwayt (?1649–1717), which is less than ten miles north of Bath, vividly illustrates the Baroque garden style at this time that Addison, Pope and Walpole found such an anathema.[104]

Walpole adopts pejorative language to decry the manifestation of art in gardens but insists that despite the fact that 'such preposterous inconveniencies prevailed from age to age, good sense in this country perceived the want of something at once more grand and natural'. This was the English medieval deer park which he describes as 'contracted forests and extended gardens', which, for Walpole, are the origins of the landscape garden. Walpole's description is not dissimilar to Addison's observations on 'Fontaine-bleau'. Walpole supports his contention by referring to Hentzner's *Journey into England* where Hentzner confirms that deer parks are common in, and unique to, England making their first appearance at Woodstock.[105] Woodstock particularly appeals to Walpole because of its rich historical and romantic association with Henry II (1133–1189) and 'fair Rosamund'.[106] Walpole's admiration for the intricacy of the woodland, park and garden corresponds with Addison's account of the elements he applauded in France and Italy but here transposed to English soil. In Addison's words, '… where we see a large Extent of Ground covered over with an agreeable Mixture of gardens and Forest, which represent everywhere an artificial Rudeness.'[107]

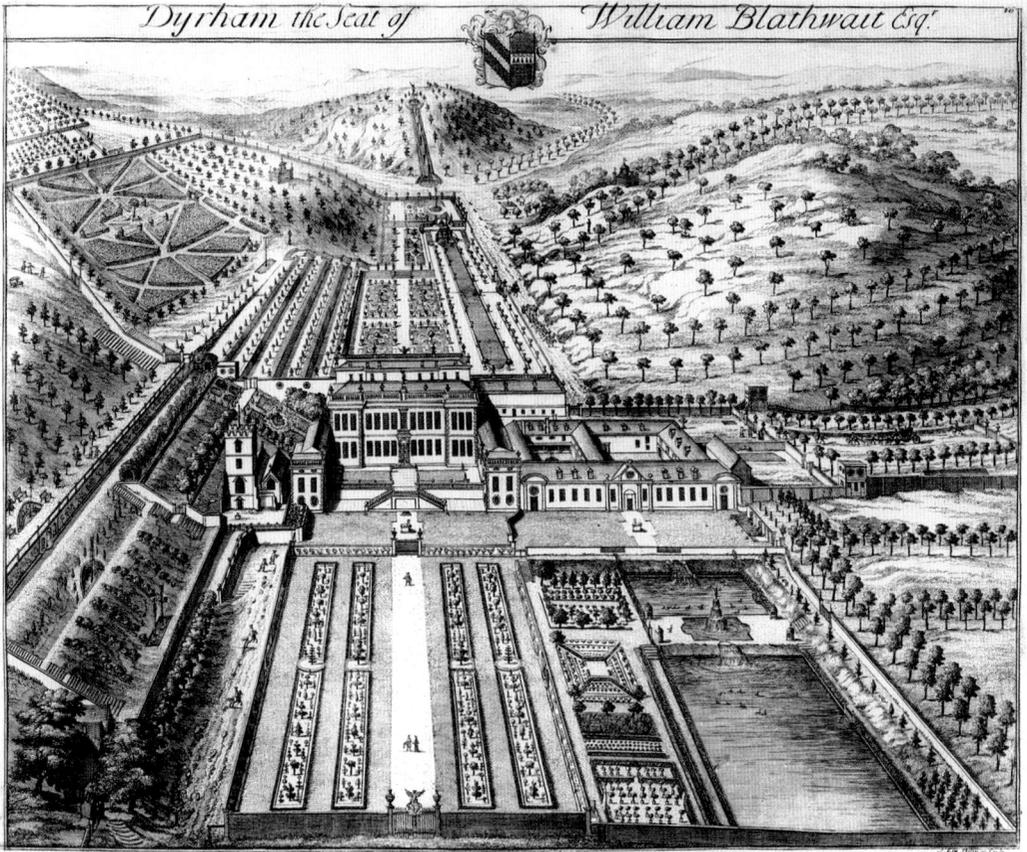

Dyrham the Seat of William Blathwait Esq.

He dismisses out-of-hand all Roman, ancient, and foreign precedents for modern gardening as containing too much artifice or lacking in imagination. 'In other words they were what sumptuous gardens have been in all ages till the present, unnatural, enriched by art, possibly with fountains, statues, balustrades and summer-houses, and were anything but verdant and rural'.[108] And echoing Addison, he also derides early English forerunners as progenitors of the new style as they had made gardens; 'inclosed with walls … to the exclusion of nature and prospect … insipid and unanimated'.[109]

Addison alludes to John Milton when linking natural gardens to the Garden of Eden as the precursor and as a primary example of landscape as a source of pleasure. He had previously declared: 'If I were to name a poet that is a perfect master in all these arts of working on the imagination, I think Milton may pass for one …'[110]

… I look upon the pleasure we take in a garden as one of the most innocent delights in human life. A garden was the habitation of our first parents before the fall. It is naturally apt to fill the mind with calmness and tranquillity, and to lay all its turbulent passions at rest. It gives us great insight into the contrivance and wisdom of Providence, and suggests innumerable subjects for meditation.[111]

1.7 Engraving of Dyrham Park including the house and garden, by Johannes Kip, 1710

Walpole also uses this example of Milton's depiction of the Garden of Eden in *Paradise Lost*. He invokes Milton, writing some 50 years earlier, as the only forerunner of natural gardening, Walpole declares that Milton possessed, 'the prophetic eye of taste … to have foreseen modern gardening'. He then proceeds to quote a passage from *Paradise Lost* as testimony in favour of more natural gardens, italicising the words relevant to his contention:

> … from the sapphire fount the crisped brooks,
> Rolling on orient pearl and sands of gold,
> With mazy error under pendent shades
> Ran nectar, visiting each plant, and fed
> Flowr's worthy of paradise, which not *nice art*
> In beds and curious knots, *nature* boon
> Pour'd forth profuse on hill and dale and plain,
> Both where the morning sun first warmly smote
> The open field, and where the unpierc'd shade
> Imbrown'd the noon-tide bow'rs. – *Thus was this place*
> *A happy rural seat of various views.*[112]

In the *History of the Modern Taste*, Walpole erroneously declares that Milton had never seen Italy; a statement which supports his own contention that Italy could not have contributed to the evolution of gardens or been the precedent for Milton's visualisation of an English Eden.[113] Significantly, for our purposes, Walpole asserts that it was purely a work of Milton's imagination: 'The vigour of a boundless imagination had told him how a plan might be disposed, that would embellish nature, and restore art to its proper office, the just improvement or imitation of it'.[114]

Milton's *Paradise Lost* was subjected to critical analysis by Addison in a series of important papers in *The Spectator* and Milton was an author that he and Walpole frequently quoted. In his criticism Addison had made the same observation regarding Milton's Garden of Eden being a work of his imagination:

> The plan of it is wonderfully beautiful, and formed upon the short sketch which we have of it in holy writ. Milton's exuberance of imagination has poured forth such a redundancy of ornaments on this seat of happiness and innocence, that it would be endless to point out each particular.[115]

Addison is implicitly critical of the practices of George London (16?–1714) and Henry Wise (1653–1738) deprecating their motivation for profit rather than landscape improvement. They were both nurserymen and garden designers and together were largely responsible for the laying-out, supplying and planting most of the formal gardens at this time:

> But as our great Modellers of Gardens have their Magazines of Plants to dispose of, it is very natural for them to tear up all the Beautiful Plantations of Fruit Trees, and contrive a Plan that may most turn to their own profit, in taking off their Evergreens, and like the Moveable Plants, with which their Shops are plentifully stocked.[116]

Walpole likewise denigrates the current crop of garden designers and concurs with Addison's sentiments when he directly names and blames London and Wise for providing the materials and carrying the 'absurdities' into practice. '… London and Wise had stocked our gardens with giants, animals, monsters, coats of arms and mottoes in yew, box and holly'.[117]

It is by now apparent that Walpole's essay is predicated on Addison's seminal 'Pleasures of the Imagination' and Pope's precepts, like Walpole's, encapsulate those of Addison. However, Walpole credits Pope's slight writings on the subject of gardens as the catalyst for reform in the nation's approach to landscape design. Walpole cites 'the admirable paper in the *Guardian*, no. 173', as the inspiration behind the landscape designer Charles Bridgeman (1690–1738) developing a more natural, but still semi-formal landscape style declaring that he too:

Banished verdant sculpture, and did not revert to the square precision of the foregoing age. He enlarged his plans, disdained to make every division tally to its opposite, and though he still adhered much to strait walks with high clipped hedges, they were only his great lines; the rest he diversified by wilderness, and with loose groves of oak, though still within surrounding hedges.[118]

This quotation provides us with a good example of Walpole's methodology throughout the *History of the Modern Taste*. He has taken lines by Pope, which are fundamentally based on Addison, then uses these ideas and rewrites or paraphrases them. This tactic, though it relies on Addison's innovative earlier essay, does not acknowledge his influence.

It is correct that Pope, through his poetry, became one of the main proponents of respecting 'the Genius of the place', advocating a more natural landscape style in garden design that worked with nature and natural topography rather than imposing geometrical patterns upon it.[119] However, commentators have neglected Addison's elegant essays in *The Spectator* and other writing as the origins of these ideas in favour of Pope's acerbic attacks on the practitioners of formal gardening in the *Guardian* prose essay of 1713 and his poetic attack in his *Epistle to Burlington* of 1731.[120] Apart from these two pieces, Pope wrote no treatise on the subject nor published anything on his own garden or how his ideas might be carried into practice.[121] Pope did achieve, in *Windsor Forest*, an evocation of the 'rude' natural landscape of composed scenes full of variety and interest. The perpetually interesting scenes that were promoted by Addison and endorsed by Walpole's 'animated landscape' in the *History of the Modern Taste* are evident in Pope's lines:

Here hills and vales, the woodland and the plain,
Here earth and water seem to strive again,
Not Chaos – like together crush'd and bruis'd,
But, as the world, harmoniously confus'd:
Where order in variety we see,
And where, tho' all things differ, all agree.
Here waving groves a chequer'd scene display,

And part admit, and part exclude the day …
There interspers'd in lawns and op'ning glades,
Thin trees arise that shun each other's shades.[122]

Pope's indignant ridicule in his *Guardian* essay contrasts with Addison's stylistic approach in *The Spectator* essays where he uses gentle satirical humour to educate in matters of taste. Pope, like Addison, severely criticised formal layouts as stylised, uniform and geometrical with planting severely manicured into architectural forms and with elaborate fountains, water features and very formal statuary.[123] Promoting irregular beauty through his poetry, particularly in *Epistle IV, To Richard Boyle, Earl of Burlington: Of the Use of Riches* (1731), he endorsed 'the simplicity of unadorned nature', and advocated concealing boundaries: 'He gains all points who pleasingly confounds, / Surprizes, varies and conceals the Bounds'. Walpole too had approved the introduction of 'cultivated fields, and even morsels of a forest appearance' into the designed landscape, citing the 'sunk fence' as the 'leading step' in the blurring of distinctions between nature and art in the garden.[124] Addison's essential elements of variety and surprise and the concealment of 'Art' in landscape were features also clearly defined by Pope: 'Let not each beauty ev'ry where be spy'd, / Where half the skill is decently to hide'.[125]

Addison's landscape theories developed and evolved through the combination of composing and reading the rhetorical expression in ancient literature where he experienced 'verbal' and 'imaging' pictures and their capacity to initiate pleasing reflections. Painting principles also played a significant role in the development of his precepts and the visual depictions of art and his heightened perceptions provided him with the principles he astutely applied to landscape. In the *History of the Modern Taste* Walpole too constantly invokes painting tropes to describe Kent's landscapes, asserting that: 'The great principles on which he worked were perspective, light and shade'.[126] Walpole praised William Kent for developing planting strategies to facilitate this concept of screening and revealing; using trees to break 'uniformity', he 'blotted out some parts by thick shades' to increase variety and create interest.

Judicious planting achieved an element of surprise by concealment and enticement, 'to make the richest scene more enchanting by reserving it to a farther advance of the spectator's step'.[127] These ideas correspond to Addison's statement that:

The design of art is to assist action as much as possible in the representation of nature; for the appearance of reality is that which moves us in all representations, and these have always the greater force the nearer they approach to nature, and the less they show of imitation.[128]

This argument is also reinforced in Addison's praise of Chinese gardens as 'genius in works of this nature, and therefore always conceal the art by which they direct themselves.' This alludes to Sir William Temple's (1628–1699) *Upon the Gardens of Epicurus* (1685) which Addison knew wherein Temple praises Chinese *Sharawadgi*, a term he used to express their genius for concealing art in their planting.[129]

1.8 View of
Richmond Hill,
Twickenham,
and Mr. Pope's
house from
the terrace at
Strawberry Hill,
W. Pars, 1772

The concept of incorporating the wider landscape into the prospect from the garden was first promoted by Addison and adopted by Pope when he suggested that the layout 'Calls in the Country'. Addison had explored how: '... Such wide and undetermined Prospects are as pleasing to the Fancy, as the Speculations of Eternity or Infinitude are to the Understanding ...'[130] These ideas resonate in Walpole's commending Kent for leaping the fence in seeing 'that all nature was a garden' calling in the 'distant views' by crowning 'an easy eminence with happy ornament' thereby extending the 'perspective by delusive comparison'.[131] Addison insisted that the landscape should also be appropriately populated with animals to enliven the prospect, and land beyond the boundary of the pleasure ground should be utilised as part of the overall setting. 'For this Reason there is nothing that more enlivens a Prospect than Rivers, Jetteaus, or Falls of Water, where the Scene is perpetually shifting, and entertaining the Sight every Moment with something that is new.'[132]

This is the same idea that occurs in Walpole's statement that 'Prospect, animated prospect, is the theatre that will always be the most frequented.'[133] Walpole insists that the 'capital stroke' that enabled the landscape improvements to happen was the introduction of the ha-ha, a sunken ditch used to make an invisible boundary so as not to interrupt the view, and he

erroneously credits Bridgeman with its introduction.[134] Walpole states: 'the sunk fence ascertained the specific garden, but that it might not draw too obvious a line of distinction between the neat and the rude, the contiguous out-lying parts came to be included in a kind of general design.'[135]

Of course this concept of uninterrupted views and concealing barriers as we have seen was first promulgated by Addison in his observation that the mind of man hates objects like walls or mountains that restrict views, imposing 'restraint or 'confinement' on the imagination. He cites 'a spacious Horizon is an Image of Liberty', allowing the sight to 'range abroad' taking delight in the 'Immensity of its Views', thus enabling the spectator's mind 'to lose itself amidst the Variety of Objects that offer themselves to its Observation.'[136]

Addison's 'hints' on the primary pleasures to be derived from the appreciation of visual beauty in landscapes combined with secondary principles, an ability for landscape to arouse pleasurable emotional responses in the viewer – are ideas wholeheartedly taken up by Pope and Walpole. At Strawberry Hill, Walpole's creative imagination achieved a scene that, in Addison's terminology, 'looked like so many painted views in perspective.' He created a landscape for posterity based on Addison's premise regarding philosophers and gardening, stating that 'Nothing can be more delightful than to entertain ourselves with Prospects of our own making and to walk under those Shades which our own Industry has raised.'[137]

Addison's thinking on the superiority of the imagination over that of the intellectual faculty will be demonstrated to have a significant impact on Walpole. As we shall see the notion of the agreeable mixture of woods and garden and the poetic notion of 'enchanted ground' informs Walpole's vision for Strawberry Hill. He invokes scenes and characters from the *Metamorphoses* which concur with Addison's view that 'Ovid, in his *Metamorphoses*, has shown us how the imagination may be affected by what is strange.'[138] The inspiration of prospect, borrowed views and animated landscape was a concept that Walpole embraced and disseminated in his theory and the choice of location at Strawberry Hill where he exploited the natural advantages of the site to the full. Walpole put into practice the premise of uniting the sister arts of poetry, painting and gardening with the creation of his Gothic castle and a picturesque landscape of the imagination in his designs at Strawberry Hill. For example he created a Bower in the garden at Strawberry Hill that contains all the ingredients ascribed by Addison to the poetic creator and writer of romances; '… contrivers of bowers and grottoes, trelliages and cascades, are romance writers.' The creation of moods was particularly essential for evoking an emotional or contemplative response, and Addison refers specifically to the medieval romance genre and its associational qualities:

In short, our Souls are at present delightfully lost and bewildered in a pleasing Delusion, and we walk about like the Enchanted Hero of a Romance, who sees beautiful Castles, Woods and Meadows; and at the same time hears the warbling of Birds, and the purling of Streams; but upon the finishing of some secret Spell, the fantastick Scene breaks up, and the disconsolate Knight finds himself on a barren Heath, or in a solitary Desert.[139]

This quotation encapsulates Horace Walpole's view of the world, constructing Strawberry Hill as architecture of association, a castle in the imagination where he could live-out his fantasy where one 'might play at fancying yourself in a castle described by Spenser' surrounded by his 'enchanted little landscape'.[140] People passing by would no doubt reflect on the idea of the generic castle and the character of the man and his links to British history as Addison explained in relation to 'secondary pleasures' how 'it is in the Power of the Imagination, when it is once Stocked with particular Ideas, to enlarge, compound, and vary them at her own Pleasure.'[141]

It is not overstating the case to say that Addison's basic formulation of his ideas laid the foundation for later developments in relation to his key concepts of Taste, Imagination, Greatness, Association of Ideas, Nature, Original Genius, Novelty, Beauty and Sublimity. Nor is it to exaggerate that Walpole is indeed indebted to Addison, who laid out in simple terms a series of precepts and problems which later theorists grappled with throughout the eighteenth century. Walpole saw the implications and potential of Addison's precepts and suggestions and he reworked, developed and added to Addison's systematic formulation of ideas and embellished, paraphrased and rewrote them in his own inimitable style without acknowledging the 'Original Genius'. The written discourse theorist Hugh Blair (1718–1800) commended Addison for his innovative enquiry into taste and the imagination:

Mr. Addison was the first who attempted a regular enquiry [into the pleasures of taste], in his Essay on the Pleasures of the Imagination … He has reduced these Pleasures under three heads; Beauty, Grandeur, and Novelty. His speculations on this subject, not exceedingly profound, are, however, very beautiful and entertaining; and he has the merit of opening a track, which was before unbeaten.[142]

The association of ideas is essentially linked to notions of taste and imagination. The 'polite' observer must possess a fund of knowledge and previous experiences from which he can draw. In the cases cited of Vanbrugh's and Walpole's reaction to history, the disposition of buildings and the memories elicited, they arise not from a quality inherent in the thing itself, but from their personal emotive and associative reaction to it. The instantaneous train of thought evinced in this concept would manifest itself most clearly in Walpole as he inevitably made concrete connections through an association of ideas in response to buildings and landscape compositions over a prolonged period.

He 'takes the hint' from Addison's contribution to the subject of taste and association in architecture in the 'Pleasures of the Imagination' in order to counteract Addison's notion particularly regarding the greater merits of Classical versus Gothic architecture. Walpole's decision to build a little Gothic castle at Strawberry Hill realises in built form Addison's assertions that '*Greatness of Manner* in Architecture, which has such force upon the Imagination, that a Building, where *it* appears, shall give the Mind nobler Ideas than one twenty times the Bulk, where the Manner is ordinary or little.'[143] The discussion regarding the respective associative values of the

different styles in the *Anecdotes of Painting* appears to be a direct riposte to Addison's assertions regarding their comparative success in stimulating the imagination. Walpole was also to make important pronouncements on taste and imagination in antiquarian studies and on architectural taste in *Anecdotes of Painting*. Through these we can trace the development of his taste and sensory responses which are inextricably linked to Addison.

Endnotes

1. *The Connoisseur*, 13 May 1756, in Aronson, A. 'The Anatomy of Taste', *Modern Language Notes*, vol. 61, No. 4 (April 1946), pp. 228–236.

2. Anthony Ashley Cooper, 3rd Earl of Shaftesbury, *Characteristicks of Men, Manners, Opinions, Times,* vol. II containing 'An Enquiry Concerning Virtue and Merit; The Moralists: A Philosophical Rhapsody,' (3 vols London, 1711). Walpole owned the eight-volume 1723 edition.

3. Paulson, R. *Breaking and Remaking: Aesthetic Practice in England, 1700–1820* (New Brunswick and London, 1989), p. 2.

4. Addison, *The Spectator*, No. 10, 12 March 1710–11.

5. Addison, 'Remarks on Several Parts of Italy' (London, 1705), *Works* (1837).

6. *Correspondence*, Walpole to Gray, 15 October 1735, vol. 13, pp. 85.

7. Ibid., Walpole to Dickenson, 22 December 1787, vol. 31, p. 256.

8. Addison, *The Spectator*, No. 411, 21 June 1712.

9. Ibid., No. 409, 19 June 1712.

10. Weekly Register, 6 February 1731, 'An Essay on Taste in General', *Gentleman's Magazine*, February 1731, I, 55, in Aronson, 'The Anatomy of Taste', *Modern Language Notes*, 51 (1946), pp. 228–236.

11. Propriety or Politeness, are key to the understanding a complete system of conduct which covered every facet of eighteenth-century life. These rules placed an emphasis on public propriety, ceremony and decorum and placed culture at their centre. The rules governed manners, morals, literature and taste and what was appropriate to the individual's position in society. Architecture, residences, gardens, appropriate use of rooms, dress, poetic diction and the promotion of literature as a standard of civilised taste all came under these fixed conventions and hierarchical codes.

12. Addison wrote frequently on landscape and garden design in *The Spectator* essays. See Woodbridge, K. *The Stourhead Landscape* (National Trust, 2002), pp. 6–7; Mowl, T. *Gentleman and Players: Gardeners of the English Landscape*, 'Addison, Switzer and "that inexpressible somewhat"' (Stroud, 2000), pp. 79–92; Batey, M. 'The Pleasures of the Imagination: Joseph Addison's Influence on Early Landscape Gardens', *Garden History*, vol. 33, No. 2 (Autumn 2005), pp.189–209.

13. Addison, J. 'Essay on Virgil's Georgics', *The Works of the Right Honourable Joseph Addison*, Thomas Tickell (ed.) (4 vols, London, 1721). See also *The Spectator* (by Addison and Steele) Bond, D.F. (ed.) (Oxford, 1965).

14. Addison, *The Spectator*, No. 412, 23 June 1712.

15. Addison referred specifically to Locke with regard to the nature of colour observing: 'that great Modern Discovery … Namely, that Light and Colours, as apprehended by the Imagination, are only Ideas in the Mind, and not Qualities that have any Existance in Matter. As this is a Truth which has been proved incontestably by many Modern Philosophers, and is indeed one of the finest Speculations in that Science, if the *English* Reader would see the Notion explained at large, he may find it in the Eighth Chapter of the Second Book of Mr. Lock's *Essay on Human Understanding.*' *The Spectator*, No. 412, 24 June 1712.

16. *Satirical poems published anonymously by William Mason: with notes by Horace Walpole, now first printed from his manuscript* (ed.) Toynbee, P. (Oxford, 1926), p. 43.

17. Addison, *The Spectator*, No. 411, 21 June 1712.

18. Ibid., No. 411, 21 June 1712.

19. Ibid., No. 416, 27 June 1712.

20. Ibid., No. 417, 28 June 1712. William Wordsworth, Preface to *Lyrical Ballads* (1798).

21. On the influence of ideas of association in Picturesque theory, see Clark, H.F. 'Eighteenth-century Elysiums; The Role of "Association" in the Landscape Movement', *The Journal of the Warburg and Courtauld Institutes,* vol. VI (1943), pp. 165–89; Brewer, J. *The Pleasures of the Imagination; English Culture in the Eighteenth Century* (Chicago, 1997); Van Eck, C. '"The splendid effects of architecture, and its power to affect the mind:" The Workings of Picturesque Association', in Birksted, J. (ed.) *Landscapes of Memory and Experience* (London and New York, 2000), pp. 245–59. Van Eck, C. (ed.) *British Architectural Theory 1540–1750: An Anthology of Texts (Reinterpreting Classicism)* (Surrey, 2003), pp. 144, 165–6. Hart, V. *Sir John Vanbrugh: Storyteller in Stone* (London and New Haven, 2008), pp. 83–110.

22. Locke, *An Essay concerning Human Understanding,* Book II, Chapter XXXIII, 'Of the Association of Ideas' (London, 1690).

23. Addison, *The Spectator*, No. 110, 6 July 1711.

24. Ibid., No. 12, 14 March 1710–11.

25. It needs to be mentioned that Addison was undoubtedly indebted to the earlier philosophies of Locke, Hobbes, Dryden and Descartes, and there is probably a reciprocal influence on John Vanbrugh. For a discussion of Addison's contribution to eighteenth-century criticism and his influence on later critics see 'Addison's Contribution to Criticism' in Jones, R.F. *et al., The Seventeenth Century: Studies in the History of English Thought and Literature form Bacon to Pope* (Oxford, 1965).

26. Ibid., No. 417, 28 June 1712.

27. Ibid., No. 411, 21 June 1712.

28. Ibid., No. 417, 28 June 1712.

29. *Correspondence*, Walpole to West, 2 October 1740, vol. 13, p. 231.

30. The main themes of Ovid's supernatural tales are love and transformation. Walpole owned Ovid's *Metamorphose, in fifteen books.* Translated by various hands and published by Samuel Garth, 3rd edn (London, 1727). He also had these books with him at Eton and Cambridge and frequently quotes from them in the correspondence with particular reference to change and transformation. *Metamorphoses by Ovid.* http://classics.mit.edu/Ovid/metam.1.first.html. Accessed May 2011. All quotations are from this edition.

31. Addison, *Works*, 'Dialogues upon the Usefulness of Medals, Dialogue III,' (1726) pp. 305–306.

32. The earlier manuscript was published in 1864 by J. Dykes Campbell as *Some Portions of Essays contributed to The Spectator by Mr Joseph Addison* (Glasgow, 1864). Reference in Batey, M. 'The Pleasures of the Imagination: Joseph Addison's Influence on Early Landscape Gardens,' *Garden History*, vol. 33. No. 2 (Autumn 2005), pp. 189–209. The original manuscript is in Harvard University's Houghton Library, MS Eng. 772.

33. Addison, *The Spectator*, No. 329, 18 March 1711.

34. Walpole, *Books of Materials*, 1771–85, p. 6.

35. *Correspondence*, Conway to Walpole, 18 April 1745, vol. 37, p. 189.

36. *Æneid*, ix. 448, translates as 'Immovable rock of the capital'.

37. *Correspondence*, Walpole to Montagu, 6 May 1736, vol. 9, p. 3.

38. Addison, *The Spectator*, No. 118, 16 July 1711.

39. Quoted at http://www.sourcetext.com/sourcebook/library/barrell/06avon.htm. Accessed 21 September 2010.

40. Addison, *The Spectator*, No. 414, 25 June 1712.

41. Ibid., No. 417, 28 June 1712.

42. Ibid., No. 15, 17 March 1710–11.

43. Walpole, *History of the Modern Taste in Gardening*, p. 39.

44. Addison, *The Spectator,* No. 414, 25 June 1712.

45. Joseph Spence records the following anecdotes regarding Pope's observations on Addison in his *Anecdotes, Observations, and Characters of Books and Men Collected from the Conversation of Mr Pope, and other Eminent Persons of this Time* (London, 1820). 'My acquaintance with Mr. Addison commenced in 1712', p. 195: 'I liked him then as much as I liked any man, and was very fond of his

conversation …' p. 196. 'He encouraged me in my design of translating the *Iliad*, which was begun that year, and finished in 1718. When Mr. Addison had finished his *Cato*, he brought it to me; desired to have my sincere opinion of it, and left it with me for 3 or 4 days', p. 196.

46. J.C. Loudon in his *Encyclopaedia of Gardening and Landscape Gardening* … (London, 1783–1843) cites the 'first examples of modern landscape gardening were Pope at Twickenham, and Addison at Bilton: first artists of the modern style, Bridgeman and Kent', pp. 236–249. Cited in Chase, Isabel Wakelin Urban, *Horace Walpole: Gardenist, An Edition of Walpole's A History of the Modern Taste in Gardening with an Estimate of Walpole's Contribution to Landscape Architecture* (Princeton, 1943), p. 57.

47. Pope: *Poetical Works*, Davis, H. (ed.) (London, 1983) Preface to 'Epistle IV. To Richard Boyle, Earl of Burlington: Of the Use of Riches' (1731), p. 314.

48. Plumb, *Sir Robert Walpole,* vol. 1, p. 206.

49. Hart confirms that Vanbrugh subscribed to the original octavo edition of 1712, but also the republished edition of 1721; see Hart, *Sir John Vanbrugh,* p. 87. The Kit-Cat Club was an early eighteenth-century gentleman's club frequented by cultured members of the Whig party and played an important role as an arbiter of taste. It had many prominent members including Joseph Addison, John Vanbrugh, William Congreve (1670–1729) the poet, the artist Godfrey Kneller (1646–1723) and many politicians included the Duke of Marlborough (1650–1722) the Earl of Burlington (1694–1753), Sir Robert Walpole and Richard Temple, 1st Viscount Cobham (1675–1749). The Dormer's at Rousham were also members.

50. Addison travelled to Herrenhausen as Lord Halifax's secretary. Vanbrugh accompanied them in his position as Clarenceux King-at-Arms for the presentation of the Garter to the Electoral Prince; later George the second.

51. Hart, *Sir John Vanbrugh,* pp. 109–110.

52. Addison, *The Spectator,* No. 420, 2 July 1712.

53. For a full explanation of Vanbrugh's interest in association in landscape see Hart, *Sir John Vanbrugh.*

54. Addison, *The Spectator*, No. 110, 6 July 1711.

55. Ibid., No. 110, 6 July 1711.

56. 'REASONS OFFER'D FOR PRESERVING SOME PART OF THE OLD MANOUR' of 11 JUNE 1709' sent to the Duchess of Marlborough. Accurately transcribed from British Library Additional MS 61353, Nos. 62–63, and (other copies Nos. 64–65, 66–67). Hart, *Sir John Vanbrugh,* Appendix 1, p. 252.

57. Ibid.

58. Addison, *Works,* 'Rosamund' (1707) p. 467.

59. Pope, *Poetical Works,* 'Dunciad' IV, 301. 'To happy convents, bosomed deep in vines, / Where slumber abbots, purple as their wines'. The 4th book of the *Dunciad* was published in March 1742.

60. *Correspondence*, Walpole to Bentley, 18 September 1755, vol. 35, p. 251.

61. Walpole, *Anecdotes of Painting*, p. 394.

62. *Correspondence*, Walpole to Conway, 6 October 1785, vol. 39, p. 435.

63. Ibid., Walpole to Lady Ossory, 1 December 1786, vol. 33, pp. 541–542.

64. Addison, *The Spectator,* No. 415, 26 June 1712.

65. Addison, *Works,* 'Remarks on several parts of Italy' vol. III, p. 354.

66. *The Letters of Joseph Addison*, Graham, W. (ed.) (Oxford, 1941), letter 23 to Dr John Hough [1651–1743] Bishop of Lichfield, Rome, Wednesday 2 July 1701, p. 27.

67. *Correspondence*, Walpole to West, 22 March 1740, vol. 13, p. 204.

68. Addison, *Works,* 'Remarks' vol. III, pp. 364–65.

69. Walpole, *Anecdotes of Painting*, pp. 94–5. Walpole uses the term Grecian to describe all Classical architecture.

70. Addison, *The Spectator,* No. 415, 26 June 1712.

71. Fréart, R. *A Parallel of the ancient architecture and the modern* (Paris, 1650) … made English … by John Evelyn, published as, *A parallel of the antient architecture with the modern: in a collection of ten principal authors who have written upon the five orders* … (London, 1664). See *The Spectator* No. 415, 26 June 1712.

72. Addison, *The Spectator*, No. 415, 26 June 1712.

73. Walpole, *Books of Materials* (1759), p. 52.

74. Walpole, *Anecdotes of Painting*, pp. 94–5.

75. Ibid., pp. 94–5.

76. *Correspondence*, Walpole to Mann, 8 December 1756, vol. 21, p. 31.

77. Ibid., Walpole to Cole, 12 July 1778, vol. 2, p. 100.

78. It is clear from this reference to Walpole's *The History of the Modern Taste in Gardening*, which was printed by April 1771 but was not published until 1780 was circulating amongst his friends. 'It is with great satisfaction I inform your Ladyship that the taste of English gardening makes great progress here [Paris] – not owing alas! to mine but to Mr Whateley's book which has been translated'. *Correspondence*, Walpole to Lady Ossory, 11 August 1771, vol. 32, p. 55.

79. His polemic linked the development of the 'English Taste in Gardening' with the British constitution and the notion of political liberty enshrined within that constitution – an association which is a precursor of Richard Payne Knight's (1750–1824) thinking expressed in *The Landscape*: a didactic poem in three books: addressed to Uvedale Price, Esq. (1795). Walpole's patriotism is politically motivated and he discounts foreign influences, disparages the notion of antecedents and Classical precedents, insisting on English national Whig credentials.

80. It is prudent to note that William Mason, Walpole's sometime friend and correspondent did acknowledge Addison's considerable influence as the catalyst that heralded the reforming process against the formal garden in favour of more natural gardening in his long poem *The English Garden* which he was composing during the 1760s. 'I here call Addison, Pope, Kent, &c. the Champions of the true taste, because they absolutely brought it into execution. The beginning therefore of an actual reformation may be fixed at that time when *The Spectator* first appeared'. Mason, W. *The English Garden* (4 vols, London, 1783) Book 1, n, x, verse 503. In the 4th edn of *Anecdotes of Painting* published in 1786 Walpole finally, but reluctantly admits that 'Spenser and Addison ought not to have been omitted in the list of authors who were not blind to the graces of natural taste', p. 401.

81. Mason, *Satirical Poems*, p. 42. Preface and Notes by Walpole on William Mason's *An Heroic Epistle to Sir William Chambers* (London, 1773) in response to his [Chambers] *Dissertation on Oriental Gardening* (London, 1772).

82. Addison, *Works*, 'Tatler', 20 April 1710.

83. Burke, E. *A Philosophical Enquiry into the Origin of Our Ideas of the Sublime and Beautiful* (London, 1757).

84. *Correspondence*, Walpole to West, 28 September 1739, vol. 13, p. 181.

85. *Correspondence*, Walpole to West, 28 September 1739, vol. 13, pp. 181–182.

86. *Correspondence of Thomas Gray*, vol. 1, letter 74, Gray to West, November 1739.

87. Addison, *The Spectator*, No. 412, 23 June 1712.

88. Ibid., No. 412, 23 June 1712.

89. *Correspondence*, Walpole to West, 22 March 1740, vol. 13, p. 204.

90. *Correspondence of Thomas Gray*, vol. 1, letter 76, Gray to Mrs Gray, November 1739.

91. Addison, *The Spectator*, No. 412, 23 June 1712.

92. Addison, *Works*, 'A Letter from Italy' (1701).

93. Addison, *The Spectator*, No. 412, 23 June 1712.

94. Mason, *Satirical Poems*, pp. 43–45.

95. Addison, *The Spectator*, No. 414, 25 June 1712.

96. Graham, *The Letters of Joseph Addison*, 'To William Congreve [Blois, December 1699]', letter 10, p. 11. This letter was also published in *The Guardian*, No. 101, 7 July 1713.

97. Addison, *The Spectator*, No. 412, 23 June 1712.

98. Ibid., No. 414, 25 June 1712.

99. Walpole, *History of the Modern Taste*, p. 26.

100. Addison, *The Spectator*, No. 414, 25 June 1712.

101. Walpole, *History of the Modern Taste,* p. 26.

102. Ibid., p. 26.

103. Ibid., p. 28.

104. Blathwayt was advised by George London, who was also working at Longleat, Wiltshire which was also laid out in this severe geometric form. It is interesting to note that Dyrham would have been reaching maturity as Strawberry Hill was being laid out and demonstrates how formal and informal gardens existed alongside one another in the early part of the eighteenth-century.

105. Hentzner, *Journey into England,* p. 93.

106. Rosamund Clifford (before 1150–c.1176) mistress of Henry II and often referred to as 'The Fair Rosamund' was renowned for her great beauty. Henry kept his mistress in a hunting lodge which he constructed within the park at Woodstock and laid-out a labyrinthine garden for her – 'Rosamund's Bower', which was destroyed when Blenheim Palace was built. Rosamund was poisoned by Henry's jealous wife Eleanor. Walpole supports the notion that Woodstock was the first park and uses the opportunity to recall the romantic legend pertaining to her relationship with the King and the garden he surrounded her in: 'If so, it might be the foundation of a legend that Henry II secured his mistress in a labyrinth; it was no doubt more difficult to find her in a park than a palace, where the intricacy of the woods and various lodges buried in covert might conceal her actual habitation', *History of the Modern Taste,* p. 29.

107. Addison, *The Spectator,* No. 414, June 25, 1712.

108. Walpole, *History of the Modern Taste,* p. 21.

109. Ibid., p. 25.

110. Addison, *The Spectator,* No. 417, 28 June 1712.

111. Ibid., No. 477, 6 September 1712.

112. Walpole, *History of the Modern Taste,* p. 31. The quotation is from Milton, J. *Paradise Lost,* book IV, lines 235–245.

113. Milton travelled to Italy and France on a Grand Tour from 1638–39. See, Demaray, H.D. 'Milton's "Perfect" Paradise and the Landscapes of Italy', *Milton Quarterly* (2007). http://onlinelibrary.wiley.com/doi/10.1111/j.1094-348X.1974.tb00908.x/full. Accessed 31 October 2010.

114. Walpole, *History of the Modern Taste,* p. 32.

115. Addison, *The Spectator,* No. 321, 8 March 1711–12.

116. Ibid., No. 414, 25 June 1712.

117. Walpole, *History of the Modern Taste,* p. 41.

118. Ibid., p. 42.

119. Pope's *Epistle to Burlington* (1731) sets out his concise theory of landscape aesthetics, incorporating painting principles and advocating irregular, naturalistic design. The *Epistle* contains most of the essential elements that were later to become components of the picturesque landscape, derived from Addison. See Harney, M. 'Alexander Pope and Prior Park: An essay in Landscape and Literature' in *Studies in the History of Gardens & Designed Landscapes,* vol. 27, No. 3 (2007), relating how Pope's theories were applied to the landscape at Prior Park, Bath, and Pope's influence on the work of William Kent.

120. See Hunt, J.D. and Willis, P. (eds), *The Genius of the Place: English Landscape Garden, 1620–1820* (Cambridge, MA, 1988); Batey, M. *Alexander Pope: The Poet and the Landscape* (London, 1999); and Taylor, P. (ed.) *The Oxford Companion to the Garden* (Oxford, 2006) which doesn't even mention Addison.

121. The main exception to this was a letter he sent to Martha Blount in 1724 when he gives the most detailed account of a garden he ever wrote following a visit to Sherborne Castle in Dorset where he elucidates on how he would make changes to improve the park. However, it should be noted that he did not advocate sweeping away all the formal, geometrical elements of the landscape but proposed juxtaposing and enhancing the scene with more natural romantic nature of the site. *The Correspondence of Alexander Pope,* Sherburn, G. (ed.) (5 vols, Oxford, 1963), vol. II, p, 236.

122. Pope: *Poetical Works,* 'Windsor Forest' (1704–13), lines 11–18; 21–22, pp. 37–50.

123. *The Prose Works of Alexander Pope,* Ault, N. (ed.) (Oxford, 1936), 'On Gardens', *The Guardian,* No.173, 28 September 1713, pp. 145–51.

124. Walpole, *History of the Modern Taste,* pp. 42–3.

125. Pope: *Poetical Works*, 'Epistle IV to Richard Boyle, Earl of Burlington: Of the Use of Riches' (1731), lines 55–56.

126. Walpole, *History of the Modern Taste*, pp. 44–45.

127. Ibid., p. 44.

128. Addison, *The Spectator* No. 541, 20 November 1712.

129. Ibid., No. 414, 25 June 25 1712. Temple wrote: 'Among us, the beauty of building and planting is placed chiefly in some certain proportions, symmetries, or uniformities; our walks and our trees ranged so as to answer one another, and at exact distances. The Chineses scorn this way of planting, and say, a boy, that can tell an hundred, may plant walks of trees in straight lines, and over-against one another, and to what length and extent he pleases. But their greatest reach of imagination is employed in contriving figures, where the beauty shall be great, and strike the eye, but without any order or disposition of parts that shall be commonly or easily observed: and, though we have hardly any notion of this sort of beauty, yet they have a particular word to express it, and, where they find it hit their eye at first sight, they say the sharawadgi is fine or is admirable, or any such expression of esteem'. Sir William Temple, *Works* (London, 1757), vol. III, pp. 229–30. *Sharawadgi* is in fact a Japanese word connoting asymmetry, Murray, C. *Garden History*, vol. 26, No. 2 (Winter, 1998), pp. 208–213.

130. Addison, *The Spectator*, No. 412, 23 June 1712.

131. Walpole, *History of the Modern Taste*, pp. 43–44.

132. Addison, *The Spectator*, No. 412, 23 June 1712.

133. Walpole, *History of the Modern Taste*, p. 54.

134. Despite Walpole's claims in the *History of the Modern Taste* that it was an English innovation it originated in France and the technical aspects were described in Dezallier d'Argenville's *La theorie et la pratique du jardinage …* (Paris, 1709). John James (1673–1746) had translated this into English as *The Theory and Practice of Gardening …* (London, 1712).

135. Walpole, *History of the Modern Taste*, p. 42.

136. Addison, *The Spectator*, No. 412, 23 June 1712.

137. Ibid., No. 583, 20 August 1714.

138. Ibid., No. 417, 28 June 1712.

139. Ibid., No. 412, 24 June 1712.

140. *Correspondence*, Walpole to Wharton, 21 August 1762, vol. 40, p. 255.

141. Addison, *The Spectator*, No. 416, 27 June 1712.

142. Blair, H. *Lectures on Rhetoric and Belles Lettres*, iii, 4th edn (London, 1790), 1, pp. 55–56; quoted in. Hipple, W.J. *The Beautiful, The Sublime and the Picturesque in Eighteenth-Century British Aesthetic Theory* (Illinois, 1957) p. 24.

143. Addison, *The Spectator*, No. 415, 26 June 1712.

'Giving an idea of the spirit of the times': *Anecdotes* and Antiquarianism

This chapter investigates Walpole's role as an antiquary and establishes how his relationship with the Society of Antiquaries affected his style of authorship and his decision to publish his own antiquarian research. Just as Addison had made the subject of taste and good citizenship the central tenet of his accessible *Spectator* essays, Walpole's reason for writing was to make the subject of antiquarian matters and English history popular while inculcating taste and erudition through his publications. It will become apparent that a conflict arises between his role as a dedicated antiquarian and his natural impulse to invoke his historical imagination when making an assessment of a building, its contents or occupants, past and present.

Antiquarian pursuits were an important aspect of eighteenth-century polite culture. Connoisseurship and collecting were seen as an expression of taste and judgement. Politeness in the eighteenth century defined the archetypal gentleman, and the accomplished gentleman demonstrated his good taste through his social interactions and culturally elite pursuits. Politeness assumed an ideological weight that was closely linked to Whig political discourse and the notion of liberty and freedom of expression and to Gothic architecture. Through these interrelationships we begin to trace the threads and themes emerging between the various theories which emerge as being closely linked.[1] We will see that Walpole particularly made connections and demonstrated the associations and links that could be made through seemingly disparate ideas.[2]

1717 marked both the year of Walpole's birth and a formalisation of the meetings and proceedings of the Society of Antiquaries, heralding a new interest in English history, particularly in medieval ancestry and a renewed awareness of Gothic architecture.[3] *The Antiquities of Warwickshire* (1656) of Sir William Dugdale (1605–86) was an important publication which signalled a resurgence of interest in local history and antiquities. Walpole owned the 1730 edition wherein Dugdale reviews the antiquarian pursuits of Anthony à Wood (1632–95) as well as the research interests of Thomas Hearne (1678–1735), the antiquarian most frequently referred to by Walpole.

Walpole also owned Dugdale's *The history of St. Paul's cathedral in London, from its foundation* (1658) and other antiquarian texts including John Dart's two volume *Westmonasterium; Or The history and antiquities of the Abbey Church of St. Peter's Westminster* (1742) *The History and Antiquities of the Cathedral Church of Canterbury* (1726) and *Baronage of England* (1675–6). In all, Walpole possessed in excess of 7,300 books of which some 500 were concerned with English antiquities and topography.[4] There can be little doubt that these texts ignited his imagination, inspiring him to research English antiquities as he used many of these texts for his various publications and as design sources for architectural details at Strawberry Hill.

Walpole's antiquarian interests covered three specific fields – Gothic architecture, county and family history and heraldry, including his own, and English portraiture, including prints. Although exhibits and papers presented to meetings of the Society of Antiquaries after 1755 were largely Classical there was an increasing interest in medieval styles and studies of this area were developing slowly. The antiquarian William Stukeley (1687–1765) had built a Gothic Hermitage in his garden at Stamford in 1738 and the Gothic Revival mock ruined castle at Hagley, Worcestershire by Sanderson Miller (1716–80) dates from 1746. The Gothic Temple at Stowe, Buckinghamshire by James Gibbs (1682–1754) was completed (1741–9) and Walpole was part of this trend, beginning the process of Gothicising Strawberry Hill using archaeological sources from 1749.[5]

In 1750, Walpole wrote to Mann regarding a marked increase in owners improving their estates and buildings in a variety of styles. He begins by making a comparison between the situation in England and Italy, declares his preference for asymmetry and unsurprisingly announces that the English win out in matters of taste:

… by what I saw in Tuscany and by the prints their villas are strangely out of taste, and laboured by their unnatural regularity and art to destroy the romanticness of the situations.[6] I wish you could see the villas and seats here! The country wears a new face; everybody is improving their places, and as they don't fortify their plantations with entrenchments of walls and high hedges, one has the benefit of them even in passing by. The dispersed buildings, I mean, temples, bridges etc. are generally Gothic or Chinese and give a whimsical air of novelty that is very pleasing.[7]

Simultaneously, Walpole and his coterie, who formed the architectural 'Strawberry committee', were fostering an interest in and promoting Gothic taste in architecture, literature and art. From its inception the Society employed an engraver and one of the earliest was George Vertue (1684–1756).

Walpole knew Vertue well, conversing and corresponding with him from the 1740s and he also sponsored Walpole's admittance to the Society of Antiquaries. Walpole had also collaborated with him, writing prefaces to Vertue's catalogues of the Collections of Charles I (1751), James II, and George Villiers, Duke of Buckingham (1758). Walpole's *Anecdotes of Painting* is based on the collected research of Vertue whose 39 notebooks he had purchased

from his widow for an astonishing £100.[8] It was Vertue who influenced, and was largely responsible for, the Society's regular publication of engravings depicting medieval antiquities in this period. William Stukeley was the chief proponent of English antiquities within the Society, presenting many dissertations to the fellows, on Druids, Stonehenge and other notable English monuments and culture. Stukeley was prolific in his studies of English antiquities as was Vertue, who presented papers on castles.

Walpole's contributions to their research activities were negligible. On 14 February 1760 he 'propounded questions to the Society on the ancient method of painting'; and on 26 January 1761 he 'exhibited a golden Bracelet found … in a meadow belonging to the Earl of Thomond at Short Grove in Essex.'[9]

He developed and harboured a growing resentment and a degree of antipathy toward the type of research the antiquaries carried out and he became increasingly disgruntled and disparaging of their activities. It is entirely possible that Walpole felt that his idiosyncratic approach to antiquarian research was not considered scholarly and that he felt some discomfiture presenting his findings to the learned society members. Following the establishment of his press at Strawberry Hill, Walpole authored and printed his own works. 'Elzivirianum opens today; you shall taste its first fruits. I find people have a notion that it is very mysterious – they don't know how I should abhor to profane Strawberry with politics.'[10] None of his writings on antiquarian subjects were ever submitted to the Society's journal *Archaeologia* which was first published in 1768.

Walpole was a Whig patriot in every area of his life and his literary output was often polemical and linked to politics and the British constitution. He wished to inculcate taste into the research and publications of the Society of Antiquaries while simultaneously informing and educating the reading public of their own history, society and culture. However, this had to be done in an entertaining manner that incited the imagination of the reader. Walpole wanted to rescue antiquarianism from the dull and academic remit of the Society of Antiquarians and assume the role of popularising antiquarian research. His stated aim was to remove the subject out of the hands of the learned society which, in Walpole's estimation, produced dry, uninteresting tracts that no-one but an antiquary would read, declaring '… I do not see why books of antiquities should not be made as amusing as writings on any other subject'.[11]

He wanted to impose strictures on the scope of antiquarian study and repeatedly condemned the Society when it strayed into inappropriate topics or outside the realm of British antiquities. The contents of the third volume, particularly the paper on the survival of the Cornish language, provoked him still further:

What diversion might laughers make of the Society! Dolly Pentraeth, the old woman of Mouse-hole, and Mr Pennek's nurse, V.p.81, would have furnished Foote with two personages for a farce. The same grave judge's dissertation on patriarchal customs seems to have as much to do with British antiquities, as the Lapland witches that sell wind – and pray what business has the Society with Roman inscriptions in Dalmatia?[12]

However, Walpole often commended papers that recorded or possibly made a contribution to the knowledge and survival of what he considered to be important buildings and significant events in English history:

I am most pleased with the account of Nonsuch, imperfect as it is … Well, I am glad they publish away. The vanity of figuring in these repositories will make many persons contribute their MSS, and every now and then something valuable will come to light, which its own intrinsic merit might not have saved.[13]

Meaningless enquiries incensed him, and the increasingly scholarly and methodical approach to antiquarian matters was resented by Walpole who favoured a more creative and interpretative manner of demonstrating antiquarian taste. At a time when enquiry into the Middle Ages was in its infancy Walpole was among the first to promote 'Gothic Taste' in his *Anecdotes of Painting*, and was an admirer of 'gloomth,' a phrase he coined as early as 1753. Walpole wanted to breathe life into the past, not produce dry texts that no-one but scholars and academics lacking in imagination and ideas of taste would read. He admitted in private correspondence that he was not interested in the minutiae but in portraying the *zeitgeist* of antiquarian inquiry:

Then I have a wicked quality in an antiquary, nay one that annihilates the essence; that is, I cannot bring myself to a habit of minute accuracy about very indifferent points. I do not doubt but there is a swarm of diminutive inaccuracies in my *Anecdotes* – well! if there is, I bequeath free leave of correction to the microscopic intellects of my continuators. I took dates and facts from the sedulous and faithful Vertue, and piqued myself on little but on giving an idea of the spirit of the times with regard to the arts of different periods.[14]

Nevertheless, despite their differences of opinion regarding appropriate subjects and methods of presentation Walpole's *Anecdotes of Painting* was well received by the Society. Even so, in the preface he took the opportunity to take a swipe at the perceived quality of antiquarian studies and the readership of these works in general. 'But the truths we antiquaries search for, do not seem of importance enough to be supported by the fictions: the world in general thinks our studies of little consequence; they do not grow valuable by being stuffed with guesses and invention'.[15]

In contrast to *Anecdotes of Painting*, Walpole's *Historic Doubts on the Life and Reign of King Richard III* was not well received by Society nor its learned members. A controversy over the publication erupted when Dean Milles (1714–1784) President of the Society read a paper to the members that was not particularly favourable and which was published in the first volume of *Archaeologia* in 1768.[16] Walpole responded to the criticism in a private letter to Cole[17] and publicly by publishing a pamphlet at his Strawberry Hill Press.[18] On 7 and 14 January 1771 however, a second extremely critical paper was read at the Antiquaries, this time by Robert Masters (1713–1798) Fellow of Ben'et College, Cambridge (now Corpus Christi).[19] From this point, although Walpole remained a Fellow of the Society he never attended another meeting and his remarks directed at the society and antiquaries became increasingly

vitriolic, later commenting, 'I dropped my attendance there four or five years ago from being sick of their ignorance and stupidity, and have not been three times amongst them since.[20] They have chosen to expose their dullness to the world, and crowned it with Dean Milles's nonsense.'[21] Writing to Cole, his friend and fellow antiquary after the publication of the second volume of *Archaeologia*, Walpole ridicules the papers published. 'It seems all is fish that comes out of the net of the Society. Mercy on us! What a cartload of bricks and rubbish and Roman ruins they have piled together.'[22] His embroilment in this series of disputes regarding his erroneous interpretation of a manuscript published in his *Historic Doubts* completely soured his relationship and resulted in his resigning from the society.[23]

No doubt his decision to attempt to wrest the subject of English antiquarianism from the learned Society was the culmination of a series of long-standing disputes and disagreements with the members and their methodologies in reporting and interpreting of history and archaeological findings. It is important to remember that antiquarianism was a leisurely pursuit for Walpole; he was first and foremost a gentleman of means, free to pursue his own interests. Thereafter, Walpole attempted to set up a rival publication to the *Archaeologia*, titled *Miscellaneous Antiquities*. To Cole he frequently complained that antiquaries were incapable of making their publications interesting and accessible to the general reader:

I love antiquities, but I scarce ever knew an antiquary who knew how to write upon them. Their understandings seem as much in ruins as the things they describe. For the Antiquarian Society, I shall leave them in peace with Whittington and his cat. As my contempt for them has not however made me disgusted with what they do not understand, antiquities, I have published two numbers of *Miscellanies,* and they are very welcome to mumble them with their toothless gums.[24]

However, the publication failed and Walpole complained that although they were generally well received the public were unwilling to pay a price which would defray the costs of production.

Walpole and others who were interested in 'Gothic Taste' would not see the Middle Ages and medieval art become as great a field of scholarly and creative inquiry for the Fellows of the Society until the 1770s, and then it was largely through studying tombs as datable works of art. With the excavation of the tomb of Edward I (1239–1307) in Westminster Abbey by the Society in 1772, in the presence of a delegation of Fellows and the Abbey officials, Walpole thought with the pursuit of knowledge through studying the *contents* of tombs that learning was triumphing over taste. He wrote a furious letter to Cole, which is worth quoting in full as it sets out Walpole's manifesto on taste. It also adumbrates in embittered tones his theory on what was proper and worthwhile in antiquarian pursuits and his long-held view of contemporary antiquarian research methodology:

The antiquaries will be as ridiculous as they used to be; and since it is impossible to infuse taste into them, they will be as dry and dull as their predecessors. One may

revive what perished, but it will perish again, if more life is not breathed into it than it enjoyed originally. Facts, dates and names will never please the multitude, unless there is some style and manner to recommend them, and unless some novelty is struck out from their appearance. The best merit of the Society lies in their prints; for their volumes, no mortal will ever touch them but an antiquary.[25]

It is apparent from these exchanges and from Walpole's recording of buildings that a constant tension exists between his role as an antiquary and his active historical imagination. Antiquarian study should inevitably lead him towards providing bare factual description. However, his historical imagination and desire for interpretation and associational reference that enriches the pursuit of knowledge and subsequently enlivens the text pulls him in the opposite direction. He records his observation of buildings and their interiors and the antiquarian curiosities they contain in his *Books of Materials* as references for his writing and often recounted them in correspondence to his friends.[26] What is apparent from these accounts is the enthusiasm and enjoyment of the experience, responding enthusiastically to the architecture of the house, its former owners and present occupants. The statement he makes in the *Anecdotes of Painting* regarding his preference for Gothic, because he values structures that 'furnished me with most ideas', also applies to his architectural criticism of other historic building types. His response to buildings is usually emotive rather than comprising a straightforward description of its architectural history or building type. For Walpole, every structure related its own historical narrative through association and imagination. For example following a visit to Welbeck, Nottinghamshire, a former Abbey site converted to a country house by the architects Robert Smythson (1535–1614) and his son John (d.1634) in the seventeenth century, Walpole comments:

I went to Welbeck – It is impossible to describe the bales of Cavendishes, Harley's, Holleses, Veres, and Ogles: every chamber is tapestried with them; nay, and with ten thousand other fat morsels; all their histories inscribed; all their arms, crests, devices, sculptured on chimneys of various English marbles in ancient forms (and to say truth, most of them ugly). Then such a Gothic hall, with pendent fretwork in imitation of the old, and with a chimney-piece extremely like mine in the library! Such water-colour pictures! such historic fragments! In short, such an so much of everything I like ...[27]

Writing to Lady Ossory many years later he reminisces on this aspect of freedom and imaginative pleasure he gained from his antiquarian pursuits:

The study of antiquity has a multitude of advantages over other pursuits. All its discoveries produce new lights and no disappointments ... Then by choosing your period, you may choose your party; and in the Wars of the Roses change according to the prevailing side, with every revolution. All this naturally follows, if you dive into the secrets of old families. You grow interested about their heroes, and forget our contemporaries and the present state,

 from what height fallen![28]

... Thus, a little too like a genuine antiquary, I have answered your ladyship's questions, without satisfying your curiosity.[29]

Walpole genuinely wanted to imbue taste into antiquarian pursuits, but significantly he wanted antiquarians to concentrate their efforts on discovering English antiquities, because of the pleasure to be gained from recalling the past. He ardently professes:

I was the first soul that ever endeavoured to introduce a little taste into English antiquities, and have persuaded the world not to laugh at our Hearne's and Hollingshed's, and the graceless loggerheads fly in my face! but I have left them [The Society of Antiquaries] to themselves and could not have left them in worse hands.[30]

We will now see how Walpole's penchant for relating the story behind the architects, inhabitants of the buildings, their collections, and the historic fabric of the structure manifests in his most valuable contribution to antiquarian research, *Anecdotes of Painting in England.*

'It is the history of our architecture I should search after, especially of the beautiful Gothic': *Anecdotes* and Architecture

This section explores Walpole's views on architecture as publicly expressed in *Anecdotes of Painting* and privately through his *Correspondence* and in *Books of Materials*. From this we can discern how his architectural taste develops through his antiquarian research and how he acquired extensive knowledge through visiting buildings. It also determines how Walpole's Gothic theories are formed through his antiquarian research and first-hand experience of buildings. It confirms that while Walpole confessed he wanted to write a history of the 'beautiful Gothic' he did in fact write a treatise on the subject as a riposte to Addison's assertions that Classical architecture was superior in producing a pleasurable response. Largely written during the period 1762–71, but researched earlier, *Anecdotes of Painting* is contemporaneous with the construction and expansion of Strawberry Hill and it is in this context that the discussion will take place. Walpole's architectural predilections expressed in the *Anecdotes of Painting* are important for understanding his decision to build a Gothic villa at Strawberry Hill as an architectural expression of imagination and association.

Anecdotes of Painting represents the earliest attempt to chart the development of the arts in England and lay the foundations for the study of art history. In this respect it remains an authoritative reference source, particularly for sixteenth and seventeenth-century paintings. This popular and influential book is still valued for its history of early English portraiture. Walpole substantially enhanced and added to Vertue's copious manuscripts from his own encyclopaedic knowledge and he possessed an excellent memory for portraits. His talent as an author and editor of Vertue's extensive notes places Walpole as the best historian of English portraiture of this period. Walpole collected fine prints and portraits, mainly for their association and anecdotal potential. He amassed a collection mainly of English heads which was both good and extensive, accumulating in excess of twelve thousand prints.

Anecdotes of Painting also includes a survey and critique of English architecture and architects in England categorised by the reigns of monarchs. Beginning with a general survey of architecture it then undertakes to provide biographical sketches and significant works of particular architects. It is Walpole's architectural evaluations in *Anecdotes of Painting* that will be subjected to scrutiny in the following discussion. He communicated to his fellow antiquary Henry Zouch (c.1725–95) his purpose and outline methodology of what would be included and excluded in the architectural discussion.

You judge very rightly, Sir, that I do not intend to meddle with accounts of religious houses: I should not think of them at all unless I could learn the names of any of the architects, not of the founders. It is the history of our architecture I should search after, especially of the beautiful Gothic. I have by no means digested the plan of my intended work; the materials I have ready in great quantities in Vertue's MSS. But he has collected little with regard to our architects, except Inigo Jones.[31]

Walpole adopts a rhetorical tactic of gentle persuasion through entertaining anecdotes, wit and a concise method to inculcate his ideas of taste into the reader as he instructs them in the history of English architects and architecture:

It is unlucky for the world, that our earliest ancestors were not aware of the curiosity which would inspire their descendants of knowing minutely every thing relating to them. When they placed three or four branches of trees across the trunks of others, and covered them with boughs or straw to keep out the weather, the good people were not apprised that they were discovering architecture, and that it would be learnedly agitated some thousands of years afterwards who was the inventor of that stupendous science.[32]

Walpole summarily dismisses the period prior to Henry IV (c.1366–1413, reigned 1399–1413) as having little recorded to warrant inclusion in the history. He suggests that prior to that date there were no architects or architecture of note, no distinguishing characteristics in architectural styles, so consequently, nothing worth describing:

Danes, Saxons, Normans were all ignorant enough to have claims to peculiar ugliness in their fashions. It was difficult to ascertain the period when one ungracious form jostled out another: and the perplexity at last led them into such refinement, that the term *Gothic Architecture*, inflicted as a reproach on our ancient buildings in general by ancestors who revived the Grecian taste, is now considered but a species of modern elegance, by those who wish to distinguish the Saxon style from it.[33]

For Walpole, 'beautiful' architecture begins with the Gothic style which reached its height of perfection in the Reign of Henry IV 'and remained in vogue until towards the end of the reign of Henry VIII' (1491–1547, reigned 1509–1547).[34] In a footnote Walpole muses on the precise time that Gothic appeared:

When men enquire, 'who invented Gothic buildings?' they might as well ask, 'who invented bad Latin?' The former was a corruption of the Roman architecture, as the latter was the Roman language. Both were debased in barbarous ages, both were refined as the age polished itself; but neither was restored to the original standard. Beautiful Gothic architecture was engrafted on Saxon deformity; and pure Italian succeeded to vitiated Latin.[35]

Walpole discusses ancient architects that made a significant contribution to the practice, reserving his highest praise for the architect of Windsor Castle, a historic building type which was influential in the design of Strawberry Hill. Founder of Winchester and New College, Oxford, William Wykeham (1324–1404) was the first, at New College, to incorporate a chapel as an integral part of the original design scheme of front quadrangle, dining hall and cloisters.

This configuration was to become a model for later colleges and ecclesiastical and collegiate Gothic had a significant impact on Walpole's own creation:

But the brightest name in this list is William of Wykeham, who from being clerk of the works rose to bishop of Winchester and lord chancellor; a height which few men have reached by mere merit in the mechanic science. Wykeham had the sole direction of the buildings at Windsor and Queensboro-castle; not to mention his own foundations.[36]

It seems certain that Walpole's preference for Gothic architecture sprang in part from his belief that abbots were their own architects and created atmospheric interiors through 'vaults, tombs, painted windows, gloom and perspective' which 'infused such sensations of romantic devotion'.[37] But it was also, in part, a reaction to his absolute distaste for what he termed the 'bastard style' evidenced in the great rebuilds of the Elizabethan era such as Wollaton, Nottingham (1580–88), Copthall, Essex (c.1564) and Burghley, Lincolnshire (1558–87):

The taste of all these stately mansions was that bastard style which intervened between Gothic and Grecian architecture; or which perhaps was the style that had been invented for the houses of the nobility, when they first ventured, on the settlement of the kingdom after the termination of the quarrel between the Roses, to abandon their fortified dungeons, and consult convenience and magnificence; for I am persuaded that what we call Gothic architecture was confined solely to religious buildings, and never entered into the decoration of private house.[38]

He digresses into a discussion on why this type of architecture was more utilitarian and why it was no longer necessary to continue to build in that style:

In more ancient times the mansions of the great lords were, as I have mentioned before, built for defence and strength rather than convenience. The walls thick, the windows pierced wherever it was most necessary for them to look abroad, instead of being contrived for symmetry or to illuminate the chambers. To that style succeeded the richness and delicacy of the Gothic. As this declined, before the Grecian taste was established, space and vastness seem to have been their whole ideas of grandeur. The palaces erected in the reign of Elizabeth by the memorable countess of Shrewsbury, Elizabeth of Hardwicke [c.1521–1608] are exactly in this style. The apartments are lofty and enormous, and they know not how to furnish them. Pictures, had they

good ones, would be lost in chambers of such height: tapestry, their chief moveable, was not commonly perfect enough to be real magnificence. Fretted ceilings, graceful mouldings of windows, and painted glass, the ornaments of the preceding age, were fallen into disuse. Immense lights composed of bad glass in diamond panes, cast an air of poverty on their most costly apartments. That at Hardwicke, still preserved as it was furnished for the reception and imprisonment of the queen of Scots, is a curious picture of that bad age and style.[39]

Walpole's reflections here are interesting and confirm that it is only because of its associative potential where 'my imagination helped me to like the apartment of the Queen of Scots' (Mary, 1542–87) and the consequent intellectual stimulation it caused that made the visit worthwhile.[40] In his *Books of Materials* he draws a similar conclusion regarding his critique of Hardwick Hall, Derbyshire constructed in the 1590s as being of the 'mungrel species' and devoid of taste:

2.1 Hardwick
Hall from Daniel
and Samuel
Lyson's *Magna
Britannia*, 1807

Never was I less charmed in my life. The house is not Gothic, but of that betweenity, that intervened when Gothic declined and Palladian was creeping in – rather, this is totally naked of either. It has vast chambers, aye, vast, such as the nobility of that time delighted in and did not know how to furnish.[41]

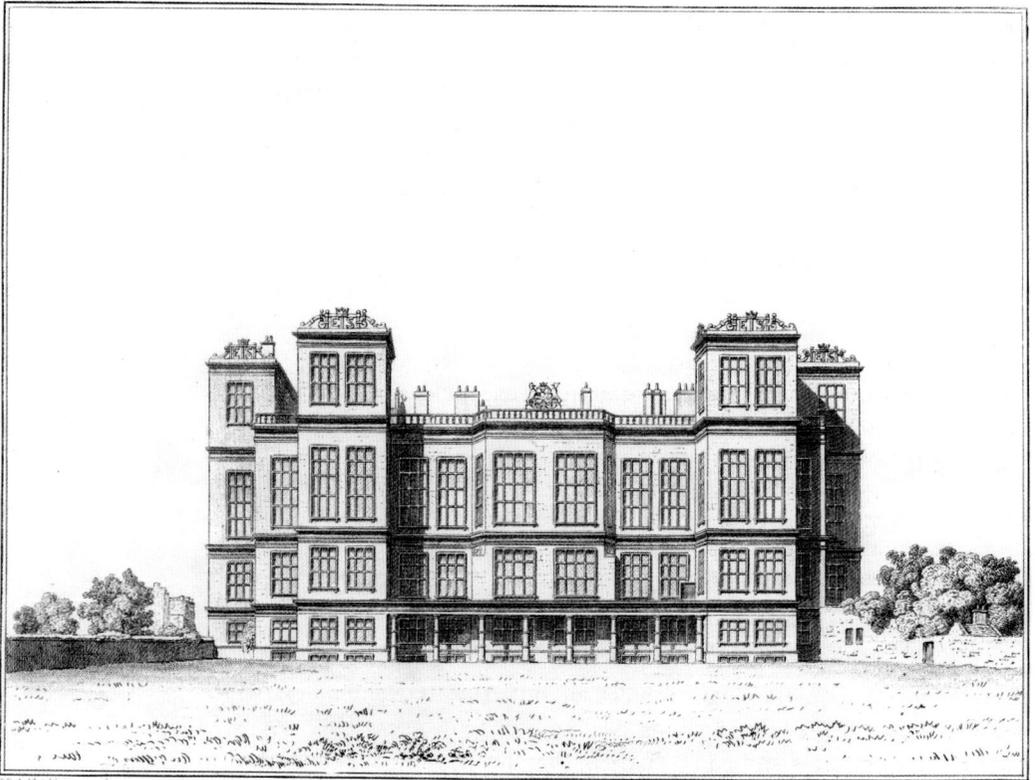

East View of Hardwick Hall.

Walpole frequently complained that these vast rooms made the display of paintings and artefacts difficult and uninspiring. He would overcome these problems at Strawberry Hill by creating rooms that were based on the ancient style but at a reduced scale; an innovative method of display that would enable the viewer to see the pictures and objects. Trist was the adjective he deployed in connection with this style of architecture. He used it as a pejorative term to indicate it lacked interest or that it was dreary, dull and forlorn. Despite Ham House (1610) being his niece's residence and its situation in the verdant beauty of the Thames, its dreary and lacklustre interior could not engage his imagination. 'The old furniture is so magnificently ancient, dreary and decayed, that at every step one's spirits sink, and all my passion for antiquity could not keep them up ...'[42]

Of all the styles and periods surveyed by Walpole it is important to note that 'Beautiful Gothic architecture' of the early-fifteenth century is the only 'true' style to receive unconditional accolades. It is largely from this period that he selected Gothic features that appealed to him as characteristic and decorative for Strawberry Hill.

It is apparent from the foregoing discussion that Walpole held a deep regard for medieval structures; however the reader will notice a distinct change of tone in the *Anecdotes of Painting* when he begins to discuss English Gothic architecture. Walpole's discussion on the effects of Gothic architecture is articulated in enthusiastic tones that suggest a complex emotional engagement with the subject that is lacking in his analysis of other styles. But his assessment is also inextricably linked to notions of taste and genius. Walpole cites Inigo Jones (1573–1652) as an architect who possesses taste, but lacks the essential quality of genius when it comes to designing in Gothic. 'Inigo Jones seems to me to have more taste than genius. A genius is original, invents. Taste selects, perhaps copies with judgement'.[43] Gothic architects did both. It was this model of genius and invention that Walpole would emulate and adopt at Strawberry Hill.

It is not that Walpole dislikes Classical architecture – in fact he positively approves and admires the 'rational beauties' of the style for public buildings. In 1750 he wrote to Mann that Strawberry Hill would be Gothic because it was appropriate in the context and allowed for irregularity:

The Grecian is only proper for magnificent and public buildings. Columns and all their beautiful ornaments look ridiculous when crowded into a closet or a cheesecake house. The variety is little, and admits no charming irregularities. I am almost as fond of the *sharawaggi*, or Chinese want of symmetry, in buildings, as in grounds or gardens.[44]

This statement suggests that scale is an important consideration which explains why much of the detailing he chose for Strawberry Hill was taken from tombs, oratories and small chapels. Significantly, he also remarked to John Pinkerton (1758–1826) the Scottish antiquarian that 'the Gothic style seems to speak an amplification of the minute, not a diminution of the great.'[45]

However, it is undoubtedly the effect of irregularity and 'unrestrained licentiousness' exhibited in Gothic architecture which appeals to his senses and possesses the unique ability to transport and enchant him:

I certainly do not mean by this little contrast to make any comparison between the rational beauties of regular architecture and the unrestrained licentiousness of that which is called Gothic. Yet I am clear that the persons who executed the latter, had much more knowledge of their art, more taste, more genius, and more propriety than we choose to imagine. There is a magic hardiness in the execution of some of their works, which would not have sustained themselves if dictated by mere caprice … It is sufficient to observe, that Inigo Jones, sir Christopher Wren and Kent, who certainly understood beauty, blundered into the heaviest and clumsiest compositions whenever they aimed at imitation of the Gothic – Is an art despicable in which great masters cannot shine? Considering how scrupulously our architects confine themselves to antique precedent, perhaps some deviations into Gothic may a little relieve them from that servile imitation. I mean that they should study both tastes, not blend them; that they should dare to invent in the one, since they will hazard nothing in the other.[46]

He uses the same argument as Pope had done in his *Epistle to Burlington* in condemning those who slavishly copy ancient models and antique precedent. This is merely copying an ordered set of rules and proportions. To build in Gothic, the architect needs to possess taste, genius and invention. Walpole believes there is no definitive set of rules that can be applied to Gothic – the architect must be able to produce the quality of 'unrestrained licentiousness' which triggers an emotive response in the onlooker. In a footnote Walpole uses painting metaphors to elaborate on why Gothic has the ability to evoke a passionate associative response:

And why, but because gloom and well applied obscurity are better friends to devotion than wealth! A dark landscape, savage with rocks and precipices, by Salvator Rosa, may be preferred to a serene sunshine of Claud not because it is more pleasing, but a more striking picture. Cato is a regular drama, Macbeth is an extravagant one: yet who thinks the genius of Addison equal to Shakespeare's? The one copies rules, the other passions.[47]

He also invokes a literary trope to compare and contrast authors who can inspire and provoke, just as Addison does in response to different types of landscape. His comparison of Addison, as an example of an author who follows rules of taste and notions of Classical decorum, with Shakespeare as an original genius who stirs the passions but 'undoubtedly wanted taste', in this context is surely not an accidental one.[48] Just as Addison had used a poetic trope to distinguish different types of landscape Walpole too used a literary metaphor to distinguish between architectural styles, insisting that 'A Gothic cathedral strikes one like the enthusiasm of poetry; St. Paul's like the good sense of prose.'[49]

He also wrote elsewhere that strict adherence to rules prohibited inventive expression, in literature and architecture: 'Rules prevent faults but prevent improvement too. The moment the Romans had settled the rules of the five

orders, they were afraid to invent. The Gothic architects had never been told that they must not pass such and such lines. It is the same in all arts.'[50]

He also asserts that in domestic architecture this inflexible observation of rules was neither applicable nor appropriate:

I do not believe that the Romans ever used regular architecture for private houses. This might also be ascertained, by examining what columns remain, and measuring whether any of them exist between the dimensions for very large buildings, and those for niches, which however large, would still be too small to have been used for houses. Mr. Chute thinks Gothic buildings were designed by bishops and monks, who from observing the effect of the gloom of their convents, applied it to churches. It is happily thought. The style of Gothic is different in every country which shows it formed itself in each, and was not imported from any peculiar country.[51]

Walpole agrees with Chute and attributes the development and enhancement of the Gothic style to those in charge of ecclesiastical institutions, a significant notion for his designs at Strawberry Hill. He reasserts that the bishops and abbots were also architects intimately involved in the design of their institution, and that in England, as in other countries Gothic developed differently:

As all other arts were confined to cloisters, so undoubtedly was architecture too; and when we read that such a bishop or such an abbot built such and such an edifice, I am persuaded that they often gave the plans as well as furnished the necessary funds; but as those chroniclers scarce ever specify when this was or was not the case, we must not at this distance of time pretend to conjecture what prelates were or were not capable of directing their own foundations.[52]

The notion that the arts and Gothic architecture were instigated by and confined to cloisters was a concept that inspired Walpole. It indicated to him that they would provide a rich source of ideas and materials for his project at Strawberry Hill.

Walpole laments that the names of most ancient architects are not written into history, particularly regretting the omission of those who practised in the Gothic style. He gives advice to any reader who may want to copy Gothic ornament where the best examples may be found, based on his research for Gothic models for constructing and ornamenting Strawberry Hill:

I have myself turned over most of our histories of churches, and can find nothing like the names of artists. With respect to the builders of Gothic, it is a real loss: there is beauty, genius and invention enough in their works to make one wish to know the authors. I will say no more on this subject, than that, on considering and comparing its progress, the delicacy, lightness, and taste of its ornaments, it seems to have been at its perfection about the reign of Henry IV as may be seen particularly by the tombs of the archbishops at Canterbury. That cathedral I should recommend preferably to Westminster, to those who would borrow ornaments in that style. The fret-work in the small oratories at Winchester and the part behind the choir at Gloucester would furnish beautiful models. The windows in several cathedrals offer graceful patterns; for airy towers of almost filigraine we have none to be compared with those of Rheims.[53]

Tombs and funerary monuments proved to be a critical, rich resource for architectural elements at Strawberry Hill and he uses many of the very models he cites in *Anecdotes of Painting,* particularly for interior detailing. In a footnote Walpole adds further observations on excellent examples of Gothic which fall outside the parameters of dates he ascribes to the best Gothic period. The examples are supplied to him by Thomas Gray and some of those cited are imitated, copied or interpreted at Strawberry Hill:

Some instances of particular beauty, whose constructions date at different æras from what I have mentioned, have been pointed out to me by a gentleman to whose taste I readily yield; such as the nave of the minster at York (in the great and simple style) and the choir of the same church (in the rich and filigraine workmanship), both of the reign of Edward III. The Lady-chapel (now Trinity-church) at Ely, and the Lantern-tower in the same cathedral, noble works at the same time: and the chapel of bishop West (also at Ely), who died in 1533, for exquisite art in the lesser style.[54]

There is no doubt that Walpole's discussion of Gothic is about the emotive, associative effects it produces in the mind of the spectator. It is not that Walpole could not have produced a straightforward history of the style as his comments clearly indicate that he is discerning and knowledgeable. It is the tension between the role of antiquary and his historical imaginative impulse that cannot be reconciled with his account. It is apparent from the outline of a projected history adumbrated below that he had the capability to give a strict account of the development of Gothic architecture:

With regard to a history of Gothic architecture, in which he [James Essex 1722–1784] desires my advice, the plan I think should lie in a very simple compass.[55] Was I to execute it, it should be thus. I would give a series of plates even from the conclusion of Saxon architecture, beginning with the round Roman arch, and going on to show how they plastered and zigzagged it, and then how better ornaments crept in, till the beautiful Gothic was arrived at its perfection; then how it deceased in Henry the Eighth's reign, Archbishop Warham's tomb at Canterbury being I believe the last example of unbastardized Gothic.[56] A very few plates more would demonstrate its change. Holbein embroidered it with some morsels of true architecture; in Queen Elizabeth's reign there was scarce any architecture at all; I mean no pillars, or seldom; buildings then becoming quite plain. Under James a barbarous composition succeeded. A single plate of something of Inigo Jones, in his heaviest and worst style should terminate the work, for he soon stepped into the true and perfect Grecian.

However, it is clear that Walpole's interest and knowledge is largely confined to the inherent qualities of Gothic and its ornament. He knows nothing of structural practices or building methodology and subtly declines to contribute on this aspect.

The next part Mr Essex can do better than anybody, and is perhaps the only person who can do it. This should consist of observations on the art, proportions and method of building, and the reasons observed by the Gothic architects for what they did. This would show what great men they were, and how they raised such aerial or stupendous masses, though unassisted by half the lights

now enjoyed by their successors. The prices, and the wages of workmen, and the comparative value of money and provisions at the several periods, should be stated, as far as it is possible to get materials.

Walpole, as expected, singles out for inclusion the exquisite ornament displayed in tombs, small chapels and oratories for particular attention:

The last part (I don't know whether it should not be first part) nobody can do so well as yourself. This must be to ascertain the chronological period of each building – and not only of each building, but of each tomb, that shall be exhibited, for you know the great delicacy and richness of Gothic ornaments was exhausted on small chapels, oratories and tombs. For my own part I should wish to have added detached samples of the various patterns of ornaments, which would not be a great many, as excepting pinnacles, there is scarce one which does not branch from the trefoil; quatrefoils, cinquefoils, etc., being but various modifications of it. I believe almost all the ramifications of windows are so: and of them there should be samples too ...[57]

This fascination with ornament over built fabric is apparent throughout the *Anecdotes of Painting* and his other commentaries. Walpole's largest entry on any building in the *Anecdotes of Painting* is expended on King's College Chapel, Cambridge, a building he confesses he is particularly fond of. However, after describing in some detail the various indentures relevant to its execution he describes not the building but the stained glass and the artists that executed them only remarking that 'It was in the reign of Henry VIII. That the chapel of King's college, Cambridge was finished; a work, alone sufficient to ennoble any age ...'[58]

After Walpole's animated digression into the imaginative potential of Gothic he matter-of-factly resumes his critique of other architectural styles and architects. He stresses that he particularly dislikes hybrid species or the mixing of styles which result in a debased Gothic. He considers this impure style of architecture as uncultured, uncouth and unpolished. He blames the introduction of the 'mungrel species' that he abhors on the influx of Italians at Court serving the king suggesting they were not competent architects, so their deficiencies resulted in 'a barbarous mixture':

It is certain that the Gothic taste remained in vogue till towards the end of the reign of Henry VIII. His father's chapel at Westminster is entirely of that manner. So is Wolsey's tomb-house at Windsor. But soon after the Grecian style was introduced; and no wonder, when so many Italians were entertained in the king's service. They had seen that architecture revived in their own country in all its purity – but whether they were not perfectly master's of it, or that it was necessary to introduce the innovation by degrees, it certainly did not at first obtain full possession. It was plaistered upon Gothic, and made a barbarous mixture. Regular columns, with ornaments neither Grecian nor Gothic, and half embroidered with foliage, were crammed over frontispieces, façades and chimneys, and lost all grace by wanting simplicity. This mungrel species lasted till late in the reign of James the first [1566–1625, reigned 1603–1625].[59]

He credits the German artist and architect Hans Holbein (1497/8–1543) whose art he nevertheless admires as the instigator of this deformation of architectural style in England. He cites Holbein's work at Wilton House, Wiltshire as the

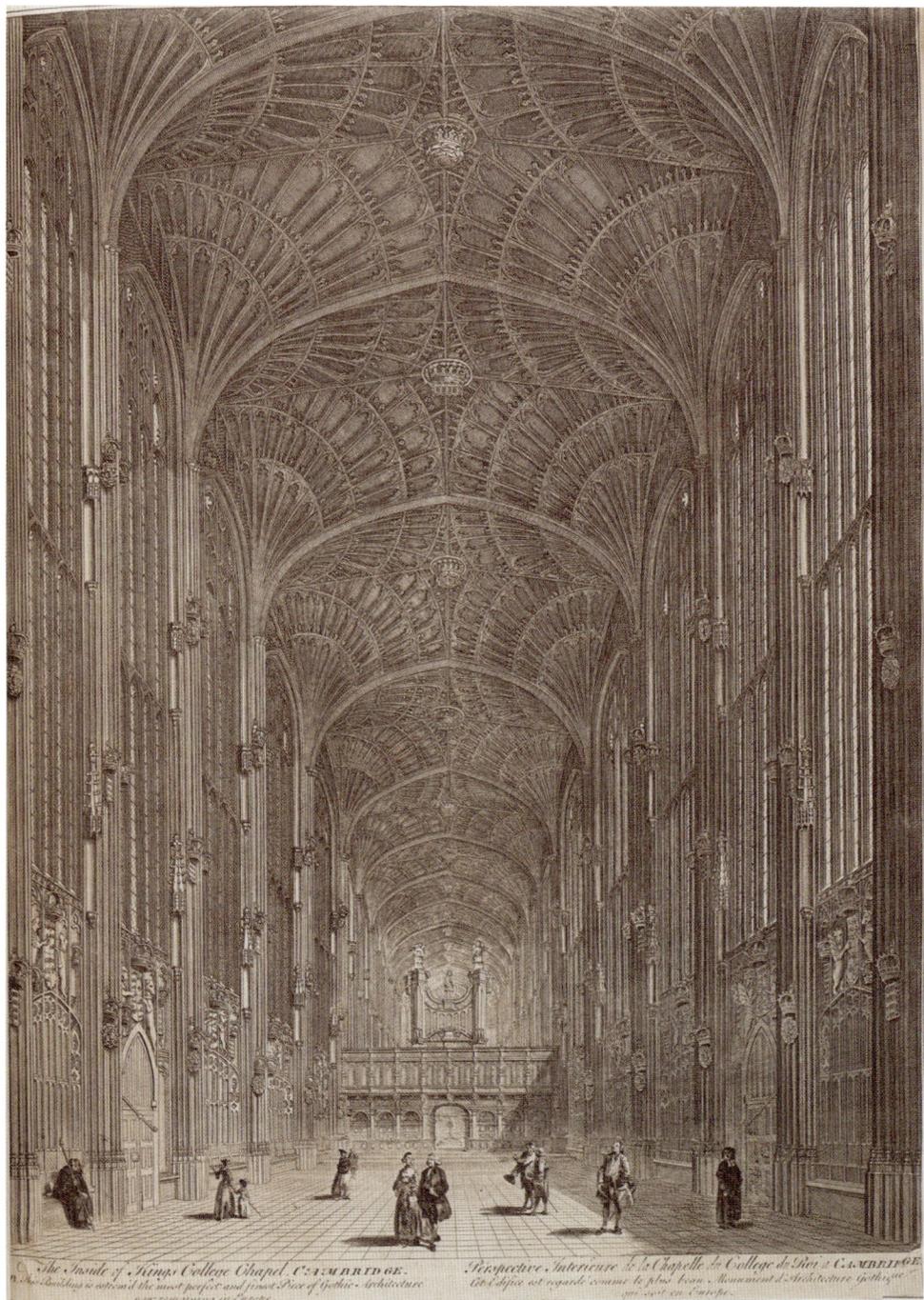

The Inside of King's College Chapel, CAMBRIDGE. Perspective Interieure de la Chapelle du College du Roi à CAMBRIDGE.
This Building is esteem'd the most perfect and finest Piece of Gothic Architecture Cet Edifice est regardé comme le plus beau Monument d'Architecture Gothique
now remaining in Europe qui soit en Europe.

2.2 King's College Chapel

beginning of this process of mixing styles, although in this instance he still describes it as 'beautiful'. Walpole was to name a room in his villa the Holbein Room where he hung originals and copies of Holbein's paintings:[60]

The beginning of the reformation in building seems owing to Holbein.[61] His porch at Wilton, though purer than the works of his successors, is of this bastard sort; but the ornaments and proportions are graceful and well chosen. I have seen of his drawings too in the same kind.[62]

Walpole always associates the taste and culture of the reigning monarch with the advancement of the arts during their reign. He unreservedly admires the progress that took place in the arts during the reign of Charles I (1600–1649, reigned 1625–1649).

He asserts that this period signified the beginning of 'real taste' in English arts and despite the prevailing perception that Walpole looked to a medieval past he did in fact collect much seventeenth-century art and many artefacts from this period:

The accession of this prince was the first æra of real taste in England. As his temper was not profuse, the expence he made in collections, and the rewards he bestowed upon men of true genius and merit, are proofs of his judgement. He knew how and when to bestow … A prince who patronizes the arts, and can distinguish abilities, enriches his country, and is at once generous and an œconomist.[63] … the king, who spared neither favours nor money to enrich his collection, invited Albano into England by a letter written in his own hand.[64]

Reading his account of Charles I we are left with the distinct impression that his admiration for him stems from his intellectual capacity and his erudition and taste in arts matters, not for his role as King. Charles I is portrayed as delighting in the acquisition of learning and demonstrating an extensive knowledge of the fine arts and antiquity. Walpole quotes a source that describes Charles as an accomplished antiquary and art historian and depicts him as pursuing similar pursuits to himself. There can be no doubt it was this King's capacity as virtuoso, erudite connoisseur and collector of virtù that he admired. These were qualities that Walpole desired other monarchs should emulate as patrons, practitioners and sophisticated supporters of taste in the arts in England.[65] 'He was skilled in things of antiquity, could judge medals whether they had the number of years they pretended unto; his libraries and cabinets were full of those things on which length of time put the value of rarities'.[66] Charles I also encouraged English architectural talent and Walpole lavishly praises the 'indisputable genius' of Inigo Jones as the man 'who would save England from the disgrace of not having her representative among the arts'. Walpole lauds him as the first truly *English* architect to introduce a purer Classical style into English architecture declaring, 'Vitruvius drew up his grammar, Palladio showed him the practice, Rome displayed a theatre worthy of his emulation, and king Charles was ready to encourage, employ and reward his talents. This is the history of Inigo Jones.'[67]

Even Jones was not exempt from Walpole's censure when he practised Gothic architecture, criticising his works at St Paul's and Winchester Cathedrals. In Walpole's estimation, Jones committed the unforgivable sin of inappropriately mixing Classical architecture with Gothic:

In the restoration of that cathedral he made two capital faults. He first renewed the sides with very bad Gothic, and then added a Roman portico, magnificent and beautiful indeed, but which had no affinity with the ancient parts that remained, and made his own Gothic appear ten times heavier. He committed the same error at Winchester, thrusting a screen in the Roman or Grecian taste into the middle of that cathedral. Jones indeed was by no means successful when he attempted Gothic. The chapel of Lincoln's-inn has none of the characteristics of that architecture. The cloister beneath seems oppressed by the weight of the building above.[68]

Of the reign of Charles II (1630–1685, reigned 1660–1685) Walpole concludes that architecture during this period was corrupted by French influences, the only noteworthy achievement being the completion of St Paul's. 'Though in general the taste was bad, and corrupted by imitations of the French, yet, as it produced St Paul's, may be said to have flourished in this reign; whole countries, an age often gets a name for one capital work.'[69] Of Sir Christopher Wren (1632–1723), Walpole insists that St Paul's Cathedral, demonstrates 'the greatness, of sir Christopher's genius' and credits him with designing 'the noblest temple', the largest palace [Hampton Court] and the most sumptuous hospital [Greenwich] in such a kingdom as Britain.'[70] However, he condemns him too for mixing Classical architecture with Gothic at Hampton Court, Richmond upon Thames which 'was sacrificed to the god of false taste' – French influence:[71]

The great campanile at Christ-church, Oxford is noble, and, though not so light as a Gothic architect would have performed it, does not disgrace the modern. His want of taste in the ancient style is the best excuse for another fault, the union of Grecian and Gothic. The Ionic colonnade that crosses the inner quadrangle at Hampton-court is a glaring blemish, by its want of harmony with the rest of the Wolsey fabric. Kent was on the point of repeating this incongruity in the same place in the late reign, but was over-ruled by my father.[72]

Walpole's criticism of William Kent in relation to his essays in Gothic as clumsy and inappropriate is signalled in this instance and will be established as a constant theme in his architectural criticism. He goes on to sum up Wren as possessing 'great abilities rather than taste'.[73]

The reign of the Dutch King William III (1650–1702, reigned 1689–1702) is dismissed out-of-hand. 'This prince, like most of those in our annals, contributed nothing to the advancement of the arts. He was born in a country where taste never flourished, and nature had not given it to him as an embellishment to his great qualities'. Although Walpole commends William Talman (1650–1719) for the 'elegance and lightness' of the front of Chatsworth, no other architect is mentioned in this period.[74]

'The Reign of Anne [1665–1714, reigned 1702–1714] so illustrated by heroes, poets, and authors, was not equally fortunate in artists'. He does not have a good word to say of any of the architects during her reign stridently declaring that 'one man there was, who disgraced this period by his architecture as much as he enlivened it by his wit'.[75] He is referring to Sir John Vanbrugh, and launches a vitriolic attack almost certainly because of his designs in what he sees as a French Baroque style:

He wants all the merit of his writings to protect him from the censure due to his designs. What Pope said of his comedies, is much more applicable to his buildings –

How Van wants grace!

Grace! He wanted eyes, he wanted all ideas of proportion, convenience, propriety. He undertook vast designs, and composed heaps of littleness. The style of no age, no country, appears in his works; he broke through all rule, and compensated for it by no imagination.[76]

He echoes Pope's contemporary criticism in his *Epistle to Burlington* of: 'the false Taste of Magnificence; the first grand Error of which is to imagine that Greatness consists in the size and Dimension, instead of the Proportion and Harmony of the whole: Lo! What huge heaps of littleness around! / The whole, a labour'd quarry above ground.'[77]

Although many believe Pope's criticism was referring to Cannons, Middlesex (1713–24), Walpole's reference to Pope's lines would seem to confirm that it was directed at the Duke of Marlborough for the palatial structure of Blenheim Palace (1705–20). Many, including Walpole, viewed Blenheim as an extravagant national scandal at the time. This is corroborated by his footnote where he remarks that 'if the design and details are defective, the merit of grandeur remains with the person who is at the expence of the fabric, not with the architect who executes his commands'. Of course this is not an unbiased opinion as his scathing commentary is firstly targeted at the Duke of Marlborough for commissioning Vanbrugh, at Blenheim, and selecting an inappropriate 'foreign' Baroque style for a 'national monument'. This bitter personal attack is also partially motivated by rivalry in matters of taste between the palace at Blenheim and Houghton Hall (1722–35). The direct attack on Vanbrugh could be seen, by association, as an indirect attack on the taste of the Duke of Marlborough. Walpole's objective in denigrating Marlborough's formidable Baroque house and collection is to publically promote and defend his father Robert Walpole's supremacy in matters of correct taste. Although privately Walpole never praised Robert Walpole's Houghton Hall it was nevertheless at the cutting edge of current Palladian architectural design, housing one of the most magnificent collections of the period. Walpole concludes that Vanbrugh's lack of taste was due to his copying inappropriate French models: 'if Vanbrugh had borrowed from Vitruvius as happily as from Dancour, Inigo Jones would not be the first architect of Britain.'[78] There is a degree of ambiguity in this statement which implies that *if* Vanbrugh had chosen an English architectural style he would

not be attracting censure; he *could* have been England's leading architect. Walpole states that Vanbrugh was capricious and 'wanted taste' but he implies that at least he dared to be inventive, a quality that he admired in Inigo Jones who used antique models but imaginatively interpreted and adapted them to create his own version of Classicism. That aside, he continues in the same condemnatory tones of Vanbrugh's work and its long-term effect in terms of taste in architectural styles: 'He seems to have hollowed quarries rather than to have built houses; and should his edifices, as they seem formed to do, out-last all record, what architecture will posterity think was that of our ancestors?'[79] This statement recalls Addison's comments on 'barbarous Buildings' referring specifically to the cathedral at Siena. Addison had criticised the builders of Gothic remarking what 'Miracles of Architecture they would have left us, had they only been instructed in the right way' and Walpole applies this censure to Vanbrugh's architecture.[80]

He reproaches the reign of George I (1660–1727, reigned 1714–1727) as 'the period in which the arts were sunk to the lowest ebb in Britain.'[81] Denigrating architecture too he holds the foreign Hanoverian George I responsible for not leading by example or supporting the arts:

Architecture was perverted to mere house-building, where it retained not a little of Vanbrugh; and, if employed on churches, produced at best but corrupt and tawdry imitations of Christopher Wren. The new monarch was void of taste, and not likely at an advanced age to encourage the embellishment of a country, to which he had little partiality.[82]

In the *Anecdotes of Painting* Walpole adopts the same polemical stance of linking architecture with nationalism as he does in the *History of the Modern Taste in Gardening*. He unconditionally condemns anything that smacks of foreign influence for its corrupting influence on English architectural development. He summarises architecture up to the end of the reign of George I and his argument is indebted to Pope's *Epistle to Burlington,* a poetic satire on false taste and Walpole makes explicit links between composing poetry and designing buildings. Foreign architecture attracts opprobrium for the influence of the Baroque on English architects leading to the destruction or defacement of true English Gothic style. Ecclesiastical Gothic is again singled out as the only 'true' English style advancing architecture to a state of 'venerable' perfection displayed in 'the bold scenery of Gothic architecture, with all its airy embroidery and pensile vaults':

The stages of no art have been more distinctly marked than those of architecture in Britain. It is not probable that our masters the Romans ever taught us more than the construction of arches. Those, imposed on clusters of disproportioned pillars, composed the whole grammar of our Saxon ancestors. Churches and castles were the only buildings, I should suppose they erected of stone. As no taste was bestowed on the former, no beauty was sought in the latter. Masses to resist, and uncouth towers for keeping watch, were all the conveniencies they demanded. As even luxury was not secure but in a church, succeeding refinements were solely laid out on religious fabric, till by degrees was perfected

the bold scenery of Gothic architecture, with all its airy embroidery and pensile vaults. Holbein, as I have shown, checked the false but venerable style, and first attempted to sober it to classic measures; but not having gone far enough, his imitators, without his taste, compounded a mongrel species, that had no boldness, no lightness, and no system. This lasted till Inigo Jones, like his countrymen and contemporary Milton, disclosed the beauties of ancient Greece, and established simplicity, harmony and proportion. The school however was too chaste to flourish long. Sir Christopher Wren lived to see it almost expire before him; and after a mixture of French and Dutch ugliness had expelled truth, without erecting any certain style in its stead, Vanbrugh with his ponderous and unmeaning masses overwhelmed architecture in mere masonry. Will posterity believe that such piles were erected in the very period when St. Paul's was finishing?[83]

Nicholas Hawksmoor (1661–1736) is allowed a slight reprieve from the wholesale criticism levelled at this period despite his association with Vanbrugh at Blenheim and Castle Howard. Walpole portrays Hawksmoor as a disciple of Wren, singling out the 'magnificent mausoleum' at Castle Howard for particular praise.[84] After chronicling his works Walpole acknowledges: 'His knowledge in every science connected with his art is much commended, and his character remains unblemished.'[85] However, in Walpole's 'impartial' opinion, James Gibbs is allotted the title of 'most distinguished architect' of the period. Presumably for his work at All Souls, Oxford, a composition he greatly admired, which Walpole had wrongly credited to Gibbs when the design is Hawksmoor's. Walpole declares that Gibbs had 'blundered into a picturesque scenery not void of grandeur'.

Despite the error in attribution, which he corrected in later editions, Gibbs too is damned with faint praise, for he had:

… without deviating from established rules, proved, what has been seen in other arts, that mere mechanic knowledge may avoid faults, without furnishing beauties; that grace does not depend on rules; and that taste is not to be learnt … Gibbs, like Vanbrugh, had no aversion to ponderosity, but not being endued with much invention, was only regularly heavy. His praise was fidelity to rules, his failing, want of grace.[86]

Walpole's patriotism, antiquarian interests and architectural preferences are manifested through his discussion on architecture in the *Anecdotes of Painting*. He cleverly manages to dismiss out-of-hand almost all architecture except English Gothic. He places the blame for the lack of taste and progress in English architecture on architects copying foreign models when they should have studied English Gothic architecture for examples of correct taste. In a footnote to a later addition Walpole corrects his 'mistake and strange negligence' in his previous attribution to Gibbs for the work in the quadrangle of All Souls, Oxford. Obviating some of his criticism he explains why architects like Hawksmoor got Gothic wrong:

When Hawksmoor lived, Gothic architecture had been little studied, nor were its constituent beauties at all understood: and whatever the intention of the architect or of his directors was, I believe they blundered, if they thought the new buildings at All Souls are in the true Gothic style … as they might have been taken for a mixture of Vanbrugh's and Batty Langley's clumsy misconceptions.[87]

He immediately resumes his censure of Gibbs's designs as lacking in taste:

In 1728 Gibbs published a large folio of his own designs, which will confirm
the character I have given of his works. His arched windows, his rustic-laced
windows, his barbarous buildings for gardens, his cumbrous chimney-pieces, and
vases without grace, are striking proofs of his want of taste.[88]

Colen Campbell (1676–1729) is cursorily dispensed with, despite providing
the original design for Houghton Hall as 'a countryman of Gibbs, had fewer
faults but not more imagination.'

Walpole's introduction to the reign of George II (1683–1760, reigned 1727–
1760) is more positively embraced in terms of its contributions and advances
in architecture, if not in art, as a more 'shining period in the history of the
arts'. Walpole argues that architecture was reaching the peak of perfection
during the period 1727–60, significantly, contemporaneous with Walpole and
the construction of Strawberry Hill. His later argument, delineated in the
History of the Modern Taste in Gardening wherein he introduces gardening into
the sphere of the creative arts, is first signalled in the *Anecdotes of Painting*,
thus placing it alongside the 'sister arts' of painting, poetry and architecture.
It is in this period he asserts that the English attain the epitome of perfection
in architecture and gardening, contemporaneous with his own venture into
architecture and the creation of the landscape at Strawberry Hill:

It was in the reign of George the second that architecture revived in antique
purity; and that an art unknown to every age and climate not only started into
being, but advanced with master-steps to vigorous perfection: I mean the art of
gardening, or as I should choose to call it, *the art of creating landscape* …[89]

This is an important statement that will be discussed later; suffice to say here,
that it is key to understanding the developments at Strawberry Hill. Walpole
continues his discussion on the reign of George II commenting:

… to have an exact view of so long a reign as that of George the second, it must be
remembered that many of the artists already recorded lived past the beginning of it,
and were principal performers … Gibbs and Campbell were still at the head of their
respective professions. Each art improved before the old professors left the stage.[90]

Significantly, Walpole attributes the advances in architectural knowledge
to the availability of published materials of antiquarian precedents and
Classical models that permitted architecture to exhibit her 'true principles
and correct taste':

Noble publications of Palladio, Jones, and the antique, recalled her to her true
principles and correct taste; she found men of genius to execute her rules, and
patrons to countenance their labours. She found more, and what Rome could not
boast, men of the first rank contributed to embellish their country by buildings of
their own design in the purest style of antique composition.[91]

The Neo-Classical Revival, to which Walpole refers, manifested in Palladian
taste, was by 1724 gradually becoming established as the prevailing mode of

expression in English architecture and was in the supremacy by around 1730.[92] The first volume of Colen Campbell's *Vitruvius Brittanicus* was published in 1715, and Palladio's *I Quattro Libri Dell' Architettura*, translated into English by Giacomo Leoni (1686–1746) the same year, became the pattern book of taste and the designs illustrated were widely copied, often slavishly, with little originality or variety.[93] Significantly, the use of published drawings of Gothic architecture in antiquarian tracts became the main source and methodology used for architectural precedent and details at Strawberry Hill. Walpole omits reference to Campbell's publication, despite the fact that he was architect of his father's mansion, Houghton Hall, a key building in eighteenth-century architectural history.[94] Walpole refers to Houghton under the entry for Thomas Ripley (1682–1758) stating that 'Campbell gave the original design, but was much improved by Ripley' and omits mention of alterations to the design by Gibbs.[95] He offers no opinion on his father's house, presumably because of the negative connotations he associated with Houghton Hall. Walpole refers to Leoni's publication; however, significantly, he mentions Campbell's and Kent's patron Lord Burlington (1694–1753), a 'gentlemen of the first rank' as the practitioner of 'true principles and correct taste' in the Palladian style:[96]

Leoni, by publishing and imitating Palladio, disencumbered architecture from some of the weight by which it had been overloaded. Kent, lord Burlington, and lord Pembroke though the first two were no foes to heavy ornament, restored every other grace to that imposing science, and left art in possession of all its rights ...[97]

Henry Herbert (1693–1750) 9th Earl of Pembroke, another gifted amateur is particularly congratulated for his architectural designs and for opening up the prospect at Wilton: 'for removing: all that obstructed the views to or from his palace, and threw Palladio's theatric bridge over the river'. He also commended the 'water-house in lord Orford's park at Houghton', both of which 'are incontestable proofs of his taste'.[98]

In his discussion of architects during this period, Walpole dispenses his severest criticism on those that have dared to dabble in Gothic. This appears to be a deliberate tactic on Walpole's part to denigrate all practitioners of the style prior to his use of Gothic at Strawberry Hill. For example, the attempts at Gothic of Sanderson Miller are included as an afterthought in the *Addenda* where Walpole grudgingly admits that he 'was skilled in Gothic architecture, and gave several designs for buildings in that style in the reign of George II', without mentioning where they were.[99] However, this is somewhat disingenuous as his private correspondence records his visit to Hagley and his emotive associational response to Miller's Gothic ruin set in the landscape at Hagley, asserting its associative qualities. 'There is extreme taste in the park: the seats are not the best, but there is not one absurdity. There is a ruined castle, built by Miller, that would get him his freedom even of Strawberry: it has the true rust of the Barons' War.'[100]

Walpole's observations on the success of Hagley's building are confirmed in Heeley's independent commentary:

… one cannot resist an involuntary pause – struck with its character, the mind naturally falls into reflections, while curiosity is on the wing, to be acquainted with its history; and I make no doubt that an antiquarian like my friend, would sigh to know in what æra it was founded, and by whom: – what sieges it had sustained; – what blood had been spilt upon its walls: – and would lament that hostile discord; or the iron hand of an all-mouldering time, should so rapaciously destroy it. Believe me, the appearance of this antique pile has the power of stamping these impressions on the mind, so masterly is it executed to deceive.[101]

It may seem surprising that he included a relatively minor architect such as Batty Langley (1696–1751) in the *Anecdotes of Painting* but it quickly becomes apparent that Langley is there to receive Walpole's greatest opprobrium for an architect in this reign. He blames Langley's *Gothic Architecture, Improved by Rules and Proportions …* for teaching 'carpenters to massacre that venerable species'. Thus, almost singlehandedly Langley was responsible for bringing the ancient 'beautiful Gothic' into disrepute.[102]

[Langley] who endeavoured to adopt Gothic architecture to Roman measures; as sir Philip Sidney attempted to regulate verse by Roman feet. Langley went farther, and (for he never copied Gothic) *invented* five orders for that style. All that his books achieved, has been to teach carpenters to massacre that venerable species, and to give occasion to those who know nothing about the matter, and who mistake their clumsy efforts for real imitations, to censure the productions of our ancestors, whose bold and beautiful fabrics sir Christopher Wren viewed and reviewed with astonishment, and never mentioned without esteem.[103]

Walpole describes him as 'a barbarous architect' and is scathing of his attempts in Gothic and for producing a pattern book that tried to impose rules and introduce order into the style. Langley's publication, combined with his crude attempts to imitate Gothic, fuelled Walpole's enmity towards him. In Walpole's estimation Langley was responsible for providing ample opportunity for others to build in bad Gothic thus denigrating further the venerable English style.

In *The History of the Modern Taste in Gardening* Walpole claims credit for the 'natural style' of gardening as indisputably English. *Anecdotes of Painting* too has a patriotic, political dimension being a biographical dictionary of artists in England chronicling the history and evolution of its art and architecture. Walpole asserts that progress in the arts is indicative 'of the flourishing state of a country, that it daily makes improvements in arts and sciences' and therefore represents a reflection of a successful Whig constitution.[104] 'A good government, that indulges its subjects in the exercise of their own thoughts, will see a thousand inventions springing up, refinements will follow, and much pleasure and satisfaction will be produced, at least before that excess arrives which so justly said to be the forerunner of ruin.'[105]

Of course Walpole associated Gothic taste with Whig taste so there was an additional political dimension to his imaginative choice in its liberalising tendencies and represented individualism and artistic freedom. Walpole suggests that it is the freedom of the individual that is responsible for the creative and scientific advances evidenced, not produced at the edict of a ruler

Batty Langley Inv.^t 1742

T L Sc

2.3 *An Umbrello for the Centre or Intersection of Walks in Woods, Wilderness's & c.*
Batty Langley, Plate LV, 1742

or the church, but through generous private subscription supporting native genius. Like his treatise on the development of the English landscape style discussed later, he declares that architecture has reached its peak during the current period:

Architecture, the most suitable field in which the genius of a people arrived at superiority may range, seems reviving. The taste and skill of Mr. Adam [Robert, 1728–1792] is formed for public works. Mr. Chambers's [William, 1723–1796] treatise is the most sensible book, and most exempt from prejudices, that was ever written on that science. But of all the works that distinguish this age, none perhaps excel those beautiful editions of Balbec and Palmyra – not published at the command of Louis quartoze, or the expense of a cardinal nephew, but undertaken by private curiosity and good sense, and trusted to the taste of a polished nation.[106]

Although *Anecdotes of Painting* was revised and reprinted with the advertisement for the fourth edition appearing in 1786, the history and analysis effectively cease with the architecture of Burlington and Kent. The advertisement interestingly includes only a brief comment on Mr. Wyat (1746–1813) as successor to Burlington and Kent citing James Wyatt's Pantheon, Oxford Street, London, as an example of where 'taste must stop.'[107] He summarised his observations in a letter to Mann:

We have almost a statuary or two, and very good architects; but as Vanbrugh dealt in quarries, and Kent in lumber, Adam, our most admired, is all gingerbread filigraine, and fan painting. Wyat, less fashionable, has as much taste, is grander, and more pure. We have private houses that cost more than the Palace Pitti. Will you never come and see your fine country, before it is undone?[108]

In the *Anecdotes of Painting* there is no attempt to include contemporary architects and architecture on the pretext that publication was delayed 'from motives of tenderness' so as not to 'wound the affections, or offend the prejudices' of their surviving relatives. Walpole abruptly ends his work at a point where he avoids discussing in detail his contemporaries in the field of the arts and architecture except to record that it was an improving situation because of the example set by Lord Burlington and William Kent. James Wyatt is mentioned in later editions because of his purity of style and good taste evidenced at the Pantheon 'uniting grandeur and lightness, simplicity and ornament'. Walpole concludes:

The work is continued as far as the author intended to go, though he is sensible he could continue with it with more satisfaction to himself, as the arts, at least those of painting and architecture, are emerging from that wretched state in which they lay at the accession of George the first. To architecture, taste and vigour were given by lord Burlington and Kent – They have successors worthy of the tone they gave; if, as refinement generally verges to extreme contrarieties, Kent's ponderosity does not degenerate into filligraine – but the modern Pantheon, uniting grandeur and lightness, simplicity and ornament, seems to have marked the medium, where taste must stop. The architect who shall endeavour to refine on Mr. Wyat, will perhaps give date to the age of embroidery …[109]

It should also be remembered that Wyatt's inclusion probably occurred for his work in Gothic as Walpole admired Wyatt for being an architect who 'is capable of *thinking* in the spirit of the founders'. Walpole's friend Thomas Barrett MP (1743–1803) was inspired by Strawberry Hill to Gothicise his house, Lee Priory, near Canterbury, Kent, employing Wyatt to carry out the works from 1782–90 – his first attempt at a Gothic mansion.

Walpole described Lee enthusiastically as 'a child of Strawberry prettier than the parent … the quintessence of Gothic taste, more exquisitely executed'.[110] 'Mr. Wyat, at Mr Barrett's at Lee near Canterbury, has, with a disciple's fidelity to the models of his masters, superadded the invention of a genius. The little library has all the air of an abbot's study, except that it discovers more taste'.[111] Walpole later commissioned Wyatt in 1790 to build the Offices and Gothic bridge at Strawberry Hill.

Walpole singles out Giovanni Battista Piranesi (1720–78) for particular praise and responds enthusiastically to his dramatic drawings because they are imaginative and spontaneous expressions of vision and picturesque qualities. Products of the unfettered mind they are unrestricted by rules, with no sense of order imposed, licentious products of an unrestrained imagination. Walpole suggests that architects should follow Piranesi's model, so that:

This delicate redundance of ornament growing into our architecture might perhaps be checked, if our artists would study the sublime dreams of Piranesi, who seems to have conceived visions of Rome beyond what it boasted even in the meridian of splendour. Savage as Salvator Rosa, fierce as Michael Angelo, and exuberant as Rubens, he has imagined scenes that would startle geometry, and exhaust the Indies to realize. He piles palaces on bridges, and temples on palaces, and scales heaven with mountains of edifices. Yet what taste in his boldness! what grandeur in his wildness! What labour and thought both in his rashness and details! Architecture, indeed, has in a manner two sexes: its masculine dignity can only exert its muscles in public works and at public expence; its softer beauties come better within the compass of private residence and enjoyment.[112]

A summation of Walpole's architectural taste expressed in the *Anecdotes of Painting* would conclude that he attributes the beginning of the 'true' style of British architecture to the period between the reign of Henry IV (1399–1413) and the end of the reign of Henry VIII (1509–1547). He nonetheless lauds praise on the 'indisputable genius' of Inigo Jones as the 'first architect of Britain' who succeeded in producing worthy architecture with his innovative interpretation of Classical style. Closing the discussion with an assessment of eighteenth-century practitioners he wholeheartedly endorses Lord Burlington as Jones's successor for exhibiting 'true principles and correct taste.'

In *Anecdotes of Painting* notions of impropriety and taste, purity of style, inventiveness, genius and imagination emerge as the criteria by which Walpole judges architects and architecture. Architects must be authentic and strictly avoid mixing styles or choosing an inappropriate style within the context of the building. He unequivocally condemns ponderosity, incongruity or absurdity where there is no rational justification for the design decision.

Other characteristics that attract censure include excessive contrast, vastness or a forlorn appearance, with lofty interiors attracting particular disapproval because of their limitations for display. Utility is an important consideration; the building must be comfortable, function properly and be fit for purpose (Walpole's 'conveniencies') and be moderately spacious but not vast. To appeal to the senses buildings must display variety, irregularity, inventiveness and in the detail and ornamentation, display multiplicity, delicacy and intricacy. His letter to Montagu after visiting Hinchinbrook House, Cambridge, articulates the elements that hold a particular appeal. 'The house of Hinchinbrook is most comfortable, and just what I like; old, spacious, irregular, yet not vast or forlorn.'[113]

Whereas in *Anecdotes of Painting* Walpole's chronicling of progress in the arts remains factual and influential, his assessment of the history and development of architecture is often contradictory, inconsistent, subjective, and judgemental. His view is often prejudiced by his own tastes and preferences or coloured by the individual recipients of his observations. The immediacy of his criticism and his predilection for engagement with the historical occupants of the building, the subjects of artworks or the quality of the portraits hanging in the interiors meant that his rich historical imagination often influences his judgement. Significantly, Walpole's contemporary architectural criticism suggests that the task of improving the arts and architecture lies not within the province of the monarchy but with the gentleman connoisseur who possesses the requisite exuberance of imagination as the new arbiter of taste. Here we witness a subtle agenda emerging in that it is through buildings designed for the connoisseur's pleasure and to please his own taste that fine architecture will be exhibited.

'Apollo of the Arts': Walpole and Burlington – Arbiters of Taste

With his patronage of Campbell and the latter's influence through his architecture and publishing, Burlington and his faction were the major force in the promotion of Classical taste in the arts and architectural world that determined and defined standards of 'taste' for most of the eighteenth century.

Walpole's assessment of the progress of the arts during the reign of King George II acclaimed Burlington as the principal supporter and patron of the arts; and he, not the monarch is portrayed as the true arbiter of taste. This change of emphasis in matters of taste shifting from monarchy towards connoisseurship and the gentleman amateur is an important transfer of monarchical responsibility for promotion of the arts and cultural pursuits to the remit of the innovative and influential individual. The true arbiter of architectural taste is no longer the court or the professional architect but the gentleman amateur – a notion supported by Rocquet writing in 1755:

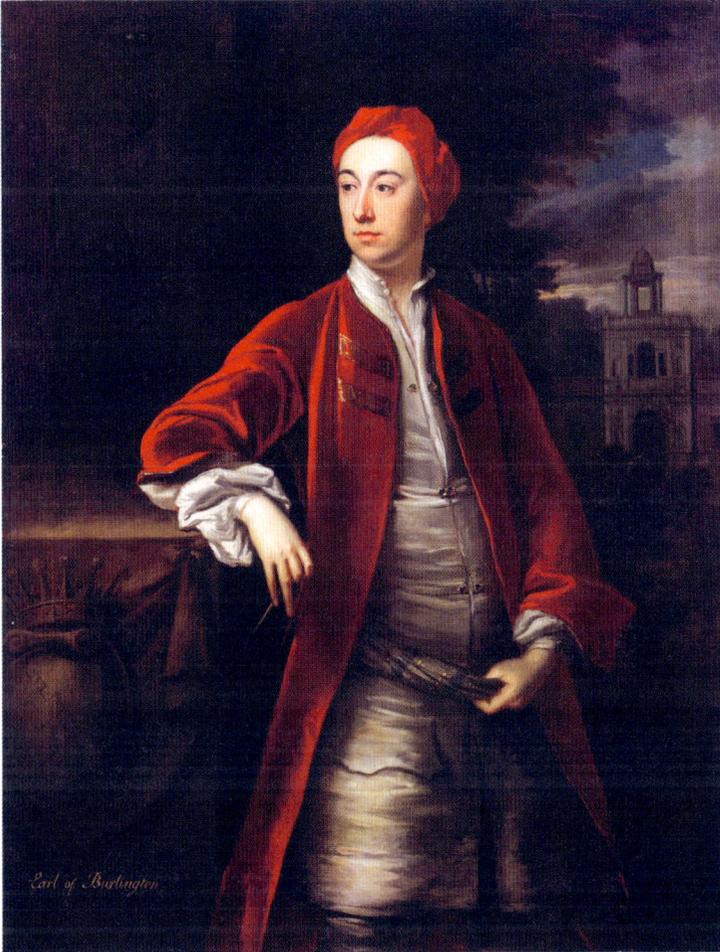

2.4 *Richard Boyle, 3rd Earl of Burlington and 4th Earl of Cork* by Jonathan Richardson, c.1717–1719

Those persons who are employed to build for private persons, have neither occasion to introduce the great parts of architecture, nor even always follow their own taste: in England more than in any other country, every man would fain be his own architect. In regard to this article they are less subject perhaps to the direction of mode and fashion than any other people; for every man gives his reason in defence of opposite tastes.[114]

For Walpole, Burlington is the epitome of the accomplished gentleman architect and final arbiter in matters of taste. He is portrayed as the 'Apollo of the Arts', a selfless, self-effacing individual who promoted the arts and supported genius in others.

Never were protection and great wealth more generously and more judiciously diffused than by this great person, who had every quality of genius and artist, except envy. Though his own designs were more chaste and classic than Kent's, he entertained him in his house till his death, and was

more studious to extend his friend's fame than his own ... His enthusiasm for the works of Inigo Jones was so active, that he repaired the church of Covent-garden because it was the production of that great master, and purchased a gateway at Beaufort-garden in Chelsea, and transported the identical stones to Chiswick with religious attachment. With the same zeal for pure architecture, he assisted Kent in publishing designs for Whitehall ...[115]

Not only was Burlington a patron of the arts, he was as an architect of some renown and Walpole's panegyric on Burlington is the longest entry in *Anecdotes of Painting* on an amateur architect. He singles out the grand colonnade added to Burlington House in Piccadilly as a prime example of imposing antique architecture, and of his villa at Chiswick, Walpole observes:

His lordship's house at Chiswick, the idea of which is borrowed from a well-known villa of Palladio, is a model of taste, though not without faults, some of which are occasioned by too strict adherence to rules and symmetry ...[116] Yet these blemishes, and lord Hervey's wit, who said the house was too small to inhabit, and too large to hang to one's watch, cannot deprecate the taste that reigns in the whole. The larger court, dignified by picturesque cedars, and the classic scenery of the small court that unites the old and the new house, are more worth seeing than many fragments of ancient grandeur, which our travellers visit under all the dangers attendant on long voyages. The garden is in the Italian taste, but divested of conceits, and far preferable to every style that reigned till our late improvements. The buildings are heavy, and not equal to the purity of the house. The lavish quantity of urns and sculpture behind the garden-front should be retrenched.[117]

It seems clear that Walpole wants to be compared with Burlington in matters of taste and creative ability, but contrasted to in terms of architectural style.[118] As Burlington was crowned arbiter of taste for reinterpreting Palladio's Classical designs on English soil, Walpole sought the equivalent accolade for reviving the taste for Gothic through native English models. Walpole makes this apparent in an early letter to Mann, written in 1753, illustrating that he had this notion in mind from the inception of the villa. 'As my castle is so diminutive, I gave myself a Burlington-air, and say, that as Chiswick is a model of Grecian architecture, Strawberry Hill is to so of Gothic.'[119] In his analysis Walpole insists on establishing Burlington with his protégé William Kent as an inseparable, complementary team. Kent had edited the *Designs of Inigo Jones* (1727) for Burlington and he received many architectural commissions in the Palladian style. Together they epitomised the perfect combination of accomplished architect and genius in landscape design. Walpole says of Kent:

He was a painter, and architect, and the father of modern gardening. In the first character, he was below mediocrity; in the second, he was a restorer of the science; in the last an original, and the inventor of an art that realizes painting, and improves nature. Mahomet imagined an Elysium, but Kent created many.[120]

Walpole thereby signals that he valued Kent for his landscape designs over and above his efforts in art or architecture where he cites many instances of 'his incapacity'. Kent's architectural talents are summarised as possessing 'an excellent taste for ornament', but on occasion here too he committed 'trifling impropriety'. Of Kent's celebrated monument to Shakespeare in Westminster Abbey, Walpole declares it 'preposterous'.[121] He states, 'As Kent's genius was not universal, he succeeded as ill in Gothic,' particularly criticising his designs for Esher Place, Surrey as 'proofs how little he conceived either the principles or graces of that architecture.'[122] But as we shall see, although in hindsight Walpole denigrated the mixed style of the architectural detail of Kent's Gothic at Esher Place he greatly admired the overall concept and the design and setting of the building in the landscape.[123] Thus it is demonstrated once again the importance that Walpole placed on the setting of buildings, and their associative potential and picturesque qualities that he had approved in the disposition of the buildings at Hawksmoor's All Souls, Oxford.

Whereas Walpole consistently denigrates Kent's forays into Gothic, his Classical architecture draws fulsome praise from Walpole, 'in architecture his taste was deservedly admired'. The Temple of Venus at Stowe 'has simplicity and merit' and Holkham, Norfolk is Kent's 'favourite production'. Though ever equivocal in his evaluation of Kent, Walpole declares that even Holkham is not without its faults; 'but they are Kent's faults, and marked with all the peculiarities of his style.'[124] In his assessment of Kent, he asserts that he was much sought after by those who 'affected taste'. 'Kent's style however predominated authoritatively during his life; and his oracle was so much consulted by all those who affected taste, that nothing was thought complete without his assistance.' The monograph on Kent concludes by signalling that he will write a more substantial piece on his major contribution to English landscape designs where he intends to 'consider him as the inventor of modern gardening'.[125] The model of cooperation and reciprocity that existed between Burlington and Kent was to have a significant influence on Walpole's working relationship with John Chute at Strawberry Hill.

Walpole flouted current taste, creating a Gothic villa set in a complementary but contrasting landscape setting. His reasons for doing so are complex. Of primary importance was the value that Walpole placed on Gothic architecture for its imaginative and associational potential – it would furnish him with plentiful ideas for stimulating pleasurable memories and inspiration. It also constitutes an architectural riposte, a complete antithesis to the Palladian mansion that his father had built at Houghton which held many negative personal connotations for Walpole. Finally, it represented an opportunity for him to surpass the other Gothic architects he had criticised in the *Anecdotes of Painting* for their inability to recreate 'beautiful Gothic'. In his recreation of Gothic 'principles or graces' he would establish himself as Burlington's equivalent in Gothic taste.

The combination of Burlington as arbiter of taste in architectural matters and Kent as an 'oracle' in matters pertaining to landscape is a partnership that Walpole and his own 'oracle in taste', John Chute would follow and hope to exceed. If Walpole wished to emulate and be compared with Burlington he also desired to improve on Kent's Gothic and landscape designs by using his antiquarian knowledge to construct a villa based on English architectural models. He would at the same time advance Kent's early essays in naturalistic English landscape style, creating an enchanting setting, a landscape for the imagination at his Gothic castle at Strawberry Hill.

'Gothic Pilgrimages': In Search of the 'Beautiful Gothic'

Using primary sources, this section establishes the architectural and archaeological precedents that were influential in formulating Walpole's views on Gothic architecture. His opinions of Gothic buildings expressed in the *Correspondence* and other unpublished material are analysed to establish and compare the buildings and sources that he knew in order to determine their influence on his theories and practice. There is scrutiny of Walpole's response to the form and setting of buildings he particularly admired and from where he drew his basic inspiration. It is explained how these are eventually manifested in the landscape of the imagination he created at Strawberry Hill.

Anecdotes of Painting is a decisive text which set out Walpole's architectural taste, even though it is something of a polemic in favour of developing an English architectural style and its unequivocal promotion of Gothic architecture. In order to understand his theory and attitude to Gothic it is necessary to analyse his response to the many country seats he visited from an early age. These visits enabled him to form opinions and speak knowledgeably on architecture, landscape and the contents of these buildings, particularly paintings. Walpole wrote extensively on the subject of his visits, in letters, journal entries and anecdotes. In these he sets out his personal manifesto in relation to those subjects and to questions of taste in a manner he was to continue throughout his life. From these sources we can chronicle the formulation and development of his thinking through his reaction to different sites and monitor how his taste manifests and develops. The culmination of his endeavours resulted in the picturesque composition he designed at Strawberry Hill that finally fired his imagination.

The basis of Walpole's art and architectural criticism elucidated in *Anecdotes of Painting* may have begun with Vertue's notebooks but these are enhanced and informed by his own series of visits to country seats which he undertook most years between June and September from 1749

into the 1780s when he toured on at least eighteen separate occasions. His antiquarian friend Cole recalls accompanying him on one such a visit:

… I went with Mr Walpole in his chariot, and leaving my horse behind me, I could not resist the temptation of attending him: both as I had never been at most of the places, and as I knew I should see all in the highest perfection, as he was so nice a judge of painting and architecture, and as every place and picture would be accessible …[126]

These visits enabled Walpole to formulate his architectural taste and to advise others on how they could improve and enhance their properties. For example, on a visit to his friend Richard Rigby's (1722–88) Mistley Hall, Essex in 1745, prior to the acquisition of Strawberry Hill, there is an early indication of his predilection for envisioning how a house could take the greatest advantage of its setting and be converted into a desirable residence by judicious alteration. He relates his acute observations to George Montagu:

Tis the charmingest place by nature, and the most trumpery by art that I ever saw. The house stands on a high hill on an arm of the sea, which winds itself before two sides of the house. On the right and left at the very foot of this hill lie two towns, the one, of market quality, and the other with a wharf where the ships come up. This last was to have a church, but by a lucky want of religion in the inhabitants who would not contribute to building a steeple, it remains an absolute antique temple with a portico, on the very strand. Cross the arm of the sea, you see six churches, and charming woody hills in Suffolk. All this parent Nature did for this place; but its godfathers and godmothers I believe promised it should renounce all the pomps and vanities of this world, for they have patched up a square house full of windows, low rooms and thin walls; piled up walls wherever there was a glimpse of a prospect; planted avenues that go nowhere, and dug fish ponds where there should be avenues.[127]

The same day Walpole wrote to Charles Hanbury Williams (1708–59) and articulated what appears to be the first reference to how a bad house and situation could be redesigned. Given enough funding, taste and imagination he suggests ideas for the transformation to realise its true potential:

I like Mistley prodigiously; if it were not for the house, and the walls and the avenues, which are all bad and déplacées, it would be a delightful place; I have built Roman porticos, Gothic spires, and Chinese galleries in plentiful ideas there. Indeed the river goes to sea so often, that half the day one is enquiring for water; but when Rigby has married some great City fortune, and got a taste, which last is consequence of t'other, he may make one of the finest seats in England there.[128]

Walpole enthuses about the influence he manages to exert regarding alterations to the house and landscape in order to take advantage of its setting. He explains how he would dispense with the present formality and replace art with nature and in this we have the first indication of his capacity for rebuilding in a more appropriate style of architecture. He also advised on making significant interventions in the landscape to take full

advantage of its situation. Mistley, although not a Gothic conversion, was an antecedent for the renovation of buildings and landscapes that were to reach their fruition at Strawberry Hill:

You can't imagine how he has improved it! You have always heard me extravagant in the praise of the situation. He has demolished all his paternal intrenchments of walls and square gardens, opened lawns, swelled out a bow window, erected a portico, planted groves, stifled ponds, and flounced himself with flowering shrubs, and Kent-fences. You may imagine that I have had a little hand in this. Since I have came hither I have projected a colonnade to join his mansion to the offices, have been the death of a tree that intercepted the view of a bridge, for which too I have drawn a new white rail, and shall be an absolute travelling Jupiter at Baucis and Philomen's, for I have persuaded him to transform a cottage into a church, by exalting a spire upon the end of it as Talbot has done.[129]

The formulation of the later treatises on architecture expressed in *Anecdotes of Painting* and landscape theory conveyed in the *History of the Modern Taste* also begin to emerge in this early correspondence.

It is apparent from the analysis of architects and architecture in *Anecdotes* that if architecture is to elicit a pleasurable emotional response then the type of building most likely to provoke this reaction is ancient Gothic structures, as they are steeped in architectural and social history that provoke historical imagination. Gothic exhibits grace and lightness, proportion, magnificence, beauty and taste, the architectural elements deemed essential in buildings displaying imaginative potential. Although Classical buildings are admired where appropriate, Gothic buildings bespeak natural genius and inventiveness and provide the greatest degree of imaginative pleasure.

Walpole's early years were spent at Eton College, Windsor, founded in 1440 and situated within sight of the medieval Windsor Castle crowning a steep site half-a-mile across the Thames. Windsor Castle represented the epitome of English history with its iconic skyline of turrets, battlements and round tower. His relationship as a young man to these medieval Gothic buildings was the catalyst for his developing such an acute sense of history.

When his father Robert died on 18 March 1745, despite being left the lease on the house in Arlington Street, Horace returned to the environs of Eton and Windsor. Writing to Mann he reports 'I have taken a pretty house at Windsor, and am going thither for the remainder of the summer'.[130]

The impression of Windsor Castle and St George's Chapel was so deeply embedded that some 60 years later he recalls in a letter to Berry his emotive response to these structures. St George's Chapel conveys the atmosphere of 'gloomth' that Walpole was to find so appealing and sought to replicate at his villa:

I went with General Conway on Wednesday morning from Park Place to visit one of my antediluvian passions – not a Statira or Roxana – but one pre-existent to myself – one – Windsor Castle; and I was so delighted and so juvenile, that without attending to anything but my eyes, I stood full two hours and half, and found that half my lameness consists in my indolence. Two Berry's, a Gothic

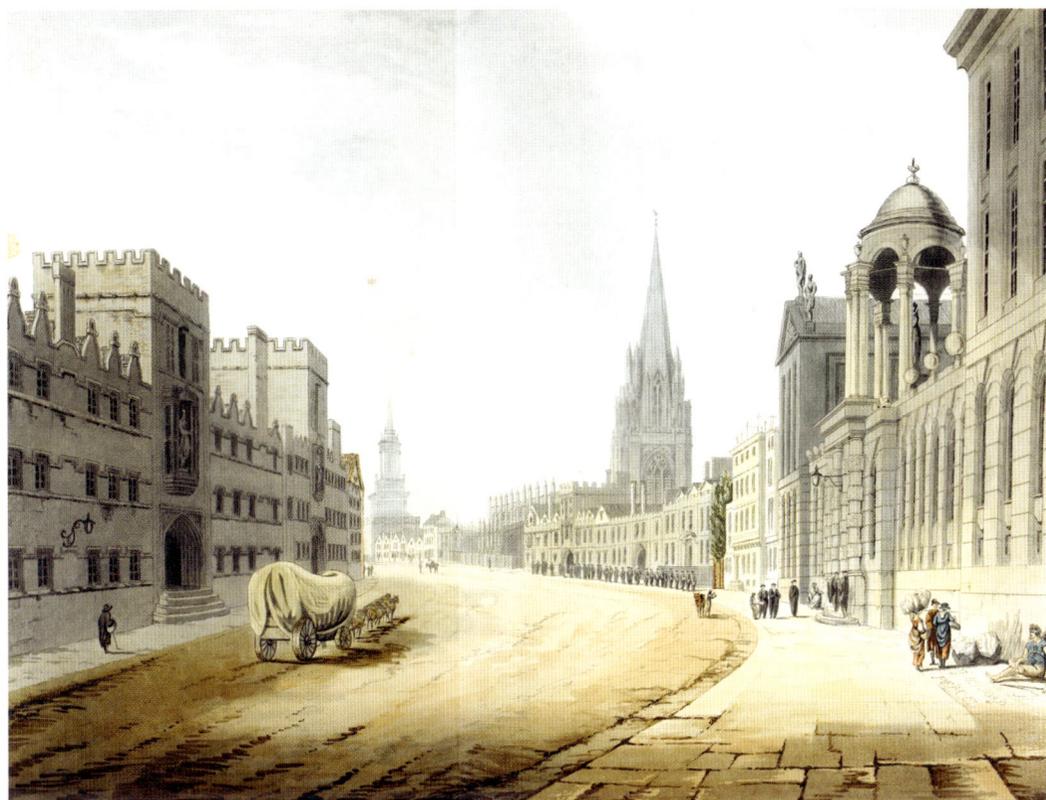

2.5 View of High Street, Oxford, J.W. Edy, 1790

chapel and an historic castle are anodynes to a torpid mind – I now fancy that old age was invented by the lazy. St George's Chapel that I always worshipped, though so dark and black that I could see nothing distinctly, is now being cleaned and decorated, a scene of lightness and graces. Mr Conway was so struck with its Gothic beauties and taste, that he owned the Grecian style would not admit half the variety of its imagination ...[131]

Oxford too had a similar effect on Walpole and throughout his life he consistently expressed his affection and admiration for its mixture of ecclesiastical and collegiate Gothic. He unequivocally praised Oxford from the moment he first saw it in 1736, writing to Montagu '... I have been on a jaunt to Oxford. As you have seen it, I shall only say I think it one of the most agreeable places I ever set my eyes on.'[132]

Returning to Oxford in 1753 he elucidates in a letter to Bentley how the Gothicism of the place had the power to infuse his imagination with monastic scenes:

As I was quite alone, I did not care to see anything; but as soon as it was dark I ventured out, and the moon rose as I was wandering among the colleges, and gave me a charming venerable Gothic scene, which was not lessened by the monkish appearance of the old fellows stealing to their pleasures.[133]

A further visit to Oxford with Conway some years later resulted in an additional letter to Montagu communicating how he had indulged antiquarian pursuits, relating that he could imagine taking up residence there:

… I believe I saw more antique holes and corners than Tom Hearne did in threescore years. You know my rage for Oxford; if King's College would not take it ill, I don't know but I should retire thither, and profess Jacobitism that I might enjoy some venerable set of chambers.[134]

He continued to express sentiments towards Oxford, singling out particularly the profusion of stained glass. *Anecdotes of Painting* had recorded the history of painted glass and how noblemen and gentlemen had been responsible for keeping the tradition going in private residences following its wholesale destruction in religious buildings during the Reformation:

The first interruption given to it was by the reformation, which banished the art out of churches; yet it was in some measure kept up in the escutcheons of the nobility and gentry in the windows of their seats. Towards the end of Elizabeth it was omitted even there, yet the practice did not entirely cease.[135]

This was to be a significant architectural element essential to the ornamenting of Strawberry Hill. Walpole records his preference for Oxford to his university town of Cambridge in a letter to Bentley, remarking on 'the profusion of painted glass'. 'The whole air of the town [Oxford] charms me; and what remains of true Gothic *un-Gibbs'd*, and the profusion of painted glass, were entertainments enough to me … All I will tell you more of Oxford is, that Fashion has so far prevailed over her collegiate sister [Cambridge]'.[136] Oxford remained a deep and abiding passion, his long-held enthusiasm for the place recorded in a letter to Lady Ossory of 1778. 'I visited my passion, Oxford, one morning. Mr Wyat has built a handsome gateway to Christ Church, taken, I think, from Claudius's arch; and is building an observatory of which I have some doubts.'[137] This letter also explains his theory in relation to stained glass, an obsession which we will see was to find expression at Strawberry Hill. He had previously seen the new stained glass window painted by Jarvis (1749–1804) depicting Joshua Reynolds (1723–92) 'nativity' exhibited in Pall Mall where it had a significant impact. In an earlier letter to Mason Walpole had enthused on its display at Royal Academy Exhibition in 1779. 'Jarvis's window from Sir Joshua's "Nativity" is glorious. The room being darkened and the sun shining through the transparencies, realises the illumination that is supposed to be diffused from the glory and has a magic effect.'[138] In contrast, on his return from seeing it inserted in the upper portions of the west window in New College Chapel, Oxford he records his disappointment:

… Sir Joshua's 'Nativity' – but alas! It is just the reverse of the glorious appearance it made in the dark chamber at Pall Mall. It is too high, the ante-chapel where it is placed is too narrow to see it but foreshortened, and the washy Virtues round it are so faint and light, that the dark shepherds and the *chiaroscuro* that are meant to relieve the glory, child and angels, obscure the whole. I foresaw long ago that Jarvis's colours being many of them not transparent, could not have

the effect of old painted glass. Indeed to see his window tolerably, I was forced to climb into the organ loft, by such a pair of stairs, that not having broken my neck, I can almost believe that I could dance a minuet on a horse galloping full speed.[139]

The need to darken the room to obtain the desired effect is also expressed in a manuscript note of Walpole when discussing an exhibition of coloured glass of the Swiss-French painter Jean-Etienne Liotard (1702–89):

There is the same defect in the glass-paintings of Jervais; most of his colours are not transparent, and their great beauty is produced by the strong lights in the spots for the sun or moon in opposition to the darkness surrounding them: thence his windows cannot serve like the ancient painted windows to illuminate a church or chamber.[140]

He makes a similar observation in a letter to his cousin Henry Seymour Conway regarding the incongruity of juxtaposing old and new glass as he does about this practice in Gothic architecture in *Anecdotes of Painting*: 'the old and the new are as mismatched as an orange and a lemon.'[141] No doubt Walpole's knowledge was developed in part from these visits and his experience gained from the placement and commissioning of his own stained glass at Strawberry Hill.

Walpole's relationship to Cambridge is more ambivalent than that to Oxford although it would appear that he came to recall it with greater affection with the passage of time:

However, I made myself amends with the University [Cambridge], which I have not seen these four and twenty years, and which revived many youthful scenes, which merely from their being youthful are forty times pleasanter than any other ideas. You know I always long to live at Oxford – I felt that I could like to live even at Cambridge again. The colleges are much cleaned and improved since my days, and the trees and groves more venerable; but the town is tumbling about their ears.[142]

Writing to Mason after a recent visit to Cambridge he reminisces on his time there and compares Strawberry Hill unfavourably with the chapel at King's College:

I took one day to walk through [Cambridge] and dine with old Cole. I sighed to take the vows at the former. I think I could pass my last days there with great comfort. King's Chapel is more beautiful than Strawberry Hill. A bookish monk is a happy being, he is neither disposed to laugh, nor to feel, and scarce knows that the other two divisions are fools and villains.[143]

He reiterated his affection for the Chapel to Cole following their recent visit stating that it still held a place of affection in his heart:

I dote on Cambridge and could like to be often there – the beauty of King's College Chapel, now it is restored, penetrated me with a visionary longing to be a monk in it – though my life has been passed in turbulent scenes, in pleasures – or rather pastimes, and in much fashionable dissipation, still books, antiquity and virtù kept hold of a corner of my heart, and since necessity has forced me of late years to be a man of business, my disposition tends to be a recluse for what remains.[144]

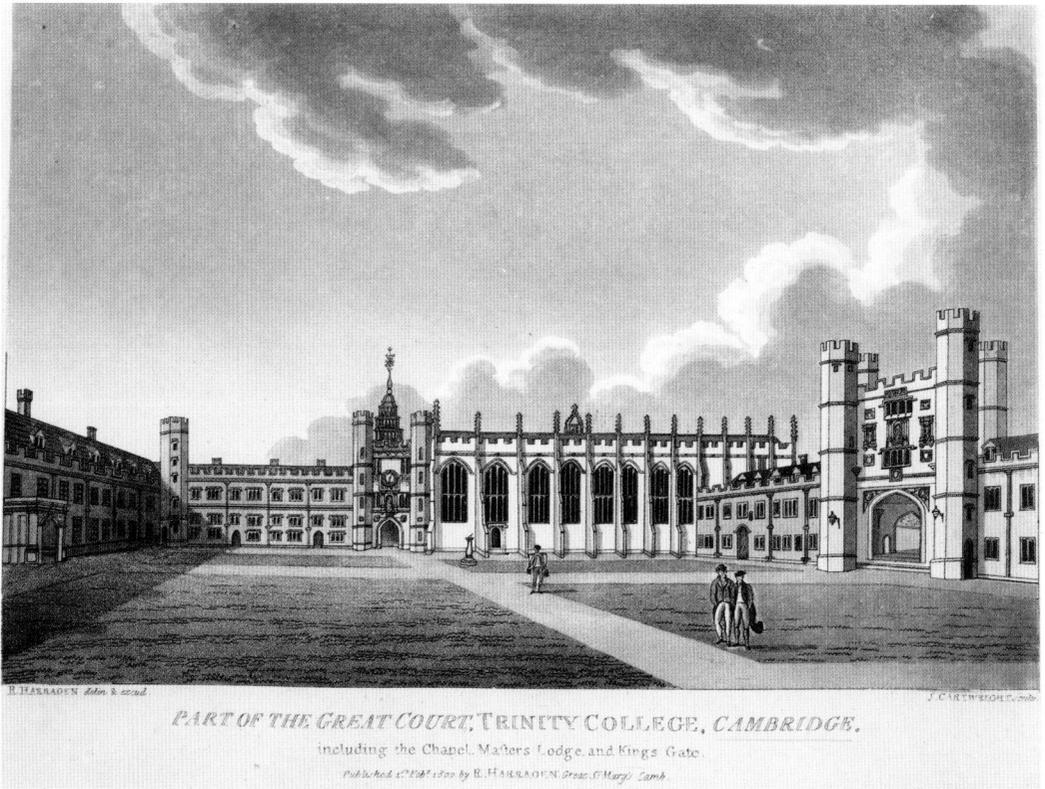

PART OF THE GREAT COURT, TRINITY COLLEGE, CAMBRIDGE.
including the Chapel, Masters Lodge and Kings Gate.

2.6 Part of the Great Court, Trinity College Cambridge, J. Cartwright, 1800

Nowhere is the power of Gothic buildings to fire his imagination more evident than in the inspiration that the Great Court at Trinity College, Cambridge gave for depicting the ancient structure that is the subject of his novel, *The Castle of Otranto*.

In the *Description of the Villa* Walpole confesses that Strawberry Hill had inspired the novel but it is clear that the conception of his Gothic castle at Twickenham interrelates with his writing, research and travels to produce romantic interpretations of the past derived from a combination of people and places that stimulate his imagination. In a letter of 1775 to his French friend Madame du Deffand he writes:[145]

En entrant dans un colléges que j'avais entiérement oublié, je me trouvais précisément dans la cour de mon château. Les tours, les portes, la chapelle, la grande sale, tout y répondait avec la plus grande exactitude. Enfin l'idée de ce college m'était restée dans le tête sans y penser, et je m'en étais servi pour le plan de mon château sans m'en apercevoir; de sorte que je croyais entrer tout de bon dans celui d'Otrante.

[Entering a college which I had entirely forgotten, I found myself precisely in the courtyard of my castle. The towers, the doors, the chapel, the great hall, all corresponded [or 'echoed' might be a closer translation of the French text, which is literally 'answered'] with the greatest accuracy. Finally the idea of

this college had remained in my mind without thinking about it, and I had used it for the plan of my castle without noticing; so that I thought I was truly entering Otranto].[146]

It is evident that Oxford and Cambridge, Eton College and Windsor Castle were significant influences for the conversion of Strawberry Hill. In addition, Walpole also undertook a series of 'Gothic pilgrimages' in search of the beautiful Gothic, collecting ideas and seeking inspiration for Strawberry Hill. Although he admits he saw Esher Place prior to the visit in 1748 there is no substantive record before this letter which coincides with his intention of Gothicising Strawberry Hill. It is clear, however, that despite his criticism of Kent's Gothic work in the *Anecdotes of Painting* that overall Kent's Gothicising of Waynflete's Tower is exempt from his censure. The building combined with its rich pictorial landscape setting on the shores of the River Mole make a significant impression on him. 'Esher, I have seen again twice and prefer it to all villas, even to Southcote's; Kent is Kentissime there.'[147] Walpole made strong associations with the history of Esher Place, a former Cardinal Wolsey (1473–1530) residence.[148]

This historical association proved significant for gaining Walpole's approval. Kent demolished the original medieval and Tudor parts in 1729 leaving only the fifteenth-century gatehouse, constructed 1475–80. In one of the earliest eighteenth-century examples of Gothic Revival architecture Kent added two three-bay ranges to either side of the gatehouse, remodelling the ogee arched windows as well as adding a single-storey ogee-arched porch between the existing turrets. Other additions include the three-light and quatrefoil windows above the porch. The combination of Kent's transformation of its Gothic buildings and the conversion of its landscape setting into an Elysium (1730–33) were undoubtedly catalysts for Walpole's own designs at Strawberry Hill.

On another excursion through Kent and Sussex with John Chute in 1752, he and Walpole visited Battle Abbey, Sussex. The tone of the letter suggests that they are fully immersed in the Gothic experience:

Here we are, my dear Sir, in the middle of our pilgrimage; and lest we should never return from this holy land of abbeys and Gothic castles, I begin a letter to you, that I hope some charitable monk, when he has buried our bones, will deliver to you. We have had piteous distress, but then we have seen glorious sights![149]

Walpole elucidates on how the eleventh-century Battle Abbey, built by William the Conqueror (1028–87) for the monks as thanks to God for winning the battle of Hastings in 1066, would be an ideal location for stimulating the imagination because of its significance in English history. He writes to Montagu, quoting Chute, on how they had discussed the possibilities for converting this historic site for domestic habitation, had it been available:

Battel Abbey stands at the end of the town exactly as Warwick Castle does at Warwick; but the house of Webster have taken due care that it should not resemble it in anything else. A vast building, which they call the old refectory,

but which I believe was the original church, is now barn, coach-house etc. The situation is noble, above the level of abbeys: what does remain of gateways and towers is beautiful, particularly the flat side of the cloister, which is now the front of the mansion house … The grounds and what has been a park, lie in a vile condition … Mr Chute says, 'What charming things we should have done if Battel Abbey had been to be sold at Mrs Chevenix's as Strawberry was!'[150]

The expedition also included Herstmonceux, Sussex, and we will see later how the historic fifteenth-century moated medieval castle also became a source for copying architectural elements for Strawberry Hill. Walpole relates to Montagu how it remained as 'perfect as the first day' it was constructed during the reign of Henry VI (1421–1471, reigned 1422–1461 and 1470–1471):

It is seated at the end of a large vale, five miles in a direct line to the sea, with wings of blue hills covered with wood, one of which falls down to the house in a sweep of 100 acres. The building for the convenience of water to the moat sees nothing at all; indeed it is entirely imagined on a plan of defence, with drawbridges actually in being, round towers, watch-towers mounted on them, and battlements pierced for the passage of arrows from long bows. It was built in the time of Henry VI and is as perfect as the first day.[151]

The ancient motte-and-bailey castle at Tonbridge, Kent, likewise was the subject of discussion in a letter to Bentley. Walpole suggests that the committee formed for the improvements at Strawberry Hill could productively employ their talents to the setting of the eleventh-century castle erected by a kinsman of William the Conqueror:

We lay that night at Tunbridge town, and were surprised with the ruins of the old castle. The gateway is perfect, and the enclosure formed into a vineyard … and the walls spread with fruit, and the mount on which the keep stood, planted in the same way. The prospect is charming, and a breach in the wall opens below to a pretty Gothic bridge of three arches over the Medway. We honoured the man for his taste – not but that we wished the committee at Strawberry Hill were to sit upon it, and stick cypresses among the hollows.[152]

All his life Walpole maintained his interest in these ancient structures and their inhabitants. He continued his antiquarian researches and subsequently researched the roll of the Earls of Warwick. He comments on the historical associations of Warwick Castle, which held the deepest appeal for him.

In his letter to Lady Ossory of 10 June 1777 he writes of how the association with significant historical figures play an important role in his fascination:

… that your stay at Warwick Castle will be short. You must be charmed with it; I think, awed: at least, my Gothic superstition sees every tower haunted with Beauchamps, and I could not sleep there without dreaming of Queen Elizabeth in all her pomp and pageantries. Then the chapel in the church! [Beauchamp Chapel in St Mary's Church, Warwick] … Oh! but in the Castle is a portrait of my hero, Lord Brook of the civil War; and another of Lady Catherine Grey [1540–1568] and her son …[153]

He was still recounting his fond memories of the historical inhabitants of Warwick years later. 'Warwick Castle and Stowe I know by heart: – the first I had rather possess than any seat upon earth – not that I think it is the most beautiful of all, though charming, [but] because I am so intimate with all its proprietors for the last thousand years.'[154]

Walpole also visited Fawsley Hall, Northamptonshire, which had been a royal manor since the seventh century and was extended in the early fifteenth century. Elizabeth I had visited in 1575 and Walpole recorded his astute observations of the building history in his *Books of Materials* of July 1763.

… the middle & the other wing seem to have been built (their outsides) from the reign of Henry 7th to the middle of Elizabeth; but the inside is exceedingly ancient, perhaps posterior to no other house in England, being most irregular, and apparently put together with no plan or design: the Hall is one of the most beautifull rooms I ever saw, in the Gothic taste, very lofty, not very wide, the cieling pendent & with arches of wooden work pierced, like the roof of a college-hall. On the left hand of the Entrance is a very slim & high bow window richly carved and adorned with the alliances of the family in painted glass, the whole most beautifull. A window runs almost round the hall, even over the chimney, the funnels being carried up without the buttresses. These windows are also full of arms; there are still extant in the whole sixty coats entire, besides three perfect little figures of Knights, one of which is a Vere …[155]

Wroxton Abbey, Oxfordshire is a Jacobean house built on the foundations of a thirteenth-century Augustan priory. Although Walpole spent a 'delightful day' there he disliked the house describing it as 'neither good nor agreeable'. However, the new chapel with painted glass by Van Linge (1623) relocated here from elsewhere in 1747, was more to his taste. 'The Chapel is new, but in a pretty Gothic taste, with a very long window of painted glass, very tolerable. The frieze is pendent, just in the manner I propose for the eating room [the Great Parlour, completed in 1754] at Strawberry Hill.'[156] As for the landscape, he found only one incident commendable:

This scene consists of a beautiful lake entirely shut in wood: the head falls into a fine cascade, and that into a serpentine river, over which is a little Gothic seat like a round temple, lifted up by a shaggy mount … and the tower is in a good plain Gothic style …[157]

Walpole visited Stowe in August 1753 and despite political misgivings regarding the shifting political alliances of the late owner Sir Richard Temple, Viscount Cobham (1675–1749) he expressed his approval of the associative landscape.[158] Despite his wholesale criticism of Gibbs in the *Anecdotes of Painting* his Temple of Liberty (1741–9), built as a temple and later dedicated 'to the liberty of our ancestors' (1745) received much approbation from Walpole.

This building was undoubtedly influential on Strawberry Hill, particularly with regard to the decorative scheme and the use of Gothic iconography, heraldic motifs and peripatetic stained glass. He grudgingly admits to Chute:

2.7 The Gothic
Temple, Stowe,
B. Seeley, 1783
edition

The Gothic Temple

… in the heretical corner of my heart I adore the Gothic building, which by some
unusual inspiration Gibbs has made pure and beautiful and venerable. The style
has a propensity to the Venetian or mosque – Gothic, and the great column near
it makes the whole put one in mind of the Place of St Mark.[159] The windows are
throughout consecrated with painted glass: most of it from a Priory at Warwick, a
present from that foolish [Mr Wise] … The situation is pretty, the front charming,
composed of two round and two square towers. The court within is incomplete
on one side; but above stairs is a vast gallery with four bow windows and twelve
other large ones, all filled with the arms of the old peers of England, with all
quarterings entire.[160]

It will be apparent in later discussion how Gibbs's Gothic Temple of Liberty
was particularly influential in the design adopted for the ceiling decoration in
the library and other features at Strawberry Hill.

That these 'pilgrimages' were undertaken to find design inspirations and
to confirm the authenticity of printed sources is apparent from Walpole's visit
to the cathedral at Worcester. This is made clear in a letter to Bentley:

The cathedral is pretty, and has several tombs, and clusters of light pillars
of Derbyshire marble, lately cleaned. Gothicism and the restoration of the
architecture, and not of the bastard breed spreads extremely in this part of the
world. Prince Arthur's tomb, from whence we took the paper for the hall and
staircase, to my great surprise, is on a less scale than the paper, and it is not of
brass but stone, wretchedly whitewashed.[161]

2.8 The tomb of Cardinal Beaufort, Winchester Cathedral, 1447

Walpole had imitated the design of Prince Arthur's (1486–1502) tomb from a plate of the screen in his copy of Francis Sandford, *A Genealogical History of the Kings of England*, 1677. However, his expression of surprise indicates that the proportions and materials of the original were not as anticipated either in scale or texture.

The architecture of funerary monuments held a particular fascination. They appear to represent the ultimate in Gothic architectural ornament and their close association with particular individuals meant that the imaginative potential is exponentially increased. On a visit to Winchester Cathedral in 1755 Walpole elucidates to Bentley on why he finds the 'richness and great delicacy' afforded on tombs, oratories and small chapels so appealing. 'I like the smugness of the cathedral, and the profusion of the most beautiful Gothic tombs. That of Cardinal Beaufort (1375–1447) is in a style more free and of more taste than anything I have seen of the kind.'

The powerful historical figures buried there continue to inspire:

… besides the monuments of the Saxon kings … there are those of six such great or considerable men as Beaufort, William of Wickham, him of Wainfleet, the Bishops Fox and Gardiner and my Lord Treasurer Portland – How much power and ambition under half a dozen stones! I own, I grow to look on tombs as lasting mansions, instead of observing them for curious pieces of architecture![162]

The edition of Gray's *Elegy* published with his collaboration in 1753 had accompanying illustrations by Bentley which involved the reader in antiquarian activities. The frontispiece portrayed a scene which Walpole described as 'a church-yard and a village-church built out of the remains of an abbey' and validated the study of tombs and inscriptions as a means of accessing authentic histories.[163] The concept portrayed of building a

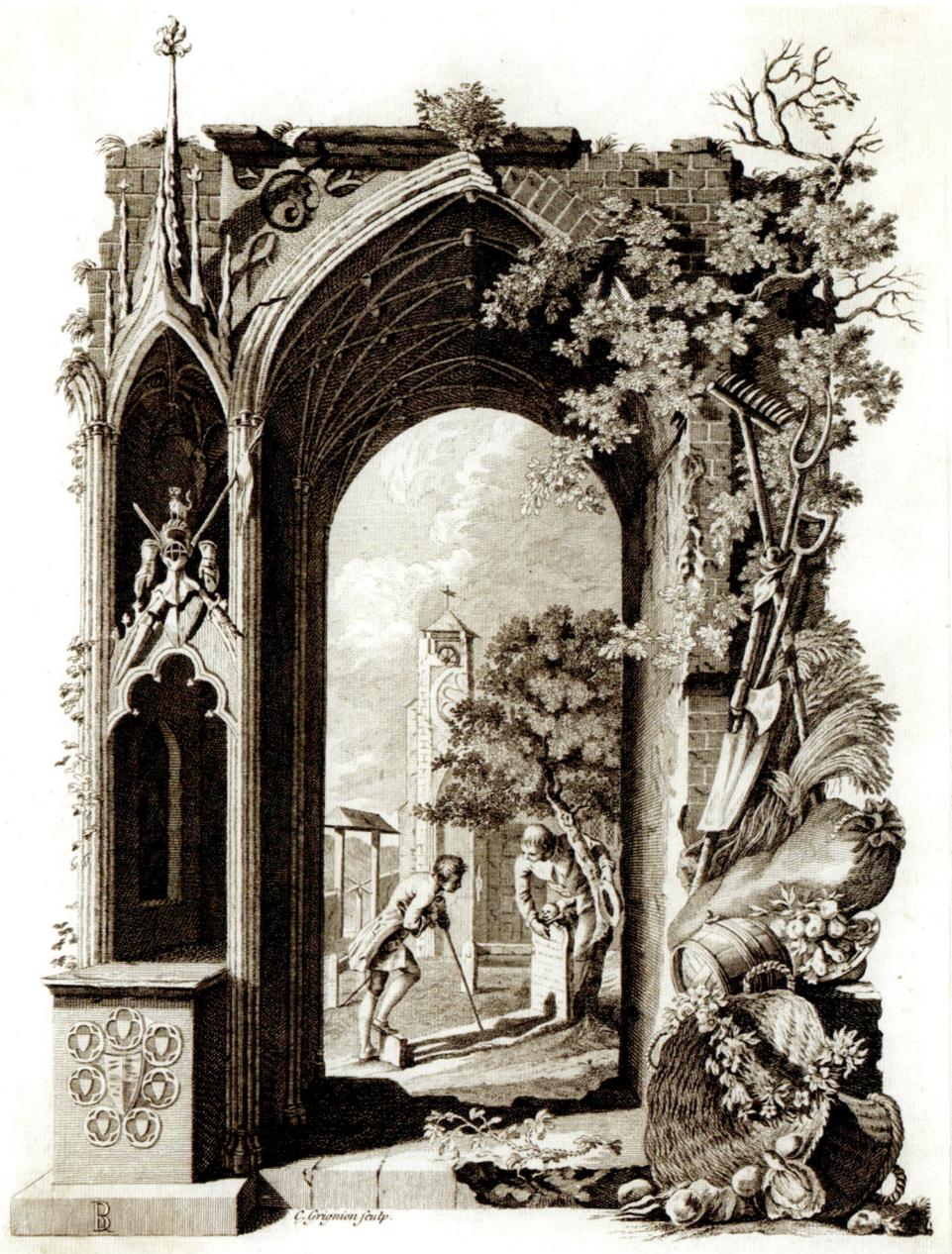

2.9 Frontispiece to *Elegy written in a Country Church-yard*, R. Bentley, 1753

picturesque composition out of the fragmentary remains of ancient structures and the use of tombs a source of architectural quotation redolent of the past is to have a significant impact at Strawberry Hill.

The assertion that these antiquarian pilgrimages were undertaken to acquire ideas and artefacts is again supported by a visit to Malvern Abbey, Worcestershire as part of the same expedition. Remarking to Bentley on his specific purpose:

> … I was hunting for John of Gaunt and King Edward. The greatest curiosity, at least what I had never seen before, was the whole floor and far up the sides of the church had been, if I may call it so, wainscoted with red and yellow tiles, extremely polished, and diversified with coats of arms, and inscriptions and mosaic. I have since found the same at Glocester, and have been so fortunate as to purchase from the sexton about a dozen, which think what an acquisition for Strawberry![164]

Gloucester Cathedral was to prove a particularly rich design source and the ancient tiles he procured from the sexton at Gloucester Cathedral were inlaid in the floor of the China Cabinet at Strawberry Hill. Walpole commended to Bentley the Lady Chapel in Gloucester Cathedral, and particularly the abbot's cloister which provided an exquisite model for Gothic detail:

> Our Lady's Chapel has a bold kind of portal, and several ceilings of chapels, and tribunes in a beautiful taste: but of all delight, is what they call the abbot's cloister. It is the very thing that you would build, when you had extracted all the quintessence of trefoils, arches, and lightness. In the church is a star-window of eight points, that is prettier than our rose-windows.[165]

Anecdotes of Painting also recommends that 'the fret-work … behind the choir at Gloucester' on the grounds that they 'would furnish beautiful models'. The visit to Gloucester Cathedral afforded him an opportunity to assess Kent's work in Gothic which he went on to disparage in the *Anecdotes of Painting*. He compared Kent's bad attempts to integrate new Gothic juxtaposed to old with Wren's work at Christ Church, Oxford, commenting to Bentley:

> Kent designed the screen; but he knew no more than he did anywhere else how to enter into the true Gothic taste.[166] Sir Christopher Wren, who built the tower of the great gateway at Christ Church, has catched the graces of it as happily as you could do: there is particularly a niche between two compartments of a window, that is a masterpiece.[167]

At Burford Priory, Oxfordshire Walpole admires the effect of viewing the garden through arches, which may have provided the inspiration for the cloister at Strawberry Hill. He comments to Bentley: '… the front is good; and a chapel connected by two or three arches, which let the garden appear through, has a pretty effect.'[168] In a further missive to Bentley Walpole expresses his contentment in following his antiquarian pursuits: 'I amuse myself with Gothic and painted glass, and am as grave about my own trifles as I could be at Ratisbon.'[169]

Walpole's architectural criticism in the *Anecdotes of Painting* demonstrated that he thoroughly disapproved of Batty Langley's version of Gothic as advocated in his *Gothic Architecture Improved by Rules and Proportions.* In a letter to Bentley he disparagingly discusses Latimers, Buckinghamshire where in the past he had stayed with his cousin Conway. '… the house has undergone Batty Langley-discipline: half the ornaments are of bastard Gothic, and half of Hallet's mongrel Chinese.[170] I want to write over the doors of most modern edifices, *Repaired and Beautified, Langley and Hallet churchwardens.*'[171] It is important to understand the reasons informing Walpole's vehement dislike of Batty Langley's Gothic. Walpole believed that Gothic structures as revived in the eighteenth century should be copied or imitated from authentic, original models. His detestation of Langley is based on his observation that Langley invented his own idiosyncratic Gothic style, and in the process attempted to impose his own set of rules. He was guilty of desecrating true Gothic. Walpole disliked Kent's attempts at Gothic for the same reason. He condemned Langley in *Anecdotes of Painting* for teaching others to 'massacre that venerable species', of true Gothic. He had visited Painshill, Surrey before, remarking: 'I have been to see Mr Hamilton's [Painshill] near Cobham, where he has really made a fine place out of a cursed hill.'[172] Recording another visit to Painshill on 22 August 1761 Walpole repeats his assertion that Langley's Gothic is anachronistic, erroneous and unmeaning and explains why he believes it to be inappropriate. He also condemns other interventions in the landscape to be similarly devoid of taste:

… went again to Mr Charles Hamilton's at Payne's hill near Cobham, to see the Gothic building & the Roman ruin. The former is taken from Battey Langley's book (which does not contain a single design of true or good Gothic) & is made worse by pendent ornaments in the arches, & by being closed on two sides at bottom, which cheeks that have no relation to Gothic. The whole is an unmeaning edifice. In all Gothic designs, they should be made to imitate something that was of that time, a part of a church, a castle, a convent, or a mansion. The Goths never built summer-houses or temples in a garden. This at Mr Hamilton's stands on the brow of a hill – there an imitation of a fort or watch tower had been proper. The ruin is much better imagined, but has great faults. It represents a triumphal Arch, & yet never could have been a column, which would certainly have accompanied so rich a Soffite. Then this Arch is made to have been a Columbarium. You may as well suppose an Alderman's family buried *in* Temple bar. Had it been closed behind, & there is no reason it should not, for it leads nowhere, one might imagine it a private burial-place, tho the fashion uncommon. The upper row of niches in the columbarium are too high, & in a proportion more gothic than Roman. The tessellated pavement unluckily resembles a painted oil cloth.[173]

Walpole's statement that Gothic 'should be made to imitate something that was of that time, a part of a church, a castle, a convent, or a mansion' is significant. It confirms that his continual references to Strawberry Hill as an 'abbey', 'cloister', 'castle' or mansion are to emphasise that its architectural elements are imitated from either original Gothic buildings that he had seen or copied from printed antiquarian design sources. He believed that his

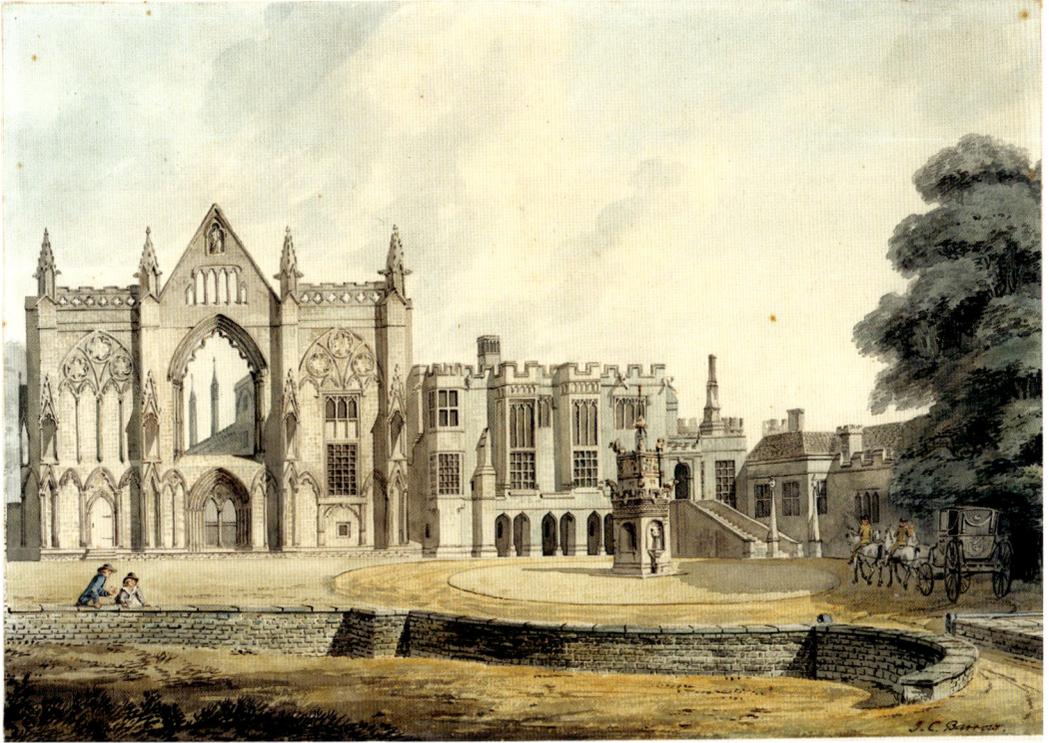

2.10
Newstead Abbey,
Nottinghamshire,
J.C. Barrow, 1793

concept of Gothic as manifested at Strawberry Hill was an appropriate use of authentic Gothic applied to a private dwelling, supposedly built on monastic foundations.

He constantly reveals his imaginative engagement with the form of ecclesiastical Gothic architecture particularly displayed in abbeys and affirms his belief, later reiterated in *Anecdotes of Painting*, that the abbots of monasteries were the original architects responsible for the design of the buildings they occupied. 'Newsteade delighted me. There is grace and Gothic indeed – good chambers and a comfortable house. The monks formerly were the only sensible people that had really good mansions.'[174]

There is more detailed information on the interior and decoration of the abbey in his correspondence with Montagu:

As I returned, I saw Newstead and Althorpe; I like both. The former is the very abbey. The great east window of the church remains, and connects with the house; the hall entire, the refectory entire, the cloister untouched with the ancient cistern of the convent and their arms on it, a private chapel quite perfect. The park, which is still charming, has not been so much unprofaned.[175]

In Walpole's history and criticism of architecture we see distinct patterns and themes emerging which are important to recognise for their impact on the architecture at Strawberry Hill. The buildings he values most are those that convey historical atmosphere through which form, contents, material

remains and occupants, past and present, inform architectural significance and enhance the experience of imaginative engagement.

By now it is also apparent that the tours were significant events for seeking inspirational models of architecture and picturesque settings at first hand. Through the analysis undertaken it is also been established that he valued Gothic architecture and appreciated other buildings for the history they evoked and story they told of present and former occupants. They enthused and inspired historical imagination and the correspondence testifies that ancient architecture, medieval castles and abbey sites held a particular fascination as building types and for their links with English history.

All his life Walpole celebrated the pleasures that the imagination could provide and the pleasing combination of picturesque architecture combined with an animated landscape setting were a constant source of intellectual stimulation and sensory gratification. In a footnote to his discussion of Hawksmoor's work at All Souls, Oxford recounted in *Anecdotes of Painting* Walpole expands on how a picturesque ensemble can appeal directly to the imagination but also how its arrangement can provoke sensations of 'visionary enchantment' in the onlooker. Although he condemns the decoration of the buildings at All Souls because it is not in the 'genuine style' he praises the overall conception and disposition of the buildings in the quadrangle:

… which has blundered into a picturesque scenery not void of grandeur, especially if seen through the gate that leads from the schools. The assemblage of buildings in that quarter, though no single one is beautiful, always struck me with a singular pleasure, as it conveys such a vision of large edifices, unbroken by private houses, as the mind is apt to entertain of renowned cities that exist no longer.[176]

This digression into the associative, picturesque qualities of architecture is uncharacteristic of the general tenor of Walpole's history and criticism in *Anecdotes of Painting*, except when relegated to a footnote. However, it is typical of his observations related in private correspondence and his *Books of Materials*.

He links the picturesque ensemble at All Souls to the effect that the buildings in the landscape provoke at Stowe. Walpole describes how the multiplicity of scenes and variety of architectural elements disposed in the landscape at Stowe provoke a chain of associations that stimulate the imagination enabling the viewer to envision the past and recall works of art:

It is the same kind of visionary enchantment that strikes in the gardens at Stowe. Though some of the buildings, particularly those of Vanbrugh and Gibbs, are far from beautiful, yet the rich landscapes occasioned by the multiplicity of temples and obelisks, and the various pictures that present themselves as we shift our situation, occasion surprise and pleasure, sometimes recalling Albano's landscapes to our mind, and oftener to our fancy the idolatrous and luxurious vales of Daphne and Tempe.[177]

It is the ability of the overall composition to invoke pleasing reflection, recalling paintings, people, and literature as the observer discovers different scenes, as in a theatre, as he moves around the garden. The effect Walpole is describing is that of a mobile parallax where spectators are subjected to different views as they move through the landscape, alternating between viewer and object. It is that sense of movement and contrast occasioned by looking from different perspectives that Addison had deemed essential to invoke a pleasurable imaginative response. The effect is of a sense of diffusion that affects the emotions of the beholder through the association of ideas important to Walpole as he uses English history and scenes from the past as a resource of historic material to inspire ideas and furnish his imagination. In this concept he concurred with Addison in perceiving the imagination as a creative force.

Further evidence of Walpole's imaginative response to a historic environment is confirmed in this recollection of Hampton Court, which once again recalls and reflects Vanbrugh and Addison:

As I pass a great deal of time at Hampton Court ... I was strolling in the gardens in the evening with my nieces ... It was moonlight and late, and very hot, and the lofty facade of the palace, and the trimmed yews and canal, made me fancy myself of a party in Grammont's time – so you don't wonder that by the help of imagination I never passed an evening more deliciously.[178] When by the aid of some historic vision and local circumstance I can romance myself into pleasure, I know nothing transports me so much. Pray, steal from your soldiery, and try this secret at Bevis Mount, and Nettley Abbey. There are Lord and Lady Peterborough and Pope to people the former scene, and who you please at Nettley – I sometimes dream, that one day or other somebody will stroll about poor Strawberry and talk of Lady Ossory – but alas! I am no poet, and my castle is of paper, and my castle and my attachment and I, shall soon vanish and be forgotten together![179]

These links to history through the association of people, architecture and places inform Walpole's emotive response. He recalls Pope's relationship with Bevis Mount, Southampton where he was a frequent visitor and after which 'Pope's walk' was named. The historical associations that Vanbrugh articulated connecting buildings and inhabitants are significant motivating factors behind Walpole's impulse for the landscape of the imagination that he created at Strawberry Hill – he hopes to invoke the same associative leap of imagination in visitors to his creation to recall him to future generations.

Walpole's antiquarian research and expeditions examining Gothic buildings and sites enabled him to produce a picturesque ensemble capable of stimulating the imagination. With the creation of Strawberry Hill Walpole desires posterity to recall him as the amateur architect who surpassed all previous attempts at reproducing correct English Gothic. He wanted to be remembered as the arbiter of taste for reviving the Gothic style equivalent to the way Burlington was credited for the Palladian Revival. At Strawberry Hill he will surpass Langley and Kent and 'improve' on Kent's attempts at landscape design.

Endnotes

1. Klein, L.E. 'Liberty, Manners, and Politeness in Early Eighteenth-Century England', *The Historical Journal*, vol. 32, No. 3 (September 1989), pp. 583–605.

2. See Rosemary Sweet, 'Antiquaries and Antiquities in Eighteenth-Century England', *Eighteenth-Century Studies*, 34 (Maryland, 2001), pp. 181–206.

3. The College of Antiquaries founded 1586 was a precursor to the Society of Antiquaries. It was largely a debating society which was forbidden to meet by James I in 1614. The Society of Antiquaries began to meet informally in 1707 but its proceedings were not formalised until 1717. The Society received its Royal Charter in 1751.

4. Hazen, *A Catalogue of Horace Walpole's Library*, p. liv.

5. The first English Gothick garden pavilions are of a 'political' or 'patriotic' nature: the Gothic Temple (after 1717), Shotover, Oxfordhire, attributed to William Townesend, and Alfred's Hall (1721–32), Cirencester Park, Gloucestershire. Other examples of Gothick garden buildings include the Gothic Temple at Stowe (1741–49) by James Gibbs; the Cuttle Mill (c.1740), Rousham, Oxfordshire, by William Kent and Edgehill Castle Tower (1745–47) Radway, Warwickshire, built for himself by Sanderson Miller. *Grove Art Online*, 'Gothic Revival'. http://www.oxfordartonline.com/. Accessed 26 August 2011. Alfred's Hall at Cirencester Park is attributed to Pope and said by Christopher Hussey to be 'probably the first of the mock castles': 'Cirencester Park', *Country Life*, 107 (23 July 1950), quoted in Brownell, M.R. *Alexander Pope and the Arts of Georgian England* (Oxford, 1978), p. 272.

6. Zocchi's drawings of the Florentine Villas which Mann had sent to Walpole.

7. *Correspondence*, Walpole to Mann, 2 August 1750, vol. 20, p. 166.

8. Walpole probably became acquainted at Downing Street where he made an inventory of the pictures. There is documentary and anecdotal evidence that Walpole loaned him pictures from his collection to engrave. Vertue received a presentation copy of Walpole's *Aedes Walpoliana* (1747) and Walpole helped publish posthumously a catalogue of Charles I's collection that Vertue had been working on in 1751. Brownell contends that Vertue was the dominant influence in Walpole's taste for portraiture. Brownell, M.R. *The Prime Minister of Taste* (London, 2001), pp. 69–91.

9. Evans, J. *A History of the Society of Antiquaries* (Oxford, 1956), p. 120.

10. *Correspondence*, Walpole to Montagu, 16 July 1757, vol. 9, p. 214. He alludes to the assumption that he would use the press for publishing political pamphlets, which Walpole never did.

11. Ibid., Walpole to Zouch, 20 March 1762, vol. 16, p. 52.

12. Ibid., Walpole to Cole, 2 June 1779, vol. 2, p. 206.

13. Ibid., Walpole to Cole, 2 June 1779, vol. 2, p. 206.

14. Ibid., Walpole to Cole, 15 February 1782, vol. 2, pp. 300–301.

15. Walpole, *Anecdotes of Painting*, p. 33.

16. *Archaeologia*, p. 361.

17. *Correspondence*, Walpole to Cole, 20 December 1770, vol. 1, p. 206.

18. Walpole, 'A Reply to the Observations of the Rev. Dr Mills … on the Wardrobe Account' (1774), *Works* (1798) II, 221.

19. The offending article was printed in *Archaeologia*, II, p. 198. Evans, A *History of the Society of Antiquaries*, p. 167.

20. Walpole had his name taken from the books of the Society late in July 1772 (*post* 28 July 1772; 'Short Notes', 1772).

21. Milles's *Observations* is the last article in *Archaeologia*, vol. 1.

22. *Correspondence*, Walpole to Cole, 7 April 1773, vol. 1, p. 206.

23. Walpole was elected to an honorary member of the Society of Antiquaries of Scotland in 1781. *Correspondence*, Walpole to Dalrymple, 10 February 1781, vol. 15, p. 150.

24. *Correspondence*, Walpole to Cole, 8 January 1773, vol. 1, pp. 292–293.

25. Ibid., Walpole to Cole, 28 May 1774, vol. 1, p. 330.

26. These visits, undertaken 1751–84, were transcribed and published as, 'Horace Walpole's Journal of Visits to Country Seats', Toynbee, P. (ed.) *Transactions of the Walpole Society*, Annual 16 (London, 1928).

27. *Correspondence*, Walpole to Bentley, August 1756, vol. 35, p. 271.

28. John Milton, *Paradise Lost*, I, 92.

29. *Correspondence*, Walpole to Lady Ossory 15 August 1782, vol. 33, p. 350.

30. Ibid., Walpole to Mason, 10 July 1775, vol. 28, p. 213.

31. Ibid., Walpole to Zouch 15 March 1759, vol. 16, p. 27.

32. Walpole, *Anecdotes of Painting*, p. 92.

33. Ibid., p. 93.

34. Ibid., p. 93.

35. Ibid., p. 93.

36. Ibid., p. 98.

37. Ibid., p. 94.

38. Ibid., p. 144.

39. Ibid., p. 147.

40. *Correspondence*, Walpole to Strafford, 4 September 1760, vol. 35, p. 304.

41. *Books of Materials* (1761), p. 119.

42. *Correspondence*, Walpole to Montagu, 11 June 1770, vol. 10, p. 306.

43. Ibid., Walpole to Wren, 9 August 1764, vol. 40, pp. 352–53.

44. Ibid., Walpole to Mann, 25 February 1750, vol. 20, p. 127. Sir William Temple was apparently the first to attribute to the Chinese this word for 'studied irregularity'.

45. Pinkerton, J. *Walpoliana* II (London, 1799), 59, LXXIX.

46. Walpole, *Anecdotes of Painting*, pp. 94–96.

47. Ibid., p. 95.

48. *Correspondence*, Walpole to Wren, 9 August 1764, vol. 40, pp. 352–53.

49. Walpole, *Works*, 'Detached Thoughts' vol. IV, p. 368.

50. Walpole, *Books of Materials* (1759), p. 53.

51. General remarks recorded in Horace Walpole's unpublished *Books of Materials* for *Anecdotes of Painting, &c.* Chap VI, 'Architecture and Architects'.

52. Walpole, *Anecdotes of Painting*, pp. 96–97.

53. Ibid., p. 99.

54. Ibid., p. 99.

55. The three paragraphs following were published, with changes and omissions, in Gough's *Sepulchral Monuments of Great Britain* (London, 1786), vol. I, part 1, Preface, pp. 2–3. Cole communicated the extract to Gough when the latter was planning the work in 1781–2. *Correspondence*, Walpole to Gough 21 June 1786, vol. 42, pp. 168–70.

56. William Warham (1450–1532), Archbishop of Canterbury; for a print of his tomb, see John Dart, *History of Antiquities of the Cathedral Church of Canterbury* (London, 1726), p. 167.

57. *Correspondence*, Walpole to Cole, 11 August 1769, vol. 1, pp. 190–192.

58. Walpole, *Anecdotes of Painting*, p. 88.

59. Ibid., p. 100.

60. Ibid., p. 83.

61. Hans Holbein was born in Germany became King's Painter to Henry VIII and was renowned as the greatest sixteenth-century portraitist in England.

62. Ibid., p. 100.

63. Ibid., p. 180.

64. Ibid., p. 186.

65. In a letter to the antiquarian Lort Walpole admits 'I never could think Charles I a good king, because he was a great collector. I cannot reckon him a bad virtuoso, because he sought to great power.' *Correspondence*, Walpole to Lort, 16 March 1762, vol. 16, p. 158.

66. Walpole, *Anecdotes of Painting*, p. 180.

67. Ibid., p. 267.

68. Ibid., p. 270.

69. Ibid., p. 345.

70. Ibid., p. 346.

71. Ibid., p. 347.

72. Ibid., p. 348.

73. Ibid., p. 349.

74. Ibid., p. 385.

75. Ibid., p. 386.

76. Ibid., pp. 394–5.

77. Pope, *Poetical Works*, 'Epistle IV to Burlington', p. 314.

78. Walpole, *Anecdotes of Painting*, p. 396.

79. Ibid., p. 395.

80. Addison, *Works*, 'Remarks on several parts of Italy,' vol. III, pp. 364–65.

81. Walpole, *Anecdotes of Painting*, p. 403.

82. Ibid., p. 404.

83. Ibid., p. 430.

84. Ibid., p. 431.

85. Ibid., p. 432.

86. Ibid., p. 432.

87. Ibid., p. 433.

88. Ibid., p. 434.

89. Ibid., p. 438.

90. Ibid., p. 438.

91. Ibid., p. 483.

92. Campbell, C. *Vitruvius Britannicus* (3 vols, London, 1715–25) also looks at the history of early eighteenth-century gardens and contains garden designs that were influential for the future development of garden theory.

93. 'The first volume was very timely. The Whigs were associated with city merchants and with an aristocratic oligarchy who together were to be responsible for a new era of prosperity'. Architecturally this manifested itself in an increased demand for private house building, which was to be a style that would express the new self-confident nationalism: the 'antique simplicity' of Classical virtù was accepted as an ideal. Campbell's plates provide many examples of domestic architecture and very few public and ecclesiastical designs. His enterprise was soon rewarded by Lord Burlington's endorsement of his approach to architecture. Tavernor, R. *Palladio and Palladianism* (London, 1991) p. 153.

94. Houghton Hall, Norfolk, was begun in 1722 to designs by Colen Campbell but completed under the auspices of Thomas Ripley in 1735. The corner towers of the original design were not executed and the final design included corner domes designed by James Gibbs. William Kent designed the interiors, c.1725–35.

95. He defends Thomas Ripley who was responsible for completing his father Robert Walpole's house at Houghton which resulted in his being the subject of Pope's satire on two separate occasions declaring that these jibes were politically motivated: 'The truth is, politics and partiality concurred to help on these censures. Ripley was employed by the minister, and had not the countenance of lord Burlington, the patron of Pope … yet Ripley, in the mechanic part, and in the disposition of apartments and conveniencies, was unluckily superior to the earl himself [Burlington]. Lord Orford's at Houghton, of which Campbell gave the original design, but was much improved by Ripley, and lord Walpole's at Woolterton, one of the best houses of the size in England, will, as long as they remain, acquit this artist of the charge of ignorance.

96. Burlington established the fashion for Palladianism in the early eighteenth-century by paying for the publication of drawings of Palladio in 1730 and Inigo Jones' works by William Kent in 1727. Inigo Jones was the first architect to introduce the designs of Palladio and Palladianism into England.

97. Walpole, *Anecdotes of Painting*, p. 438.

98. Ibid., p. 486.

99. Ibid., p. 495.

100. *Correspondence*, Walpole to Bentley, September 1753, vol. 35, pp. 148–9.

101. Heeley, J. *Letters on the Beauties of Hagley, Envil and the Leasowes* (London, 1777), 1, 161, pp. 173–74.

102. The full title is Batty Langley, *Gothic architecture improved by rules and proportions, In many grand designs of columns, doors, windows, chimney-pieces, arcades, colonades, porticos, umbrellos, temples and pavillions, & c., with plans, elevations and profiles geometrically explained* (London, 1742).

103. Walpole, *Anecdotes of Painting*, p. 485.

104. *Correspondence,* Walpole to Lady Ossory, 11 August 1771, vol. 32, p. 55.

105. Walpole, *Anecdotes of Painting,* p. 6.

106. Ibid., p. 8. Walpole employed Adam at Strawberry Hill in 1766 to design the round Room but later reversed his opinion of Adam, denigrating his architecture as 'shreds and remnants', 'gingerbread' and 'snippets of embroidery'. He takes a public snipe at him in the advertisement to the fourth volume of the *Anecdotes of Painting*, 4th edn (1786) when he comments that architecture should not degenerate into filligraine, a term he used to criticise Adam's later works. *Works*, p. 398. The publications on Balbec and Palmyra refer to the antiquarian Robert Wood's (1717–1771) *The ruins of Palmyra; otherwise Tedmor in the desart* (London, 1753) and *The ruins of Balbec, otherwise Heliopolis in Coelosyria* (London, 1757).

107. 'Advertisement to the fourth volume of the *Anecdotes of Painting*', *Works*, p. 398.

108. *Correspondence*, Walpole to Mann, 17 April 1775, vol. 24, p. 93.

109. 'Advertisement to the fourth volume of the *Anecdotes of Painting*', *Works*, p. 398.

110. *Correspondence*, Walpole to Berry, 23 July 1790, vol. 12, p. 111.

111. Walpole, *Anecdotes of Painting*, p. 433.

112. Ibid., p. 398.

113. *Correspondence*, Walpole to Montagu, 30 May 1763, vol. 10, p. 79.

114. Rouquet, J.A. *The Present State of the Arts in England* (London, 1755) (Facsimile reprint, London, 1970).

115. Walpole, *Anecdotes of Painting*, p. 486.

116. The model was in fact Vincenzo Scamozzi's (1548–1616) Villa Rocca Pisani (1574), with novel adaptations. It was Burlington's first major architectural design and is the building in which his contribution to Palladianism is given its clearest expression.

117. Ibid., p. 487.

118. Ibid., p. 488.

119. *Correspondence*, Walpole to Mann, 4 March 1753, vol. 20, pp. 361–362.

120. Walpole, *History of the Modern Taste*, p. 488.

121. Ibid., p. 489.

122. Ibid., p. 490. Thomas Gray described Kent's Gothic at Esher thus: 'you do not say enough of Esher. it is my other favourite place. it was a Villa of Cardinal Wolsey's, of wch nothing but a part of the Gateway remain'd. Mr Kent supplied the rest, but I think with you, that he had not read the Gothic

Classics with taste or attention. he introduced a mix'd Style, wch now goes by the name of the *Battey Langley* Manner. he is an Architect, that has publish'd a book of bad Designs.' *Correspondence of Thomas Gray*, vol. 1, letter 191, Gray to Wharton, August 1754.

123. Walpole, *Anecdotes of Painting*, p. 488.

124. Ibid., p. 491.

125. Ibid., p. 491.

126. *Correspondence*, Walpole to Montagu, vol. 10, p. 332, 'The Rev. William Cole's Account of his Tour with Walpole', 1763 from the British Museum Add. MSS 5834 pp. 41–63, Appendix 4.

127. Ibid., Walpole to Montagu, 25 June 1745, vol. 9, p. 15. This house was constructed in 1735, replacing an older house which was demolished. Its appearance was significantly changed by Robert Adam in 1776. This house was demolished in 1835.

128. Ibid., Walpole to Williams, 25 June 1745, vol. 30, p. 87.

129. Ibid., Walpole to Montagu, 5 July 1749, vol. 9, p. 88.

130. Ibid., Walpole to Mann, 12 August 1746, vol. 19, p. 297.

131. Ibid., Walpole to Berry, 9 October 1791, vol. 11, p. 362.

132. Ibid., Walpole to Montagu, 20 May 1736, vol. 9, p. 4.

133. Ibid., Walpole to Bentley, September 1753, vol. 35, p. 147.

134. Ibid., Walpole to Montagu, 19 July 1760, vol. 9, p. 288. Thomas Hearne, antiquary, lived at St Edmund Hall.

135. Walpole, *Anecdotes of Painting*, p. 158.

136. *Correspondence*, Walpole to Bentley, September 1753, vol. 35, p. 155. Walpole means not altered by Gibbs.

137. Ibid., Walpole to Lady Ossory, 27 September 1778, vol. 33, pp. 54–55. The original design for the Radcliffe Observatory was by Henry Keene with work commencing in 1772. Keene died in 1776 and work continued to a new design by Wyatt based on the Tower of the Winds which had been recently published in Stuart and Revett's *Antiquities of Athens* (London, 1762).

138. Ibid., Walpole to Mason, 11 May 1783, vol. 29, p. 301.

139. Ibid., Walpole to Lady Ossory, 9 July 1783, vol. 33, p. 418.

140. MS note in Walpole's copy of *Anecdotes of Painting*, vol. IV (1780).

141. *Correspondence*, Walpole to Conway, 6 October 1785, vol. 39, p. 435.

142. Ibid., Walpole to Montagu, 23 July 1763, vol. 10, p. 92.

143. Ibid., Walpole to Mason, 2 May 1777, vol. 28, p. 40.

144. Ibid., Walpole to Cole, 22 May 1777, vol. 2, p. 46.

145. Walpole, *Description of the Villa*, preface, p. IV. See also Berry, *Works*, vol. 3, pp. 397–8; Lewis, *Genesis of Strawberry Hill* and Mehrotra, K.H. *Horace Walpole and the English Novel* (New York, 1970) pp. 17–18 who discusses how rooms within Strawberry Hill apparently appear in the novel.

146. Translation by Gaelle Jolly. *Correspondence*, Walpole to du Deffand, 27 January 1775, vol. 4, p. 143. Dr Warren Hunting Smith has conclusively identified the college with Trinity, *Times Literary Supplement*, 23 May 1936. Reference in Ketton-Cremer, *Biography*, p. 194.

147. Ibid., Walpole to Montagu, 11 August 1748, vol. 9, p. 71. Esher Place, Surrey was celebrated by the poets Pope and James Thomson (1700–1748). Southcote's refers to Woburn Farm, Chertsey.

148. Cardinal Wolsey was appointed chaplain to Henry VII in 1507, became a Privy Councillor and was made Chancellor and a Cardinal from 1515–29 under Henry VIII. He was associated with Esher Place where he resided as Bishop of Winchester and was placed under house arrest there following his fall from grace allegedly for failing to obtain Henry VIII's divorce from Katherine of Aragon so that he could marry Anne Boleyn. He also owned Hampton Court Palace for a time. Walpole owned Wolsey's hat which he kept in the Holbein Chamber, named after the King's Painter to Henry VIII, Hans Holbein.

149. Ibid., Walpole to Bentley, 5 August 1752, vol. 35, p. 131.

150. Ibid., Walpole to Bentley, 5 August 1752, vol. 35, p. 140.

151. Ibid., Walpole to Bentley, 5 August 1752, vol. 35, p. 139.

152. Ibid., Walpole to Bentley, 5 August 1752, vol. 35, p. 135.

153. Ibid., Walpole to Lady Ossory, 10 June 1777, vol. 32, pp. 352–353.

154. Ibid., Walpole to Conway, 6 October 1785, vol. 39, p. 435.

155. *Horace Walpole's Journal of Visits to Country Seats*, Toynbee, p. 51.

156. The frieze and the star on the ceiling above the altar surrounding the Agnus Dei are thought to have been designed by Sanderson Miller.

157. *Correspondence*, Walpole to Chute, 4 August 1753, vol. 35, pp. 73–4. The Gothic seat and tower were designed by Sanderson Miller.

158. He broke with Sir Robert Walpole in 1733 and retired to Stowe to build and plant his political satire.

159. Lord Cobham's Pillar was also thought to have been designed by Gibbs see Benton Seeley, *Stowe. A Description of the House and Gardens of the Most Noble & Puissant Prince, George-Grenville-Nugent-Temple Marquis of Buckingham* (London, 1797), p. 9. It was erected under the supervision of Lancelot 'Capability' Brown 1747–49, who also altered the design of the base.

160. *Correspondence*, Walpole to Chute, 4 August 1753, vol. 35, pp. 75–7. Matthew Wise of the Priory, Warwick, eldest son of Henry Wise the gardener.

161. Ibid., Walpole to Bentley, September 1753, vol. 35, p. 150.

162. Ibid., Walpole to Bentley, 18 September 1755, vol. 35, p. 250.

163. Gray, T, *Odes* with Designs by Mr R. Bentley for six poems by Mr T. Gray (Twickenham, 1753).

164. *Correspondence,* Walpole to Bentley, September 1753, vol. 35, p. 152.

165. Ibid., Walpole to Bentley, September 1753, vol. 35, p. 154.

166. Kent's screen at Gloucester Cathedral was erected in 1741 and removed in 1820.

167. Ibid., Walpole to Bentley, September 1753, vol. 35, p. 154.

168. Ibid., Walpole to Bentley, September 1753, vol. 35, p. 155.

169. Ibid., Walpole to Mann, 6 October 1753, vol. 20, p. 396. The medieval town of Ratisbon (Regensburg) Germany, was inscribed as a World Heritage site in 2006. The Treaty of Ratisbon was signed in 1684 to end fighting between France and Spain and to bringing an end to piracy around the Island of Tortuga. 'This medieval town contains many buildings of exceptional quality that testify to its history as a trading centre and to its influence on the region from the 9th century. A notable number of historic structures span some two millennia and include ancient Roman, Romanesque and Gothic buildings. Regensburg's 11th – to – 13th – century architecture – including the market, city hall and cathedral – still defines the character of the town marked by tall buildings, dark and narrow lanes, and strong fortifications'. http://whc.unesco.org/en/list/1155. Accessed 28 May 2011.

170. William Hallett (c.1707–1781) was a fashionable cabinet maker.

171. *Correspondence*, Walpole to Bentley, 5 July 1754, vol. 35, p. 233.

172. Ibid., Walpole to Montagu, 11 August 1748, vol. 9, p. 71. Painshill was an early example of large-scale landscape garden. In the *History of the Modern Taste* Walpole cites it as an example of a forest or savage garden. 'I mean that kind of alpine scene, composed almost wholly of pines and firs, a few birch, and such trees to assimilate with a savage mountainous country. Mr. Charles Hamilton, at Pains-hill, in my opinion has given a perfect example of this in the utmost boundary of his garden. All is great and foreign and rude; the walk seems not designed, but cut through the wood of pines; and the style of the whole is so grand, and conducted with so serious an air of wild and uncultivated extent, that when you look down on this seeming forest, you are amazed to find it contain a very few acres.' Walpole, *History of the Modern Taste*, pp. 52–3.

173. *Horace Walpole's Journal of Visits to Country Seats*, Toynbee, p. 37.

174. *Correspondence*, Walpole to Strafford, 4 September 1760, vol. 35, p. 305.

175. Ibid., Walpole to Montagu, 1 September 1760, vol. 9, p. 299.

176. Walpole, *Anecdotes of Painting*, p. 433.

177. Ibid., p. 434.

178. Walpole wrote: 'I know all that can be told about the periods I delight in … I can scarce read Grammont and Madame de Sévigné because I know them by heart'. Philibert, comte de Gramont (1621–1707) was the subject of the entertaining memoires which portray life at the Court of Charles II, a subject that fascinated Walpole. He owned the *Mémoires de Grammont* and had it in mind to publish a new edition at the Strawberry Hill Press.

179. *Correspondence*, Walpole to Lady Ossory, 11 August 1778, vol. 33, pp. 42–43. Walpole recalls Pope's long association with Bevis Mount where he was a frequent visitor and had a 'Pope's walk' named after him.

'I am going to build a little Gothic castle at Strawberry Hill': Creation of a Seat – Part 1

This chapter explores the design concepts for Strawberry Hill and establishes that they are not primarily based around architectural precedent but rather around eighteenth-century theories of the imagination, matters of 'Taste' and antiquarianism. It ascertains how Walpole indulged his patriotic preoccupation with the past to create a Gothic building and compatible landscape context as an innovative means of stimulating his imagination by expressing historical interpretation through material objects. The cultural importance of the villa concept is discussed in relation to his experimental retreat at Twickenham where he developed and tested these ideas. The reader is then led through a descriptive virtual tour of the building assisted by contemporary illustrations, largely commissioned by Walpole. There is a reassessment of the villa and in the next chapter, its landscape, revealing that the ensemble is not so much a part of the conventionally-conceived linear progression of eighteenth-century architectural style but, rather, an original essay in contemporary notions of imagination, association and concepts of visual pleasure.

Strawberry Hill is an architectural conceit, an asymmetrically-planned picturesque building drawing on antiquarian printed design sources.[1] It is also the earliest house entirely conceived in the Neo-Gothic style and deliberately constructed to convey a multi-period character, presented as if it is based on monastic foundations. Moreover, it is the first purpose-built antiquarian 'museum' interior, a sequence of theatrical spaces that played with scale, colour and atmosphere, specifically designed to generate surprise and wonder in order to stimulate the imagination. A series of theatrical effects and different moods are created as background to Walpole's collection of cultural and historical artefacts, artfully displayed to produce their own narrative.

In a self-deprecating introduction to *A Description of the villa of Mr Horace Walpole … at Strawberry Hill* (1784), the earliest fully-illustrated account of any British house, he explains his reasons for publishing an account of the villa and his collection:

3.1 [Title-page] *A Description of the Villa of Mr. Horace Walpole at Strawberry Hill*, printed by Thomas Kirgate, 1784

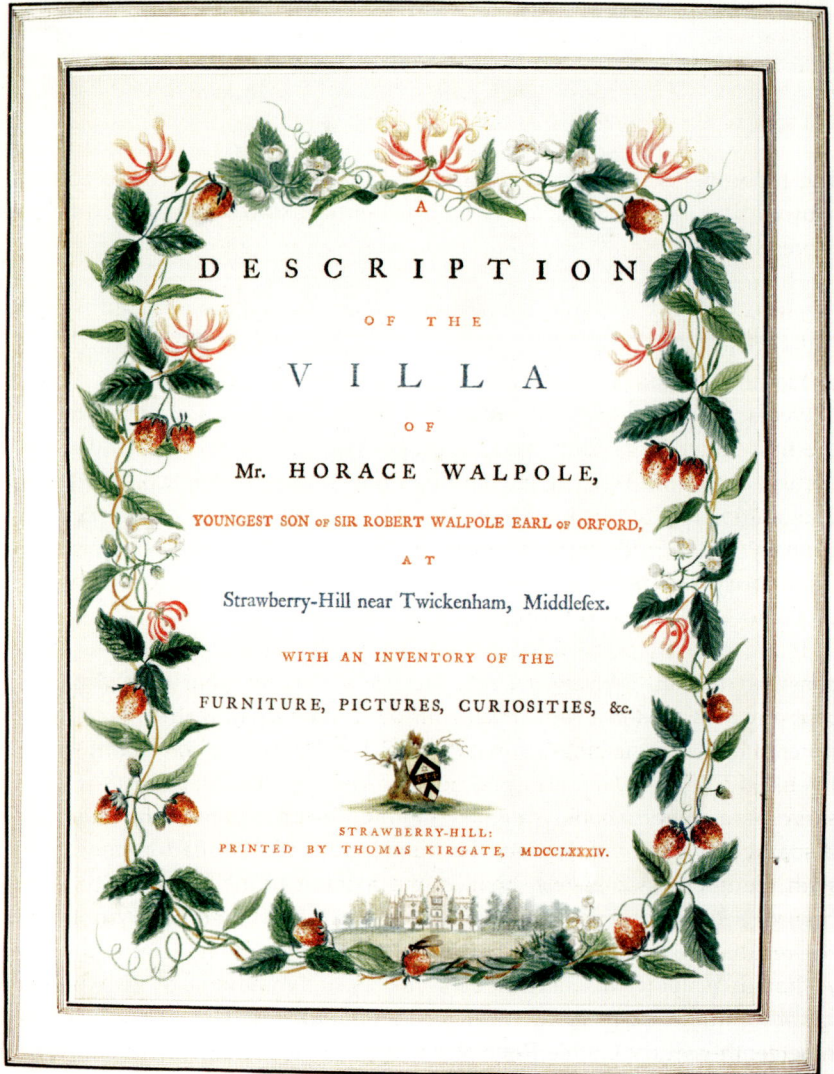

It will look, I fear, a little like arrogance in a private Man to give a printed Description of his Villa and Collection, in which everything is diminutive. It is not, however, intended for public sale, and originally was meant only to assist those who visited the place. A farther view succeeded; that of exhibiting specimens of Gothic architecture, as collected from standards in cathedrals and chapel-tombs, and shewing how they may be applied to chimney-pieces, ceilings, windows, balustrades, loggias, &c. The general disuse of Gothic architecture, and the decay and alterations so frequently made in churches, gives prints a chance of being the sole preservatives of that style.[2]

When he discusses Canterbury Cathedral, Walpole gives an example of his practice of using 'specimens of Gothic architecture, as collected from standards in cathedrals and chapel-tombs':

Canterbury I know by heart. It was the chief fund of my chimney pieces, and other morsels. The tomb of the Black Prince I [1330–1376] have no doubt being of the time; his father's and mother's figures in the Abbey are also bronze, and well executed, and the first posterior to his son's, as also that of Richard II [1367–1400] and of Henry IV [1366–1413] that you saw at Canterbury.[3]

The monuments he referred to functioned not merely as decorative design sources; they simultaneously recall illustrious historical people and events and represent a significant example of exquisite Gothic. For example, Archbishop Warham's (1450–1532) tomb, discussed later, provided the model for the chimney-piece in the Holbein Chamber and also embodied what Walpole believed to be 'the last example of unbastardized Gothic.' It also brought to his imagination the historical character and the significant role Warham played as the last Catholic Archbishop of Canterbury and his part in arranging the first marriage of Catherine of Aragon (1485–1536) into the Tudor royal family. Each time Walpole encountered the chimney-piece it recalled to his imagination a multiplicity of thoughts that coincide with Addison's notion of primary and secondary pleasure, the immediate and the associative: visits to Canterbury and the people he went with, the historic person commemorated by the tomb and their contribution to English history.

It is apparent that Walpole feels compelled to justify his decision to construct a villa *'affecting not only obsolete architecture, but pretending to an observance of the costume even in the furniture'*, but which nevertheless contained much modern furnishings, portraiture and artefacts. Walpole states that his intention was to record his collection for visitors, but in addition, it would serve as a pattern book for good Gothic design. Unlike Batty Langley's disparaged earlier publication, this catalogue could be read in conjunction with the house as a pattern book in the manner of the earlier texts, except here we see not the engraving on the page and instructions on how to achieve the results; the designs display correct Gothic taste and are executed in-situ. Although Walpole was meticulous in his research methods, this is where the quest for authenticity and accurate representation that was to preoccupy the nineteenth-century Gothic Revivalists ended as the designs Walpole copied from a Gothic tomb would be applied equally well to a bookcase or a chimney-piece. His concern was to make associations between the architecture and the imagination, not to reproduce exact imitations. Walpole was nothing if not eclectic and whilst in the latter stages of development he tried to achieve a degree of archaeological correctness, the early attempts could be just as fanciful, whimsical and non-archaeological in their interpretation of Gothic as Batty Langley or William Kent. Fearing however, that Strawberry Hill might appear somewhat heterogeneous and idiosyncratic he rationalises the disparity of mixing the ancient with the modern, writing:

In truth, I did not mean to make my house so Gothic as to exclude convenience, and modern refinements in luxury. The designs of the inside and outside are strictly ancient, but the decorations are modern.[4] Would our ancestors, before the reformation of architecture, not have deposited in their gloomy castles

antique statues and fine pictures, beautiful vases and ornamental china, if they had possessed them? ... But I do not mean to defend by argument a small capricious house.[5]

The notion of realising a personal, associative context for Strawberry Hill is acknowledged in his defensive statement that: *'It was built to please my own taste and in some degree to realize my own visions.'*[6]

The site consisted of a small house, approximately five acres of 'divers lands and tenements in Twickenham' and various other parcels of land nearby. Walpole chose the location because of its proximity to Pope's villa, another 'autobiographical site', which was inextricably linked to the poet and the river Thames as it flowed beside Twickenham. We know that he associated the Thames with British history and culture, Parliament, Windsor Castle and Eton College. This, combined with the 'Arcadian' setting of the many other important villas situated along the Thames, was undoubtedly an added attraction.

Before reconstructing the Gothic villa and landscape in more detail it is necessary to appreciate the cultural significance of the emerging sub-urban villa as a building type. Far from being a seat of ostentatious dynastic display, the idea of the villa was essentially that of a pleasurable retreat from the city and from public life to a place of retirement and relaxation for the owner and his circle. Just as Addison had retreated to Bilton, at Twickenham, Walpole, like Pope before him, was at leisure to indulge his theories on associative Gothic and garden design at his own semi-rural retreat occupied for part of the year on the banks of the Thames.

He deliberately selected the Gothic style for his villa with the intention of using it as an architecture of association which stimulated his imagination and would simultaneously evoke correlations between himself and an historicised past through associative means. However, there were also other considerations for the choice of style and his decision to use architectural quotations, mainly from ancient tombs and ecclesiastical buildings. Walpole deliberately set out to create the impression that Strawberry Hill was built on surviving monastic foundations following the Dissolution of the Monasteries and later integrated into an ancestral home, incorporating aggrandised additions from later periods. This accords precisely with Addison's precepts of monastic ruins having the ability to induce a powerful emotional response through their association with historical events, the mind of the spectator being stimulated to complete the narrative suggested by their ruinous state. In an early letter written during the conversion of the villa, Walpole explains to a disbelieving Horace Mann his decision to build in Gothic style, having posed the question, 'Why will you make it Gothic?'[7] Walpole responded that his choice was in some respects determined by its capacity for 'charming irregularities' and ability to facilitate asymmetry, both of which were essential elements of Addison's theory.[8] But, for him, the monastery and the castle were also evocative historical building types and he continually oscillates between fortified and monastic vocabulary to describe Strawberry Hill.

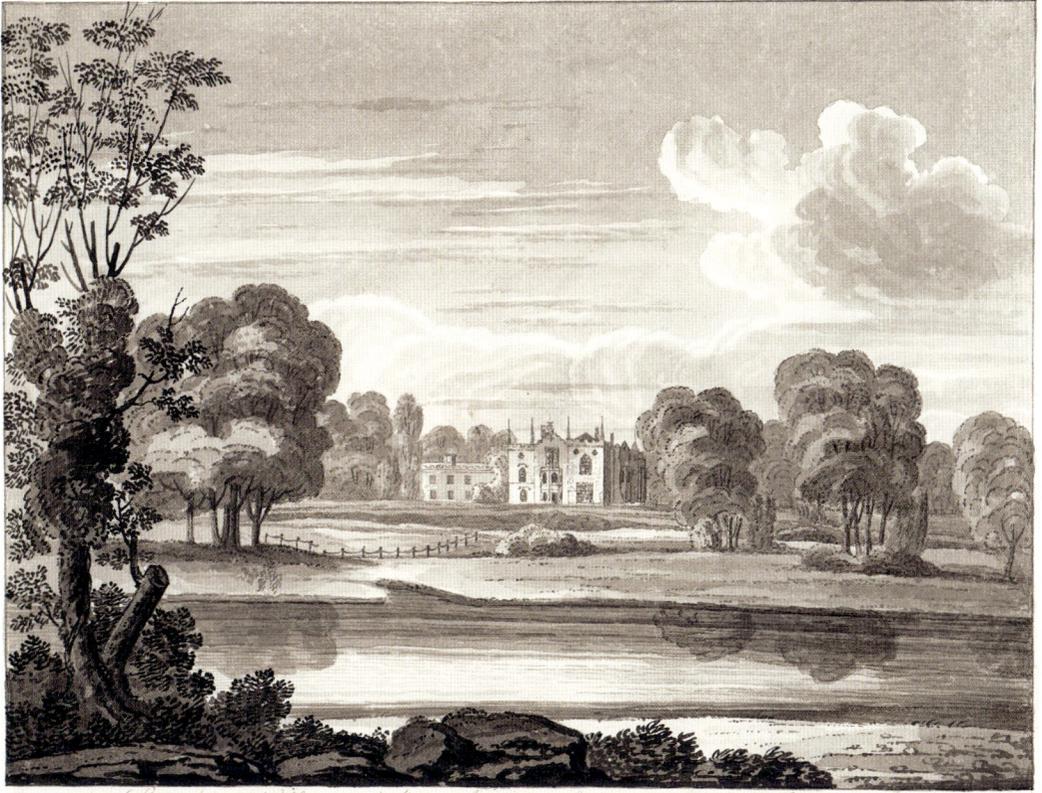

Strawberry Hill general View taken from the opposite side of the Thames.

We have seen how he imaginatively, emotionally and intellectually engaged with monastic ruins and he also relates to his friend George Montagu that his direct ancestors had lived in a Welsh Castle. 'I should have liked to visit the castles and groves of your old Welsh ancestors with you; by the draughts I have seen, I have always imagined that Wales preserved the greatest remains of ancient days, and have often wished to visit Picton Castle; the seat of my Philipps progenitors.'[9]

3.2 Strawberry Hill general view taken from the opposite side of the Thames, attributed to J.C. Barrow

The dual nature of the Gothicising process – monastery and castle – is expressed in just such language in a communication with Montagu:

We emerge very fast out of shavings, and hammerings and pastings: the painted glass is full-blown in every window, and the gorgeous Saints that were brought out for one day on the festival of Saint George Montagu, are fixed forever in the tabernacles they are to inhabit. The castle is not only in the beauty, the garden is at the height of all its sweets, and today we had a glimpse of the sun as he passed by …[10]

Walpole flouted current taste to create a diminutive Gothic house designed to appear as though the accretions had been added at different periods – a most innovative concept at the time. Authenticity was not his concern; his

purpose was to recreate the 'effect' of the past, the perception that it was an ancient structure. Walpole makes clear his intention of creating a fictive history for the site in a letter to Montagu, written during the early stages of construction, relating his vision for creating the impression of an ancestral building that would invoke 'pleasing reflections':

> You will think me very fickle, and that I have but slight regard to the castle (I am building) of my ancestors, when you hear that I have been these last eight days in London amid dust and stinks, instead of syringa, roses, battlements, and niches; but you perhaps recollect that I have another Gothic passion, which is for squabbles in the Wittenagemot.[11]

While doubtless the 'Gothic Pilgrimages' that Walpole undertook had a profound effect in providing ideas and inspiration for the architectural and ornamental detail deployed at Strawberry Hill, his researches into printed antiquarian design sources, combined with first-hand experience, were seminal. All these worked together to reinforce the design concept that underpinned the villa. From 1749 it was constructed using archaeologically correct decorative components selected from antiquarian prints or copied from the original and modified to reduced proportions. All architectural features were carefully chosen as examples of 'beautiful' Gothic, many derived from tombs, though crucially recalling significant people, memorable places and momentous events in English history, all striking examples of Addison's assertion that

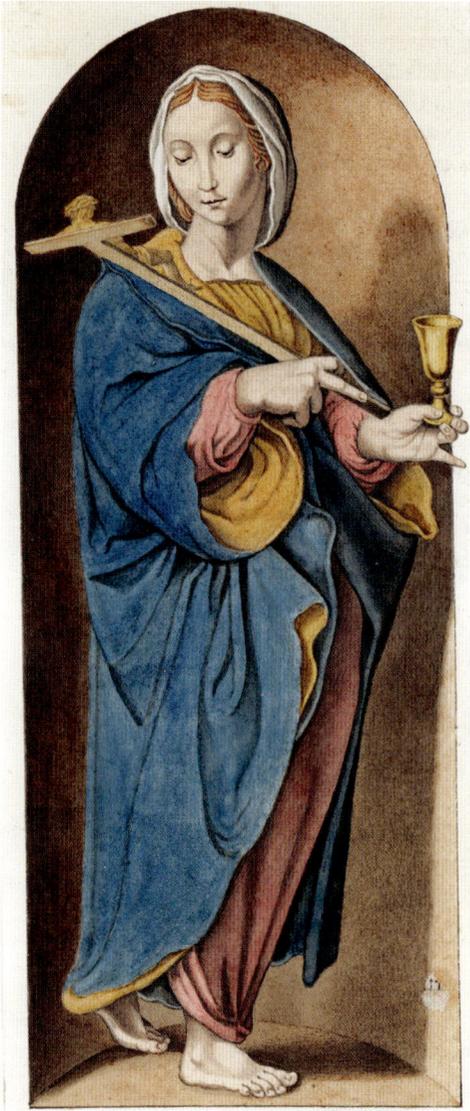

3.3 Painted glass in the Library: Faith

'history pleases the imagination'. The effect he strived to attain was created by incorporating quintessential Gothic elements that were readily associated with castles and ecclesiastical or monastic buildings, such as crenellations, pinnacles, trefoils, pointed arches and stained and painted glass which immediately signified historical associations. For Walpole, coloured glass was iconographic and an important visual signifier of ancient Gothic and he made great endeavours to secure fragments for his villa.

The use of coloured glass created an air of solemnity, 'gloomth' and ambiguity generated through diffused glowing light which cast a tinted glow throughout the internal spaces creating an ambience and atmosphere that

was essential to the character and interpretation of Strawberry Hill. Addison similarly describes how poets trigger sensory and emotional responses using epithets from colours as a stimulus to produce an effect in the mind.

Walpole credits Lord Cobham's sourcing of painted glass for the Gothic Temple at Stowe as a precedent for incorporating stained glass from ancient buildings into a new structure to create the impression that it was very old. In *Anecdotes of Painting* Walpole had pointed out the model he was following and how he sourced from abroad the vast quantities required for Strawberry Hill:

… A few lovers of the art collected some dispersed panes from ancient buildings, particularly the late lord Cobham, who erected a gothic temple at Stowe, and filled it with arms of old nobility, &c. About the year 1753, one Asciotti an Italian, who had married a Flemish woman, brought a parcel of painted glass from Flanders, and sold it for a few guineas to the honourable Mr. Bateman [1705–1773] of Old Windsor. Upon that I sent Asciotti again to Flanders, who brought me 450 pieces, for which, including the expence of his journey, I paid him thirty-six guineas.[12]

On obtaining the 'immense cargo of painted glass from Flanders', Walpole confirms that 'my castle will I believe begin to rear its battlements next spring', and that the insertion of stained glass would be used to convey his fictive ancestral history … 'I call them the achievements of the old Counts of Strawberry.'[13]

However, it is entirely probable that Walpole got the idea for buying and inserting heraldic glass depicting coats of arms and historical figures from an earlier visit to Hall Place, Bexley during his 'Gothic Pilgrimage'. This is the first mention, in the correspondence, of this peripatetic practice of translating fragments into a different building. It also coincides with Walpole's transformation of Strawberry Hill:

There are some Scotch arms taken from the rebels in the '15, and many old coats of arms on glass, brought from Newhall, which now belongs to Olmius:[14] Mr Conyers bought a window there for only a hundred pound, on which was painted Harry the Eighth and one of his Queens at full length: he has put it up at Copt Hall.[15]

The acquisition of stained glass, preferably depicting heraldic motifs was a primary consideration in the Gothicising process and Walpole frequently entreats friends to obtain fragments wherever possible.

This is evidenced in a letter to Mann, written at the outset of the project, which also explicitly confirms Walpole's' intention to redesign the villa in the Gothic style:

PS. My dear Sir, I must trouble you with a commission, which I don't know whether you can execute. I am going to build a little Gothic castle at Strawberry Hill. If you can pick me up any fragments of old painted glass, arms or anything, I shall be excessively obliged to you. I can't say I remember any such thing in Italy, but out of old chateaus I imagine one might get it cheap, if there is any.[16]

3.4 Walpole
family arms

His conscription of friends to assist in the Gothicising process was evidently successful as he relates to Mann his intention to distribute the glass he has acquired throughout the villa. 'I have amassed such quantities of painted glass, that every window in my castle will be illuminated with it: the adjusting and disposing it is a vast amusement.'[17] He had told Mann of his intention to insert glass liberally throughout the building: 'I must tell you by the way, that the castle, when finished, will have two and thirty windows enriched with painted glass.'[18] However, there was not an unlimited supply and when the availability of glass from demolishing or ruined buildings diminished; Walpole resorted to commissioning glass from contemporary makers in the ancient manner. 'I am enraged and almost in despair, at Pearson the glass-painter, he is so idle and dissolute – he has done very little of the window, though what he has done is glorious, and approaches very nearly to Price.'[19] He also reported to Montagu how he collected fragments of glass and other ancient objects on his excursions for incorporating into the fabric of Strawberry Hill. 'I have picked up a little painted glass too, and have got a promise of

3.5 Chimney piece in the Refectory

some old statues, lately dug up, which formerly adorned the cathedral of Lichfield – you see, I continue to labour in my vocation'.[20]

The sourcing of Gothic fragments continued throughout the duration of the project. Gray recounts how he too is tasked with informing Walpole of suitable opportunities for acquiring historic artefacts from demolishing buildings:

Mr GRAY (upon the information of Mr Palgrave) lets Mr Walpole know, that there is at *Luton* a chapel built in Henry VII's time, by a Lord Hoo and Hastings, and lined throughout with most beautiful Gothic woodwork; this is going to be demolished, and he imagines, Mr Walpole may have its inside for a song.[21]

The early works to the original house were carried out to the design and direction of William Robinson of the Board of Works. However, in retrospect, Walpole apparently did not consider Robinson's alterations, which were in the manner of Kent's Gothic at Esher, to be sufficiently correct. Thereafter Robinson was relegated to a supervisory role and became indispensable as

3.6 'Elevation of the Columbarium at Strawberry Hill' [not executed], Richd. Bentley, 1750–60

Clerk of Works until 1773 for the alterations and building works designed by others. Walpole then formed a 'committee' made up of close friends to consult and advise on the transformation of the small house into a Gothic castle.

The 'Strawberry Committee' of amateur designers consisted of Walpole, John Chute an accomplished amateur architect, antiquarian and connoisseur who played a pivotal role as his 'oracle in taste'. Richard Bentley, a skilled artist and draughtsman, remained an essential member until he fell out with Walpole in 1761, designing the Gothic chimney pieces for the Yellow Bedchamber, Blue Bedchamber and for the Great Parlour or Refectory (1754).

But, for a time, Bentley's finished designs epitomised the exemplary Gothic he was striving to achieve, 'grace', irregularity, 'lightness and solemnity', epithets Addison had used when describing the attributes necessary for imaginative engagement and to stimulate pleasure. Commenting on his own sketch for a monument, which Bentley then worked-up, Walpole lauds praise on Bentley for capturing the essence of Gothic design. He commends him for surpassing the achievements of Kent and other predecessors who had previously attempted to produce Gothic:

The thought was my own, adopted from the antique columbaria, and applied to Gothic. The execution of the design was Mr Bentley's who alone of all mankind could unite the grace of Grecian architecture and the irregular lightness and solemnity of Gothic. Kent and many of our builders sought this, but have never found it. Mr Chute, who has as much taste as Mr Bentley, thinks this little sketch, a perfect model. The *soffite* is more beautiful than anything of either style separate … On the whole I think there is simplicity and decency, with a degree of ornament that destroys neither.[22]

The poet Thomas Gray was a member of the committee too, as was the politician and amateur architect Thomas Pitt (1737–93), 1st Baron Camelford, for a short time, until Walpole fell out with him over a political matter. Walpole notifies Mann of Pitt's involvement. 'Mr T. Pitt has taken a small house at Twickenham within a stone's throw of me. This will add to the comfort of my

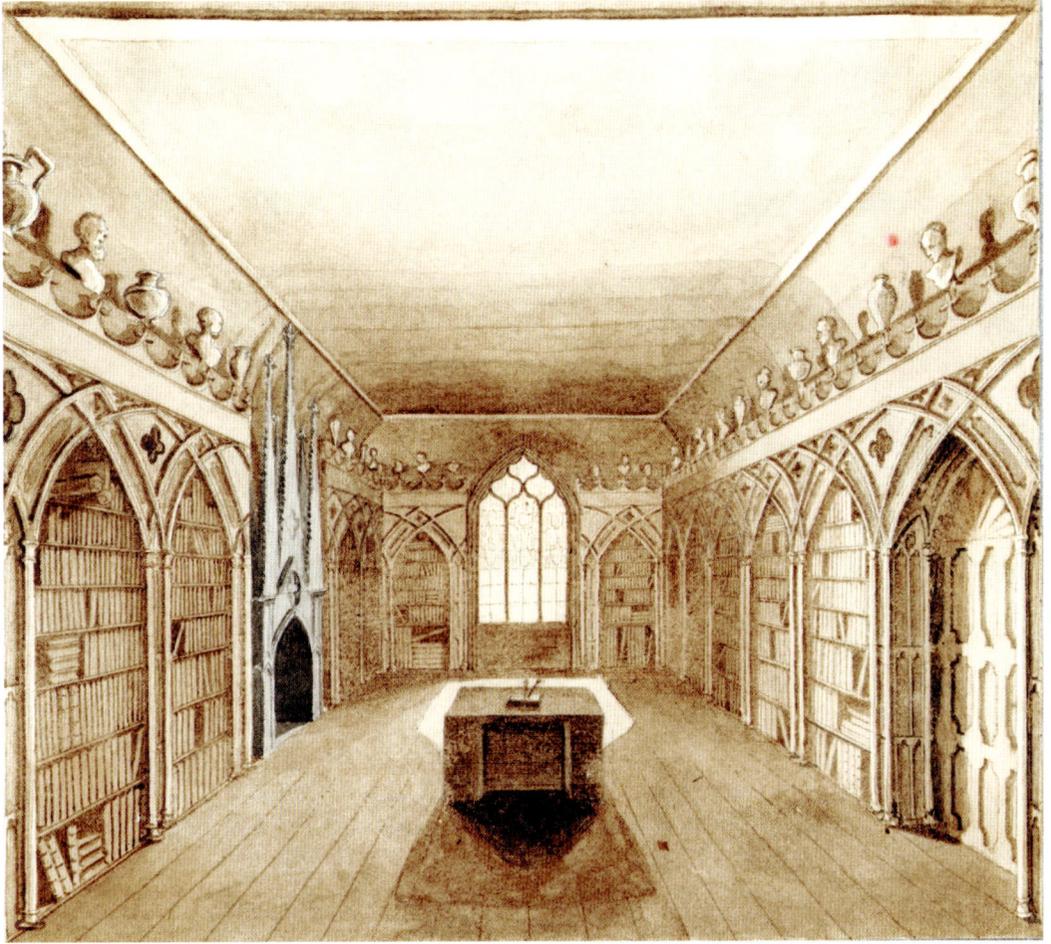

3.7 [Rejected] 'Design for the Library at Strawberry Hill by Mr Bentley', 1750–60

Strawberry-tide. He draws Gothic with taste, and is already engaged on the ornaments of my Cabinet [grated door] and Gallery [chimneypiece].'[23] The following letter highlights that there was some competition between various members of the committee to have their design adopted. In this case Walpole advises Bentley that his design for the library was to be rejected and Chute's executed.

It also reveals that the development of the design was not a precise science but an imaginative and often collaborative process which was continually reworked until the desired results were achieved:

For the library, it cannot have the Strawberry Imprimatur: the double arches and double pinnacles are most ungraceful; and the doors below the book-cases in Mr Chute's design had a conventual look, which yours totally wants. For this time we shall put your genius in commission, and, like some other regents, execute our own plan without minding our sovereign. For the chimney, I do not wonder you missed our instructions: we could not contrive to understand them ourselves; and therefore, determining nothing but to have the old picture stuck

in a thicket of pinnacles, we left it to you to find out the how. I believe it will be a little difficult; but as I suppose *facera quia impossibile est*, is full as easy as *credere*, why – you must do it.[24]

Walpole wrote to Bentley again in March to confirm that work would commence on executing the library, and predicated the source for elements of the design, which would give immediate visual pleasure and simultaneously recall the original through association:

We have determined upon the plan for the library, which we find will fall in exactly with the proportions of the room, with no variations from the little door-case of St Paul's, but widening the larger arches. I believe I shall beg your assistance again about the chimney-piece and the ceiling: but I can decide nothing till I have been at Strawberry.[25]

However, it was Chute's artistic ability and skill as an architect that were to have a significant impact on Walpole's building endeavours. As the collection of drawings in his hand demonstrates he was principally responsible for the south and east exterior elevations (excluding the central section with the bay which is part of the 1748 phase designed by Robinson) and much interior detail, including the Refectory, Library, Holbein Chamber, Round Tower and Gallery were to his designs.

Walpole exercised overall control of the committee and performed the role of antiquarian, searching for architectural and imaginative precedents and sketching-out ideas, although in reality there was no strict division of labour and he was inevitably the final arbiter in matters of taste. On Chute's death in 1776 Walpole lamented that Chute was 'my oracle in taste, the standard

3.8 'One side of the Library at Strawberry Hill', J. Chute, 1753

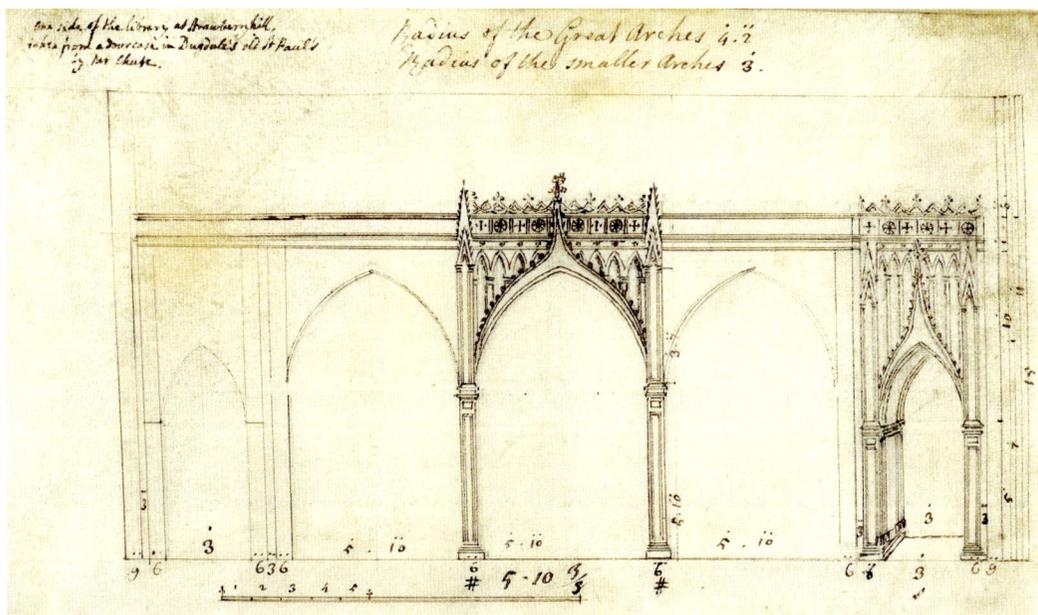

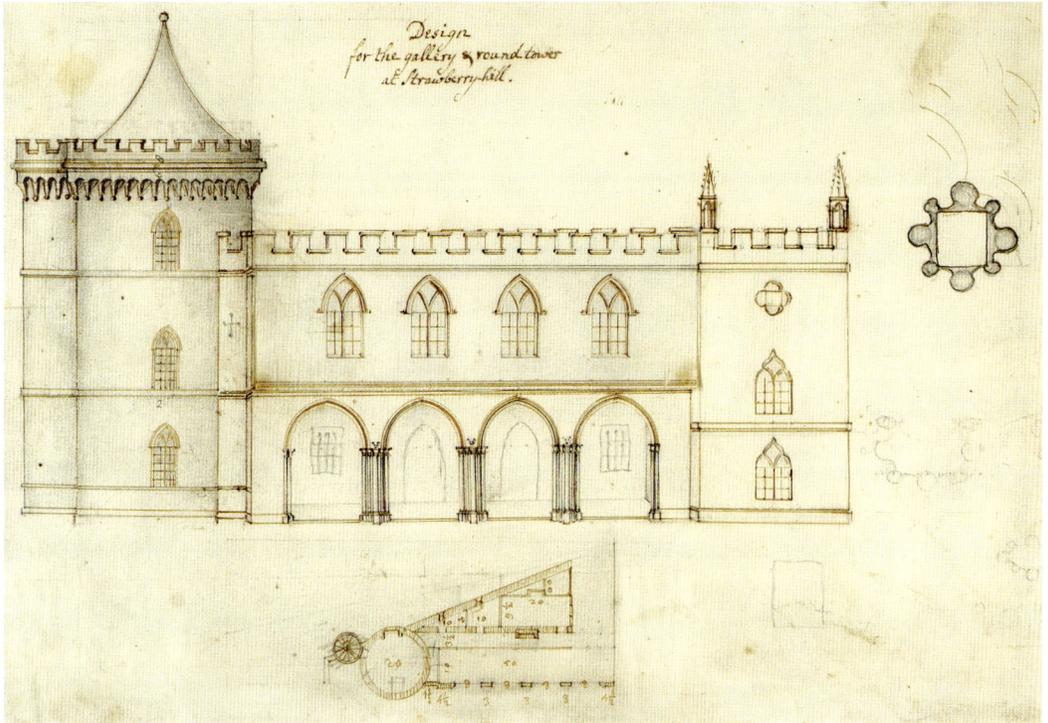

3.9 'Design for the Gallery and Round Tower at Strawberry Hill', J. Chute, 1753

to whom I submitted my trifles and the genius who presided over poor Strawberry', and this is not an exaggeration of Chute's contribution to the designs at Strawberry Hill.[26]

Walpole had written of Robert Adam in *Anecdotes of Painting* that 'the taste and skill of Mr Adam is formed for public works' and he was the first professional architect to be commissioned for designs for the Round Drawing Room in the Round Tower in 1766. Walpole was apparently pleased with the outcome, later commissioning him for designs for the cottage in the garden (not executed).

From 1773, however, his opinion of Adam changes to one of hostility and thereafter he continually snipes at his designs as 'snippets of embroidery' and 'shreds and remnants and *clinquant*.'[27] However, even eminent architects like Adam were carrying out Walpole's vision, not producing their own design interpretations. For instance Adam was not given a free hand to design, Walpole dictated the sources he was to use, sending him his own copies of Sir William Dugdale's *History of St Paul's Cathedral in London* (1658), with plates by Wenceslas Hollar (1607–77) and John Dart's *Westmonasterium* (1742), from which to take the basic designs from the tomb in Westminster Abbey and the Rose Window at the east end of St Paul's. He also commissioned James Essex for the Beauclerc Tower (1776), the Gothic Gate (1778), the New Offices (1776) and the Gothic Bridge (1778). The antiquarian Cole had introduced his mutual friends when the Cambridge architect James Essex was keen to obtain

Walpole's advice on a treatise he was projecting on Gothic architecture. Essex was elected a fellow of the Society of Antiquaries in 1772 and published papers on medieval architecture in *Archaeologica* but the proposed *History of Gothic Architecture in England*, for which he solicited suggestions from Walpole, remains to this day unpublished.[28] Walpole had 'a plan' for the Offices which Essex duly drew up but following his death in 1784 the Offices and the Gothic bridge were later executed by James Wyatt in the 1790s.

Walpole became acquainted with Wyatt through his antiquarian research to ask if he was 'descended from Sir Thomas Wyat [1503–1542] who lived in the time of Henry Vll', taking the opportunity to inform him 'how extremely I admire your taste.'[29] We have seen how Walpole had enthusiastically praised Wyatt in *Anecdotes of Painting* and he continually compared and contrasted his architecture favourably to that of the Adam brothers. Walpole particularly admired Wyatt's designs for Lee Priory which was inspired by Strawberry Hill, including a 'Strawberry room' modelled on Walpole's Holbein Chamber. He commented:

I have seen over and over again Mr Barret's plans, and approve them exceedingly. The Gothic parts are classic; you must consider the whole as Gothic modernized in parts, not as what it is – the reverse. Mr Wyatt, if more employed in that style, will show as much taste and imagination, as he does in Grecian.[30]

According to Neale, Walpole sent the following description of Lee Priory to Edward Hasted (1732–1812) the historian of Kent, which makes it apparent that the concept is based on Strawberry Hill.[31]

The three fronts of the house convey an idea of a small convent, never attempted to be demolished, but partly modernized, and adapted to the habitation of a gentleman's family. The scene around presents correspondent images; gently rising ground, ancient spreading trees, and the adjoining rivulet, seem to form a site selected by monks, much at their ease, with a view rather to cheerful retirement than to austere meditation; while at the same time no distant prospects tantalized them with views of opulence and busy society.[32]

Walpole was undoubtedly proud and flattered that Wyatt directly based his model on Strawberry Hill, reflecting and 'improving' on the original which Walpole admitted was but 'a sketch by beginners' as the committee, unlike Wyatt had not '*studied* the science.' This, his professionalism and the 'taste and imagination' he possessed, most certainly led to Walpole's later commissioning him to execute the offices and bridge at Strawberry Hill.

As well as establishing a printing press, Walpole also kept a resident artist, Johann Heinrich Müntz (1727–98) who recorded the villa in illustrations and was temporarily part of the committee from 1755–59, during the tenure of his occupancy at Strawberry Hill.

With the aid of the committee, the villa developed and expanded over time into a Gothic castle. In the *Description of the Villa,* Walpole records its ambiguous, accretive nature. 'The castle now existing was not entirely built from the ground, but formed at different times, by alterations of and additions

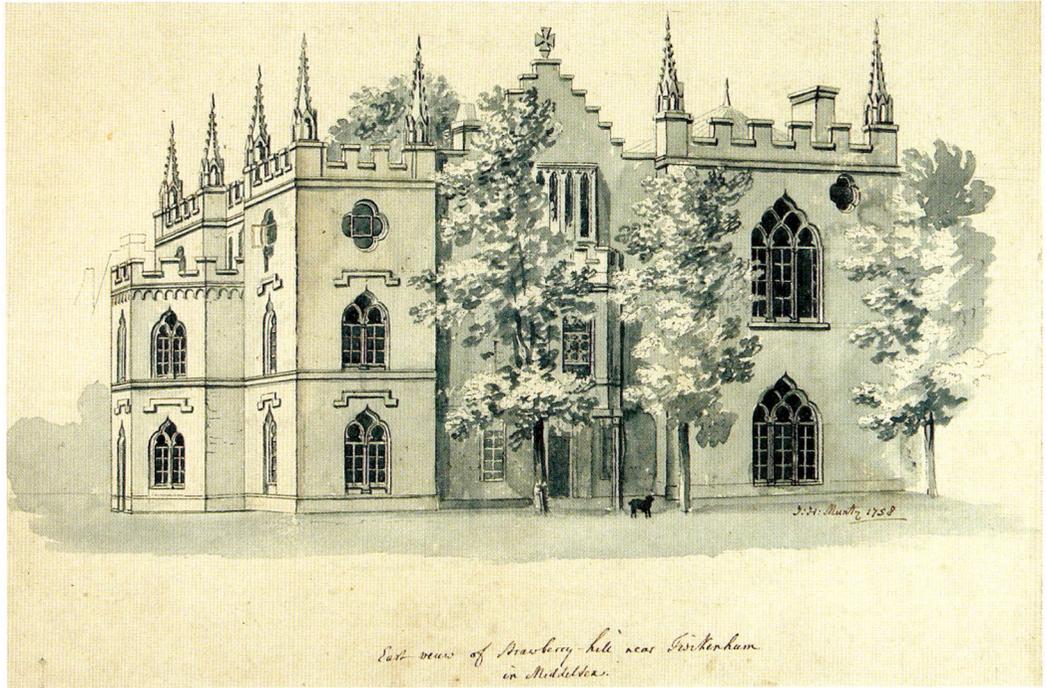

3.10 East view of Strawberry Hill near Twickenham in Middlesex, J.H. Müntz, 1758

to the old small house.'[33] Walpole reported its provenance to Conway, relating its proximity to Pope and connecting it with previous illustrious tenants that had resided there prior to his acquisition. It is apparent from his description of the property as 'a little play-thing' and a 'bauble' that he visualised it from its inception as a place of pleasure and entertainment:

You perceive by my date that I am got into a new camp, and have left my tub at Windsor. It is a little play-thing-house that I got out of Mrs Chenevix's shop, and is the prettiest bauble you ever saw … Two delightful roads, that you call dusty, supply me continually with coaches and chaises: barges as solemn as barons of the Exchequer move under my window; Richmond Hill and Ham Walks bound my prospect … Lord John Sackville [1713–1765] *predecessed* me here, and instituted certain games *cricketalia,* which have been celebrated this very evening in honour of him in a neighbouring meadow.[34]

It is already established how the connection of buildings with significant historical persons feeds Walpole's imagination and the prestige of previous residents of the site is of interest to him. In the case of the lodging house he was to convert into the Gothic castle, preceding occupants of note included the Poet Laureate Colly Cibber (1671–1757) who 'wrote one of his plays here, the *Refusal or the Lady's Philosophy*' followed by other eminent residents, 'Talbot, Bishop of Durham [1658–1730]… then Henry Bridges marquis of Carnarvon [1708–1771] son of James duke of Chandos [1673–1744] and since duke himself …'[35] He later incorporated some of their supposed arms into a chimneypiece.

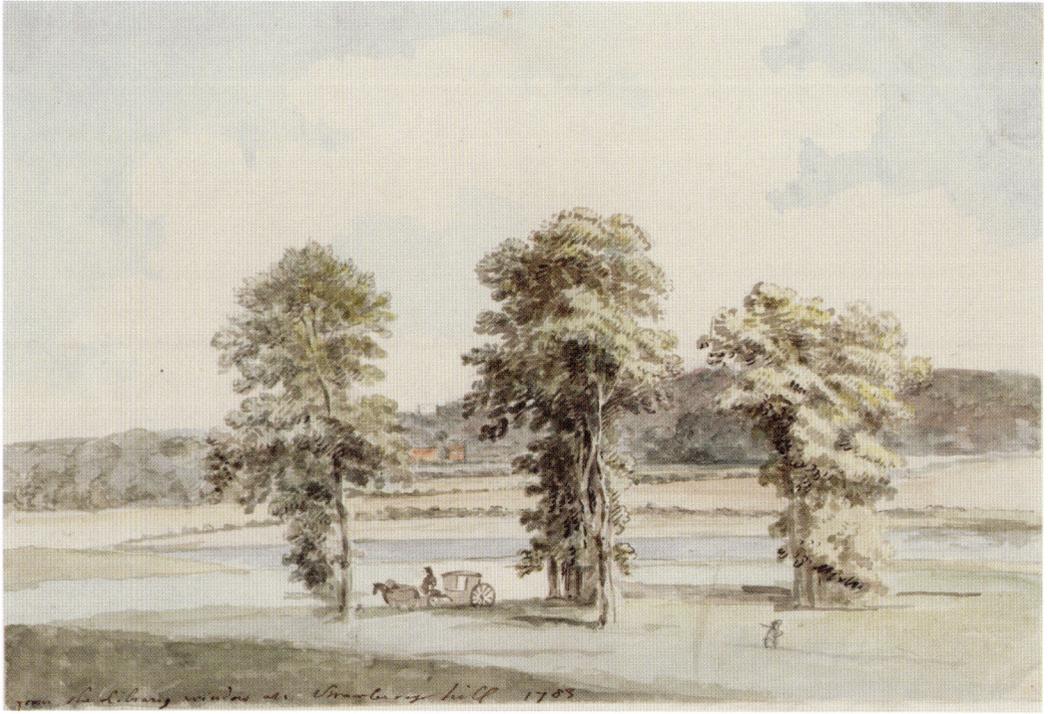

3.11 View
from the Library
window at
Strawberry Hill,
E. Edwards, 1783

The setting was also of paramount importance and it is evident from Walpole's comments that the design of the house and the layout of the grounds were an integrated process, itself an innovative and still-quite-novel concept at this date. Writing to Mann it is clear he signals his intention to name the villa Strawberry Hill and that he was delighted with his new acquisition:

I am now returning to my villa, where I have been making some alterations: you shall hear from me from *Strawberry Hill*, which I have found out in my lease, is the old name of my house, so pray, never call it Twickenham again. I like being there, better than I have liked being anywhere since I came to England … I can truly say that I never was happy but at Florence, and you must allow it very natural to wish to be happy once more.[36]

He wrote to Williams of its acquisition, its diminutive size and his delight at the prospect of altering and enlarging it:

You perceive by the date of my letter that my love for London is wore out; I have got an extreme pretty place just by Twickenham, which I am likely to be pleased with for at least some time, as I have many alterations to make. The prospect is delightful, the house very small, and till I added two or three rooms scarce habitable: at present it will hold as many people as I wish to see here.[37]

It is evident from the beginning that he had ambitious plans to remodel the house and the first alterations of 1747 to the small L-shaped structure concentrated on the utilitarian aspects of living, moving the kitchen and

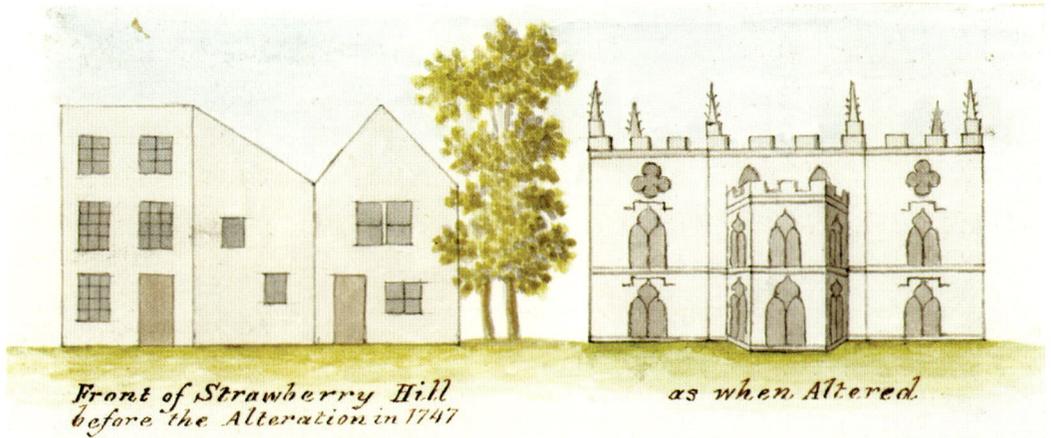

Front of Strawberry Hill before the Alteration in 1747 *as when Altered.*

adding a breakfast room, 'not truly gothic', designed by Robinson.[38] A further
phase of development followed in 1748–9 in order to transform the diminutive
dwelling into a more habitable size.

3.12 Front of
Strawberry Hill
before and after
alterations

This expansion enhanced the relationship of the house with its wider
landscape setting, and 'undetermined prospects' as advocated by Addison, by
converting a bedroom, with views, into a Breakfast Room thereby maximising
the prospect of the surrounding vistas by the addition of a bow-window to
the east, garden side, recorded in a letter to Mann.[39] 'I am come hither for a
few days to repose myself after a torrent of diversions, and am writing to you
in my charming bow-window, with a tranquillity and satisfaction …'[40]

Walpole records in 1748 that: 'the little improvement I am making, have
really turned Strawberry Hill into a charming villa.'[41] However, the earliest
extant reference signalling his intention to remodel Strawberry Hill in the
Gothic manner is found in a letter to Montagu in September 1749, following
the outright purchase of the property.[42] Referring to his intention to ask for
the stained glass at Cheyney's which 'is dropping down', Walpole continues:

… but in half the windows are beautiful arms painted in glass. As these are so
totally neglected, I propose making a push and begging them of the Duke of
Bedford: they would be magnificent at Strawberry Castle. Did I tell you that I
have found a text in Deuteronomy, to authorize my future battlements? *When thou
buildest a new house, then thou shalt make a battlement for thy roof, that thou bring not
blood upon thy house, if any man fall from thence.*[43]

During this more measured Gothicising phase, Walpole began to significantly
alter and extend Strawberry Hill, making the south front Gothic and moving
the original entrance from the river-side of the house to a new position
adjacent to Hampton Court Road.

During 1753 he was building and remodelling on the ground floor, the Little
Parlour, the Yellow Bedchamber (which was later renamed the Beauty Room),
Hall and Staircase; on the first floor, the Blue Breakfast Room, Red Bedchamber,
Armoury, Green Closet and the Star Chamber. The additional floors in the three-

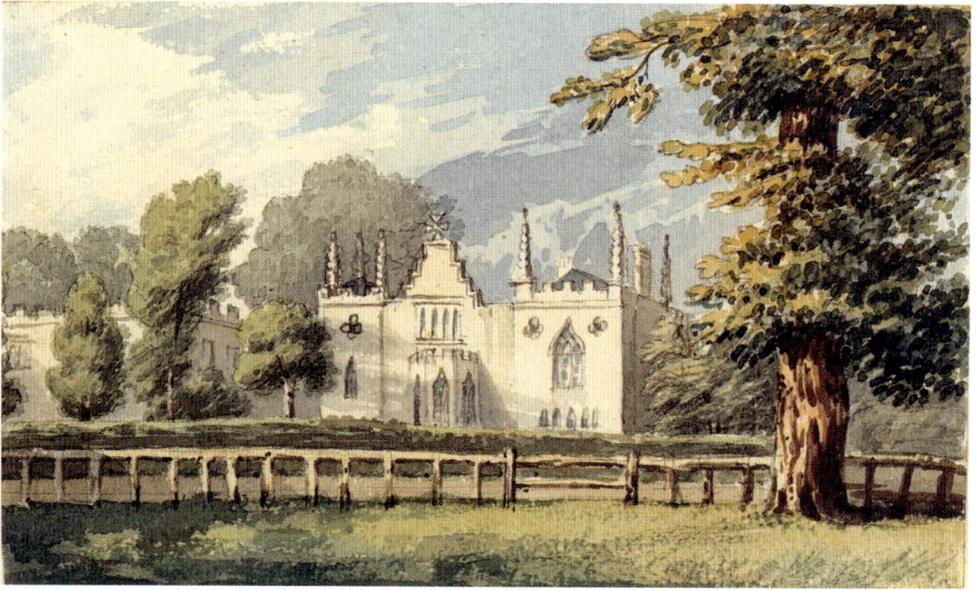

3.13 Strawberry Hill east front

3.14 Elevation of Gothic buildings: N. entrance to Strawberry Hill, J. Chute, 1753

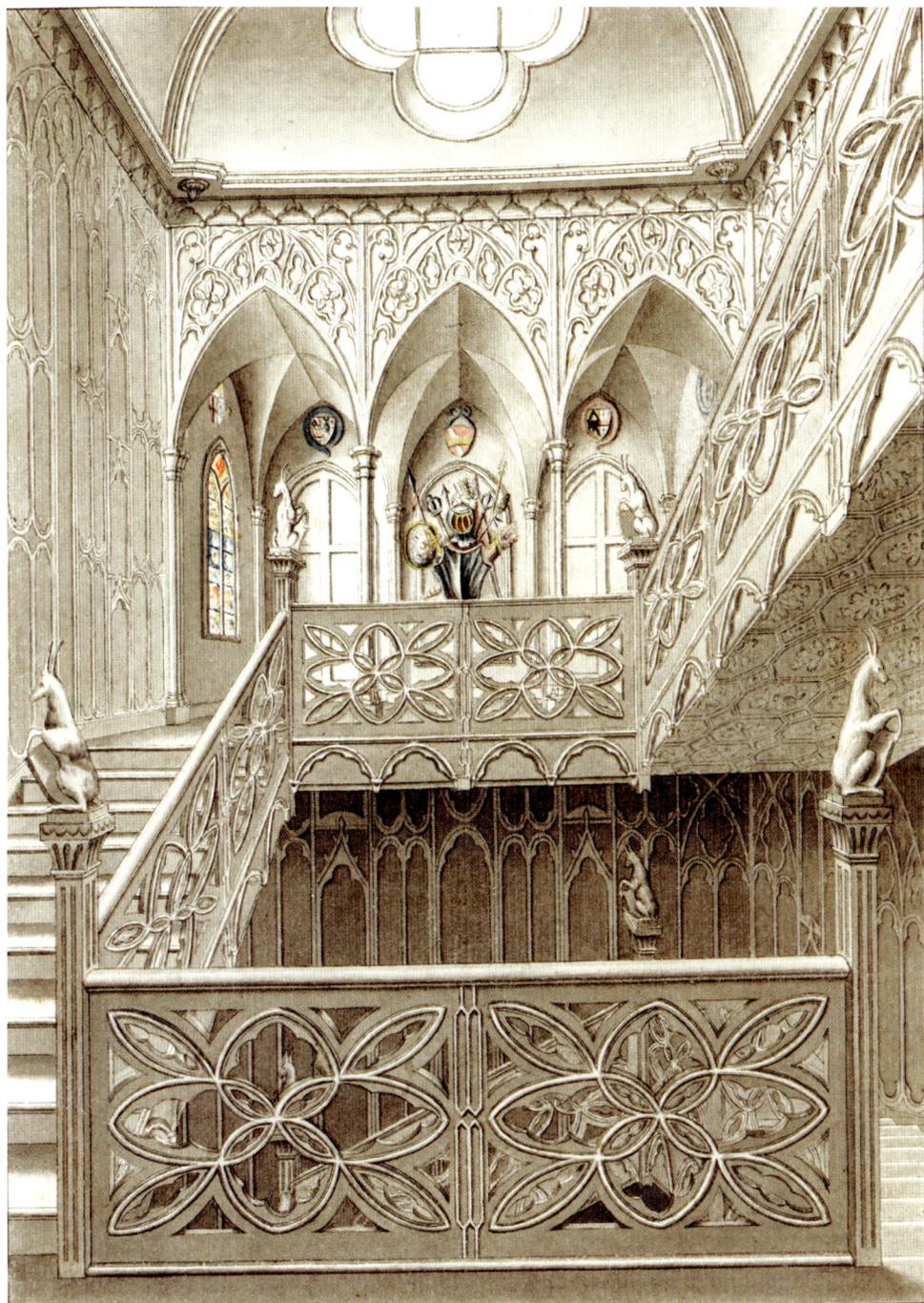

3.15 Staircase at Strawberry Hill, J. Carter

storey section generated a tower and the central bay was reconstructed in order to allow a new staircase to be inserted to create the Hall and the Armoury.[44] The concept of the Armoury and its potential for imaginative engagement through its association with historic events is highlighted in the following article which appeared in a *Gentleman's Magazine* of 1739:

Methinks there was something respectable in those old hospitable Gothick Halls, hung round with helmets, Breast-Plates, and Swords of our Ancestors; I entered them with a Constitutional Sort of Reverence, and look'd upon those Arms with Gratitude, as the Terror of former Ministers, and the Check of Kings. Nay, I even imagin'd that I here saw some of those good Swords, that had procur'd the Confirmation of the Magna Charta, and humbled Spencers and Gravestons.[45]

Walpole kept a close eye on the progress of Hall and Staircase and he was accompanied by his architect on frequent visits to inspect the alterations to the diminutive house. 'Mr Chute and I are come hither for a day or two to inspect the progress of the Gothic staircase, which is so pretty and so small, that I am inclined to wrap it up and send it to you in my letter.'[46]

Walpole projected further additions to the house as soon as this phase was complete. Writing to Mann he informs him of his intentions to create new accommodation which will substantially increase the available space. 'The only two good chambers I shall have, are not yet built; they will be an eating-room [Refectory or Great Parlour] and a library, each 20 by 30 and the latter 15 feet high … We pique ourselves upon nothing but simplicity, and have no carvings, gildings, paintings, inlayings or tawdry business.'[47]

Work on the historicising alterations carried on apace. The effect that Walpole was creating gave the castle mainly monastic and Tudor associations while links with his own ancestors are increasingly evident. The mood that he wished to evoke for the building 'so Gothic and so venerably gloomy' recalls Addison's observation on monastic sites as 'exceedingly solemn and venerable', combined with its 'enchanted little landscape setting' is apparent in a letter from Mann which reiterates Walpole's concept for the integrated design of the interior and exterior. It also makes reference to the Gothic atmosphere of Mr Chute's room, decorated with its 'college of arms, with its bow-window darkened with painted glass, and shaded again with limes!'[48]

Walpole confirms that 'The Library, and Refectory, or Great Parlour, were entirely new built in 1753 all to Chute's designs.'[49] Walpole's Gothic library was the first in that style.

Most of the house was also rendered in roughcast lime plaster to recall earlier buildings and painted white at this time, the provenance for this being undoubtedly Windsor Castle. In *Anecdotes of Painting* Walpole quotes from a Latin text which confirms that Windsor Castle was painted white which translates as: 'That ye cause to be whitened all the old wall round our tower above mentioned'.[50] Thus Walpole acquires the necessary provenance for him to paint the exterior of Strawberry Hill the same colour. 'The little that I believe you would care to know relating to the Strawberry annals, is, that the great tower is finished on the outside, and the whole whitened, and has a charming effect) …'[51]

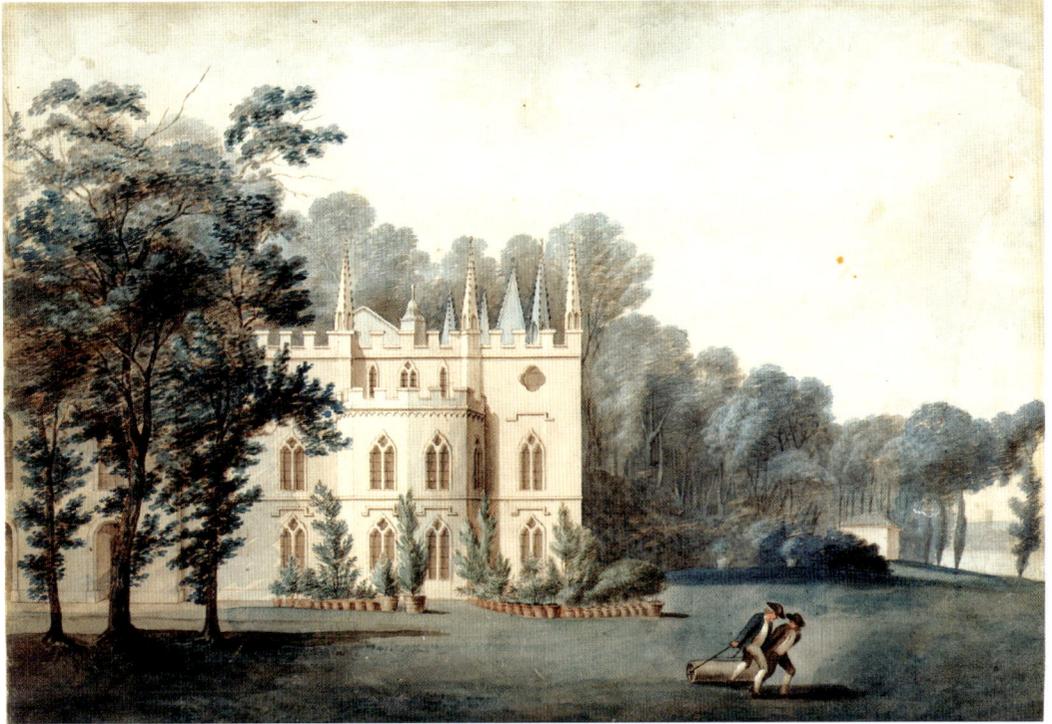

3.16 Strawberry Hill, south view

Significantly, it concurs with Addison's idea that in emulating historic castle structures it exhibits 'greatness of manner' and its concomitant effects. '*Greatness of Manner* in Architecture, which has such force upon the Imagination, that a small Building, where *it* appears, shall give the Mind nobler Ideas than one twenty times the Bulk, where the Manner is ordinary or little.'

The building works continued with the addition, in 1755, above the Breakfast Room, of Walpole's bedroom with a Gothic chimneypiece designed by Chute.[52] 1756 saw the Gothic gable added to complete Walpole's second-floor Blue Bedchamber confirmed in this letter to Bentley.[53] 'I am fitting up the old kitchen for a china-room: I am building a bedchamber for myself over the old blue-room, in which I intend to die, though not yet'.[54]

The Gothic fireplace in the China Room is also probably by Chute. As mentioned earlier Walpole projected a Gothic columbarium in 1757, but this was never executed. 'The monument about which you ask, you shall see in a drawing, when finished; It is a simple Gothic arch, something in the manner of the columbaria; a Gothic columbarium is a new thought of my own, of which I am fond, and going to execute one at Strawberry.'[55]

A further phase of development was undertaken between 1758–61, resulting in the addition of a small four-bay arcaded Cloister with a groin-vaulted ceiling and adjoining pantry with the Holbein Chamber above, designed by Chute.[56] Walpole tells Mann of his latest works:

I am again got into the hands of builders, though this time to a very small extent; only, the addition of a little cloister and bed-chamber [The Holbein Chamber]. A day may come that will produce a gallery, a round tower, a large cloister, and a cabinet, in the manner of a little chapel – but I am too poor for these ambitious designs yet …[57]

The idea of a room named after Holbein is probably inspired by the one at Windsor Castle or alternatively from a visit to Cowdray, west Sussex in 1749, as part of Walpole's Gothic tour. He and Chute were particularly enamoured of Cowdray's historical association with Margaret Plantagenet, Countess of Salisbury (1473–1541) who was imprisoned there and later executed for treason at the Tower of London on the orders of Henry VIII:

Our greatest pleasure was seeing Cowdry, which is repairing … We thought of old Margaret of Clarence, who lived there; one of her accusations was built on the bulls found there: it was the palace of her great uncle the Marquis of Montacute. I was charmed with the front, and the court and the fountain. But the room called Holbein's, except the curiosity of it, is wretchedly painted, and infinitely inferior to those delightful histories of Harry the Eighth in the private apartments at Windsor.[58]

3.17 Sketch for the upper windows in the Holbein Chamber, Richd. Bentley, 1750–60

Walpole's competitive nature likely inspired him to improve on previous Holbein Chambers, but when Cowdray was later destroyed by fire, Walpole lamented on the loss of that 'that loveliest and perfectest of all ancient mansions Cowdry was on Monday night [24 September] last totally burnt to the ground in six hours … It is a grievous loss to us Goths!'[59] The completion of the Holbein Chamber at Strawberry Hill is recorded in a letter to Strafford. 'I long to have your approbation of my Holbein Chamber; it has a comely sobriety that I think answers very well to the tone it should have.'[60]

During 1759 the route of Hampton Court Road was shifted slightly to the north to enable further extensions. Coincidental with the works to the house Walpole was perpetually acquiring additional plots of land and demolishing unwanted buildings on the site, such as the old printing house, which he replaced with a new one in a different location, to make way for the Gallery and Round Tower, designed by Chute in 1759. 'I have just finished the Holbein Chamber, that I flatter myself you will not dislike; and I have begun to build a new printing-house, that the old one may make room for the Gallery and Round Tower.'[61]

Walpole informs Mann that he is about to embark on this building project: 'I am flounced again into building – a round tower, gallery, cloister and

3.18 Farm yard and printing house belonging to Strawberry Hill, E. Edwards, 1784

chapel, all starting up'.[62] This major extension took place between 1760 and 1764 which saw the appearance of the Round Tower, the Gallery with the Great Cloister below, the Chapel, or Cabinet, later the Tribune which is mostly to Chute's design.[63] The Oratory, Prior's Garden and screen, Servant's Hall and associated Cellars were also part of this phase.[64]

The alternation between monastic and castle Gothic is again evident in his reference to the castle-like crenellations of the Round Tower corroborated in a letter to Montagu, wherein Walpole makes reference that: 'My tower erects its battlements bravely ...'[65] The Round Tower also provided Walpole with extensive views to Pembroke Lodge and Richmond Park, sites associated with history and his father's political offices. He is by this time enchanted with the transformation of the villa into a fairy-tale Gothic castle, insisting that Gray's friend and correspondent, Thomas Wharton (1728–90) Professor of Poetry at Oxford, pay him a visit. He is confident that Wharton will be able to make the same imaginative connections with history and literature as they engender in him, recalling Addison's comments on the 'Field of Antiquities' that he experienced in Rome, where he found 'that it is almost impossible to survey them without taking new Hints, and raising different Reflexions':

3.19 Inside
of Oratory at
the entrance
of Strawberry
Hill, J. Chute

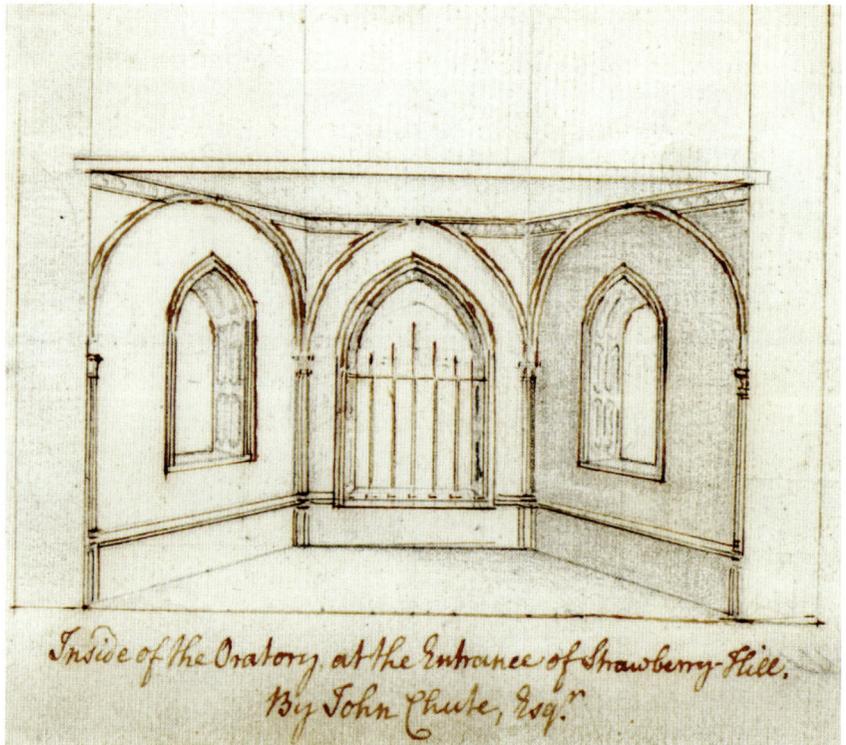

Inside of the Oratory, at the Entrance of Strawberry-Hill.
By John Chute, Esq.ʳ

You would find some attempts at Gothic, some miniatures of scenes which I am pleased to find you love – cloisters, screens, round towers, and a printing house, all indeed of baby dimensions, would put you a little in mind of the age of Caxton and Wynken. You might play at fancying yourself in a castle described by Spenser.[66]

Walpole is again ambivalent in his descriptions of the changes that have occurred, sometimes referring to Strawberry Hill as a castle and at other times insisting on its monastic connotations, admitting that '… though I have built a convent, I have not so much of the monk in me as not to blush – nor can content myself with praying to our Lady of Strawberries to reward you.'[67]

He cites his growing collection as the reason for the extensions and additions. 'In truth, my collection was too great already to be lodged humbly; it has extended my walls, and pomp followed. It was a neat little house; it now will be a comfortable one, and except one fine apartment [the Gallery] does not deviate from its simplicity …'[68]

Once Chute's designs for the Round Tower based on one at Chute's ancestral home at the Vyne, Hampshire were commenced, an embattled wall, contiguous to the relocated road was also constructed.[69]

Another developmental phase was commenced between 1770–74 creating the Great North Bedchamber, designed by Chute, The Gothic Gateway into the garden from the Hampton Court Road to a design by Walpole's architect, James Essex and the Chapel in the Woods, also designed by Chute.[70]

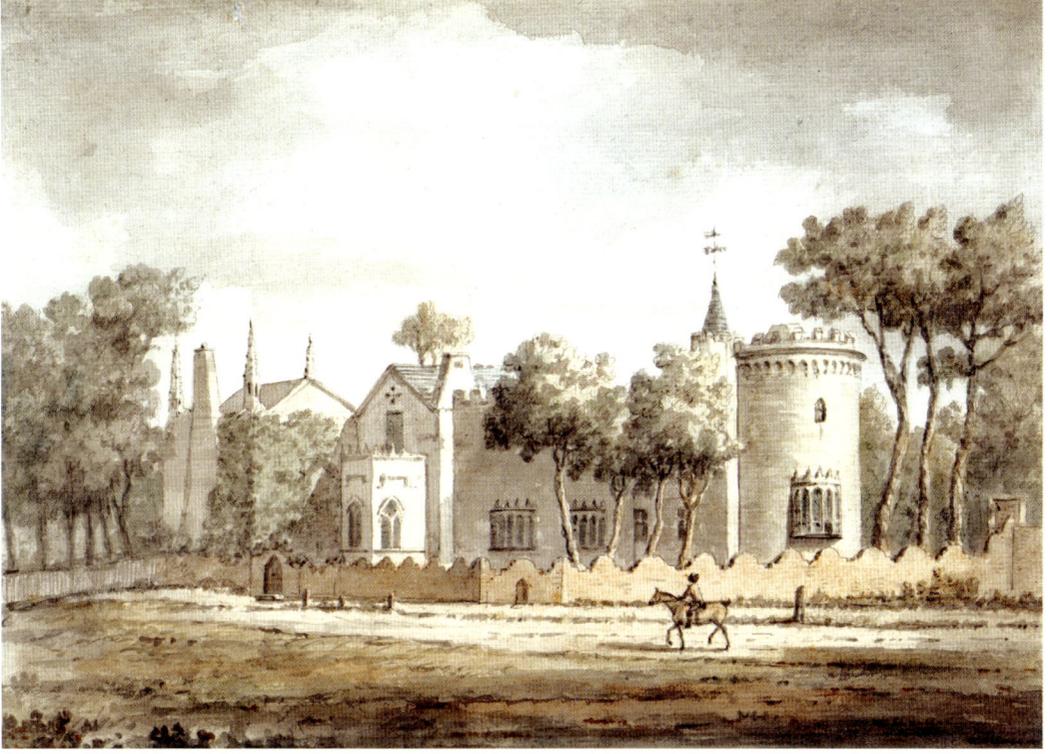

3.20 North front of Strawberry Hill, W. Marlow, c.1784

Walpole informs Mann of the completion of the Round Tower and new kitchen on the ground floor and comments that these further Gothic accretions have transformed his residence from a humble villa into a castle. 'The round tower is finished and magnificent; and the state bedchamber proceeds fast – for as you must know the little villa is grown into a superb castle.'[71]

In this letter to Mason, Walpole advises him of progress with his two current building projects at Strawberry Hill, including the commencement of the Chapel in the garden. Chute provided the designs, precisely copied from the Audley tombs in Salisbury Cathedral and built by Thomas Gayfere (1720–1812), master mason to Westminster Abbey. He refers to the State Bedchamber and verifies that the effect of the Gothic accretions is to enhance the impression of an ancient structure:

… I am continuing my immortal labours with those durable materials, painted glass, and carved wood and stone. The foundations of the Chapel in the garden are to be dug on Monday. The State Bedchamber advances rapidly, and will, I hope be finished before my journey to Yorkshire. In short, this *old, very old castle*, as his prints called old Parr, is very near being perfect, that it will certainly be ready by the time I die, to be improved with Indian paper; or to have the windows cut down to the ground by some travelled lady.[72]

His delight with the current changes does not see the cessation of building projects and by July 1774 he informs Cole that when he acquires sufficient

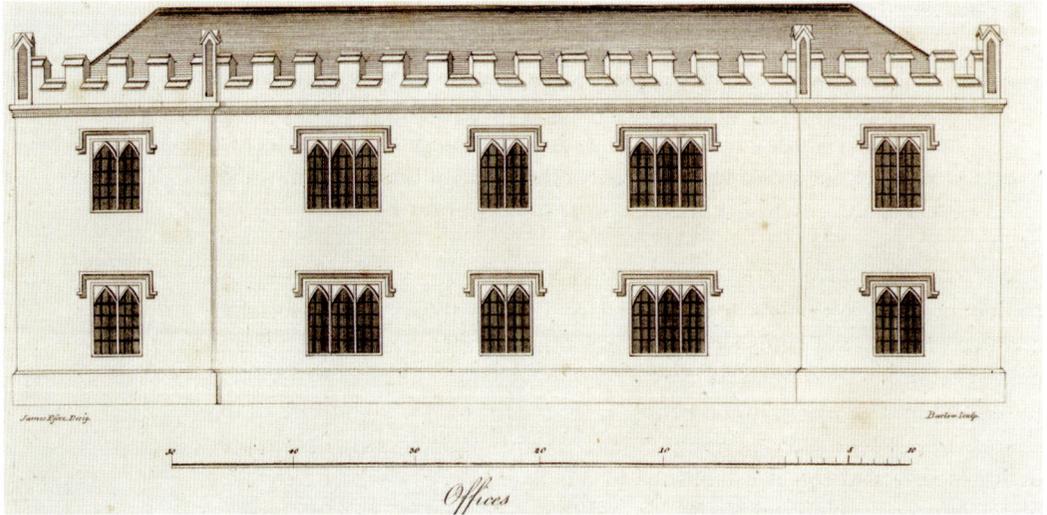

3.21 View of
the Offices, J.
Essex, designer,
J.C. Barlow

funds he intends to execute New Offices designed by Essex. 'If ever I am
richer, I shall consult the same honest man about building my offices for
which I have a plan, but if have no more money ever, I will run in debt and
distress myself; and there remit my designs to chance and a little economy.'[73]

In 1771, Essex was paid for his designs for the Beauclerc Tower and the
New Offices, which recall Oxford colleges, and Walpole again confirms that
the concepts are his and entreats Cole:

What is become of Mr Essex? Does he never visit London? I wish I could tempt him
thither of hither. I am not only thinking of building my offices in a collegiate style,
for which I have a good design and wish to consult him, but I am actually wanting
assistance this very moment about a smaller gallery [Beauclerc Closet] that I wish to
add this summer; and which if Mr Essex were here he should build directly.[74]

The Beauclerc Tower with a hexagonal closet was projected by Chute in 1758
but not executed until 1776 by Essex. It was inspired by one at Thornbury
Castle, Gloucestershire which Walpole had seen, commenting that 'the ruins
are half ruined. It would have been glorious, if finished.'[75]

Essex had a notorious reputation for being unavailable once he had
submitted his designs and for not seeing the works through to completion.
Walpole clearly shows his irritation at not being able to contact him regarding
completing his project to build a tower 'so exactly of the fourteenth century'
but fears upsetting him in case he would not appear at all.

I did not think Mr Essex could have come so malapropos; but it is difficult to get
him, and he has built me a tower so exactly of the fourteenth century, that I dare
not put him off, lest it should not be ready for furnishing next spring. It is one of
those tall thin Flemish towers that are crowned with a roof like an extinguisher,
and puts one in mind of that at Thornbury, called *Buckingham's Plotting Closet*.'[76]

The Beauclerc Tower gives us a specific example of how the ideas of association and imagination expressed here were so crucial to the concepts that Walpole was effecting at Strawberry Hill, bringing together the fourteenth-century Gothic architecture that he loved and through associations with Thornbury Castle. Imaginatively, they recall events in English history with his reference to the 'plotting closet' evoking memories of the Duke of Buckingham (1478–1521) who began the castle but was convicted for disloyalty to Henry VIII and executed for high treason.

Correspondence relating to the Beauclerc Tower also supports the contention that Walpole's texts are based on the theories of associative architecture and the landscape he is executing at Strawberry Hill. This is evidenced in the links he makes between the design and construction of this tower and his discussion in the *History of the Modern Taste in Gardening* of the concept of a Bower. He is undoubtedly describing significant elements of his own property and this is established in this letter to Cole, where he makes direct association between his Bower and that described in the *History of the Modern Taste,* where he had written: 'The enchantment of antique appellations has consecrated a pleasing idea of a royal residence, of which we now regret the extinction. Havering in the Bower, the jointure of many dowager queens, conveys to us the notion of a romantic scene.'[77]

Describing the Beauclerc Tower to Cole he affirms its romantic nature and its royal links:

I don't know anybody so much in the wrong as you are for not coming to me this summer; you would see such a marvellous closet, so small, so perfect, so respectable; you would swear it came out of Havering in the Bower, and that Catherine de Valois used to retire into it to write Owen Tudor.[78] ... Lady Di's drawings – no offence to yours, are hung on the Indian blue damask, the ceiling, door and surbase are gilt, and in the window are two brave fleurs-de-lise and a lion of England, all royally crowned in painted glass, which as Queen Catherine never did happen to write a *billet doux* in this closet, signify Beauclerc, the denomination of the Tower. The cabinet is to be sacred and not shown to the profane.[79]

Walpole had previously written to Cole informing him how the addition of the new yet old tower enhanced the Gothic castle, inviting him to 'visit my new tower, diminutive as it is. It adds much to the antique air of the whole in both fronts ...'[80] Walpole relates to Cole the pleasing effect that the irregular roof-line created by the addition of the tower adding to the overall asymmetry of the composition just as Addison had predicated in the 'Pleasures of the Imagination' essays how unique characteristics and irregularity were essential for stimulating the emotions, 'and yet is not strong enough to be inconsistent with tranquillity.' 'I have carried this little tower higher than the round one, and it has an exceedingly pretty effect, breaking the long line of the house picturesquely, and looking very ancient, thus, I wish this or anything else could tempt you hither.'[81]

3.22 Strawberry
Hill view from the
northeast road,
E. Edwards, 1783

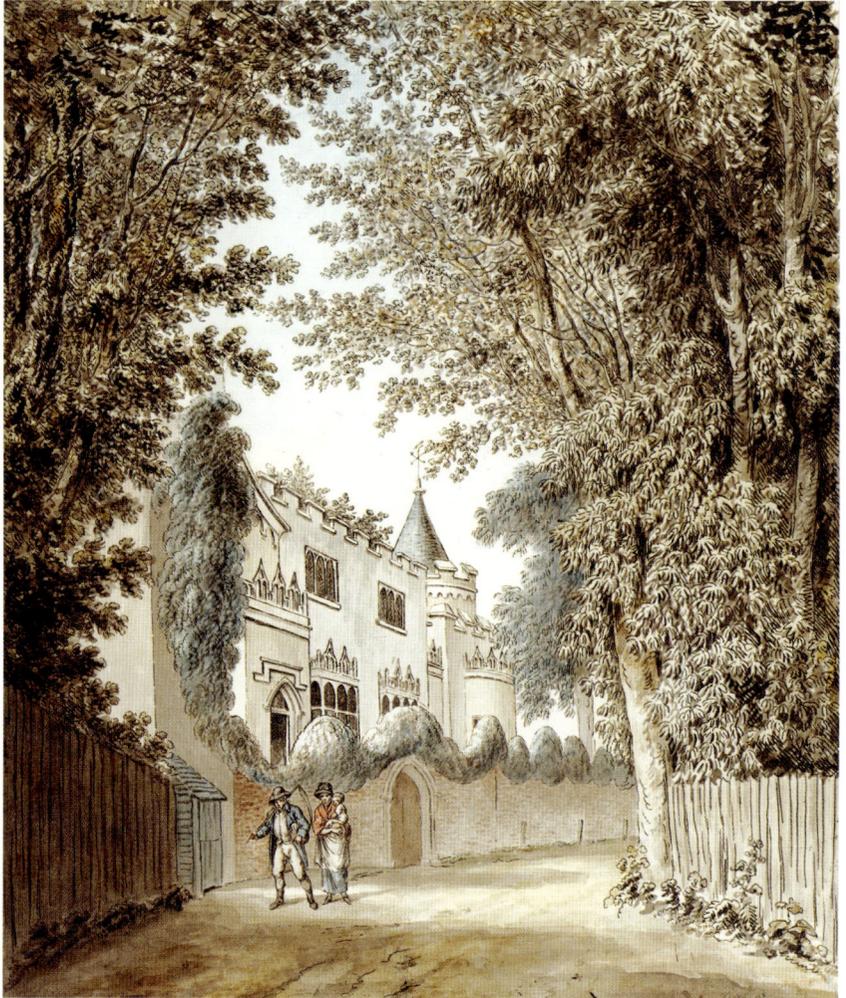

It is evident in this comment to Lady Ossory that these accretions are meant
to evoke ancient architecture, the antithesis of most building projects: '… I am
waiting for Mr Essex to finish my new tower, which, as my farmer said, is still
older than the rest.'[82] By June 1779 the new cottage in the garden, replacing
that vacated by his tenant was complete, but the letter to Mann indicates the
Round Tower is only now finishing. 'I have come hither for two months, very
busy with finishing my round tower, which has stood still these five years,
and with an enchanting new cottage that I have built, and other little works.'[83]
As already noted, Essex's designs for the offices were not carried out until
the 1790s by James Wyatt and Walpole laments on the increased cost.[84] 'My
personal history is short and dull. I have made my chief visits; my offices
advance, and I have got in most of my hay, and such a quantity that, I believe,
I believe it will pay for half a yard of my building.'[85] Essex also supplied
designs for a Gothic bridge in 1778 but this too was not carried out until 1792.

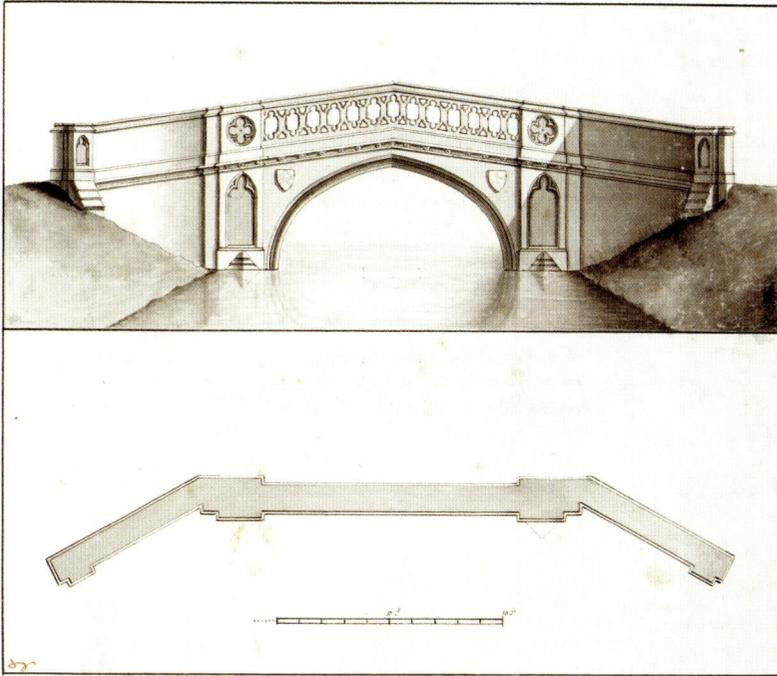

3.23 Bridge over Cross Deep in the approach to Strawberry Hill

Before the final phase was complete, Walpole had expressed his contentment with the Gothic accretions carried out so far:

I have finished this house and place these three years, and yet am content with and enjoy it – a very uncommon case in a country where nobody is pleased but while they are improving, and when they are tired the moment they have done. I choose my house should enjoy itself, which poor houses and gardens seldom do, for people go on mending till they die, and the next comer, who likes to improve too, begins to mend all that has been done … when the sum of it all is, that I am content with a small house and garden, and with being nobody.[86]

Evidence to support that Walpole was deliberately constructing a fictitious ancestral home is also confirmed in the response to a letter from Cole entreating him to supply any surplus Gothic materials he has acquired building Strawberry Hill to Gothicise his own house:

I wish I could return these favours by contributing to the decoration of your *new old* house; but as you know, I erected an old house, not demolished one, I had no windows or frames for windows but what I bespoke on purpose for the places where they are. My painted glass was so exhausted, before I got through my design, that I was forced to have the windows in the gallery painted on purpose by Pecket …[87]

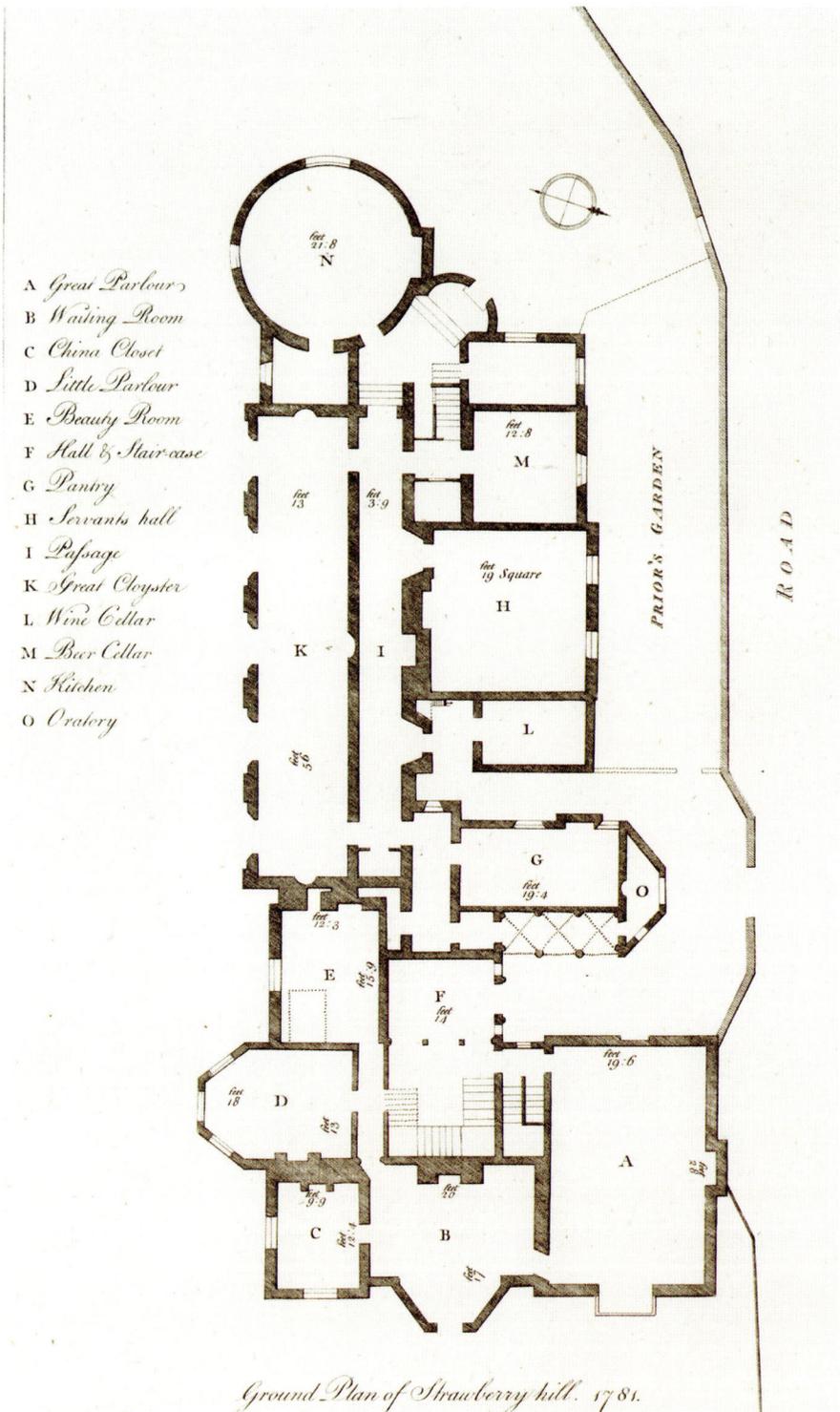

A *Great Parlour*
B *Waiting Room*
C *China Closet*
D *Little Parlour*
E *Beauty Room*
F *Hall & Stair-case*
G *Pantry*
H *Servants hall*
I *Passage*
K *Great Cloyster*
L *Wine Cellar*
M *Beer Cellar*
N *Kitchen*
O *Oratory*

Ground Plan of Strawberry hill. 1781.

3.24 Ground plan of Strawberry Hill, 1781

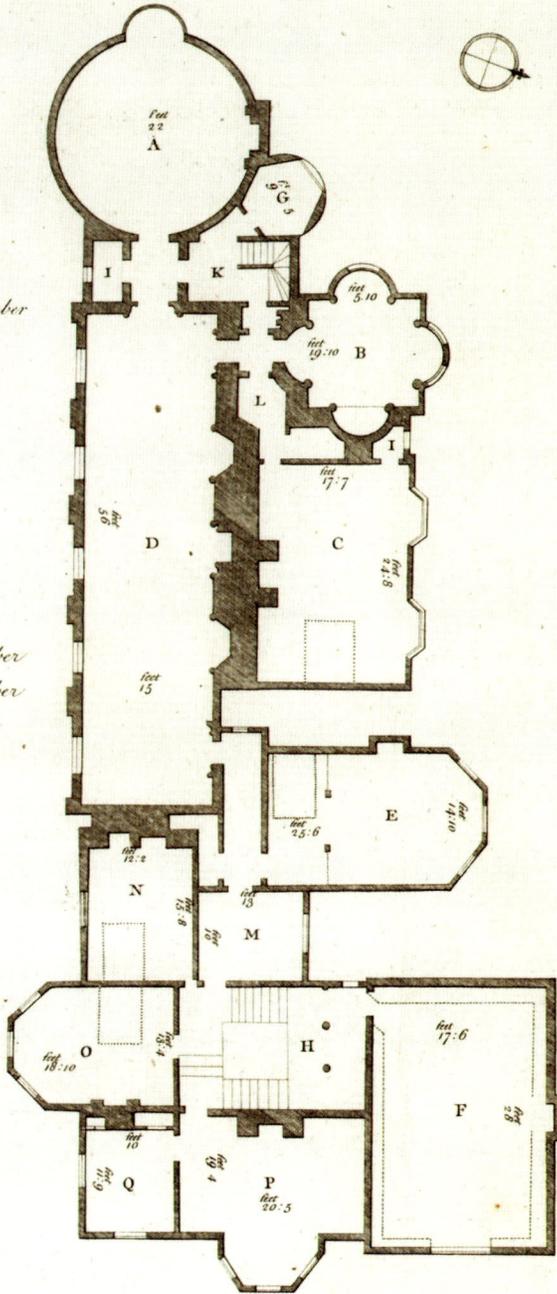

A Round Room
B Cabinet
C Great Bed Chamber
D Gallery
E Holbein Room
F Library
G Beauclerc Closet
H Armory
I China Closets
K Back Stairs
L Passage
M Star Chamber
N Red Bedchamber
O Blue Bedchamber
P Breakfast Room
Q Green Closet

Principal Floor of Strawberry hill. 1781.

3.25 Plan of the principal floor of Strawberry Hill, 1781

'The castle (I am building) of my ancestors': History and Aesthetic Effects at Strawberry Hill

The following section follows the route delineated by Walpole in the *Description of Strawberry Hill* and explores the museum quality of the interior of the building to understand how Walpole achieves different effects to stimulate his own imagination and that of his guests and visitors. In a remarkable document titled, *Walpole's Account of the Aesthetic Effects at Strawberry Hill* (1772) he explains how, through the application of his theory, different moods, impressions and sensations can be stimulated in the observer:[88] 'Great effects may be produced by the disposition of a House, & by studying lights & shades, and by attending to a harmony of colours. I have practised all these rules in my house at Strawberry Hill, & have observed the impressions made on Spectators by these arts.'[89]

This significant statement is derived from Addison's insistence that the reader receives imaginative stimulation from being immersed in the 'confusion' and 'profusion' of 'different colours' and exposure to continual changes in atmosphere through the disposition of 'light and shade' to evoke the senses through different sensory experiences. Using terminology derived from painterly principles Addison applies the theory of association to landscape, concepts which Walpole embraces and appropriates for the interior too.

We will establish that Walpole clothed a small, nondescript building in a Gothic skin and created a journey through a sequence of moods and atmospheres using a series of different theatrical effects. He makes his intentions clear and signifies his engagement with this theory apparent in this significant statement:

I do not mention my own House, which is a small one, but by comparison, & as a sample of what might be done on a magnificent scale, if perspective, the effects of light & shade, Harmony in the colouring of the furniture & picturesque taste were observed in the whole. I need not say how much the result of my house is improved by the humility of the Entrance, & the simplicity of the first rooms, so little promising the expence of the great apartment.[90]

These innovative concepts include disposition in planning and changes in levels and scale, variations in colour, light and shade, framing and concealing, and a sense of movement from the small dark spaces of the original house to expansive light interiors created in the later accretions. The visitor is escorted through a succession of dynamic spatial experiences designed to give the impression that the building developed over centuries starting from monastic foundations with later additions mostly of the sixteenth and seventeenth centuries as the Tudor and Stuart periods held a particular fascination for him.

Walpole considered the reign of Henry VIII and English history up to the Civil War (1642–51) as the most significant periods in English history. Although, as an antiquary, Walpole was somewhat ambivalent about Henry VIII's programme of the Dissolution of the Monasteries:

... there is no forgiving him that destruction of ancient monuments and gothic piles and painted glass by the suppression of the monasteries; a reformation, as he called it, which we antiquaries almost devoutly lament, yet he had countenanced the arts so long, and they acquired such solid foundation here, that they were scarce eradicated by that second storm which broke upon them during the civil war – an æra we antiquaries lament with no less devotion than the former.[91]

Walpole indicated to Bentley that he approved of the Reformation and the break with Rome. '... my love of abbeys shall not make me hate the Reformation till that makes me grow a Jacobite like the rest of my antiquarian predecessors; of whom Dart in particular wrote Billingsgate against Cromwell and the regicides.'[92]

We progress from the public Gothic spaces recreating monastic foundations to the private, intimate interiors, founded on the plan of a royal residence, to a series of State Apartments with the Gallery, Round Drawing Room, and Great North Bedchamber, arranged so visitors would experience emotional and sensational responses and expressions of surprise and wonder as they viewed approximately 4,000 artefacts, excluding books and prints decorating the spaces. The collection, carefully arranged in the museum interior, created a journey through history, breathing life into the mainly British and European works of art and artefacts. The villa was furnished with original seventeenth-century furniture or modern furniture commissioned by Walpole in the same style to convey their ancient form. The furniture was made from ebony, wearing what Walpole described as 'the true black hood' to give it the appearance of being ancient.[93] The furnishings, architectural elements and artefacts constituted the material remains of historical figures and past cultures, all of which had their own narrative and an innate capacity to illuminate the past and inform guests as they passed through a variety of transitional architectural spaces and engaged with their historical themes.

The specially-commissioned illustrations of the mansion and its interior that accompany the text of the *Description of the Villa* are crucial to the interpretation of the historic interior and our understanding of how Walpole wanted the villa to be perceived. However, some of these are misleading, for example the illustration of the Tribune depicts the room as being significantly larger than the 16 feet across that it actually is. Neither does it realistically portray the fantastic quantity of objects displayed or reveal the sense of clutter that must have characterised the space. Walpole maintained complete control of the atmosphere he wished to convey through the illustrative material and this is confirmed when he asks Bentley if Müntz, is capable of documenting the changes that are taking place and capturing the specific impression of the villa that he wishes to portray: 'Can he paint perspectives, and cathedral-aisles, and holy glooms?'[94]

Walpole amassed a significant collection of painted and sculptural portraits and prints, recognising the historical, commemorative function of portraiture. It would appear that his purpose was to encapsulate, enshrine and commemorate his ancestors and other great men of the past. They were an illustrated account of

3.26 Hanging scheme window side

key figures in history depicting honour, renown, nationalism, and ancient times. Portraiture was an indicator of character, meant to evoke the virtues and intellect of the subject and inspire emulation and draw inspiration from them, and with depictions of descendants, to invite comparisons with them. They formed the visual equivalent of a written history and embodied the notion of memory and commemoration. The collection assembled by Walpole encompassed monarchs, which glorified rulers and in turn his country, and by association himself. For Walpole the representation of key figures, eminent men and women, and heroes of British history hanging alongside the Walpole family and friends simultaneously demonstrated the same attributes of the sitters and the superior position of the Walpole family and its place in history. Contemporary visitors would have known what was being represented and understood their purpose, significance and meaning. As the artist Jonathan Richardson (1665–1745) noted in 1715, 'Painting gives us not only the Persons, but the Characters of Great Men. The Air of the Head and Mein in general, gives strong Indications of the Mind and illustrates what the Historian says more expressly and particularly.'[95]

At Strawberry Hill, they were arranged and displayed in a particular way throughout the villa to portray and evoke notions of Walpole's own particular 'family history' through association. Walpole had also expressed his concept for hanging pictures to enhance their display potential to create variety and interest. 'In hanging pictures, opposition makes harmony. Histo:ries should be mixed with Landscapes or heads; & the two latter shd be mixed. Sizes too thus.'[96]

Indeed the interior display follows Walpole's picture hanging principles which he illustrated in a sketch of mixing portraits with landscapes and different sizes of canvas to convey the impression of accretion over time.

Walpole had a predilection for portraiture over other genres of paintings and 'portraits of remarkable persons' hung in every room in the mansion.[97] He had emotionally described these visual renderings, writing that '... portraits are but melancholy pleasures in long absences!'[98] Portraiture formed a significant part of the collection, igniting his historical imagination by their potential for anecdote and the associations that the figures depicted brought to his mind. 'I prefer portraits, really interesting, not only to landscape painting, but also to history … a real portrait we know is truth itself: and it calls up so may collateral ideas, as to fill an intelligent mind more than any other species.'[99]

3.27 Hanging scheme side opposite to the chimney

'Mr Walpole is very ready to oblige any curious persons with the sight of his house and collection': Visiting Strawberry – a Walk through History

The eighteenth-century visitor would have first viewed the picturesque Gothic castle from the Hampton Court Road which passed directly along the north façade of the house: 'the approach to the house through lofty trees, the embattled walls overgrown with ivy, the spiry pinnacles, the grave air of the building, give it all the appearance of an old abbey.'[100]

Monastic and religious medieval associations increased as the visitor approached the Oratory and the Abbot's or Prior's Garden glimpsed from a small paved courtyard through an ornate Gothic screen based on the tomb of Roger Niger, Bishop of London, in Old St Paul's, our first introduction to the architecture of death associated with Strawberry Hill.

3.28 North
front of
Strawberry Hill,
I. Barlow, 1786

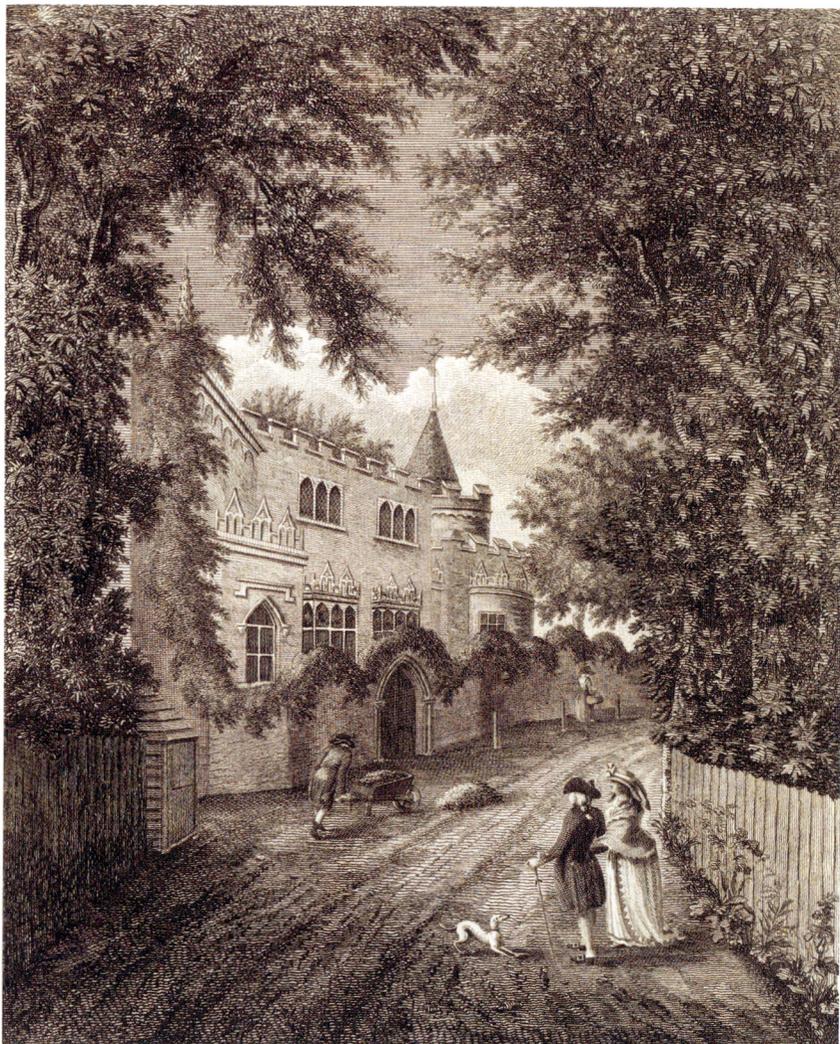

3.28 North front of Strawberry Hill, I. Barlow, 1786

There may be some irony in Walpole's decision to take the design of the screen from the thirteenth-century tomb of Roger Niger, who was referred to as a saint after his burial place at St Paul's became a place of pilgrimage because of a solar eclipse that took place during his interment.[101] In his *Description of the Villa*, Walpole emphasises the monastic atmosphere through nomenclatures and decorative features of the opening sequence of spartan stone-coloured interconnected spaces that visitors encounter as they enter the property:

Entering by the great north gate, the first object that presents itself is a small oratory inclosed with iron rails; in front, an altar, on which stands a saint in bronze; open niches, and stone basons for holy water; designed by Mr John Chute, esq; of the Vine in Hampshire. On the right hand is a small garden called the abbot's garden, parted off by an open screen ...[102]

3.29 Screen
to the Abbat's
Garden at
Strawberry Hill
from a tomb in
Old St Paul's,
J. Chute, 1753

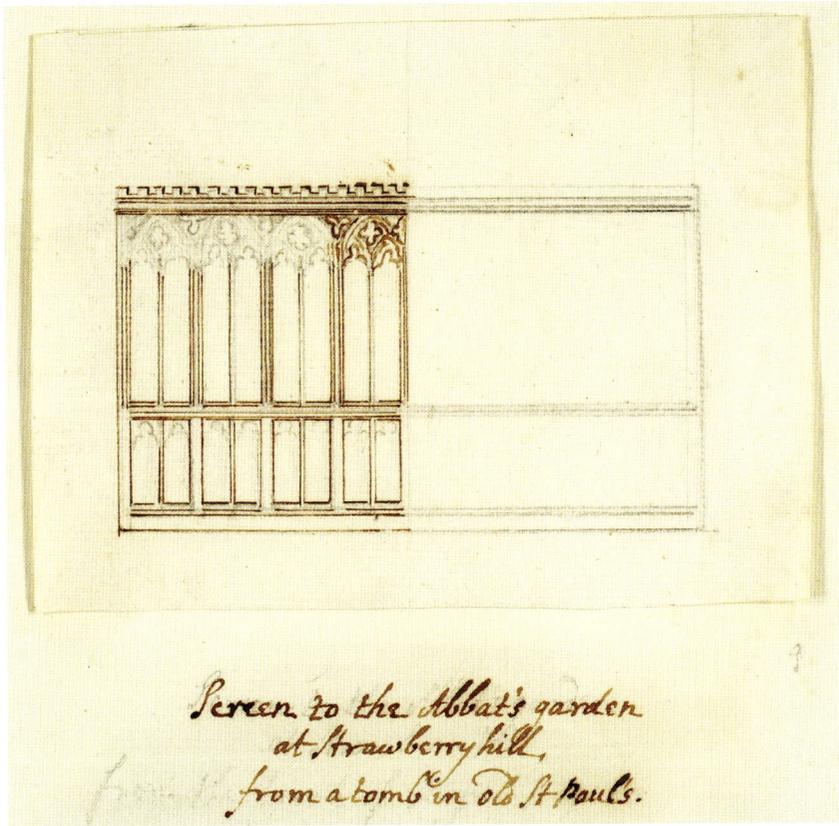

Screen to the Abbat's garden
at Strawberry hill,
from a tomb in old St Pauls.

The emphasis on the building's contrived monastic foundations is deliberately created to give the idea that the remnants of the old small house survive from the Dissolution of the Monasteries and were subsequently incorporated into an ancestral home, a common practice following their destruction. This notion is consolidated when, for privacy and security, Walpole screened the house from the road with an embattled wall taken from a Jacobean prodigy house visually juxtaposing the different architectural styles to demonstrate the accretive nature of the house. He confirms in the *Description of the Villa* that it is an architectural quotation: 'the embattled wall to the road is taken from a print of Ashton-house in Warwickshire, in Dugdale's history of that county'.[103] The wall also enclosed and sheltered the Prior's Garden taking the form of a *Hortus Conclusus,* an enclosed medieval garden with deep historical and biblical associations. Its distinctive character is that of a private space, inward, secluded and reflective, a place of meditation and contemplation – just what a pilgrim would expect to see if visiting a 'monastery'.

Imaginatively, references to the 'Prior's' garden would have set the scene for the Gothic interior of the 'Abbey'. 'Bernini's Apollo and Daphne in bronze', characters from Ovid's *Metamorphoses,* were located in the entrance courtyard

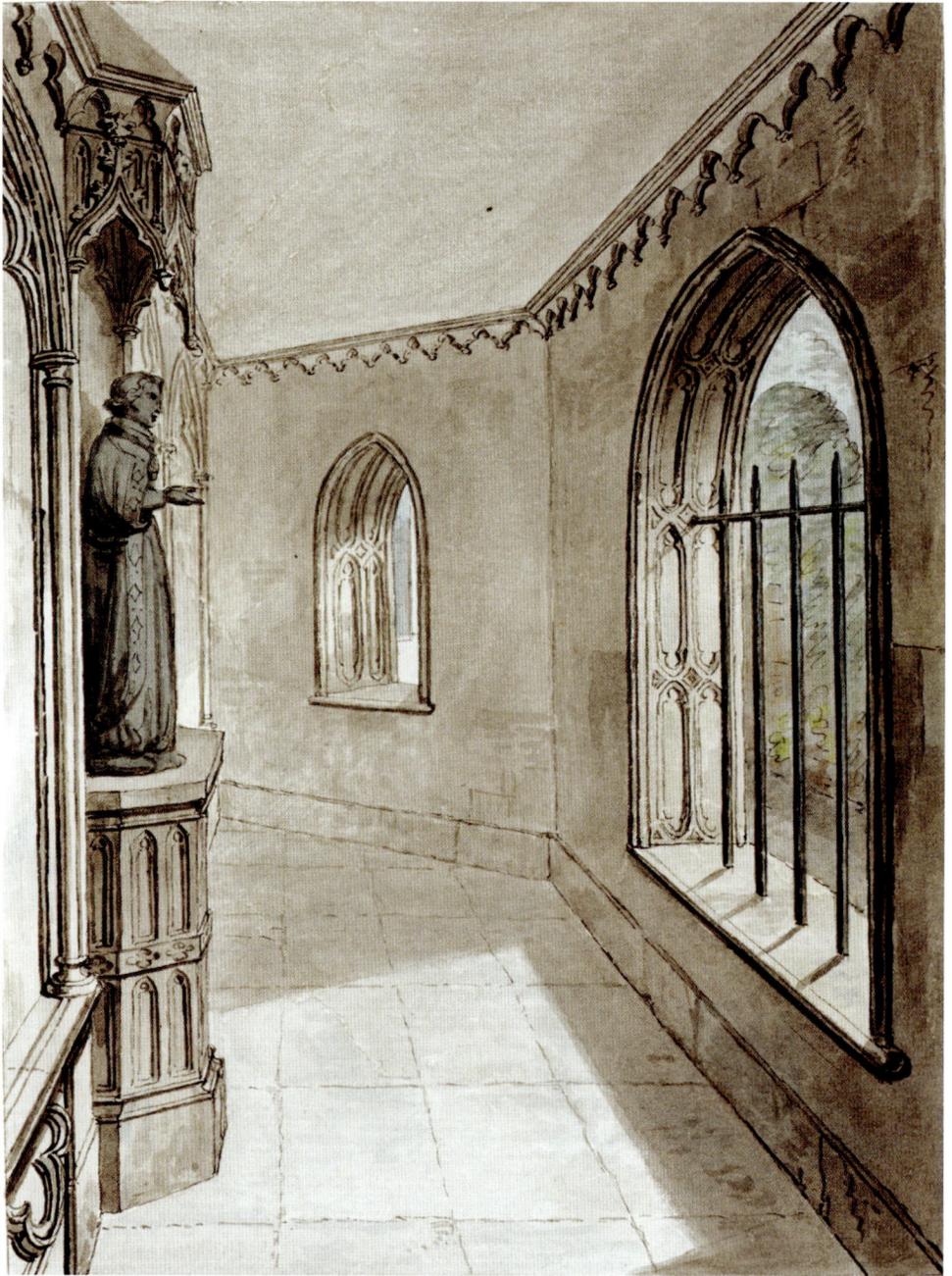

3.30 View in the Oratory, looking west, J. Carter

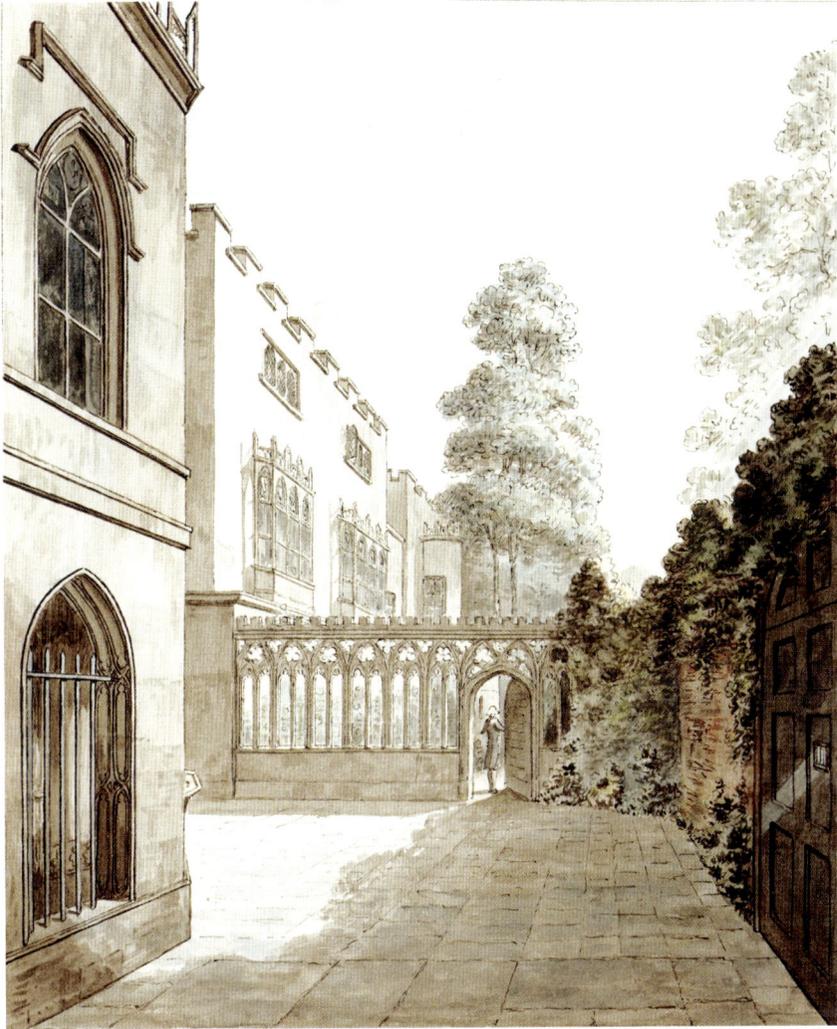

3.31 The screen to the Prior's Garden, E. Edwards

reminding visitors of the fate of Daphne who metamorphosed into laurel to escape her pursuer Apollo.[104] They also anticipate themes of enchantment that the visitor will experience in the garden which evoke Addison's statement that, 'Ovid, in his *Metamorphoses*, has shown us how the imagination may be affected by what is strange.'

Then the monastic theme resumes: 'Passing on the left, by a small cloyster, is the entrance to the house, the narrow front of which was designed by Richard Bentley.'[105]

A lancet arched door leads to the Winding Cloister which Walpole describes, 'on right hand are some ancient bas-reliefs; and a brass plate with the effigies of Ralph Walpole [d.1302] bishop of Norwich and Ely, engraven by Müntz.'[106] Walpole admitted to Cole that the model for his supposed relation was a Catholic martyr who had been hung drawn and quartered for treason

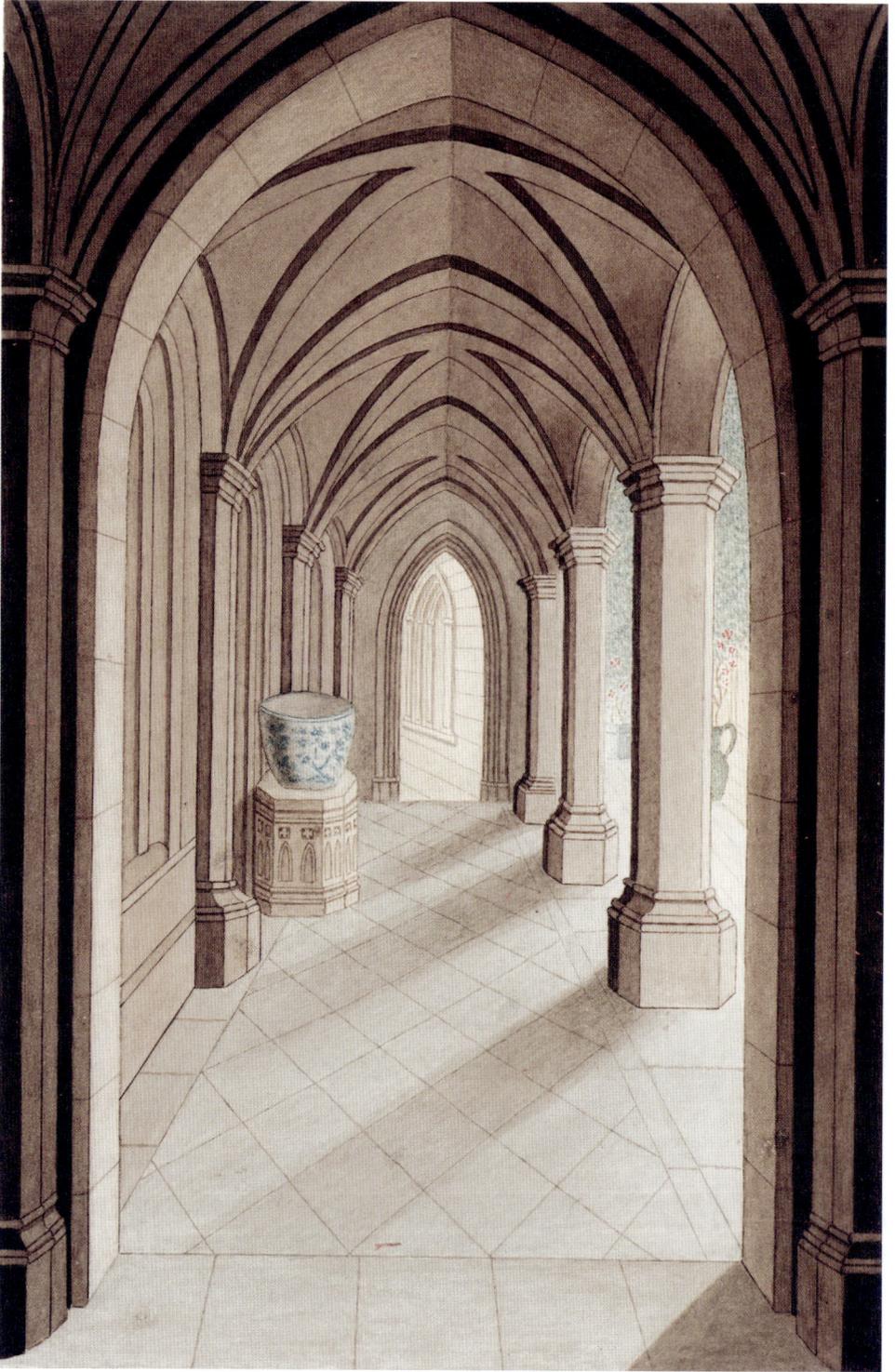

3.32 Cloister with china fish bowl

3.33 Entrance of Strawberry Hill, E. Edwards, 1781

by Elizabeth I. 'My brass plate for Bishop Walpole was copied exactly from the print in Dart's *Westminster* of the tomb of Robert Dalby Bishop of Durham, with the sole alteration of the name.'[107] The accretive nature of Strawberry Hill now manifests itself through the placement: 'over the door are three shields of Walpole, Shorter and Robsart', signifying a subtle, but momentary change from the monastic to the ancestral home of the Walpole family.[108]

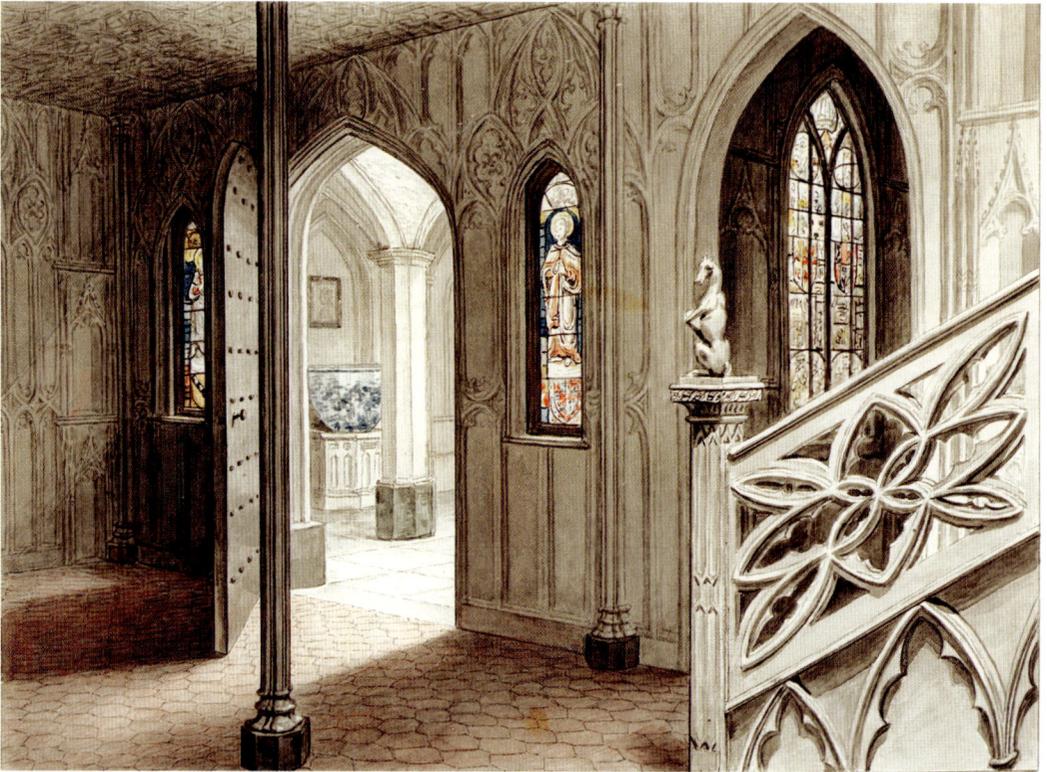

3.34 View
from the Hall at
Strawberry Hill,
J. Carter, 1788

The monastic theme then reappears briefly when Walpole describes to Mann what he might expect to see: 'From hence under two gloomy arches, you come to the hall and staircase, which it is impossible to describe to you, as it is the most particular and chief beauty of the castle.'[109] Walpole's *Description of the Villa* provides additional information for the first sight of the interior on entering the building. 'You first enter a small gloomy hall paved with hexagon tyles, and lighted by two narrow windows of painted glass, representing St. John and St. Francis.'[110]

Walpole made specific reference to the contrasting effects that he wanted to achieve when first entering the house: 'With regard to light and shades. The first Entrance strikes by the gloom: the Staircase opens upwards to a greater light.'[111] Six Gothic doors were located in the hallway giving the misleading impression that they led-off to many more rooms, when, in-fact, two of them were merely storage areas. The illusion was enhanced by low light levels, grey painted walls and balustrades added to the dark atmosphere giving a mysterious quality to the space.

The complex 'history' of the building is also expressed through constant references to the Hall by Walpole as the Paraclete after the Paraclete Monastery founded by Abelard and again alluding to Addison's monastic ruins where the mind of the observer is subjected to immense intellectual and sensory stimulation. The monastic association is confirmed in a letter to Mann. 'I was going to tell you

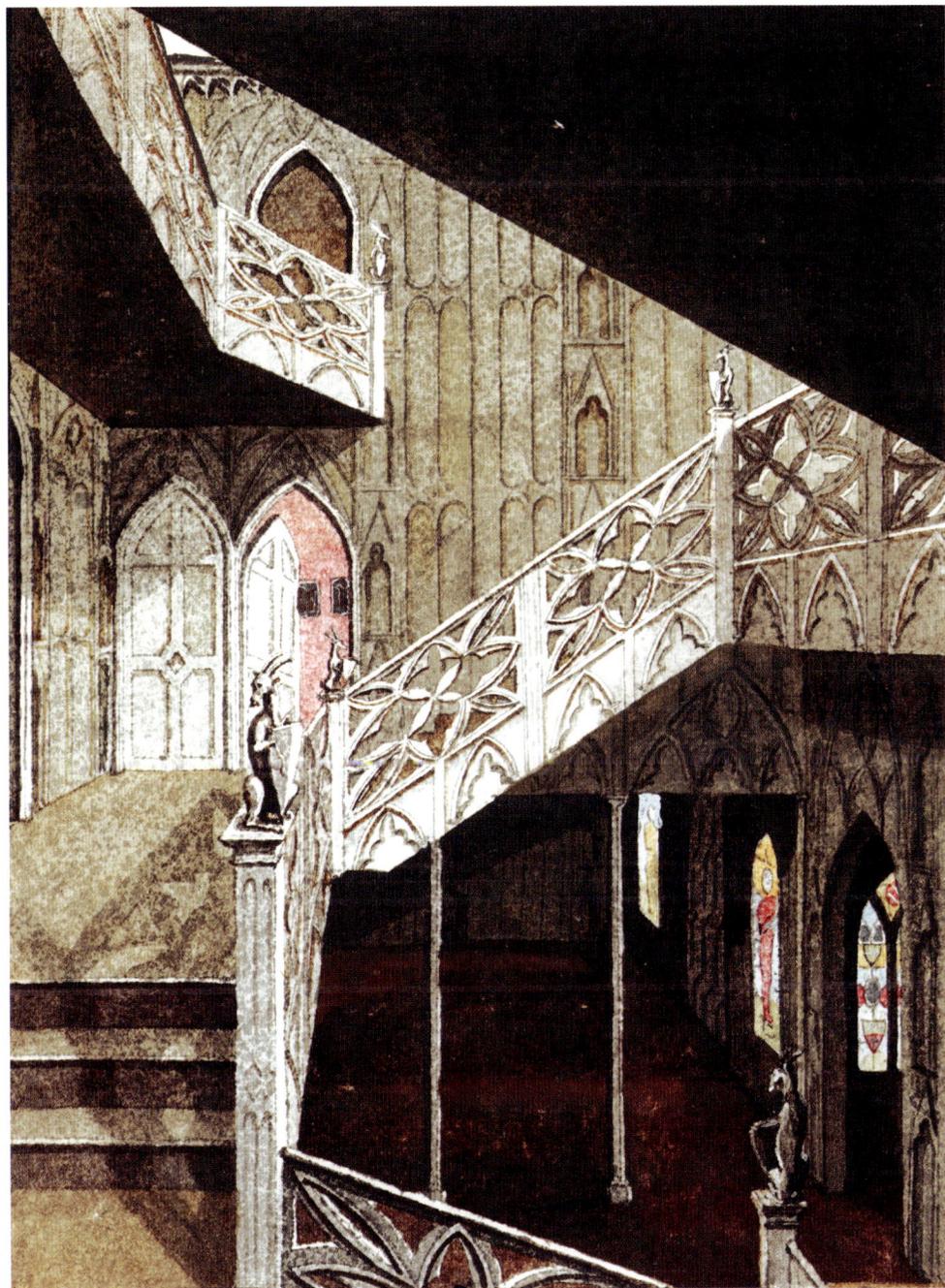

3.35 Perspective of the Hall and Staircase at Strawberry Hill, R. Bentley

that my house is so monastic that I have a little hall decked with long saints in lean arched windows and with taper columns, which we call the Paraclete, in memory of Eloisa's cloister.'[112] Here Walpole evokes Pope's popular Gothic poem *Eloisa To Abelard,* in which Eloisa laments her misfortunes and their exile to separate convents occasioned by their love:

In these deep solitudes and awful cells,
Where heav'nly-pensive contemplation dwells,
And ever-musing melancholy reigns …[113]

This created the ambience of a medieval or monastic space and these connotations are then combined with evocations of the Elizabethan period in which Walpole had an abiding interest as a significant epoch of English history. His passion for the English monarchy and particularly the Houses of Lancaster and Tudor are manifested throughout the house and he connects the ancestral theme through the decorative elements of heraldic beasts, carved out of wood, but painted stone-colour. This concept is probably based on that at Knole, Kent which Walpole had seen on his 'Gothic Pilgrimage'. Walpole effusively describes its overall effect to Mann: 'the lightest Gothic balustrade to the staircase, adorned with antelopes (our supporters) bearing shields; lean windows fattened with rich saints in painted glass.' The *Description of the villa* is more matter-of-fact:[114]

This hall is united with the staircase, and both are hung with gothic paper painted by one Tudor, from the screen of Prince Arthur's tomb in the cathedral of Worcester … In the well of the staircase, by a cord of black and yellow, hangs a gothic lantern of tin japanned, designed by Mr Bentley, and filled with painted glass; the door of it has an old pane with the arms of Vere earl of Oxford.[115]

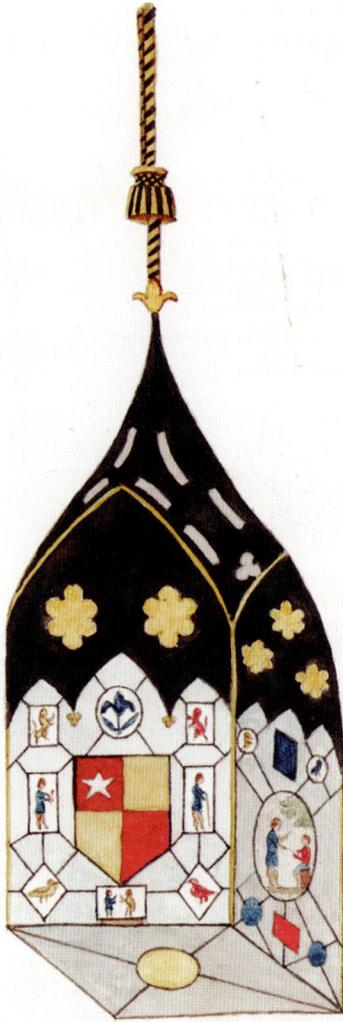

3.36 Gothic lantern in the Hall

The Hall and Staircase were hung with grey panelled Gothic paper, 'painted in perspective to represent Gothic fretwork' to a design by Bentley.[116] The Gothic 'gloomth' in the Hall and Armoury, are spaces that partially inspired Walpole's Gothic novel, *The Castle of Otranto*. However, firm links are evoked through the association of the cloister's ecclesiastical Gothic with English kings, the House of Tudor and to the Walpole dynasty through references and the atmosphere of 'venerable gloom' encountered in the Hall, lit by a single lamp containing heraldic glass:

The armoury bespeaks the ancient chivalry of the lords of the castle, and I have filled Mr Bentley's Gothic lanthorn with painted glass, which casts the most venerable gloom on the stairs which was ever seen since the days of Abelard: 'Lost in a convent's solitary gloom!'[117] The lanthorn itself in which I have stuck a coat of the Veres is supposed to have come from Castle Henningham.[118]

Walpole's placing the de Vere's, Earls of Oxford, Coat of Arms, whose ancestral seat was the motte-and-bailey Hedingham Castle, Essex is intended to convey, through association, links to John de Vere, 13th Earl of Oxford (1442–1513), a significant military commander in the Wars of the Roses. He helped to win the campaign at the Battle of Bosworth Fields during Henry VII's reign and is visually and imaginatively associated with the tomb of Arthur Tudor, Prince of Wales (1486–1502), first son of Henry VII and Elizabeth of York (1466–1503) who died before his father and never became king. One of his godfathers was John de Vere whose family arms appear on the lamp.

Although the Armoury was located on the shadowy landing, up a second flight of stairs of the top-lit staircase, the observer is only allowed a brief anticipatory glimpse at this stage of his journey. An air of anticipation is created as the viewer is immediately diverted:

Turning to the left, through a small passage, over the entrance of which is an ancient carving in wood of the arms of queen Elizabeth, 1567, and in a window of painted glass, you enter the Refectory or Great Parlour. It is thirty feet long; twenty wide, and twelve high; hung with paper in imitation of stucco. The chimney piece was designed by Mr Bentley.[119]

Designed to be overwhelmingly Gothic to represent a medieval great hall, and hung with portraits of Walpole's family with only one exception, the Great Parlour gives the impression of an ancestral family seat. Bentley's chimneypiece, unlike the majority of others which are based on tombs, is a work of sheer invention.

3.37 Great Parlour, J. Carter

3.38 Chimney
in the Great
Parlour, T. Morris

The stained and painted glass is restricted to the upper parts of the windows
and although not an ancient practice it allowed Walpole to achieve the air
of 'gloomth' he wishes to convey, while still allowing the views into the
animated landscape that he so cherished. The use of filtered and coloured
lights created an atmosphere of antiquity which was central to the character
of the Gothic spaces. The pendent frieze is taken from the chapel at Wroxton
Abbey, Oxfordshire which Walpole and Chute had visited in 1749.[120]

Part country house dining room and part refectory, the Great Parlour's
overriding theme follows tradition, focusing on a portraiture display of
immediate family and friends. Over the chimneypiece there is, 'a conversation',
by Joshua Reynolds (1723–92), of Walpole's close friends. 'Richard, second lord
Edgcumbe [1716–1761] is drawing at a table in the library at Strawberry-hill;
George James [Gilly] Williams is looking over him; George Augustus Selwyn
[1719–1791] stands on the other side with a book in his hand.' Other portraits
arranged around the room include 'a head of Sir Horace Mann, resident at
Florence', and 'opposite to it his brother Galfridus Mann [1706–1756].'[121]

Themes of ancestry, genealogy, and lineage, are articulated through design and decoration and the use of fragments and artefacts such as heraldic devices, and 'some fine painted glass.' There are also two 'ancient' looking-glasses containing pictures of his immediate family:

… in a gothic frame of black and gold, designed by Mr Walpole. Inclosed in the tops of the frames, with their arms and coronets, are the portraits of George Walpole third earl of Orford [1730–1791] and of George Cholmondely viscount Malpas [1724–1764] eldest son of George earl of Cholmondely [1703–1770] and of Mary [1705–1731] second daughter of sir Robert Walpole …[122]

Other members of Walpole's family are represented and his mother and father are present in large portraits. 'At the end of the room, over against the window, sir Robert Walpole, knight of the garter, afterwards earl of Orford. On one side of him, Catherine, eldest daughter of John Shorter, of Bybrook in Kent, first wife of sir Robert Walpole'.[123] The *Description of the Villa* contains a long and detailed account of the portraits of other close relatives, including his own 'Horace Walpole, third son of sir Robert and Catherine Shorter.'[124]

Specially-designed black Gothic chairs and a table reinforce the impression of Gothicism and 'gloomth' which Walpole created: 'The chairs are black, of a gothic pattern, designed by Mr Bentley and Mr Walpole.'[125]

These were based on similar ones he had seen at Esher Place and he writes to Gray, 'As I remember, there were certain low chairs, that looked like ebony, at Esher, and were old and pretty. Why should not Mr. Bentley improve upon them?'[126] The chairs, designed in ecclesiastical Gothic and based on medieval lancet windows also cast illusionistic shadows against the wall. They were sketched by Walpole for Bentley to refine:

My idea is, a black back, higher, but not much higher than common chairs, and extremely light, with matted bottoms. As I found yours came not, I have been trying to make out something like the windows – for example – Here is a drawing of a chair with a back resembling a three-light ecclesiastical window. I would have only a sort of black sticks, pierced through: you must hatch this egg soon, for I want chairs in the room extremely.[127]

The Waiting Room functioned as a reception area for people arriving by boat with views to the Thames. Walpole described it to Mann as 'a cool little hall where we generally dine, hung with paper to imitate Dutch tiles'.[128] An interior of King's College Chapel, Cambridge (1746–55) by Canaletto (1697–1768) adorned the walls. It also displayed 'a head in artificial stone of John

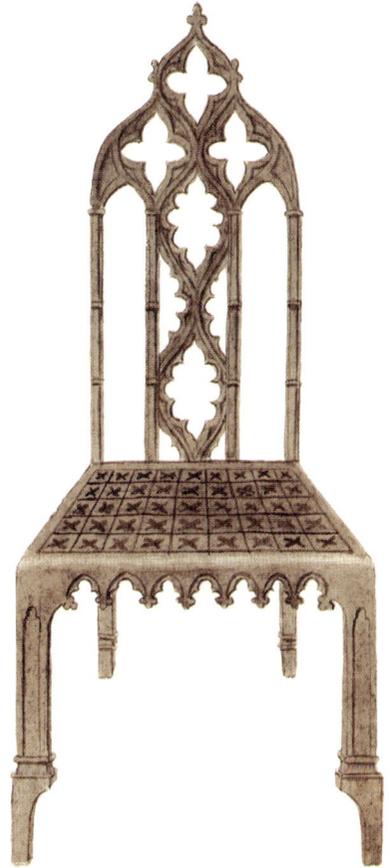

3.39
A Gothic chair

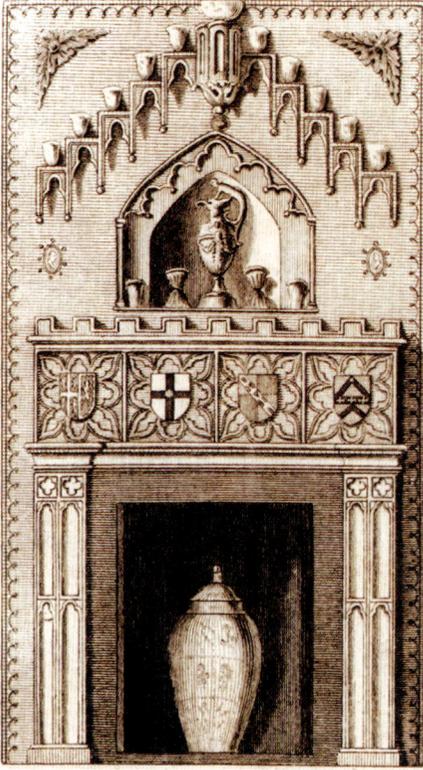

Dryden the poet, great uncle of Catherine Shorter lady Walpole', thereby ensuring the connection between the great poet and his mother's family.[129] Yet more artefacts with ecclesiastical, ancient and royal associations are mentioned:

… a large altar candlestick of metal, inlaid with gothic inscriptions, very ancient: and a pair of ancient bellows … with a bust of Charles 2nd … the man holds a plan like St Paul's; thence it has been supposed to be a portrait of Sir Christopher Wren, but does not resemble him, nor are the arms his.[130]

It is evident from Walpole's account that decoration and architectural details for the China Room were those he encountered on the Grand Tour. Commenting on the source for the ceiling decoration he informs Mann, 'Three years ago I had the ceiling of my china room painted from one I had observed in the little Borghese Villa [at Frascati]. I was hoarding ideas for a future Strawberry even in those days of giddiness, when I seemed to attend to nothing.'[131] His 'Gothic Pilgrimages' and other tours are also primary sources for the fireplace, the latter embellished with the arms of the present and some previous occupants of Strawberry Hill, juxtaposed with royalty.

Ancient fragments, either collected during these visits, or gifts from others, also form part of the fabric or the extensive densely-packed display of ceramics, tiles, and other decorative arts:

Painted glass in the windows, and crests of Shorter and Gestinthorpe; the ceiling painted with convolvulus's on poles, by Müntz from a ceiling in the Borghese villa at Frascati …[132] In the floor some very ancient tyles with arms, from the cathedral at Gloucester. The upper part of the chimney-piece is taken from a window of an ancient farm-house, formerly Bradfield-hall, belonging to lord Grimston in Essex; the lower part from a chimney at Hurst Monceaux in Sussex: it is adorned with the arms of Talbot, Bridges, Sackville and Walpole, the principle persons who have inhabited Strawberry-hill … on the sides, George 2d. and Frederic prince of Wales, in Battersea enamel … in the chimney … two tiles from Bysham–abbey.[133] … a tyle from the kitchen of William the Conqueror at Caen in Normandy.[134]

The husband of Walpole's niece, Charles Churchill sent him the tile from William the Conqueror's kitchen and he confirms that he obtained others during a visit to Gloucester Cathedral:

I had not then got the draught of the Conqueror's kitchen, and the tiles you were so good as to send to me … I weep over the ruined kitchen, but enjoy the tiles. They are exactly like a few which I obtained from the cathedral of Gloucester, when it was new paved; they are inlaid in the floor of my china-

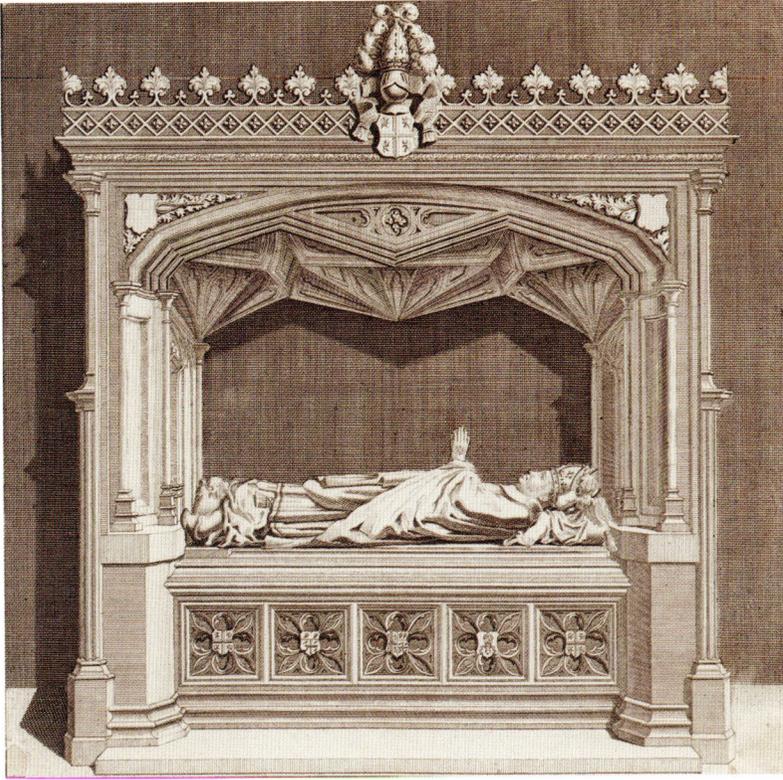

3.41 Tomb
of Thomas
Ruthall, Bishop
of Durham

room. I would have got enough to pave it entirely; but the canons who were
flinging them away, had so much devotion left, that they enjoined me not to
pave a pagoda with them, nor put them to any profane use. As scruples increase
in a ration to their decrease, I did not know but a china-room might casuistically
be interpreted a pagoda, and sued for no more. My cloister is finished and
consecrated; but as I intend to convert the old blue and white hall next to the
china-room, into a Gothic columbarium [not executed], I should seriously be
glad to finish the floor with Norman tiles.[135]

The Little Parlour, decorated with the heraldic iconography of Walpole and
others has a bay-window capturing views to three sides of the animated
landscape, garden and the Thames. Despite being hung with grey gothic
tracery paper and furnished with the ubiquitous dark furniture the bow-
window ensured that it was a light and sunny private room:

Over the door is a shield of Mr. Walpole's arms and quartering's in painted glass
by Price. The room is lighted by a bow window, in which, among other pieces
of painted glass, are the arms of Ayliffe, impaling Clifford of Frampton, given
by Mr. George Selwyn. The Chimney is taken from the tomb of Thomas Ruthall
bishop of Durham, in Westminster-abbey. The room is hung with gothic paper
of stone colour in mosaic, on which are wooden prints by Jackson of Venice; and
furnished with a table and eight chairs of ebony, bought at lady Conyers's at
Great Stoughton in Huntingdonshire, as were others in the chambers.[136]

Designed by Bentley and modelled on Bishop Ruthall's (d.1523) tomb, the Gothic chimney-piece is surmounted by Walpole's arms. Once again, this device expresses links between his lineage and the House of Tudor as Ruthall was in the service of Henry VII who made him a privy councillor and Bishop of Durham in 1509. Following the death of Henry VII, before his position was consecrated, his appointment was later ratified by Henry VIII who continued him as secretary, later making him keeper of the Privy Seal. He served alongside Wolsey and was much involved in preparations for the defence of England when James IV (1473–1513) of Scotland threatened war.[137]

The private Yellow Bedchamber, later the Beauty Room, is decorated with portraits of significant beautiful women of the Stuart Court. It is evocatively named after a

3.42 Chimney in the Yellow Bedchamber, T. Morris

corresponding room at Windsor Castle which housed the 'Windsor Beauties'. In a letter to Mann of 1753 he describes it thus: 'The room on the ground floor … is a bedchamber hung with yellow paper and prints, framed in a new manner invented by Lord Cardigan, that is, with black and white borders printed.'[138] By 1776 he expresses his intention to change the name of the room in order to alter the theme to the House of Stuart to accommodate the acquisition of portraits of Stuart beauties: 'I have turned the little yellow bedchamber below stairs into a beauty room, with the pictures I bought [nineteen small heads in oil of the Court of Charles II], along with the Cowley [by Sir Peter Lely 1618–1680], at Mr Lovibond's sale.'[139] It is clear from the *Description of the Villa* that the room has been redecorated and there follows a long and detailed description of the sitters, often relating their roles as wives or mistresses and their sexual liaisons:

The [be-pinnacled] chimney-piece was designed by Mr Bentley [original not known]. The room is hung with grey spotted paper … Over the chimney, Charles 2d [1630–1685]. James duke of York [1633–1701] and Mary princess of Orange [1631–1660] when children … A fine portrait of sir Peter Lely, after himself. Elizabeth Wriothesly countess of Southampton [1646–1690] and afterwards first wife of Ralph the first duke of Montagu [1638–1709]… Nineteen small heads in oil of the court of Charles 2d. (except Sachariffa) …[140]

This is the final of the small-scale rooms of the original building on the ground floor and Walpole now guides the visitor up a flight of stairs, past a 'View of Richmond Hill' to The Blue Breakfast Room where the same view is seen from the windows. This room too is part of the early phase of development which Walpole complained was 'not truly gothic':

Furnished with blue paper, and blue and white linen. Black and yellow painted glass in the bow window. The chimney-piece and windows are not truly gothic, but were designed by Mr. W. Robinson of the Board of Works, before there was any design of farther improvements to the house.

This room, highly unusual at this time, is the first brightly coloured room encountered and is a complete contrast to the predominantly grey Gothic spaces. According to Walpole, the blue colour was deliberately chosen to make a stark contrast with the gloomy entrance and the vista from the window. The lime trees outside of the window produced dappled light and sense of movement in the room, while the bay-window provided vistas

3.43 Chimney in the Blue Bedchamber, R. Bentley

to the river, animated landscape and extensive prospects beyond, all like Addison's 'so many painted views in perspective.'[141] 'The blue room relieves the Eye from the conven:tual retirement of the Entrance by discovering a most beautiful landscape from the windows, set off by the overarching trees.'[142]

Walpole furnished the room with many miniatures from his extensive collection and scenes from nature, which also brought the outside into the room. He informed Mann in 1753 that this was the room, decorated with modern furnishings, that he occupied most of the time:

… where we always live, hung with blue and white paper in stripes adorned with festoons, and a thousand plump chairs, couches and luxurious settees covered with linen of the same pattern, and with a bow-window commanding the prospect, and gloomed with limes that shade half each window, already darkened with painted glass in chiaroscuro, set in deep blue glass.[143]

The suggestion is that this space was mainly for private use and decorated with themes that reflected the views to the garden and the river. Nevertheless, the early Kent-style chimneypiece was surmounted by Walpole's Saracen's head crest ensuring that themes of ancestry and lineage were ever-present.

Still in the older section of the house, the Green Closet is only entered through the Breakfast Room. Walpole described it thus: 'The green closet is all light and cheerfulness within & without.'[144] It has double-aspect windows containing 'some very curious pieces of painted glass', which overlooked and reflected the garden, river and the busy road.[145] Uniquely it is the only room in the house where landscape paintings were used extensively and although Walpole never built a ruin in his garden this room contained 24 views of

3.44 Stained
glass from
Green Closet:
rose impaling a
pomegranate

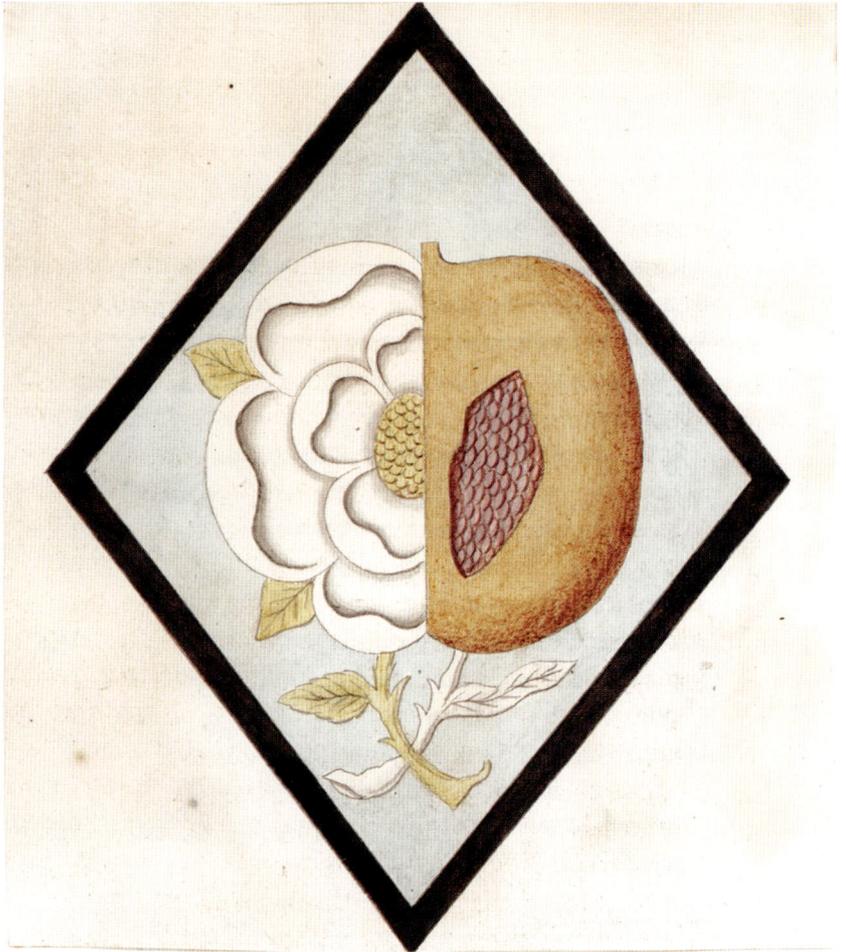

Classical ruins by Pietro Lucatelli (1630–d. after 1690). Heraldry was also a dominant feature with the arms of England and those of Henry VIII entwined with Catherine of Aragon. It also had an image of Lord Herbert of Cherbury (1583–1648) a chivalric knight whom Walpole greatly admired, and whose biography printed at Strawberry Hill and for which he had written the preface.

Walpole's letter to Mann in 1753 describing the alteration and additions to-date describes it thus:

… in the tower beyond is the charming closet where I am now writing to you. It is hung with green paper and water-colour pictures; has two windows; the one in the drawing looks to the garden, the other to the beautiful prospect; and the top of each glutted with the richest painted glass of the arms of England, crimson roses, and twenty other pieces of green, purple and historic bits.[146]

The glass, as with the iconography of the other rooms, told its particular story. However, whereas the meaning of the chimneypieces and their historic

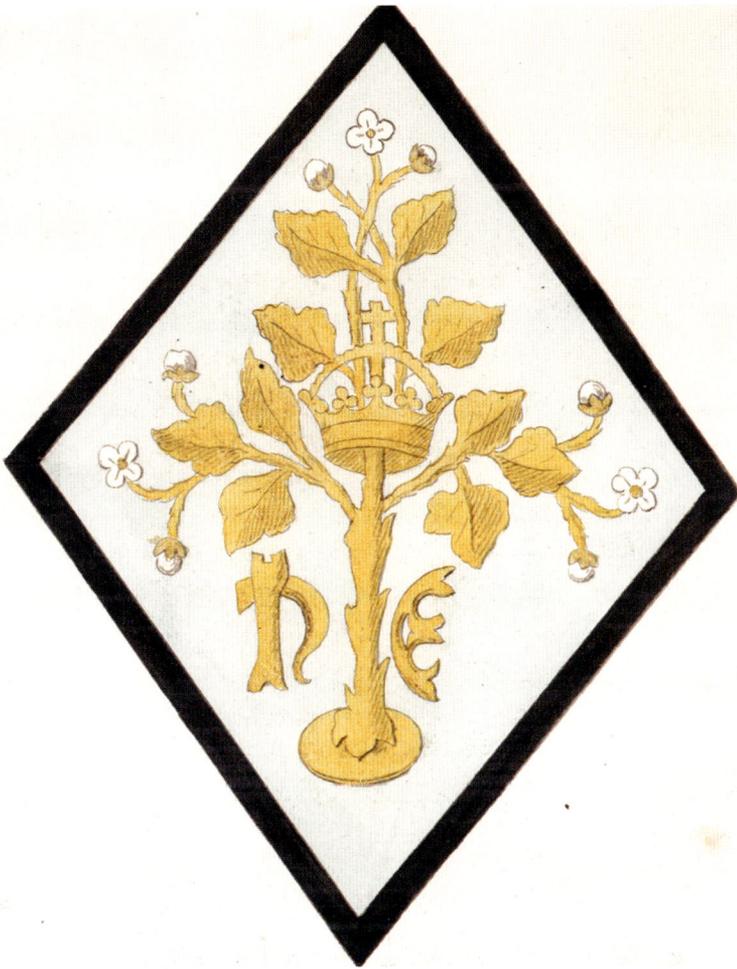

3.45 Stained glass from Green Closet: crown in a thorn bush

associations are not usually explained by Walpole in this case he elucidates on the 'other curious panes' recording significant historical events:

… one with a rose impaling a pomgranite, the device of Henry 8th. And Catherine of Arragon; others with a crown in a thorn-bush between the letter H and E, the device of Henry 7th, which he assumed after the battle of Bosworth, where Richard's crown was found in that manner.[147]

Many of the pictures in this closet also had their own story to tell, some notorious, for example a 'view of Mr. Pope's house at Twickenham, painted since the alterations made by sir William Stanhope [1702–1772]' an act which Walpole deplored. There was also 'a portrait of Sarah Malcolm [1710–1733] who was hanged for murdering her mistress and two other women in the Temple … the day before her execution.'[148]

The Blue Bedchamber, overlooking the garden and en-route between the Refectory and the Library is also located in the original small-scale building.

This was Walpole's original bedroom and was completed to his design. It had a Bentley-designed fireplace and contained a large quantity of glass to enable a visual connection with the landscape. The main theme was Walpole's family and their patronage of the arts and it was hung with over a 100 portraits of close friends and family. There was artwork by John Giles Eckardt (or Eccardt, 1720–79), Grinling Gibbons (1648–1721), Van Dyck (1599–1641), Gray and Bentley all of whom the Walpole family had supported as patrons. A portrait of Robert Walpole as Chancellor of the Exchequer 'leaning against busts of George 1st and 2nd to denote his being first minister to those kings', demonstrating his powerful political position; beside him, with her peculiar emblems lady Walpole with 'flowers, shells, a pallet and pencils, to mark her love of the arts.'[149] There was also the portrait by Eccardt of Walpole holding his first book, *Aedes Walpoliana*, the catalogue of Robert Walpole's art collection at Houghton. This portrait (1754) and those of his friends Bentley and Gray, by the same hand, portray the sitters in historicised seventeenth-century costume: 'Mr Walpole; from Vandyck; leaning on Ædes Walpolianæ: behind him a view of Strawberry Hill. The frames are of black and gold, carved after those to Lombard's prints from Vandyck, but with emblems peculiar to each person' (see Fig P.1).[150]

In Walpole's case, the emblems depict him with his first publication as an art historian and as antiquarian portrayed through the presence of the Gothic Strawberry Hill in the background. Gray's particular emblems are a motto which alludes to his role as a poet and author of *Ode on a Distant Prospect of Eton College* (1742) which had been published in 1753 with illustrations by Bentley, commissioned by Walpole. He had described the combination of modern and ancient decoration of the chamber in a letter to Bentley:

The bow-window room over the supper parlour is finished: hung with a plain blue paper, with a chintz bed and chairs, my father and mother over the chimney in the Gibbons frame, about which you know we were in dispute what to do. I have fixed on black and gold, and it has a charming effect over your chimney with the two dropping points, which is executed exactly; and the old grate of Henry VIII which you bought, is within it. In each panel around the room is a single picture; Gray's, Sir Charles William's, and yours, in their black and gold frames; mine is to match yours; … you can't imagine how new and pretty the furniture is. – I believe you must send me an attestation under your own hand that you knew nothing of it, that Mr Rigby may allow that at least one room was by my own direction. As the library and great parlour grow finished, you shall have exact notice.[151]

The next room described is the Red Bedchamber, with a window overlooking the garden. This is, 'Mr Chute's bedchamber, hung with red in the same manner' as the Yellow Bedchamber, with, 'prints, framed in a new manner … that is, with black and white borders printed'.[152] There was also a sketch by Kent, and portraits of Pope and members of his family that had belonged to the poet.

Only on leaving this room does the visitor emerge into the top-lit staircase proper to view the gloomy niches displaying armour and weaponry on the dimly-lit landing below that they had momentarily glimpsed on entering the house. The Armoury was one of the most important and innovative, if somewhat diminutive, spaces in the castle, evoking a medieval concept.

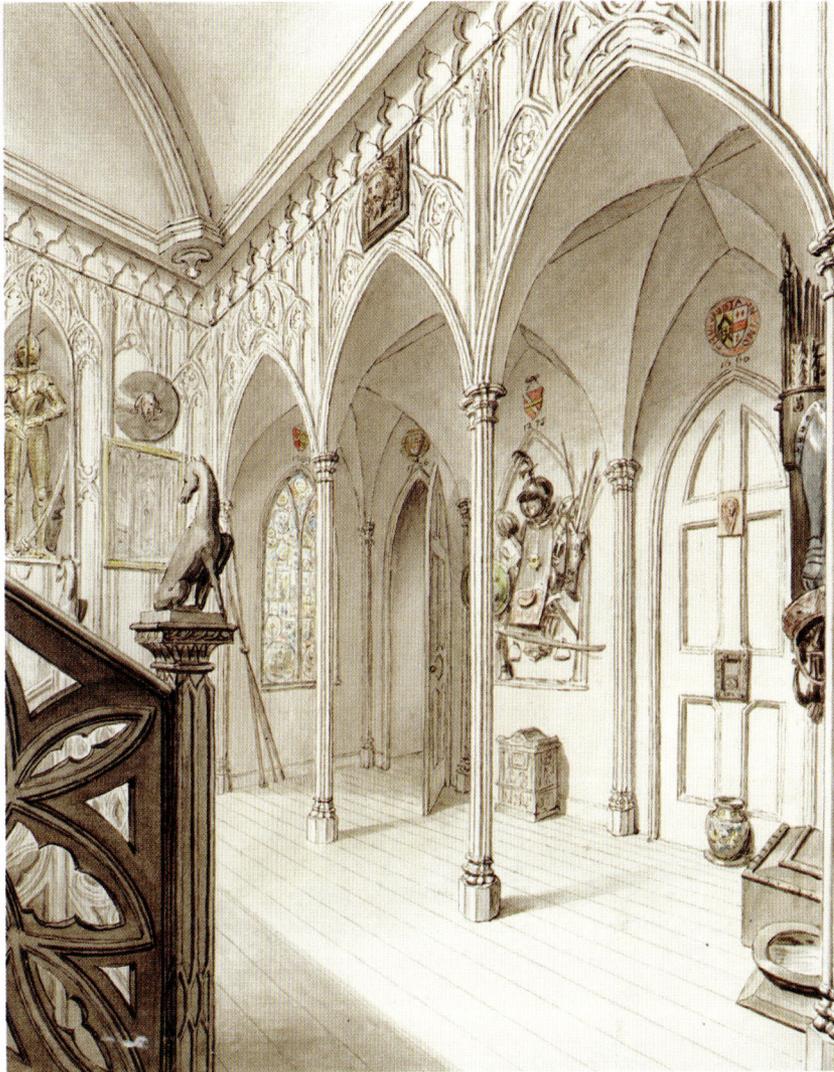

3.46 Hall and Armoury, J. Carter

The armoury is a recreation, in miniature, of a Gothic baronial hall, recalling in the display of armour his ancestors' supposed participation in the crusades. The inspiration behind this display was probably his visit to the Palazzo Caprara, Bologna, during his Grand Tour where he observed a similar arrangement of armour and artefacts. He wrote to West: 'We have seen a furniture here in a much prettier taste; a gallery of Count Caprara's: In the panels between the windows are pendant trophies of various arms taken by one of his ancestors from the Turks. They are whimsical, romantic and have a pretty effect.'[153] The collection of armour and weapons also enhanced the perception that the visitor was in an ancient medieval house further consolidated with Gothic arches and the armorial quartering's of Walpole's ancestors painted on the walls, deliberately displayed to link back to the

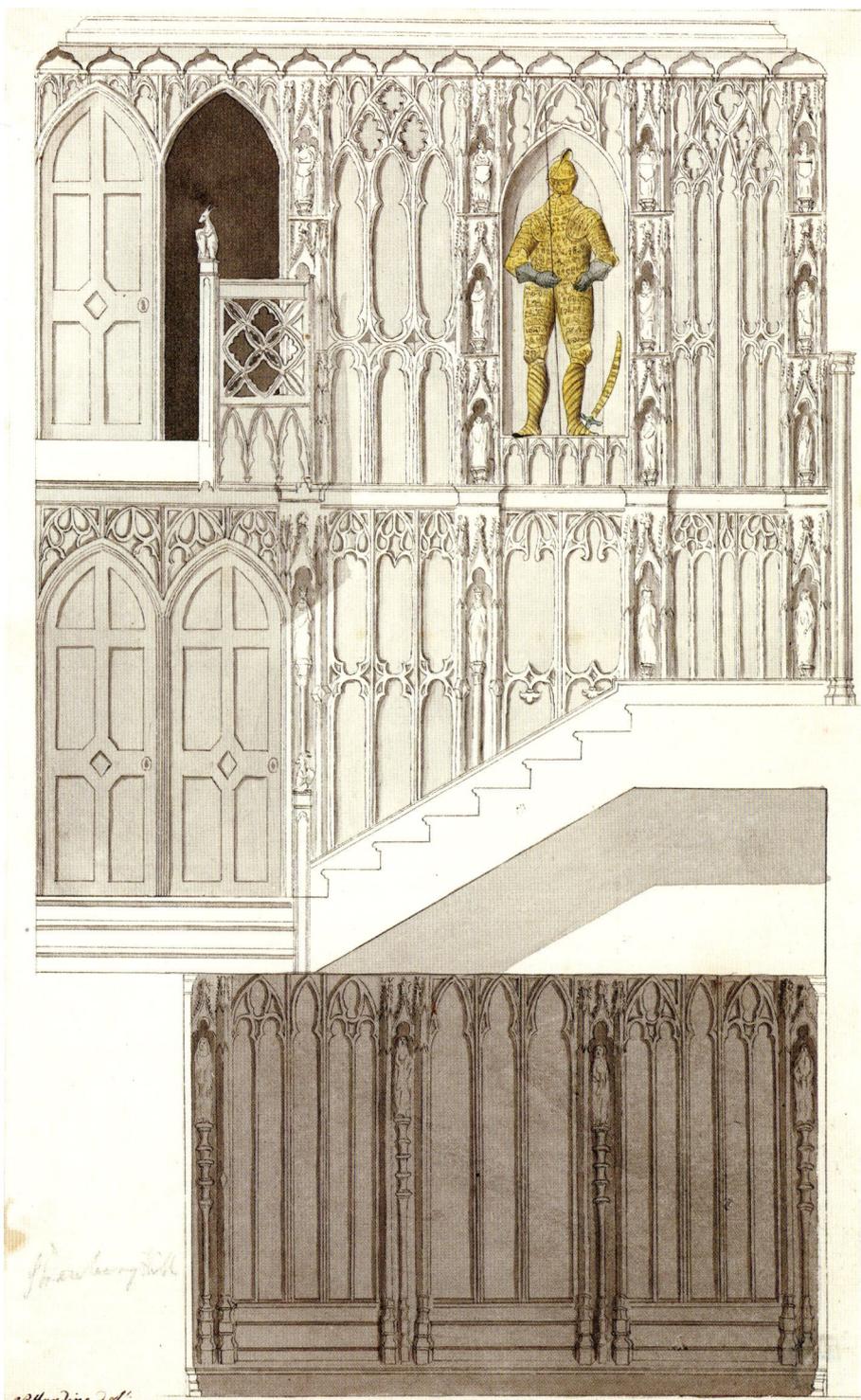

3.47 Elevation of the Hall with Francis I armour, G.P. Harding

crusaders and through association to the Tudors and earlier kings in the iconography of the Hall and Staircase: '… a vestibule [Armoury] open with three arches on the landing place, and niches full of trophies of old coats of mail, Indian shields made of rhinoceros's hides, broadswords, quivers, long bows, arrows and spears – all *supposed* to be taken by Sir Terry Robsart [1464–?] in the holy wars.'[154]

This is a prime example of how Walpole constructs a complex fiction for the building and the artefacts that decorate it in this significant public space. He implies that his ancestor fought in the crusades and links Robsart through the placement of dynastic portraits of the House of Lancaster to his own ancestry:

Henry 5th and his family … this picture came out of Tart-hall, Westminster; and I imagine that this, and two others of Henry 6th and 7th. were done by order of Henry 7th. In honour of the house of Lancaster. I have heard that that of Henry 6th came out of the palace of Shene.[155]

Walpole corresponded with Cole informing him why the acquisitions of portraits belonging to the House of Lancaster were so important to him:

In short, I have bought his two pictures of Henry V and Henry VIII and their families … But in fact, these two with my marriages of Henry VI and VII compose such a suite of the House of Lancaster, and enrich my Gothic house so completely, that I would not deny myself … I have bought much cheaper at the same sale a picture of Henry VIII and Charles V in one piece, both much younger than I ever saw any portrait of either.[156]

Walpole's fascination with English monarchs continues with the placement of a head of Henry III (1207–1272) who had fought the feudal barons over the Magna Carta (1215):

Over the middle arcade is a curious ancient head of Henry 3d. carved in alto-relievo on oak from the church of Barnwell near Oundle in Northamptonshire which he endowed. The head is very like to the effigies on his tomb, and to that in painted glass in the chapel here at Strawberry Hill.[157]

Walpole acquired weapons and other objects suitable for display in the niches on the staircase, culminating in 1771 with a suit of armour to enhance its Baronial posturing as an ancient display of combat armour. This later acquisition retrospectively also made a subtle visual association with the Gothic villa as the imaginary *Castle of Otranto*: 'I am making a very curious purchase at Paris, the complete armour of Francis the First (1494–1547). It is gilt in relief, and is very rich and beautiful. It comes out of the Crozat collection'.[158] Francis I's armour, though, most obviously connects with the Tudor theme as the French King had attempted to negotiate an alliance with Henry VIII on the Field of Cloth of Gold in 1520.

In a light-hearted letter to his friend Lady Mary Coke (1727–1811), to whom he dedicated the second edition of *The Castle of Otranto*, Walpole describes dressing up as her 'mock hero' with items from his own collection:[159]

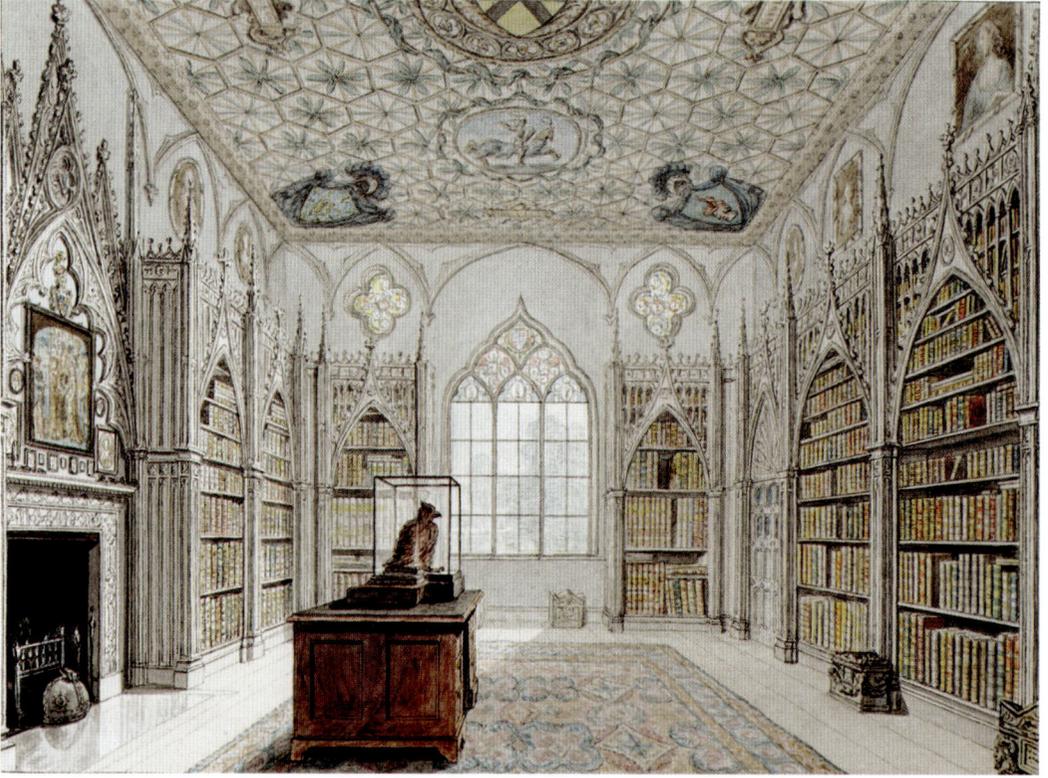

3.48 The
Library, J. Carter

… other great men have been made heroes, whom nature never intended for the profession, yet I cannot help laughing to think what a figure I shall make! for I am too much a Goth and not so much a hero, but I will be completely armed – and from my own armoury here. A rusty helmet with rotten wadding; a coat of mail which came from Coombe, and belonged to a trooper of the Earl of Warwick; it will be full heavy for my strength, but there is a mark of it being bullet-proof – alas! I had forgot I am to be shot – one gauntlet; I have no more; a Persian shield enamelled, a Chinese bow, quiver and arrows, an Indian sabre and dagger, and a spear made of wood with fifty points.[160]

The window on the staircase unites the display with the supposed monastic foundations of this part of the house and is described in *A Catalogue of the Classic Contents of Strawberry Hill Collected by Horace Walpole …* (1842) as 'The small window of fine old stained glass, including the following subjects, Abraham and Isaac, Lot and his brother separating, Isaac and Rebecca at the Well and 4 others.'[161]

Architecturally the most accomplished and sustained essay in Walpole's Gothic interior was his Library which suggested the monastic scholarship of an abbey. The design brought together three great ecclesiastical buildings, using architectural quotations from Canterbury Cathedral, Old St Paul's and Westminster Abbey in this impressive space. Impressions of the room as an ancient structure were enhanced by the idea of depth and fortification created through wall thicknesses where the doorway was cut through at an angle.

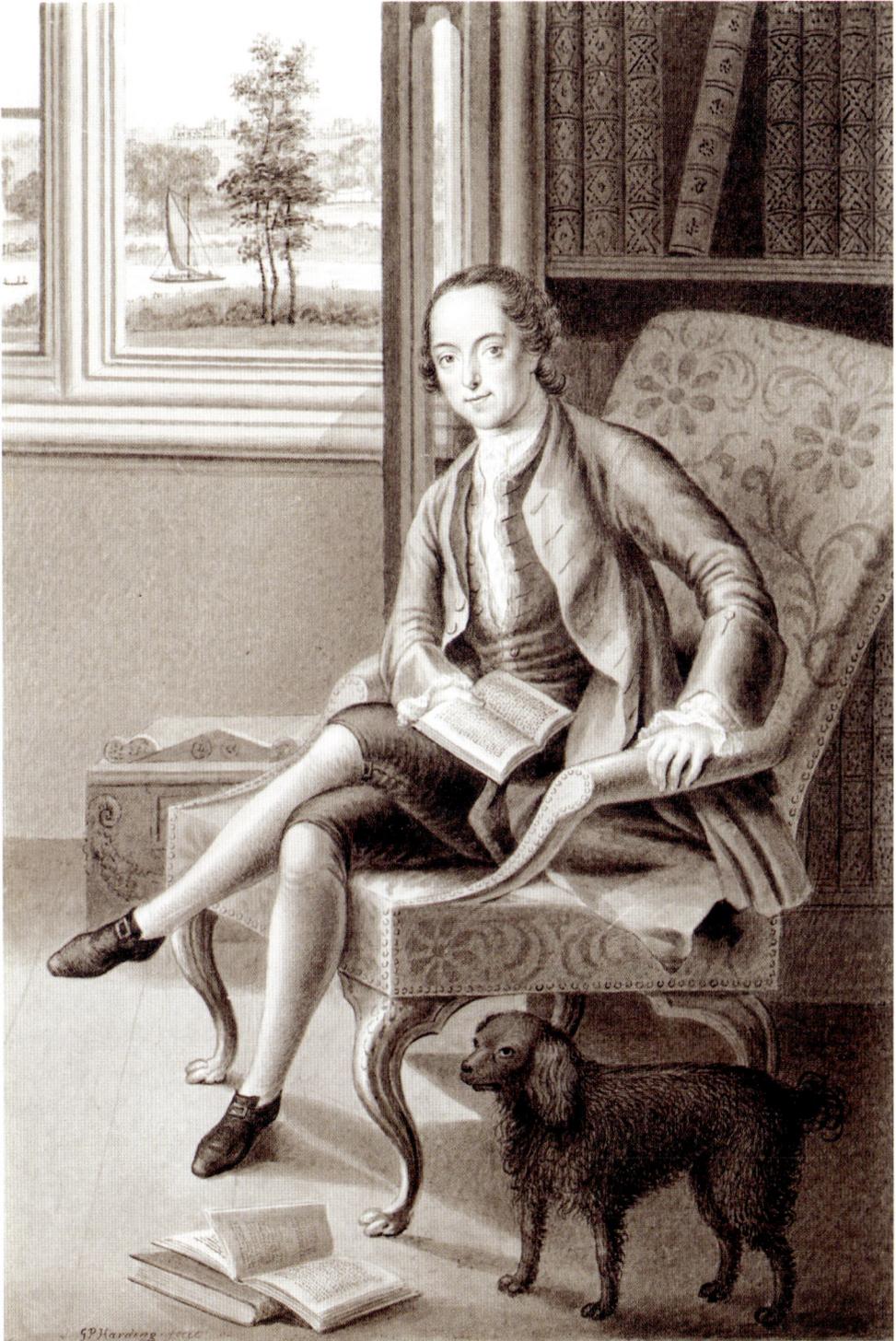

3.49 Portrait of Horace Walpole in his Library G.P. Harding, after J. Müntz

Walpole's letter to Bentley confirms its monastic connotations: 'You will allow that when I do admit anybody within my cloister, I choose them well. My present occupation is putting up my books; and thanks to arches, and pinnacles, and pierced columns, I shall not appear scantily provided!'[162] The contents of the Library, its iconography and decorative scheme, furnishings, painting and statuary, made significant statements regarding the status and aspirations of its creator, proclaiming Walpole as scholar and connoisseur and associating his history with that of the English nation.

Walpole's extensive book collection, including the Wenceslas Hollar prints, used for the design of the library, were 'arranged within Gothic arches of pierced work, taken from a side-door case to the choir in Dugdale's *St Paul's*. The doors themselves designed by Mr Chute'.[163] The arches were wood carvings painted stone colour, rather than the stone of the original. *The Ambulator* records that '*The Library* contains a select collection of books, and books of prints among which are many volumes of English portraits, from the earliest to the present times.'[164]

The monumental chimneypiece reproduces elements from two Gothic tombs. The first is 'imitated from the tomb of John of Eltham [1316–1336], earl of Cornwall, in Westminster-abbey; the stone-work from that of Thomas duke of Clarence at Canterbury.' John of Eltham was one of the Plantagenet Kings and heir to the English throne (1327–30). He died at the age of 20 but not before some accounts report that he was responsible for burning Lesmahagow Abbey when it was occupied. Thomas of Lancaster, 1st Duke of Clarence (1387–1421), second son of Henry IV (1366–1413) was also a Plantagenet. Other Plantagenets are also represented: 'Over the chimney, an ancient and valuable piece, representing the marriage of Henry 6th, which was surmounted by his arms.[165]

Walpole's lineage and personal history and links to other royal and national histories were made through architecture, decorative elements and portraiture. English kings were represented, portraits of Henry VI, Henry VIII, and the first Stuart King, James I were juxtaposed alongside Walpole's family portraits, linking their history with kingship. The windows also contained the largest display of stained and painted glass including, 'a large shield of the arms of England', and shields of Prince Arthur, 1st son of Henry VII from New College, Oxford and the Roses of York and Lancaster, a layer that celebrates Tudor history, as in other rooms.[166] Charles I and II, Royal Coats of Arms and knights in roundels are also displayed in the heraldic glass amid colours associated with heraldry. Classical antique and other objects decorated the room, including a clock, 'a present from Henry 8th. to Anne Boleyn [1501–1536]' … 'on the top sits a lion holding the arms of England, which are also on the sides', with Walpole's extensive collection, including rare books and prints lining the walls.[167]

Walpole played a major part in the decorative scheme for the ceiling in the library painted with heraldic motifs to his own design, providing Bentley with a sketch of the impression he wanted to create which Bentley would 'adjust and dimension' for the work to be carried out:

I must apply to you for my library ceiling; of which I send you some rudiments. I propose to have it all painted by Clermont; and the principal part in chiaroscuro, on the design which you drew for the Paraclete: but as the pattern would be surfeiting so often repeated in an extension of 20 feet by 30, I propose to break and enliven it by compartments in colours, according to the enclosed sketch, which you must adjust and dimension.[168]

3.50 Designs for the ceiling in the Library at Strawberry Hill, Horace Walpole, 1754

The ceiling with his supposed crusader antecedents and their family motto, 'to say what one feels' were prominently displayed in Latin in the heraldic ceiling decoration which was carried out by Jean-François Clermont (1717–1807), at a cost of 70 pounds.[169] The inspiration is surely the Gothic Temple at Stowe which Walpole had seen in 1753, the year prior to the ceiling decoration at Strawberry Hill. He describes the ceiling of Gibbs's building to Chute as 'all filled with the arms of the old peers of England, with all quarterings entire.'[170]

The Gothic detailing on the Strawberry Hill ceiling framed portraiture and crusader motifs and Saracen devices from the tombs of his remote ancestors and putative crusaders. Walpole's inclusion of Lord Ludovic Robsart, Lord Bourchier, K.G; who had been standard bearer to Henry V at Agincourt, is an association he particularly values:

In the middle is the shield of Walpole surrounded by the quarters borne by the family. At each end in a round is a knight on horseback, in the manner of ancient seals; that next to the window bears the arms of Fitz Osbert, the other of Robsart. At the four corners are shields, helmets and mantles; on one shield is a large H, on another W, semèe of cross crosslets, in imitation of an ancient bearing of the Howards in Blomfield's Norfolk. On another shield is the Saracen's head, the crest

of the family, but here the Catherine-wheel is above the cap, not on it; having been so borne by the Robsarts, as appears from a tomb of Ludovic Robsart lord Bourchier, in Westminster-abbey. On the fourth shield is an antelope, one of lord Orford's supporters, with the arms about his neck, resting under a tree, as in old devices. On either side is the motto of the family, *Fari quæ sentiat*; at the ends, M.DCC.LIV, the year in which the room was finished, expressed in Gothic letters: the whole on mosaic ground.[171]

Walpole's Blue Bedchamber, from which he had his dream vision, in June 1764, that 'on the uppermost banister of a great staircase I saw a gigantic hand in armour', an event that partly inspired *The Castle of Otranto*, was located on the private second floor.[172] It was largely furnished with portraits of friends, including Chute, and other drawings by friends. Either side of the bed, Walpole hung a copy of the Magna Carta and the death warrant of Charles I. The stained glass too recalled the significant figure of Anne Boleyn, the first English queen to be executed.[173]

This room seems to epitomise Addison's notion of association and recollection connected to people, places and events 'when the fancy thus reflects on the scenes that have passed in it formerly' and his comments of 'how history pleases the imagination'. The chimney-piece had vine-leaf motifs, possibly a visual pun on the Vyne in Hampshire, Chute's country seat. The room has a large window overlooking the garden, rather suggesting that the area of the garden Walpole named 'Anna Bullen's walk', could be seen from here:

The chimney-piece was designed by Mr Chute, and has great grace. In the window, composed of seven lights, are several curious pieces of painted glass; as, the arms of Anne Boleyn with the quarterings which the king allowed her to bear of the families from which she descended though with no right of quartering ...[174]

Cole questioned the provenance of the arms but Walpole insisted that despite his reservations, imaginatively he would continue to associate them with her: 'I should like that they were those of the family of Boleyn; and since I cannot be sure they were not, why should not I fancy them so?'[175] Initially betrothed to Lord Henry Percy (c.1502–37) Boleyn's relationship with him was terminated by Cardinal Wolsey. Anne married Henry VIII in 1533 and gave birth to the future Elizabeth I, but was later imprisoned then executed at the Tower of London in 1536. Henry VIII's desire to obtain an annulment for his marriage to Catherine of Aragon so that he could marry Anne eventually causes the break with Rome, and the Act of Supremacy (1534). This legislation resulted in the English Reformation with his declaration as Head of the Church of England. All these significant historical events stemmed from his relationship with Anne Boleyn who is portrayed in the main theme of this room.

The attempted assassination of Boleyn's daughter, the future Elizabeth I, by a member of the Walpole family is recorded in the next room in the sequence, the Plaid Bedchamber. This chamber was also situated in the South Tower and Walpole sparingly describes this space except to report that it had

the 'portrait of Henry Walpole the jesuit, who was executed for attempting
to poison queen Elizabeth.' The portrait disported the arms of the Walpole
family in one corner of the picture.[176] The Scottish references in this deeply
unfashionable tartan room decoration, surely allude to the Catholic Mary
Queen of Scots being executed for allegedly plotting to kill Elizabeth too.
Thus, once again, 'the last Roman Catholic branch of the family', associates
with a potentially significant event in English history.

Next, are a series of three related spaces, the Star Chamber, trunk ceiled
passage and the Holbein Chamber. The first in the sequence, the Star Chamber
is characterised by 'gloomth' and exudes an air of confinement and restriction.
Walpole's stated intention for the atmosphere of 'The Star chamber and dusky
passage again prepare for you for solemnity.'[177] The nomenclature of the Star

3.52 Passage to the Gallery, and interior of the Holbein Room, at Strawberry Hill, J. Carter (not after 1772)

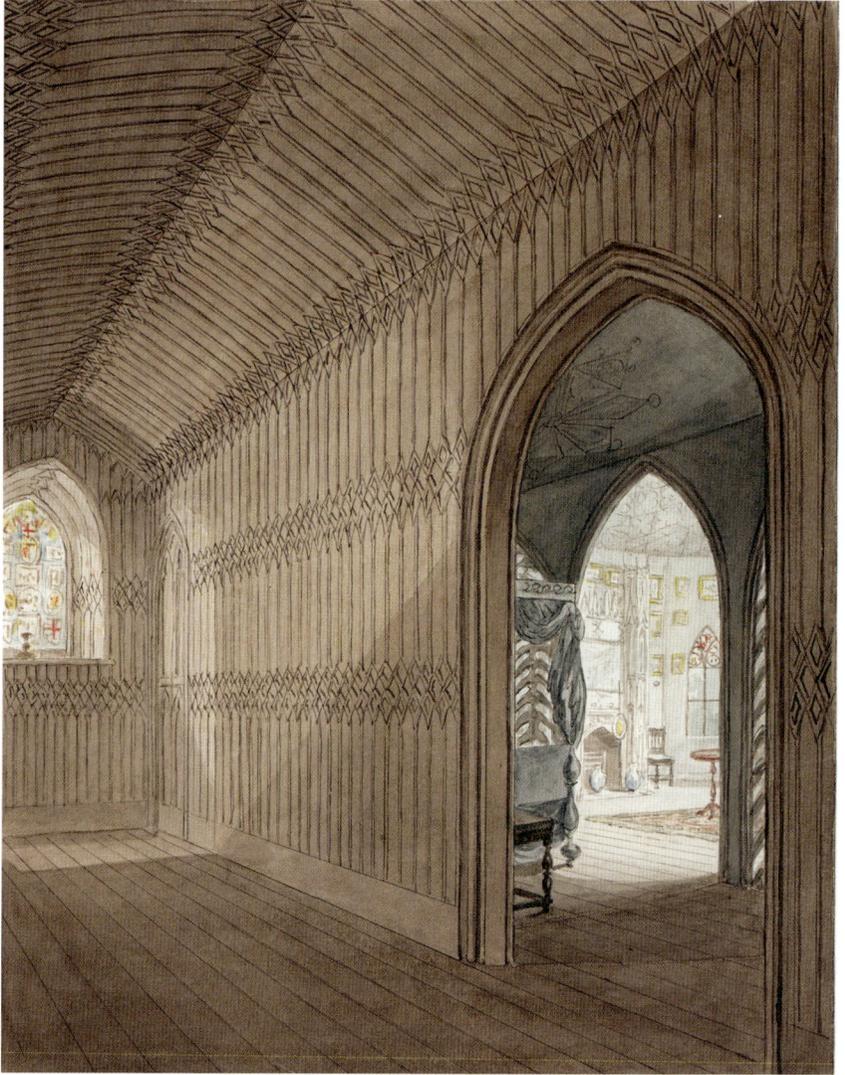

Chamber at Strawberry Hill, complete by 1754, is an architectural quotation from an apartment within the royal palace at Westminster which influenced the design and decoration of the room. It is a 'small anti-room' with 'one large window entirely' filled with painted glass, creating an atmosphere of 'gloomth' and the illusion of a small chapel.[178] At Westminster, during the fourteenth and fifteenth centuries the Star Chamber was used as a court to exercise jurisdiction over the landed gentry and other prominent people and comprised members of the King's Privy Council, including the treasurer, chancellor and other justices. It was widely used as a political weapon under the auspices of Cardinal Wolsey and came to represent the misuse and abuse of power by the monarchy. Walpole placed a bust, which he believed to be

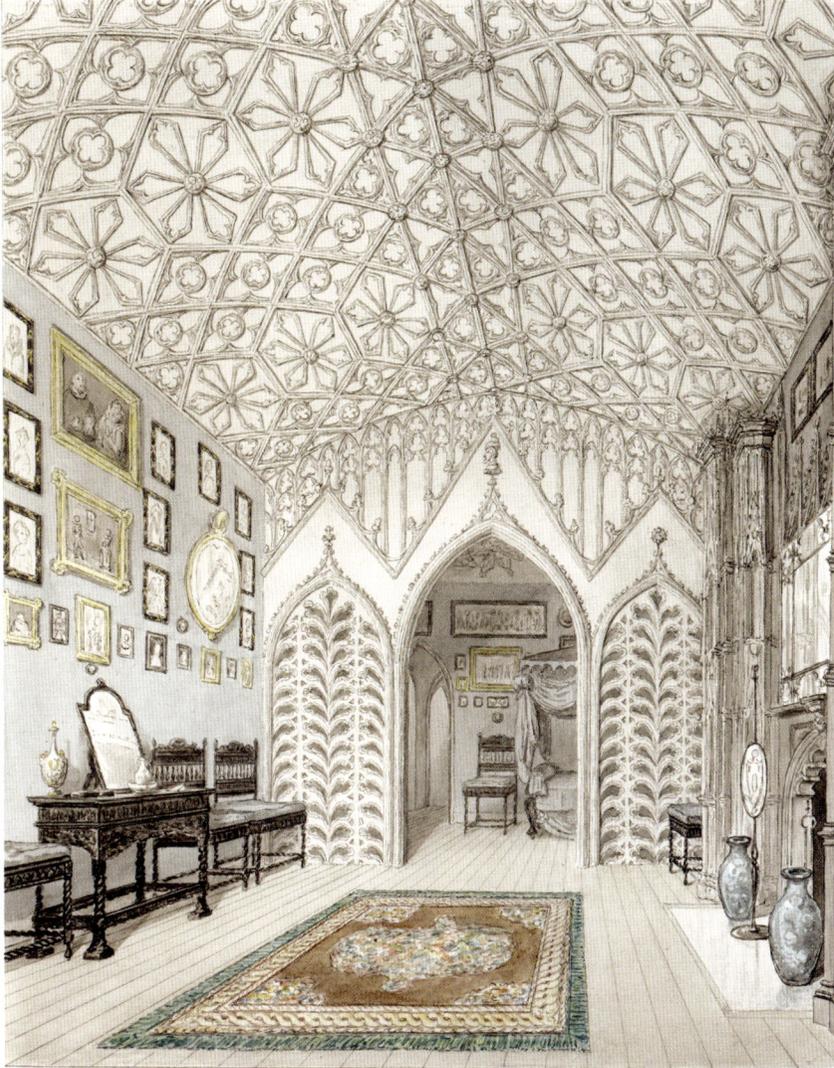

3.53 Holbein Chamber, J. Carter

of Henry VII in agony in the chamber. Henry was responsible for replacing the royal council with the Court of the Star Chamber. Although there is no documentary evidence to support the decorative style, Walpole speculated from his antiquarian enquiries that it contained a ceiling painted with a night sky and gilt stars and this is the form it took at Strawberry Hill. In *Anecdotes of Painting,* Walpole quotes from an early text in the reign of Henry III that contains the first mention of a Star Chamber at Winchester which provides evidence of paint colours and decoration and Walpole followed this colour scheme at Strawberry Hill '… that he cause the chamber at Winchester to be painted of a green colour, and with stars of gold (*and compartments?*), in which may be painted histories from the Old and New Testament.'[179]

From the enclosed, inquisitorial overtones of the Star Chamber, the visitor enters into another small, dark narrow passage resembling those in Oxford Colleges, under-lit by one amber-coloured window.

Walpole describes it as 'a trunk-cieled passage, lighted by a window of painted glass, in which are many quarterings of Latton, a family formerly seated at Esher in Surrey.' Esher Place we recall is a former Wolsey residence which he occupied in his position as Bishop of Winchester.[180] Following his fall from power he was placed under house arrest there, fuelling Walpole's mood of interment.

Walpole makes an immediate connection between these former spaces, Henry VIII and the Holbein Room at Windsor Castle. Although, according to Walpole this chamber is not meant to exhibit the solemnity evoked by the Star Chamber:

… the Holbein-chamber softens that Idea, yet still maintains a grave tone; for
the whole is a kind of Chiaro Scuro. It is hung with purple & has a purple bed.
Almost all the pictures and drawings faintly coloured, & the ebony chairs give the
darkest shade, while the fretted ceiling & and a sprinkling of gold on the frames
afford the lights; as the painted glass darkens part of the windows, & heightens
the landscapes to which they look.[181]

This room, emanating a purple glow, must have come as a surprise and revelation on emerging from the dark passage. The Holbein Chamber was probably constructed to house the newly-acquired collection of Holbein's works. The papier-mâché ceiling designed by Müntz 'is taken from the queen's dressing-room at Windsor', which had been remodelled by Henry VII.[182] The Chamber has an elaborate monumental Portland Stone chimneypiece, the most ornate in the house, based on Archbishop Warham's tomb at Canterbury. Warnham was a useful diplomat in the court of Henry VII who helped arrange the marriage of Henry's son, Arthur, Prince of Wales and Catherine of Aragon. He became the last Catholic Archbishop of Canterbury and Lord Chancellor in 1504 and was succeeded by Wolsey whose red hat hung next to the bed in the room.[183]

The Holbein Chamber, focusing on the early-sixteenth century, consistently evokes and celebrates the Tudor Court of Henry VIII and associated English history. He is a monarch that Walpole praised in *Anecdotes of Painting*: 'The accession of this sumptuous prince brought along with it the establishment of the arts. He was opulent, grand and liberal – how many invitations to artists!'[184]

The Chamber centrally recalls Hans Holbein (1497–1543), King's Painter to Henry VIII and his patrons included Anne Boleyn and Thomas Cromwell (c.1485–1540), Chief Minister to Henry VIII and advocator of the English Reformation. The Chamber was hung with purple paper and a combination of old armorial and newly-commissioned stained and painted glass depicting the Arms of England filled the windows which created very low light-levels which accentuated the landscape views. It too was furnished with carved ebony furniture. The paintings demonstrated a direct link with the Tudor Court and Strawberry Hill and past generations through the placement

3.54 Chimney
piece in the
Holbein Chamber

of courtiers of the Tudor Court – six original Holbeins, and 34 'tracings' of Holbein 'taken off in oil-paper by Vertue from the original drawings of Holbein in Queen Caroline's closet at Kensington, now removed to Buckingham house.'[185] There were also two Holbein sculptures, and seven drawings in the manner of Holbein and six other works by Vertue. Walpole dedicates 34 pages to Holbein in the *Anecdotes of Painting* particularly praising his ability to express character, calling him 'a real genius': 'Holbein was equal to dignified character – He could express the piercing genius of [Thomas] More [1478–1535] or the grace of Anne Boleyn …'[186]

3.55 Chairs
in the Holbein
Chamber

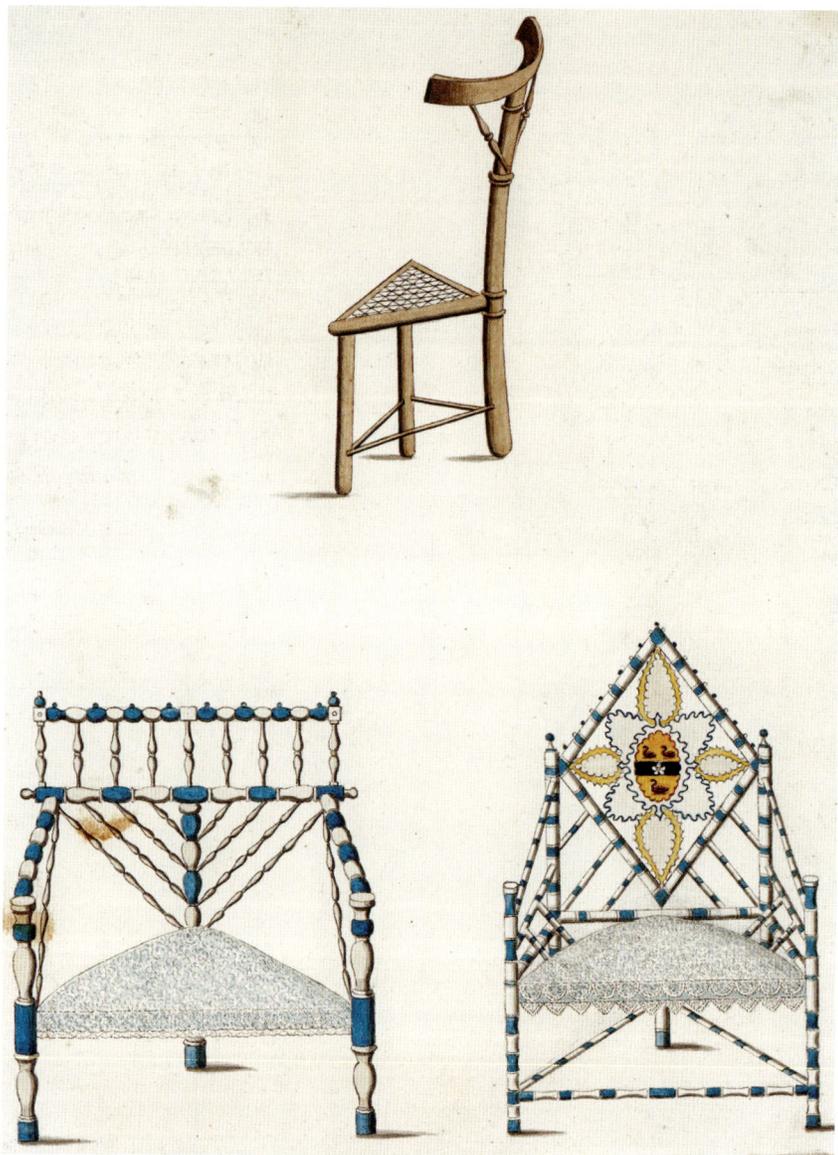

Symbols from Walpole's arms, the crosslet, Saracen's head and Catherine
wheel were weaved into the decorative scheme associating him with the royal
display. Thomas Gray describes to Wharton the effect of the Holbein Chamber
and entreated him to come and see the chamber which was in the 'best tast[e]
he has yet done' and describing the contrasts that Walpole had outlined:

Mr W[alpole]: has lately made a new Bed-chamber [Holbein Chamber], wch
as it is in the best tast of anything he has yet done, & in your own Gothic
way, I must describe a little. you enter a peaked door at one corner of the

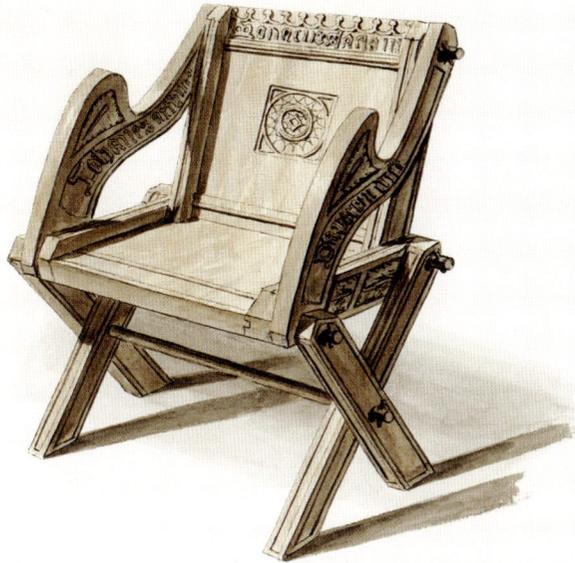

3.56 A very ancient chair of oak, which came out of Glastonbury-abbey, J. Carter

room (out of a narrow winding passage, you may be sure) into an Alcove, in wch the bed is to stand, formed by a screen of pierced work opening by one large arch in the middle to the rest of the chamber, wch is lighted at the other end by a bow-window of three days, whose tops are of rich painted glass in mosaic.[187] the cieling is coved & fretted in star & quatrefoil compartments with roses at the intersections, all in papier-mâché. the chimney on your left is the high-altar in the Cathedral of Rouen (from whence the Screen is also taken)[188] consisting of a low surbased Arch between two octagon Towers, whose pinnacles almost reach the Cieling, all of Nich-work, the chairs & dressing-table are real carved Ebony, pick'd up at auctions. the hangings uniform purple paper, hung all over with the Court of Henry, ye 8th, copied after the Holbein's in the Queen's Closet at Kensington, in black & gold frames. the bed is to be either from Burleigh (for Ld Exeter is new-furnishing it & means to sell some of his original household-stuff) of rich old tarnish'd embroidery; or if that is not to be had, & it must be new, it is to be of cut velvet with a dark purple pattern on a stone-colour sattin-ground. & deep mixt fringes, & tassels. there's for you, but I want you to see it.[189]

The bed which was intended to come from Burghley, the Tudor mansion built by Queen Elizabeth's chief adviser and Lord High Treasurer, Sir Henry Cecil (1521–98), did not materialise, so Walpole commissioned a new one, at a cost of about £90. It was, as Walpole records, 'of purple cloth lined with white satin, a plume of white and purple feathers on the centre of the tester'.[190] He also informed Chute that he had purchased an ancient chair from Glastonbury Abbey to enhance the effect and because it signified an association with the thirteenth century. 'I am deeper than ever in Gothic antiquities; I have bought a monk of Glastonbury's chair full of scraps of the psalms, and some seals of most reverend illegibility. I pass all my mornings in the thirteenth century, and my evenings with the century that is coming on.'[191]

From this chamber Walpole's description leads us through the trunk-ceiled passage, modelled on sixteenth-century precedents: 'the dusky passage [which] makes the richness & largness of the gallery appear much more considerable, tho it is much ornamented to compensate for its having less prospect than the other rooms', into the sumptuous interior of The Long Gallery.[192]

Completed in 1762, it is based on the concept of an Elizabethan Long Gallery and carried out largely to Chute's designs. This was the first in a series of three state chambers which accord with one another in type, though Walpole states 'In the three large rooms a harmony is presented, tho there are differences in all according to circumstances.'[193] In contrast to the previous small-scale rooms of the original building, furnished mostly with ancient furniture, this large room, meant for entertainment, was richly furnished with mainly modern materials and specially commissioned furniture in Gothic style. This expansive, theatrical space, 'FIFTY-SIX feet long, seventeen high, and thirteen wide without the five recesses', is architecturally the most significant room in the house and represents a celebration of the culture of the family.[194] The room is mostly decorated with family portraits and the stained glass in this room celebrates the history of the Walpoles with their quarterings displayed in the upper parts of the windows. Elements of the Gallery are derived from fine Gothic precedents, such as the large door, which is taken from a drawing by Müntz of the north door of St Albans and 'the chimney-piece designed by Mr. John Chute, and Mr. Thomas Pitt of Boconnoch.'[195] The ceiling vaults too are 'taken from one of the side aisles of Henry VII's Chapel' in Westminster Abbey, where Walpole had placed the monument to his mother. 'I am going to strawberry for a few days *pour faire mes pâques*. The gallery advances rapidly. The ceiling is Henry VII's Chapel [Westminster Abbey] *in propiâ persona*: the canopies are all placed …'[196]

The chimneypiece is derived from Archbishop Bourchier's tomb at Canterbury. Thomas Bourchier (c.1404–86) was made Archbishop in 1454 and Lord Chancellor in 1455. He acted as a conciliator during the Wars of the Roses (1455–1487) and was responsible for crowning three English Kings, the Plantagenets Edward IV (1461), Richard III (1483), and the first Tudor King, Henry VII (1486).

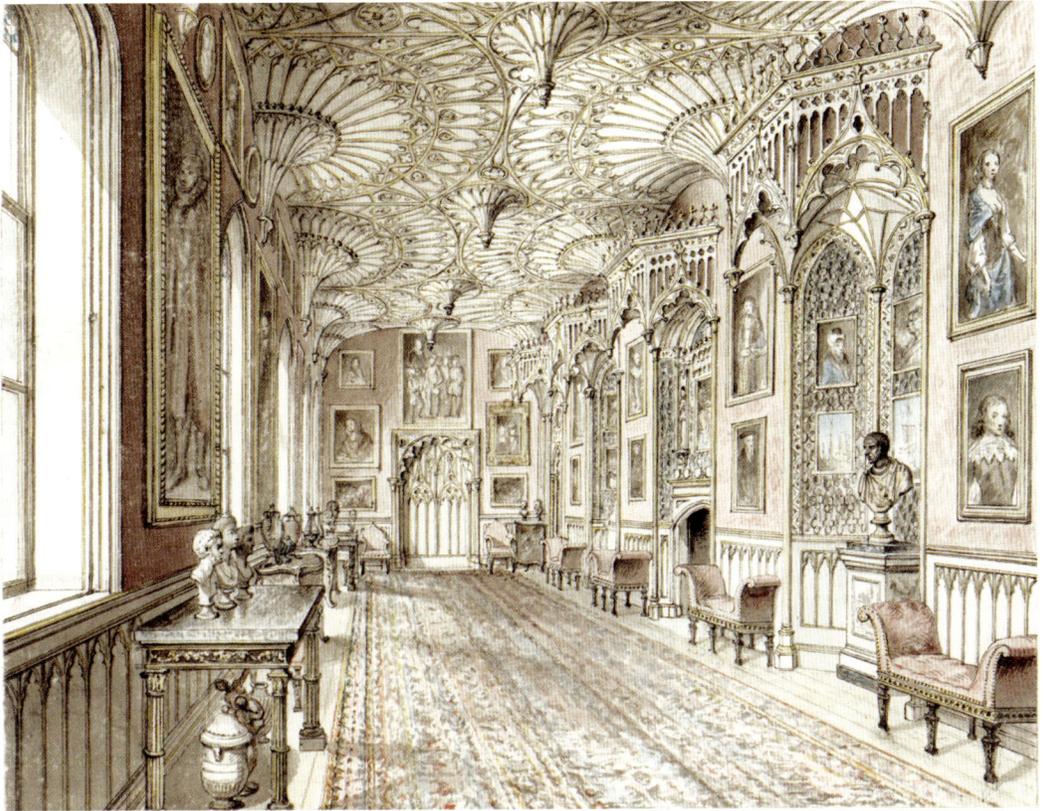

3.57 Gallery at Strawberry Hill, E. Edwards, 1781

The Gallery, despite the Gothic and Tudor elements, nevertheless deviates significantly from Walpole's stated preference for 'gloomth' and Gothic simplicity, which Walpole admits himself: 'My Gallery occupies me entirely, but grows rather too magnificent for my humility; however, having at no time created myself a philosopher, I am at liberty to please myself without minding a contradiction or two.'[197]

This room is the antithesis of the dusky dark and gloomy interiors of the earlier rooms in its impressive scale and luxurious almost baroque decorative scheme. Here there are glittering ornaments with gilt fretwork and an arrangement of glittering mirrored niches with papier-mâché fan-vaulting by Thomas Bromwich of Lydgate Hill. Walpole describes the decoration and furnishing of the Gallery as consisting of 'a high surbase of white & gold, the chairs & settees, tho crimson like the hangings, have frames of black & gold, as have the tables'.[198] Hung in crimson Norwich damask, this opulent, theatrical room was furnished like a picture gallery, displaying large, mostly seventeenth-century portraits, including a portrait of a Jacobean gentleman that also partly inspired Walpole's *Castle of Otranto*. 'The picture quitting its panel, did not you recollect the portrait of Lord Falkland all in white in my gallery? Shall I even confess to you what was the origin of this romance?'[199]

There were also maritime pictures and landscapes hung according to his principles juxtaposed with Classical sculpture such as the Boccapadugli eagle on a pedestal, for which Mann had outbid the Pope. The layout is partially based on the Petit Château at Chantilly which Walpole and Gray visited on their Grand Tour.[200] This influence is admitted to Lady Mary Hervey (1700–1768) almost 30 years later as a source of inspiration:

Chantilly is so exactly what it was when I saw it above twenty years ago, [In May 1739 with Thomas Gray] that I recollected the very position of Monsieur de Luc's chair and the gallery. The latter gave me the first idea of mine; but, presumption apart, mine is a thousand times prettier.[201]

This is a very specific example of how Addison's theory works in practice for Walpole's recollected memories: 'We may observe, that any single circumstance of what we have formerly seen often raises up a whole scene of imagery, and awakens numberless ideas that before slept in the imagination.'[202]

The Strawberry Hill interpretation has five windows on one side with recesses in the opposite wall 'finished with a gold net-work over looking glass', similar to the arrangement at Chantilly, but with six windows and six mirrors opposite. In Walpole's Gallery there is extensive use of mirror work framing the pictures, in the niches, and on the piers, but unusually, rather than placing the mirrors on the piers between the windows, they were on the opposite side to the window wall to create infinite reflection, direct and indirect light, while simultaneously revealing the landscape and bringing it into the room. Walpole also commented on the extensive use of lighting and its brilliant effect. 'To be sure the illumination of the Gallery surpassed the Palace of the Sun; and when its fretted ceiling, which you know is richer than the roof of paradise.'[203]

We recall that Walpole was consistently critical of the display of pictures in ancient English long galleries as the rooms were so lofty, dingy and tasteless that observers were unable to see the pictures. Walpole's Gallery is designed to overcome these difficulties. Filled with direct and reflected light, his finest and largest portraits and other pictures were hung frame-to-frame as outlined in his hanging plan to accomplish the maximum pleasurable effect.

He kept a close eye on the progress of the Gallery admitting that as it nears completion; '… I quit the gallery almost in the critical minute of consummation. Gilder's, carvers, upholsterers, and picture-cleaners are labouring at their several forges, and I do not love to trust a hammer or brush without my own supervisal.'[204]

Walpole appeared somewhat embarrassed by its glittering effect, admitting to his childhood friend and antiquary Bishop Lyttleton 'I shall long to have your Lordship see it, though I shall blush, for it is much more splendid than I intended, and too magnificent for me.'[205] Thomas Gray also commented on its brilliancy to Wharton:

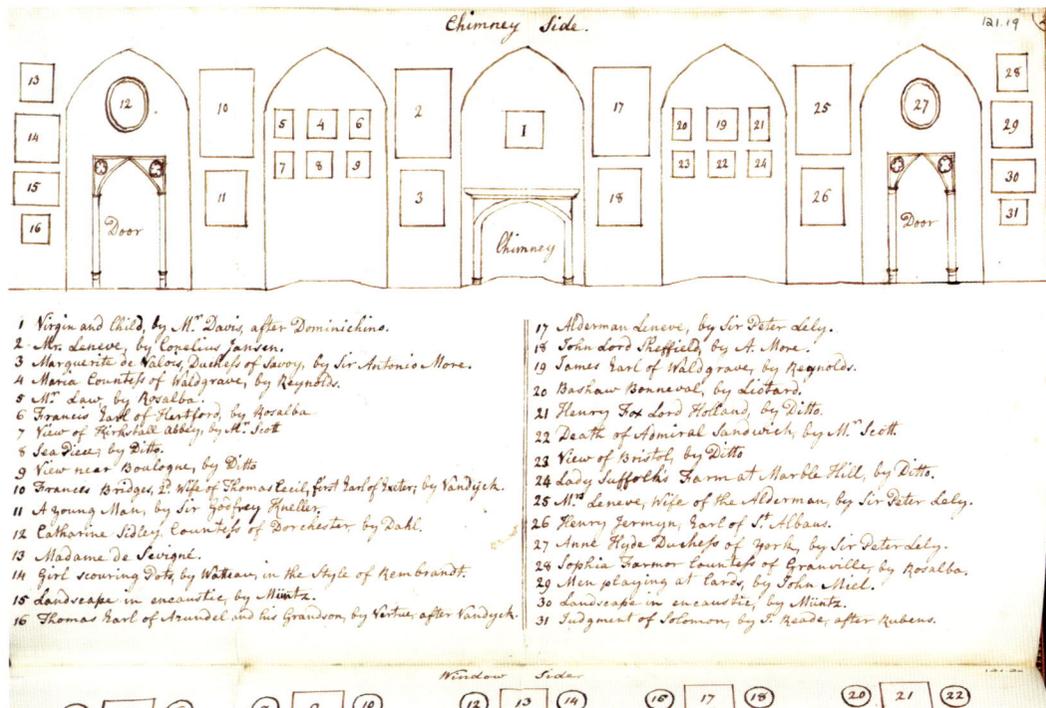

Chimney Side.

1 Virgin and Child, by Mr Davis, after Dominichino.
2 Mr. Leneve, by Cornelius Jansen.
3 Marguerite de Valois, Duchess of Savoy, by Sir Antonio More.
4 Maria Countess of Waldegrave, by Reynolds.
5 Mrs Law, by Rosalba.
6 Francis Earl of Hertford, by Rosalba
7 View of Kirkstall abbey, by Mr Scott
8 Sea Piece, by Ditto.
9 View near Boulogne, by Ditto
10 Frances Bridges, 2d Wife of Thomas Cecil, first Earl of Exeter; by Vandyck.
11 A young Man, by Sir Godfrey Kneller.
12 Catharine Sidley, Countess of Dorchester, by Dahl.
13 Madame de Sevigne.
14 Girl scouring Pots, by Watteau, in the Style of Rembrandt.
15 Landscape in encaustic, by Müntz.
16 Thomas Earl of Arundel and his Grandson, by Vertue, after Vandyck.
17 Alderman Leneve, by Sir Peter Lely.
18 John Lord Sheffield, by A. More.
19 James Earl of Waldegrave, by Reynolds.
20 Bashaw Bonneval, by Liotard.
21 Henry Fox Lord Holland, by Ditto.
22 Death of Admiral Sandwich, by Mr Scott.
23 View of Bristol, by Ditto
24 Lady Suffolk's Farm at Marble Hill, by Ditto.
25 Mrs Leneve, wife of the Alderman, by Sir Peter Lely.
26 Henry Jermyn, Earl of St. Albans.
27 Anne Hyde Duchess of York, by Sir Peter Lely.
28 Sophia Farmor Countess of Granville, by Rosalba.
29 Men playing at Cards, by John Miel.
30 Landscape in encaustic, by Müntz.
31 Judgment of Solomon, by J. Reade, after Rubens.

Window Side

Mr. W: who dined with me, seem'd mighty happy for the time he stay'd, & said he could like to live here [Cambridge]: but hurried home in the evening to his new Gallery, wch is all Gothicism, & gold, & crimson, & looking-glass. he has purchased at an auction in Suffolk ebony-chairs & old moveables enough to load a waggon.[206]

3.58 Pictures in the Gallery – chimney side

The Round Drawing Room, another in the sequence of the newly-created state rooms, was located through a narrow dark passageway at the far end of the Long Gallery. Walpole conveys the overall effect that he wants to achieve through the use of perspective, colour scheme and its restful, anticipatory nature:

The round room with its great bow-window of painted glass terminates the Gallery to great advantage by the perspective & colours, & has more effect than the same window in the gallery, by leaving room for some expectation. The pictures in it are few & in large spaces, but fine, & give an air of repose & grandeur which many pictures destroy. The Gallery is for the pictures, but the pictures in the round room serve as furniture.[207]

The scagliola chimneypiece, derived from the shrine of Edward the Confessor (c.1003–66) in Westminster Abbey was 'improved by Mr Adam':

For this year past, I have been projecting a chimney in imitation of the tomb of Edward the Confessor, and had partly given it up, on finding how enormously expensive it would be. Mr Adam has drawn me a design a little in that style, prettier it is true, and at half the price.[208]

3.59 The
Round Drawing
Room, J. Carter

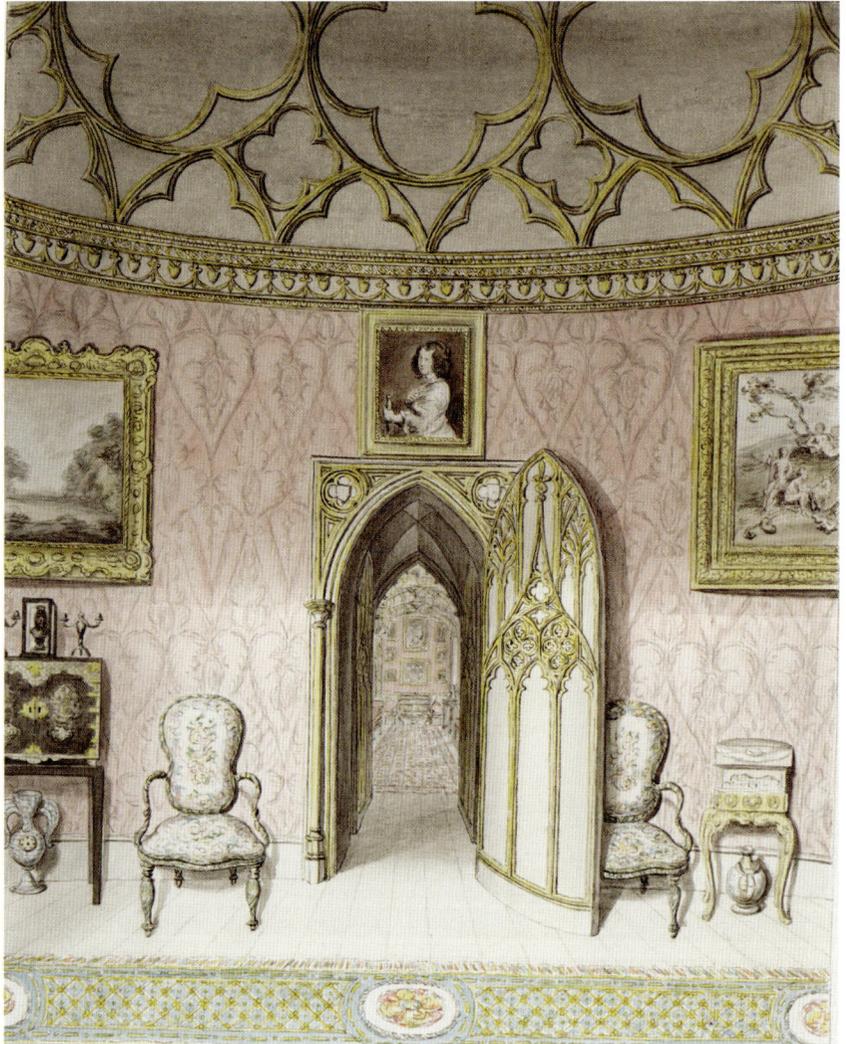

Walpole intended to make an explicit link with English history and Westminster Abbey which Henry III had rebuilt in the thirteenth century. Henry III was responsible for the Saxon King, Edward the Confessor being reburied in the Abbey and he was also the first Plantagenet monarch to be temporarily buried there, in the same tomb as Edward the Confessor, until his own sarcophagus was completed. The association is made explicit by Cole, responding to Walpole's request for him to visit. 'I long to take a walk in your gallery and give a peep into the round chamber. I shall then more than fancy I am in some castle in King Edward III's time.'[209] Walpole gives precise instructions to Adam for detailing the room, except for the Gothic panelling of the bay-window which was based on the tomb of Eleanor of Castile (1241–90), first Queen Consort to Edward I (1239–1307), mother of Edward II (1284–1327) and grandmother to Edward III (1312–77), the iconography linking the dynasty:[210]

Mr Walpole has sent Mr Adam the two books, and hopes at his leisure he will think of the ceiling and chimney-piece. The ceiling is to be taken from the plate 165 of St Paul's, the circular window. The chimney from the shrine of Edward the Confessor, at Westminster. The diameter of the room is 22 feet. The enclosed little end is for the bed, which Mr Walpole begs to have drawn out too.[211]

The 'great bow window', was filled solidly with stained glass to prevent exterior views which could be seen on approaching from the Gallery. The window therefore appeared more effective seen in perspective through narrowing doors. The painted glass depicted 'a large shield of the arms of Robert Dudley earl of Leicester' (1532–64), an intimate friend of Elizabeth I. 'Under it a thornbush with H R, the device of Henry 7th; arms of queen Elizabeth … other arms of nobility.'[212] Originally designed as a bedchamber, it never functioned as such, but was used like a private state bedchamber for entertaining and receiving visitors. The harmonious, modern decorative scheme was similar to that of the Gallery, '… crimson likewise, as the damask goes to the skirting board, the chairs are tapestry with green & gold frames that correspond with the pillars of the chimney.'[213] The link with the concept of royal bedchambers is made explicit in a letter to Mason. 'The circular drawing-room was worthy of the presence of Queen Bess, as many of the old ladies, who remember her, affirmed …'[214] The *Ambulator* describes the Round Room thus: 'lighted by a window of fine painted glass, is richly ornamented, and has a beautiful chimney-piece of marble, gilt and inlaid with scaliogla. The few pictures in this room are by great masters …'[215]

Entered or viewed from the dazzling Gallery, the mood of the next room in the sequence, the Tribune was in complete contrast with an air of solemnity and 'gloomth' created by dense painted glass by William Price II.

The Tribune variously known as the Chapel or Cabinet suggests that Walpole was ambivalent about the precise theme that he wanted to emphasise and this is supported by the heterogeneous nature of the collection it displayed. However, the mood he intended the space to convey is made clear when he states that 'The Chapel has a true air of a place of Devotion & that impression makes it please, tho seen after so much larger spaces. The number of curiosities in it takes up the attention, & seem to be the completion of the collection.'[216] Made to contain Walpole's finest things, 'kept under lock and key' and named after the Tribuna, the room of treasures at the Uffizi in Florence, but here the tracery is made of papier-mâché.[217] The stone-coloured vault with gold ornament is said to be taken from the Chapter House at York Cathedral but the flowering tracery is derived from the west window of York. The Tribuna was sparsely furnished, designed to be an internal space with no exterior views to detract the attention from the hundreds of treasures displayed within which included portraits of Henry VIII's wives and what Walpole believed to be 'Henry 8th's dagger' and 'a small bust in bronze of Caligula … found, at the very first discovery of Herculaneum.'[218]

3.60 Cabinet at
Strawberry Hill,
E. Edwards, 1781

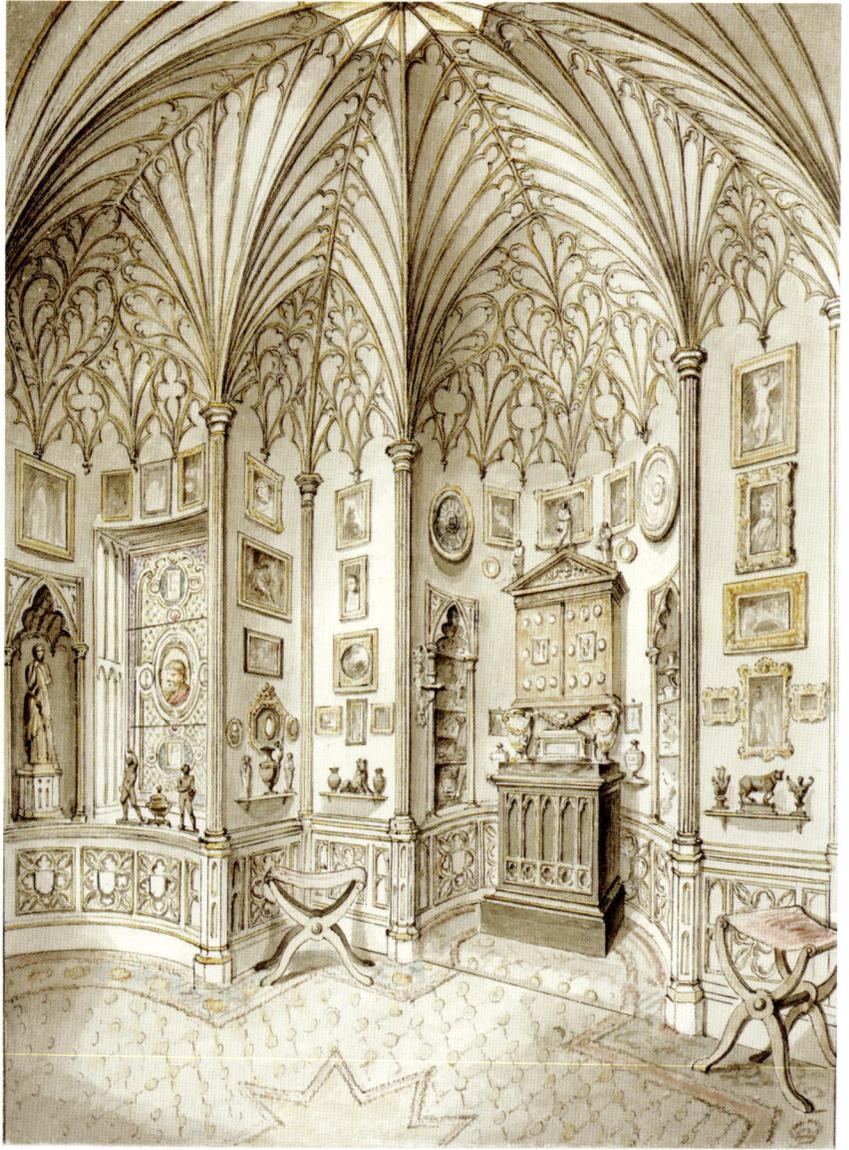

The majority of the design is Chute's but the pattern for the niches is, like
those in the Gallery, taken from Müntz's drawing of the north door of St
Albans. The Gothic grated door, painted to resemble ironwork, was designed
by Pitt. A stone-coloured medieval chapel-effect was created through the use
of stained glass in this Gothic space although influences of Italian medieval
architecture and Renaissance classicism were evident through the architecture
and the display of sculptures, bronzes and other items redolent of a cultured
well-travelled Grand Tourist's collection. The model for his Mother's cenotaph
in Westminster Abbey was also displayed among a vast profusion of objects,

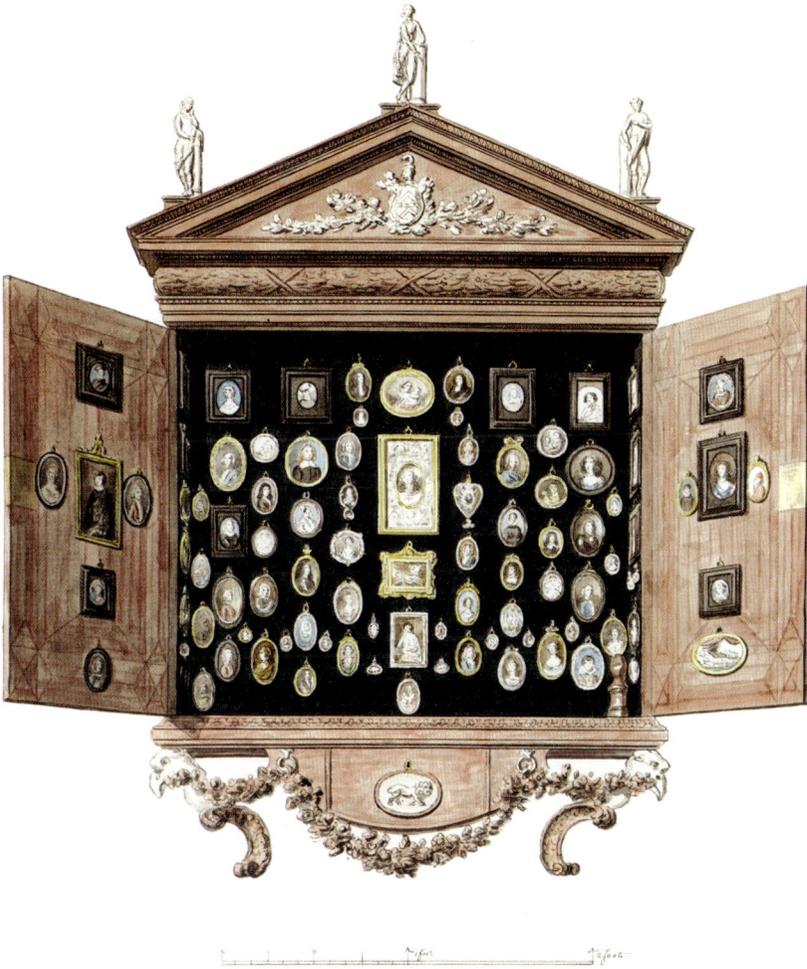

pictures, and artefacts.[219] A star-shaped moon-strip containing yellow stained glass of the type used in churches was located in the ceiling, 'that throws a golden gloom all over the room.'[220]

Continuing the dynastic theme of the previous room Walpole records, 'On the right hand stands an altar of black and gold, with a marble slab of the same colours, taken from the tomb of two children of Edward 3d. in Westminster Abbey.'[221] Over the altar was the most prominent feature, 'a cabinet of rosewood, designed by Mr. Walpole.'

The Classical hanging cabinet, with his arms in the pediment, contained Walpole's treasured objects and his collection of enamels and miniatures, many of them of kings, queens, royal courtiers and other illustrious historical people. The room also contained an innovative, moveable, rectangular window frame filled with densely painted glass to create 'gloomth' that could be removed to admit light, depending on the effect the circumstances

required. A letter from Walpole to Mann confirms that his aim for the chapel is to convey an atmosphere for the Cabinet, 'that is to have all the air of a Catholic chapel – bar consecration.'[222] Walpole informed Montagu of progress on the building and the impression the Chapel was to make: 'The chapel is quite finished, except the carpet. The sable mass of the altar gives it a very sober air, for notwithstanding the solemnity of the painted windows, it has a gaudiness that was a little profane.'[223] The desired effect was accomplished and recorded in the *Ambulator*:

This little room is beyond conception splendid and enchanting. Entire windows of painted glass, in which are heads of Christ and two Apostles, surrounded with beautiful mosaics, a star of yellow stained glass in the centre of the dome; the carpet, imitating the mosaic of the windows and the star in the ceiling; and the gilt mouldings and ornaments; all conspire to throw such a golden gloam over the whole room, as to give it the solemn air of a Romish Chapel; especially when first viewed through the grated door. The pictures, bronzes, antiquities, gems, and curiosities, are too numerous to be detailed. But one thing we must notice; a small silver bell, of the most exquisite workmanship, covered over with lizards, grasshoppers, and other insects, in the highest relief, by Benvenuto Cellini.[224]

In a letter to Conway, Walpole repeats Lady Ailesbury's compliments on the ancient air he has managed to convey in the Tribune: 'that it is the finest, the prettiest, the newest and the oldest thing in the world …'[225]

Next, a small passage led to the 'very royal chamber', the Great North Bedchamber, a name which alludes to the sixteenth and seventeenth century equivalent in ancient great houses.

Designed by Chute, it was the last room constructed and like the Gallery, hung with crimson Norwich damask. Following the sombreness of the Chapel, the Great Bedchamber is meant for contrast and to inspire surprise and awe in the visitor on the principles outlined by Addison, of being 'new or uncommon' thereby filling 'the soul with an agreeable surprise' that 'gratifies curiosity':

The sobriety of the Chapel, & the idea of having seen all the House, make the opening of the great bedchamber the more surprising, from its not being expected, & from the striking con:trast between the awe impressed by the Chapel, & the gush of light, gaudiness & grandeur of the bedchamber, in the midst of which Stands the Tapestry bed, glowing with natural flowers in wreaths on a white ground. I have seen a much finer bed of Tapestry at Versailles, the whole effect of which is lost, by the hangings being exactly of the same colours. Here the room is hung with a deep rose colour which sets off all the others.[226]

Walpole insists that its gaudy tones are offset by more neutral colours to harmonise them with the overall dusky Gothic tone of the house and he emphasises the important connection of the room with the landscape:

In the State bedchamber, there are half the chairs of tapestry to suit the bed, with white and gold frames against the damask, while the other half are ebony with deep-rose – : colour'd cushions, to take off from the great gaudiness of the bed & chairs, & to bring back the room to the gothic tone of the House. The tops of the

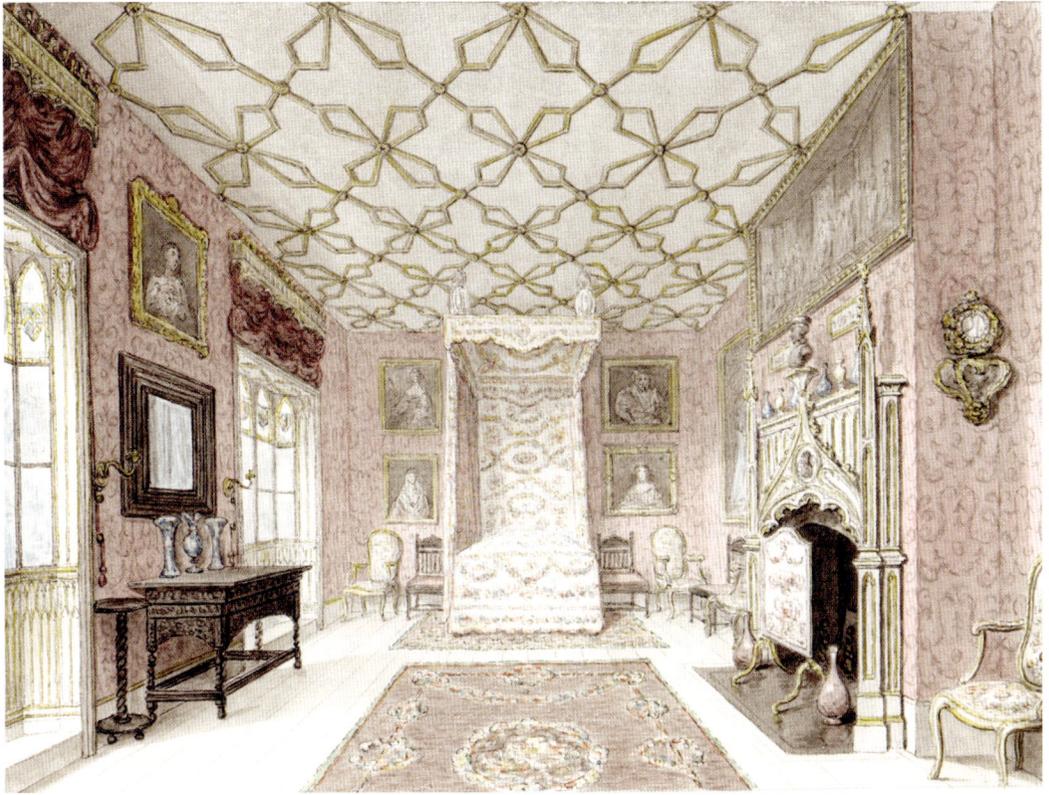

Windows tho adorned with painted glass to suit the rest, have only single shields in each upper pane & a border, while the great size of the rest of the window, which is of plate glass, & the uncommon chearfullness of the Views, makes the Outside as beautiful as the Inside.[227]

3.62 The Great North Bedchamber, J. Carter

Themes of ancestry and genealogy were evident through heraldry and newly commissioned armorial glass, 'In the bow window are ten coats of arms in painted glass, by Peckitt of York, with the principal matches of the family of Walpole.'[228] Chute designed the Gothic doors and the ceiling which is imitated from one in the north bedchamber at the Vyne of c.1520. The fireplace is taken from Bishop Dudley's tomb in Westminster Abbey, designed by Walpole, and executed in Portland stone by Thomas Gayfere. William Dudley (d.1493), Bishop of Durham (1476–83) was a supporter of Richard, Duke of Gloucester (1452–85) later King Richard III (1483–85) in his bid for the throne – Richard being the last of the Plantagenet dynasty and the last English King to die in battle. The arms of Henry VII were displayed in the chimney-back and a dynastic picture of Henry VIII with his children, all of whom were to rule England, hung above the fireplace. Overall it had the appearance of a royal chamber, but much of the furnishing was in French style and there were other associations with the French court in the portraiture and sculpture. However, the House of Tudor and English history

are the predominant themes of this room evidenced through the portraiture and iconography of the decoration, including a spur worn by William III at the Boyne and a pair of gloves worn by James I and the 'speculum of kennel-coal ... used to deceive the mob by Dr Dee, the conjurer in the reign of queen Elizabeth.'[229] Walpole told Conway in 1756 that he 'was outbid for Oliver Cromwell's [1599–1658] nightcap'.[230] Walpole was content with the last room to be constructed, remarking to Mason, 'I found my new bedchamber finished, and it is so charming that I have lost all envy of Castle Howard', which he recently seen.[231]

From this room the route was down the back stairs to the Beauclerc Closet, by Essex, the last room of the main house to be constructed. 'I have had a Gothic architect from Cambridge to design me a gallery, which will end in a mouse, that is, in an hexagon closet of seven feet in diameter.'[232] This further round tower was constructed as a private space, specifically to hang a set of seven drawings by Lady Diana Beauclerk (1734–1808), a noblewoman, artist and friend of Walpole, to illustrate his incestuous drama, *The Mysterious Mother* (1768). This is a prime example of how the building and interior at Strawberry Hill were designed, altered and expanded, specifically to house his collection, commissioning his architect to design a space suitable to contain specific items:

I am to have Mr Essex tomorrow from Cambridge to try if he can hang me
on anywhere another room for Lady Di's drawings ... because I will have a
sanctuary for them, not to be shown to all the profane that come to see the house,
who in truth almost drive me out of my house.[233]

Walpole again makes a specific link with the notion of a royal bower and the Beauclerc Closet:

... is a hexagon, built in 1776, and designed by Mr. Essex, architect, of Cambridge,
who drew the cieling, door window and surbase. In the window is a lion and two
fleurs de lys, royally crowned, ancient, but repaired and ornamented by Price;
and being bearings in the royal arms serve for Beauclerc.[234]

The Great Cloister was the last significant space, connecting the interior with the exterior through arched bays separated by piers and where the visitor's tour terminated before walking into the garden.

The room was a complete contrast after the sumptuous later interiors of the state-like apartments. It returned the theme back to the monastic roots of the building through the architectural space which has a groin-vaulted ceiling, plain white rendered walls, stone tiled floor, heavily-grilled tall arched windows and niches. The inspiration probably came from his visit to Burford Priory in 1753 where he had commented on the view through 'two or three arches' into the garden 'has a pretty effect'.[235] The space was furnished with triangular chairs, an ancient form. There are doorways at either end of the cloister which connect to the Winding Cloister and back stairs.

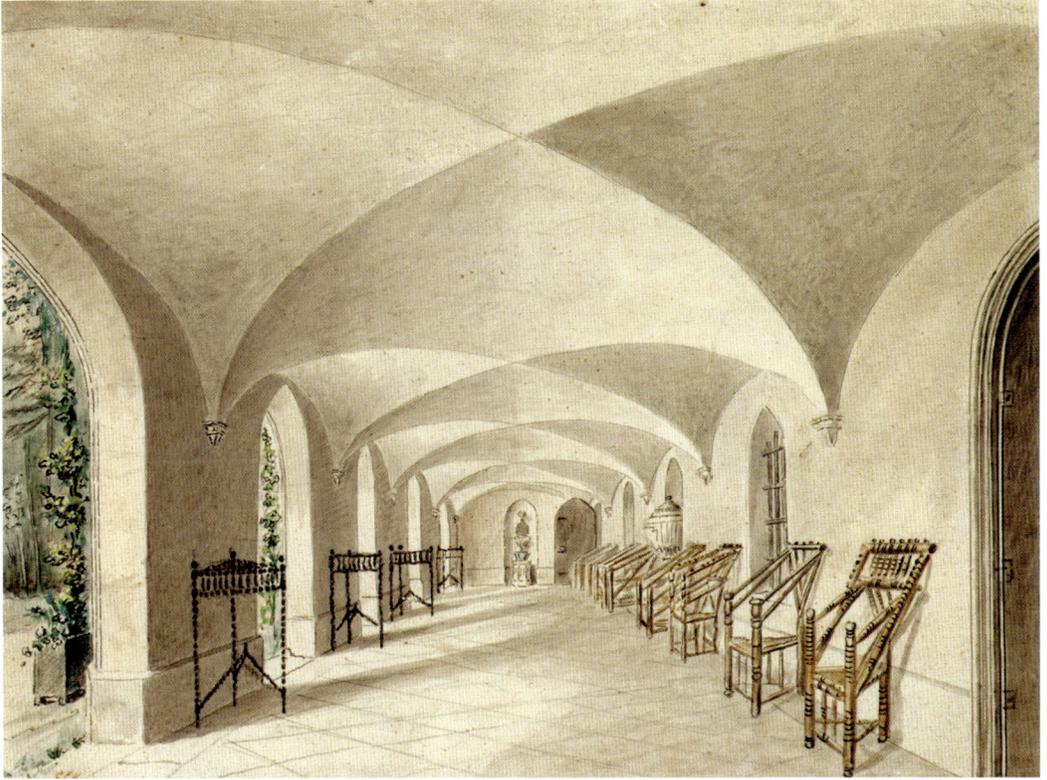

Walpole heaps unstinting praise on Chute's collegiate design for the Great Cloister, but registers some reservation regarding how it can be ornamented with portraiture:

3.63 The Great Cloisters at Strawberry Hill, G.P Harding

Well, how delightful! How the deuce did you contrive to get such proportion? You will certainly have all the women with short legs come to you to design high-heeled shoes for them. The cloister, instead of a wine-cellar, has the air of a college … In short, you have found a proportion and given a simplicity and lightness to it that I never expected. I have but one fault to find, and that is no bigger than my little finger; I think the buttresses too slight; and yet I fear, widening them would destroy the beauty of the space round the windows. There is another thing which is more than a fear, for it seems an impossibility, that is, of getting pictures over the windows within; if I can't, what shall I do with the spaces?[236]

Walpole asked Montagu to locate appropriate furniture to place in the cloister as this and other current projects were nearing completion:

I am now flattering doing a dirty thing, flattering you to preface a commission. Dicky Bateman has picked up a whole cloister-full of old chairs in Herefordshire – he bought them one and one, here and there in farm-houses, for three and six pence and a crown apiece. They are of wood, the seats triangular, the backs, arms, and legs loaded with turnery. A thousand to one but there are plenty up and down Cheshire too … Take notice, no two need be of the same pattern …

I am expecting Mr. Chute to hold a chapter on the cabinet – a barge-load of niches, window-frames and ribs is arrived. The cloister is paving, the privy-garden making, painted glass adjusting to the windows on the backstairs – with so many irons in the fire, you may imagine I have not much time to write.[237]

Walpole eventually acquired Bateman's 'cargo of ancient chairs', confirming that they 'at least have found their resting-place in their old age' when the contents of his house were sold, placing, '12 Welsh chairs in the Great Cloister and 4 in the cottage library.'[238] He confirms this in a further letter to Lady Ossory: 'I have crammed my Cloister with three cartloads of lumbering chairs from Mr. Bateman's, and at last am surfeited with the immovable movables of our forefathers.'[239]

It is by now apparent that Walpole did not fit into the stereotypical model of the eighteenth-century antiquarian collector. Strawberry Hill is unique in having an intellectual idea behind the sequence of theatrical stage sets and museum quality, historically-themed rooms with their carefully contrived ornament and display bringing to life the material remains of the past and stimulating the imagination of the spectator through their links to history. Lady Mary Coke wrote in her *Journal* on 25 July 1772:

I was to dine at Strawberry Hill … There are new things at Strawberry since I saw it: 'tis the most amusing house I ever was in: so many pictures and things to help one to ideas, when one wants a fresh collection; entertainment without company. What a great sum of money it must have cost him.[240]

There can be no doubt that the overall conception of Strawberry Hill was carefully thought out, and any alteration or removal of significant objects ruined the effect of the scheme as Walpole conceived it. This is demonstrated when he remonstrates with Lady Ossory for removing her own portrait from its position in the Breakfast Room:

I was in a monstrous passion at your taking away your picture, and so I am sure will my ghost be, if it is ever removed out of this blue room while poor Strawberry exists. One is an artificial being: I and my friends and this place compose but one idea in my mind, and it is lopping a limb to touch any of the constituent parts – so, how I should not have been angry, I don't know.[241]

Walpole's main objective was to stimulate the imagination of the viewer by evoking historical associations between the architecture of the castle, the iconography of the rooms, his collection and Walpole himself. Together they formed the chief amusement of his life and where he could give free rein to his imagination that in Addison's words 'takes the hint, and leads us unexpectedly into cities or theatres, plains or meadows'.

My closet is as perfect in its way as the library, and it would be difficult to suspect it had not been a remnant of the ancient convent only newly painted and gilt – my cabinet, nay nor house, convey any conception; every true Goth must perceive that they are the works of fancy than of imitation.[242]

A significant letter to Montagu gives an insight into how Walpole perceived the different atmosphere and moods he wanted to achieve at Strawberry Hill. It makes clear that the overall effect was meant to convey an atmosphere of 'enchantment and fairyism, which is the tone of the place', which directly links to Addison's statement that 'in the *Metamorphoses*, we … see nothing but scenes of magic lying round us'.[243]

His promotion of Gothic as *the* English architectural style coalesces with his theory of landscape as an entirely English innovation and both have their origins in his opinion that the English have supremacy in all matters of taste, but especially in architecture and landscape design. In a letter to Mann, he explains the nature of his Gothic intentions as he reproaches him for having resided too long, 'amidst true taste, to understand venerable barbarism'. Chiding him regarding the mood and impression he wants to create, Walpole insists:

You say 'you suppose my garden is to be Gothic too.' That's can't be; Gothic is merely architecture; and as one has a satisfaction in imprinting the gloomth of abbeys and cathedrals on one's house, so one's garden on the contrary is to be nothing but riant, and the gaiety of nature.[244]

Walpole's final words in the preface to the *Description of the Villa* also emphasised the importance of the setting of Strawberry Hill as a source of pleasure and inspiration:

… could I describe the gay but tranquil scene where it stands, and add the beauty of the landscape to the romantic cast of the mansion, it would raise more pleasing sensations than a dry list of curiosities can excite: at least the prospect would recall the good humour of those who might be disposed to condemn the fantastic fabric, and to think it a very proper habitation of, as it was the scene that inspired, the author of *The Castle of Otranto*.[245]

Walpole created a complementary landscape of the imagination at Strawberry Hill and the next chapter will explore how his theory of landscape developed and was manifested there. It will establish how he combined the 'sister arts – poetry, painting and gardening, or the science of landscape' to make a building and landscape setting that was sublime, painterly and picturesque. It is this scene of 'enchanted ground' that we shall visit next.

Endnotes

1. Dart's *Westminster* was a particularly lucrative source providing the designs for the altar in the Cabinet, the fan vaulting in the Gallery and the chimneypiece in the Little Parlour.

2. Walpole, *Description of the Villa*, preface, p. I.

3. *Correspondence*, Walpole to Berry, 24 September 1794, vol. 12, p. 105.

4. In a footnote he adds: And the mixture may be denominated, in some words of Pope, *A Gothic Vatican of Greece and Rome*, p. 3.

5. Walpole, *Description of the Villa*, p. IV.

6. Ibid., p. IV.

7. *Correspondence*, Mann to Walpole, 13 February 1750, vol. 20, p. 119.

8. Ibid., Walpole to Mann, 25 February 1750, vol. 20, p. 127.

9. Ibid., Walpole to Montagu, 10 September 1750, vol. 9, p. 112.

10. Ibid., Walpole to Montagu, 22 May 1753, vol. 9, p. 147.

11. Ibid., Walpole to Montagu, 11 June 1753, vol. 9, p. 192.

12. Walpole, *Anecdotes of Painting*, p. 159.

13. *Correspondence*, Walpole to Mann, 18 October 1750, vol. 20, pp. 199–200.

14. New Hall, Boreham, Essex, was built by Henry VIII c.1520. It was mostly pulled down in 1737.

15. Ibid., Walpole to Montagu, 20 July 1749, vol. 9, p. 92. A house has been recorded on the site of Copt or Copped Hall, Essex since the twelfth-century. It was conveyed to the Abbotts of Waltham in 1350 and partially rebuilt in the sixteenth-century when Queen Elizabeth gave it to her friend Sir Thomas Heneage (1532–1595) in 1564. A new Palladian mansion replaced the earlier house to the designs of John Sanderson (d.1774) aided by the architect Thomas Prowse (1708–1767) and Sir Roger Newdigate (1719–1806) of Arbury Hall, on a different site, which was completed in 1758. This house was altered in the nineteenth-century and burned in 1917. It is currently undergoing restoration. http://www.coppedhalltrust.org.uk/. Accessed 15 July 2011.

16. *Correspondence*, Walpole to Mann, 10 January 1750, vol. 20, p. 111.

17. Ibid., Walpole to Horace Mann, 17 April 1753, vol. 20, p. 372.

18. Ibid., Walpole to Mann, 12 June 1753, vol. 20, pp. 379–380.

19. Ibid., Walpole to Cole, 20 November 1770, vol. 1, p. 201. James Pearson (d.1805), who had been engaged to paint the glass in the east window of Ely Cathedral. He also painted some of the glass at Strawberry Hill. William Price (d.1765), the younger, 'whose colours are fine, whose drawing good, and whose taste in ornaments and mosaic is far superior to any of his predecessors, is equal to the antique, to the god Italian masters, and only surpassed by his own singular modesty.' *Anecdotes of Painting*, p. 159. He painted some of the glass at Strawberry Hill, Westminster Abbey, Winchester College, and New College, Oxford. Notes to the *Correspondence* vol. 1, p. 201.

20. *Correspondence*, Walpole to Montagu, 20 August 1758, vol. 9, p. 224.

21. Ibid., Gray to Walpole, c. April 1769, vol. 14, p. 184.

22. Ibid., Walpole to Mann, 24 October 1758, vol. 21, p. 250.

23. Ibid., Walpole to Mann, 13 April 1762, vol. 22, p. 25.

24. Ibid., Walpole to Bentley, 19 December 1753, vol. 35, pp. 157–8.

25. Ibid., Walpole to Bentley, 2 March 1754, vol. 35, p. 164.

26. Ibid., Walpole to Mann, 27 May 1776, vol. 24, p. 209.

27. See *Correspondence*, Walpole to Mann, 22 April 1775, and Walpole to Mason, 14 February 1782. It is not known why Walpole altered his opinion of Adam but in Walpole's notes to *Mason's Satirical Poems* (p. 65) it appears that his enmity was connected to the Adam's brothers failed lottery scheme for the Adelphi Terrace, London. According to Walpole it 'proved a notorious cheat, the fortunate finding their prizes some thousands short of the estimated value'. It may be conjectured that Walpole too had speculated and was a victim of the scandal.

28. The manuscript and drawings remain with his papers in the British Library.

29. *Correspondence*, Walpole to Wyatt, 26 July 1772, vol. 41, p. 231.

30. Ibid., Walpole to Hardinge, August 1785, vol. 35, p. 635.

31. Neale, J.P. *Views of the Seats of Noblemen and Gentlemen*, second series; (1842–9), vol. ii, 'Lee Priory'. For an Illustrated account of Lee Priory see Hugh Honour, 'A House of the Gothic Revival', *Country Life* (1952), cxi, 1665–6.

32. *Correspondence*, Walpole to Berry, 27 September 1794, vol. 12, p. 111, n. 31.

33. Walpole, *Description of the Villa*, p. 2.

34. *Correspondence*, Walpole to Conway, 8 June 1747, vol. 37, pp. 269–270.

35. Walpole, *Description of the Villa*, p. 1.

36. *Correspondence*, Walpole to Mann, 7 June 1748, vol. 19, p. 486. 'The house was built by Earl of Bradford's coachman, and was called by the common people *Chopp'd Straw Hall*, they supposing, that, by feeding his lordship's horses with chopped straw, he had saved money enough to build his house; but the piece of ground on which it stands is called in all the old leases, *Strawberry-Hill Shot*, from whence it takes its name.' Walpole, *Description of the Villa*, p. 2.

37. Ibid., Walpole to Williams, 27 June 1748, vol. 30, pp. 113–114.

38. Walpole, *Description of the Villa*, p. 17.

39. *Strawberry Hill Accounts*, Toynbee, P. (Oxford, 1927), pp. 1, 34. The former Breakfast Room was remodelled into a Turkish Boudoir (1856–8) by Lady Waldegrave but fragments of Robinson's original design remain in the lower part of the room.

40. *Correspondence*, Walpole to Mann, 3 May 1749, vol. 20, p. 46.

41. Ibid., Walpole to Mann, c. August, 1748, vol. 19, p. 497.

42. Entries in the accounts are as follows: *Accounts* (8 July 1749), 2, 'Pd Mrs Chenevix for a Piece of Land the Barn, Lawyers &c' (£43–15s–0d) and 'Pd the Purchase of the Estate' (£776–10s–0d), *Accounts* (February 1749), 2.

43. *Correspondence*, Walpole to Montagu, 28 September 1749, vol. 9, p. 102. Cheyney's refers to Chesham Bois House, Buckinghamshire which was purchased by the Duke of Bedford in 1735. The house fell into complete dereliction and was demolished by the early 1800s.

44. For a detailed analysis of the stages of construction and their accretive effect see, Guillery, P. 'Strawberry Hill, Building and Site: Part 1, The Building', *Architectural History,* vol. 38 (Leeds, 1995) and Snodin, M. 'Strawberry Hill, Building and Site: Part 2, The Site', *Architectural History,* vol. 38 (Leeds, 1995) and the invaluable W.S. Lewis's *The Genesis of Strawberry Hill* (New York, 1934).

45. *Common Sense*, No. 150 (15 December 1739) reprinted in *The Gentleman's Magazine*, 9 (December 1739), 641.

46. *Correspondence*, Walpole to Mann, 4 March 1753, vol. 20, pp. 361–362.

47. Ibid., Walpole to Mann, 12 June 1753, vol. 20, pp. 379–380.

48. Ibid., Mann to Walpole, 13 July 1753, vol. 20, p. 387.

49. Walpole, *Description of the Villa*, p. 2.

50. Walpole, *Anecdotes of Painting*, p. 14.

51. *Correspondence*, Walpole to Bentley, 18 May 1754, vol. 35, p. 174.

52. Lewis, *Genesis*, p. 74.

53. Ibid., p. 74.

54. *Correspondence*, Walpole to Bentley, 31 October 1755, vol. 35, p. 259.

55. Ibid., Walpole to Mann, 20 November 1757, vol. 21, p. 157.

56. Lewis, *Genesis*, p. 75.

57. *Correspondence*, Walpole to Mann, 9 September 1758, vol. 21, p. 238.

58. Ibid., Walpole to Montagu, 26 August 1749, vol. 9, p. 97.

59. Ibid., Walpole to Berry, 26 September 1793, vol. 12, p. 16.

60. The chapel-cabinet later became known as the Tribune, named after the Tribuna at the Uffizi in Florence. *Correspondence*, Walpole to Strafford, 30 October 1759, vol. 35, p. 298.

61. Ibid., Walpole to Strafford, 13 September 1759, vol. 35, p. 296.

62. Beside the rooms that Walpole lists here he also added an oratory, kitchen, larders, pantries etc. Ibid., Walpole to Mann, 24 May 1760, vol. 21, p. 410.

63. Walpole paid 'For the Chapel' (£84–0s–0d), *Accounts* (1759), 8.

64. Lewis, *Genesis*, pp. 79–81.

65. *Correspondence*, Walpole to Montagu, 12 August 1760, vol. 9, p. 292. This refers to the Round Tower.

66. Ibid., Walpole to Wharton 21 August 1762, vol. 40, p. 255.

67. Ibid., Walpole to Cole, 30 September 1762, vol. 1, p. 28.

68. Ibid., Walpole to Montagu, 1 July 1763, vol. 10, p. 85.

69. 'Pd for the round Tower & embattled wall (£454–0s–0d), *Accounts*, 8; Walpole, *Description of the Villa*, p. 2.

70. Lewis, *Genesis*, p. 81.

71. *Correspondence*, Walpole to Mann, 11 June 1771, vol. 23, p. 311.

72. Ibid., Walpole to Mason, 9 May 1772, vol. 28, p. 28.

73. Ibid., Walpole to Cole, 21 July 1774. vol. 1, p. 338.

74. Ibid., Walpole to Cole, 1 June 1776, vol. 2, p. 13.

75. Ibid., Walpole to Lady Ossory 9 October 1776, vol. 32, p. 322.

76. Ibid., Walpole to Lady Ossory, 9 October 1776, vol. 32, p. 322.

77. Walpole, *History of the Modern Taste*, p. 28.

78. *Correspondence*, Walpole to Mason, 6 July 1777, vol. 28, p. 318. A royal mansion at Pyrgo in the liberty of Havering-atte-Bower, Essex was used in the late Middle Ages as a dower house for the queens of England. Catherine de Valois (1401–37), was Queen of Henry V. There is no evidence that she ever used Havering in the Bower. Owen Tudor (1400–1461) (m. c.1429) refers to the widowed Queen Catherine. Notes paraphrased from *Correspondence*, vol. 28, p. 318.

79. Ibid., Walpole to Mason, 6 July 1777, vol. 28, p. 318.

80. Ibid., Walpole to Cole, 27 February 1777, vol. 2, p. 41.

81. Ibid., Walpole to Cole, 9 September 1776, vol. 2, p. 24.

82. Ibid., Walpole to Lady Ossory, 22 September 1776, vol. 32, p. 320.

83. Ibid., Walpole to Horace Mann, 14 June 1779, vol. 23, p. 128.

84. 'To Mr Essex the Architect for the Beauclerc Tower & designing the Offices &c),' (£31–10s–0d), *Accounts* (1777), 16.

85. *Correspondence* Walpole to Berry, 2 July 1790, vol. 11, p. 74.

86. Ibid., Walpole to Mann, 7 May 1775, vol. 24, p. 101.

87. Ibid., Walpole to Cole, 6 June 1768, vol. 1, p. 145.

88. The title appears to have been a later addition to the MS as 'aesthetic' is a nineteenth-century German term.

89. *Walpole's Account of the Aesthetic Effects at Strawberry Hill* (1772) MS13–1947 in the Fitzwilliam Museum, Cambridge.

90. Ibid.

91. Walpole, *Anecdotes of Painting*, p. 52.

92. *Correspondence*, Walpole to Bentley, September 1753, vol. 35, p. 146.

93. Ibid., Walpole to Montagu, 30 May 1763, vol. 10, p. 77.

94. Ibid., Walpole to Bentley, 3 November 1754, vol. 35, p. 186.

95. Richardson, J. 'An Essay on the Theory of Painting' (London, 1715) pp. 12–13, quoted in Haskell, *History and its Images: Art and the Interpretation of the Past* (London, 1993), p. 70.

96. Walpole, *Aesthetic Effects*.

97. *Walpole, Description of the Villa*, preface, II.

98. *Correspondence*, Walpole to Berry, 2 July 1790, vol. 11, p. 77.

99. *Walpoliana,* Pinkerton, 1, p. 26.

100. Ferrar, J. *Tour from Dublin to London in 1795 through the Isle of Anglsea, Bangor, Conway … and Kensington* (Dublin, 1796).

101. Bishop Niger died in 1241. Beeleigh Abbey, constructed in 1180 near Maldon in Essex, where the Bishop's heart was buried also became a place of pilgrimage. The engraving of his tomb was illustrated in Dugdale's *St Paul's* (1659).

102. Walpole, *Description of the Villa*, p. 2.

103. Ibid., p. 2.

104. 'Gape Earth, and this unhappy wretch intomb; / Or change my form, whence all my sorrows come. / Scarce had she finish'd, when her feet she found / Benumb'd with cold, and fasten'd to the ground; / A filmy rind about her body grows; / Her hair to leaves, her arms extend to boughs: / The nymph is all into a lawrel gone'. Ovid, *Metamorphoses*, http://classics.mit.edu/Ovid/metam.1.first.html. Accessed 28 October 2010. Walpole would have seen the sculpture of Daphne and Apollo in the Galleria Borghese, Rome, during his Grand Tour with Thomas Gray.

105. The 'small cloyster' contained 'two blue and white Delft flower-pots; and a bas-relief head in marble' of 'Princess Eleanora d'Este' given to Walpole by the great collector and Minister at Naples, William Hamilton. It also housed the 'large blue and white china tub in which Mr. Walpole's cat was drowned,' *Description of the Villa*, p. 2. The event was memorialised in Thomas Gray's poem; *Ode on the death of a favourite cat* (1747–8).

106. Walpole, *Description of the Villa*, footnote, p. 2.

107. *Correspondence*, Walpole to Cole, 15 August 1778, vol. 2, p. 106.

108. Walpole, *Description of the Villa*, p. 2.

109. *Correspondence*, Horace Walpole to Mann, 12 June 1753, vol. 20, pp. 379–380.

110. Walpole, *Description of the Villa*, p. 3.

111. Walpole, *Aesthetic Effects*.

112. *Correspondence*, Walpole to Mann, 17 April 1753, vol. 20, p. 372.

113. Pope, *Poetical Works*, 'Eloisa To Abelard' lines, 1–3, p. 110.

114. *Correspondence*, Walpole to Mann, 12 June 1753, vol. 20, pp. 379–380. The design for the pattern of the balustrading is taken from a print illustrating a screen at the Cathedral at Rouen.

115. Walpole, *Description of the Villa*, p. 3.

116. *Correspondence*, Walpole to Mann, 12 June 1753, vol. 20, p. 379. The trompe l'oeil wallpaper was painted by Cornelius Dixon, a scene painter at the Drury lane theatre. Thomas Gray describes the creative process that would have been used at Strawberry Hill in a letter to Wharton. *Correspondence of Thomas Gray*, vol. 2, letter 348, Gray to Wharton, 22 October 1761.

117. Pope, *Poetical Works*, 'Eloisa to Abelard' line 38.

118. *Correspondence*, Walpole to Montagu, 11 June 1753, vol. 9, p. 149.

119. Walpole, *Description of the Villa*, pp. 3–4.

120. *Horace Walpole's Journal of Visits to Country Seats*, Toynbee, p. 51.

121. Walpole, *Description of the Villa*, pp. 3–4.

122. Ibid., pp. 3–4.

123. Ibid., p. 4.

124. Ibid., p. 5.

125. Ibid., p. 4.

126. *Correspondence of Thomas Gray*, vol. 1, letter 169, Gray to Walpole, July, 1752.

127. *Correspondence*, Walpole to Bentley, 27 July 1754, vol. 35, pp. 181–182.

128. Ibid., Walpole to Mann, 12 June 1753, vol. 20, pp. 379–380.

129. Walpole, *Description of the Villa*, p. 6.

130. Ibid., p. 6.

131. *Correspondence*, Walpole to Mann, 27 January 1761, vol. 21, p. 471.

132. Walpole, *Description of the Villa*, p. 6.

133. Ibid., p. 6.

134. Ibid., p. 13.

135. *Correspondence*, Walpole to Churchill, 27 March 1764, vol. 36, pp. 38–39.

136. Walpole, *Description of the Villa*, p. 15.

137. http://www.oxforddnb.com/. Accessed 25 July 2011.

138. *Correspondence*, Walpole to Mann, 12 June 1753, vol. 20, pp. 379–380.

139. Ibid., Walpole to Lady Ossory, 20 June 1776, vol. 32, pp. 294–295.

140. Walpole, *Description of the Villa*, pp. 16–17.

141. There were no curtains in any room except the Great North Bedchamber at Strawberry Hill. Sliding shutters, which recessed into the walls, were used so that the windows too acted as a framing device to the painted glass inserted in the windows. Significantly they served the same purpose for the views into the surrounding animated landscape, which were paramount for Walpole, bringing nature into the interior.

142. Walpole, *Aesthetic Effects*.

143. *Correspondence*, Walpole to Mann, 12 June 1753, vol. 20, pp. 379–380.

144. Walpole, *Aesthetic Effects*.

145. Walpole, *Description of the Villa*, p. 23.

146. *Correspondence*, Walpole to Mann, 12 June 1753, vol. 20, pp. 379–380.

147. Walpole, *Description of the Villa*, p. 23.

148. Ibid., p. 24.

149. Ibid., p. 29.

150. Ibid., p. 29.

151. *Correspondence*, Walpole to Bentley, 18 May 1754, vol. 35, p. 174.

152. Ibid., Walpole to Mann, 12 June 1753, vol. 20, pp. 379–380.

153. Ibid., Walpole to West, 14 December 1739, vol. 13, p. 194.

154. Ibid., Walpole to Mann, 12 June 1753, vol. 20, p. 379–380. Robsart was the most romantic ancestor Walpole discovered in his genealogical researches. He was an ancestor of Sir Robert Walpole who was a Knight of the Garter.

155. Walpole, *Description of the Villa*, p. 31.

156. *Correspondence*, Walpole to Cole, 7 April 1773, vol. 1, p. 305.

157. Walpole, *Description of the Villa*, p. 32.

158. *Correspondence*, Walpole to Cole, 23 October 1771, vol. 1, p. 243.

159. Lady Mary Coke, estranged wife of Edward Coke, Viscount Coke (1719–53) of Holkham Hall, Norfolk had been a long-term friend of Walpole but they fell-out when Walpole's niece married the Duke of Gloucester, a relationship of which she disapproved. See *Correspondence*, Walpole to Mann, 28 November 1773, vol. 23, p. 530.

160. Ibid., Walpole to Coke, 30 June 1762, vol. 31, p. 26.

161. Robins, T. *A Catalogue of the Classic Contents of Strawberry Hill Collected by Horace Walpole, 1717–1797* (London, 1842), pp. xxiv, 55.

162. *Correspondence*, Walpole to Bentley, 24 December 1754, vol. 35, p. 200.

163. Walpole, *Description of the Villa*, p. 33.

164. *Ambulator: or, a Pocket Companion in a Tour Round London* (London, 1800), pp. 233–237.

165. Walpole, *Description of the Villa*, p. 33. Walpole's attribution has since been disproved and the painting is in fact, *Marriage of a Saint*, c.1475–1500, Flemish. http://lwlimages.library.yale.edu/strawberryhill/oneitem.asp?id=45. Accessed 26 July 2011.

166. Ibid., p. 34.

167. Ibid., p. 36.

168. *Correspondence*, Walpole to Bentley, 17 March 1754, vol. 35, p. 171.

169. Ibid., Walpole to Chute, 30 April 1753, vol. 35, pp. 79–80.

170. Ibid., Walpole to Chute, 4 August 1753, vol. 35, pp. 75–7.

171. Walpole, *Description of the Villa*, pp. 33–4.

172. *Correspondence,* Walpole to Cole, 9 March 1765, vol. 1, p. 88.

173. Anne Boleyn was Mother of Queen Elizabeth I and second wife of King Henry VIII of England. Daniel Lysons, *Environs of London* (4 vols, London, 1792–96) vol. III, 561, says, of Twickenham Manor-house, that tradition reports it to have been the residence of Henry VIII's queens'.

174. Walpole, *Description of the Villa*, p. 40.

175. In *Description of the Villa* Walpole says that the arms are those of 'Tate, impaling Boleyn or Sanders, for the colour of chevron is turned black.' *Correspondence,* Walpole to Cole, 15 June 1780, vol. 2, p. 225.

176. Walpole, *Description of the Villa*, p. 42.

177. Walpole, *Aesthetic Effects*.

178. Walpole, *Description of the Villa*, p. 42.

179. Walpole, *Anecdotes of Painting*, p. 15. Stellari auro, set with stars of gold. This alludes to the fashion of studding the ceiling and frequently the side walls of rich chambers, with stars of gold, upon a ground of green or blue, in compartments.

180. Walpole, *Description of the Villa*, p. 42.

181. Walpole, *Aesthetic Effects*.

182. Walpole, *Description of the Villa*, p. 42.

183. Ibid., p. 43.

184. Walpole, *Anecdotes of Painting*, p. 51.

185. Walpole, *Description of the Villa*, p. 44.

186. Walpole, *Anecdotes of Painting,* pp. 58–92. Walpole asserts that: 'Holbein's talents were not confined to pictures; he was an architect, he modelled, carved, was excellent in designing ornaments, and gave draughts and prints for several books, some of which he is supposed to have cut himself.' Walpole, *Anecdotes of Painting,* p. 61.

187. 'Day' is used in the sense of light of a mullioned window.

188. Gray's memory was at fault here. Walpole, in his account of this room in the *Description of the Villa,* in which both the chimneypiece and the pierced screen are figured, he says: 'The chimney-piece, designed by Mr Bentley, is chiefly taken from the Tomb of Archbishop Warham at Canterbury … the pierced arches of the screen from the gates of the choir at Rouen'. Walpole, *Description of the Villa*, p. 43.

189. *Correspondence of Thomas Gray,* vol. 2, letter 303, Gray to Wharton, September, 1759.

190. Walpole, *Description of the Villa*, p. 43.

191. *Correspondence,* Walpole to Chute, 1 February 1759 vol. 35, p. 107.

192. Walpole, *Aesthetic Effects*.

193. Ibid.

194. Walpole, *Description of the Villa,* p. 47.

195. Ibid., p. 47.

196. *Correspondence,* Walpole to Montagu, 25 March 1763, vol. 10, p. 53.

197. Ibid., Walpole to Mann, 30 June 1763, vol. 22, p. 152.

198. Walpole, *Aesthetic Effects*.

199. *Correspondence,* Walpole to Cole, 9 March 1765, vol. 1, p. 88.

200. 'The eagle found in the gardens of the Boccapadugli within the precinct of the Caracalla's baths at Rome, in the year 1742'. Walpole, *Description of the Villa,* p. 49.

201. *Correspondence,* Walpole to Lady Hervey, 15 September 1765, vol. 31, pp. 45–46.

202. Addison, *The Spectator,* No. 417, 28 June 1712.

203. Ibid., Walpole to Mason, 11 October 1778, vol. 28, p. 446.

204. Ibid., Walpole to Montagu, 1 July 1763, vol. 10, p. 85.

205. Ibid., Walpole to Bishop Lyttleton, 10 July 1763, vol. 40, p. 288.

206. *Correspondence of Thomas Gray*, vol. 2, letter 373, Gray to Wharton, August 1763.

207. Walpole, *Aesthetic Effects*.

208. *Correspondence*, Walpole to Hamilton, 22 September 1768, vol. 35, p. 407. The chimney-piece for the round room designed by Robert Adam was executed in 1769. The drawings are in the Soane Museum.

209. Ibid., Cole to Walpole, 5 October 1768, vol. 1, p. 155.

210. The present armorial stained glass is a later addition installed by Lady Waldegrave.

211. Ibid., Walpole to Robert Adam, c.26 September 1766, vol. 41, p. 39.

212. Walpole, *Description of the Villa*, p. 53.

213. Walpole, *Aesthetic Effects*.

214. *Correspondence*, Walpole to Mason, 11 October 1778, vol. 28, p. 446.

215. *The Ambulator*, pp. 233–237.

216. Walpole, *Aesthetic Effects*.

217. *Correspondence*, Walpole to lady Ossory, 15 September 1787, vol. 33, p. 575.

218. Walpole, *Description of the Villa*, pp. 62–63.

219. 17 pages in *Description of the Villa* list the contents of the room.

220. Walpole, *Description of the Villa*, p. 55.

221. Ibid., p. 55.

222. *Correspondence*, Walpole to Mann, 8 July 1759, vol. 21, p. 306.

223. Ibid., Walpole to Montagu, 14 April 1763, vol. 10, p. 34.

224. *Ambulator*, pp. 233–237. Walpole's attribution of the bell to Cellini has since been disproved.

225. *Correspondence*, Walpole to Conway, 9 September 1762, vol. 38, p. 175.

226. Walpole, *Aesthetic Effects*.

227. Ibid.

228. Walpole, *Description of the Villa*, p. 75.

229. Ibid., p. 77.

230. *Correspondence*, Walpole to Conway, 12 February 1756, vol. 37, p. 440.

231. Ibid., Walpole to Mason, 21 August 1772, vol. 28, p. 42.

232. Ibid., Walpole to Conway, 30 June 1776, vol. 39, p. 276. The Beauclerc Tower, as completed, is actually 9ft 5ins in diameter and was the last addition to the house itself.

233. Ibid., Walpole to Lady Ossory, 20 June 1776, vol. 32, pp. 294–295.

234. Walpole, *Description of the Villa*, p. 78.

235. *Correspondence*, Walpole to Bentley, September 1753, vol. 35, p. 155.

236. Ibid., Walpole to Chute, 4 November 1759, vol. 35, p. 110.

237. Ibid., Walpole to Montagu, 20 August 1761, vol. 9, pp. 384–5.

238. Ibid., Walpole to Lady Ossory, 23 July 1775, vol. 32, p. 242.

239. Ibid., Walpole to Lady Ossory, 3 August 1775, vol. 32, p. 247.

240. Lady Mary Coke's *Journal*, IV, 102–103 in *Correspondence*, vol. 31, p. 168.

241. *Correspondence*, Walpole to Lady Ossory, 3 June 1778, vol. 33, p. 17.

242. Ibid., Walpole to Berry, 17 October 1794, vol. 12, p. 137.

243. Ibid., Walpole to Montagu, 17 May 1763, vol. 10, p. 72.

244. Ibid., Walpole to Horace Mann, 17 April 1753, vol. 20, p. 372.

245. Walpole, *Description of the Villa*, preface, p. IV.

'The art of creating landscape': Creation of a Seat – Part 2

Using primary sources, this chapter establishes the garden precedents that were influential in formulating Walpole's views on landscape, with reference to *The History of the Modern Taste in Gardening,* his *Correspondence,* and other unpublished material. The section analsyes and compares the gardens which Walpole knew in order to determine their influence on his theories and practice. Finally, there is scrutiny of Walpole's response to the picturesque romantic landscapes from where he drew his basic inspiration with an explanation of how these are eventually manifested in the landscape at Strawberry Hill.

In order to ascertain Walpole's opinion on landscapes and imagination it is necessary to quote from his private correspondence and journal entries as well as his public pronouncements. His published writing is sometimes designed to flatter associates, friends and relatives rather than portray his true feelings. Walpole wrote many letters and anecdotes on the subject of his visits to various country seats. From these sources we can chronicle the formulation and development of his thinking through his reaction to different sites and monitor how his manifesto for composing imaginative associative landscapes develops. His treatise on gardens elucidated in the *History of the Modern Taste* is a seminal text for establishing his theories on landscape even if it is occasionally subjective.

In the *History of the Modern Taste,* Walpole cites his father's 23-acre garden at the family estate, Houghton as 'One of the first gardens planted in this simple though still formal style'. The park surrounding the new Palladian house was laid out with great avenues of trees 'by Mr Eyre, an imitator of Bridgeman', offering far-reaching vistas into the Norfolk countryside across the ha-ha.[1] Just as the house at Houghton was at the cutting edge of current architectural taste, the landscape design of 1720 was to be one of the earliest attempts to create a more naturalistic setting adopting the principles of an estate garden that Addison had defined: 'Why may not a whole Estate be thrown into a kind of garden by frequent Plantations, that may turn as much to Profit, as the Pleasure of the Owner?'[2] The topography of the site was not naturally conducive to fertile cultivation, with 1,000 acres of parkland situated on a 'bleak windswept plateau.'[3] Yet, within ten years Lord Hervey could comment that, 'by the force

of manuring and planting, so changed the face of the country, that the park is a pleasant, fertile island of his own creation in the middle of a naked sea.'[4] Robert Walpole was actively involved with the landscape design at Houghton where he created sweeping lawns adjacent to the house with densely-wooded areas either side, planting groves and clumps and artfully deploying belts of trees to screen out unwanted views. He removed the village completely outside of the designed landscape. There were further extensive woodland plantations covering over 330 acres, a deer park, avenues, orchards and a kitchen garden. He fully embraced the practical advantage inherent in Addison's precept of making cultivated lands part of the view so that 'a Man might make a pretty Landskip of his own Possessions.' The introduction of a ha-ha meant that vistas across the distant lake into the wider landscape were encompassed within the park and Walpole's *History of the Modern Taste* supports the contention that this device enabled the grounds at Houghton to be laid out so that the boundaries were blurred until there was not 'too obvious a line of distinction between the neat and the rude.' 'The contiguous ground of the park without the sunk fence was to be harmonized with the lawn within; and the garden in its turn was to be set free from its prim regularity, that it might assort with the wilder country without.'[5] Walpole's description of Houghton borrows significant words and phrases from Addison. He distinguishes this type of landscape as 'the garden which connects itself with a park'; however, the overall concept accords with Addison's precepts. The natural landscape designs at Houghton made a significant impression on young Horace and he recalls the garden and the opportunity it gave him for solitude and reflection. In a letter to Charles Lyttleton he relates, 'I spent my time at Houghton for the first week almost alone; we have a charming garden all wilderness; much adapted to my romantic inclinations.'[6] Following a decline in family fortunes, the house and garden suffered from ruination and neglect. Returning to Houghton in 1761, Walpole recalls in disappointed tones its abandoned state:

When I had drunk tea, I strolled into the garden – they told me, it is now called *the pleasure ground* – what a dissonant idea of pleasure – those groves, those *allées,* where I have passed so many charming moments, are now stripped up, or overgrown; many fond paths I could not unravel, though with a very exact clue in my memory – I met two gamekeepers, and a thousand hares! In the days when all my soul was tuned to pleasure and vivacity (and you will think perhaps it is far from being out of tune yet) I hated Houghton and its solitude – yet I loved this garden; as now, with many regrets I love Houghton – Houghton, I know not what to call it, a monument of grandeur or ruin![7]

Houghton can be described as a transitional garden, still maintaining some formal features such as avenues and clipped hedging while simultaneously incorporating natural landscape and 'borrowed views' into the overall scene. As witnessed by Walpole's own commentary, even though he apparently disliked Houghton Hall, the garden managed to stimulate his imagination and romantic inclinations.

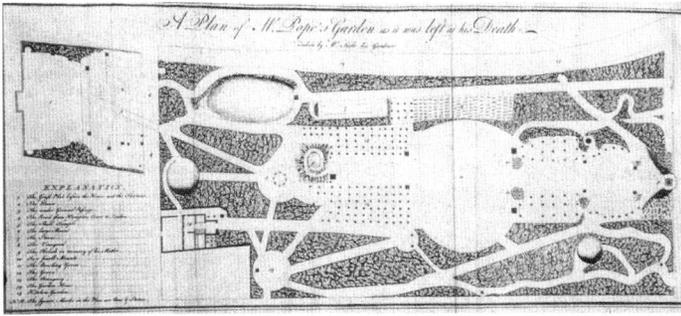

4.1 A plan of Mr. Pope's Garden as it was left at his death, John Searle, 1745

Walpole's predilection for linking particular people and events with the production of an imaginative, pleasurable response is nowhere more apparent than in his choice of location for his Gothic villa because of its association with Pope; the author Walpole quotes most often after Addison. Pope's own garden at Twickenham, which Walpole greatly admired, represented the epitome of the 'poetic garden' where the mind of the poet was stimulated by a balanced combination of art and nature through successively experiencing quotations from antiquity.

Pope succeeded in creating a context where the mind was liberated to operate freely thus allowing psychological and physical pleasures. Although Pope's garden was emblematic and ornamental, it was also utilitarian and practical, mediating between the natural and artificial – in Addison's words a picturesque composition of 'art and nature'.

On acquiring Strawberry Hill, Pope was deliberately (mis)quoted and mentioned in one of the first letters Walpole wrote from his new residence, which also recalls Addison's 'natural embroidery of the meadows':

It is set in enamelled meadows with filigree hedges:
A small Euphrates through the piece is roll'd,
And little finches wave their wings in gold.[8]

Dowagers as plenty as flounders inhabit all around, and Pope's ghost is just now skimming under my window by a most poetical moonlight … I have about land enough [5 acres] to keep such a farm as Noah's, when he set up in the ark with a pair of each kind.[9]

It is also evident from the *Correspondence* that he took visitors to see Pope's garden: 'We then went to see Pope's grotto and garden, and returned to a magnificent dinner in the refectory. In the evening we walked, had tea, coffee and lemonade in the gallery, which was illuminated with a thousand, or thirty candles.'[10] Pope's garden is described in some detail in the *History of the Modern Taste* where Walpole endeavours to explain that 'Mr. Pope undoubtedly contributed to form his taste' [Kent's], and informs us that:

… the design of the prince of Wales's garden at Carlton-house was evidently borrowed from the poet's at Twickenham … There was little of affected modesty in the latter, when he said, of all his works he was most proud of his garden. And yet it was a singular effort of art and taste to impress so much variety and scenery on a spot of five acres. The passing through the gloom from the grotto to the opening day, the retiring and again assembling shades, the dusky groves, the larger lawn, and the solemnity of the termination at the cypresses that lead up to his mother's tomb, are managed with exquisite judgement; and though lord Peterborough assisted him

'To form his quincunx and to rank his vines'

those were not the most pleasing ingredients of his little perspective.[11]

According to Sir Thomas Robinson (1703–1777) the new garden at Carlton House 'had the appearance of beautiful nature' where Kent had used a painter's eye to 'work without either level or line.' Robinson declared 'Mr Kent's notion of gardening' as expressed at Carlton House as the catalyst that sparked the trend for modern gardening where 'without being told, one would imagine art had no part in the finishing', a concept that was to become one of the central tenets of the English landscape movement.[12]

Pope's garden was destroyed by a subsequent purchaser of the property some years later, an event that caused anguish to Walpole who lamented that the 'modern taste has gone too far in its desire to improve':

I must tell you a private woe that has happened to me in my neighbourhood – Sir William Stanhope bought Pope's house and garden. The former was so small and bad, one could not pardon his hollowing out that fragment of the rock Parnassus into habitable chambers – but would you believe it, he has cut down the sacred groves themselves! In short, it was a little bit of ground of five acres, enclosed with three lanes and seeing nothing. Pope had twisted and twirled and rhymed and harmonized this, till it appeared two or three sweet little lawns opening and opening beyond one another, and the whole surrounded with thick impenetrable woods. Sir William, by advice of his son-in-law Mr Ellis, has hacked and hewed these groves, wriggled a winding gravel walk through them with an edging of shrubs, in what they call the modern taste, and in short, has desired the three lanes walk in again – and now is forced to shut them out again by a wall, for there was not a muse could make a little maid's water, but she was spied by every country fellow that went by with a pipe in his mouth.[13]

Walpole linguistically links the poet to his garden, and its wanton destruction was deeply embedded in Walpole's memory. He referred to its devastation again some 20 years later in relation to the remodelling of the Uffizzi Gallery in Florence. It is important to note the mental connections Walpole made between the gallery and Pope's garden, both of which he viewed as sacrosanct and as influential on the internal layout and landscape at Strawberry Hill:

If that inestimable chamber [Uffizzi Gallery] is not inviolate, what mortal structure is! Zoffanii's picture, however, will rise in value, as a portrait of what that room *was* – yet its becoming more precious will not, I doubt, expedite the sale of it. It is a pity that those who love to display taste, will not be content with

showing their genius without making alterations; and then we should have more samples of the styles of different ages. Some monuments of our predecessors ought to be sacred. Sir William Stanhope was persuaded by Sir Thomas Robinson and Mr Ellis (the present possessor) to *improve* Pope's garden here in the neighbourhood. The poet had valued himself on the disposition of it, with reason. Though containing but five square acres, enclosed by three lanes, he had managed it with such art and deception, that it seemed a wood, and its boundaries where nowhere discoverable. It is true, it was closely planted, and consequently damp. Refined taste went to work; the vocal groves were thinned, modish shrubs replaced them – and light and three lanes broke in; and the muses wanted to tie up their garters, there is not a nook to do it without being seen.[14]

Walpole's sadness at the destruction of Pope's garden signifies his disillusion with the unimaginative practitioners of the 'new taste' in gardening that needlessly destroyed an important garden in the name of 'improvements'. Its significance was that it was intimately and imaginatively associated with the poet and his poetry. His references to Pope's 'sacred groves', where he had 'rhymed and harmonized' the garden into 'vocal groves,' the home of the 'muses', illustrate how Walpole perceived that the poet and the landscape were inextricably linked. His comments that Pope had 'managed it with such art and deception, that it seemed a wood, and its boundaries were nowhere discoverable' adheres to the landscape theory of concealing art in nature. His plea to retain 'more samples of the styles of different ages' is the same argument he makes in support of applying Gothic architectural elements to his villa. This strongly suggests that Walpole viewed Pope's garden as transitional, still containing emblematic features alongside the more expressive natural elements and he advocated keeping it intact for precisely those reasons.

Commenting on William Kent's death in a letter to Charles Hanbury Williams dated June 1748, Walpole states, 'I think there is great danger everywhere of our relapsing into bad taste, for scarce any school retains its purity after the death of the institutor.'[15] With the destruction of Pope's seminal garden, Walpole might have believed his prophecy was indeed realised.

Kent was one of the most prolific pioneers in disseminating the 'modern style' and implementing the new taste for informal landscape and Walpole gives him full credit for his accomplishments in the *History of the Modern Taste*. Kent prepared the way for the transition from formal to informal landscapes, putting the earlier theories of Addison and Pope into practice, designing gardens that appeared to be natural, albeit contrived – a combination of 'art' and 'nature'. Kent and Lord Burlington had direct experience of Italian gardens, art and architecture and Kent too was particularly inspired by Italy; in fact he was variously known as 'Kentino' or 'signior' and spoke Italian. Pope met Kent through the auspices of Burlington and Kent designed some features in Pope's garden: 'I forgot to tell you in my way to Esher on Sunday I call'd upon Mr Pope, he's going upon new works in his garden that I design'd there …'[16] Kent was also involved or associated with designs at Rousham, Esher, and Stowe – all of which were influential on Strawberry Hill.

We will look at these three landscapes and also Hagley in detail, together with other significant landscapes that more generally exemplify Walpole's landscape theories and display the characteristics that he deployed at Strawberry Hill. All these gardens took advantage of extensive prospects and framed views; they blend symmetry and regularity with the natural landscape and are in complete harmony with Addison's theories of landscapes that could stimulate the imagination in the contrasts, opening glades and intimate shades, achieved through variety in planting and incorporation of incidents in their design.

It has been demonstrated that the inspiration and ideas for developing Walpole's villa and landscape of the imagination at Strawberry Hill were sought through a series of 'tours' that Walpole undertook and recorded. His visit to Euston Park, Thetford is one of the earliest documented which succinctly demonstrates the associative connections he was continually to make between a place and a character. Here he intellectually and emotionally links the new landscape designs that Kent is carrying out with Addison's writing on liberty in *A letter from Italy:* 'It is one of the most admired seats in England – in my opinion, because Kent has a most absolute disposition of it. Kent is now so fashionable, that, like Addison's *Liberty*, he "Can make bleak rocks and barren mountains smile".'[17] The letter is important because it gives an insight into the (un)conscious connection Walpole makes between the landscape of Italy, the British constitution and English landscape. Walpole linked Addison's poem *Liberty* to Italy with his reference to 'classic ground' in a letter to the great collector William Hamilton (1731–1803).[18] 'Herculaneum will afford you, as it does me, an inexhaustible fund of amusement, and you cannot stir a step without being in classic ground.'[19] Walpole's visit to Euston Park also gives an early indication of his preferences for linking the designer of the landscape to the site. It also signals the importance of the setting of the building, his insistence on prospect as essential to any site, and his passion for tree planting – all of which were to be significant factors at Strawberry Hill:

The house is large and bad … and stands as all old houses do for convenience of water and shelter, in a hole; so it neither sees, nor is seen … The park is fine, the old woods excessively so: they are much grander than Mr Kent's passion, clumps – that is, sticking a dozen trees here and there, till a lawn looks like a ten of spades. Clumps have their beauty; but in a great extent of country, how trifling to scatter arbours, where you should spread forests![20]

The Old Park at Euston, consisting largely of formal avenues, was designed by the diarist John Evelyn (1620–1706) author of *Sylva* (1664), while Kent laid out the new park and river setting and designed a garden Temple and other structures in 1738.[21]

In his *History of the Modern Taste*, written almost 40 years later, Walpole had not altered his opinion regarding Kent's deficiency in his short term approach to tree planting:

His clumps were puny; he aimed at immediate effect, and planted not for futurity … One sees no large woods … Nor are we yet entirely risen above a too great frequency of small clumps … How common to see three or four beeches, then as many larches, a third knot of cypresses, and a revolution of all three![22]

Despite this minor criticism, Walpole's *History of the Modern Taste* firmly establishes Kent as the practitioner hero declaring, 'it remains to show to what degree Mr Kent invented the new style, and what hints he had received to suggest and conduct his undertaking.'[23]

Kent's appearance on the scene as a garden designer fortuitously corresponded with the innovation of the ha-ha, the 'capital stroke' that enabled the English Landscape style to develop. According to Walpole, Kent was able to use the opportunity the ha-ha afforded for unhindered prospects and delight in nature, and to put the principles of pictorial composition which characterised his designs into practice. He celebrates Kent as the English genius and the first garden designer to use picturesque landscape principles and lauds him as the designer who 'invented or established' the 'garden that connects itself to a park' – a claim we have now revised through the discussion of Addison above:[24]

At that moment appeared Kent, painter enough to taste the charms of landscape, bold and opinionative enough to dare and dictate, and born to strike out a great system from the twilight of imperfect essays. He leaped the fence, and saw that all nature was a garden. He felt the delicious contrast of hill and valley changing imperceptibly into each other, tasted the beauty of the gentle swell, or concave scoop, and remarked how loose groves crowned an easy eminence with happy ornament, and while they called in the distant view between their graceful stems, removed and extended the perspective by delusive comparison. Thus the pencil of his imagination bestowed all the arts of landscape on the scenes he handled. The great principles on which he worked were perspective, light and shade.[25]

Joseph Spence (1699–1768) records in his *Anecdotes, Observations and Characteristics of Books and Men … * (1734–36) that Walpole 'has proved that Kent was the first artist who diffused the prevailing taste of landscape gardening, and adds that Pope undoubtedly contributed to form Kent's taste.'[26] However, although Kent undoubtedly helped to disseminate the new concepts in landscape design and developed his own idiosyncratic style, it seems clear that Pope advised him and that the original theory was Pope's, derived of course from Addison.[27]

Esher Place, one of Kent's best works, does not survive, but was considered by some commentators to be more painterly and picturesque than Rousham which does survive.

At Esher, working from 1730–33, Kent Gothicised Waynflete's Tower and removed most of the earlier formal layout depicted by Knyff and Kip (1707). He laid-out new gardens with sweeping lawns down to the river's edge realising picturesque views and vistas from the house and across the landscape. Kent created a dense grove with a combination of straight and serpentine paths which led to small clearings and character areas containing

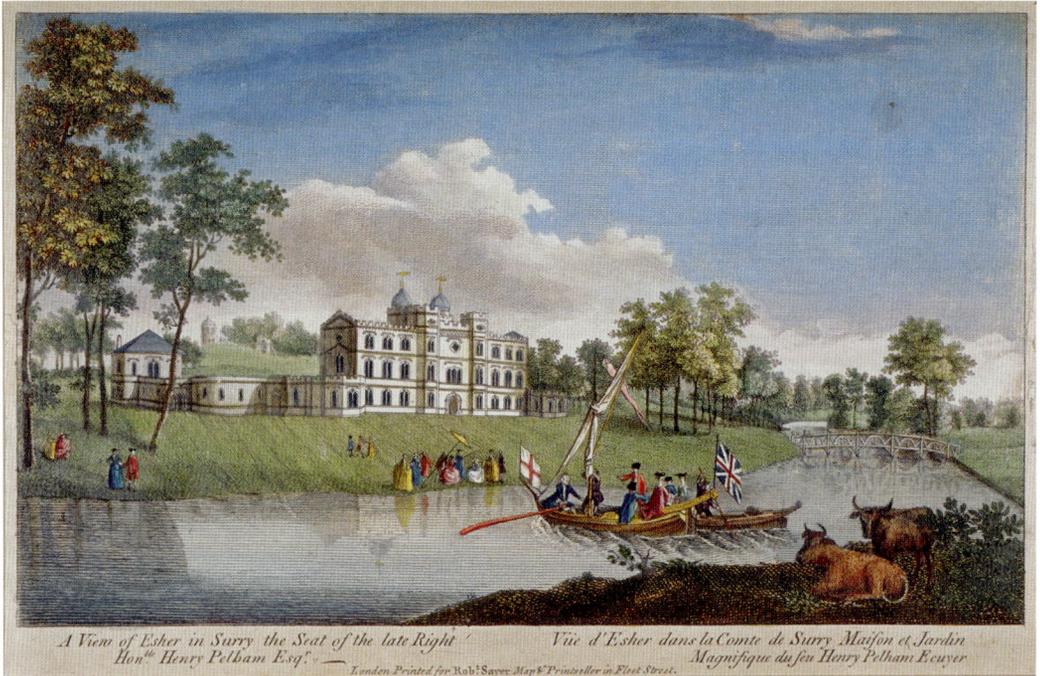

A View of Esher in Surry the Seat of the late Right
Hon.ble Henry Pelham Esq.r.
London Printed for Rob.t Sayer Map & Printseller in Fleet Street.

Vüe d'Esher dans la Comte de Surry Maison et Jardin
Magnifique du feu Henry Pelham Ecuyer

4.2 A view
of Esher Place,
c.1800

a mixture of floriferous shrubs and cypress trees 'overhung to a vast height
with woodbines, lilacs and laburnums, and dignified by those tall shapely
cypresses'.[28] Walpole records in a later visit its association with Kent:

The day was delightful, the scene transporting, the trees, lawns, concaves, all
in the perfection in which the ghost of Kent would joy to see them … We had a
magnificent dinner, cloaked in the modesty of earthenware: French horns and
hautboys on the lawn. We walked to the belvedere on the summit of the hill, where
a threatened storm only served to heighten the beauty of the landscape, a rainbow
on a dark cloud falling precisely behind the tower of a neighbouring church,
between another tower, and the building at Claremont … From thence we passed
into the wood, and the ladies formed a circle on chairs before the mouth of the cave,
which was overhung to a vast height with woodbines, lilacs and laburnums, and
dignified by those tall shapely cypresses. On the descent of the hill were placed the
French horns; the abigails, servants, and neighbours wandering below the river – in
short, it was Parnassus as Watteau should have painted it …[29]

Here again, we see Walpole's trope of composing painterly picturesque scenes
being used to describe this Arcadian scene. Thomas Whateley (1726–72)
author of *Observations on Modern Gardening* (1770) whom Walpole credits
with outlining 'A system of rules pushed to a greater degree of refinement,
and collected from the best examples and practice', gives us a contemporary
description of Kent's grove at Esher:[30]

The grove at Esher-Place was planted by the same masterly hand [Kent] … but
the grove winds along the bank of a large river, on the side and at the foot of

a very sudden ascent, the upper part of which is covered with wood. In one place it presses close to the covert; rises from it in another, and stretches in a third across a bold recess, which runs high up high into the thicket. The trees sometimes overspread the flat below; sometimes leave an open space to the river; at other times crown the brow of a large knole, climb up a steep, or hang on a gentle declivity. These varieties in the situation more than compensate for the want of variety in the disposition of the trees; and the many happy circumstances which concur

'In Esher's peaceful grove/Where Kent and nature vie for Pelham's love',[31]

Renders this little spot more agreeable than any at Claremont.[32]

Walpole admits that like any artist, Kent returned to recurring themes and features at the various landscapes where he worked which make his hand distinctive from others. There is a marked similarity in the dense grove he planted at Esher with other groves at Rousham, Claremont, Surrey Pope's villa and Wilton and, as we shall see later, at Walpole's Strawberry Hill.[33]

A return of some particular thought were common to him with other painters, and make his *hand* known. A small lake edged by a winding bank with scattered trees that led to a seat at the head of the pond, was common at Claremont, Esher and other of his designs.[34]

Walpole concurs with Whateley that Kent took advantage of the beauties inherent in the site situated on the River Mole and uses the same quotation from Pope to emphasise its pictorial potential, creating a series of Addison's 'painted views in perspective:'

'At Esher / Where Kent and Nature vied for Pelham's love': The prospects more than aided the painter's genius – they marked out the points where his art was necessary or not; but thence left his judgement in possession of all its glory.[35]

Walpole admired Kent's abilities to modify and enhance his landscapes, often retaining some elements, introducing new features to add depth, variety and complexity without appearing contrived, 'Having routed professed art, for the modern gardener exerts his talents to conceal his art.'[36] This insistence on responding to natural topography is also encapsulated in Pope's line, 'Consult the Genius of the Place in all', recalling Addison's observations on Fontainebleau, where the king had 'Humourd the Genius of the Place and only made use of so much Art as is necessary to Help and regulate Nature without reforming her too much.'[37] The concept is echoed in Walpole's premise that 'Situations are everywhere so various, that there can never be sameness, while the disposition of the ground is studied and followed and every incident of view turned to advantage.'[38]

Walpole visited Stowe, on a number of occasions where he was always 'charmed with the variety of scenes. I do like that Albano glut of buildings, let them ever so be condemned'. Pope was involved with laying out the Elysian Fields where from 1733 Kent was designing buildings. Stowe is particularly

important for understanding how the primary and secondary principles of the imagination, the association of ideas and the scenic art of composing landscape pictures are internalised and expressed by Walpole:

I have been here these two days, extremely amused and charmed indeed. Wherever you stand you see an Albano landscape. Half as many buildings I believe would be too many, but such a profusion give inexpressible richness. You may imagine I have some private reflections entertaining enough, not very communicable to the company: ... But I have no patience at building and planting a satire![39]

The Stowe landscape and its historical associations impact significantly on Walpole. 'In that province you call a garden' he amusingly recalls:

We supped in a grotto in the Elysian Fields, and were refreshed with rivers of dew and gentle showers dripped from all the trees; and put us in mind of the heroic ages, when kings and queens and shepherds and shepherdesses, and lived in caves, and were wet to the skin two or three times a day.[40]

The anticipation of a forthcoming visit initiates reflection and recollection when he muses, 'Yet shall I have many a private smile to myself, as I wander among all those consecrated and desecrated buildings, and think what company I am in, and of all that is past.'[41]

Following a visit by Walpole to Stowe in later life, the power of the physical place and its association with his personal and national history feed his imagination with 'an infinite variety of images' that become increasingly evocative and the cumulative effect of history, personages and landscape that Addison had declared, 'furnishes out all those Scenes that are most apt to delight the Imagination.'[42] The ability of the imagination to heighten pleasure and invoke introspection, emotion and sensation are nowhere more evident than in Walpole's response to Stowe. His imagination 'takes the hint' and leads him into a series of recollections in tranquillity where memories are triggered to induce a chain of associative thoughts:

... but in reality the number of buildings and variety of scenes in the garden made every day different from the rest; and my meditations on so historic a spot prevented my being tired. Every acre brings to one's mind some instance of parts or pedantry, of the taste or want of taste, of the ambition, or love of fame, or greatness, or miscarriages of those that have inhabited, decorated, planned or visited the place. Pope, Congreve, Vanbrugh, Kent, Gibbs, Lord Cobham, Lord Chesterfield, the mob of nephews, the Lyttletons, Grenvilles, Wests, Leonidas Glover, and Wilkes and the late Prince of Wales, the King of Denmark, Princess Amelia, and the proud monuments of Lord Chatham's services, now enshrined there, then anathematized there, and now again commanding there, with the Temple of Friendship like the temple of Janus, sometimes open to war, and sometimes shut up in factious cabals, all those images crowd upon one's memory and add visionary personages to the charming scenes, that are so enriched with fanes and temples, that the real prospects are little less than visions themselves ... But the chief entertainment of the week, at least what was so to the Princess, is an arch which Lord Temple has erected to her honour in the most enchanting of all picturesque scenes. It is inscribed on one side Ameliæ Sophiæ Aug. and

has a medallion of her in the other. It is placed on an eminence at the top of the Elysian fields, in a grove of orange trees. You come to it on a sudden, and are startled with delight on looking through it: you at once see through a glade the river winding at bottom; from which a thicket rises, arched over with trees, but opened, and discovering a hillock full of haycocks, beyond which in front is the Palladian bridge, and again over that, a larger hill crowned with a castle. It is a tall landscape, framed by the arch and the overbowering trees, and comprehending more beauties of light, shade and buildings, than any picture of Albano I ever saw … So many heathen temples around, had made me talk as a Roman poet would have done; but I corrected my verses, and made them insipid enough to offend nobody. Good night. I am rejoiced to be once more in the gay solitude of my own little Tempe.[43]

Stowe's seminal landscape confirms that the elements Addison deemed essential for imaginative engagement are present including variety, spontaneity, movement, light, shade, intricacy, and beauty. Whateley observes of its characteristics:

The whole space is divided into a number of scenes, each distinguished with taste and fancy; and the changes are so frequent, so sudden, and complete, the transitions so artfully conducted, that the same ideas are never continued or repeated to satiety … On the right of the lawn but concealed from the house, is a perfect garden scene, called the queen's amphitheatre, where art is avowed, though formality is avoided … The scene altogether is a most animated landscape; and the splendour of the buildings; the reflection in the lake; the transparency of the water, and the picturesque beauty of its form, diversified by little groupes on the brink, while on the broadest expanse no more trees cast their shadows than are sufficient to vary the tints of the surface; all these circumstances, vying in lustre with each other, and uniting in the point to which every part of the scene is related, diffuse a peculiar brilliancy over the whole composition.[44]

'Stowe I know by heart', said Walpole. With this intimate knowledge he must have understood its significance in terms of the history of gardens as the archetypal Pleasure Garden, reflecting the successive hands of Vanbrugh, Bridgeman, Kent, Lancelot 'Capability' Brown (1716–83) and Gibbs.[45] Yet, despite the fact that Kent's Elysian Fields were a highly innovative example of the use of contrived art, concealed by nature and displaying ideal beauty that drew praise from every contemporary visitor, Walpole does not mention Stowe in the *History of the Modern Taste in Gardening*. The conclusion therefore might be that it was omitted because of its connections with the political position of Lord Cobham and his opposition to Walpole's father Robert Walpole, the first 'Prime Minister'. This notion is supported by Walpole's exclamation, 'But I have no patience at building and planting a satire! Such is the Temple of Modern Virtue in ruins!' Contemporary commentators associated the headless statue it contained with Sir Robert Walpole and his administration.[46] The iconography in the garden also reflects the principles set out in 'The Pleasures of the Imagination' essays. It implicitly embodies Addison's 'Spirit of Liberty' being laid out to follow nature, another connection that readers could draw from the political Whig message implied in the iconography and the inherent spirit of place. If Walpole could conjure

all these memories, associations and connections of Stowe then his readers with the faculty of 'taste' could make the same links, as they possess the same capacity for correlation. Walpole would, at all costs, want to avoid reminding the reading public of the acrimony and factional in-fighting that had occurred within the Whig party by including Stowe – even though 'the vastness pleases me more than I can defend' – he left it out.[47]

Both Stowe and Rousham, Oxfordshire, demonstrate a symbiotic relationship with the creation of idyllic landscape settings and Classical Arcadias. Kent remodelled Rousham House, dating from around 1635, in an Early Tudor, free-Gothic style in 1738 for General James Dormer (1679–1741). Kent altered the gardens originally laid out by Charles Bridgeman at the same time. Pope was also involved with Rousham, which he had visited in 1724. In a letter to Martha Blount (1690–1762) he writes, 'I lay one night at Rousham, which is the prettiest place for water-falls, jetts, ponds inclosed with beautiful scenes of green and hanging wood, that ever I saw.'[48] Although it was the Bridgeman garden he was relating, prior to Kent's involvement, it is clear from his account that it was already an idyllic landscape setting which Kent enhanced further. Walpole found Rousham the 'most engaging of all Kent's works' and believes that the model for the design was Pope's, 'at least in the opening and retiring shades of Venus's vale.'[49] The gardens at Rousham are the most complete small-scale extant example of Kent's painterly designs. Walpole praises Kent's ability to confer the skill and painting principles he learnt as an artist onto landscapes, a trope of composition that derives from Vanbrugh and Addison. 'Thus the pencil of his imagination bestowed all the arts of landscape on the scenes he handled. The great principles on which he worked were perspective, and light and shade.'[50] The gardens at Rousham remain one of Kent's greatest and most influential scenic essays containing many of the features Walpole was to deploy at Twickenham. The relationship of the landscape to the River Cherwell, which runs through the gardens and is incorporated in the designed landscape, surely influenced him:

But the greatest pleasure we had [Walpole and Conway] was in seeing Sir Charles Cotterel's at Rousham; it has reinstated Kent with me; he has nowhere shown so much taste. The house is old and bad. He has improved it, stuck as close as *he* could to Gothic, has made a delightful library and the whole is comfortable – the garden is Daphne in little; the sweetest little groves, streams, glades, porticos, cascades and river, imaginable; all the scenes are perfectly classic – well, if I had such a house, such a library, so pretty a place, and so pretty a wife – I think I should let King George send to Herrenhausen for a master of the ceremonies.[51]

The natural and architectural elements at Rousham are the epitome of painterly planting and design, containing ponds, cascades, groves, private recesses, serpentine walks and views out across the landscape to Gothic eye-catchers, cultivated fields, extensive prospects and animated landscape. All these elements combined were surely a model for later landscape additions as Strawberry Hill expanded and developed. In his *Books of Materials*, Walpole records:

The garden of 25 acres; the best thing I have seen of Kent, Gothic buildings, Arcade from ancient baths, temples, old bridge, palladian do., river, slender stream winding thro grass walks in a wood, cascades overgrown with ivy; grove of Venus of Medici.[52] The whole, sweet.[53]

At Rousham, Kent improved the Bridgeman landscape by planting firs, flowering shrubs and trees and altered the contours of the landscape by levelling terraces, creating concave slopes and widening the river Cherwell to make more of a figure within the garden. He also called in the views by situating eye-catchers beyond the bounds and opening up the prospects to an animated landscape. The contemporaneous head gardener of Rousham, John McClary, gives an account of the garden and describes the scenes as he conducts the reader on an imaginary tour around the garden:

… when your eye drops upon a very fine concave Slope, at the Bottom Of which runs the Beautiful River Charwell, and at the top stands two pretty Garden Seats, one on each side, backed with the two Hillocks of Scotch Firrs. Here you set down, first in one seat, and then in the other, from whence (perhaps at this time), you have the prettiest view in the Whole World. Tho' the most extensive part of it is but short, yet you see from hence five pretty Country villages, and the Grand Triumphant Arch in Aston Field, together with the naturial turnings of the Hills, to let that charming River down to butify our Gardens. And what closes our Long view is a very pretty Corn Mill, built in the Gothick manner, but nothing can please the eye like our Short view. There is a fine meadow, cut off from the Gardens only by the River Charwell, whereon is all sorts of Cattle feeding, which Looks the same as if they was feeding in the Garden, and through the middle of the Meadows runs a Great High Road, which goes from several hills to several Cities. There you see Carrier's Wagons, Gentlemen's Equipages, Women riding, Men walking and sometimes twenty Droves of Cattle goes by in a Day. Then you see Hayford Bridge (which Carries the Great Road over the Charwell), which is a fine, stone bridge, Six Hundred Feet long and Thirty broad, with a Parripet Wall on each Side, finely Coped, and it is supported by ten Spaces and Arches. Here you see the water comes gliding through the Arches, and all the pretty natiurial turnings and windings of the River; for half a Mile and one Yard, which is the length of the Gardens by the River Side.[54]

The garden designs of Kent and Pope could be described as being on the cusp between the 'poetic' garden and later picturesque garden theory, where the garden was composed to resemble a painted scene. Such gardens used principles of art such as perspective, chiaroscuro, colour, light and shade, often 'framing' or depicting *capriccio* scenes. Garden theories at this period were advancing rapidly and Kent played a significant role in the progression of Whig notions in pictorial landscape design. He was also one of the first garden designers to explore the visual significance of Gothic as a style particularly identified with nature, natural settings and association with Englishness and English culture.

The deployment of Gothic incidents for their associative qualities and potential to add interest or enliven landscape scenes or prospects to stimulate the imagination was a device frequently used by the amateur architect Sanderson Miller. The reader will remember that Miller had built a Gothic

ruin at Hagley in 1748 which Walpole admired when he visited in September 1753. He was derisory about the house that existed at that time describing it as 'immeasurably bad and old', but there can be no doubt that the setting at Hagley epitomises everything that Walpole feels passionate about in terms of the ability of Gothic buildings and their situation to stimulate the imagination.[55] Walpole enthusiastically recounts the effect that Hagley has when he gives a full detailed account in this letter where we witness him enraptured by its romantic character:[56]

You might draw, but I can't describe the enchanting scenes of the park: it is a hill of three miles, but broke into all manner of beauty; such lawns, such wood, rills, cascades, and a thickness of verdure quite to the summit of the hill, and commanding such a vale of towns and meadows, and woods extending quite to the Black Mountains in Wales, that I quite forgot my favourite Thames! – Indeed, I prefer nothing to Hagley but Mount Edgecumbe. There is extreme taste in the park: the seats are not the best, but there is not one absurdity. There is a ruined castle, built by Miller, that would get him his freedom even of Strawberry: it has the true rust of the Barons' War. Then there is a scene of a small lake with cascades falling down such a Parnassus! With a circular temple on the distant eminence; and there is such a fairy dale, with more cascades gushing out of rocks! and there is a hermitage, so exactly like those in Sadler's prints, on the brow of a shady mountain, stealing peeps into the glorious wood below! and there is such a pretty well under a wood, like the Samaritan woman's in a picture of Nicolò Poussin! and there is such a wood without the park, enjoying such a prospect! and there is such a mountain on t'other side of the park commanding all prospects, that I wore my eyes out with gazing, my feet with climbing, and my tongue and my vocabulary with commending![57]

Here Walpole is commenting on the successful combination of art and nature, the romantic Gothic ruin with its imaginative historical references conveying a sense of the past, situated in a divine landscape setting. The arrangement of the building and its setting prompted Walpole to remark that together they form 'such a Parnassus', thus invoking them as a source of literary and poetic inspiration. The design at Hagley incorporates extensive natural prospects, far-reaching vistas and cultivated scenes viewed from a circuit walk, creating a series of beautiful tableaux as though it were a landscape painting. This notion is encapsulated in Walpole's observation on the improvements to landscape in the *History of the Modern Taste* where 'The demolition of walls laying open each improvement, every journey is made through a succession of pictures', or in Addison's 'so many painted views in perspective'.[58] These ideas of combining associative Gothic architecture with visual beauty in landscapes, as used by Kent at Esher and Miller at Hagley, were evocative and appealing to Walpole. The animated landscape and 'beautiful prospects' from Hagley that Whateley describes were attributes considered necessary for imaginative and associative potential and epitomise what Walpole wanted to achieve with the setting and building at Strawberry Hill:

The busy town of Stourbridge is just below them; the ruins of Dudley castle rise in the offskip; the country is full of industry and inhabitants, and as small portion

of the moor, where the minerals, manufactured in the neighbourhood, are dug, breaking in upon the horizon, accounts for the richness, without derogating displayed, that chief beauty of all gardens, prospect and fortunate points of view.[59]

Stowe, Rousham, Esher, Hagley, and Strawberry Hill all took advantage of the extensive prospects and framed views afforded by their topographical situation. These designed landscapes were laid out to take advantage of the setting by creating diversity and interest with a series of contrasts and transitional spaces through opening glades and intimate shades achieved with variety in planting and the framing of iconographic incidents.

Thus, Walpole's picture-conscious approach to buildings and settings manifests itself from the beginning of his recorded responses to the places he visits and it is in his private correspondence and anecdotes that we can see how inspirational models helped to formulate his own ideas as many of the elements he observes on his tours were incorporated into Strawberry Hill. The imaginative association with the historical place and its power to invoke memories and be incorporated into design elements at Strawberry Hill are also apparent from these motivating explorations. After visiting Penshurst House, Sussex with Chute, Walpole writes to Bentley, 'When we had seen Penshurst, we borrowed saddles, and bestriding the horses of our post-chaise, set out for Hever to visit a tomb of Sir Thomas Bullen Earl of Wiltshire, partly with a view to talk of it in Anna Bullen's walk at Strawberry Hill.'[60]

The specific act of linking, by association, through an appellation, a particular part of the site to a historical figure that could be recalled every time the walk was encountered or mentioned meant that, 'Memory heightens the Delightfulness of the Original' and allows him simultaneously to reflect on the visit he had made to Hever Castle, Kent with Chute and the impact Anne Boleyn had made on the course of English history. The picturesque quality and perspectives of the scenes he recalls, combined with the psychological and emotional effects they engender, render these letters and accounts as some of his most memorable and intimate. The principles of naturalistic design that he advocates in the *History of the Modern Taste,* were formulated from his designed landscape at Strawberry Hill, where he put into practice and improved upon the best examples he had encountered on his expeditions.

'The enclosed enchanted little landscape then is Strawberry Hill': Creating a Place for the Imagination

This section interprets the landscape setting at Strawberry Hill, in relation to Walpole's landscape theory and establishes him as successor to Addison, Pope and Kent, advancing the change to more naturalistic gardening through his literature and landscape design. Although his claims that the English invented the naturalistic garden are doubtful, it may be argued that he was the first to design a building and landscape as a complementary picturesque composition. Here we reassess the garden at Strawberry Hill as central to the

4.3 Slight sketch
of the general
ground plot
of the Gothic
mansion

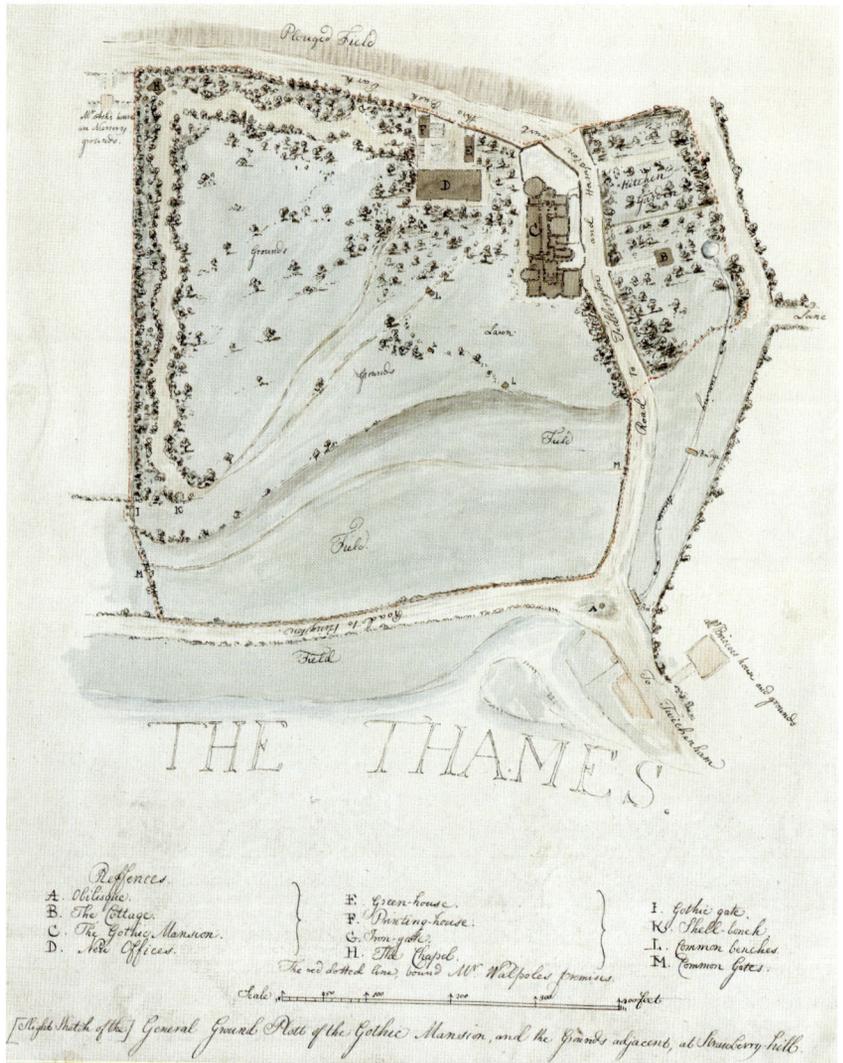

evolution of garden theory and practice for most of the eighteenth century.
It was argued earlier that the innovative theories expressed at Strawberry
Hill were influenced by the theories of Addison and Pope, the latter being
immensely influential on Kent – the practitioner who Walpole particularly
admired and emulated.

It is no longer possible to experience this garden in its original conception
because much has been lost, altered or developed. Strawberry Hill embodies
views, ideas and opinions of the self-styled arbiter of taste on landscapes,
taste and culture – for while Walpole formed a 'committee' to advise on the
conversion and remodelling of the Gothic villa, the landscape is essentially a
personal story. His statement in the *History of the Modern Taste,* with its implied
criticism of contemporary professional landscape designers, sets out his ethos:

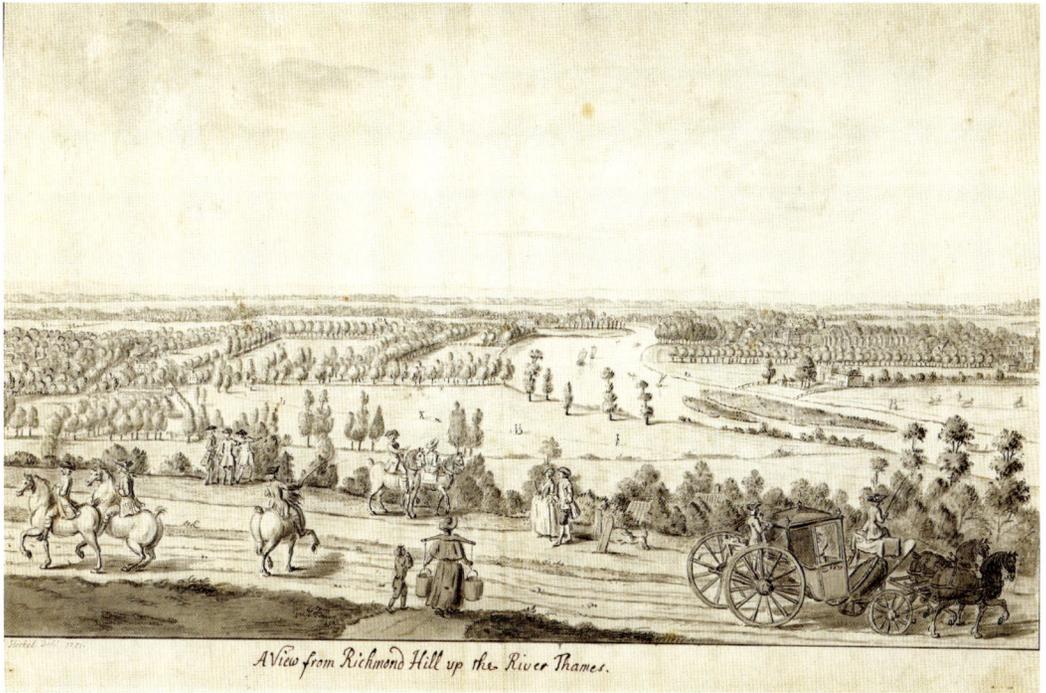

A View from Richmond Hill up the River Thames.

In general it is probably true, that the possessor, if he has any taste, must be the designer of his own improvements. He sees the situation in all seasons of the year, at all times of the day. He knows where beauty will not clash with convenience, and observes in his silent walks and accidental rides a thousand hints that might escape a person who in a few days sketches out a pretty picture, but had not the leisure to examine the details and relations of every part.[61]

4.4 A view from Richmond Hill up the River Thames, A. Heckel, 1751

The views to the river, combined with the long views and prospects to the surrounding landscape from within the site and their potential for design and expansion, provided Walpole with an opportunity to carry out his ethos articulated in the *History of the Modern Taste*: 'an open country is but a canvass on which a landscape might be designed.'[62]

Documentary evidence points to elements of the landscape being designed by Walpole as soon as he acquired the site of about five acres. His concept for the relationship of the house to its landscape took advantage of the natural topography and exploited its borrowed prospects, just as Addison had advocated. The house is situated on level ground with a slight slope to the north east in the direction of the river Thames. The original building was at the edge of Twickenham's development at that time and the natural topography allowed extensive views to the river and into the surrounding countryside, across the landscape to the villages of Richmond, Twickenham and Kingston.

Addison insists on incorporating natural elements within the view and comments how he delights in seeing 'a River winding through Woods & Meadows', and Walpole makes it apparent in his writing that if a house is situated

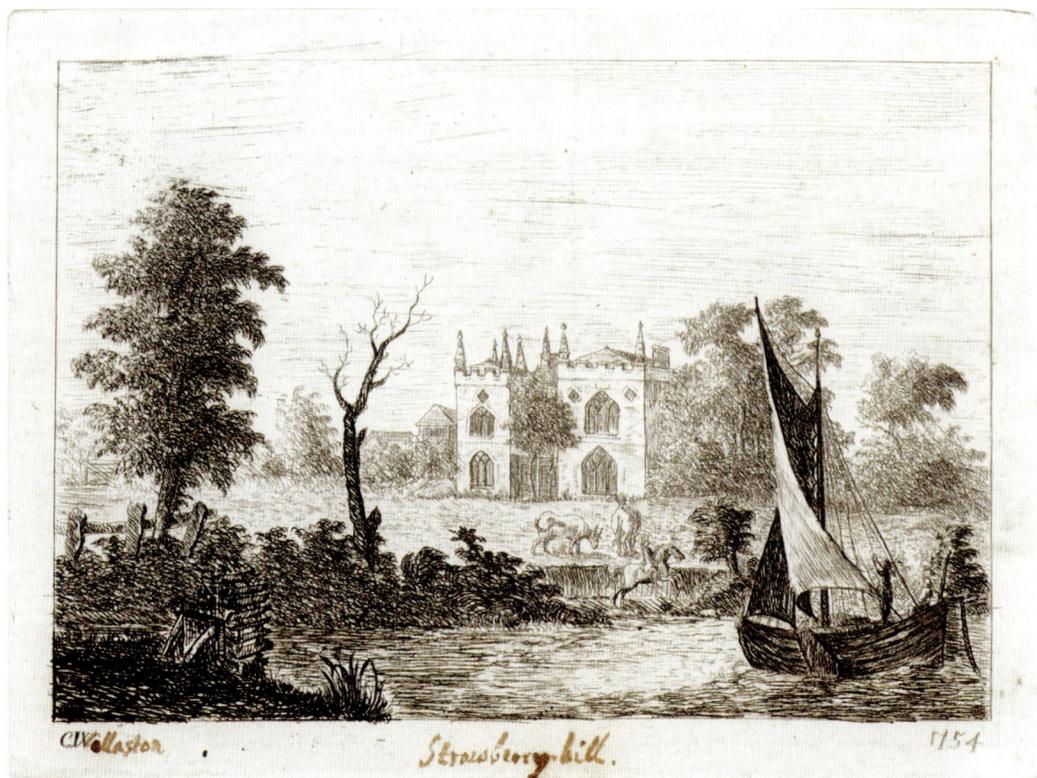

4.5 Strawberry
Hill, C.W.
Wollaston, 1754

on a river it is essential to include the river in the overall picture to enhance the wider landscape setting. There are many instances in the correspondence when he comments on this aspect of landscape design, for example:

About a mile from Worcester you break upon a sweet view of the Severn. A little farther on the banks is Mr Lechmere's house [Severn End], but he has given it strict charge to a troop of willows never to let him see the river: to his right hand extends the fairest meadow covered with cattle that ever you saw: at the end of it is the town of Upton, with a church half ruined, and a bridge of six arches, which I believe with little trouble he might see from his garden.[63]

Similarly, at his friend and correspondent George Selwyn's house, Matson, Gloucestershire, Walpole observes how the prospect could be improved by managing the water and including the town and the river in the prospect:

… it is lofty enough for an Alp, yet is a mountain of turf to the very top, has wood scattered all over it, springs that long to be cascades in twenty places of it: and from the summit it beats even Sir George Lyttleton's views, [Hagley] by having the city of Glocester at its foot, and the Severn widening to the horizon.[64]

He clearly disparages any designer who deliberately excludes a river from the overall scene and this is made explicit in his observations on the setting of Ham House on the River Thames:

I went yesterday to see my niece in her new principality of Ham.[65] It delighted me and made me peevish. Close to the Thames, in the centre of all rich and verdant beauty, it is so blocked up and barricaded with walls, vast trees and gates, that you think yourself an hundred miles off and an hundred years back … He seems as much afraid of water as a cat, for though you might enjoy the Thames from every window of three sides of the house, you may tumble into it before you would guess it was there. In short, our ancestors had so little idea of taste and beauty, that I should not have been surprised if they had hung their pictures with the painted sides to the wall. Think of such a palace commanding all the reach of Richmond and Twickenham, with a domain from the foot of Richmond Hill to Kingston Bridge, and then imagine its being as dismal and prospectless as if it stood

On Stanmore's wintry wild![66]

The site at Strawberry Hill took full advantage of its riverside location and this is confirmed by Walpole's antiquarian friend William Cole: 'Mr Walpole's garden, which, however, is within a furlong or two of the river, and his own meadows go quite down to the banks of it, and nothing to obstruct the view of that most beautifying fluid, which makes everything handsome that is within its influence.'[67]

The landscape, like the Gothic villa, was designed to create the impression of an ancient site that had evolved, modified by accretions over time. The Rocque map (1746) depicts the original small L-shaped structure Chopp'd Straw Hall to the south of Twickenham Field with a short formal avenue running south-east, some outbuildings to the south-west and a kitchen garden to the south but otherwise with little planting and virtually isolated on the edge of pastoral open country.[68]

Historically, water meadows separated the garden and grounds from the Thames. Walpole continually purchased land to the south and east to secure views to the river and wider landscape and gradually enlarged his holding from the original five acres to a total of 46, buying approximately 41 separate plots from 17 owners.[69] The *Correspondence* attests that Walpole began working on the landscape almost immediately after he had acquired the site in 1747 initially carrying out a campaign of tree planting commencing

4.6 Detail from the John Rocque map, Middlesex, 1746

with the grove near the house, maintaining the paramount views of an open aspect to the river. Walpole established sweeping lawns, punctuated by groups of trees to break the uniformity and raised a natural terrace to take advantage of the prospects, as Cole again attests.[70] 'From Mr Walpole's garden and house you have the most beautiful and charming prospect of Richmond, with variety of fine villas and gardens on the banks of the Thames, which river alone would sufficiently recommend any situation.'[71] The extensive structural tree planting programme saw him purchasing 122 trees of mainly native species in an initial phase to create a 'medieval'

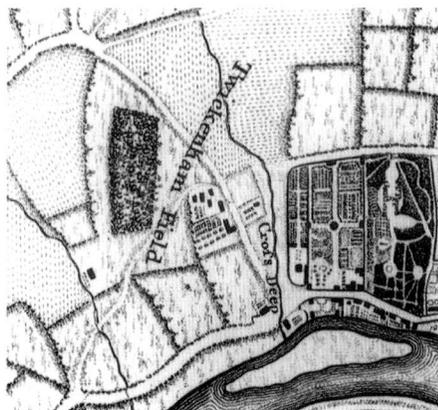

4.7 South view
of Strawberry
Hill, E.
Edwards, 1783

grove to the south of the house. He purchased some 300 trees in the first four years and these were supplemented by others that he propagated in his own nursery which he had quickly established, probably on the site of the kitchen garden.[72] This intensive burst of activity in the beginning soon created the impression that the trees had existed long before he acquired the 'ancient' site and had only recently been taken into the modern pleasure ground. Walpole advocates this device in the *History of the Modern Taste* as a means of signifying the house and its occupant were of some importance:

A great avenue cut through woods, perhaps before entering a park has a noble air, and
Like footmen running before coaches
To tell the inn what Lord approaches,
Announces the habitation of some man of distinction.[73]

A 'grove' has ancient connotations and Walpole's formal grove near the house was intersected by straight paths through the trees so that they 'called in the distant view between their graceful stems, removed and extended the perspective through delusive comparison.'[74]

 He also planted loosely configured groves of oak, lime, elm and walnut and a serpentine wood with a mixture of deciduous and evergreen trees,

4.8 View from Strawberry Hill, E. Edwards, 1783

including laurel and various floriferous shrubs around the south and west perimeters. It was an ancient English tradition that a house had woodland around it and he describes in the *History of the Modern Taste* how ancient parks 'were contacted forests, and extended gardens.'[75] Walpole's 'Gothic pilgrimage' with Chute in 1749 included a visit to Arundel Castle and Petworth, Sussex where he particularly admired the 'magnificence of the park' commenting it would come to epitomise all that modern gardening hoped to achieve. He made particular reference to the redesign of an old park in the new style as: 'A specimen of what our gardens will be, may be seen at Petworth, where the portion of the park nearest the house has been allotted to the modern style.'[76] He emphasised that the new layout had evolved from the ancient deer park incorporating 'oaks two hundred years old.' It was in this manner that he laid out the grove at Strawberry Hill, planting prodigious numbers of trees in an ancient grid-like pattern, combining the old avenue and blending existing trees, then cutting through an avenue aligned on a particular prospect or feature, again just as Addison had described in *Philander's* walks.

His enthusiasm for Petworth, like his response to Woodstock, is fuelled by its sense of place in history, its antiquity – medieval feudal parkland where kings had hunted: 'We were charmed with the magnificence of the park at Petworth, which is Percy to the backbone; but the house and garden did not

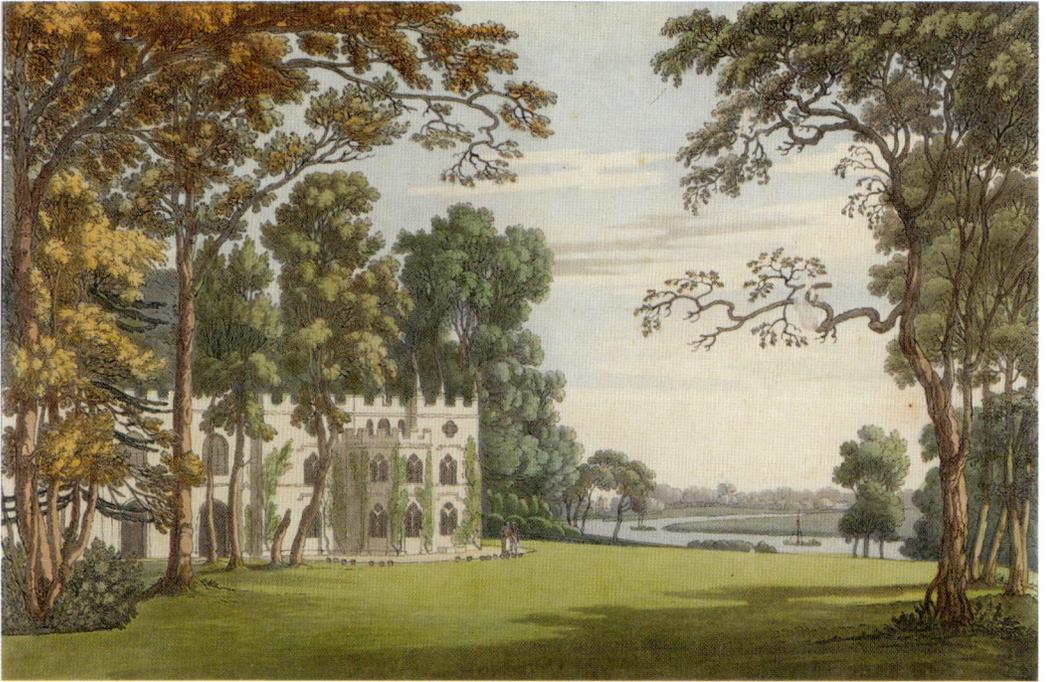

4.9 Prospect from Strawberry Hill, J. Farington, RA, 1793

please our antiquarian spirit.'[77] Its importance for Walpole was in its potential to inspire the imagination through its ancient landscape setting and its links to history, a notion he was to emulate at Strawberry Hill.

The structural planting at Strawberry Hill established the groves, created woodland boundaries, framed particular views and screened unwanted views in and out of the villa and the landscape.

These were carried out in the manner of Kent as elucidated using painting metaphors in the *History of the Modern Taste*:

Groupes of trees broke too uniform or extensive a lawn; evergreens and woods were opposed to the glare of the champain, and where the view was less fortunate, or so much exposed as to be beheld at once, he blotted out some parts by thick shades, to divide it into variety, or to make the richest scene more enchanting by reserving it to a farther advance of the spectator's step. Thus selecting favourite objects, and veiling deformities by screens of plantations; sometimes allowing the rudest waste to add its foil to the richest theatre, he realised the compositions of the greatest masters in painting.[78]

Walpole relates the progress of the formal grove which was to so frustrate him years later: 'the grove nearest the house comes on much; you know I had almost despaired of its ever making a figure.'[79] It then grew so profusely that he complained: 'I have been thinning my wood of trees, and planting them out more into the field.'[80] Pictorial evidence affirms that he applies in his landscape the method of achieving a painterly effect that, in the *History of the Modern Taste*, he attributes to Kent:

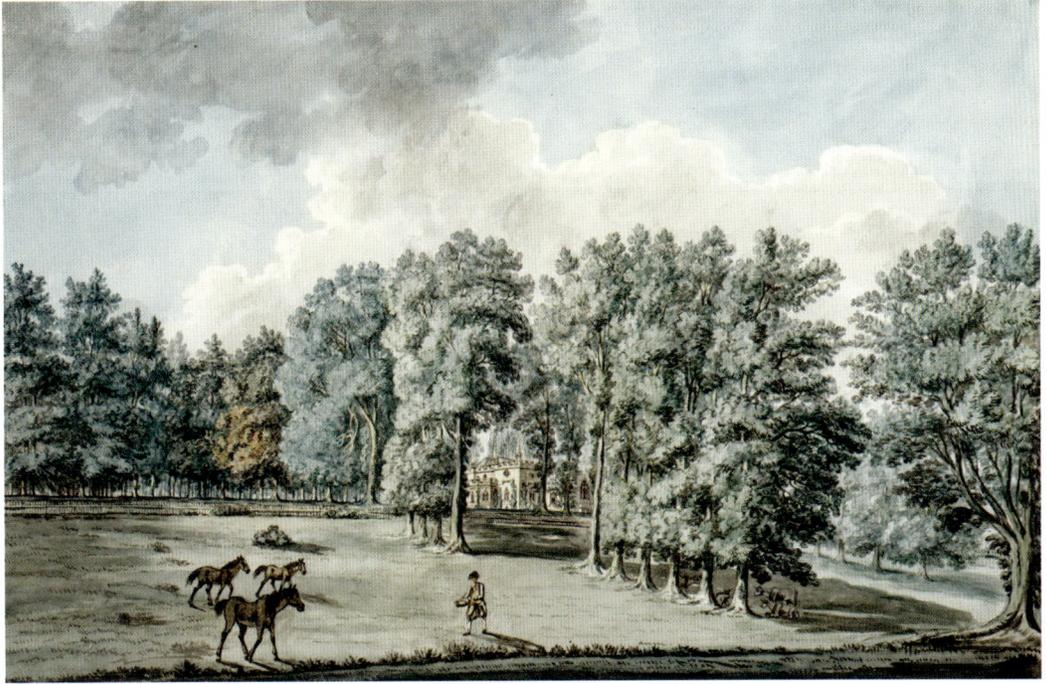

4.10 View of Strawberry Hill, Dobbyns

Where the united plumage of an ancient wood extended wide its undulating canopy, and stood venerable in its darkness, Kent thinned the foremost ranks, and left so many detached and scattered trees, as softened the approach of gloom and blended a chequered light with the thus lengthened shadows of the remaining columns.[81]

His own words best describe his delight on obtaining the modest house at Strawberry Hill. It is interesting to note that from the outset he enhanced the pastoral scene of his 'little new farm' by purchasing sheep of a particular hue and he describes the picture in art historical terms as a 'study', and that the prospect, not the building, prior to its Gothic conversion, is the most important feature:

The house is so small, that I can send it to you in a letter to look at: the prospect is as delightful as possible, commanding the river, the town and Richmond Park; and being situated on a hill that descends to the Thames through two or three little meadows, where I have some Turkish sheep and two cows, all studied in their colours for becoming the view.[82]

He adopts the model of productively-cultivated landscape, combining pleasure and practicality with arable and pasture land appropriately populated with animals to enliven the prospect incorporating 'Fields of Corn [to] make a pleasant Prospect' as outlined by Addison. The land beyond the boundary of the pleasure ground was also incorporated in his own designed landscape at Strawberry Hill, effectively creating a small-scale estate garden.

The setting recalls Addison's statement that 'Hence it is that we take Delight in a Prospect which is well laid out', and diversified with 'Fields and Meadows, Woods and Rivers' to make a scene that 'is perpetually shifting and entertaining the Sight every Moment with something that is new.'[83] One of the earliest letters written from his new landscape at Strawberry Hill suggests that the utilitarian aspects were put to immediate effect:

I have little matter for writing as you can find in a camp. I don't call myself farmer or country gentleman, for though I have all the ingredients to compose those characters, yet like ten pieces of card in the trick you found out, I don't know how to put them together. But, in short, planting and fowls and cows and sheep are my whole business …[84]

The subject of planting dominates early correspondence to friends and is undoubtedly a major preoccupation with him expressing irritation at the rate of growth of his trees and the inherent difficulties in transplanting existing oaks:

My present and sole occupation is planting, in which I have made great progress, and talk very learnedly with the nurserymen, except that now and then a lettuce run to seed overturns all my botany, as I have more than once taken it for a curious West Indian flowering shrub. Then the deliberation with which trees grow, is extremely inconvenient to my natural impatience. I lament living in so barbarous an age, when we are come to so little perfection in gardening. I am persuaded that a hundred and fifty years hence it will be as common to remove oaks a hundred and fifty years old, as it is now to transplant tulip roots.[85]

The reader will recall that an important theme associated with Walpole's landscape design suggested by Addison is that of Ovid's *Metamorphoses*, a connection he continually makes in relation to his garden activities: 'I am all plantation and sprout away like a chaste nymph in the *Metamorphosis*.' Walpole signs off the letter stating 'Adieu! Nothing should make me leave off so shortly, but that my gardener waits for me, and you must allow that he is to be preferred to all in the world.'[86] Readily assuming the persona of a landed gentleman, he is clearly delighted at the prospect of developing the landscape as finances allow:

This sounds very much like a country gentleman; I am so much so, that I tell you honestly I am much too busy with my plantations to call upon you and tell you how glad I am of your good fortune – Had it happened to me just now, I believe I should lay it all out in trees.[87]

Walpole's new role as a country gentleman surprises his close friend Mann as he remembers how the young Horace had not enjoyed his visits to his father's house in rural Norfolk:

Remembering with how much reluctancy you always went to Houghton, and that you was ever the last in town, I should never have thought you would turn so complete a country gentleman as to leave all the amusements of the town at their greatest height to go and plant and lay out your acres … can I send you no seeds from hence to plant there?[88]

Walpole immediately set about acquiring additional land as the original five acres had increased to approximately 14 acres by December 1748. The only significant topographical works at this time were the construction of a 200-metre natural terrace, to take full advantage of the river views and borrowed prospect into the surrounding countryside and the animated landscapes of Twickenham and Richmond, enlivened by passing traffic:

I am extremely busy planting; I have gotten four more acres, which makes my territory prodigious in a situation where land is so scarce and villas as abundant as formerly at Tivoli and Baiæ. I have now about fourteen acres, and am making a terrace the whole breadth of my garden on the brow of a natural hill, with meadows at the foot, and commanding the river, the village, Richmond Hill and the Park and part of Kingston – but I hope never to show it you.[89]

Given Walpole's later dismissal of the influence of Italy on the modern English Landscape style in the *History of the Modern Taste*, it is interesting to note that at this point he compares Twickenham to Italian towns in their picturesque disposition. Gothicising the house had begun almost simultaneously with Walpole introducing structural planting to frame the villa, where 'the living landscape was chastened or polished, not transformed.'[90] He screened unwanted views and concealed buildings and elements that interfered with the larger picture and created new vistas, prospects and borrowed views where desirable. It is clear from the frequent references in the correspondence that the garden was his sole occupation at this time: 'I dig and plant till it is dark: all my works are revived and proceeding'.[91] He was also relishing indulgence in rural pursuits on his 'little farm' which included a fish pond, recalling the self-sufficiency of monastic sites:

I am now as I told you returned to my plough with as much humility and pride as any of my great predecessors; we lead quite a rural life, have had a sheep-shearing, a haymaking, a syllabub under the cow, and a fishing – of three goldfish out of Po-Yang, for a present to Madame Clive: they breed with me excessively, and are grown to the size a small perch. Everything grows, if tempests would let it; but I have had two of my largest trees broke today with the wind, and another last week. I am much obliged to you for the flower you offer me, but by the description is an Austrian rose, and I have several now in bloom. Mr Bentley is with me, finishing the drawings for Gray's Odes; there are some mandarin-cats fishing for goldfish which will delight you: *au reste*, he is just where he was …[92]

Walpole wrote to Mann again in 1753, enclosing a site plan (now lost) drawn by Bentley when he had extended the house and most of the designed landscape was in place. The later estate plan (c.1793) (Fig 4.3) illustrates the completed garden with features that Walpole mentions in the letter and is useful, if somewhat misleading in the detail, for reconstructing what would have been a delightful picturesque fusion of the new taste for naturalistic gardening and the informality associated with Gothic architecture:

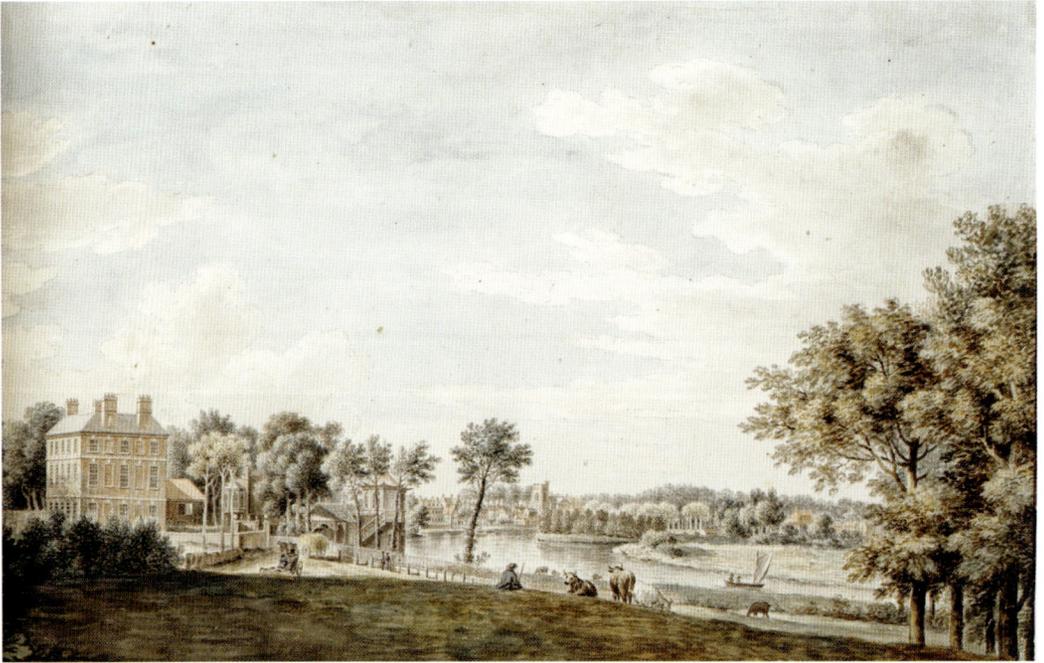

4.11 View of
Twickenham
from Strawberry
Hill, J.H. Müntz

The enclosed enchanted little landscape, then is Strawberry Hill … This view of
the castle is what I have just finished, and is the only side that will be regular.[93]
Directly before it is an open grove through which you see a field which is
bounded by a serpentine wood of all kind of trees and flowering shrubs and
flowers. The lawn before the house is situated on the top of small hill, from
whence to the left you see the town and church of Twickenham encircling a turn
of the river, that looks exactly like a seaport in miniature. The opposite shore is
a most delicious meadow, bounded by Richmond Hill which loses itself in the
noble woods of the park to the end of the prospect on the right, where is another
turn of the river and the suburbs of Kingston as luckily placed as Twickenham is
on the left; and a natural terrace on the brow of my hill, with meadows of my own
down to the river, commands both extremities. Is this not a tolerable prospect?
You must figure that all this is perpetually enlivened by a navigation of boats and
barges, and by a road below my terrace, with coaches, post-chaises, wagons, and
horsemen constantly in motion, and the fields speckled with cows, horses, and
sheep. Now you shall walk into the house …[94]

The emphasis that Walpole continues to place on the recurring theme
of enchantment in association with the building and its landscape is
significant. The prospect and setting are clearly established as being of
prime importance. Walpole insists in the *History of the Modern Taste* that the
'chief beauty of all gardens, prospect and fortunate points of view', and,
'animated prospect, is the theatre that will always be the most frequented';
he obviously had Strawberry Hill in mind, although apparently it was not
animated enough:

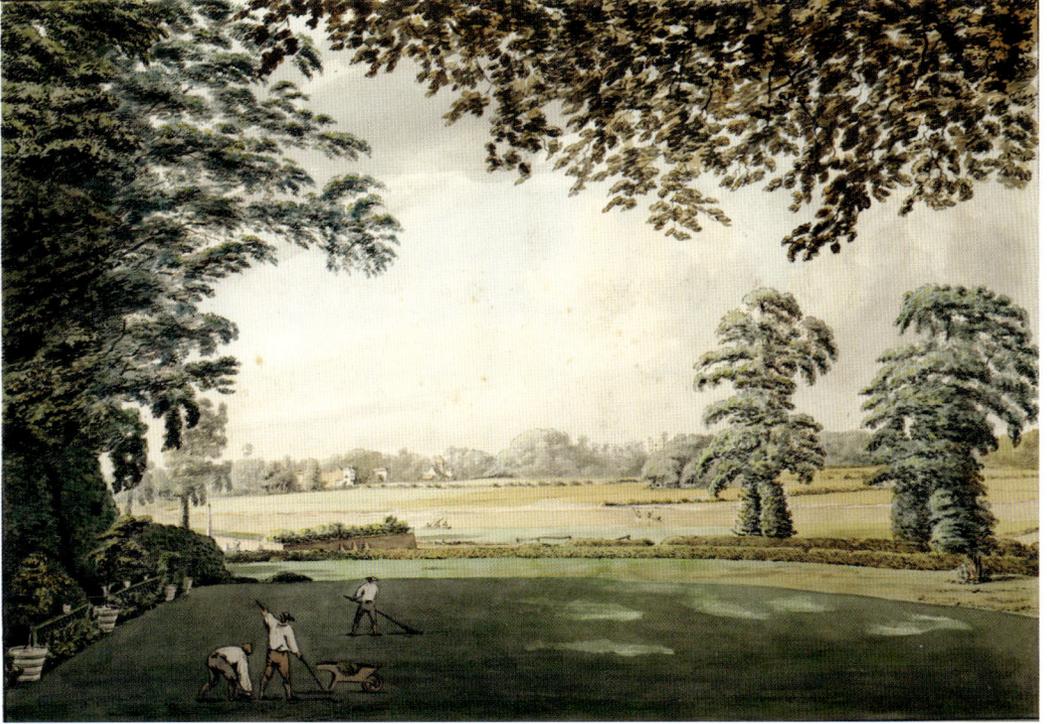

4.12 View of
Twickenham and
part of Richmond
Hill from the
Blue Room at
Strawberry Hill,
J.C. Barrow, 1789

I have a passion for seeing passengers, provided they do pass; and though I have
the river, the road and two foot-paths before my Blue Room at Strawberry, I used
to think my own house dull whenever I came from my brother's [Lacy House,
Richmond]. Such a partiality have I for moving objects, that in advertisements of
country-houses, I have thought it a recommendation when there was a N.B. of
three stage coaches pass by the door every day.[95]

All the ingredients of Addison's theories are here, irregularity of natural
landscape, borrowed views, spontaneity, movement and constant variety
that incorporates, in Addison's terminology, 'everything that is new or
uncommon, raises a pleasure in the imagination because it fills the soul with
an agreeable surprise, gratifies its curiosity, and gives it an idea of which it
was never before possessed' – and significantly providing the potential for the
strange present in the scenes in the 'enchanted little landscape'.

'The gay but tranquil scene': Experiencing Strawberry Hill

The first encounter that visitors to the Gothic castle had with Walpole's landscape
was glimpsing the Prior's Garden through a screen. This small enclosed garden
was linear and formal in arrangement with both rectangular and an apsidal flower
bed planted with many perfumed species appropriate to its religious symbolism.

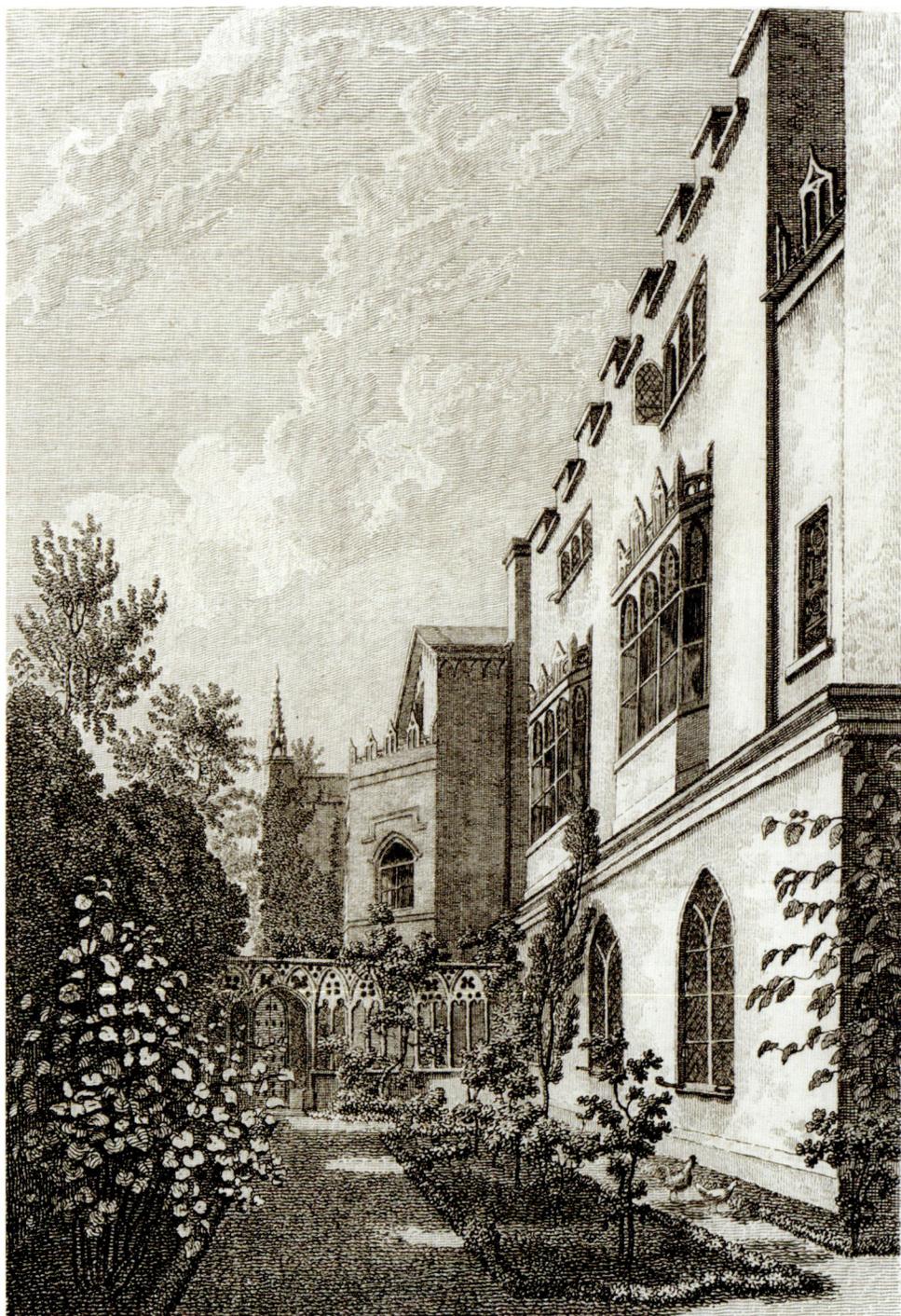

4.13 View of the Prior's Garden at Strawberry Hill, G. Pars

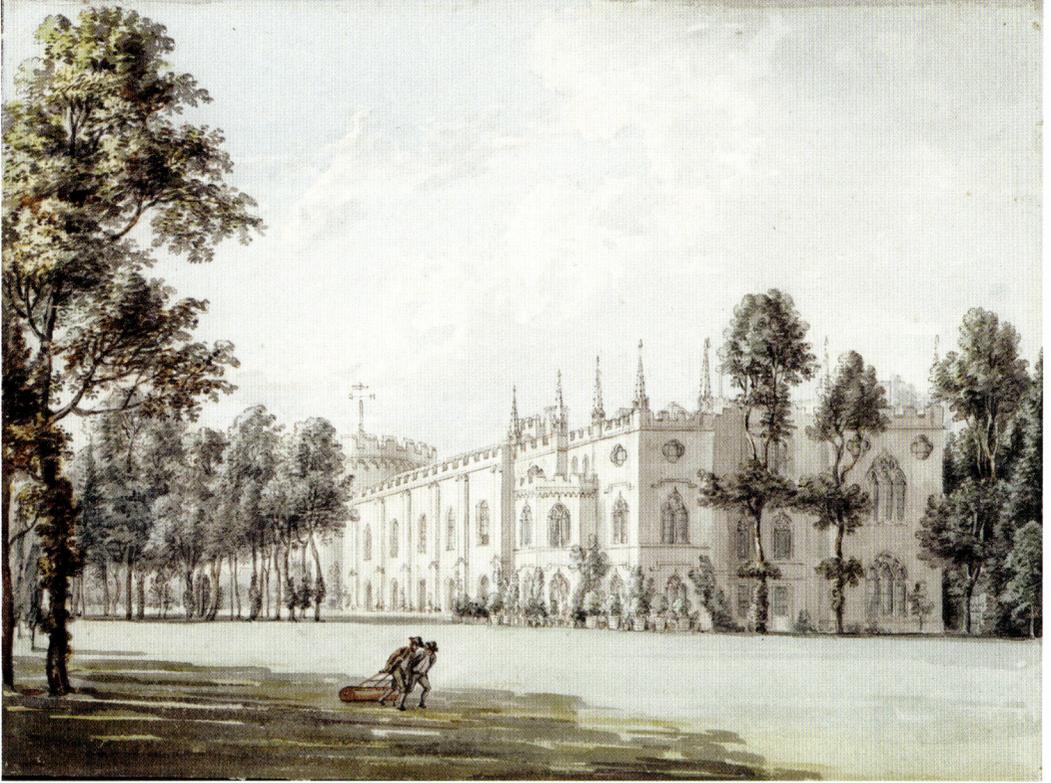

4.14 East view of Strawberry Hill, P. Sandby c.1769

There were gravel paths edged with box around its perimeter with climbers clambering up the walls. Walpole added a further screen to the west end in 1789 making the garden completely enclosed.[96] This space fulfilled Walpole's stated preference for an 'old fashioned' formal garden near to the house for reasons of convenience, a methodology later adopted by the 'father of modern gardening' Humphry Repton (1752–1818).[97] Walpole believed that isolating the house in a landscape was a 'defect':

> Sheltered and even close walks in so very uncertain climate as ours, are comforts ill exchanged for the few picturesque days that we enjoy: and whenever a family can purloin a warm and even something of an old fashioned garden from the landscape designed for them by the undertaker in fashion, without interfering with the bigger picture, they will find satisfaction on those days that do not invite strangers to come and see their improvements.[98]

Visitors to Strawberry Hill would have then participated in a guided tour by the housekeeper (or Walpole himself if they were important enough) of the antiquarian contents of the interior, eventually emerging, after experiencing a series of Gothic spaces, from the 'gloomth' of the historicised interior with an increasing sense of history, into the 'greenth' of the garden. Exiting through

the Great Cloister, an open, groin-vaulted outdoor room which functioned as the connection between the interior and exterior, the visitor would meet the 'agreeable surprise' occasioned by the expansive views of the sweeping Great Lawn, Grove, and Serpentine Wood.

Walpole created a series of distinct areas linking discrete but interrelated features by a sinuous path that wended its way around the southern and western extremities of the site, connecting the buildings to the furthermost features in the landscape. The reconstruction will follow this route as Walpole frequently refers to walking his 'circuit', suggesting that it was designed to be experienced in a particular sequence. Dense planting concealed each episode from the next and added the essential components of visual contrast in structure, texture, colour and form, providing intricacy, variety and surprise. The loosely configured serpentine path gave opportunities for framed pictorial compositions 'that compose a picture of the greatest variety' as well as giving the illusion of an unending journey, while the poetic incidents gave at the same time the opposite impression of small-scale, seclusion and intimacy and possibilities for reflection and contemplation. Walpole used associative, emblematic and iconographic elements to create pictorial effects that were carefully contrived to evoke 'moods' in landscape as a means of stimulating his imagination. The Winding or Serpentine Walk was perhaps created as a walk through Elysium, a journey from darkness into light, terminating at the Shell Bench, a memorial to Walpole's mother overlooking the river.[99] The inspiration came from the Elysian Fields at Stowe and Venus Vale at Rousham, but here the theme combines a landscape of memory and reflection that also alludes to the potential for transformation through Ovidian reference.[100] However, we should remember that Elysium also represents a place or state of ideal or perfect happiness. The walk would have had planting that accorded with an Elysian landscape memory of melancholic trees and shrubs, such as larch, yew and laurel and undoubtedly a carpet of asphodel, which in poetic tradition is an immortal flower said to cover the Elysian meadows. The walk would have been conceived to create different atmospheric moods, through a succession of spatial experiences making a series of natural transitions, from gothic gloom formed by dark evergreens after which the visitor would emerge into hanging woods, then into small clearings and intimate spaces lit by dappled sunlight penetrating the trees. There was, in addition, a series of structured incidents related to death, change and transformation encountered on the route which symbolically represented a journey from death to rebirth that embraces introspection and reflection, ending with references to creation in the form of the Shell which alludes to Venus, Goddess of Love, Beauty and Fertility. Hope is reflected by the emergence into the light open space with views of the river Thames and the wider landscape conveying a feeling of liberation following the enclosed and confined nature of the walk.

Walpole's designed landscape was, in some respects, intended to contrast with the building to enhance 'the gay variety of scene' which he had singled out for praise in Pope's garden and in Addison's description of his own garden as 'so mixed and interwoven'. It was to be cheerful and pleasant to

look at expressing 'the gaiety of nature', although while areas near the house conveyed this pleasant and agreeable aspect, other areas, particularly the Winding Walk, were of a different character to convey different scenarios akin to Addison's 'irregularity in my plantations.'[101] Theatrical effects were obtained through diverse spatial devices with the careful placement of objects against graduated shrubberies to obtain backdrops. The intermixing of different species of deciduous and evergreen trees and shrubs gave complementary areas of light and shade, creating a series of atmospheric moods through colour, smell and visual contrast, of 'ten thousand different colours', scents and sounds enhancing the painterly chiaroscuro effect. Transitions were made from Gothic gloom formed by evergreens such as laurel and yew, with 'shady walks that are adorned with evergreen oaks, handsome variegated hollies, deciduous cypresses.'[102] Planting variously framed, revealed and concealed buildings and artefacts, exhibiting 'genius in works of this nature, and therefore always conceal the art by which they direct themselves', leading the visitor into hanging woods or clearings and intimate spaces infused with dappled sunlight penetrating the trees. The long views contrasted with more intimate, secluded spots containing unrestricted shrubs and flowers, 'a natural wilderness' dispersed to appear thriving naturally in the undergrowth.

The planting schemes at Strawberry Hill demonstrate significant similarities with those in the Venus Vale, described by John McClary, Head Gardener at Rousham, which we will recall Walpole had visited:

> … into one of the noblest Green Serpentine Walks that was ever seen, or ever made. View narrowly as you goe along and you perhaps see a greater veriaty of evergreens, and Flowering Shrubs than you can possibly see in any one Walk in the World. At the end of this Walk stands a four-seat Forrist Chair, where you set down, and view what, and where, you walked along. There you see the deferant sorts of Flowers peeping through the defferant sorts of Evergreens. Here you think the Laurel produces a Rose, the Holly a Syringo, the Yew a Liloc, and the sweet Honeysuckle is peeping out from every Leafe of the Evergreens; in short, they are so mixt together that you'd think every Leafe of the Evergreenes produced one Flower or an other. From thence, you turn down a little Serpentine gravel Path, into a little Opening, made with Yew, and other Evergreens as dark and Melancholly as it was posable to make it, and on one side of it stands a pretty little Gothic building (which 'I') designed for Proserpine's Cave, and placed in it five Figures in Bass Reliefe, done by the best Hand in England …[103]

The Serpentine Walk visually demonstrated variety and surprise to the perpetual curiosity of the visitor, with a path that meandered around the boundary of the site with regular and irregular features and objects placed to be discovered on the journey. The visitor had glimpses and alternating views of landscape outside the garden and diverse architectural features, structures and planting. The planting was strategically positioned so that prospects and buildings were continuously seen or merely glimpsed from time to time as the visitor progressed around the prescribed route. The disposition of objects alternating with startlingly revealed views added to the sense of theatre – a scenographic allusion carefully controlled for the privileged resident or guest.

4.15 Gothic
garden gate,
T. Morris

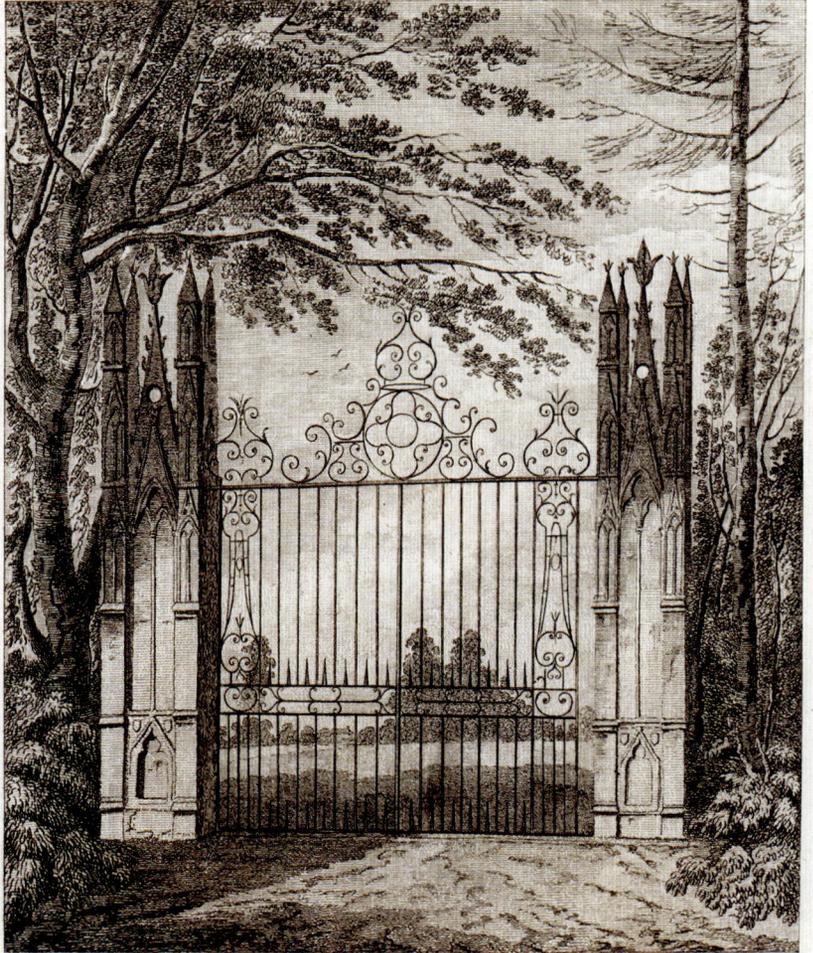

We have seen how Walpole used theories of landscape design in the interior juxtaposing Classical artefacts with Gothic and he used the same approach in the garden in the placement of incidents which he appreciated for their poetical, metaphorical and philosophical associations.

The Gothic gate was the first 'medieval' incident encountered on the circuit, with the pier design based on tomb architecture.[104] 'Strawberry is in the most perfect beauty, the verdure exquisite, and the shades venerably extended. I have made a Gothic gateway to the garden, the piers of which are of artificial stone and very respectable.' [105]

The Gothic style of the gate at once connects the garden, through architectural association, to the castle, embattled wall, Prior's Garden, and other structures, the Chapel in the Woods and the later collegiate Gothic of the New Offices. The gate led into the Serpentine Walk from the Hampton Court Road sending a visual signal to approaching visitors of the Gothic castle. It probably also served as a pedestrian entrance to the garden.

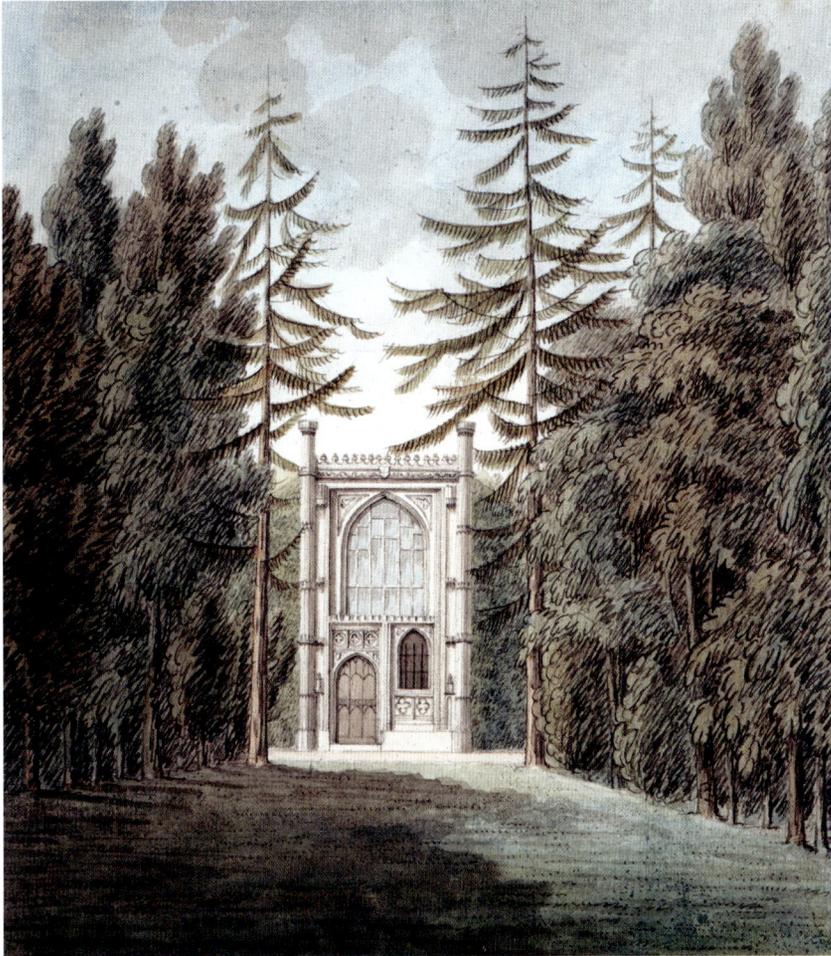

Walpole had already purchased the 'iron gates' in 1769 and requested James Essex to provide drawings for the Gothic gate piers to be derived from the canopy of the twelfth Bishop of Ely that you can walk through in the cathedral:

Imprimis then, here are the directions for Mr Essex for the piers of my gates. Bishop Luda must not be offended at my converting his tomb into a gateway. Many a saint and confessor, I doubt, will be glad soon to be *passed through*, as it will at least secure his being *passed over* … The width of the iron gates is six feet two, and they are seven feet ten high. Each pilaster is one foot one wide: the whole width with interstices is eight feet ten. The ornament over the gates is four feet four to the point. Perhaps you will understand me from this scrawl. The piers should certainly, I think, be a little, and not much higher than the ornament over the gates, but Mr Essex will judge best of the proper proportion. I would not have any bas relief or figures in the bases. The tops to be in this manner – nothing over the gates themselves. (I have drawn these piers too wide … Remember to ask me for acacias, and anything else with which I can pay some of my debts to you.[106]

The Chapel in the Woods (1771–73) came next in the sequence and sat sombrely in the far south-west corner of the circuit, surrounded by larches and other melancholic planting to create a gloomy, reflective atmosphere which would 'fill the mind with calmness and tranquillity, and to lay all its turbulent passions at rest.'

The Chapel, seen on approaches from the north and east, was meant to represent an ancient building type, the Oratory or private place of worship attached to a nobleman's house, castle or monastery. This too is based on the architecture of death here erected specifically to house a shrine, with the subjects of the windows making direct links with the histories expressed in the interior of the castle:

> I am building a small chapel too in my garden to receive two valuable pieces of antiquity, and which have been presents singularly lucky for me. They are the window from Bexhill with the portraits of Henry III and his Queen, procured for me by lord Ashburnham. The other great part of the tomb of Cappoccio, mentioned likewise in my *Anecdotes of Painting* on the subject of the Confessor's shrine, and sent to me from Rome by Mr Hamilton our minister at Naples. It is very extraordinary that I should happen to be the master of these curiosities. After next summer, by which time my castle and collection will be complete (for if I buy more, I must build another castle for another collection) I propose to form the catalogue and description, and shall take the liberty to call on you for your assistance. In the meantime there is enough new to divert you.[107]

Walpole makes frequent references to the new Chapel in his correspondence at this juncture, for example he encourages Cole to visit soon: 'By that time will be finished a delightful chapel I am building in my garden, to contain the shrine of Capoccio and the window with Henry III and his Queen.'[108] Although it was never meant for worship, he jokes to Cole that, 'The new chapel in the garden is almost finished, and you must come to the dedication.'[109] Like many of the architectural elements at Strawberry Hill its origins were in tomb architecture; this particular design was derived from Bishop Audley's Chantry Chapel in Salisbury Cathedral. Walpole commissioned Thomas Gayfere to construct the Chapel in stuccoed brick with a carved Portland stone façade. Walpole incorporated stained glass illustrating 'the portraits of Henry III and his Queen' from the church at Bexhill, Sussex.[110] He apparently intended to make another explicit pictorial link with English history as had done in the castle through the association of Westminster Abbey, Edward the Confessor, and Henry III.

Cole did not see the Chapel when it was building in 1772 so Walpole is still entreating him in 1774 to come and see his new delight which McCarthy describes as 'the finest garden building of the period in the Gothic Style.'[111]

> We are almost freezing here in the midst of beautiful verdure with a profusion of blossoms and flowers: but I keep good fires, and seem to feel warm weather while I look through the window, for the way to insure summer in England, is to have it framed and glazed in a comfortable room … You shall be inaugurated in my chapel, which is more venerable than your parish church, and has the genuine air of antiquity …[112]

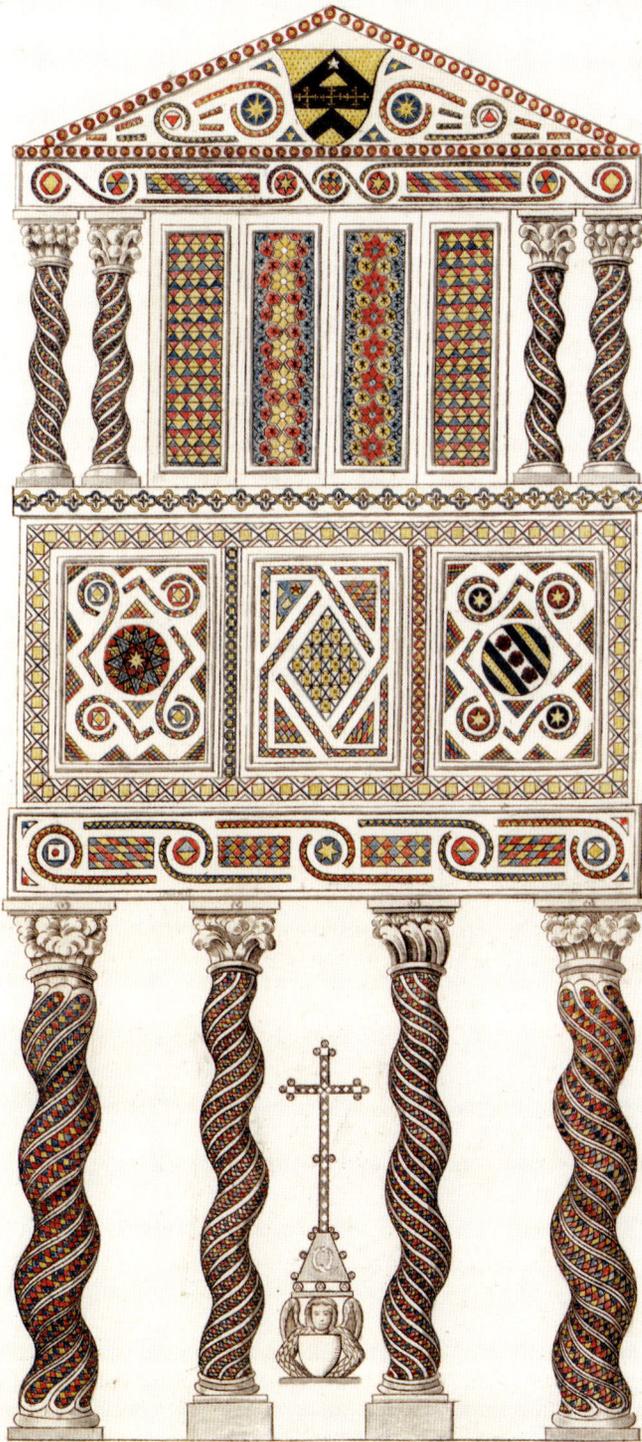

4.17　The shrine inside the Chapel

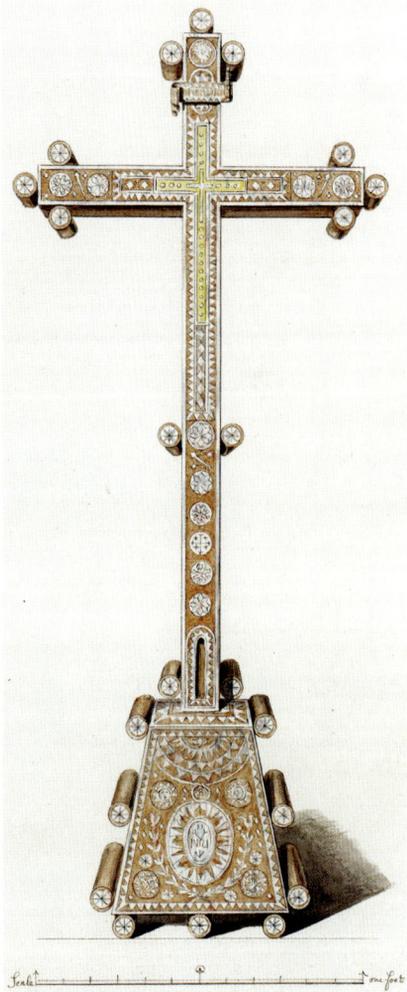

Hamilton had sent Walpole 'parts of a magnificent shrine of mosaic, three stories high', which Walpole had repaired, altered and re-erected in the Chapel in the Woods. The shrine was brought in 1768 from the church of Santa Maria Maggiore in Rome.[113]

Cole eventually made the long-awaited visit to the Chapel and shrine which was thought to be associated with English history through its sculptor who had possibly executed Edward the Confessor's tomb. Thus, another associative connection with events in English history was established 'to please the imagination':

> Before dinner Mr Walpole walked with me into the garden to show me his newly erected Chapel, as he calls it, with the shrine in it from the Church of Santa Maria Maggiore at Rome, where it was erected in 1256, by Gio. Giacomo Capoccio and Vinia, his wife, over the bodies of the holy martyrs, Simplicius, Faustina, and Beatrice, and was executed by Pietro Cavalini, who made the shrine of Edward the Confessor in Westminster Abbey.[114] It is a very curious monument of white marble, standing on twisted pillars, and inlaid with other rich marbles; but altered from what it was when standing in San Mary Maggiore at Rome. It is also mended and completed by the ingenious artist who erected the beautiful marble chimney-piece in the circular drawing room at the end of the gallery.[115] This occupies the whole end of the chapel, the great and only window to which is filled with painted glass from Bexhill in Sussex. There are besides a strange jumble of crucifixes and profane ornaments.[116] It is so small that half a dozen people will fill it. The front is exquisitely performed in the truest Gothic taste.[117]

4.18 The Crucifix under the shrine in the Chapel, J. Carter

Built both for practical and visual purposes, the Chapel housed significant new artefacts of historical and architectural interest, including a crucifix, marble bust of St John the Baptist by Donatello (1386–1466) and four painted panels which had been doors to an altar-piece from Edmunsbury Abbey, Suffolk which Walpole had 'sawed into four pictures.'[118]

These too portrayed significant ecclesiastical and royal personages associated with events in English history. The Chapel was also intended to provide an opportunity for introspection and reflection through its ecclesiastical associations and its function in death.[119] Although not visually connected to the house, architecturally, symbolically and emotively, it referred back to the villa and recalls through its melancholy scenes Walpole's themes of separation and death and brings to mind his frequent references to *Eloisa To Abelard* and their exile into a cloistered existence in the Paraclete, another connection to the monastic space of the house:

The darksome pines that o'er yon rocks reclin'd
Wave high, and murmur to the hollow wind,
The wand'ring streams that shine between the hills,
The grots that echo to the tinkling rills,
The dying gales that pant upon the trees,
The lakes that quiver to the curling breeze;
No more these scenes my meditation aid,
Or lull to rest the visionary maid.
But o'er the twilight groves and dusky caves,
Long-sounding aisles, and intermingled graves,
Black Melancholy sits, and round her throws
A death-like silence, and a dread repose:
Her gloomy presence saddens all the scene,
Shades ev'ry flow'r, and darkens ev'ry green,
Deepens the murmur of the falling floods,
And breathes a browner horror on the woods.[120]

Other artefacts encountered on the circuit included a 'large antique sarcophagus in marble, with bas-reliefs', and 'two ossuaria'. Through their physical form as receptacles for the dead, and through associative meaning they recall Elysium and memory.[121] Walpole had acquired the sepulchral altar in 1753 through Mann:

What I shall trouble you to buy is for the garden: there is a small recess; for which I should be glad to have an antique Roman sepulchral altar, of the kind of the pedestal to my eagle; but as it will stand out of doors, I should not desire to have a fine one: a moderate, I image, might be picked up easily at Rome at a moderate price: if you could order anybody to buy one, I should be much obliged to you.[122]

Walpole writes to Mann to relate its safe arrival and location in his garden. 'It arrived here – I mean, the tomb … and this morning churchyarded itself in the corner of my wood, where I hope it will remain till some future virtuoso shall dig it up, and publish it in *a collection of Roman antiquities in Britain.*'[123] It would have been situated among gloomy, melancholy planting appropriate to, and associated with, tombs and burial including elms which Addison had observed look 'exceedingly solemn and venerable.' There would also have been 'sepulchral Cypress, Lawrel, Pine, and Bays, Yew, and all Trees, whose Verdure ne're decays, Are planted in long Rows, where Mourners walk.'[124] Other tombs which Walpole solicited for the garden, to increase the association of the Winding Walk with mourning, would have been situated in a suitably melancholic horticultural context. Mann informs Walpole of an impending gift from Italy:

My Lord [Lucan] or my Lady has picked up a pretty little sarcophagus at Rome for you with the bones of a child in it. What a treasure for your chapel! But I believe I ought not to have mentioned it, and indeed I am sorry I have, as it will take off the merit of it as a surprise, but my Lord dares not venture to send home his purchases until peaceable times, as no ships from Italy escape the French.[125]

This is likely to be the 'large antique sarcophagus in marble, with bas reliefs, from the collection of Bryan Fairfax, esq' recorded in *A Description of Strawberry Hill.*[126]

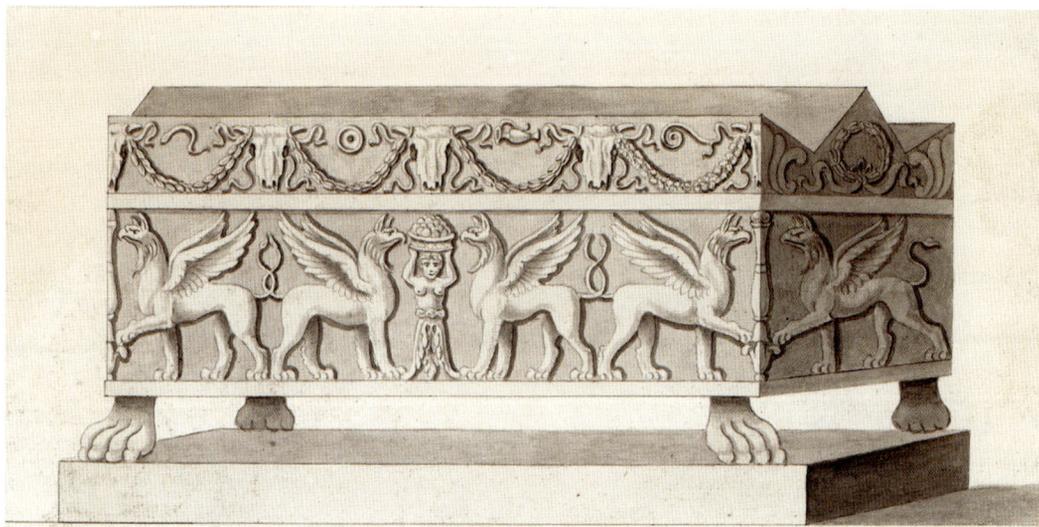

4.19 Marble
sarcophagus

The nomenclature of the Winding Walk links to the Winding Cloister of the
castle and there are significant allusions in the Winding Walk to Classical
antiquity and literature, particularly Ovid's *Metamorphoses* whose main
themes are love and transformation. Addison also points out that 'Ovid,
in his *Metamorphoses*, has shown us how the imagination may be affected
by what is strange.' Themes of death are invoked through architecture,
including the Chapel containing a shrine and ossuary and the sepulchral
altar; however, there are also possibilities for imaginative engagement and
the potential for change and transformation symbolised by scenes from
Ovid's supernatural tale.[127]

Walpole situates the God of dreams 'The sleeping Morpheus in plaister',
who is traditionally depicted asleep surrounded by poppies as an incident
in the circuit.[128] The presence of Morpheus is a palpable reminder of the God
who shapes our dreams and visions and according to Ovid is responsible for
producing images of the human form often invoking to the dreamer the dead
or departed. His appearance here suggests that the garden allows Walpole
to indulge in supernatural fancy and imaginative magical response which
surpasses everyday experience. Ovid in the garden authorised the enchanted
and the marvellous and imparted exceptional meaning and pleasure to this
spot 'we are walking on enchanted ground, and see nothing but scenes of
magic lying round us.'

The next episode was the oak Shell Bench designed by Bentley and based
on Botticelli's *Birth of Venus* (1486) which was oriented to the river Thames and
surrounding landscape with another Gothic Gate nearby.

Venus, the Roman Goddess of Love, Beauty and Fertility who as
Aphrodite in Greek mythology is linked to themes in Ovid's *Metamorphoses*
for she too was similarly 'transformed' and recreated on the shore at
Paphos, Cyprus. Walpole makes a direct link in his correspondence, which

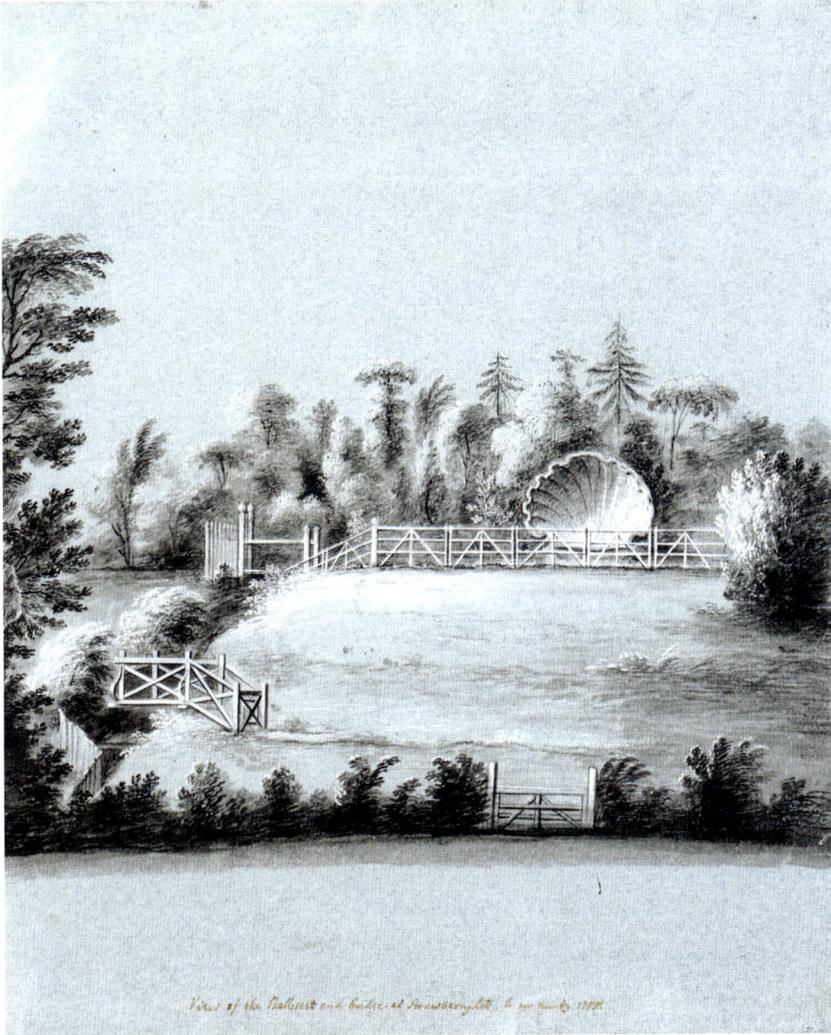

4.20 View of the Shell Seat and bridge at Strawberry Hill, J.H. Müntz, 1755

the erudite reader would have recognised through its associative qualities, when he relates 'Strawberry Hill is grown a perfect Paphos, it is the land of beauties. On Wednesday the Duchesses of Hamilton [1733–1790] and Richmond, and Lady Ailesbury [1721–1803] dined there, the two latter stayed all night. There never was so pretty a sight as to see them all three sitting in the shell ...'[129]

However, it is contended that it was erected in remembrance of Walpole's mother who had a celebrated grotto overlooking the Thames in her garden at Orford House, Chelsea, where she died. The following verses were addressed to Lady Walpole, upon her receiving a present of shells from Guernsey to decorate her grotto, which make a direct reference to Venus and her shell:

See how the isles obeisance pay
To Walpole's most auspicious sway:
Each little isle, with general zeal,
Sends grateful every precious shell;
Shells, in which Venus and her train
Of nymphs, ride stately o'er the main.
The rarities in South Sea found
In the thrice happy isles abound,
To make the Walpole's grotto fine,
And rival grotto Caroline.
Learn from the isles, ye Britons, learn
Exalted merit to discern;
And, free from prejudice and passion,
Do homage to its exaltation:
Shall Chelsea Grot its beauty owe
To presents puny isles bestow?
The fame of Walpole is above
Mean monuments of private love –
Let Chelsea Grotto be bedeck'd
With marks of national respect …[130]

Significantly, we will remember that Lady Walpole's portrait hanging in the interior depicted her emblems as 'flowers, shells, a pallet and pencils, to mark her love of the arts.'[131] The verses link, by association, the Grotto, Walpole's mother and his father's place in history as first Prime Minister, simultaneously evoking both personal and national history and therefore a potent imaginative symbol for Walpole. The Shell Bench, with its asymmetrical Rococo motifs and scrollwork that recall the shell-adorned grotto at Chelsea, was carefully placed among the roots of an oak to appear as if it was a product of the tree and make the association of Venus seeking refuge in woodland. The rose, myrtle, apple and lime trees are symbols traditionally associated with the Goddess and accompany depictions of Venus and therefore Walpole would have set the Shell Bench within this horticultural context:

On rosie beds beneath the myrtle shade …
With such a rueful Fate th' affrighted maid
Sought green recesses in the wood-land glade.[132]

The literary association with Ovid's *Metamorphoses*, which Walpole frequently mentions in relation to the garden because of its themes of change and transformation, is unmistakeable. Ovid's characters inhabit a natural world where strange and transforming events happen and it has been established that Walpole associated Strawberry Hill with Ovid from its inception.

Walpole was given a gift of an 'extraordinary large brainstone', which he placed on a stone pedestal in the garden which provokes thoughts of rusticity and his interest in antiquarian studies. However, the brain is also the seat of sensation, imagination, memory and thought and is figuratively associated with the intellect, so it may allude to this aspect too.

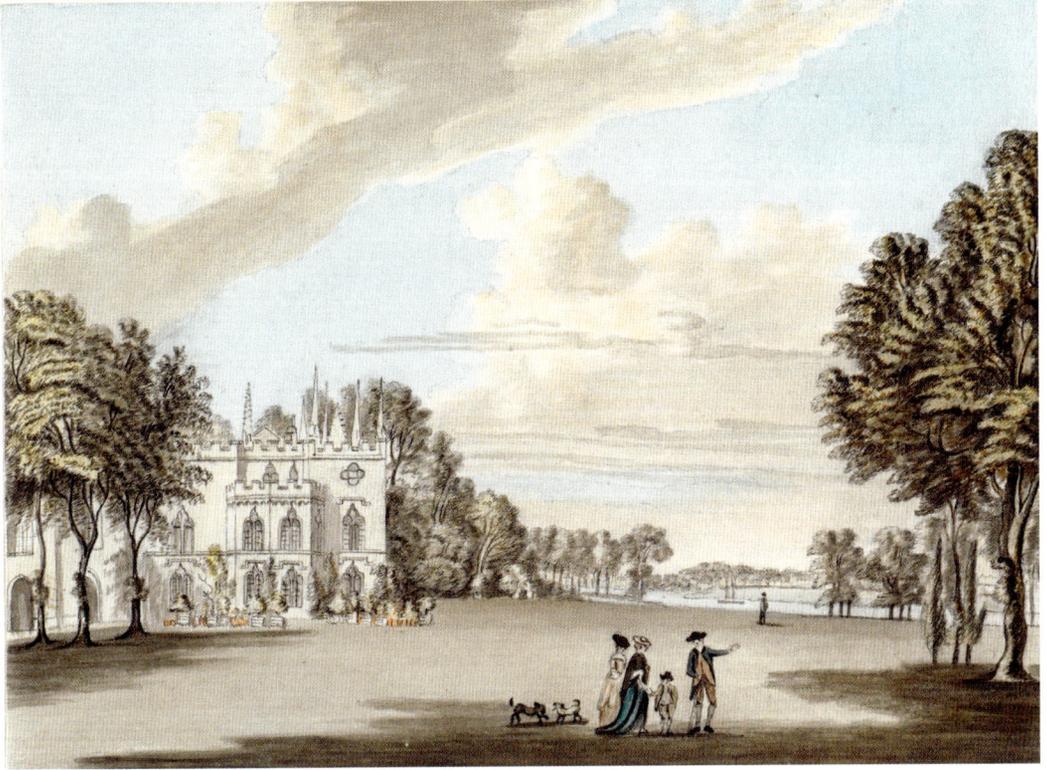

4.21
Strawberry Hill,
Mr. Walpole's
south view,
M. Griffith, 1781

After experiencing a series of contrasting scenes, moods and episodes, associative incidents and character areas, all with increasing sense of theatre, the visitor eventually emerges into the dramatic expanse of the Lawn and atmospheric Open Grove where the walk terminated and where perspective views of the villa provided the closing sequence.

Walpole clearly distinguished the characteristics of the Lawn and the Grove. The correspondence indicates some of the type of trees planted in the areas of the Grove, Terrace and meadows beyond:

We have had a tremendous tempest of wind this morning before five o'clock; it did not wake me till the close, though it has done me mischief. It has levelled the two tall elms in meadow beyond the clump of walnut trees, and snapped two others short in the grove near the terrace.[133]

The Lawn, by contrast, was a sweeping expanse of grass with no planting indicated in any of the illustrative material. He did however place some potted plants towards the Grove and there is evidence of specimen trees standing forward of the tree belt, thus loosening the edges in the manner of Kent. Indeed the Lawn area was named 'the bowling green' by Walpole himself when he describes Sir Charles William's daughter going into the garden and how she '... went on the bowling-green, and drew a perspective view of the castle from the angle in a manner to deserve the thanks of the *committee* ...'[134]

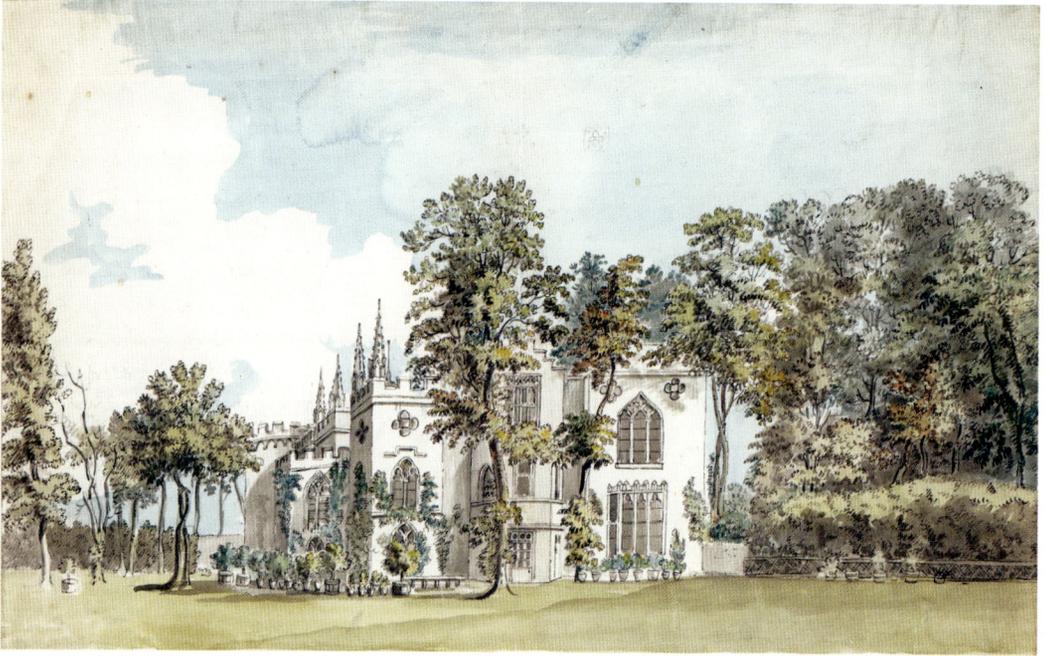

4.22 East view of Strawberry Hill, Capn Grose, 1787

The mention of the committee in this context supports the contention that they were involved in aspects relating to the building but not the landscape. The Grove near the house as mentioned above, was a grid-like tree plantation of varying depth separating the open ground with views through the trunks and no 'laurel lawn' or understory evident to restrict the sight.

In addition, Walpole created a gap by cutting an avenue through the trees to allow long views and give the appearance of an ancient grove incorporated into a landscape in the 'Modern taste'. Although there was no planting apparent beneath the trees, mistletoe and scented climbers were placed at their base in order to ascend through the branches and hang down in festoons, providing scent and colour which combine to 'heighten the Pleasures of the Imagination, and make even the Colours and Verdure of the Landskip appear more agreeable'. Mr Ashe, a nurseryman in Twickenham had supplied Pope with plants and when Walpole had requested that his tree planting was carried out in an irregular manner, he replied, 'Yes, Sir, I understand: you would have then hang down somewhat poetical.'[135]

The ideas for poetical planting, despite Walpole's dismissal of the influence of the landscapes of Italy, were undoubtedly informed by scenes that Walpole had witnessed with Gray during the Grand Tour. The picture evoked also agrees with Addison's observations on Italian landscape. Gray writes:

The minute one leaves his Holiness's dominions, the face of things begins to change from wide uncultivated plains to olive groves and well-tilled fields of corn, intermixed with ranks of elms, every one of which has its vine twining about it, and hanging in festoons between the rows from one tree to another.

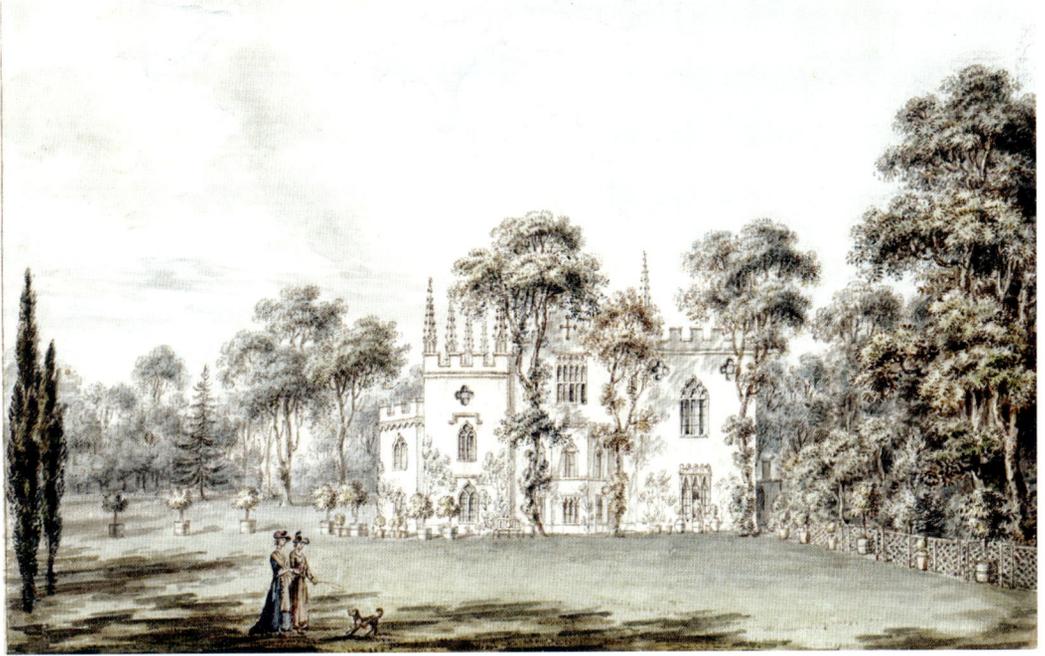

The great old fig-trees, the oranges in full bloom, and myrtles in every hedge, make one of the delightfullest scenes you can conceive.[136]

4.23 East view of Strawberry Hill, W. Watts

Writing to Bentley in 1753, Walpole alludes to the fact that this particular style of planting was adopted at Strawberry Hill. '... your drawings become more and more picturesque; you write with more wit, and paint with more *melancholy*, than anybody ever did: your woody mountains hang down *somewhat so poetical*, as Mr Ashe said.'[137] It is obviously an effect that Walpole enjoys and he also associates this type of planting with Milton's depiction of the Garden of Eden, 'the plan of it is wonderfully beautiful' in *Paradise Lost*: 'The apple and walnut trees bend down with fruit as in a poetic description of Paradise.'[138]

The Gardener at Rousham, John McClary describes the grove planted by Kent, a scene which bears a marked resemblance to Walpole's own description of Strawberry Hill:

... You moves on to the right through a fine open Grove of Oaks, Elms, Beach, Alder, Plains and Horse Chestnuts, all in Flower now, and sixty Feet high. This Grove is a hundred Feet broad, and Five Hundred feet Long. On one side runs the River, the other is Backt with all sorts of Evergreens and Flowering shrubs intermixt. When you come to the End of this Grove, you comes to two Garden Seats, where you set down, but sure no Tongue can express the Beautiful View that presents itself to your eyes.[139]

Walpole also adopted different mowing regimes for different areas of the garden to create distinctive character areas, with the grass in the 'Grounds' longer than the Lawn or Bowling Green, where it was kept short.

Walpole consciously rejected strict formality but the 'polite' symmetrical garden façade of the villa was more ordered and the planting regular in contrast to other areas of the garden. Much of the illustrative material commissioned by Walpole shows plants in pots and tubs close to the south and east façades of the house suggesting they were a regular feature in these positions. They undoubtedly contained perfumed plants such as orange trees, as Walpole was very fond of their evocative scent, Addison's 'Fragrancy of Smells or Perfumes', which intensify imaginative pleasure infusing the house. He records that the perfume of flowers is more evocative than colour:

Mr Gray often vexed me by finding him heaping notes on an interleaved Linnæus, instead of pranking on his lyre. Dr Darwin indeed the sublime, the divine, has poured all the powers of poetry into the flower-garden; and he has immortalized all the intrigues of the lady-plants ...[140] I only suggest this – not that I am at all a botanist myself – even my passion for flowers lies chiefly in my nose: I care much more for their odours than for their hues or for the anatomy of their pistils.[141]

There were also climbers scaling the walls, one of which was probably the ivy sent from Florence by Mann, to add colour to the diversified scene:

I have been putting up for Mr Wright, Lord Henley's nephew, some seeds of an odd ivy with red leaves, which he though very rare when he saw it in Boboli. I should think it would make a very venerable appearance through one of your painted glass windows at Strawberry Castle, I send you a few seeds enclosed, as I believe the sowing time advances.[142]

Lime trees planted close to the building were a key feature of the east elevation and are apparent in numerous images. They provide a more 'filtered light' enhancing the atmosphere of 'gloomth', with colour and animation to the interior, but limbed-up to ensure that views out to the river were not obscured by foliage. There was also a graduated shrubbery extending to the north east of the house, principally to screen the Hampton Court Road, which is depicted in later views as becoming overgrown as it reached maturity. Walpole later erected trellis work to achieve a 'gay and delightful effect', with pots in front of the shrubbery in the manner he had seen illustrated in prints of Herculaneum, encountered in Paris and subsequently described in the *History of the Modern Taste*.[143]

A cottage was located on the other side of Teddington Road in what had been the kitchen garden. After the death of his tenant it became a retreat for Walpole on the days when the house and garden were invaded by visitors:

... when I retire, it shall only be to London and Strawberry Hill – in London one can live as one will, and at Strawberry I will live as I please. Apropos, my good old tenant Frankland is dead, and I am in possession of his cottage, which will be a delightfully-additional plaything at Strawberry.[144] I shall be violently tempted to stick in a few cypresses and lilacs there, before I go to Paris.[145]

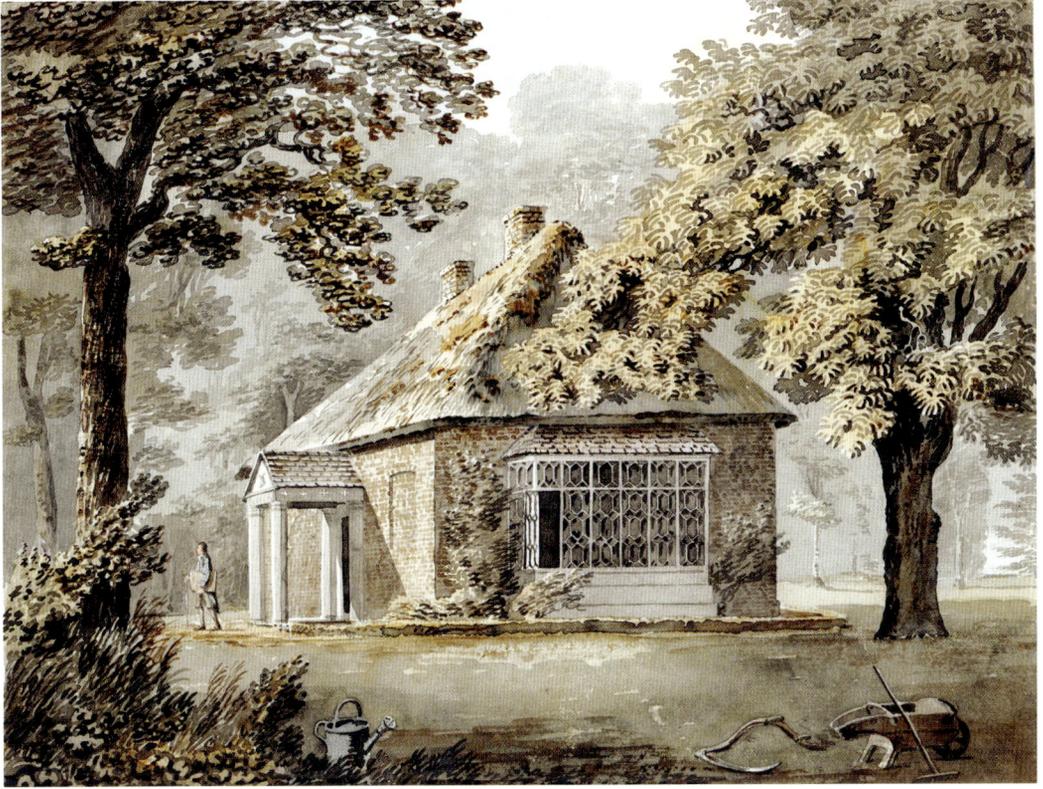

4.24 The Cottage, J.C. Barrow, 1791

Walpole obviously delighted in the prospect of being able to plant-out a small-scale flower garden which was to have a more secluded bower-like character than other areas of the landscape:

I have lately had an accession to my territory here, by the death of good old Frankland to whom I had given for his life the lease of the cottage and garden 'cross the road. Besides a little pleasure in planting and in crowding it with flowers, I intend to make what I am sure you are antiquarian enough to approve, a bower, though your friends the abbots did not indulge in such retreats, at least under that appellation; but though we love the same ages, you must excuse worldly me for preferring the romantic scenes of antiquity.[146]

We will remember that the opening scene of Addison's opera, *Rosamund* was set in a bower in Woodstock Park and a 'Bower' evokes specific connections in Walpole's thoughts; moreover, in a later discussion he linguistically links his bower specifically to that of Rosamund. In the *History of the Modern Taste*, he makes an associative connection with it as a place to stimulate the imagination. Its historic provenance and association with important personages from history undoubtedly made the idea of a Bower retreat appeal to Walpole's imagination. Once again Walpole is embracing Addison's notion of enchanted ground, recollecting an Elysium surrounded by flowers, woods, water and 'wild variety' where 'woodbines, roses, jessamines, / Aramanths

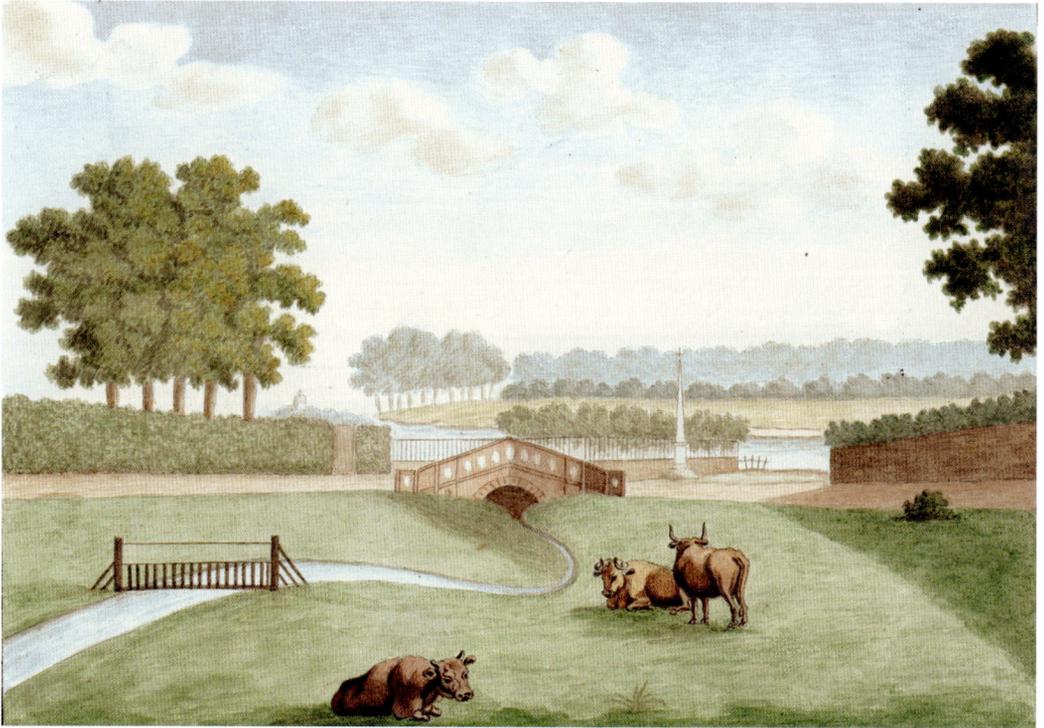

4.25 View from the Cottage at Strawberry Hill

and eglantines, / with intermingling sweets have wove / the partly-colour'd gay alcove'.[147] Small in scale, Walpole's thatched Bower consisted of three 'rooms', including a 'Tea Room', 'hung with green paper and prints' and the 'Little Library', also 'painted green and white' with a picture of Milton hung over the chimney and an 'antique bas-relief with the story of Mars and Venus' in the key stone of the chimney, a further Ovidian reference.[148] The Bower was set within woodland but with a strategic view to the river, his Gothic Bridge and the 'eye-catcher' obelisk placed at the junction of Hampton Court Road and Cross Deep, via a well-defined opening cut through the trees.

Some commentators associate the obelisk with that of Pope, apparently displaced with the remodelling of his garden, while others suggest Walpole had a hand in its being relocated to this spot, but this is difficult to corroborate.[149] However, it is significant that Walpole erected a Gothic Bridge in 1792 designed in 1778 by James Essex, to span the Cross Deep stream adjacent to the obelisk, thereby making a visual connection between them.

A slightly later account of the transformed bower by Ironside (1797) gives a description of the building in its by now dilapidated setting:

On the opposite side of the road, and near the house, is a neat building of brick, thatched at top, to imitate a cottage with casement windows. It consists of three rooms. It stands in a grove of elms &c. In the middle of a good garden, but that is also much neglected. The sitting rooms are ornamented with prints. Here Mr Walpole used to retire when company came to view the house. There is a pretty lawn before it, and a good view down the Thames.[150]

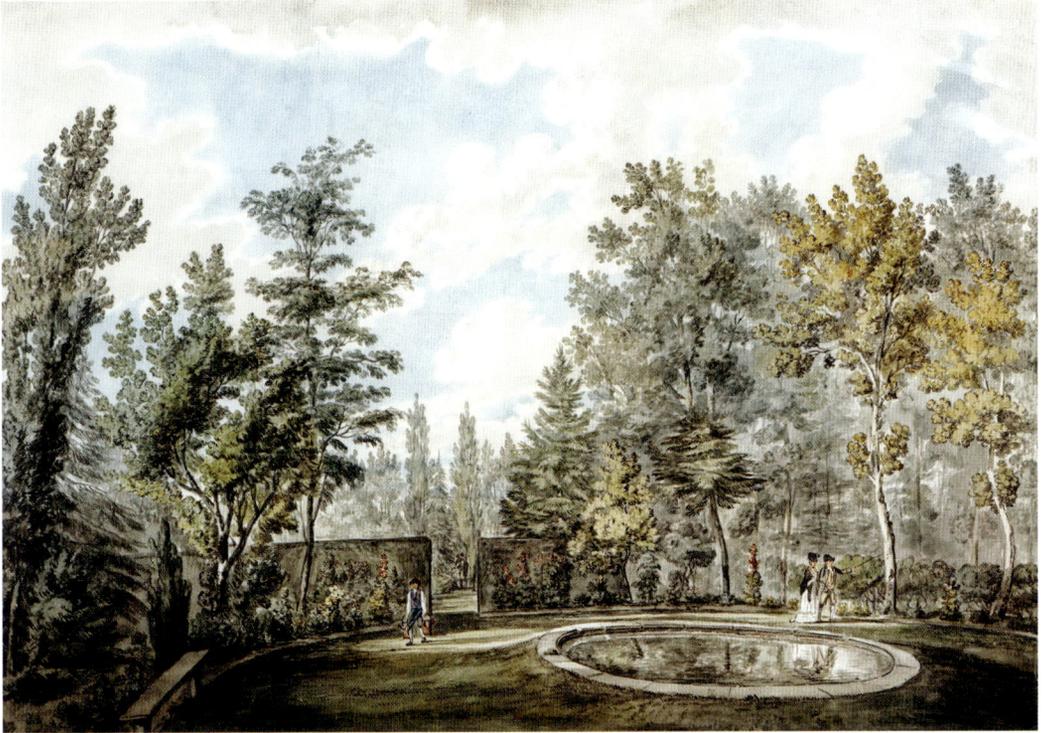

The notion of residing in an enchanted, animated landscape as depicted in the *Metamorphoses* also appears as a theme in relation to the bower:

4.26 View in the Cottage Garden at Strawberry Hill, Dobbyns, 1786

I wished for you today; Mr Chute and Mr Cowslade dined here; the day was divine; the sun gleamed down into the chapel in all the glory of popery; the gallery was all radiance; we drank our coffee on the bench under the great ash, the verdure was delicious, our tea in the Holbein room, by which a thousand chaises and barges passed; and I showed them my new cottage and garden over the way, which they had never seen, and with which they were enchanted. It is so retired, so modest, and yet so cheerful and trim, that I expect you to fall in love with it. I intend to bring it a handful of *treillage* and *agréments* from Paris, for being cross the road and quite detached, it is to have nothing Gothic about it, nor pretend to call cousins with the mansion-house.[151]

However, Walpole later added a Gothic porch to the Cottage and the Gothic Bridge within the garden connected both stylistically with the villa:

Mr Essex has called on me and left a drawing of a bridge with which I am perfectly pleased – but I was unluckily out of town, he left no direction, and I know not where to seek him in the overgrown pottle of hay. I still hope he will call again before his return.[152]

Walpole's love of medieval romance and Edmund Spenser's (c.1552–1599) *The Faerie Queen* (1751) are also influential in the planting of the bower garden, Spenser's poetry providing the best imagery for a Bower garden located in romantic seclusion:

My bower is determined, but not all what it is to be. Though I write romances,
I cannot tell how to build all that belongs to them. Madame Danois in the fairy
tales used to tapestry them with jonquils, but as that furniture will not last above
a fortnight in the year, I shall prefer something more huckaback. I have decided
that the outside shall be treillage, which however, I shall not commence, till I have
again seen some of old Louis's old-fashioned *galanteries* at Versailles. Rosamond's
bower, you and I and Tom Hearne know was a labyrinth, but as my territory will
admit of a very short clue, I lay aside all thoughts of a mazy habitation; though a
bower is very different from an arbour, and must have more chambers than one.[153]
In short, I both know and don't know what it should be. I am almost afraid that I
must go and read Spenser, and wade through his allegories and drawling stanzas
to get a picture.[154]

Nearby there was a round pool fed from the stream and a flower garden.

He also created a pond and a series of cascades by damming the stream
which ran through this section of the garden: 'I have just made two
cascades …' and in a later commentary, 'My cascades give themselves the airs
of cataracts'.[155] He also makes a further reference to Ovid when he mentions
nymphs from the *Metamorphoses* in the context of his newly-created streams
and cascades: 'I have just made two cascades; but my naiads are fools to Mrs
C[hetwynd] or my Lady S[ondes], and don't give me a gallon of water in a
week.'[156] No doubt the water features were created using Addison's model,
as he describes 'the rill of water concealed by art' that 'seems to be of its
own producing.' In the *History of the Modern Taste* Walpole explains how this
naturalistic effect was achieved 'The gentle stream was taught to serpentize
seemingly at its pleasure, and where discontinued by different levels, its
course appeared to be concealed by thickets properly interspersed, and
glittered again at a distance where it might be supposed naturally to arrive.'[157]

Walpole, like Addison, thought in terms of pictures, and employed visual
effects and spatial devices to form a series of carefully orchestrated framed views
and picturesque compositions. As visitors made the winding walk through the
Serpentine Wood, they continually had parallactic visions of the Gothic castle,
experiencing oblique glimpses and encountering multiple perspectives of the
southern and east facades through sparsely planted trees and clumps grouped
in the manner of Kent.[158] As previously mentioned, Walpole singles out the
invention of the ha-ha for particular praise as the 'capital stroke' which enabled
the garden designer to carry out Pope's poetical vision of 'calling in the country'
and this device was employed on the southern perimeter boundary to separate
unobtrusively the designed landscape from the fields and woods beyond.[159]
Wherever Walpole had to erect fencing for practical purposes, he used simple
rustic materials and screened them with planting.

Walpole owned Spence's *Anecdotes, Observations and Characters* where he
records Pope elucidating on the use of different species of plants to obtain a
painterly effect: 'The light and shades in gardening are managed by disposing
the thick grove-work, the thin, and the openings, in a proper manner.'[160] He
recalls Pope on how the use of perspective in planting could be achieved by
borrowing the principles of painting, 'You may distance things by darkening

them, and by narrowing the plantation more and more towards the end, in the same manner as they do in painting.'[161] The principles of painting and composing scenes are a recurring theme in Addison's writing on landscapes and in a letter to Montagu in November 1755, Walpole too describes how principles could be applied to planting to achieve compositions that were painterly and picturesque:

> Above all cypresses which, I think, are my chief passion: there is nothing so picturesque when they stand two or three in a clump upon a little hillock or rising above low shrubs, and particularly near buildings. There is another bit of picture of which I am fond, and that is, a larch or a spruce fir planted behind a weeping willow, and shooting upwards as the willow depends. I think for courts about a house or winter gardens, almond trees mixed with evergreens, particularly with Scots firs have a pretty effect, before anything else comes out; whereas almond trees, being generally planted among other trees, and being in bloom before other trees have leaves, have no ground to show the beauty of their blossoms.[162]

The predilection for lilac, jasmine and orange trees testifies that Walpole held a preference for perfumed plants, particularly orange trees and orange blossom and it seems likely that he acquired his affection for these while in Florence as there are frequent references in the correspondence between Walpole and Mann regarding these in Mann's garden. This partiality for orange trees expressed in 1743, was to manifest itself later at Strawberry Hill where their sight and smell undoubtedly recalled Florence and Mann to his imagination: 'My orange trees are all in bloom, and are so strong I can hardly bear the room. You'll think me a strange beast, as Mr Chute does, who is as fond of smells as you'.[163] Walpole evocatively describes the feeling engendered by experiencing colour, inhaling scents and their capacity for triggering his imagination:

> I am just come from the garden in the most oriental of all evenings, and from breathing odours beyond those of Araby. The acacias, which the Arabians have the sense to worship, are covered with blossoms, the honeysuckles dangle from every tree in festoons, the syringas are thickets of sweets, and the newcut hay of the field in the garden tempers the balmy gales with simple freshness while a thousand sky-rockets launched into the air at Ranelagh or Marylebone illuminate the scene and give it an air of Haroun Alraschid's paradise.[164]

Significantly, we will recall that Addison emphasises how sensory pleasure increases if more than one sense is stimulated simultaneously: 'Thus if there arises a Fragrancy of Smells or Perfumes, they heighten the Pleasures of the Imagination, and make even the Colours and Verdure of the Landskip appear more agreeable; for the Ideas of both Senses recommend each other.'[165] Walpole frequently mentions sensuous and sensory stimulation derived from visual display, colour, texture and forms and how the fragrance of plants is particularly evocative: 'I came hither yesterday, and am transported, like you, with the beauty of the country; ay, and with its perfumed air too. The *lilac-tide* scents even the insides of the rooms.'[166] The 'pleasure of lilac, jonquil and hyacinth season' is the most frequently mentioned in his correspondence as one of his chief passions.

All this combined with the animation provided by passers-by 'My house is a bower of tuberoses, and all Twitnamshire is passing through my meadows to the races at Hampton Court. The picture is incredibly beautiful ...'[167] It made Strawberry Hill a place that Walpole compared to Elysium: 'The season is divine, and Strawberry Hill greener than the Elysian Fields ...' and it is here that he enjoys a state of perfect happiness that he frequently shares with others.[168]

Having recorded in 1753 Walpole's reaction and delight in acquiring and designing 'this enchanted little landscape', we will now allow him the last word when we witness the importance of the building, its landscape setting and its ability to instil 'Pleasures of the Imagination' some 30 years later.

I shall now be expecting your nephew soon, and I trust, with a perfectly good account of you. The next time he visits you I may be able to send you a description of my *Galleria*. I have long been preparing it, and it is almost finished, with some prints, which however, I doubt, will convey no very adequate idea of it. In the first place they are but moderately executed: I could not afford to pay our principal engravers, whose prices are equal to, nay, far above those of former capital painters. In the next, as there is a solemnity in the house, of which the cuts will give you an idea, they cannot add the gay variety of the scene without, which is very different from every side, and almost from every chamber and makes a most agreeable contrast; the house being placed almost in an elbow of the Thames which surrounds half, and consequently beautifies three of the aspects. Then my little hill, and diminutive enough it is, gazes up to royal Richmond; and Twickenham on the left, and Kingstonwick on the right, are seen across bends of the river, which on each hand appears like a Lilliputian seaport. Swans, cows, sheep, coaches, post-chaises, carts, horse-men and foot-passengers are continually in view. The fourth scene is a large common-field, a constant prospect of harvest and its stages, traversed under my windows by the great road to Hampton Court – in short, an animated view of the country. These moving pictures compensate the conventual gloom of the inside, which however, when the sun shines, is gorgeous, as he appears all crimson and gold and azure through the painted glass – now to be quite fair, you must turn the perspective and look at the vision through the diminishing end of the telescope; for nothing is so small as the whole; and even Mount Richmond would not reach up to Fiesole's shoe-buckle. If your nephew is still with you, he will confirm the truth of all the pomp and all the humility of my description. I grieve that you would never come and cast an eye on it! – but are even our visions pure from annoy? does not some drawback always hang over them? – and being visions, how rapidly must not they fleet away? yes, yes, our smiles and tears are almost as transient as the lustre of the morning and the shadows of the evening; and almost as frequently interchanged. Our passions form airy balloons; we know not how to *direct* them; and the very inflammable matter that transports, often makes the bubble burst. Adieu![169]

We can infer from this letter that Walpole was successful in putting the precepts of eighteenth-century theories of association and imagination, as espoused by Addison, into practice at Strawberry Hill, where 'Nothing can be more delightful than to entertain ourselves with prospects of our own making and to walk under those shades which our own industry has raised.'[170] The selection of planting for evoking moods and character, originally proposed by Addison to 'compose a picture of the greatest variety', became an essential

tool of eighteenth-century gardeners and early put into practice at Strawberry Hill. Walpole used poetic principles to make transitions from 'gloomth', with enclosed, dense evergreen, emerging into open spaces of contrasting light and shade to create a garden that encouraged 'curiosity' and providing multiple sensory experiences at 'the height of its greenth, blueth, gloomth, honeysuckle-and syringahood.'[171]

Walpole created a place for the imagination amidst a 'gay variety of scene', where the principles that Addison had deemed conducive to imaginative pleasurable emotions, found their full fruition. The site was characterised by a scene of 'moving pictures' and 'an animated view of the country' providing variety and diversity. Innovative ideas and 'novel' features elicited 'agreeable surprise' through continual change and movement. New or unusual events and uncommon occurrences were in abundance, complementing and contrasting each other both in the interior and the landscape. Together, they had the capacity to elicit an emotional response in the onlooker and were a continual source of imaginative pleasure to Walpole and his visitors.

Endnotes

1. Walpole, *History of the Modern Taste*, p. 43. Although Walpole credits Mr Eyre, there is a plan of the estate at Houghton attributed to Bridgeman in the Bodleian Library, MS Gough drawings. Assuming that Horace Walpole was fully *au fait* with work being carried out at Houghton, it seems that Robert Walpole was involved in altering the original Bridgeman plan and overseeing the execution of the works, presumably carried out under the supervision of Mr Eyre. See Morris, S. *Houghton Hall Park and Gardens: The Vision of a Minister*, unpublished MA thesis, The Architectural Association (nd).

2. Addison, *The Spectator*, No. 414, 25 June 1712.

3. Plumb, *Sir Robert Walpole: The making of a Statesman*, p. 82.

4. Ketton-Kremer, R.W. *Norfolk Assembly* (London, 1957) 'Hervey and His Friends', p. 178. The foundations of the house were laid in 1721 and Lord Hervey was writing to the Prince of Wales in 1731.

5. Walpole, *History of the Modern Taste*, p. 43.

6. *Correspondence*, Walpole to Lyttleton, 27 July 1736. vol. 40, p. 21.

7. Ibid., Walpole to Montagu, 25–30 March 1761, vol. 9, p. 348.

8. Pope, *Works*, 'Moral Essays', Epistle V, II. 29–30, 'A small Euphrates through the piece is roll'd, / And little eagles wave their wings in gold.'

9. *Correspondence*, Walpole to Conway, 8 June 1747, vol. 37, pp. 269–270.

10. Ibid., Walpole to Montagu, 11 May 1769, vol. 10, p. 279.

11. Walpole, *History of the Modern Taste*, p. 47. The *Newcastle General Magazine, or Monthly Intelligencer*, 1, 25–28 (January 1748) gives a contemporary account of Pope's garden.

12. For the full quotation from Robinson on Kent's innovative garden design at Carlton House, see: Harris, J. *The Palladian Revival: Lord Burlington, his villa and garden at Chiswick* (London, 1994), pp. 196–7.

13. *Correspondence*, Walpole to Mann, 20 June 1760, vol. 21, pp. 418.

14. Ibid., Walpole to Mann, 28 August 1781, vol. 25, p. 177.

15. Ibid., Walpole to Williams, 27 June 1748, vol. 30, p. 114.

16. Tipping, H.A. 'Four Unpublished Letters from William Kent to Lord Burlington,' *Architectural Review*, vol. lxiii (May and June 1928) pp. 180–83.

17. Addison, *Works*, 'A Letter from Italy', To The Right Honourable Charles Lord Halifax In The Year MDCC (1701). 'Tis Liberty that crowns Brittania's isle, / And makes her barren rocks and her bleak mountains smile'. This was one of Walpole's favourite quotes.

18. Addison, *Works*, 'A Letter from Italy', Poetic fields encompass me around, / And still I seem to tread on classic ground.

19. *Correspondence*, Walpole to Hamilton, 15 October 1765, vol. 40, p. 384.

20. Ibid., Walpole to Mann, 20 June 1743, vol. 18, p. 255.

21. Evelyn's *Sylva*, or *A Discourse on Forest Trees* (London, 1664) was a treatise aimed at increasing tree planting in England to support the growing navy. Concerted forestation served the dual purposes of investment and ornamentation. It fulfilled economic purposes determined by the land management philosophy prevalent of that time of 'ornament with profit': simultaneously adorning the landscape as well as providing timber. The publication of Evelyn's *Sylva* commissioned by the Royal Society advocated the replanting of the depleted ancient hunting parks traditionally attached to nobleman's seats and this may also have been an influencing factor in its promotion of its visual qualities combined with timber production.

22. Walpole, *History of the Modern Taste*, p. 48.

23. Ibid., p. 40.

24. Ibid., p. 52.

25. Ibid., pp. 44–45.

26. Spence, J. *Anecdotes, Observations, and Characters of Books and Men Collected from the Conversation of Mr Pope, and other Eminent Persons of this Time* (1734–36) (London, 1820) p. XXV. However, there is a footnote taken from Spence's Papers which appears to dispute Pope's influence and asserts: 'Mr. Kent was the sole beginner of the present National Taste in Gardening. Witness his works at Kensington Gardens below Bayswater. – And at Lord Burlington's at Chiswick; the latter in October 1733. Mr Scot has a drawing of the first thing done that way there, of Kent's. He had shown his skill before at Lord Cobham's, and by a design for Mr. Pope's Mount'.

27. See Harney, 'Pope and Prior Park', pp. 183–196.

28. *Correspondence*, Walpole to Montagu, 17 May 1763, vol. 10, p. 73.

29. Ibid., Walpole to Montagu, 17 May 1763, vol. 10, p. 73.

30. Walpole, *History of the Modern Taste*, pp. 51–2.

31. Pope, *Works* 'Epilogue to the Satires', Dialogue: II, 66–67. James Thomson (1700–1748) *Seasons* (1726–30) similarly praised Esher and Claremont as retreats, 'Claremont's terrasses height, and Esher's Groves, / where in the sweetest solitude, embraced / by the soft windings of the silent Mole / From courts and senates Pelham finds repose'.

32. Whateley, T. *Observations on Modern Gardening* (London, 1770), pp. 50–51.

33. Kent also designed a Hermitage at Esher resembling the ones at Stowe and Richmond.

34. Walpole, *History of the Modern Taste*, p. 49.

35. Ibid., p. 48.

36. Ibid., p. 49.

37. Pope, *Poetical Works*, 'Epistle IV to Richard Boyle, Earl of Burlington: Of the Use of Riches', line 57, p. 316.

38. Walpole, *History of the Modern Taste*, p. 56.

39. *Correspondence*, Walpole to Chute, 4 August 1753, vol. 35, pp. 75–7.

40. Ibid., Walpole to Conway, 12 July 1770, vol. 39, p. 129. No doubt this experience of visiting a grotto in inclement weather prompted Walpole to write in his *History of the Modern Taste* that: 'Grottos in this climate are recesses only to be looked at transiently' and explains why he never constructed one at Strawberry Hill, unlike his illustrious neighbour Pope. Walpole, *History of the Modern Taste*, p. 51.

41. *Correspondence*, Walpole to Montagu, 29 June 1777, vol. 10, p. 311.

42. Addison, *The Spectator*, No. 414, 25 June 1712.

43. *Correspondence*, Walpole to Montagu, 7 July 1770, vol. 10, pp. 313–316.

44. Whateley, *Observations on Modern Gardening*, pp. 213–214.

45. *Correspondence*, Walpole to Conway, 6 October 1785, vol. 39, p. 435.

46. Although there is no direct evidence that the statue signified Sir Robert, the iconography the Temple of Modern Virtue at Stowe represents Lord Cobham's falling out with Sir Robert Walpole, over the Excise Bill in 1733 which resulted in him being dismissed from his regiment and joining the Whig opposition against Walpole. The mutilated torso in contemporary dress invoked Sir Robert recorded in a contemporaneous comparative account by an anonymous French visitor in 1748 suggests – see *Stowe Landscape Garden*, The National Trust (nd), p. 27. Recent scholarship however suggests the headless statue was that of the King of France, Louis XIV (1638–1715).

47. *Correspondence*, Walpole to Conway, 6 October 1785, vol. 39, p. 436.

48. Pope, *Correspondence of Alexander Pope*, vol. II, p. 513.

49. Walpole, *History of the Modern Taste*, p. 48.

50. Ibid., p. 48.

51. *Correspondence*, Walpole to Montagu, 19 July 1760, vol. 9, p. 290.

52. In the early eighteenth century the Medici Venus was to become the most popular garden ornament inspired by her appearance in Vanbrugh's Rotondo or Tempietto of Venus erected in 1721 at Stowe. Kent also built a Temple to Venus, c.1731 in her lesser known guise as the Roman Goddess of the garden. There was also a Venus in the garden at Hagley by 1751.

53. *Books of Materials*, journey to Rousham, Ditchley, Blenheim, 17 (1760).

54. Transcript of a letter written in 1750 or 1760 by John McClary.

55. Sanderson Miller was commissioned to build a new Hagley Hall to a Palladian design (1756–60). Meir, J. *Sanderson Miller and his Landscapes* (Chichester, 2006), p. 123.

56. *Correspondence*, Walpole to Bentley, September 1753, vol. 35, p. 147.

57. Ibid., Walpole to Bentley, September 1753, vol. 35, pp. 148–9.

58. Walpole, *History of the Modern Taste*, p. 56.

59. Whateley, *Observations on Modern Gardening*, pp. 194–195.

60. *Correspondence*, Walpole to Bentley, 5 August 1752, vol. 35, p. 142. Walpole paid for a 'wood walk' in June 1752 and although it is not known precisely where Anne Bullen's walk was at Strawberry Hill, Toynbee conjectures that it was the winding walk in the serpentine wood bordering the lawn, *Strawberry Hill Accounts*, Toynbee, p. 4.

61. Walpole, *History of the Modern Taste*, p. 58.

62. Ibid., p. 57.

63. *Correspondence*, Walpole to Bentley, September 1753, vol. 35, p. 153.

64. Ibid., Walpole to Bentley, September 1753, vol. 35, p. 153.

65. Ham House, Petersham, built 1610, enlarged 1672–5.

66. Ibid., Walpole to Montagu, 11 June 1770, vol. 10, p. 306.

67. Ibid., vol. 2, Appendix 5, 'Cole's Account of his Visit to Strawberry Hill 30 October 1762, Add MS 5841, FF. 87–8.

68. Pope's villa and garden are on the far right.

69. The Landscape Agency, *Landscape Conservation Plan* (2006), p. 12.

70. 'The Lawn between my Groves and the Wood, and the Wood itself were common field, and so was the meadow under my terrace … I enclosed them all without opposition, but I have by my will given £300 to the poor of the parish as a compensation, which it certainly is, added to my building a large house and keeping a family here, which is of much more advantage to the parish than for a few Cattle to be turned in at Michaelmass'. *Advice to my successors at Strawberry Hill*, 28 February 1784, Lewis Walpole Library MS.

71. *Correspondence*, vol. 2, Appendix 5, 'Cole's Account of his Visit to Strawberry Hill 30 October 1762', Add MS 5841, FF. 87–8.

72. It is evident that Walpole became quite a horticultural expert, propagating many plants and species for his own garden and supplying them to others.

73. Walpole, *History of the Modern Taste*, p. 50.

74. Ibid., p. 44.

75. Ibid., p. 29.

76. Ibid., p. 56.

77. *Correspondence*, Walpole to Montagu, 26 August 1749, vol. 9, p. 97.

78. Walpole, *History of the Modern Taste*, p. 44.

79. *Correspondence*, Walpole to Bentley, 17 May 1754, vol. 35, p. 173.

80. Ibid., Walpole to Bentley, 31 October 1755, vol. 35, p. 259.

81. Walpole, *History of the Modern Taste*, p. 46.

82. *Correspondence*, Walpole to Mann 5 June 1747, vol. 19, p. 414. Walpole obtained permission to graze the land at this juncture subsequently purchasing the freehold in 1748.

83. Addison, *The Spectator*, No. 414, 25 June 1712.

84. *Correspondence*, Walpole to Conway 24 June 1748, vol. 37, p. 287.

85. Ibid., Walpole to Conway, 29 August 1748, vol. 37, pp. 292–293.

86. Ibid., Walpole to Montagu, 20 October 1748, vol. 9, p. 80.

87. Ibid., Walpole to Fox, 20 October 1748, vol. 30, p. 117.

88. Ibid., Walpole to Mann, 7 February 1749, vol. 20, p. 25.

89. Ibid., Walpole to Mann, 26 December 1748, vol. 20, p. 16.

90. This was Walpole's opinion on the works of Kent articulated in his *History of the Modern Taste*, p. 45.

91. Ibid., Walpole to Montagu, 28 September 1749, vol. 9, p. 103.

92. Ibid., Walpole to Montagu, 6 June 1749, vol. 9, p. 134.

93. The view, also lost, was of the south side towards the north east with the villa and the river Thames juxtaposed to demonstrate their proximity.

94. Ibid., Walpole to Mann, 12 June 1753, vol. 20, pp. 379–380.

95. Ibid., Walpole to Lady Ossory, 26 December 1793, vol. 34, p. 196.

96. *Strawberry Hill Accounts*, Toynbee, 'New Screen at end of the Prior's garden', £14–16s–0d (1789), p. 18.

97. Humphry Repton was delighted by Strawberry Hill and admired Walpole's *The History of the Modern Taste*, remarking that although Walpole claimed to be writing a history, 'in his lively and ingenious manner, Walpole had given, 'both the history and the rules of art better than any other theorists'. *Observations on the Theory and Practice of Landscape Gardening* (London, 1803), p. 160. Repton also advocated 'specialised gardens' which he referred to as 'episodes' in the landscape garden.

98. *History of the Modern Taste*, p. 50.

99. The supposed state or abode of the blessed after death in Greek mythology.

100. Reference to Ovid's *Metamorphoses* are made through the placement of objects and characters that appear in his supernatural tale.

101. *Correspondence*, Walpole to Mann 27 April 1753, vol. 20, p. 372.

102. Keane, W. *The Beauties of Middlesex* (London, 1850).

103. Transcript of a letter written in 1750 or 1760 by John McClary.

104. The Gothic ironwork gates are currently located opposite the main entrance to Strawberry Hill at 331 Waldegrave Road, Twickenham.

105. *Correspondence*, Walpole to Mann 11 June 1771, vol. 23, p. 311. The piers, designed by James Essex were copied from the Tomb of Bishop Luda. The piers were made of Coade Stone an artificial stone invented and produced by Mrs Eleanor Coade (c.1732–1821). This composition, which is cast in moulds and burnt, is intended to answer the purpose of stone, for every species of ornamental architecture, at a much cheaper rate than carving. Daniel Lysons, *The Environs of London* (London, 1811), I, p. 228. Walpole employed the architect William Chambers to arbitrate in a dispute over the bill for manufacturing the piers eventually settling the account of £151–14–10 in 1773. *Strawberry Hill Accounts*, Toynbee, p. 13. *Correspondence*, William Chambers to Walpole, 8 June 1772, vol. 41, pp. 228–9, n. 8.

106. Ibid., Walpole to Cole, 15 July 1769, vol. 1, pp. 178–179. The position of the gate at this time is not entirely certain. A 'Plan of the Estate' made about 1790 and pasted into Walpole's extra illustrated copy of the 1784 *Description of the Villa* shows a 'Gothic Gate' on the south-east boundary. There was also an 'Iron Gate' which opened (theoretically) upon the road to Hampton Court on the western boundary and this is almost certainly the gate under discussion here because Walpole refers to it himself describing it as a gateway 'to the garden' and says in the correspondence that he already has the 'iron gates' to hang on the Gothic piers whereas if it was the one on the south-east boundary it would have led from the garden into the 'Green Lane' to Little Strawberry Hill and in this rural setting it is more likely to have been wooden structure. (see *A Catalogue of the classic contents … at Strawberry Hill*, 12 July 1842, lot 285 and Rowlandson's 'Temple at Strawberry Hill', 1822.

107. *Correspondence*, Walpole to Cole, 23 October 1771, vol. 1, pp. 243–244.

108. Ibid., Walpole to Cole, 17 June 1772, vol. 1, p. 256.

109. Ibid., Walpole to Cole, 25 August 1772, vol. 1, p. 275.

110. Ibid., Walpole to Cole, 23 October 1771, vol. 1, p. 244. Henry III (1207–1272), reigned (1216–1272) and his Queen Eleanor of Provence (1223–1291), Queen of England 1236–1272. The stained glass depicting the King and his Queen were procured for Walpole by the Earl of Ashburnham.

111. McCarthy, M. *The Origins of the Gothic Revival* (London, 1987), p. 62.

112. *Correspondence*, Walpole to Cole, 28 May 1774, vol. 1, p. 328.

113. Ibid., Walpole to Hamilton, 22 September 1768, vol. 35, p. 406.

114. The assertion that Cavallini (c.1259–1344) apparently made the shrine remains open to conjecture.

115. The chimneypiece, inspired by the tomb of Edward the Confessor, in Westminster, was 'improved by Mr Adam [1728–92], and beautifully executed in white marble inlaid with scagliola, by Richter'. This is probably John Augustus Richter (1772–1809), 'artist, engraver and scagliolist'. Notes to the *Correspondence.*

116. These included a bronze incense-burner, four Etruscan vases, Indian arrows, and a number of Roman urns or ossuaria, in marble.

117. Cole's Account of his visit to Strawberry Hill, 29–31 October 1774.

118. Walpole, *Description of the Villa*, p. 81.

119. *Correspondence*, Walpole to Lort, 4 June 1779, vol. 16, p. 184. Walpole describes the altar tablets: 'The sight of the MS was particularly welcome to me, because the long visit of Henry VI and his uncle Gloucester to St Edmundsbury, accounts for those rare altar tablets, that I bought at Mr. Ives's sale, on which are incontestably the portraits of Duke Humphrey, Cardinal Beaufort, and the same Archbishop that is in my "Marriage of Henry V". I knew the House of Lancaster were patrons of St Edmundsbury: but so long a visit is demonstration.' The chapel also contained figures of saints and angels, a crucifix, an engraving of a Bishop and urns etc.

120. Pope, *Poetical Works*, 'Eloisa to Abelard,' lines 155–170, p. 114.

121. Walpole, *Description of the Villa*, p. 84.

122. *Correspondence*, Walpole to Mann, 27 July 1752, vol. 20, p. 325.

123. Ibid., Walpole to Mann, 21 July 1753, vol. 20, pp. 389–390.

124. Ken, T. *Hymnotheo or the penitent a* 1700, Wks. 1721 III, 73 quoted in OED http://dictionary.oed. com/cgi/entry/50220224?single=1&query_type=word&queryword=sepulchral&first=1&max_to_show=10. Accessed 28 October 2010.

125. *Correspondence*, Mann to Walpole, 17 April 1779, vol. 24, p. 462.

126. Walpole, *Description of the Villa*, p. 84.

127. Addison, *The Spectator*, No. 418, 29 June 1712.

128. Near the Cymmerians, in his dark abode,/ Deep in a cavern, dwells the drowzy God; / Whose gloomy mansion nor the rising sun, / Nor setting, visits, nor the lightsome noon; / But lazy vapours round the region fly, / Perpetual twilight, and a doubtful sky … / About his head fantastick visions fly, / Which various images of things supply, / And mock their forms; the leaves on trees not more, / Nor bearded ears in fields, nor sands upon the shore.' Ovid, *Metamorphoses*, http://classics.mit.edu/Ovid/metam.11.eleventh.html. Accessed 28 October 2010.

129. *Correspondence*, Walpole to Montagu, 2 June 1759, vol. 9, p. 237.

130. *Gentleman's Magazine*, 1735, v. 47.

131. Walpole, *Description of the Villa*, p. 29.

132. Ovid, *Metamorphoses*, http://classics.mit.edu/Ovid/metam.10.tenth.html. Accessed 29 October 2010.

133. *Correspondence*, Walpole to Berry, 6 November 1795, vol. 12, pp. 175–76.

134. Ibid., Walpole to Bentley, 9 July 1754, vol. 35, p. 177.

135. Ibid., Walpole to Bentley, 19 December 1753, vol. 35, p. 157.

136. *The Letters of Thomas Gray, including the correspondence of Gray and Mason*, Tovey, D.C. (ed.) (3 vols, London, 1900–1912) Gray to Mrs Gray, Letter 88, June 1740.

137. *Correspondence*, Walpole to Bentley, 19 December 1753, vol. 35, p. 157.

138. Ibid., Walpole to Strafford, 4 September 1760, vol. 35, p. 304.

139. Transcript of a letter written in 1750 or 1760 by John McClary.

140. Darwin, E. (1731–1802) *The Botanic Garden*, Part II (London, 1789).

141. *Correspondence*, Walpole to Lady Ossory, 8 September 1791, vol. 34, p. 123.

142. Ibid., Mann to Walpole, 22 November 1760, vol. 21, pp. 457–58.

143. 'In the paintings of Herculaneum are a few traces of gardens, as may be seen in the second volume of the prints. They are small square inclosures formed by trellis-work, and espaliers, and regularly ornamented with vases, fountains and careatides, elegantly symmetrical, and proper for the narrow spaces alloted to the garden of a house in a capital city. From such I would not banish those playful waters that refresh a sultry mansion in town, nor the neat trellis, which preserves its wooden verdure better than natural greens exposed to dust. Those treillages in the gardens at Paris, particularly on the Boulevard, have a gay and delightful effect'. *History of the Modern Taste*, p. 56.

144. Richard Franklin was a London printer associated with *The Craftsman* (1726–52), a leading anti-Robert Walpole political journal started by Henry St John, Viscount Bolingbroke (1678–1751) and William Pulteney (1684–1764) (later Earl of Bath) in 1726. Surprisingly, given his association with the publication, he became Horace Walpole's tenant about 1753.

145. *Correspondence* Walpole to Montagu, 19 February 1765, vol. 10, pp. 147–48.

146. Ibid., Walpole to Cole, 28 February 1765, vol. 1, p. 85.

147. Addison, *Works*, 'Rosamund' (1707) p. 469.

148. Walpole *Description of the Villa*, p. 83.

149. See for example Katz, S.H. 'Horace Walpole's Landscape at Strawberry Hill', *Studies in the History of Gardens and Designed landscapes*, vol. 28, Number 1, January–March (2008), p. 48 where she asserts that it is Pope's obelisk but provides no supporting evidence and gives no reference.

150. Ironside, E. *Miscellaneous Antiquities*, begun in 1780 (London, 1797), vol. X.

151. *Correspondence*, Walpole to Montagu, 23 August 1765, vol. 10, pp. 167–168.

152. Ibid., Walpole to Cole, 21 May 1778, vol. 2, p. 79. This was the bridge, not built until 1792, 'which spanned' as Horace Walpole had written on the back of the original drawing, 'the rivulet at Twickenham which runs by Mr Walpole's flower-garden and crosses the road between that and Mr Briscoe's garden.'

153. Rosamund Clifford (d.1176?), mistress of Henry II, lived in 'an howse of a wonder workynge, so that noo creature, man nor woman, might wyn to her, but if he were instructe by the kynge, or suche as were right secret wt hym, touchynge yt mater. This house, after some writers, was named, labor intus [Labryrinthus], or Deladus [Dedalus] werke, or howse, which is to mean, after moost exposytours, an howse wrought lyke unto a knot in a garden, called a mase [maze]'. Robert Fabyan, *New Chronicles of England and France* (ed.) Henry Ellis (1811), p. 277.

154. *Correspondence*, Walpole to Cole, 9 March 1765, vol. 1, pp. 90–91. In his veneration for *The Faerie Queen* Walpole was following Pope, as Spence, Professor of Poetry at Oxford, had recorded Pope's love for Spenser which he conveyed to Kent. William Mason recorded that Pope's 'bold associate', William Kent, 'frequently declared that he caught his taste in gardening from reading the picturesque descriptions of Spenser'. Dr Thomas Wharton, who succeeded Spence at Oxford, made reference to Walpole in his *Observations on the Faerie Queene*.

155. Ibid., Walpole to Conway, 25 December 1770, vol. 39, p. 133.

156. Ibid., Walpole to Earl of Strafford, 25 June 1768, vol. 35, p. 324.

157. Walpole, *History of the Modern Taste*, p. 45.

158. See the earlier discussion on Walpole's observations on the phenomenon of mobile parallax in the discussion on the buildings in the landscape at Stowe.

159. Ibid., p. 42. The ha-ha is a sunken ditch used to make an invisible boundary so as not to interrupt the view.

160. Spence, *Anecdotes, Observations, and Characters*, p. 109.

161. Walpole, *Anecdotes of Painting*, p. 158.

162. *Correspondence*, Walpole to Montagu, 8 November 1755, vol. 9, pp. 177–8.

163. Ibid., Walpole to Mann, 21 May 1743, vol. 18, p. 230.

164. Ibid., Walpole to Montagu, 10 June 1765, vol. 10, p. 156.

165. Addison, *The Spectator*, No. 412, 23 June 1712.

166. Ibid., Walpole to Conway 21 May 1784, vol. 39, p. 411.

167. Ibid., Walpole to Lady Ossory, 9 August 1773, vol. 32, pp. 136–137.

168. Ibid., Walpole to Lady Ossory, 26 June 1773, vol. 32, p. 132.

169. Ibid., Walpole to Mann, 30 September 1784, vol. 25, p. 532.

170. Addison, *The Spectator* No. 583, 20 August 1712.

171. *Correspondence*, Walpole to Montagu, 8 June 1754, vol. 9, p. 162.

Epilogue:
'A genius is original, invents. Taste selects, perhaps copies with judgement'

At Strawberry Hill the faculty of the imagination was given primacy over that of intellect. The house and its landscape are a fusion of history and fiction, an architectural palimpsest fabricated from the semantics of Gothic, where the accumulation of parts stood for the whole. Gothic was chosen as the architectural style that would furnish Walpole with most ideas and give him imaginative freedom. The landscape setting too was a blank canvas upon which Walpole could inscribe an enchanted, historicist, commemorative garden. Addison provided the intellectual and theoretical background and Walpole's designs refashioned and developed his concepts of pleasures of the imagination into original and stimulating associational ideas 'to please his own taste'. The castle, complementary landscape and collection are linked as unified forms of display. Walpole constructed a visual narrative that led the observer through periods in history to stimulate, through imaginative association, a dynamic dialogue with the past.

Walpole significantly admitted that he had 'great difficulty not connecting every inanimate thing with the idea of some person, or of not affixing some idea of imaginary persons to whatever I should see'.[1] This book has made clear for the first time that, while the architectural borrowings at Strawberry Hill had inherent Gothic qualities, vitally they also represent visual connections to historic figures and significant events in English history. It has been demonstrated, for example, that the relationship between Henry VIII and Anne Boleyn and its impact on the course of English history is a significant theme in the iconography in the house and its associated landscape. He created an alternative museum for the imagination that moved away from the conventional reconstruction of history through the inanimate displays of the British Museum and instead gave primacy to images, objects and artefacts brought together in a 'cabinet of curiosities' where their associative qualities and imaginative connections told their particular story. In doing so, he pioneered a shift from purely epistemological processes which were text-led and text-driven to display a living narrative and to illustrate a counter-history

that disrupted the hitherto traditional accounts of historians. It was Walpole's belief that written histories were unreliable; often commenting that history was a form of fiction:

But when I am sure that in all ages there can be but little dependence on history, I cannot swallow the legends of the darkest periods of our annals. In one word, Sir, I have often said that History in general is a Romance that is believed, and that Romance is a History that is not believed; and that I do not see much other difference between them – nay, I am persuaded that if the dead of any age were to revive and read their own histories, they would not believe that they were reading the history of their own time.[2]

His method of expressing historical interpretation through the material remains of the past yoked together disparate ideas providing lively and pleasing reflections central to pleasurable and emotive response. Strawberry Hill was a place made for the imagination, designed to kindle Walpole's own thoughts, reflections, and romantic impulses that provide pleasure and moments for introspection, evoking psychological effects and mental stimulation. The independent spectator too was expected to call to mind the intended historic narrative from his own knowledge, experience and imagination.

In reassessing Strawberry Hill as an entity and within its cultural context, we have made clear that Walpole is the first to apply techniques usually associated with designed landscapes to the internal spaces of a building. This was based on Addison's theory, set out in his essays, of the possibility of stimulating the imagination through sensory effects such as the creation of different moods and places conducive to philosophical reflection and to induce intellectual and emotional responses. This involved creating a theatrical sequence of spaces and pictorial compositions that ranged from the symmetrical to the asymmetrical and the irregular, with differences in scale, decorative schemes and atmosphere. The small and intimate, facilitating reflection and meditation, contrasting with the large and elaborately decorated to elicit an evocative experience of wonder and surprise. He created impressions of depth and sensations of mood, through light and shade, perspective and grouping and he used monochromatic schemes contrasted with colours in order to achieve atmosphere, variety and a sense of revelation both internally and externally. These devices stimulated the imagination and satisfied both the sensory and intellectual faculties.

Serpentine paths in the landscape framed pictorial compositions as well as providing the illusion of an unending journey despite the modest size of the garden. Inside the house, this same effect was achieved by a journey through circuitous routes, with perspective views of spaces beyond and framed views of objects and external vistas, including passage through a uniquely picturesque winding cloister. Poetic incidents gave possibilities for wider reflection, contemplation and impressions, perhaps contrasting to others of claustrophobic, small-scale seclusion and intimacy. Transitions between 'gloomth' and light, openness and enclosure, circuity and directness,

all conspired towards contrasting moods and atmosphere. Portraiture, artefacts and related texts provided a narrative experience not dissimilar to the imaginative leap of associative thought provided by the emblematic and expressive garden. As Kent had metaphorically 'leaped the fence', to bring the wider landscape into the garden, so too Walpole created an architectural experience that leaped the imagination between internal and external space.

This book identifies the garden's significance in the context of English landscape history, registering a change from the Classical emblematic garden to an expressive natural landscape that stimulates the imagination both by intellectual and sensory means, a concept that substantially predates the Romantic sensibility of nature. Evolving over a period of 50 years, the garden was Walpole's personal expression, and it reflected the ethos he laid down in the *History of the Modern taste in Gardening*: 'that the possessor if he has any taste, must be the designer of his own improvements'.[3]

Drawing together landscape, architecture and literature, Strawberry Hill is an autobiographical site, it is both a monument and a text where we can read the story of Horace Walpole, where this 'man of taste', self-aware, subtle, and ironic, created private resonances, pleasure and entertainment. His personality is omnipresent as narrator whose works are a self-affirmation, embedded in the place and its contrived histories, fused with the identity of others, some central, and some peripheral, a collusion of the historic, the visual and the sensory. It is through its history and legacy to posterity that he will be recalled and remembered to future generations.

Walpole's decision to construct a villa in 'licentious' Gothic, the complete antithesis of the Palladian power-house mansion his father Robert Walpole had constructed at Houghton, Norfolk, can certainly be read as a subversive and imaginative architectural riposte. In an act of liberation and self-expression, the asymmetrical Gothic villa at Twickenham decidedly distanced him from the 'Classical taste' of Burlington and his father's circle. In doing so, Strawberry Hill made Gothic fashionable and accomplished Walpole's desire to surpass earlier attempts at Gothic by Langley and Kent as the arbiter of new taste. When Walpole declares in the *History of the Modern Taste*, 'succeeding artists have added new master-strokes to these touches; perhaps improved or brought to perfection some that I have named', we are left with the distinct impression he is referring to himself having achieved his ambition to improve Gothic and landscape design at Strawberry Hill and surpass earlier attempts by others.

Devices of perspective and illusion in the innovative natural garden design at Strawberry Hill later became essential components of the 'Picturesque', based on the visual appreciation and linkage between natural scenery, landscape painting and asymmetrical planning. Landscape painting also provided visual images that suggested ideas for enabling the designer to compose and frame views and incidents in the landscape and construct a relationship between objects and ideas through association. The precepts delineated in Walpole's theories, rather than precursing the nineteenth-century

Gothic Revival, anticipate the Picturesque school of Uvedale Price (1747–1829), Richard Payne Knight (1751–1824), Humphry Repton and John Nash (1752–1835). The influence of Walpole's historicist architecture and interiors is most clearly seen in James Wyatt's Lee Priory,[4] Sheffield Park, Sussex and Fonthill Abbey, Wiltshire for William Beckford (1760–1844).[5] The significant influence of Walpole on Sir John Soane (1753–1837) is striking but not widely recognised. His house-museum at 13 Lincolns Inn Fields, London employs theatrical effects, diffused light and the sense of space beyond to display the connoisseur's collection.[6] Pitzhanger Manor, Ealing deploys similar dramatic effects and the Gothic Library at Stowe with its painted armorial bearings and architectural detailing based on Henry VIII's tomb are surely indebted to Strawberry Hill. Sir Walter Scott (1771–1832) too was influenced by Walpole's picturesque building and historicist interiors and Abbotsford uses detailing appropriated from medieval buildings. Writing in his preface to Walpole's *Castle of Otranto* Scott wrote that Walpole 'did not comply with the dictates of prevailing fashion, but pleased his own taste, and realized his own visions'.[7]

Addison's 'Pleasures of the Imagination' required that individuals displayed the capacity for invention and original genius and indeed Strawberry Hill constitutes an amalgamation of uniqueness and creative discovery, as the first picturesque ensemble and a place of 'visionary enchantment'. Strawberry Hill is the built manifestation of Walpole's assessment that 'a genius is original, invents. Taste selects, perhaps copies with judgement'.[8] He is the personification of Addison's cultured 'Man of Polite Imagination', whose mind was stocked with every reference and therefore able to make the connections and associations required for imaginative pleasure.[9] When Walpole, outlining the use of his theory and its effects at Strawberry Hill, remarks in his text that he has 'observed the impressions made on Spectators by these arts,' it may be that he is finally, subtly and ironically acknowledging Addison's seminal essays.[10]

Although the site continually developed and expanded over a period of 50 years it remained the vision of one man. Both the Gothic castle and the landscape established a sense of history and lineage for Walpole. Both were based on a fiction, an elaborate theatrical conceit that was both pleasurable and entertaining. Walpole was centre-stage in this theatre of the imagination. He composed framed and added variety and movement to the site through the fusion of landscape and theatrical design which suggest a reciprocal arrangement between performer and audience. Walpole created a place for his imagination to operate freely that allowed him to play out his life and demonstrate the superiority of the faculty of imagination.

Walpole's *Castle of Otranto*, the first Gothic novel, is like Strawberry Hill, a fabrication of his imagination originating in 'a head filled like mine with Gothic story'. The concept is fundamentally based on Addison's theory of how visual and sensory effects stimulate the mind of the reader to induce a psychological response.[11] The novel demonstrates the same capacity for invention and creativity and deploys the same theoretical model as the site

E.1 North entrance of Strawberry Hill with a procession of monks, Thomas Rowlandson, c.1805–10

at Strawberry Hill. In *The Castle of Otranto* Walpole created another historical fantasy based on his antiquarian interests in genealogy, lineage, and the primacy of preserving blood lines, blending 'the marvellous of old story with the natural of modern novels' just as he had combined the 'ancient and the modern' in the fabric of the Gothic castle.[12] The novel depicts Gothic space and form and changes in scale to create the same sense of drama and atmosphere through theatrical effects and employs material objects as devices to drive the plot forward. Just as the architecture and artefacts in the interior unfold and reveal an unmediated vision of an alternative history, Walpole's story creates a fictional place to disclose the truth of Manfred's act of political usurpation and restore familial inheritance rights exposed through tropes of tension, gloom, ambiguity and crumbling castle structures.

Using an architectural term to describe literature Addison states that 'the taste of most of our English poets, as well as Readers, is extremely Gothick' and declares these authors wrote 'with all the Extravagance of an irregular fancy'.[13] Walpole reiterates this notion in his preface when he remarks that 'invention has been dammed up' and emphasises that in an act of imaginative and literary freedom that 'having created a new species of romance he was at liberty to lay down what rules I thought fit for the conduct of it'.[14] Just as the creation of the castle and landscape at Strawberry Hill were licentious acts that did not abide by rules and convention, *The Castle of Otranto* exhibited imaginative freedom in literary and spatial terms. The supernatural elements conform to Addison's precepts set out in his essay on the 'fairy way of writing', which anticipates

E.2 The entry of Frederick into the *Castle of Otranto*, J. Carter, 1790

The Castle of Otranto. Addison outlines how 'these descriptions raise a pleasing kind of horror in the reader and amuse his imagination with the strangeness and novelty of the persons who are represented to them'.[15] *The Castle of Otranto* and Strawberry Hill which Walpole defined by its 'air of enchantment and fairyism' were both displays of liberty and freedom marked by genius and originality.

Walpole wrote in the second preface to *The Castle of Otranto* that he was 'leaving the powers of the fancy at liberty to expiate through the boundless realms of invention and thence of creating more interesting situations'.[16] He could have been speaking of Strawberry Hill.

He further remarked of his *Castle of Otranto:*

… Je vous avoue, ma Petite, et vous m'en trouverez plus fol que jamais, que de tous mes ouvrages c'est l'unique oùje me suis plu; j'ai laissé courir mon imagination; les visions et les passions m'échauffaient. Je l'ai fait en dépit des régles, des critiques, et des philosophies; et il me semble qu'il n'en vaille que mieux.

[… that of all my works, it is the only one I have enjoyed [*literally 'where I have enjoyed being'*]; I let my imagination run; visions and passions excited me. I did it in spite of rules, criticisms and philosophies; and it seems to me that it is for the better].[17]

Walpole's observation applies equally to Strawberry Hill which was also a unique, original and rule-breaking vision of passion and imagination.

Endnotes

1. Walpole, *Books of Materials* (1759), p. 52.

2. *Correspondence*, Walpole to Henry, 15 March 1783, vol. 15, p. 173.

3. Walpole, *History of the Modern Taste*, p. 58.

4. 'Mr Wyatt has made him too correct a Goth not to have seen all the imperfections and bad execution of my attempts; for neither Mr Bentley nor my workmen had *studied* the science, and I was always too desultory and impatient to consider that I should please myself more by allowing time, than by hurrying my plans into execution before they were ripe. My house therefore is but a sketch by beginners; yours is finished by a great master'. *Correspondence*, Walpole to Barret, 5 June 1781, vol. 42, pp. 220–221.

5. 'We first became acquainted at Sheffield Place [with James Wyatt]. And here we should acknowledge that Wyatt's natural good taste has been forced to yield to the reigning fashion of the day. The house is one of the earliest attempts at Modern Gothic, by which I mean that heterogeneous mixture of abbey, castle and manor house for which taste had been introduced by the experiments of Horace Walpole at Strawberry Hill'. *Humphry Repton's Memoirs*, Gore, A. and Carter, G. (eds) (Norwich, 2005), p. 132.

6. See particularly, Helene Mary Furjàn, *'Glorious Visions': The Theatre of Display and Sir John Soane's House-Museum* (Princeton University, unpublished PhD thesis, 2001).

7. Walter Scott, *The Miscellaneous Prose Works* (1841), 1. 306, quoted in Wainwright, C. *The Romantic Interior: the British Collector at Home 1750–1850* (London, 1989), p. 147. For a discussion on the influence and comparisons between Walpole's Strawberry Hill and Scott's Abbotsford see Wainwright, *The Romantic Interior*, pp.147–240.

8. *Correspondence*, Walpole to Wren, 9 August 1764, vol. 40, pp. 352–53.

9. Addison, *The Spectator*, No. 411, 21 June 1712.

10. Walpole *Aesthetic Effects*.

11. *Correspondence*, Walpole to Cole, 9 March 1765, vol. 1, p. 88.

12. *Horace Walpole, The Castle of Otranto* and *The Mysterious Mother*, Frank, F.S. (ed.) (London, 2003) preface to the second edition, p. 65. *Correspondence*, Walpole to Wharton, 16 March 1765, vol. 40, p. 377.

13. Addison, *The Spectator*, No. 62, 11 May 1711.

14. *The Castle of Otranto* and *The Mysterious Mother*, Frank, p. 70.

15. Addison, *The Spectator*, No. 419, 1 July 1712.

16. *The Castle of Otranto* and *The Mysterious Mother,* Frank, p. 65.

17. *Correspondence*, Walpole to du Deffand, 13 March 1767, vol. 3, pp. 263–5. Translation by Gaelle Jolly.

Select Bibliography and Further Reading

Manuscript Sources

Fitzwilliam Museum, Cambridge, MS13–1947 Walpole, H. *Account of the Aesthetic Effects at Strawberry Hill* (1772).

Harvard University, Houghton Library, MS Eng. 772. *Some Portions of Essays Contributed to The Spectator by Mr Joseph Addison.*

Lewis Walpole Library MS, Walpole, H. *Memoirs and Journals of the Reigns of George II and George III* (1751–1791).

Lewis Walpole Library MS, Walpole, H. *Books of Materials* (1759, 1771, 1786).

Lewis Walpole Library MS, Walpole, H. *Advice to my Successors at Strawberry Hill* (28 February 1784).

Lewis Walpole Library MS, Walpole, H. *Reminiscences, Written for the Amusement of Miss Mary and Miss Agnes Berry* (1788).

Printed Primary Sources

Addison, J. *The Works of Joseph Addison*: complete in three volumes: embracing the whole of the '*Spectator*,' &c. (3 vols, New York, Harper & Brothers, 1837).

—*The Letters of Joseph Addison*, Graham, W. (ed.) (Oxford, Clarendon Press, 1941).

—*The Spectator*: (by Addison and Steele) Bond, D.F. (ed.) (Oxford, Clarendon Press, 1965).

—*The Works of the Right Honourable Joseph Addison*, Tickell, T. (ed.) (4 vols, London, Jacob Tonson, 1721).

Ædes Strawberrianae. Names of purchasers and process to the sale catalogue of the collection of art and vertû, at Strawberry Hill, formed by Horace Walpole, Earl of Orford (London, 1842).

—*Names of purchasers and the prices to the detailed sale catalogue of the collection … withdrawn from Strawberry-Hill for sale in London* (London, 1842).

Ambulator: or, a Pocket Companion in a Tour Round London (10th edn, London, Scatcherd and Letterman, 1807).

Anonymous. 'An Epistolatory Description of the late Mr. Pope's House and Gardens at TWICKENHAM', The *Newcastle General Magazine, or Monthly Intelligencer*, 1: 25–28 (January, 1748).

Archaeologia, or, *Miscellaneous Tracts Relating to Antiquity* (London, Society of Antiquaries, 1770–1991).

Blair, H. *Lectures on Rhetoric and Belles Lettres*, iii (4th edn, 3 vols, Edinburgh, A. Strahan, T. Cadell, W. Creech, 1790).

Boyle, R. *Experiments and Considerations touching Colours. First occasionally written, among some other Essays, to a friend; and now suffer'd to come abroad as the beginning of an experimental history* ... (London, Henry Heringham, 1664).

Burke, E. *A Philosophical Enquiry into the Origin of Our Ideas of the Sublime and Beautiful* (London, R. & J. Dodsley, 1757).

Campbell, C. *Vitruvius Brittanicus, or, the British architect containing the plans, elevations, and sections of the regular buildings, both public and private in Great Britain* (3 vols, London, 1715–25).

Chambers, W. *Dissertation on Oriental Gardening* (London, W. Wilson, 1772).

Coke, Lady Mary, *The Letters and Journals of Lady Mary Coke* (ed.) Home J.A. (4 vols, Bath, Kingsmead Bookshops, 1970).

Common Sense, No. 150 (15 December 1739) reprinted in *The Gentleman's Magazine*, 9 (December 1739).

Cooper, A.A. 3rd Earl of Shaftesbury, *Characteristicks of Men, Manners, Opinions, Times* (3 vols, London, 1711).

d'Argenville, A.N.D. *La Theorie et la Pratique du Jardinage, Ou l'on traite à fond des beaux jardins appellés communément les jardins de propreté, comme sont les parterres, les bosquets, les boulingrins, &c. Contenant plusieurs plans et dispositions generales de jardins; nouveaux desseins ... & autres ornemens servant à la décoration & embélissement des jardins. Avec la manière de dresser un terrain* ... (Paris, Jean Martin Husson, 1709). Translated into English by John James as, *The Theory and Practice of Gardening: Wherein is Fully Handled all that Relates to Fine Gardens, Commonly called Pleasure-Gardens, as Parterres, Groves, Bowling-Greens &c.* ... (London, G. James, 1712).

Dart, J. *History of Antiquities of the Cathedral Church of Canterbury* (London, J. Cole, 1726).

Darwin, E. *The Botanic Garden* (2 vols, London, J. Johnson, 1789).

Dodsley, R. *A Collection of Poems by Several Hands* (3 vols, London, R. Dodsley, 1748).

Dykes Campbell, J. *Some Portions of Essays Contributed to The Spectator by Mr Joseph Addison* (Glasgow, Bell & Bain, 1864).

Evelyn, J. *Sylva, or A Discourse of Forest-Trees and the Propagation of Timber* (London, John Martyn, 1664).

Fabyan, R. *The New Chronicles of England and France, in two parts* by Robert Fabyan. Named by himself *The concordance of histories* (ed.) Ellis, H. (London, F.C. & J. Rivington etc. 1811).

Ferrar, J. *Tour from Dublin to London in 1795 through the Isle of Anglsea, Bangor, Conway ... and Kensington* (Dublin, 1796).

Fréart, R. *A Parallel of the ancient architecture and the modern* (Paris, 1650) … made English … by John Evelyn, published as, *A parallel of the antient architecture with the modern: in a collection of ten principal authors who have written upon the five orders …* (London, John Place, 1664).

Gough, R. *Sepulchral Monuments of Great Britain* (London, the author, 1786 & 1796).

Gray, T, *Odes* with Designs by Mr R. Bentley for six poems by Mr T. Gray (Twickenham, Strawberry Hill Press, 1753).

—*The Letters of Thomas Gray, including the correspondence of Gray and Mason,* Tovey, D.C. (ed.) (3 vols, London, George Bell and Sons, 1900–1912).

—*The Correspondence of Thomas Gray,* Toynbee, P. and Whibley, L. (eds) (3 vols, Oxford, Clarendon Press, 1935).

Hawkins, L.M. *Anecdotes, Biographical Sketches and Memoirs* (3 vols, London, F.C. and J. Rivington, 1822–24).

Heeley, J. *Letters on the Beauties of Hagley, Envil, and the Leasowes with Critical Remarks and Observations on the Modern Taste in Gardening* (1777), Hunt J.D. (ed.) (Facsimile Edition, New York, Garland, 1982).

Hentzner, P. *A Journey into England in the year 1598 (being a part of the itinerary of P.H. translated by R. Bentley,* Walpole, H. (ed.) (Twickenham, Strawberry Hill Press, 1757).

Hervey, J. *Lord Hervey and His Friends, 1726–38* (London, John Murray, 1950).

—*Lord Hervey's Memoirs* (ed.) Sedgwick, R. (London, William Kimber, 1952).

Hogarth, W. *The Analysis of Beauty, written with a view of fixing the fluctuating ideas of taste* (London, J. Reeves, 1753).

Hume, D. *A Treatise of Human Nature: Being an Attempt to Introduce the Experimental Method of Reasoning into Moral Subjects* (London, John Noon, 1739–1740).

Ironside, E. *Miscellaneous Antiquities (in continuation of the Bibliotheca topographica Britannica), No.VI, The history and antiquities of Twickenham, being the first part of parochial collections for the county of Middlesex, begun in 1780* (London, John Nichols, 1797).

Johnson, S. *A Dictionary of the English Language* sometimes published as *Johnson's Dictionary* (London, 1755).

Keane, W. *The Beauties of Middlesex*: *Being a Particular Description of the Principal Seats of the Nobility and Gentry, in the County of Middlesex, Comprising a Great Deal that is Interesting in the History, Architecture, and Internal Adornments of the Mansions, &c., and in the Gardens, Parks and Pleasure Ground Scenery, from Visits Made in 1840 & 1850* (London, Proprietor, 1850).

Langley, B. *Gothic Architecture Improved by Rules and Proportions, In many grand designs of columns, doors, windows, chimney-pieces, arcades, colonades, porticos, umbrellos, temples and pavillions, & c., with plans, elevations and profiles geometrically explained* (London, John Millan, 1742).

Locke, J. *An essay Concerning Human Understanding* (London, Thomas Basset, 1690).

Loudon, J.C. *An Encyclopaedia of Gardening Comprising the Theory and Practice of Horticulture, Floriculture, Arboriculture, and Landscape Gardening; Including All the Latest Improvements; a General History of Gardening in All Countries; and a Statistical View of Its Present State; with Suggestions for Its Future Progress in the British Isles* (London, Longman, Rees, Orme, Brown, Green, and Longman, 1835).

Lysons, D. *The Environs of London, being an historical account of the towns and villages, and hamlets within twelve miles of the capital … with biographical anecdotes and plates* (4 vols, London, T. Cadell, 1792–96).

Macaulay, T.B. 'Review of letters of Horace Walpole, Earl of Orford to Sir Horace Mann', *The Edinburgh Review*, vol. 58 (Oct 1833).

McClary, J. *Transcript of a letter written in 1750 or 1760.*

Mason, W. *An heroic epistle to Sir William Chambers, Knight, Comptroller General of His Majesty's works and author of a late Dissertation on oriental gardening: enriched with explanatory notes, chiefly extracted from that elaborate performance* (London, J. Almon, 1773).

—*An Heroic Epistle to Sir William Chambers* (London, J. Almon, 1773).

—*The English Garden* (4 vols, London, J. Dodsley, 1783).

—*Satirical poems published anonymously by William Mason: with notes by Horace Walpole, now first printed from his manuscript* (ed.) Toynbee, P. (Oxford, Clarendon Press. 1926).

Milton, J. *Paradise Lost* (10 books, London, Samuel Simmons, 1667).

Neale, J.P. *Views of the Seats of Noblemen and Gentlemen* (London, Sherwood, Neeley and Jones, 1842–9).

Palladio. *I Quattro Libri Dell'archittetura, published as The Architecture of A. Palladio, in Four Books,* Leoni, G. (ed.) (London, John Watts, 1715–20).

Payne Knight, R. *The Landscape*: a didactic poem in three books: addressed to Uvedale Price, Esq. (London, W. Bulmer & co, 1795).

Peacham, H. *The Compleat Gentleman* (London, Francis Constable, 1634).

Pope, A. 'On Gardens', *The Guardian*, No. 173 (London, 28 September 1713).

—*Eloisa to Abelard* (London, 1717).

—*Epistle IV. To Richard Boyle, Earl of Burlington: Of the Use of Riches* (London, 1731).

—*The Prose Works of Alexander Pope, vol. 1, The Earlier Works, 1711–1720* (ed.) Ault, N. (Oxford, Blackwell, 1936).

—*The Correspondence of Alexander Pope,* Sherburn, G. (ed.) (5 vols, Oxford, Oxford University Press, 1956).

—*Pope: Poetical Works,* Davis, H. (ed.) (London, Oxford University Press, 1983).

—*The Prose Works of Alexander Pope, vol. II, The Major Works, 1745–1744,* Cowler, R. (ed.) (Oxford, Blackwell, 1986).

Reid, T. *Essays on the Intellectual Powers of Man* (Edinburgh, 1785).

Repton, H. *Observations on the Theory and Practice of Landscape Gardening, Including Some Remarks on Grecian and Gothic Architecture, collected from various manuscripts, in the possession of the different noblemen and gentlemen, for whose use they were originally written: the whole tending to establish fixed principles in the respective arts* (London, J. Taylor, 1805).

—*Humphry Repton's Memoirs* (eds) Gore, A. and Carter, G. (Norwich, Michael Russell, 2005).

Richardson, J. *An Essay on the Theory of Painting. By Mr. Richardson* (London, John Churchill, 1715).

Rouquet, J.A. *The Present State of the Arts in England* (London, 1755) (Facsimile reprint, London, Cornmarket Press, 1970).

Sandford, F. *A genealogical history of the kings of England, and monarchs of Great Britain, &c. from the conquest, anno 1066 to the year, 1677 in seven parts or books, containing a discourse of their several lives, marriages, and issues, times of birth, death, places of burial, and monumental inscriptions: with their effigies, seals, tombs, cenotaphs, devises, arms, quarterings, crests, and supporters: all engraven in copper plates / furnished with several remarques and annotations by Francis Sanford, Esq* (London, the author, 1677).

Scott, W. *The Miscellaneous Prose Works* (8 vols, Edinburgh, R, Cadell, 1841–7).

Searle, J. *A Plan of Mr. Pope's Garden, as it was left at his Death: With a Plan and Perspective View of the Grotto* (London, 1745).

Seeley, B. *Stowe. A Description of the House and Gardens of the Most Noble & Puissant Prince, George-Grenville-Nugent-Temple Marquis of Buckingham* (London, the author, 1797).

Spence, J. *Anecdotes, Observations, and Characters of Books and Men Collected from the Conversation of Mr Pope, and other Eminent Persons of this Time* (1734–36) (London, W.H. Carpenter, 1820).

Stuart, J and Revett, N. *Antiquities of Athens*: *Measured and Delineated by James Stuart, FRS and FSA, and Nicholas Revett, Painters and Architects* (London, J. Haberkorn, 1762).

Temple, W. *Upon the Gardens of Epicurus* (1685) (London, Chatto and Windus, 1908).

—*The Works of Sir William Temple, bart* (London, 1757) (New York, Greenwood Press, 1968).

The Connoisseur, 13 May 1756, in Aronson, A. 'The Anatomy of Taste', *Modern Language Notes*, vol. 61, No. 4 (April 1946).

The Craftsman (1726–52).

The Gentleman's Magazine.

The Newcastle General Magazine, or Monthly Intelligencer (1747–60).

Thomson, J. *The Seasons* (1726–30).

Walpole, H. *Aedes Walpolianae* or *A Description of the Collection of Pictures at Houghton-Hall in Norfolk, the seat of the Right Honourable Sir Robert Walpole, Earl of Orford* (London, the author, 1747).

—*Journal of the Printing-Office at Strawberry Hill* (1747–95).

—*Strawberry Hill Accounts* (1747–95).

—Essays in *The World* (ed.) Moore, E. (1753–57).

—*A Catalogue of Royal and Noble Authors* (2 vols, Twickenham, Strawberry Hill Press, 1758, postscript, 1786).

—*Anecdotes of Painting in England and a Catalogue of Engravers* (5 vols, Twickenham, Strawberry Hill Press, 1762–80).

—*The Castle of Otranto, A Story. Translated by William Marshal, Gent, From the Original Italian of Onuphrio Muralto, Canon of the Church of St. Nicholas at Otranto* (London, J. Dodsley, 1764, dated 1765).

—*The Life of Lord Edward Herbert of Cherbury* (ed.) (Twickenham, Strawberry Hill Press, 1764).

—*The Mysterious Mother* (Twickenham, Strawberry Hill Press, 1768).

—*Historic Doubts on the Life and Reign of King Richard the Third* (London, J. Dodsley, 1768).

—*A Description of the Villa of Horace Walpole, Youngest Son of Sir Robert Walpole, Earl of Orford, at Strawberry Hill, near Twickenham. With an inventory of the furniture, pictures, curiosities etc.* (Twickenham, Strawberry Hill Press, 1774). HW added the following appendices to later editions: c.1781 Appendix, with list of books printed at Strawberry Hill; 1784 Additions since the Appendix; 1786 More Additions.

—'Account of my Conduct relative to the Places I hold under Government, and towards Ministers' (1782).

— *A Description of the Villa of Horace Walpole, Youngest Son of Sir Robert Walpole, Earl of Orford, at Strawberry Hill, near Twickenham. With an inventory of the furniture, pictures, curiosities etc.* (Twickenham, Strawberry Hill Press, 1784). (HW added the following appendices to later editions: c.1786 Appendix; c.1789 Curiosities Added; c.1791 More Additions. Facsimile edn (London, Gregg, 1964).

—'A Reply to the Observations of the Rev. Dr Mills, Dean of Exeter, and President of the Society of Antiquaries, on the Wardrobe Account of 1483 &c. Privately printed as Reply to Dean Milles. Written in 1770 (Twickenham, Strawberry Hill [1774]', *Works* (1798).

—*The Works of Horatio Walpole, Earl of Orford* (eds) Berry, R.G. and Berry M. (9 vols, London, G.G. and J. Robinson, 1798–1825).

—*Walpoliana*, Pinkerton. J. (compiler) (2 vols, London, R. Phillips, 1805).

—*The Castle of Otranto.* Introduction by Sir Walter Scott. Preface by C. Spurgeon. (London, Chatto, 1907).

—*Journal of the printing-office at Strawberry Hill, now first printed from the ms. of Horace Walpole,* Toynbee, P. (ed.) (London, Constable and Houghton, and Boston, Houghton Mifflin Company, 1923).

—*Reminiscences Written By Horace Walpole in 1788,* Toynbee, P. (ed.) (Oxford, Clarendon Press, 1924).

—*Strawberry Hill accounts: a record of expenditure in building, furnishing, &c., kept by Mr Horace Walpole, from 1747 to 1795, now first printed from the original ms,* Toynbee, P. (ed.) (Clarendon Press, Oxford, 1927).

—'Horace Walpole's Journal of Visits to Country Seats, etc', *Transactions of the Walpole Society*, Annual, 16 (London, Walpole Society, 1928).

—*The Yale Edition of Horace Walpole's Correspondence*, Lewis, W.S. *et al.* (eds) (48 vols, London and New Haven, Yale University Press, 1937–83).

—*Memoirs of King George II: The Yale Edition of Horace Walpole's Memoirs* (ed.) Brooke, J. (New Haven and London, Yale University Press, 1985).

—*The History of the Modern Taste in Gardening* (New York, Ursus Press, 1995).

—*The Works of Horatio Walpole, Earl of Orford, 1798. From the 1798 edition.* Sabor, P. (ed.) (5 vols, London, Pickering and Chatto, 1998).

—*Memoirs of the Reign of King George III, The Yale Edition of Horace Walpole's Memoirs* (ed.) Jarrett, D. (New Haven and London, Yale University Press, 1999).

—*Horace Walpole, The Castle of Otranto* and *The Mysterious Mother,* Frank, F.S. (ed.) (Broadview Press, Canada, 2003).

Weekly Register, 6 February 1731, 'An Essay on Taste in General', *Gentleman's Magazine*, February 1731, I, 55, in Aronson, 'The Anatomy of Taste', *Modern Language Notes*, 51 (1946).

Whateley, T. *Observations on Modern Gardening* (London, T. Payne, 1770).

Wordsworth, W. *Lyrical Ballads* (Bristol, 1798) (ed.) Mason, M. (London and New York, Longman, 1992).

Secondary Sources

Ackroyd, P. *Albion: The Origins of the English Imagination* (London, Chatto & Windus 2002).

Adams, C.K. and Lewis, W.S. 'The Portraits of Horace Walpole', *The Walpole Society,* 42 (London, 1970).

Allen, B.S. *Tides in English Taste (1619–1800): A Background for the Study of Literature* (2 vols, New York, Pageant Books, Inc, 1958).

Archer, J. 'The Beginnings of Association in British Architectural Esthetics', *Eighteenth-Century Studies,* vol. 6, No. 3 (spring, 1983).

Batey, M. 'Horace Walpole as Modern Garden Historian', *Garden History: The Journal of the Garden History Society,* 19:1 (Spring 1991).

—*Alexander Pope: The Poet and the Landscape* (London, Barn Elms, 1999).

—'The Pleasures of the Imagination: Joseph Addison's Influence on Early Landscape Gardens,' *Garden History*, vol. 33. No. 2 (Autumn 2005).

Birksted, J (ed.) *Landscapes of Memory and Experience* (London and New York, Spon Press, 2000).

Bloom, E.A. and Bloom, L.D. (eds) *Joseph Addison and Richard Steele: The Critical Heritage* (London, Routledge & Kegan Paul, 1980).

Boswell, J. *Life of Johnson*. (ed.) Chapman, R.W. (Oxford, Oxford World's Classics, 1980).

Brewer, J. *The Pleasures of the Imagination; English Culture in the Eighteenth Century* (Chicago, Chicago University Press, 1997).

Brownell, M.R. *Alexander Pope and the Arts of Georgian England* (Oxford, Oxford University Press, 1978).

—*The Prime Minister of Taste* (New Haven and London, Yale University Press, 2001).

Calloway, S., Snodin, M., Wainwright, C. *Horace Walpole and Strawberry Hill,* exh. Cat., Orleans House Gallery (Richmond-upon-Thames, 1980).

Chase, I.W.U. *Horace Walpole: Gardenist, An Edition of Walpole's A History of the Modern Taste in Gardening with an Estimate of Walpole's Contribution to Landscape Architecture* (Princeton, New Jersey, Princeton University Press, for University of Cincinnati, 1943).

Clark, H.F. 'Eighteenth-century Elysiums; The Role of "Association" in the Landscape Movement', *The Journal of the Warburg and Courtauld Institutes,* vol. VI (1943).

Clark, K. *The Gothic Revival: An Essay in the History of Taste* (London, John Murray, 1995).

Cornforth, J. *Early Georgian Interiors* (New Haven and London, Yale University Press, 2004).

Crook, J.M. 'Strawberry Hill Revisited', *Country Life,* cliii (London, 1973) 1598–1602, 1726–30, 1794–97, 1886.

Davenport-Hines, R. *Gothic: Four Hundred Years of Excess, Horror, Evil and Ruin* (New York, North Point Press, 1998).

Dobson, A. *Horace Walpole: a Memoir with an Appendix of Books Printed at the Strawberry Hill Press,* Toynbee, P. (ed.) (Oxford, Clarendon Press, 1927).

Eastlake, C.L (ed.) *A History of the Gothic Revival* (New York, Humanities Press, 1970).

Eavis, A. and Peover, M. 'Horace Walpole's painted glass at Strawberry Hill', *The Journal of Stained Glass,* vol. 19, no.3 (Somerset, 1994–5).

Evans, J. *A History of the Society of Antiquaries* (Oxford, Oxford University Press, 1956).

Fothergill, B. *The Strawberry Hill Set: Horace Walpole and his Circle* (Faber and Faber, London 1983).

Furjàn, H.M. *'Glorious Visions': The Theatre of Display and Sir John Soane's House-Museum* (Princeton University, unpublished PhD thesis, 2001).

Gascoigne, B. and Ditchburn, J. *Images of Twickenham with Hampton and Teddington* (Richmond-upon-Thames, Saint Helena Press, 1981).

Guillery, P. 'Strawberry Hill: Building and Site: Part One: 'The Building', *Architectural History,* vol. 38 (Leeds, 1995).

Harney, M. 'Alexander Pope and Prior Park: An essay in Landscape and Literature' in *Studies in the History of Gardens & Designed Landscapes*, vol. 27, No. 3 (Oxon, Taylor & Francis, 2007).

—'Strawberry Hill', *The Architectural Review.* CCXXIV NO 1341. (Nov, 2008).

Harris, J. *The Palladian Revival: Lord Burlington, his villa and garden at Chiswick* (New Haven and London, Yale University Press, 1994).

Hart, V. *Sir John Vanbrugh: Storyteller in Stone* (New Haven and London, Yale University Press, 2008).

Haskell, *History and its Images: Art and the Interpretation of the Past* (New Haven and London, Yale University Press, 1993).

Hazen, A.T. *A Bibliography of the Strawberry Hill Press* (New Haven and London, Yale University Press, 1942).

Hazen, A.T. *A Catalogue of Horace Walpole's Library* (3 vols, New Haven and London, Yale University Press, 1969).

Hazen, A.T. and Kirby, J.P. *A Bibliography of Horace Walpole* (New Haven and London, Yale University Press, 1948).

Hipple, W.J. *The Beautiful, The Sublime and the Picturesque in Eighteenth-Century British Aesthetic Theory* (Illinois, the Southern Illinois University Press, 1957).

Honour, H. 'A House of the Gothic Revival', *Country Life* (1952), cxi, 1665–6.

Hunt, J.D. *William Kent: Landscape Garden Designer: An Assessment and Catalogue of His Designs,* Willis, P. (ed.) (London, A, Zwemmer, 1987).

—*The Figure in the Landscape: Poetry, Painting and Gardening during the Eighteenth Century* (Maryland, The Johns Hopkins University Press, 1989).

—*Gardens and the Picturesque: Studies in the History of Landscape Architecture* (Cambridge, MA, The MIT Press, 1992).

—*Greater Perfections: The Practice of Garden Theory* (London, Thames & Hudson, 2000).

Hunt, J.D. and Willis, P. (eds) *The Genius of the Place: The English Landscape Garden, 1620–1820* (Cambridge, MA, The MIT Press, 1988).

Ingram, J.H. *The True Chatterton* (London, T.F. Unwin, 1910).

Inskip, P. and Jenkins, P. *Conservation Management Plan for Strawberry Hill* (Unpublished, 2006).

Jesse, J.H. *George Selwyn and His Contemporaries* (4 vols, Bickers & son, London, 1882).

Johnson, J.W. 'Horace Walpole and W.S. Lewis', *Journal of British Studies* vol. 6, No. 2 (May 1967).

Jones, R.F. et al., *The Seventeenth Century: Studies in the History of English Thought and Literature form Bacon to Pope* (London, Oxford University Press, 1951).

Katz, S.H. 'Horace Walpole's Landscape at Strawberry Hill', *Studies in the History of Gardens and Designed landscapes,* vol. 28, Number 1, January–March (Oxon, Taylor & Francis, 2008).

Ketton-Cremer, R.W. *Norfolk Assembly* (London, Faber & Faber, 1957).

—*Horace Walpole: A Biography* (New York, Longmans, Green and Company, 1940, 1946) (3rd edn, London and Ithaca, Methuen & Co, 1964).

Klein, L.F. 'Liberty, Manners, and Politeness in Early Eighteenth-Century England', *The Historical Journal*, vol. 32, No. 3 (September 1989).

Laird, M. *The Flowering of the Landscape Garden: English Pleasure Grounds 1720–1800* (Philadelphia, University of Pennsylvania Press, 1999).

Lewis, W.S. 'A Library Dedicated to the Life and Works of Horace Walpole', in *The Colophon, A Book Collectors Quarterly* (New York, Pynson Printers, 1930).

—'The Genesis of Strawberry Hill', *Metropolitan Museum Studies* 5, part 1 (New York, 1934).

—*Collector's Progress* (New York, 1951).

—*Horace Walpole's Library* (Cambridge University Press, Cambridge, 1958).

—*Horace Walpole,* Bollingen Series 35, The A.W. Mellon Lectures in the Fine Arts 9 (New York, Pantheon Books, 1961).

—*A Guide to the Life of Horace Walpole* (New Haven and London, Yale University Press, 1973).

—*Rescuing Horace Walpole* (New Haven and London, Yale University Press, 1978).

McCarthy, M. *The Origins of the Gothic Revival* (New Haven and London, Yale University Press, 1987).

Mehrotra, K.H. *Horace Walpole and the English Novel: A Study of the Influence of 'The Castle of Otranto', 1764–1820* (New York, B. Blackwell, 1970).

Meir, J. *Sanderson Miller and his Landscapes* (Chichester, Phillimore & Co Ltd, 2006).

Meyerstein, E.H.W. *A Life of Thomas Chatterton* (London, Ingpen and Grant, 1930).

Morris, S. *Houghton Hall Park and Gardens: The Vision of a Minister* (London, The Architectural Association, unpublished MA thesis, nd).

Mowl, T. *Gentleman and Players: Gardeners of the English Landscape* (Stroud, Sutton, 2000).

Murray, C. *Garden History*, vol. 26, No. 2 (Winter 1998).

Nevill, J.C. *Thomas Chatterton* (London, F. Muller. 1948).

Paulson, R. *Breaking and Remaking: Aesthetic Practice in England, 1700–1820* (New Brunswick and London, Rutgers University Press, 1989).

Plumb, J.H. *Sir Robert Walpole: The Making of a Statesman* (Cresset Press, London, 1956).

Robins, G. *A Catalogue of the Classic Contents of Strawberry Hill Collected by Horace Walpole,* April 25th and 23 following days. (London, Smith and Robins, 1842).

—*The Collection of Rare Prints and Illustrated Works, Removed for Sale in London … collected by Horace Walpole,* 13 June 1842 and 9 following days (London, Smith and Robins, 1842).

Sabor, P. (ed.) *Horace Walpole: a Reference Guide* (Boston, G.K. Hall & Co, 1984).

—*Horace Walpole: The Critical Heritage* (London, Routledge & Kegan Paul, 1987).

—'Horace Walpole: Beyond *The Castle of Ontranto',* *1650–1850: Ideas, Aesthetics, and Inquiries in the Early Modern Era,* vol. 16 (New York, AMS Press Inc, 2009).

Schama, S. *Landscape and Memory* (London, Fontana, 1996).

Silver, S.R. *The Curatorial Imagination in England, 1600–1752* (Los Angeles, University of California, unpublished PhD thesis, 2008).

Sloan, K. (ed.) with Burnett, A. *Enlightenment: Discovering the World in the Eighteenth Century* (London, British Museum Press, 2003).

Smith, W.H. (ed.) *Horace Walpole, Writer, Politician and Connoisseur: Essays on the 250th Anniversary of Walpole's Birth* (New Haven and London, Yale University Press, 1967).

Smithers, P. *The Life of Joseph Addison* (Oxford, Clarendon Press, 1968).

Snodin, Michael, 'Strawberry Hill: Building and Site: Part Two: 'The Site', *Architectural History,* vol. 38 (Leeds, 1995).

—(ed.) *Horace Walpole's Strawberry Hill* (New Haven and London, Yale University Press, 2009).

Stowe Landscape Garden, The National Trust (nd).

Sweet, R. 'Antiquaries and Antiquities in Eighteenth-Century England', *Eighteenth-Century Studies,* 34 (Maryland, The Johns Hopkins University Press, 2001).

—*Antiquaries: The Discovery of the Past in Eighteenth-Century Britain* (London, Continuum, 2004).

Tavernor, R. *Palladio and Palladianism* (London, Thames and Hudson, 1991).

The Landscape Agency, *Strawberry Hill, Landscape Conservation Plan* (unpublished, 2006).

The Oxford Companion to the Garden, Taylor, P. (ed.) (Oxford, Oxford University Press, 2006).

Thorpe, C.D. 'Addison's Contribution to Criticism' (ed.) Jones, R.F. *The Seventeenth Century: Studies in the History of English Thought and Literature from Bacon to Pope* (Stanford, California, Stanford University Press, 1951).

Tipping, H.A. 'Strawberry Hill, Middlesex', *Country Life,* lvi, pp. 18–25, 56–64 (London, 1924).

—'Four Unpublished Letters from William Kent to Lord Burlington,' *Architectural Review,* vol. Ixiii (May and June 1928).

Van Eck, C. '"The splendid effects of architecture, and its power to affect the mind": The Workings of Picturesque Association', in Birksted, J. (ed.) *Landscapes of Memory and Experience* (London, SPON Press, 2000).

—(ed.) *British Architectural Theory 1540–1750: An Anthology of Texts (Reinterpreting Classicism)* (Surrey, Ashgate, 2003).

Wainwright, C. *The Romantic Interior: The British Collector at Home 1750-1850* (New Haven and London, Yale University Press, 1989).

Williamson, T. *Polite Landscapes: Gardens and Society in England* (Stroud, Sutton, 1995).

Wood, R. *The ruins of Palmyra; otherwise Tedmor in the desart* (London, 1753)

—*The ruins of Balbec, otherwise Heliopolis in Coelosyria* (London, 1757).

Woodbridge, K. *The Stourhead Landscape* (National Trust, 2002).

Youngren, W.H. 'Addison and the Birth of Eighteenth-Century Aesthetics', *Modern Philology,* vol. 79, No. 3. (Feb, 1982).

Websites

Barrell, C.W. *'Shake-speare's' Unknown Home On the River Avon Discovered.* Edward De Vere's Ownership of a Famous Warwickshire Literary Retreat Indicates Him As the True 'Sweet Swan of Avon.' (1942). http://www.source text.com/sourcebook/library/barrell/06avon.htm.

Copped Hall Trust. http://www.coppedhalltrust.org.uk/.

Demaray, H.D. 'Milton's "Perfect" Paradise and the Landscapes of Italy', *Milton Quarterly* (2007).

Grove Art Online http://www.oxfordartonline.com/.

Ken, T. *Hymnotheo or the penitent a* 1700, Wks. 1721 III, 73, http://www.oed.com/view/ Entry/176257?redirectedFrom=sepulchral#eid.

Marriage of a Saint, The Marriage of Henry VI. http://lwlimages.library.yale.edu/ strawberryhill/oneitem.asp?id=45.

Metamorphoses by Ovid. http://classics.mit.edu/Ovid/metam.1.first.html.

Old town of Regensburg with Stadtamhof. http://whc.unesco.org/en/list/1155.

http://onlinelibrary.wiley.com/doi/10.1111/j.1094-348X.1974.tb00908.x/full.

Oxford Dictionary of National Biography http://www.oxforddnb.com/.

Index

Page numbers in *italics* refer to figures.